Art Center W9-AWH-586

Mift from
Seida Robinson
1990

A HISTORY OF

ART

PAINTING·SCULPTURE·ARCHITECTURE
Linda Pohinson

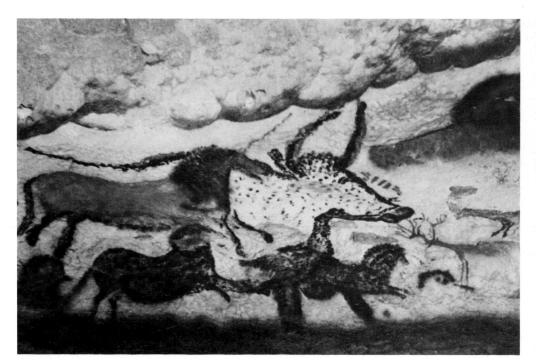

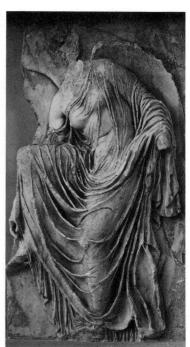

AR

FREDERICK HARTT

Paul Goodloe McIntire Professor Emeritus of the History of Art, University of Virginia

A HISTORY OF PAINTING · SCULPTURE **ARCHITECTURE**

Second Edition 1985

Project Director: MARGARET L. KAPLAN

Editor: MARGARET DONOVAN

Designer: ABBY GOLDSTEIN

Director, Rights and Reproductions: BARBARA LYONS

On the front cover: THE KLEOPHRADES PAINTER. *Rapt Maenad*. Staatliche Antikensammlungen und Glyptothek, Munich (fig. 208) On the back cover: *The Tetrarchs*. Façade of S. Marco, Venice (fig. 382)

Library of Congress Cataloging in Publication Data Hartt, Frederick.

Art: a history of painting, sculpture, architecture Bibliography: v. 1, p. ; v. 2, p.

Includes indexes.

Contents: v. 1. Magic, form, and fantasy, ancient world, Middle Ages—v. 2. The Renaissance, the Baroque, the modern world.

1. Art—History. I. Title. N5300.H283 1985 709 84-12380 ISBN 0-13-047374-X (pbk.: v. 1)

ISBN 0-13-047382-0 (pbk. : v. 2)

Published in 1985 by Harry N. Abrams, Incorporated, New York All rights reserved. No part of the contents of this book may be reproduced without the written permission of the publishers Printed and bound in Japan

TO MEYER SCHAPIRO

Scholar, teacher, counselor, friend

CONTENTS

PREFACE 11 INTRODUCTION 13 The Nature of Art

PART ONE

MAGIC, FORM, AND FANTASY 31

CHAPTER ONE ART BEFORE WRITING 33

Paleolithic Art Mesolithic Art Neolithic Art

CHAPTER TWO THE ART OF LATER ETHNIC GROUPS 46

Black African Art Oceanic Art North American Indian Art Pre-Columbian Art

PART TWO

THE ANCIENT WORLD 69

CHAPTER ONE EGYPTIAN ART 72

The Archaic Period and the Old Kingdom The Middle Kingdom and the Empire

CHAPTER TWO MESOPOTAMIAN ART 102

Sumer Akkad Neo-Sumer and Babylon Assyria Neo-Babylonia Persia

CHAPTER THREE AEGEAN ART 122

Cycladic Art Minoan Art Mycenaean Art

CHAPTER FOUR GREEK ART 133

Geometric and Orientalizing Styles The Archaic Period The Classical Period—The Severe Style and Its Consequences The Classical Period—The Age of Pericles The Classical Period—The Fourth Century The Hellenistic Period

CHAPTER FIVE ETRUSCAN ART 208

Architecture Sculpture Bronze Implements Tombs

CHAPTER SIX ROMAN ART 219

The Republic The Early Empire The Second Century
The Third Century The End of the Pagan Empire

PART THREE

THE MIDDLE AGES 283

CHAPTER ONE EARLY CHRISTIAN AND BYZANTINE ART 287

The Earliest Christian Art The Age of Constantine The Age of Justinian Middle and Later Byzantine Art

CHAPTER TWO ISLAMIC ART 349

Early Architecture Later Architecture Painting

CHAPTER THREE BARBARIAN AND CHRISTIAN ART IN NORTHERN EUROPE 369

Celtic Art The Animal Style Hiberno-Saxon Art

CHAPTER FOUR THE ART OF THE HOLY ROMAN EMPIRE 382

Carolingian Art Ottonian Art

CHAPTER FIVE ROMANESQUE ART 407

Architecture and Sculpture in France Architecture and Sculpture in Italy Vaulting in the Rhineland, Lombardy, Northumbria, and Normandy Mural Painting Manuscripts

CHAPTER SIX GOTHIC ART 446

The Beginnings of Gothic Style The French Cathedral French Manuscripts
The Later Gothic in France Germany Spain England Architecture in Italy

Following Page 495

GLOSSARY BOOKS FOR FURTHER READING INDEX PHOTOGRAPH CREDITS

MAPS

Europe and the Near East in Prehistoric Times 32 2. West Africa 47 3. South Pacific 52 4. Central and Northwestern South America 58 5. Egypt and the Near East in Ancient Times 74 6. The Hellenic World 137 7. The Acropolis, Athens 168 8. Etruria 209 9. The Roman Empire at Its Greatest Extent 220 10. Europe and the Near East in the Early Middle Ages 288 11. Europe in the High Middle Ages 409

TIME LINES

I. Art Before Writing/Later Ethnic Groups 66
II. Egyptian/Mesopotamian/Aegean 120 III. Greek 206
IV. Etruscan/Roman 280 V. Early Christian and Byzantine/Islamic/Northern
Europe 380 VI. Holy Roman Empire/Romanesque 444 VII. Gothic 494

109 HAR 1985

PREFACE

Art is the only thing that can go on mattering once it has stopped hurting.

Elizabeth Bowen

The purpose of this book is to give students of all ages something that really will go on mattering, once the bluebooks have been handed in and the painfully memorized names and dates have receded into dimmer levels of consciousness. To this end I have tried to put together a usable account of the whole history of artistic production in the Western world—an activity that ranks as the highest of all human achievements (so I maintain), surpassing even the most startling cures of modern medicine and the little machine hurtling past the last planets and out into interstellar space. Obviously no teacher can use all the material in these two volumes. But I respect teachers enough to give them their choice of what to include and what to leave out, and students enough to want them to have a book that they can keep and continue to explore on their own, whether or not they ever take another course in the history of art. General readers, equally deserving of respect, will surely not object to as full a picture as possible.

The revised edition is the product of many months of thought and labor. Much has had to be changed through experience, mine and that of other teachers. The format is different, with colorplates mixed in with black-and-white illustrations in closer proximity to the relevant text. The order of several chapters has been changed, in order to produce a more continuous flow of barbarian, Byzantine, and Renaissance art. The Introduction and time lines have been totally recast and illustrated. The Introduction may seem a little less "scholarly" than the original version, but it now includes guidelines on how to approach, look at, and think about works of art. Books have been written on this subject, many of them, and I have deliberately restricted my account to what can fit into an introduction. Also, the defeating columns of continuous print in the Introduction have been broken up by illustrations, chosen so as to provide immediate examples of the principles under discussion (figure numbers are supplied to refer to still more examples in later chapters).

Finally, a long-overdue attempt has been made to give women something approaching their just treatment in the history of art. But the reader should understand that the task is not as easy as it might seem. What can one say about women artists in periods when women were systematically excluded from all forms of artistic production except, let us say, embroidery? And what can one write about women as artistic leaders in later periods when they were still permitted only marginal participation? In those chapters in which women either do not appear at all or turn up in minor roles, an attempt is made to explain why. I hope the reader will also understand that what I say in the Introduction about Women in Art, and what I undertake in other chapters, has been carried out with goodwill and conviction. Time alone will tell whether it is sufficient.

The teacher-student relationship is one of the deepest and most productive of all human bonds. How can I forget what my own long career has owed to the teachers, graduate and undergraduate, who gave me my start? Fifty years ago, as a college sophomore, I registered for a class with Meyer Schapiro, and the whole course of my life was transformed. Not only did he introduce me to the fields of medieval and modern art, in which his knowledge is vast, but he opened my eyes to the meaning of art-historical studies and to methods of art-historical thought and investigation. I am grateful to other magnificent teachers, now no longer living, especially to Walter W. S. Cook, Walter Friedlaender, Karl Lehmann, Millard Meiss, Richard Offner, Erwin Panofsky, George Rowley, and Rudolf Wittkower, and to Richard Krautheimer. The faith, advice, and inspiration of Bernard Berenson stood me in good stead in many a difficult moment. I owe much to the generosity of Katherine S. Dreier who in 1935 opened to me her pioneer collection of modern art and to the rigorous discipline of the sculptor Robert Aitken who taught me what a line means.

At this moment I think also with warmth and happiness of all my students since I began teaching in 1939—of those seas of faces in the big survey courses at Smith College, Washington University, the University of Pennsylvania, and the University of Virginia, as well as of the advanced and graduate groups, many of whose members have themselves been teaching for a quarter of a century and are now in a position to give me valued criticism and advice.

My colleagues at the University of Virginia—Malcolm Bell III for ancient art, John J. Yiannias for Byzantine and early medieval, Marion Roberts for late medieval and Northern Renaissance, Keith P. F. Moxey for Baroque, and David Winter for the eighteenth and nineteenth centuries—read the sections of the manuscript that pertain to their special fields, gave me the benefit of their learning and insight, and made many crucial suggestions. Once the first edition was in print, Kenneth J. Conant, Miles Chappell, and Martin S. Stanford made important corrections. My former colleague Fred S. Kleiner and my present colleague John Dobbins provided many valuable corrections and suggestions for the chapters on Greek and Roman art. Helpful suggestions were also made by Karl Kilinski II. The reviewers invited by Prentice-Hall made many comments for the revision, some mutually contradictory, others extremely useful. Marvin Eisenberg in particular gave me more and better advice for the reorganization of the book than I can ever hope to acknowledge.

I deeply appreciate the confidence of the late Harry N. Abrams for having entrusted me with the task of writing this book and am grateful to the unforgettable Milton S. Fox for starting me off on it. My thanks also go to Margaret L. Kaplan for invaluable supervisory and editorial work on both editions and for valiant assistance in the crises that inevitably beset any ambitious undertaking; to John P. O'Neill for his sensitive and careful editorship of the first edition; to Margaret Donovan who with insight and patience has edited the second, collaborating with me in the innumerable problems of revision; and to Barbara Lyons and her staff who—with infinite labor—assembled all the illustrative material. The fresh new design is by Abby Goldstein, and the beautiful new maps and time lines are the work of Robert Gray. Jeryldene Wood has helped me on many matters, especially the search for new material in libraries and the revision of the text for the time lines.

Frederick Hartt Belvoir, Charlottesville, Virginia Advent, 1983

THE NATURE OF ART

What is art? That question would have been answered differently in almost every epoch of history. Our word art comes from a Latin term meaning "skill, way, or method." In ancient times and during the Middle Ages all kinds of trades and professions were known as arts. The liberal arts of the medieval curriculum included music but neither painting, sculpture, nor architecture, which were numbered among the mechanical arts, since they involved making objects by hand. At least since the fifteenth century, the term art has taken on as its principal characteristic in most societies the requirement of aesthetic appreciation as distinguished from utility. Even if its primary purpose is shelter, a great building, for example, is surely a work of art.

The word *aesthetic* derives from a Greek term for "perceive," and perception will occupy us a little farther on. What is perceived aesthetically is "beauty," according to the Oxford Dictionary, and beauty is defined as the quality of giving pleasure to the senses. Yet there are paintings, sculptures, plays, novels intended to produce terror or revulsion by the vivid representation of tragic or painful subjects. The same goes for certain moments in music, when loud or dissonant sounds, hardly distinguishable from noise, are essential for the full realization of the composer's purpose. These are undeniably works of art in the modern meaning of the term, even though beauty conceived as pleasure is largely excluded—that is, unless we are willing to count the pleasure we feel in admiring the author's ability to present reality or the not especially admirable pleasure a horror film gives to an audience seated in perfect safety.

Clearly something essential has been overlooked in the Oxford definition of beauty. To be sure, throughout history beauty has been analyzed on a far loftier plane than mere sensory pleasure, beginning in Greek philosophy with treatments of a divine order of which the beauty we perceive is a dim earthly reflection. And later writers on the philosophy of art—especially in the eighteenth century and since, culminating in the self-proclaimed "science" of aesthetics—have considered beauty from many different standpoints, constructing elaborate philosophical systems, often on the basis of limited knowledge of art and its history. Is there not some distinguishing quality in the very nature of a work of visual, literary, or musical art that can embrace both the beautiful and the repellent, so often equally important to the greatest works of art? The question may perhaps be answered in the light of a concept developed by the early twentieth-century American philosopher of education John Dewey in his book *Art as Experience*. Without necessarily subscribing to all of Dewey's doctrines, one can assent to his basic belief that all of human experience, beautiful and ugly, pleasurable and painful, even humorous and absurd, can be distilled by the artist, crystallized in a work of art, and preserved to be experienced by the observer as long as that work lasts. It is this ability to embrace human experience of all sorts and transmit it to the observer that distinguishes the work of art.

Purpose

If all of human experience can be embodied in works of art, we have then to ask, "Whose experience?" Obviously the artist's first of all. The work inevitably includes some reference to the artist's existence, but often even more to the time in which he or she lived. It may have been ordered by a patron for a specific purpose. If a building or part of a building, the work undoubtedly had a role to play in the social or religious life of the artist's time. Can we appreciate such works without knowing anything of their purpose, standing as we do at a totally different moment in history?

Perhaps we can. There are many works of prehistoric art—like the animals on cave walls and ceilings (see figs. 20, 21, and 22)—that we cannot interpret accurately in the complete absence of reliable knowledge, but to our eyes they remain beautiful and convincing. This may be because we can easily relate them to our own experience of animals. And there are others, such as the temples on the island of Malta (see fig. 35) or the colossal Easter Island sculptures (see fig. 50), that are impressive to us even if foreign to every kind of experience we can possibly know. Simply as forms, masses, lines, we find them interesting. Yet how much more articulate and intelligent our response to works of art can be if we know their purpose in the individual or corporate experience of their makers. We can take a part of a building that strikes us as beautiful, study how it was originally devised to fit a specific practical use, then watch it develop under changing pressures, sometimes to the point of total transformation. Or we can watch a type of religious image arise, change, become transfigured, or disappear, according to demands wholly outside the artist's control. Such knowledge can generate in us a deeper understanding and eventually an enriched appreciation of the works of art we study. If we learn to share the artist's experience, insofar as the historical records and the works of art themselves make it accessible to us, then our own life experience can expand and grow. We may end up appreciating the beauty and meaning of a work of art we did not even like at first.

Today people make works of art because they want to. They enjoy the excitement of creation and the feeling of achievement, not to speak of the triumph of translating their sensory impressions of the visible world into a personal language of lines, surfaces, forms, and colors. This was not always so. Throughout most of history artists worked characteristically on commission. No matter how much they enjoyed their work, and how much of themselves they poured into it, they never thought of undertaking a major work without the support of a patron and the security of a contract. In most periods of history artists in any field had a clear and definable place in society—sometimes modest, sometimes very important—and their creations thus tended to reflect the desires of their patrons and the forces in their human environment.

Today the desires that prompt patrons to buy works of art are partly aesthetic. Collectors and buyers for museums and business corporations do really experience a deep pleasure in surrounding themselves with beautiful things. But there are other purposes in collecting. Patrons want to have the best or the latest (often equated with the best) in order to acquire or retain social status. Inevitably, the thought of eventual salability to collectors can, and often does, play a formative role in determining aspects of an artist's style. It takes a courageous artist to go on turning out works of art that will not sell.

In earlier periods in history factors of aesthetic enjoyment and social prestige were also important. Great monarchs or popes enjoyed hiring talented artists not only to build palaces or cathedrals, but also to paint pictures, to carve statues, to illustrate manuscripts, or to make jewels—

partly because they enjoyed the beautiful forms and colors, but partly also to increase their apparent power and prestige.

If our appreciation of art is subject to alterations brought about by time and experience, what then is quality? What makes a work of art good? Are there standards of artistic value? These essential questions, perpetually asked anew, elude satisfactory answer on a verbal plane. One can only give examples, and even these are sure to be contradictory. The nineteenth-century American poet Emily Dickinson was once asked how she knew when a piece of verse was really poetry. "When it takes the top of your head off," she replied. But what if a work of art that ought to take the top of your head off refuses to do so? Demonstrably, the same work that moves some viewers is unrewarding to others. Moreover, time and repeated viewing can change the attitude of even an experienced person.

Often a dynamic new period in the history of art will find the works of the preceding period distasteful. Countless works of art, many doubtless of very high quality, have either perished because the next generation did not like them or have been substantially altered to fit changes in taste. (As we shall see, there are other motives for destruction as well.) And even observers of long experience can disagree in matters of quality.

The twentieth century, blessed by unprecedented methods of reproduction of works of art, has given readers a new access to the widest variety of styles and periods. Incidentally, André Malraux in his book *The Museum Without Walls* has pointed out the dangers of this very opportunity in reducing works of art of every size and character to approximately the same dimensions and texture. There is, of course, no substitute for the direct experience of the real work of art, sometimes overwhelming in its intensity no matter how many times the student has seen reproductions.

The ideal of the twentieth century is to like every "good" work of art. There is an obvious advantage in such an attitude—one gains that many more wonderful experiences. Yet there are inborn differences between people that no amount of experience can ever change. If after reading many books and seeing many works of art, ineradicable personal preferences and even blind spots still remain, the student should by no means be ashamed of them. Barriers of temperament are natural and should be expected. But—and this is all-important—such admissions should come after, not before, a wholehearted attempt to accept the most disparate works of art on their own grounds; one must not merely condemn them because they are unfamiliar. The world of art is wide and rich; there is room in it for everyone who wants to learn, to experience, above all to see.

Women in Art

Part of the explanation of women's exclusion from artistic endeavors, as well as from others, is doubtless to be sought in their physical status in times before modern medicine. What men have historically demanded of women was a home and children. Until quite recently it took a steady round of childbearing to produce a few living heirs. Most women were married in their teens, and most married women were pregnant most of the time. Many died in or as a result of endless childbirths, and relatively few survived the childbearing age for long. Men also wanted to make sure that the children were their own. In their eyes, the hurly-burly of a studio full of apprentices and assistants was no place to maintain "chastity." In fact, the pioneer woman painter Artemisia Gentileschi was actually raped in her father's studio by one of his assistants. Nor could women be permitted to study the nude figure, in periods when such study was the

foundation of all art involving human representation. As recently as 1931–34, when I attended drawing and sculpture classes at the Art School of the National Academy of Design in New York City, women and men were required to work in separate life classes, and no male model could be shown entirely nude to women. A glance at even the bathing suits of the 1920s and 1930s (not to speak of those of the 1890s) in old photographs will show how far we have come since. Modern medicine has insured that most babies will survive, and contraception can limit the number of births to those desired. Women, in the Western world at least, now outlive men. We are still trying to cope with the moral implications of the revolution in sexual attitudes, but one by-product has surely been that women can now study the human body and engage in studio life without disapproval.

Furthermore, a woman tied to domesticity and constant pregnancy could scarcely participate in any other very arduous physical activities. In the days when architects got their start as carpenters or stonemasons, and sculptors as stonecutters, it is not hard to see why women could not join in. Even painting, in the Renaissance, involved strenuous activity high on scaffolding, carrying sacks of sand and lime and pots of water. The only women artists recorded in antiquity painted portraits, which could be done in comfortable surroundings. Alas, their work is all lost. But in the Middle Ages nuns in convents, remote from male company, were considered expert painters of illuminated manuscripts. Five splendid examples known to have been painted by women are included in this revision, for the first time in any general textbook. Then, in the sixteenth and seventeenth centuries, painters' daughters (like Artemisia Gentileschi) began to participate, and the occasional woman painter appeared on her own. Some achieved excellence, and several are included here. But even as late as the eighteenth century women were still mostly limited to portrait painting (often with spectacular results).

In sculpture the widespread use of the pointing machine eventually relegated stonecutting to expert workmen, and once the procedure became less physically demanding women sculptors appeared—in the late nineteenth and twentieth centuries. And when architecture began to be taught in schools rather than springing spontaneously from woodworking or stoneworking shops women students began to attend, although they are still relatively rare.

In periods when women artists are infrequent or entirely absent I have done my best to explain why. When they begin to turn up in numbers, they take their place with the men in these pages. Since the final work of art often owes a great deal to the desires of the patron who commissioned it, consideration has also been given to women patrons, who were many times extremely imaginative and original.

PERCEPTION AND REPRESENTATION How has the artist perceived and recorded the visible world—trees, let us say—in widely separated periods in the history of art? The earliest known European landscape, a wall painting from the Greek island of Thera (fig. 1), dates from about 1500 B.C. and shows natural forms reduced to what look like flat cutouts. The contours and a few inner shapes of rocks, plants, and birds are drawn in outline (as in most very early art, or indeed the art of children or of present-day untrained adults) and simply colored in, accurately enough, however, for identification. Doubtless the occupants of the room felt they were in the midst of a "real" landscape, wrapped around

Style

- Room with landscape frescoes from the Cycladic island of Thera, including areas of modern reconstruction. Before 1500 B.C. National Archaeological Museum, Athens
- Giotto. Joachim Takes Refuge in the Wilderness, fresco, Arena Chapel, Padua, Italy. 1305–6

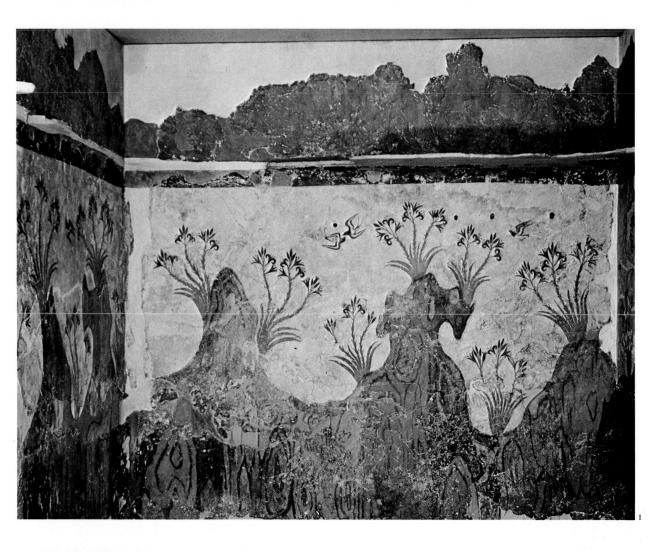

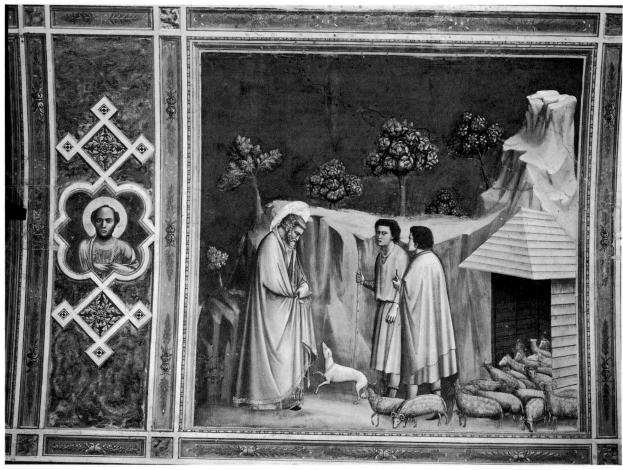

them on three walls, but few today would agree, despite the charm of the murals as decoration and the bouncing vitality of the outlines.

In a work (fig. 2) painted shortly after A.D. 1300 by the Italian artist Giotto, rocks and plants are beautifully modeled in light and shade and do seem to exist in three dimensions, yet they are anything but real to our eyes compared to the figures who stand in front of them. Accounts written by one of Giotto's followers indicate that he advised painting one rock accurately and letting that stand for a mountain or one branch for a tree. Nonetheless we know that Giotto's contemporaries thought that his paintings looked very real.

A little over a hundred years later the Netherlandish painter Jan van Eyck presents in a panel from the Ghent Altarpiece (fig. 3) a view of rocky outcroppings and vegetation similar in structure to that of Giotto's fresco, but in a manner anyone today would easily call realistic. Van Eyck's amazingly sharp perception has enabled him to render every object, from the smallest pebble in the foreground to the loftiest cloud in the sky, with an accuracy few photographs can rival. Every tree appears entire and in natural scale, down to the last leaf, and in believable light and shade. Yet is the picture as real as it seems at first sight? Do we encounter in real experience figures looking like this, all turned toward us and lined up on a rocky ledge that is sharply tilted so we can see every object clearly?

A radically different and very modern form of perception is seen in such Impressionist paintings of the late nineteenth century as Renoir's Les Grands Boulevards (fig. 4), in which all contours and indeed all details disappear, being blurred or lost as the artist seeks to seize with rapid brushstrokes a fleeting view of city life in bright sunlight and in constant motion. Trees and their component branches and foliage are now mere touches of the brush. This was the uncalculated, accidental way in which Renoir and his fellow Impressionists viewed the world, striving in their pictures for the speed and immediacy no snapshot photograph could then achieve and at the same time for a brilliance of color inaccessible to photography until many decades later. Today most viewers accept this image quite happily, but not in Renoir's day, when the Impressionists were violently attacked in print for being so *un*real!

Finally, in the twentieth century, painters fully trained in both realist and Impressionist methods transformed the image of trees into a pattern almost as unreal to our eyes as that of the Thera murals, even though it is often rendered with a freedom of brushwork that owes much to the Impressionists. To the Dutch painter Mondrian, his Red Tree (fig. 5), overpowering in its fiery red against a blue sky, translates what may have been the color of sunset light into an expression of the ultimate reality of inner individual experience.

Optically, there can have been very little difference in the images of trees transmitted to the retinas of Mondrian, Renoir, van Eyck, Giotto, and the unknown painter of Thera. The startling difference in the results is due to the differing sets of conventions, inherited or self-imposed, according to which each artist selected, reinforced, and recombined those aspects of the visual image which seemed important. Reality, in the long run, is as elusive and subjective a concept as beauty, yet just as compelling for the artist and for us.

THE VOCABULARY OF ART

Form. The form of an object is its shape, usually considered in three dimensions. (The word form is also used in music and literature, and in the visual arts as well, to mean the interrelationship of all the parts of a

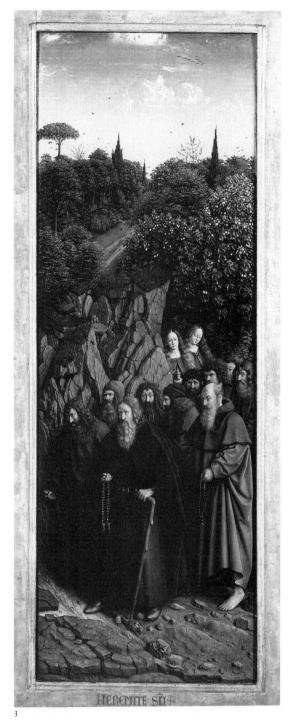

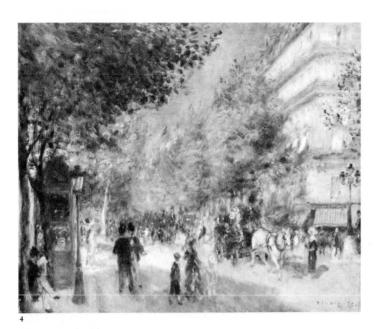

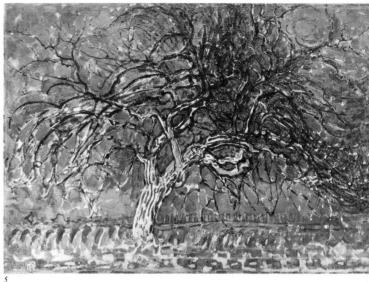

work.) Visual form is perceived first of all through binocular vision, by means of which each eye sees the object from a slightly different point of view, enabling the mind to create a three-dimensional image. The reader has only to test this proposition by closing one eye and noting the difficulty in perceiving accurately the shapes of objects and their positions in space. Form can also be perceived manually, through the sense of touch, which sends messages to the brain; by its very nature sculpture appeals to this sense. Painting, generally on flat or nearly flat surfaces, can only suggest the "3-D" effect that is the birthright of sculpture. The elements used by painting to indicate form are line, light and shade, and color, each of which as we will see can also play other important parts in the effect of the work of art.

The words volume and mass are also used almost interchangeably to indicate three-dimensionality, but without the connotation of shape, which is essential to the word form. Volume can even indicate the spatial content of an interior. The impact of mass on the observer is greatly enhanced by scale, which is an absolute quality in works of art, hence the difficulty in experiencing from small illustrations the breathtaking effect of colossal buildings like Egyptian temples or Gothic cathedrals.

Line. Line can be seen as an edge or contour, of one shape against another or against distance, by means of which form can be deduced. A line can also be drawn, like the lines of a diagram or those which make up a printed letter of the alphabet. This kind of line can not only convey a great deal of factual information but can also clearly delineate form, as in Greek vase paintings (fig. 6; see also figs. 207, 226). Lines can be independent, or several lines can cooperate in the formation of a pattern (see page 23). Generally in ancient and medieval art, lines are drawn firmly and appear unbroken, but sometimes a very lively effect is obtained by preserving in a sketchy line the actual motion of the artist's hand carrying the drawing instrument (as in some medieval manuscripts; see fig. 505, for example). Finally, line can suggest the direction of motion ("line of fire," for example), seen typically in such instances as the "sweep" or "fall" of folds of cloth (drapery is the technical term; see figs. 232 and 576, for sharply different examples).

- 3. Hubert(?) and Jan van Eyck. Hermit Saints, detail of the Ghent Altarpiece (open). Completed 1432. Oil on panel, $11'5\frac{3}{4} \times 15'1\frac{1}{2}''$ (entire altarpiece). Cathedral of St. Bavo, Ghent, Bel-
- 4. PIERRE AUGUSTE RENOIR. Les Grands Boulevards. 1875. Oil on canvas, $20\frac{1}{2} \times 25^{"}$. Collection Henry P. McIlhenny, Philadelphia
- 5. PIET MONDRIAN. The Red Tree. 1908. Oil on canvas, $27\frac{1}{2} \times 39^{\prime\prime}$. Gemeentemuseum, The Hague

Light and shade. Light falling on an object leaves a shade on the side opposite to the source of light; this shade is distinct from the shadow cast by the object on other objects or surfaces. The shade may be hard and clearcut or soft and indistinct, according to the degree of diffusion of the light that causes it. The relationship of light and shade suggests form, but can be deceptive, since shade varies not only according to projections but to the position of the source of light. The same work of sculpture can look entirely different in photographs taken in different lights. Light and shade are also often used very effectively in strong contrast to produce effects of emotion (see fig. 396).

Color. Color is subject to more precise and complex scientific analysis than any of the other elements that make up the visual experience of art. For this book the most useful terms are those describing the effects of the various ways the artist employs bue (red, blue, vellow, etc.), saturation (intensity of a single color), and value (proportion of color to black and white). Colors can be described in terms such as brilliant, soft, harmonious, dissonant, harsh, delicate, strident, dull, and in a host of other ways. Blue and its adjacent colors in the familiar color circle, green and violet, are generally felt as cool, and through association with the sky and distant landscape appear to recede from us. Yellow and red, with their intermediate neighbor orange, are warm and seem nearer. In most early painting color is applied as a flat tone from outline to outline (see, for instance, figs. 93, 114). Broken color, in contrast, utilizes brushwork to produce rich effects of light (see figs. 290, 325). Modeling in variations of warm and cool colors suggests form, but color, modeled or not, evokes by itself more immediate emotion than any element available to the artist, to such a degree that extremely saturated color, like bright red or yellow, would be felt as unbearable if applied to all four walls and the ceiling of a room.

Space may be defined as extent, either between points or limits, or without known limits, as in outer or interplanetary space. Since space encourages, limits, or directs human existence and motion, it constitutes one of the most powerful elements in art just as it does in life. An architect can set boundaries for space in actuality, as a painter or sculptor can through representation. The space of the Pantheon (fig. 7)—a Roman temple consisting of a hemispherical dome on a circular interior whose height is equal to its radius and therefore to that of the dome—has a liberating effect the minute one steps inside, almost like a view into the

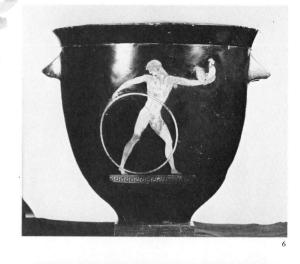

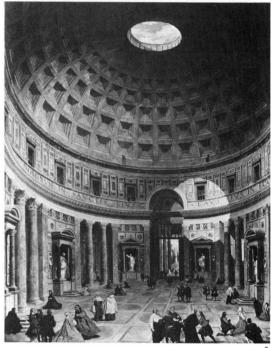

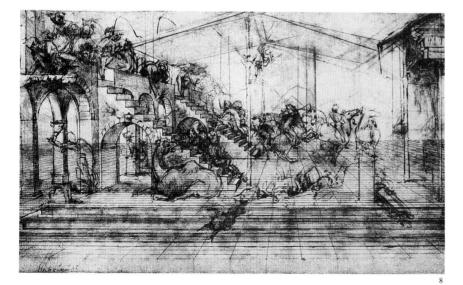

- 6. The Berlin Painter. Ganymede (portion of a bell-shaped krater found in Etruria, Italy). Early 5th century B.C. Height c. 13". The Louvre, Paris
- 7. GIOVANNI PAOLO PANNINI. Interior of the Pantheon. c. 1750. Oil on canvas, $50\frac{1}{2} \times 39^{\prime\prime}$. National Gallery of Art, Washington, D.C. Samuel H. Kress Collection
- 8. Leonardo da Vinci. Architectural Perspective and Background Figures, for the Adoration of the Magi. c. 1481. Pen and ink, wash, and white, $6\frac{1}{2} \times 11\frac{1}{2}$ ". Gabinetto dei Disegni e Stampe, Galleria degli Uffizi, Florence
- 9. King Chephren, from Giza, Egypt. c. 2530 B.C. Diorite, height 661/8". Egyptian Museum, Cairo

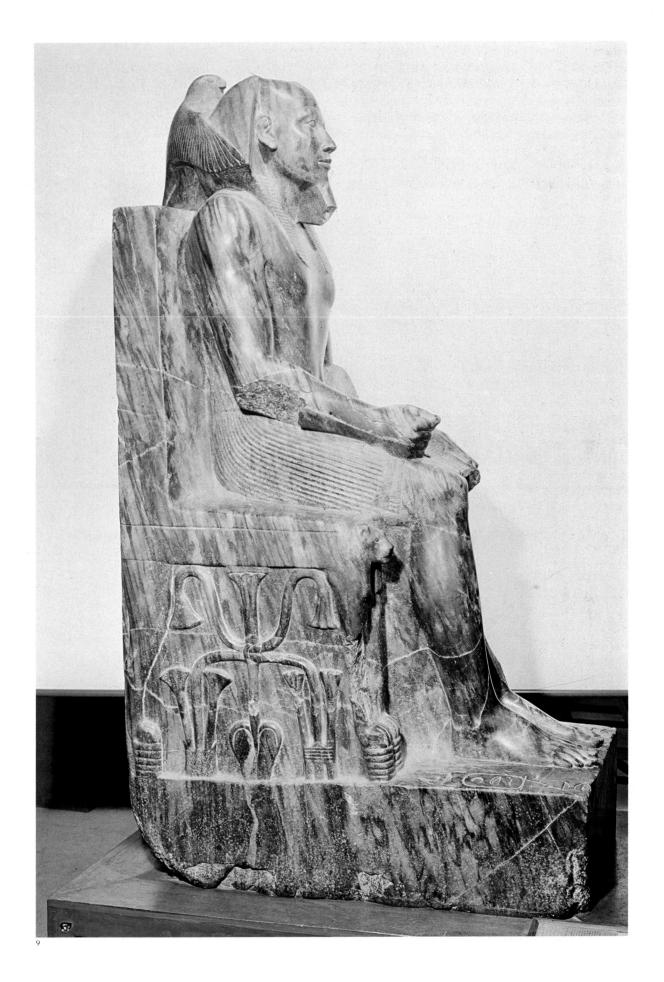

THE NATURE OF ART 21

sky (itself often called a dome). The space would seem to rotate constantly if it were not held fast by a single niche opposite the entrance. In sharp contrast the interior of the French abbey church of Vézelay (see fig. 530)—long, relatively low, and cut into segments by heavy, striped arches—seems to constrict and gradually drive the observer inward.

A painter or sculptor can represent space by means of linear perspective. This is a system in which spatial depth is indicated by means of receding parallel lines that meet at a vanishing point on the horizon and cross all lines parallel to the surface of the image, as seen in Leonardo da Vinci's preparatory drawing for a painting of the Adoration of the Magi (fig. 8). The grid thus formed controls the size of all represented objects according to their positions in its diminishing squares, so that they too diminish in an orderly fashion as they recede from the eye. Although diminution takes place just the same indoors and outdoors, a consistent system of linear perspective obviously demands a man-made enclosing structure, composed of regularly recurring elements, like a colonnade or a checkered floor. Perspective can also be atmospheric, that is, objects can lose their clarity according to their distance from us, because of the always increasing amount of moisture-laden atmosphere that intervenes (see figs. 322, 325). In early art space is generally represented diagrammatically, by superimposing distant objects above those nearby (see fig. 92). Space can even be suggested, though not represented, by means of flat. continuous backgrounds without defined limits (see figs. 225, 431).

Surface. The physical surface of any work of art is potentially eloquent. A painted surface has a texture (from the Latin word for weave), which can sometimes be consistent and unaltered; such is the case with Egyptian, Greek, and Etruscan murals (see figs. 93, 225, 305), where the surface declares the clean white plaster of the wall, or with Greek vases (see figs. 207, 208), where red clay slip is set against glossy black. Or it can be enriched as we have seen, in the rendering of light and shade and color, by countless brushstrokes so as to form a vibrant web of tone, as in Roman painting (see fig. 321). In mosaic—the art of producing an image by means of cubes of colored stone or glass—the handling of the surface is especially important. In the Middle Ages these facets were set at constantly changing angles to the light so as to sparkle (see, for instance, figs. 413, 431, 465).

Depending on the inherent properties of the material, sculpture in stone can sometimes be smooth and polished to reflect light, as in fig. 9, in green diorite (see also, for example, fig. 331 in black and white onyx; fig. 382 in red porphyry; and fig. 190 in white marble). Or the crisp details of a marble surface can be filed away so that the crystalline structure of the stone can retain light and blur shadow (see fig. 281). Or it can be left somewhat rough, showing even the tool marks, so as to give an impression of density and strength in keeping with the architecture of which it is a part (see figs. 601, 602). Sculpture cast in bronze has generally been smoothed by tools after casting to produce a polished surface reflecting light. The tool marks scratched in the original clay model from which the molds were made can be left unaltered (see fig. 265) or reinforced by cutting with a sharp metal tool into the final bronze surface (see fig. 307). Closer to our own time, the French sculptor Rodin in the late nineteenth century allowed the bronze to preserve all the freshness of the soft clay without any attempt to smooth away the marks of the fingers. Such surfaces may be compared with the free brushwork of the Impressionists, Rodin's contemporaries.

Opposites in architectural surface are the inert, quiet stone of the

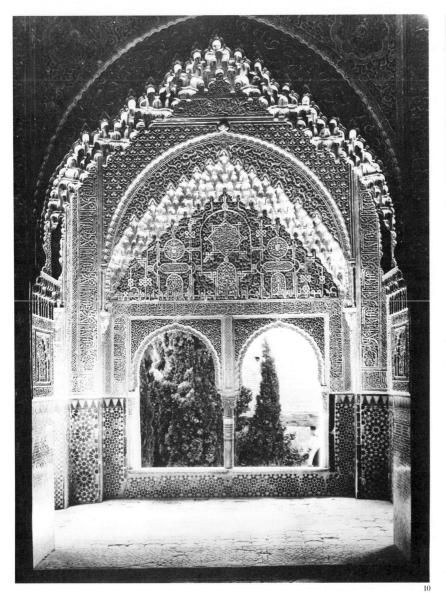

Pattern. Most of the previous elements—line, light and shade, color, surface—can be combined to form a pattern if the individual sections (known as motives) recur with some regularity, either exactly or in recognizable variations. Brilliant examples of pattern raised to a high pitch of complexity are the Islamic buildings we have just seen and the Hiberno-Saxon illuminated manuscripts of the early Middle Ages (fig. 11). Generally pattern is considered to operate only in two dimensions, so form and space have been excluded.

Composition. All of the elements we have been discussing, or any selection from them, can be combined to form a composition, understood as a general embracing order, if the artist has determined their coherence consistently. The artist may have made a preliminary sketch showing where the various sections would go, or they may have fallen into place as the artist worked. Types of composition can be enumerated almost indefi-

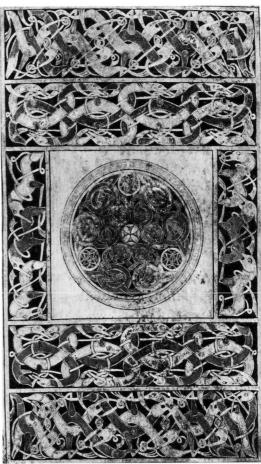

 The Queen's Chamber, the Alhambra, Granada, Spain. c. 1354–91

Decorative page from the *Book of Durrow*.
 Northumbria. 2nd half of 7th century A.D.
 Illumination. Trinity College, Dublin

nitely, according to the artist's decision to emphasize one element or another or to the kind of system the artist devises to bring all the motives together. A great many different types will appear in the following pages.

Style. Finally, in any work of art, visual, musical, or literary, the total aesthetic character, as distinguished from the content or meaning (see pp. 27-28), is known as style. In other words, style is the way in which the artist has treated the visual elements we have been considering (or such corresponding elements as words, phrases, sentences in literature; tones, melodies, harmonies in music). Names, such as primitive, archaic, classic, realistic, abstract, have been developed for styles and are capitalized if they correspond to specific countries, historical periods (Middle Ages, Renaissance), or movements (Impressionism, Cubism). Such names are useful as hooks on which to hang works of art in our minds so that we can find them again. But they can be dangerous if we consider them as entities in themselves. Indeed, if we try to force our observations of works of art into grooves predetermined by names of styles, we may find ourselves shaping various elements in order to make them fit the names, or even ignoring incongruous elements altogether. In many periods, such as Egyptian, a common style was indeed imposed on all works of art with only occasional exceptions. Nonetheless quite different styles, sometimes a surprising number of them, can exist at the same time and place, and even make war upon each other. Throughout this book an effort has been made to bring out the special style of each individual work of art and to place it in relation to the complex and perhaps even contradictory tendencies of the period in which it was produced.

In almost every society, up to and probably including the present, what we call today *iconography* (from two Greek words meaning "image" and "write"), that is, the subject matter of art, is of primary importance.

In the past iconography was generally related predominantly to religion or politics or both and was therefore likely to be systematic. In a religious building the subjects of wall paintings, stained-glass windows, or sculpture were usually worked out by the patron, often with the help of a learned adviser, so as to narrate in the proper sequence scenes from the lives of sacred beings or to present important doctrines in visible form through an array of images with a properly determined order and placing, and even with the proper colors. The artist was usually presented with such a program and required to execute it. Sometimes, as in the wall paintings in the interior of Byzantine churches, the subjects, the ways of representing them, and the places in which they could be painted were codified down to the smallest detail and keyed delicately to the Liturgy. Even in those periods in history when powerful artistic personalities worked in close relationship with patrons and advisers, artists were still not free to choose their subjects at will.

In regard to secular subjects as well, when patrons wished to commemorate their historic deeds they were certain to direct the artist as to how these should be represented. Only extremely learned artists, in certain relatively late periods of historic development, might be in a position to make crucial decisions regarding secular iconography on their own, and even then only with the general approval of the patron. Often in regard to both religious and secular subjects artists worked with the aid of iconographic handbooks compiled for the purpose.

Also, although we have little documentary evidence, the desires of the secular or religious patron for an effect—aiming at such qualities as Iconography

God as Architect, from the Bible Moralisée.
 Reims, France. Middle 13th century. Illumination. Österreichische Nationalbibliothek, Vienna

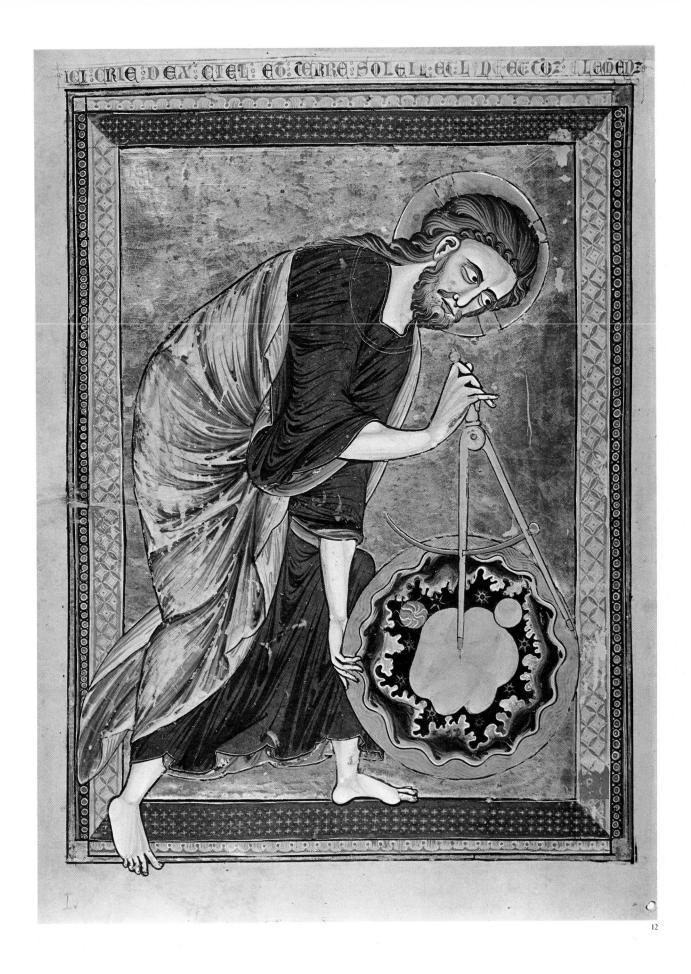

grandeur, magnificence, austerity, or delicacy—were necessarily taken into consideration by the artist, and therefore determined the prevailing mood of a work of art. Both religious and secular works of art were sometimes refused as unsuitable to the purpose for which they had been commissioned; often the artist was required to change certain crucial aspects that offended the patron. A study of the subjects of contemporary art—in those cases in which subjects are still recognizable—might well suggest patterns of social preference that have influenced artists without their being fully aware of them.

Patronage, in exercising an influence on iconography, may also affect style. For example, Christianity held the representation of the nude human body in horror, save when the soul appears naked before God for judgment or when a saint is stripped (shamed) before martyrdom. It is not likely, therefore, that an art thoroughly dominated by the more rigorous forms of Christianity, as in certain periods during the Middle Ages, could show much comprehension of or interest in the movement of the clothed figure, which can only be understood through study of the nude body. Similarly, a culture such as ancient Greece that placed a high valuation on the total human being, including physical enjoyment and athletic prowess, and displayed nude images in places of great prominence was likely to reject instinctively those colors and ornaments which might eclipse the beauty of the body.

The study of iconography can also assist us in understanding what one might call the magical aspects of works of art, for the process of representation has always seemed to be somewhat magical. Totems and symbols in early societies (see figs. 44–47) warded off evil spirits and propitiated favorable ones. Even today certain peoples defend themselves by force against the taking of photographs, which might drain off some of their strength. In many societies the injury of an image of a hated person is deemed to aid in bringing about that person's illness or death. Enemies are still burned in effigy, and a national flag is so potent a symbol that laws are made to protect it from disrespect.

When ancient city-states were defeated in battle the conquerors often destroyed or carried off the statues from the enemies' temples in order to deprive them of their gods and therefore their power. The instances of miracle-working images in the history of Christianity are innumerable and still occur. Many today feel a power emanating from a great work of art. A picture may be said to "fill a room," though it occupies only a small space on the wall, or a building to "dominate a town" when it is only one of many on the skyline, because of the supernatural power we still instinctively attribute to images.

Finally, the very existence or nonexistence of works of art has been until relatively recent times due first of all to their subjects. The patron wanted a statue or a picture of a god, a saint, an event, or a person, not primarily because of its beauty but for a specific iconographic purpose. Even in seventeenth-century Holland, in the early days of the open art market, artists often chose certain subjects for their easy salability.

The converse is often true. Taken literally, the Second Commandment severely limited if it did not indeed rule out entirely the creation of religious images by the Hebrews, the Muslims, and the Calvinists. Even more unhappily, strict interpretation of this and other religious prohibitions has resulted in the mutilation or total destruction of countless works of art. Many of the tragic losses of Greek, Roman, early Byzantine, medieval English, and Netherlandish art have resulted from what we might term destruction for anti-iconographic purposes, even when the

very groups carrying out the destruction nonetheless encouraged the production of secular art, such as plant and animal ornament, portraiture, landscapes, or still lifes.

The iconographic purpose of art, especially in the representation of events or ideas but also in the depiction of people and nature, has given the work of art its occasionally strong affinity with religion. Artists can be so moved by religious meditation, or by the contemplation of human beauty or human suffering, or by communion with nature, that they can create compelling works of art offering a strong parallel to religious experience. The religious art of the past generally offers us the most persuasive access to religious ideas. So effective can be religious art that many agnostic scholars find themselves unconsciously dealing with religious images as reverently as if they were believers.

The links between art and religion are observed at their strongest in the creative act itself, which mystifies even the artist. However carefully the process of creation can be documented in preparatory sketches and models for the finished work of art, it still eludes our understanding. In the Judeo-Christian-Islamic tradition, and in many other religions as well, God (or the gods) plays the role of an artist. God is the creator of the universe and of all living beings. Even those who profess no belief in a personal god nonetheless often speak of creative power or creative energy as inherent in the natural world. In medieval art God is often represented as an artist, sometimes specifically as an architect (fig. 12), tracing with a gigantic compass a system and an order upon the earth, which was previously "without form, and void." Conversely, in certain periods artists themselves have been considered to be endowed with divine or quasidivine powers. Certain artists have been considered saints: soon after his death Raphael was called "divine"; Michelangelo was often so addressed during his lifetime. The emotion art lovers sometimes feel in the presence of works of art is clearly akin to religious experience. An individual can become carried away and unable to move while standing before the stainedglass windows of Chartres Cathedral or the David by Michelangelo.

Of course, many works of art in the past, and many more today, were made for purposes that have a merely peripheral iconographic intent. We enjoy a well-painted realistic picture of a pleasant landscape partly because it is a pleasant landscape, with no iconographic purpose, and partly because it possesses in itself agreeable shapes and colors. Furthermore, a jewel, an arch or columns, or a passage of nonrepresentational ornament may be felt as beautiful entirely in and of itself. In most societies, however, such works have been limited to decoration or personal embellishment. Only when nonrepresentational images have been endowed with strong symbolic significance, as those in Christian art (the Cross, the initial letters in illuminated manuscripts; see figs. 426, 496), have they been raised to a considerably higher level and permitted to assume prominent positions (except, of course, in architecture, where certain basic forms exist primarily of constructional necessity and often symbolize nothing). Only in the twentieth century have people created works of art with no immediately recognizable subjects, the so-called abstractions.

Above, beyond, within iconography lies the sphere of *content*. While content is not so easy to define as iconography, which can almost always be set down in neat verbal equivalents, it relies on iconography as the blood relies on the veins through which it flows. Like all supremely important matters, content is elusive. Better to try an illustration. Let us imagine two equally competent representations (from a technical point of view that is), both depicting the same religious subject, such as the Na-

tivity or the Crucifixion. Each one shows all the prescribed figures, each personage dressed according to expectations and performing just the right actions, the settings and props fitting the narrative exactly. Iconographically, both images could be described in the selfsame words. Yet one leaves us cold despite its proficiency while the other moves us to tears. The difference is one of content, which we might try to express as the psychological message or effect of a work of art. It is the content of works of art, almost as much as their style, and in certain cases even more, that affects the observer and relates the painter, the sculptor, the architect (for buildings can excite deep emotions) to the poet, the dramatist, the novelist, the composer—indeed to the actor, the musician, the dancer. In a mysterious and still inexplicable fusion, content is at times hardly separable from style, giving it life and meaning. Iconography can be dictated to the artist; content must be really inspiring to enlist the artist's full allegiance. Like style, content is miraculously implicit in the very act of creation.

Any form of human activity has its history. The history of art, like the purpose of art, is inevitably bound up with many other aspects of history, and it is therefore generally organized according to the broad cultural divisions of history as a whole. But individual styles have their own inner cycles of change, not only from one period to the next but within any given period, or even within the work of a single artist. Iconography and purpose can be studied with little reference to the appearance of the work of art, but stylistic change, like style itself, is the special province of the study of art history. The individual work of art can and must be considered in relation to its position in a pattern of historical development if we wish to understand it fully. Long ago it occurred to people to wonder whether there might be laws governing stylistic change which, if discovered, could render more intelligible the transformations we see taking place as time is unrolled before us.

The earliest explanations of stylistic development can be classified as evolutionary in a technical sense. We possess no complete ancient account of the theory of artistic development, but the Greeks appear to have assumed a steady progression from easy to constantly more difficult stages of technical achievement. This kind of thinking, which parallels progress in representation with that in the acquisition of any other kind of technical skill, is easy enough to understand, but tends to downgrade early stages in any evolutionary sequence. Implicit also in such thinking is the idea of a summit of perfection beyond which no artist can ascend, and from which the way leads only downward, unless every now and then a later artist can recapture the lost glories of a Golden Age.

Artistic evolution is not always orderly. In ancient Egypt, for example, after an initial phase lasting for about two centuries, a complete system of conventions for representing the human figure was devised shortly after the beginning of the third millennium B.C. and changed very little for nearly three thousand years thereafter. Certainly, one cannot speak of evolution from simple to complex, or indeed of any evolution at all. Even more difficult to explain in evolutionary terms is the sudden decline in interest in the naturalistic representation of the human figure and the surrounding world in late Roman art as compared to the subtle, complex, and complete Greek and early Roman systems of representation, which had just preceded this period. It looks as if the evolutionary clock had been turned backward from the complex to the simple.

The History of Art

A new pattern of art-historical thinking, which can be characterized as evolutionary in a biographical sense, is stated in the writings of the sixteenth-century Italian architect, painter, and decorator Giorgio Vasari, who has often been called the first art historian. He compared the development of art to the life of a human being, saying that the arts, "like human bodies, have their birth, their growing up, their growing old and their dying." Vasari made no uncomfortable predictions about the death of art after his time, but his successors were not so wise. Much of the theoretical and historical writing on art during the seventeenth century looks backward nostalgically to the perfection of the High Renaissance.

Imperceptibly, the ideas of Charles Darwin in the nineteenth century began to affect the thought of art historians, and a third tendency, seldom clearly expressed but often implicit in the methods and evaluations of late-nineteenth- and early-twentieth-century writers, began to make itself felt. This theory explained stylistic change according to an inherent process that we might call evolutionary in a biological sense. Ambitious histories were written setting forth the art of entire nations or civilizations, as were monographs analyzing the careers of individual artists, in an orderly manner proceeding from early to late works as if from elementary to more advanced stages. The biological-evolutionary tendency underlies much arthistorical writing and thinking even today and is evident in the frequent use of the word evolution, generally in a Darwinian spirit.

A fourth major tendency of art-historical interpretation, which might be described as *evolutionary in a sociological sense*, has emerged during the twentieth century. Many historians have written about separate periods or events in the history of art along sociological lines, demonstrating what appear to be strong interconnections between forms and methods of representation in art and the demands of the societies for which these works were produced. Often, however, sociological explanations fail to hold up under close examination. How does one explain, for example, the simultaneous existence of two or more quite different—even mutually antagonistic—styles, representative examples of which were bought or commissioned by persons of the same social class or even by the same person?

Stylistic tendencies or preferences are, in fact, often explicable by widely differing interpretations (the notion of cause and effect in the history of art is always dangerous), sometimes not responsive to any clear-cut explanation. Three of the four theories discussed above—the technical, biological, and sociological—are still useful in different ways and at different moments in the history of art. But Vasari's biographical premise is generally renounced as a fallacious kind of reasoning by analogy.

There is something especially persuasive about the Greek theory of technical evolution. This can be shown to correspond, for example, to the learning history of a given individual, who builds new experiences into patterns created by earlier ones, and may be said to evolve from stage to stage of always greater relative difficulty. The stopping point in such a cycle might correspond to the gradual weakening of the ability to learn, and it varies widely among individuals. Certain artists never cease developing, others reach their peak at a certain moment and repeat themselves endlessly thereafter. From the achievements of one artist, the next takes over, and the developmental process continues. The element of competition also plays its part, as in the Gothic period when cathedral builders were trying to outdo each other in height and lightness of structure, or the Impressionist period, when painters worked side by side attempting to seize the most fugitive aspects of sunlight and color. Such an orderly development of refinements on the original idea motivating a school of

artists can also be made to correspond to the biological-evolutionary theory, showing (as it seems) a certain inherent momentum.

In art as in any other aspect of human life, changes of style may even result from sheer boredom. When a given style has been around to the point of saturation, artists and public alike thirst for something new. Or mutations may also occur from time to time through purely accidental discoveries, a factor that has yet to be thoroughly explored. On investigation, apparent artistic accidents may turn out to be in reality the result of subconscious tendencies that had long been brewing in an artist's mind, and that almost any striking external event could bring into full play.

The four major factors we have been considering—purpose, style, iconography, and historical position—are involved in the formation of any work of art, and all four should be taken into consideration in our study. The total work of art consists of the sum, or more exactly the product, of these four factors. At the risk of oversimplification, we may represent the total work of art as a series of circles, one for each element, arranged around a larger circle (fig. 13), all contributing to the work of art at the center, and all related to each other. In the effort to interpret any given work of art we can start anywhere in the larger circle and move in any direction, including across it, as long as we realize that those elements which are separated for the purpose of diagrammatic clarity are in reality fused into a transcendent whole, with blurred and shifting boundaries.

The only certainty in art-historical studies is that as we try to penetrate deeply into the work of art, to understand it fully, and to conjecture why and how it came to be as it is we must examine carefully in each individual instance all the factors that might have been brought to bear on the act of creation, and regard with healthy skepticism any theory that might tend to place a limitation on the still largely mysterious and totally unpredictable forces of human creativity.

STYLE Contributes to HISTORICAL WORK OF Contributes Contributes ICONOGRAPHY POSITION Contributes to Related to PURPOSE

The Total Work of Art

13. The Total Work of Art

MAGIC, FORM, AND FANTASY

ONE

The words *primitive* and *prebistoric* are often used to denote early phases in the artistic production of humanity. Both adjectives can be misleading. *Primitive* suggests crudeness and lack of knowledge, yet some of the oldest works of art we know, such as the ivory carvings and cave paintings of the first true humans in western Europe, show great refinement in their treatment of polished surfaces and considerable knowledge of methods of representation, while much later works, presumably by their descendants, sometimes betray loss of skill in both respects. The highly formalized objects made by African and North American Indian cultures close to our own time have been valued by some twentieth-century European artists because of their supposed primitivism; nonetheless, the few really ancient works as yet discovered from these same cultures are strikingly naturalistic. *Prebistoric* implies the absence of both a feeling for the past and a desire to record it, but we know from African societies that history was carefully preserved in an oral tradition whose accuracy can at times be corroborated when checked against the written records of invading cultures. The unwritten legends of the Eskimo and North American Indians may well have had a basis in historic fact.

The first section of this book brings together the arts of certain societies that flourished in a wide variety of geographic and climatic environments. Except for the Pre-Columbian societies, these cultures all lacked the ability to compile permanent records. But their arts have other important characteristics in common. One extremely important trait is the identification of representation with magical or religious power, so that the object of art itself comes into existence as the embodiment of an attempt to control or to propitiate, through ritual, natural beings or natural forces. Fantasy and magic generally operate outside the control of reason. Measure, the basis of order in art as in life, can exist only with writing, and measure is conspicuously absent from all preliterate art forms except only those which, like weaving, are by their very nature dependent on a considerable number of material elements of approximately identical size, subject to distribution and repetition. Without the rational overlay governing the art of most subsequent periods, basic human impulses find expression in rhythmic form. In a magical art the motion of the hand holding the tool takes on the quality of a dance, and visual patterns that of choreography. No wonder that works of art produced for magical purposes and based on antirational principles should have been considered "barbaric" by historic societies whose culture was based on writing or that such works should have been codified as evolutionary stages in human development by the encyclopedic science of the later nineteenth century.

A second universal trait of these arts is the total lack of concern for the representation of the space in which we all must move, or even the ground on which we stand. The surface the artist works on is the only space and the only ground (see fig. 20). Animals, birds, fish, and to a lesser extent human beings,

are widely represented, usually in conformity with transmitted stereotypes; plants appear only quite late, and then are ornamentalized. Landscape elements (save for the volcano of Çatal Hüyük, see fig. 33) never demand representation, and the immense spaces surrounding mankind, which must have appeared mysterious and challenging, are not even suggested.

Some of the arts described in this section precede chronologically the more developed phases of civilization; others persist side by side with them right up to the present time. Interestingly enough, the twentieth century, which has conquered physical space to such an extraordinary degree, and which has transcended representation by photography, the cinema, and television and even writing by means of electronic communication and records, is the first to find the art of early people artistically exciting. This may be in part because the twentieth century has also discovered the irrational basis of much of humanity's inner life through the researches of psychology and thus has found preliterate art emotionally accessible. But as we continue our study of art through later periods, even in the most highly literate cultures, it will become apparent that the irrational and impulsive nature of humanity lies fairly close to the surface and, at moments of intense individual or collective experience, can again determine essential aspects of the work of art.

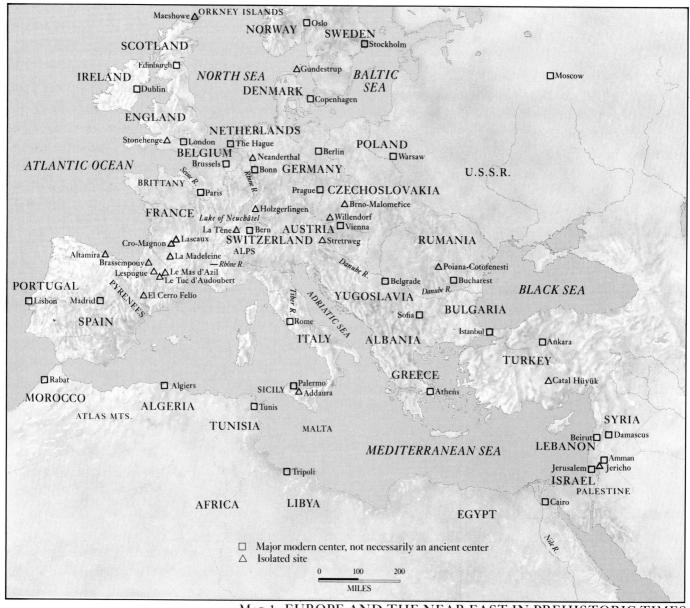

MAP 1. EUROPE AND THE NEAR EAST IN PREHISTORIC TIMES

ART BEFORE WRITING

ONE

We do not know when or how human beings took the significant step of making objects for their own interest and enjoyment rather than for pure utility; probably, we shall never know. But we do have extensive evidence, almost all of it discovered within the past hundred years, regarding human artistic production at a very early stage. Such subhuman groups as the Neanderthal did not make works of art. The first artists were the ancestors of modern Europeans, the Cro-Magnon people, who roamed over Europe, equipped with stone tools and weapons, during the last glacial period, when the Alpine region, northeastern Europe, and most of the British Isles were covered deep in glacial ice. So much of the world's water was frozen in polar ice caps and continental glaciers that coastlines were very different from their present shape, and the southern portions of the British Isles were connected with each other and the Continent. Vegetation was subarctic; most of western Europe was a tundra, and forests were limited to the Mediterranean region. In this inhospitable environment early humans, vastly outnumbered by the animals on which they depended for food, lived in caves or in temporary settlements of shelters made from mud and branches.

There seem to be no early stages in the evolution of Paleolithic art; the earliest examples are of an astonishingly high quality. This fact, coupled with the great period of time covered by the finds, suggests the existence of a strong tradition in the hands of trained artists, transmitting their knowledge and skill from generation to generation. While these early works of art have been found all the way from southern Spain and Sicily to southern Siberia, most of the discoveries have come to light in south-central France, northern Spain, and the Danube region. The approximate dates given here are based on analysis of organic material at the sites, according to the known rate of disintegration of radioactive carbon 14, absorbed by all living organisms, into nonradioactive nitrogen 14 after death. Even more surprising than the immense age of the earliest finds is the extraordinary duration of the cave culture, some twenty thousand years, or nearly twice as long as the entire period that has elapsed since.

SCULPTURE The tiny female statuette jocularly known as Venus (fig. 14), found near Willendorf in Lower Austria, is datable between 30,000 and 25,000 B.C. It is one of the earliest known representations. Grotesque as it may at first appear, the "Venus" of Willendorf is, on careful analysis, a superb work of art. The lack of any delineation of the face, the rudimentary arms crossed on the enormous bosom, and the almost equally enlarged belly and genitals indicate that the statuette was not intended as a naturalistic representation but as a fertility symbol; as such, it is compelling. From the modern point of view, the statue harmonizes spherical and spheroid volumes with such power and poise that it has influenced twentieth-century abstract sculpture. A similar but larger statuette, from Lespugue in southwestern France, is tentatively dated much later, about 20,000-18,000 B.C. In this work, carved in ivory, the swelling, organic forms of the "Venus" of Willendorf are conventionalized and become almost ornamental. Across the back of the statuette (fig. 15) runs a sort of skirt, imitating cloth, which dates weaving back to a remarkably early moment. One of the finest of these tiny sculptures is the delicate ivory head of a woman from the cave called Grotte du Pape at Brassempouy in southwestern France (fig. 16). As in the "Venus" of Willendorf, the hair is carved into a grid suggesting an elaborate hairdo, which hangs down on the sides to flank a slender neck. The pointed face is divided only by nose and eyebrows; the mouth and eyes may originally have been painted on.

As compared to these stylized images of human beings, the earliest represented animals are strikingly naturalistic. A little bison (fig. 17) carved about 12,000 B.C. from a piece of antler was found at La Madeleine in south-central France. The legs are only partially preserved, but the head, turned to look backward, is convincingly alive, with its open mouth, wide eye, mane, and furry ruff indicated by firm, sure incisions. The projections are so slight that the relief approaches the nature of drawing. Another brilliant example of animal art is the little spear-thrower (fig. 18), from Le Mas d'Azil in southwestern France, representing a chamois in a similar pose of alarm, its head turned backward and its feet brought almost together in a precarious perch on the end of the implement.

CAVE ART The most impressive creations of Paleolithic humans are the large-scale paintings, almost exclusively representing animals, which decorate the walls and ceilings of limestone caves in southwestern France and northern Spain (see figs. 20–22). Their purpose is still obscure. By analogy with the experience of surviving tribal cultures, it has been suggested that these paintings are an attempt to gain magical control, by means of representation, of the animals early humans hunted for food. Recent investigation has shown this explanation to be untenable. Judging from the bones found in the inhabited caves, the principal food of the cave dwellers was reindeer meat. But the chief animals represented, in order of frequency, were the horse, the bison, the mammoth, the ibex, the aurochs, and at long last several species of deer. Most of the paintings are found at a distance from the portions of the caves, near the entrances, where early humanity lived, worked, cooked, and ate (as at Lascaux, fig. 19). Often, the painted chambers are accessible only by crawling through long, tortuous passages or by crossing underground streams. This placing, together with the enormous size and compelling grandeur of some of these paintings, suggests that the remote chambers were sanctuaries for magical or religious rituals to which we have as yet no clue. Evidence indicates that the chambers were used continuously for thousands of years,

Paleolithic Art (Old Stone Age), 30,000–10,000 B.C.

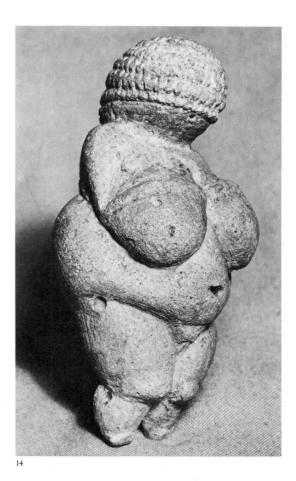

 "Venus" of Willendorf. c. 30,000–25,000 B.C. Limestone, height 4%". Naturhistorisches Museum, Vienna

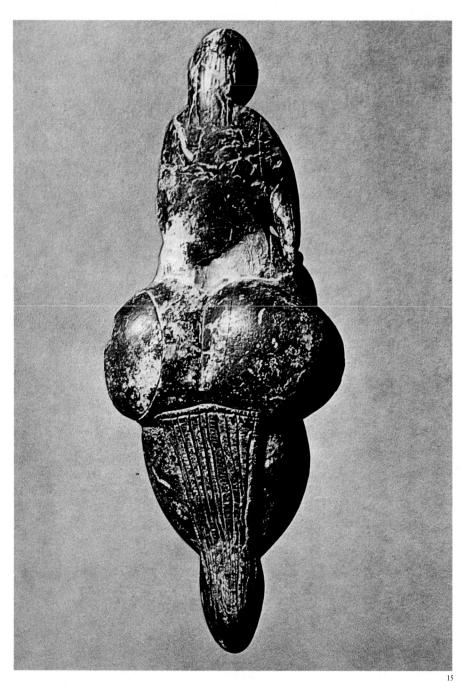

15. "Venus" of Lespugue. c. 20,000-18,000 B.C. Ivory, height 5¾". Musée de l'Homme, Paris

and microscopic analysis by the American scholar Alexander Marshack has shown that the paintings were repainted periodically, many times in fact, in layer after layer. Abstract signs and symbols, which may be the ancestors of writing, appear consistently throughout all the painted caves and also on many of the bone implements found in them. One day these symbols may yield to interpretation; possibly, they will provide the answer to the mysterious questions of the meaning and purpose of these magnificent paintings.

In the absence of natural light, the paintings could only have been done with the aid of stone lamps filled with animal fat and burning wicks of woven moss fibers or hair. The colors were derived from easily found minerals and include red, yellow, black, brown, and violet, but no green or blue. The vehicle could not have been fat, which would not penetrate into the chronically damp, porous walls; a water vehicle could amalgamate with the moisture and carry the color into the structure of the limestone. No brushes have been found, so in all probability the broad black

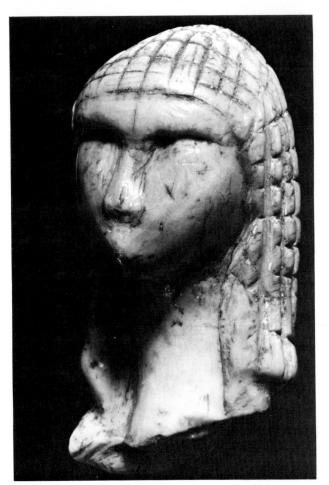

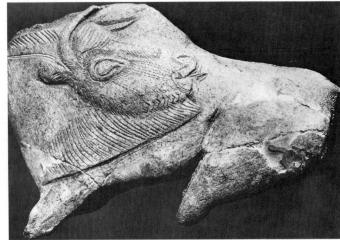

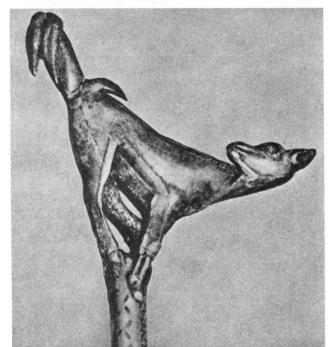

16

- Woman's Head, from Grotte du Pape, Brassempouy (Landes), France. c. 22,000 B.C.
 Ivory, height 1¹/₄". Musée des Antiquités Nationales, St.-Germain-en-Laye, France
- 17. *Bison*, from La Madeleine (Tarn), France. c. 12,000 в.с. Antler, length 4". Musée des Antiquités Nationales, St.-Germain-en-Laye
- 18. *Chamois*, from Le Mas d'Azil (Ariège), France. Antler, length 111/8". Collection Péquart, St.-Brieuc, France
- 19. Diagrammatic plan showing the layout of caves at Lascaux (Dordogne), France (Based on a diagram by the Service de l'Architecture)

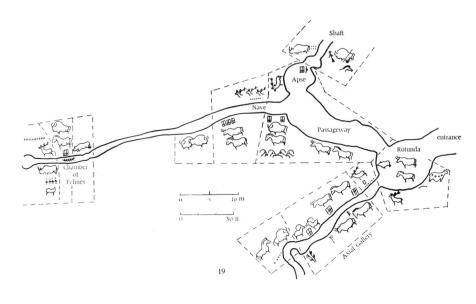

outlines were applied by means of mats of moss or hair. The surfaces appear to have been covered by paint blown from a tube; color-stained tubes of bone have been found in the caves.

The paintings have always been described as "lifelike," and so they are, but they are also in some respects standardized. The animals were invariably represented from the side, and generally as standing in an alert position, the legs tense and apart, the off legs convincingly more distant from the observer, the tail partially extended. Rarer running poses show front and rear legs extended in pairs, like the legs of rocking horses. No vegetation appears, nor even a groundline. The animals float as if by magic on the rock surface. Their liveliness is achieved by the energy of the broad, rhythmic outline, set down with full arm movements so that it pulsates around the sprayed areas of soft color.

The cave of Altamira in Spain was the first to be discovered, a century ago, but was not at once accepted as authentic. Today it is considered the finest. The famous bison on the ceiling of Altamira (fig. 20), vividly alert, are as powerful as representations of animals can be. Although artists of periods later in human history analyzed both surface and anatomical structure more extensively, the majesty of the Altamira animals has never been surpassed. The cave of Lascaux in France, dating from about 15,000 B.C. and discovered in 1940, is a close competitor to Altamira. It is one of a large number of painted caves in the Dordogne region. The low ceiling of the so-called Hall of Bulls at Lascaux (fig. 21) is covered with bulls and horses, often partly superimposed, painted with such vitality that they fairly thunder off the rock surfaces at us. In another chamber is the tragic painting of a bison pierced by a spear (fig. 22), dragging his intestines as he turns to gore a man who is represented schematically as compared to the naturalistic treatment of the animals.

Some images are in low relief, such as the tense, still throbbing bison modeled in clay (fig. 23) about 15,000 B.C. on the sloping ground of a cave at Le Tuc d'Audoubert in France; some have been carved into the rock, as are the far-from-schematic, half-reclining nude women occasionally found, always without heads. The easy pose of the relief at La Madeleine (fig. 24) contrasts sharply with the stylization of the "Venus" of Willendorf. Both reliefs are filled with the same organic power as the paintings.

Our understanding of cave paintings cannot help being different from that of the people who painted them so many thousands of years ago. Until we learn to decipher the signs and symbols appearing in the caves we have no real clue as to what may have been going through the minds of the painters, or for that matter even whether they were men or women. But we can perhaps reach them across the intervening millennia through our common humanity. To our eyes the attitudes and sometimes even the expressions of the painted animals are so intense, and the outlines painted with such force and freedom, that it would be amazing if these early artists did not experience deep creative pleasure in what they were doing, regardless of any purpose the pictures might have been intended to serve. In fact Louis-René Nougier has suggested that to the cave artists artistic creation may have seemed identical with actual creation, and that by their activity in paint they were somehow making these animals who moved through their forest world. "Prehistoric art," Nougier wrote, "is essentially action." This concept of action identifies, then, the artist's movements of arm and hand with those of the animals the artist reproduces. The fact that the individual images were so often painted right over one another would in itself show that the moment of creation, whether religious, magical, or some mysterious combination of both, was more important than the final image and its survival.

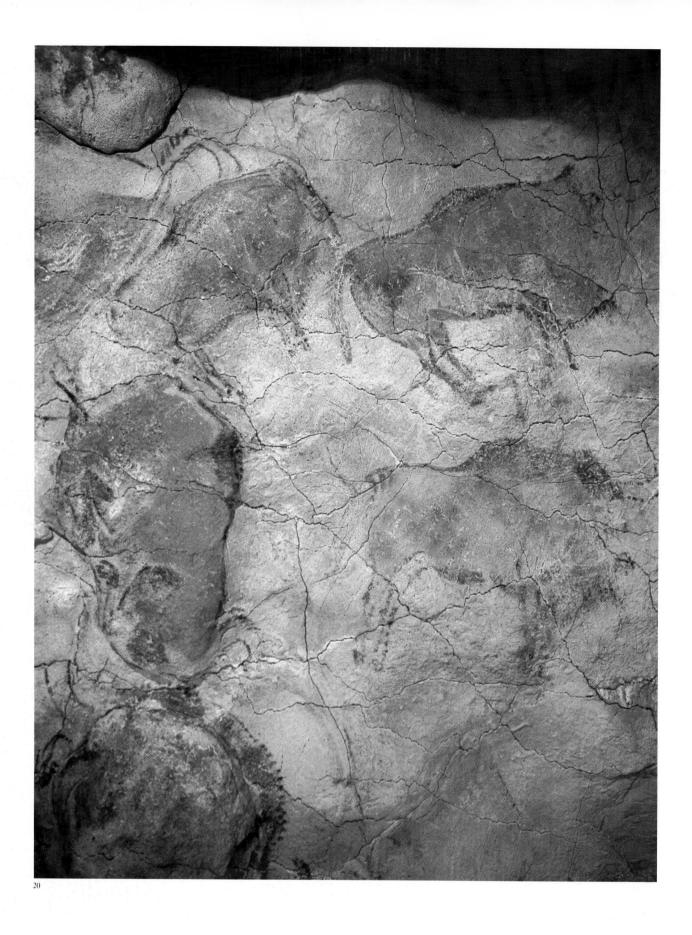

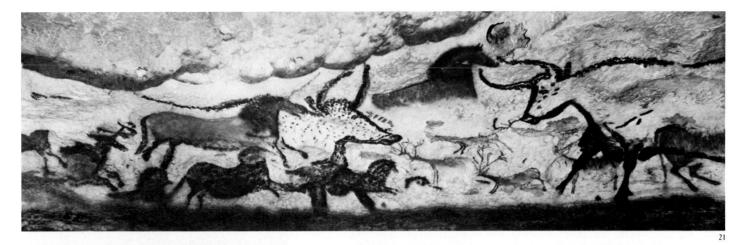

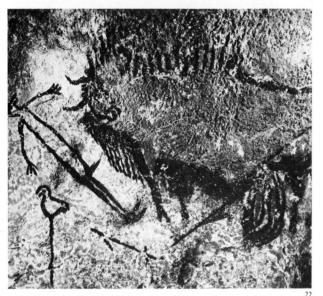

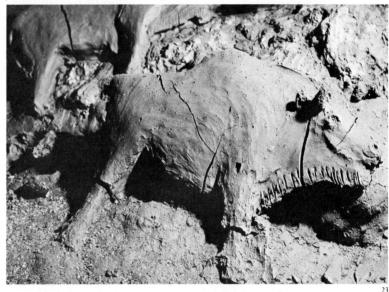

- 20. *Bison*. с. 15,000–10,000 в.с. Cave painting. Altamira, Spain
- 21. Cave painting in the Hall of Bulls, Lascaux. c. 15,000–10,000 B.C.
- 22. Wounded Bison Attacking a Man. c. 15,000–10,000 B.C. Cave painting, length of bison 43". Lascaux
- 23. *Two Bison*, from the cave at Le Tuc d'Audoubert (Ariège), France. c. 15,000 B.C. Clay low relief, length 24" each
- 24. *Reclining Woman*, from the cave at La Madeleine. Low relief

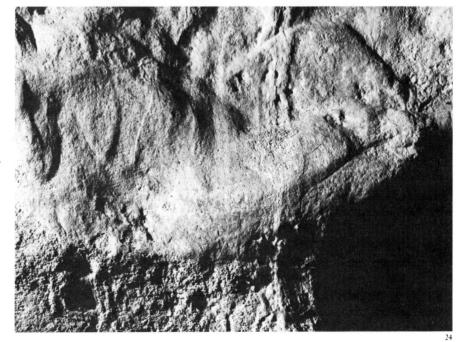

The disappearance of the great glaciers and the consequent rise in temperature brought early humanity out of the caves and fostered a gradual transition to the farming society of the Neolithic period (New Stone Age). This intermediate stage, known as the Mesolithic (Middle Stone Age), is far less rewarding artistically than the Paleolithic. Paintings were made on the walls of open shelters on rocky cliff faces. More than sixty sites have been located in eastern Spain, but the small-scale paintings of animals lack not only the size but also the vigor of the cave paintings, and were usually done in a single tone of red. An example from El Cerro Felío (fig. 25) shows a group of male and female hunters, greatly schematized but nonetheless pursuing at remarkable speed an antelope that seems to have eluded their spears and arrows. Mesolithic rock paintings of a somewhat similar style are scattered from Scandinavia to South Africa. By all means the most striking works of art from the Mesolithic period are the brilliant series of outline drawings of human figures and animals discovered in 1952 on the walls of a small cave at Addaura, just outside Palermo, Sicily (fig. 26). The figures, depicted in a variety of attitudes, may be engaged in a ritual dance, perhaps including acts of torture; the vigor and freedom of their movements remind one of certain twentieth-century works, notably those of Henri Matisse.

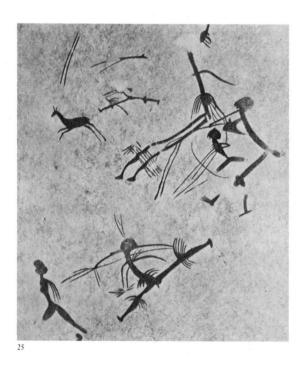

With the recession of the last glaciers, the climate grew irregularly but inexorably warmer, and humanity, all the way from the British Isles to the Indus Valley, was able to set up a new existence free from the limitations of the caves. Wild grains and legumes now flourished throughout a wide area and were eventually domesticated; so, one by one, were various species of animals. Although stone remained the principal material for weapons and tools, here and there humans discovered how to smelt certain metals. Pottery, often richly decorated, began to replace utensils of wood or stone, and weaving became highly developed. Objects made of nonindigenous materials indicate the existence of travel and commerce. Although they were still hunters, people were no longer utterly dependent on wild animals, and representations of animals consequently lost Mesolithic Art (Middle Stone Age), c. 10,000-8000 B.C.

- 25. Hunting Scene. Watercolor copy of a cave painting at El Cerro Felío (near Alacón),
- 26. Ritual Dance. Drawing in the cave at Addaura, Sicily. c. 15,000–10,000 B.C. Height of figures 10"

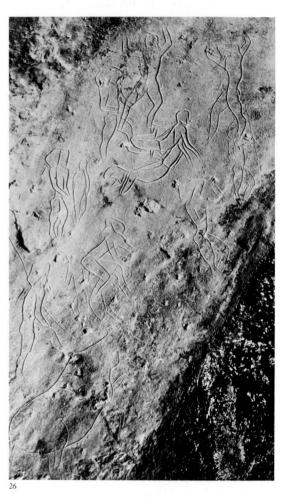

Neolithic Art (New Stone Age), 8000-3000 в.с.

the intimate naturalism so impressive in Paleolithic art. More lasting settlements grew up, some of a considerable size, and the beginnings of architecture made their appearance, these early examples being generally constructed of perishable materials such as timber, wicker, and thatch. The many Neolithic town sites excavated throughout central Europe and northern Italy have yielded much information about a wide variety of early cultures; only in the Middle East, however, have there appeared ruins of masonry structures, which can be considered the ancestors of architecture as we know it. From the evidence available, what may have been Paleolithic religious life is scarcely distinguishable from magic, but in the Neolithic period structures appear that can only be described as sanctuaries, implying the existence of an organized religion, with a priestly class making new demands on art.

JERICHO The earliest masonry town we know is the still only partially excavated city of Jericho in southern Palestine (now Jordan). Around 8000 B.C. the settlement was composed of oval mud-brick houses on stone foundations. By about 7500 B.C. it was surrounded by a rough stone wall whose preserved portions reach a height of twelve feet and was further defended by a moat cut in the rock and by at least one stone tower thirty feet high (fig. 27), the earliest known fortifications in stone. Even more impressive are the human skulls found here (fig. 28). Their features had been reconstructed in modeled plaster, with shells inserted for eyes. These skulls originally belonged to bodies buried beneath the plaster floors of

- 27. Fortifications, Jericho, Jordan. c. 7500 B.C.
- 28. Plastered Skull. c. 7000-6000 B.C. Jericho

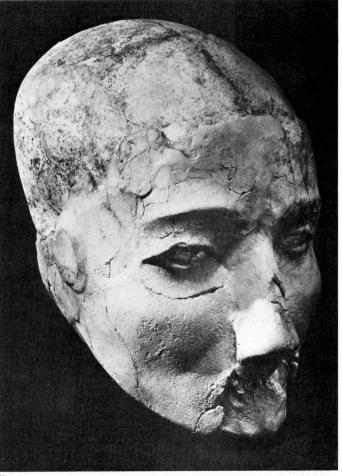

28

the houses and were doubtless intended to serve as homes for ancestral spirits, to be propitiated by the living. The soft modeling is delicately observed; when painted, these heads must have been alarmingly vivid.

CATAL HÜYÜK From 1961 to 1963, excavations in the mound of Çatal Hüyük on the plain of Anatolia, in central Turkey, disclosed a small portion of a city that, according to carbon 14 dating, enjoyed a life of some eight hundred years, from 6500 to 5700 B.C. The city was destroyed and rebuilt twelve times, the successive layers of mud brick revealing a high level of Neolithic culture, whose artifacts included woven rugs with bold decorative patterns (not preserved, but simulated in wall paintings) and polished mirrors made from obsidian, a hard volcanic stone. Oddly enough, the inhabitants had not yet discovered pottery and made their receptacles from stone or wood and from wicker. The houses (fig. 29) were clustered together without streets in a manner not unlike that of the pueblos of the American Southwest (see fig. 54), with a common outer wall for defense, and they could be entered only by means of ladders. The furniture was built in; it consisted of low plastered couches under which the bones of the dead were buried after having been exposed to vultures to remove the flesh. A remarkable series of religious artifacts has been found, including statues of a mother goddess (fig. 30) whose immense breasts and belly recall the "Venus" of Willendorf. The head appearing between her knees clearly symbolizes childbirth.

Alongside the rooms intended for lay habitation, shrines are occasionally found with couches doubtless meant for the priesthood. These shrines enclose symbols of magical potency and—even in reconstruction—of awesome grandeur. Some shrines were adorned by rows of paired wildbull horns mounted on the floor, facing entire bull skulls fixed to the wall above (fig. 31). These were probably male symbols. A stylized but very aggressive silhouette painting of a bull appears on a flanking wall. Other shrines (fig. 32) were apparently dedicated to death, symbolized by wall paintings of huge vultures devouring tiny, headless humans depicted in the poses in which corpses were buried. Schematized and flattened though they are, these birds, whose wings spread diagonally across whole walls as if wheeling through the air, must have struck terror into the hearts of the inhabitants. On one wall was found the earliest known landscape painting (fig. 33), showing Catal Hüyük itself, represented as a series of rough squares surmounted by an erupting volcano.

All excavations bring up surprises of some kind, but the urban civilization of Çatal Hüyük, with its farflung connections, was totally unexpected at so early a date. Yet after the abandonment of the town it seems to have had little or no influence on later civilizations. Only the bull deities, if that is what they were, may have been picked up in Egypt, Mesopotamia, and Crete. But after all, the bull is a natural symbol of magical strength and potency. Everything that could be salvaged from the excavations was removed to the National Archaeological Museum at Ankara, but it is especially sad to relate that the only partially uncovered ruins have now been destroyed a thirteenth time—and for good. The sun and wind have reduced them to dust, and winds and rain have carried the dust away. At least three quarters of Çatal Hüyük is still underground. Who knows what later excavations may yield?

- 29. Houses, Çatal Hüyük, Turkey. 6500-5700 B.C. (Architectural reconstruction after J. Mellaart)
- 30. Goddess Giving Birth, from Catal Hüvük. c. 6500-5700 B.C. Baked clay, height 8". Archaeological Museum, Ankara, Turkey

MEGALITHIC ARCHITECTURE A number of sites, generally on islands or near the seacoast, preserve impressive remains of monuments made partially or wholly of giant stones (megaliths). The accepted dating of these buildings has been revised in the light of the discovery that the carbon 14 method consistently underestimated by as much as eight hundred years the age of California bristlecone pine trees, in some of whose cross sections more than eight thousand rings have been counted, one for each year of life. The ancient civilization on the Mediterranean island of Malta, for example, which lasted about eight hundred years, has now been dated before 3000 B.C. A hard limestone was used for the exterior walls of the temples and for the trilithon (three-stone) portals (fig. 34). A double vinescroll ornament of unexpected rhythmic grace, the earliest known appearance of a motive that later became universal in Classical decoration, is carved in low relief on the entrance slab of one of the temples at Tarxien (fig. 35). The interiors of tombs and temples generally follow a trefoil plan; the stones are corbeled (projected one beyond the other) to form a sloping wall that probably supported a wooden roof. At the other extreme of European culture, almost as far as possible from Malta, an actual corbel vault, the earliest known, roofs a tomb chamber (fig. 36) in the center of a mound at Maeshowe, on a remote island of the Orkneys, north of Scotland. It is datable about 2800 B.C.

Long famous are the megaliths of Brittany, giant single stones known as menbirs, which march across the countryside for miles, and the dolmens or trilithons, probably intended as graves to be surrounded by mounds. A number of cromlechs, ritual stone circles, are preserved in England, the grandest of which is Stonehenge on the Salisbury Plain (figs. 37, 38). Now datable about 2000 B.C., this is the third and most ambitious circle built on the site. Claims of extraordinary astronomical com-

- 31. Shrine with bull horn and skull decoration, Çatal Hüyük. 6500–5700 в.с. (Architectural reconstruction after J. Mellaart)
- 32. Shrine with wall paintings of vultures, Çatal Hüyük. 6500–5700 B.C. (Architectural reconstruction after J. Mellaart)
- 33. Landscape painting (copy), from Çatal Hüуük. с. 6150 в.с.

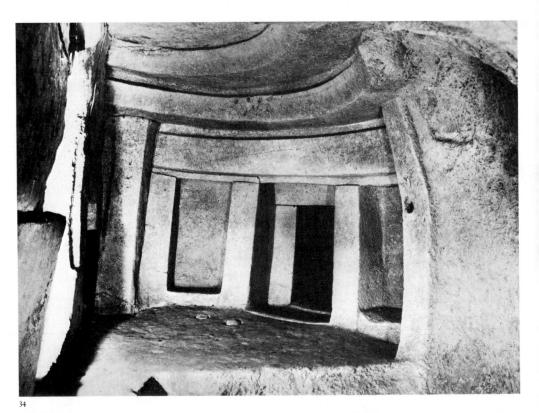

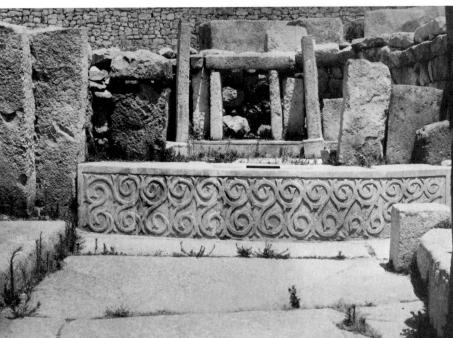

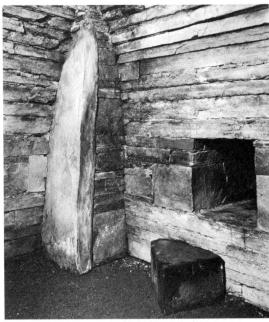

petence on behalf of these Stone Age builders, surpassing even that of the later Greeks, have been strongly challenged, but it is clear that the stones were arranged to coincide at least roughly with sunrise at the summer solstice. The impression of rude majesty they impart is tempered somewhat by the observation of considerable subtleties: these stones, weighing as much as fifty tons, were dragged for twenty-four miles by hundreds of men; they were dressed (trimmed) to taper upward and even endowed with a slight swelling known later to the Greeks as entasis; and their lintels were curved according to their places in the circle.

- 34. Trilithon portals, Hal Saflieni, Malta. Before 3000 B.C. Limestone
- 35. Entrance slab of Temple, Tarxien, Malta. Late 3rd millennium B.C. Limestone low relief
- 36. Tomb chamber, Maeshowe, Orkney Islands, Scotland. c. 2800 B.C.

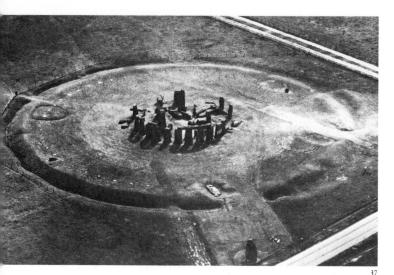

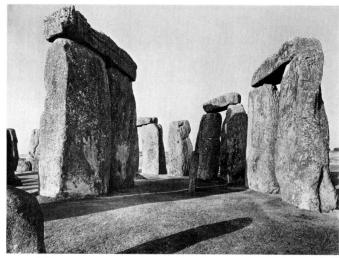

37. Aerial view of Stonehenge, Salisbury Plain, England. c. 2000 B.C.

38. Stonehenge. Salisbury Plain. Height 13'6"

Megalithic monuments such as Stonehenge remained above ground in several countries to incite speculation from awestruck people during the rest of human history. But the very existence of Stone Age painting and sculpture was unsuspected until the first chance discoveries about a hundred years ago were followed by systematic excavations in ever-increasing numbers up to our own time. We now possess a vast body of knowledge about early humanity and early societies, derived in great part from artifacts of all sorts unearthed in these excavations. We have also made another discovery of the greatest intellectual, even spiritual importance: that the species to which we belong—homo sapiens was from its very beginnings endowed with a high degree of artistic talent and that this talent was exercised over a period lasting at least five times as long as all of recorded history. On the basis of the works rediscovered by chance or by plan, we can safely say that artistic ability is not, like science or any form of learning, something achieved through millennia of struggle, but is an inborn essential of human nature. Prehistoric art, therefore, has now told us much, not only about early humanity but about ourselves. And with a force utterly unpredictable before the first objects were found, prehistoric art has inspired important aspects of the art of the twentieth century.

THE ART OF LATER ETHNIC GROUPS

TWO

Of necessity this book is chiefly concerned with the artistic traditions of European societies and of their descendants in North America. The preliterate arts introduced in Chapter One were produced by the direct ancestors of modern Europeans and thus, to a great extent, of modern North Americans. But an increasingly large proportion of North Americans are descended only in part, or not at all, from Europeans. It is therefore especially important in this introductory section to look at some characteristic works of high quality produced either by the ethnic groups who inhabited the American continent when the Europeans arrived or by those whose numbers were brought to America by Europeans against their will, as well as at the strikingly similar arts created by the peoples of the complex island chains that jewel the immensity of the Pacific Ocean.

In these cases there is obviously no direct development from preliterate to literate art, rather the sudden overlay of a comparatively late phase of the art of white people imposed, along with the other values of a white society, upon red, brown, or black preliterate groups, often by force. Much the same process took place much earlier, as we will see, when the Celtic and Germanic societies of northern Europe were conquered by the Romans. Yet the artistic traditions of these subject or displaced ethnic groups have continued to flourish up to our own time, even when adulterated by an almost inevitable admixture of values from the dominant European culture. The same basic principles of magical imagery and essential spacelessness unite these arts with those of early humanity. There is also the same tendency toward eventual abstraction, through the constant repetition of traditional ideas and forms which began as naturalistic. Mysteriously, the more recent ethnic arts have added a special invention, common to all across many thousands of miles of land and ocean—the mask. In ritual or in death, confronting the forces of the supernatural or personifying them, individuals must conceal their identity behind artificial faces, sometimes serene, more often terrifying. On these masks enormous skill and every resource of the artist are lavished for overwhelming effect.

The arts of early humanity had been dormant and forgotten for thousands of years and were rediscovered only within the past century, even the past few decades, while those of later ethnic groups were still being produced in quantity when Europeans arrived on the scene. By a fascinating historical irony, these tradition-bound arts were found by the more sophisticated European observers to be fresh and *free* from tradition, meaning of course from the customs and conventions of European society. Thus the arts of "primitive" peoples have had an enormous influence on those of European dof Europeanized American societies. Primitive became fashionable, and the forms and colors of the black African, the "South Sea" islander, and the North and South American Indian remain essential ingredients in today's culture.

Black African Art

Below the Sahara Desert stretches a vast region of Africa, including uplands, open steppes, and tropical rain forests, the home of an incredible number and variety of artistically productive black cultures. European contacts with the arts of black Africa have undergone at least five distinct phases. At first, artifacts were brought home as curiosities by early explorers, traders, and colonists. To this activity we often owe the continued existence of wooden objects, doomed to a short life in central African heat and humidity. Then, with the growth of anthropological studies in the nineteenth century, the objects were exhibited as specimens in museums of natural history. Next, in the opening years of the twentieth century, the aesthetic properties of African art were discovered as a powerful source of inspiration by adventurous European artists. Since then, archaeological investigation, still all too rare and limited, has discovered works of courtly art of astonishing beauty and great antiquity, antedating any contacts with Europeans. Finally, in our own time, quantities of cheaply produced imitations of tribal artifacts—so-called airport art have flooded the market.

The discovery in 1938 of a superb series of naturalistic heads and busts in clay and in bronze at Ife in Nigeria in central West Africa came as a total surprise. If eartists had been thoroughly familiar with the lostwax process of casting, in which a work is built up on a fireproof core with a thin layer of wax and then covered with a fireproof mold usually based on clay. When the mold has hardened, it is heated, the wax runs out, and molten metal, which assumes the shape of the original wax layer, is poured in. Invented by Bronze Age peoples, this method was known throughout the Mediterranean world in antiquity. No contacts have been traced between the Ife civilization, which flourished between the eleventh and fifteenth centuries A.D., and the Mediterranean; it is quite possible that the Ife artists discovered the lost-wax method independently. The royal heads, such as the one believed to represent the early queen Olokun (fig. 39), are of striking nobility and beauty. The broad, smooth surfaces of the skin are striated with parallel grooves representing ritual scars and are perforated around the mouth with holes possibly intended for jewels. Probably, these heads were made to surmount wooden bodies.

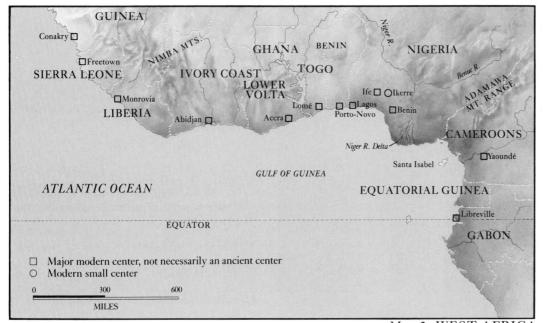

MAP 2. WEST AFRICA

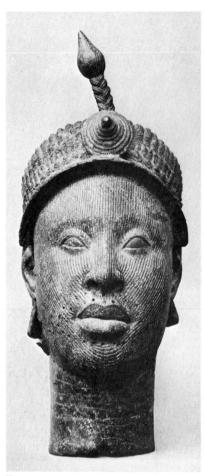

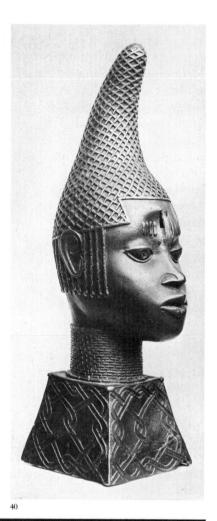

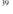

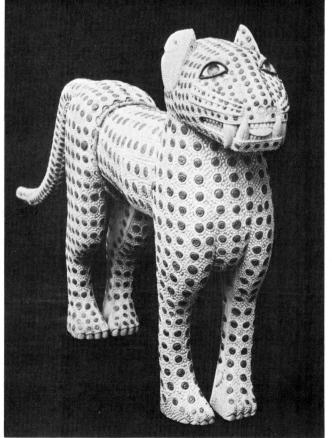

- 39. *Head of Queen Olokun*, from Ife, Nigeria. c. 11th–15th century A.D. Clay and bronze, height to top of ornament c. 36". British Museum, London
- 40. "Princess," from Benin, Nigeria. c. 14th–16th century A.D. Bronze, lifesize. British Mu-seum, London
- 41. *Leopard*, from Benin. c. 16th–17th century A.D. Ivory with brass inlay, length 325/8". British Museum, London

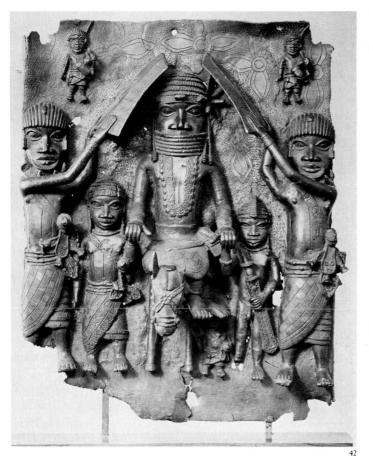

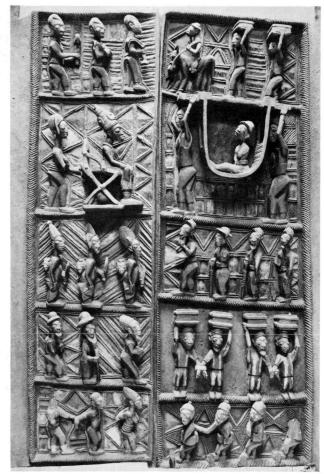

Sixteenth-century Portuguese explorers were the first Europeans to visit the nearby Nigerian kingdom of Benin. Its art, however, was not widely known until the city of Benin was destroyed in 1897 and a large number of splendid bronze objects from the palace were taken to England. Among them was the elegant and serene head of a girl, dating from the fourteenth, fifteenth, or sixteenth century, known as the "Princess" (fig. 40). She wears a high, beaded collar and a beautiful horn-shaped woven headdress. The refined workmanship of the very thin bronze casting is derived, according to oral tradition, from the older Ife culture, but a certain stylization has softened the overwhelming sense of reality of the Ife heads. Handsome leopards of ivory studded with brass disks (fig. 41), symbols of royal power, and many grand bronze reliefs from the palace, like the one representing a king symmetrically enthroned between smaller attendants (fig. 42), show other possibilities of the Benin style, which is very dense in its opposition of cylindrical volumes to surfaces enriched by parallel grooves, striations, and incised ornament.

A very few examples must suffice to indicate some of the superb artistic and expressive qualities of the vast quantities of more recent tribal art, which doubtless perpetuate the forms of older and now-lost works. Rich figural reliefs, such as the carved-wood doors from the Yoruba culture at Ikerre in Nigeria (fig. 43), which illustrate scenes from tribal life and ritual, continue some aspects of the ornamentalized Benin tradition. Much more familiar are the guardian figures of wood covered with sheet brass (fig. 44) from the Bakota tribe of Gabon in West Africa. These figures were originally set over urns containing ancestral skulls to ward off evil spirits. Their clear-cut, tense geometric forms and strong magical content aided greatly in the development of abstract art in Europe. Yo-

- 42. Mounted King with Attendants, from Benin. c. A.D. 1550–1680. Bronze relief plaque, height 191/2". Museum of Primitive Art, New
- 43. Yoruba door, from Ikerre, Nigeria. Wood. British Museum, London

ruba ceremonial masks from Nigeria were often far more complex. The one in fig. 45, for instance, culminates in a veritable explosion of cactus forms, flanked by crouching birds at either side and crowned by an animal head. Such masks, sometimes weighing as much as a hundred pounds, are used for the *epa* cult, held every two years to evoke fertility for the land and for the humans who till it.

In fact these majestic masks should always be imagined as being actually worn by participants in complex rituals of fertility or death, rituals accompanied by dances and by music of astonishing rhythmic intricacy. The *kanaga* masks (fig. 46), used in the *dama* feasts of a secret religious society of the Dogon people in the Republic of Mali, are considered so sacred and so charged with magical powers that between feasts they are kept hidden. Women and children, not yet initiated, may not go near them for fear of being harmed. The masks embody a complete world system, expressed in the outstretched wings of the cosmic bird (accidentally resembling a so-called Cross of Lorraine) and its sharp beak above the wearer's face. Even the motion of the raffia skirts and arm-fringes should be pictured as part of the total experience when one sees such works of art in glass cases or hung on walls today.

A deliberately terrifying group of masks are those of the powerful goddess Nimba (fig. 47), worshiped by the Baga people of Guinea. The wearer's head fits in the hollow of the torso, his eyes looking out between the flat and pendulous breasts, and the whole structure is supported on four leglike struts going over his shoulders and chest. Little of the wearer save his arms appears above the raffia skirt. The head, with its staring eyes and monstrous nose outlined by raised dots like nailheads, would bob and sway with the dancer's ritual motions. No twentieth-century

- 44. Bakota guardian figure, from Gabon, West Africa. Wood covered with sheet brass, height 211/4". L. van Bussel Collection, The Hague
- 45. Yoruba helmet mask, from Nigeria. Height 30¾". Koninklijk Museum voor Midden-Afrika, Tervuren, Belgium

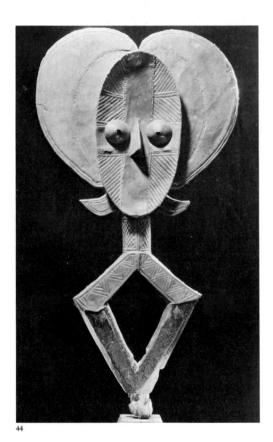

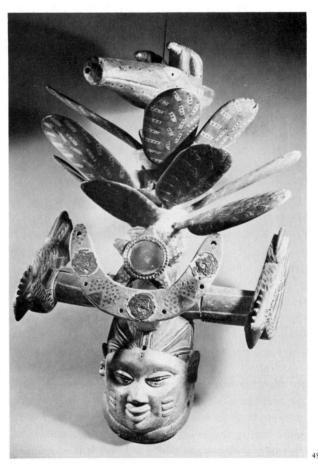

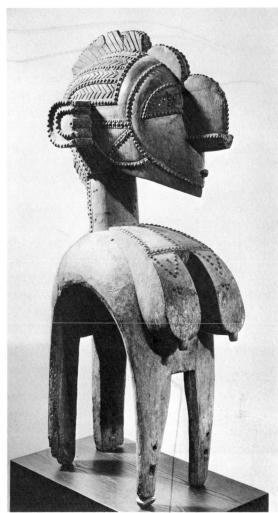

white sculpture has ever surpassed the grandeur and severity of these almost architectural forms.

Blacks who survived the horrors of the slave ships could bring no ritual objects with them, but they did not leave their creativity behind in Africa. Black folk arts of great interest grew up in areas of the American South and continue to flourish. And black artists in the twentieth century have taken their rightful place among the communities of painters, sculptors, and architects of American metropolitan centers.

A strikingly different but equally wide range of aesthetic and emotional value was exploited by the mixed Mongoloid and melanotic (dark-skinned) peoples from Asia, who as early as the second millennium B.C. settled the innumerable islands that dot the western Pacific Ocean, at a time when the lower water level in the area, as in Europe, left much of the continental shelf uncovered. The separate tribes that flourished in the rain forests of the coastal areas, the river valleys, and the mountainous uplands were often headhunters, sometimes ritual cannibals. Their surviving artifacts, usually carved in wood and painted, and therefore of quite recent date, were designed to satisfy practical and ceremonial necessities. Human and animal figures of compelling physical presence coexist with shapes that, at first sight, appear entirely abstract. But the dizzying effect on the modern observer, and presumably on the enemy, of the swirling curves and floating ovoids that decorate a war shield from the Sepik River region of

- 46. Dogon dancers wearing kanaga masks during a dama, Diamini-na, Mali
- 47. Simo mask of the goddess Nimba with carrying yoke, from the Guinea Coast. Wood, height 52". Private collection, New York

Oceanic Art

MAP 3. SOUTH PACIFIC

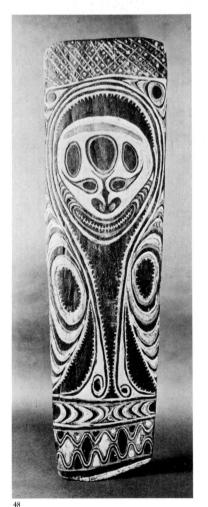

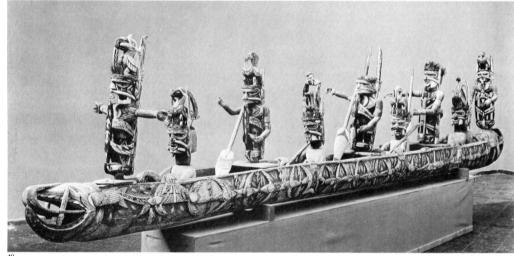

northern New Guinea (fig. 48) is stabilized by the realization that the shield is in fact a gigantic mask, with nose, eyes, and ornamentalized teeth, bearing on its brow a smaller and even more frightening face. Such objects were, of course, never intended to be seen apart from the context of tribal life, some of the intensity of which engulfs us in the huge "soul boat" from New Ireland (fig. 49) containing wooden sculptures of a dead chieftain, his relatives, and several of the enemies he has slain. The work, discovered in 1903, is unique, probably because all the other "soul boats" were actually sent to sea, perpetuating an earlier rite in which the bodies themselves were also thus treated. The fierce and jagged shapes of the stylized figures, the bird heads that crown them, and the great boat itself with its fins and its open, toothy mouth and lashing tongue compete in power and drama with the finest Northwest American Indian works.

Still unexplained are the colossal stone figures on Easter Island (fig. 50) that stand in long rows, suggesting the menhirs of Brittany, and lead along avenues to the volcanic craters from whose soft lava they were carved. As early as the seventeenth century the first European explorers noted that the inhabitants had lost track of the meaning of the statues and had pushed many of them into the sea. The backs of the heads are entirely

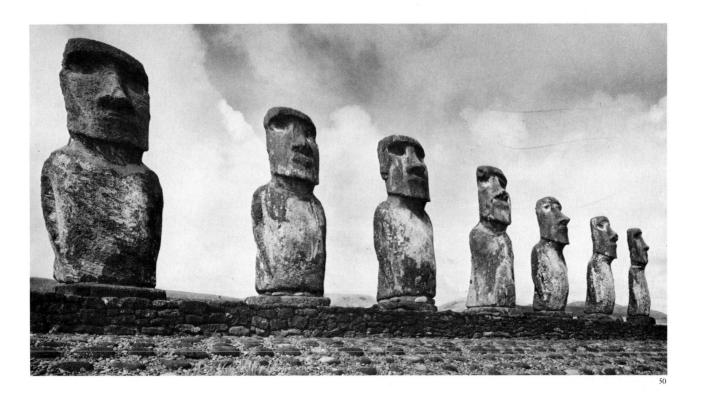

absent, the bodies barely suggested, so that the images are really a succession of staring masks, overpowering largely because of their gigantic scale, which unites them with the desolate landscape.

The first Europeans in North America may have been closer to the truth than we recognize when they called the inhabitants "Indians"; these peoples had in fact wandered from Asia, by way of a land bridge formed about 20,000 B.C. by what are now the Aleutian Islands, and they may even have brought Asiatic traditions with them. Many of these nomadic tribes of hunters were still in the Old or the Middle Stone Age, and some remained so, in spite of enforced mass migrations, until the present century.

Our conception of the American Indians is founded on an old and fallacious image of the "naked savage," nomadic and living in tepees. While the Indians of the Great Plains were indeed constrained by their environment to hunt buffalo and move constantly from place to place, this was not at all true of the tribal groups of the Southwest or the nations that once populated the central heartland of what is now the United States. These last were ethnically complex, and the tribes were strikingly different physically. They spoke scores of languages, often totally unrelated to each other. During the glacial era they hunted and gathered food, like Paleolithic humanity in Europe. But from about 7000 B.C. they lived in villages, and from about 1000 B.C. to A.D. 700 they existed by farming and inhabited groups of villages composing considerable towns along the great rivers in the center of the North American continent. Excavations have shown that these Indians maintained a widespread commerce, for materials from thousands of miles away have turned up at their burial sites. Their buildings were constructed of vertical logs, plastered with mud, like those of northern Europe.

The principal Indian architectural monuments were the famous mounds, found all the way from Florida to Wisconsin. There were once over 10,000 mounds in the Ohio Valley alone, some as much as one hundred feet high. Depending on the particular culture, these mounds

North American Indian Art

- 48. War shield, from the Sepik River region, New Guinea. Late 19th–early 20th century A.D. Wood, height 613/8". University Museum of Archaeology and Ethnology, Cambridge, England
- 49. "Soul boat," from New Ireland, New Guinea. c. A.D. 1903. Wood, length 19'. Linden-Museum, Stuttgart, Germany
- 50. Stone images. 17th century A.D. or earlier. Height 30'; weight c. 16 tons each. Easter Island, South Pacific

were employed for religious purposes, for burials, for the residences of rulers and nobles, or for temples. Some were built in the shapes of gigantic animals or birds, with wings spread (reminding us of Çatal Hüyük!), others were cones or domes, and the latest built were formed like truncated pyramids. The largest of these, at Cahokia just outside East St. Louis, Illinois, has a greater volume than the greatest of the Egyptian pyramids. Astonishingly, these millions of tons of earth were all brought up by hand, in baskets or cloths, then tamped down. Most of the mounds have perished, victims of the spade, the bulldozer, the reservoir, or the highway, but many thousands have been preserved. They are almost impossible to photograph effectively, and their full majesty can be appreciated only on the spot. But fig. 51 gives a faint idea of one of the most impressive, the Great Serpent Mound, in Adams County, Ohio, 1,247 feet in uncoiling length and holding what is apparently an egg in its open jaws. Not until the twentieth century, in works of so-called Earth Art, has anything like these great projects been attempted.

Many mounds have been excavated and approximately dated by means of carbon 14. Their inner burial chambers built of logs (or sometimes the earth itself) have yielded spectacular treasures. Aristocrats of the Hopewell culture, named after the family on whose Ohio farm the first and greatest finds were made, have been found entirely clothed in pearls and accompanied by objects of brilliant naturalistic observation and beauty of workmanship. Chief among these objects are pipes, with hollows for tobacco and a hole drilled through one end, intended to be held in the hand while smoking. The pipe representing a hawk (fig. 52), dating between 200 B.C. and A.D. 300, shows a degree of formal mastery and technical finish suggesting the art of the Old Kingdom in Egypt (see Part Two, Chapter One). The culture of the mound builders totally disappeared, no one knows why—perhaps epidemics, perhaps invasions—so that the first Europeans found the area largely deserted, except for Indians who had no memory of the mound builders, who may or may not have been their ancestors. The Indians of the lower Mississippi Valley, still utilizing their temple and palace mounds, were massacred by the thousands at the hands of De Soto and his men, but their culture had already started to decline.

The Indians of the Southwest built stupendous masonry villages in the broad cave mouths of cliffs, the grandest of which is the famous Cliff

- The Great Serpent Mound, Adams County, Ohio. Adena culture, 1000 B.C.—A.D. 400. Length 1,247'
- 52. Hopewell pipe in the form of a hawk, from Tremper Mound, Scioto County, Ohio. c. 200 B.C.-A.D. 300. Gray pipestone, height 3"; length 3½". Ohio Historical Society, Columbus
- 53. Cliff Palace, Mesa Verde, Colorado. c. A.D. 1150
- 54. Adobe pueblos, Taos, New Mexico

52

Palace at Mesa Verde in Colorado (fig. 53), dating from about 1150. Again we are reminded, perhaps accidentally, of Çatal Hüyük, because there are no streets and the houses are entered from each other, in tiers, by means of ladders. Descendants of the same Indians live today in adobe pueblos, like those in Taos, New Mexico (fig. 54), constructed on exactly the same principle. Sand paintings, intended to have a magical effect, are still produced today in the Southwest, but do not outlive the moment of their creation. Such sand paintings have been of great importance to the "Action Painters" of the 1950s in New York. Similarly, the lively, flickering designs of Indian blankets, produced by the complex interactions of basic geometric shapes (fig. 55), have much in common with the abstract paintings of the 1960s and 1970s and are often exhibited as wall hangings and appreciated as paintings. So indeed are the painted tepees and shields, the carved figures, the pottery, baskets, and beaded clothing, blazing with color and bursting with vitality of conception and design.

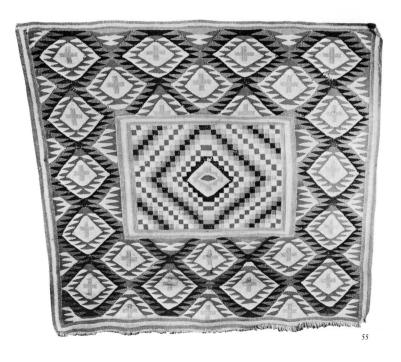

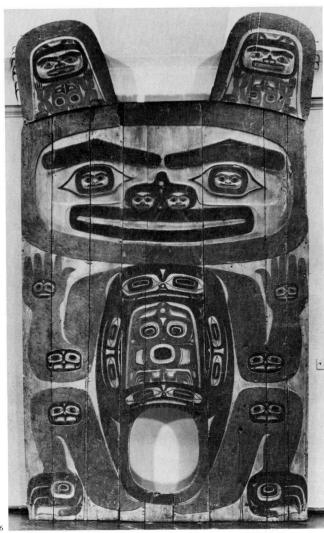

Perhaps the most powerful of more recent Indian works are the ceremonial animal sculptures of the Pacific Northwest. An effect of great mass is obtained by surrounding broad areas with incised rectangular contours having slightly rounded corners. The larger animals surprisingly disclose smaller ones—in their ears, their body joints, or even in their eyes and mouths—like the Scythian panther from southern Russia (see fig. 489). A Haida bear mask (fig. 57) of painted wood is provided with eyes and teeth of brilliant, veined blue abalone shell, suggesting that we are looking past and through the staring animal into distant sky. Even more majestic are the towering wood sculptures of the Tlingit—doorjambs, totem poles, gables, house partitions—of which one of the grandest is a colossal bear screen (fig. 56).

Few white Americans realize that some descendants of the builders of the Midwestern mounds and the Far Western cliff dwellings work in the construction of the steel frames of present-day American skyscrapers, where their immense skill, courage, and self-control are invaluable in building the most characteristic structures of the modern world. In general, while commercialized versions of the great Indian objects are being made in ever-growing numbers for the tourist trade, talented Indian artists are becoming increasingly assimilated into the currents of the dominant white culture.

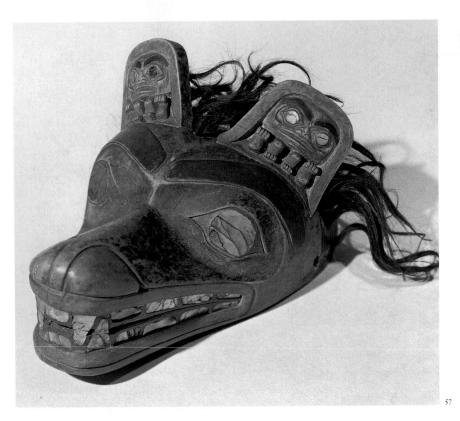

- 55. Nobility blanket. Thompson Indians (Northwest Coast). Before A.D. 1860. Peabody Museum, Harvard University, Cambridge, Massachusetts
- 56. Bear screen. Tlingit Indians (Northwest Coast). 1840. Carved and painted wood, 15 × 9'. The Denver Art Museum, Colorado
- 57. Bear mask. Haida Indians (Northwest Coast). Painted wood with abalone-shell inlay. Carnegie Museum, Anthropological Center, Meridian, Pennsylvania

Certainly to be counted among great ancient civilizations, and in part classifiable as Neolithic, are those cultures that flourished in Central America and northern South America before the arrival of the Europeans in the sixteenth century. Pre-Columbian art is indeed sometimes discussed along with ancient art, but has been placed here partly because it is an American art made by people related to the North American Indians, partly so as not to interrupt later the natural sequence from Roman to Early Christian and Byzantine art.

CENTRAL AMERICAN ART The small bands of Spanish adventurers, who with the aid of gunpowder defeated and subjugated with ease the Aztec and Inca empires and the Mayan states, were astonished at the high level of urban culture they found. Where not precluded by mountainous terrain, cities had been laid out on a grid plan with wide, straight streets. Before the Spaniards tore it down, house by house, in the protracted battle of 1520-21, Montezuma's capital, the lake city of Tenochtitlán, boasted a luxurious palace and fine residences united by a network of canals. Both the Maya and the later Aztecs possessed complex systems of hieroglyphic writing, as yet only partially deciphered, and each had a calendar so precise that both Mayan and Aztec inscriptions can be dated down to the day according to our system. While their massive temples were intended mostly for exterior use, the Maya and the Aztecs knew and employed the post-and-lintel system, the corbel arch, and the corbel vault. The Spaniards admired the craftsmanship of Aztec sculpture and minor arts, but they saw in them little artistic merit and melted down most of the gold and silver objects. They also systematically destroyed almost all Aztec manuscripts, which were written on a kind of paper made from the bark of the fig tree; only a very few illuminated examples survive. Montezuma showed the Spaniards with pride his botanical garden, which had a specimen of every identifiable plant that grew in his empire. Arithmetic and astronomy were among the great interests of both

Pre-Columbian Art

Aztecs and Maya. The Aztecs had even developed a system of universal education. Astonishingly enough, none of these original Americans knew the use of the wheel, and they had no draft animals. In most respects it can be said that the Maya and the Aztecs, at least, had reached a stage of development analogous to that of the ancient Sumerians, and that the Incas, at the very least, had arrived at about the level of predynastic Egypt.

A prominent feature of Central American life was the institution of human sacrifice, and wars were systematically conducted to obtain victims for that purpose. Human sacrifice was rationalized as essential for the propitiation of the gods of heaven and the continuance of their light and heat, but in fact it provided a staple source of protein for the conquerors in the absence of domestic animals. European hands, of course, were far from clean in respect to mass slaughter, as witness the bloody spectacles of the Roman arenas or the Christian executions of heretics by sword and fire. On their arrival the Spaniards were shocked at the endless lines of battle prisoners awaiting sacrifice, although it is debatable whether in their occupation even more human lives might not have been taken in the name of the most Christian king of Spain.

One of the most remarkable aspects of these vanished cultures to us is the lack of any certain evidence of contact between them and the rest of the world; the Incas and their predecessors in the Andes even developed in total isolation from the Aztecs in Mexico and the Maya in Yucatán. We can speculate that all the early Americans arrived from Asia by way of a land bridge formed by the Aleutian chain during the last glacial period and cut off when the glaciers receded and the water level rose. After settling in Central and South America, these peoples must have independently recapitulated much of what Asiatic, North African, and European peoples were inventing. Until about 3000 B.C. the early Americans remained in the Old Stone Age. The first mature pottery and clay statuettes can be dated about 1500 B.C. Metals and the techniques of working them were discovered fairly late, around A.D. 1000; many of the finest works of architecture and sculpture were executed with tools made of stone or bone.

Interestingly enough, nowhere in Pre-Columbian sculpture does any conception of the essential dignity of humanity require either freely walking or even freestanding human figures. Carved human images are invariably restricted in projection by the surfaces of the architecture into whose blocks they are carved. Their cramped poses are in sharp contradistinction to the sensitive observation of their faces and hands. Free from this kind of patterning, painting nonetheless conforms to the flatness of the wall. Even in painting, female figures are rare; from sculpture women (as distinguished from female deities) are entirely absent.

Teotihuacán. The Aztecs were aware that they were latecomers to the Mexican highland and that they had had predecessors there in a happier era before human sacrifice became "necessary." These earlier peoples built cities, the most impressive of which was Teotihuacán, whose main avenue of temples, dating from well before A.D. 600, has been excavated (fig. 58). The rites of early American nature worship required hilltops, and when these were unavailable, mounds were built. By the beginning of the Christian era, the mounds had reached the form of carefully constructed step-pyramids, ascended by a central flight of stairs. The parallel in form and purpose with Mesopotamian ziggurats (see figs. 123, 125) is compelling. The American structures were, however, not built of mud brick but according to an elaborate system of inner stone piers and fin

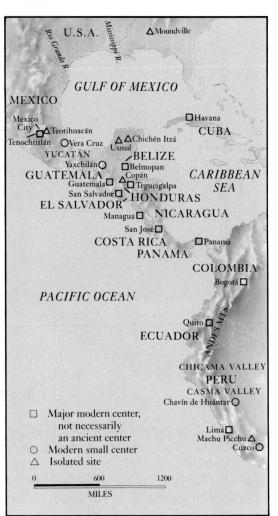

MAP 4. CENTRAL AND NORTH-WESTERN SOUTH AMERICA

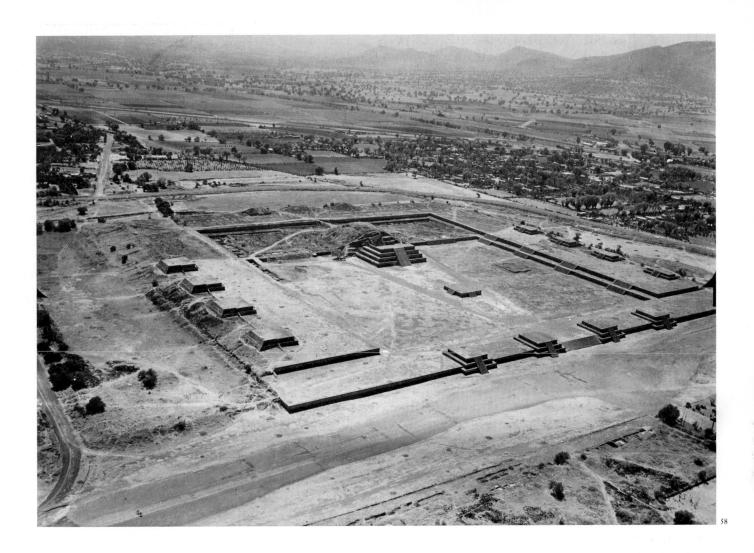

58. Ciudadela court, Teotihuacán, Mexico (view from the west). Before A.D. 600

walls, filled in with earth and rubble, and faced with well-cut stone masonry. Not only in sheer craftsmanship but also in the feeling for mass and proportion, and in the disposition of spaces, these pyramids of Teotihuacán are majestic works of architecture. With a single exception, the various levels are ornamented only with simple paneling, which accentuates their cubic grandeur.

The Olmec. The mysterious Olmec culture, which flourished on the Gulf Coast of Mexico from about 800 B.C. to about A.D. 600, produced a surprisingly naturalistic sculpture in the round, including a series of colossal heads of unknown purpose. An example from San Lorenzo Tenochtitlán (fig. 59) has been provided with a closefitting helmet, under which the brows are knitted in a frown; the prominent lips are partly open, and the large eyes stare. The mass of basalt has thus been transformed into the appearance of living flesh with astonishing power and intensity.

The pyramid with central staircase, established at Teotihuacán, was recapitulated in countless variations of size, shape, and proportion throughout central Mexico and Yucatán; its form became sharply steeper and higher in the Mayan civilization. The Maya had their own religious rites, one of which was a ball game in which the rubber ball passing back and forth overhead symbolized the course of the sun through the heavens. The reconstruction of a ball court at Copán (fig. 60), as it appeared about A.D. 600, shows the Mayan genius for the deployment of architectural masses, often unrelieved, crowned here with a windowless

story richly ornamented with the relief sculpture at which the Mava excelled. In the so-called Nunnery of the tenth century at Uxmal (fig. 61; its actual purpose is unknown), the customary cubic masonry of the lower story is contrasted with an upper zone of ornament in which lattice shapes alternate with carved masks. The horizontality of accent produces an effect unlike that of any Old World architecture. Even when the Maya were under the domination of the Toltec, who seem to have introduced human sacrifice, the originality of Mayan architecture was maintained. The Mayan-Toltecan center of Chichén Itza is filled with structures whose massive grandeur and delicate relief carving create an impression of the greatest variety and richness. The Caracol (observatory) is one of the most impressive—a cylindrical building on a lofty platform (fig. 62). Over the doorway grins a fierce mask strikingly suggestive of the Haida bear masks (see fig. 57) of the Pacific Northwest. The interior is formed by two concentric circular corridors, roofed by pointed corbel vaults.

During the "classic" Mayan period (to use the designation employed by archaeologists), which corresponds to about the first millennium of our era, sculpture in the round was rare and generally limited to ceramics and stucco. Painting, while extensive and of high quality, was executed on walls in narrow spaces, and is extremely difficult to reproduce today except in copies. Sculpture in low relief was abundant, and beautiful both in its characteristic contrast of blank and enriched areas and its spontaneous transformation of inert blocks and cubes into live masses.

A rare example of sculpture in the round is the colossal Water Goddess, dating before 700, from Teotihuacán (fig. 63). The immense size (101/2 feet high) and blocky appearance of the image may be explained by its probable function as a caryatid figure upholding a central wooden roofbeam. Its identification as a water goddess depends only on the wave motif running along the hem of the skirt, an obvious symbol omnipresent in early art all the way from Ireland to China. Not only in execution but

- 59. Colossal head, from San Lorenzo Tenochtitlán (Veracruz), Mexico. Olmec, c. 800 B.C.c. A.D. 600. Basalt, height 707/8". Museo de Antropología, Jalapa, Mexico
- 60. Main ball court, Copán, Honduras. Maya culture, c. A.D. 600 (Architectural reconstruc-

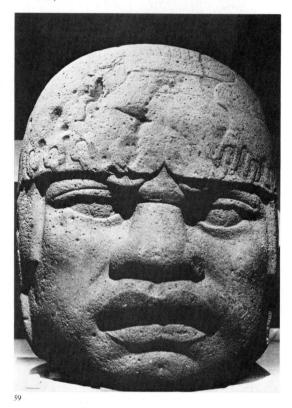

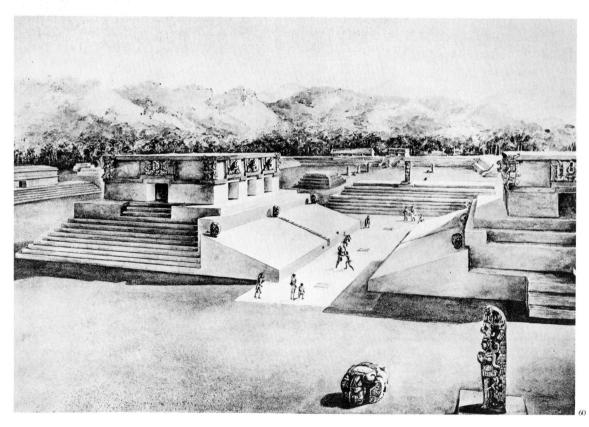

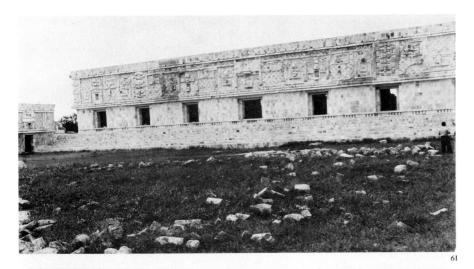

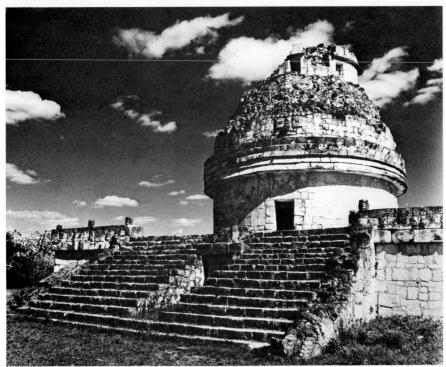

in basic conception the work is a relief. Ears, limbs, and extremities are drawn upon and carved into the flat surfaces of the block and shown frontally so that fingers and toes may be counted. The rectilinearity of the block mass controls every aspect of the representation. The eyes stare blankly forward and in the open mouth may be seen a protruding tongue. The chest contains a cavity in which, apparently, was placed a stone heart. In the dimness of an ancient interior the total effect of the towering yet squat deity must have been awesome.

Although still limited by the surface of the stone slabs into which they are lightly carved—even by the angles of the corners—the numerous stone lintels in low relief are far more flexible. A very fine relief, datable to 692-726, from the lintel of a house at Yaxchilán (fig. 64) shows a possibly ceremonial, possibly visionary subject, difficult to interpret exactly in the present state of our knowledge of Mayan hieroglyphs. These appear in the upper corners of the relief and in an upside-down, L-shaped area in the center. On the left a strange design of scrolls and scales resolves itself into a fantastic serpent or dragon, above a delicately drawn

- 61. Nunnery Quadrangle (west building), Uxmal, Yucatán, Mexico. Maya culture, 10th century A.D.
- 62. The Caracol (observatory), Chichén Itzá (Yucatán), Mexico. Maya Toltec culture, 11th century A.D.
- 63. Water Goddess, from Teotihuacán. Before A.D. 700. Basalt, height 10'6". Museo Nacional de Antropología, Mexico City

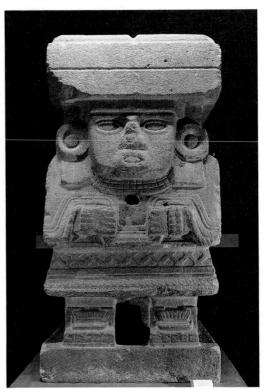

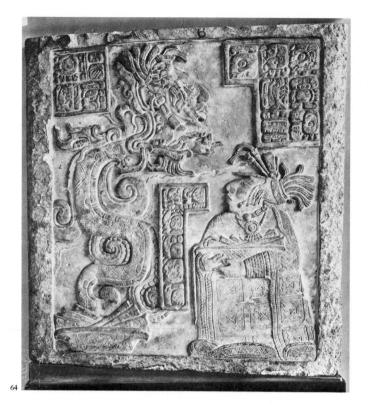

Many surviving early Mayan wall paintings cover large areas with ritual compositions either arranged in registers in a manner comparable to the tomb paintings of ancient Egypt or forming intricate patterns made up of deities, humans, animals, and plants. Dominated as in sculpture by the flatness of the wall on which they are projected, these paintings contain many surprises for a viewer accustomed to European art. Some of the later paintings abandon their rigor of planar design for a seemingly spontaneous picture of action in open space. A painting of siege operations from the thirteenth century in the Temple of the Jaguars at Chichén Itza (fig. 65) presents an astonishing panoramic view of the chaos of a battle. Yet European perspective is never suggested. The ground is synonymous with the wall surface, into which the figures are splattered as if by an explosion, attacking, resisting, counterattacking, armed with spears and defended with shields. They conform to no all-over pattern, but their poses are predetermined by convention, and they never overlap. Outlines are firm and concise, and between them the color is flatly applied. In the midst of the confusion rise two siege towers populated with attackers, themselves menaced by the enveloping folds of dragon-like creatures slithering around the beams. Once the spatial conventions of such views are accepted, the free ferocity of a battle situation is convincing.

ANDEAN ART The Andean region formed a totally distinct area of pre-Columbian culture, whose origins cannot be traced. The Spaniards arriving in Peru in 1536 found an even more recent empire than that of

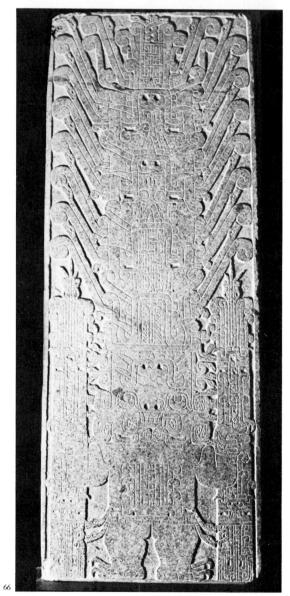

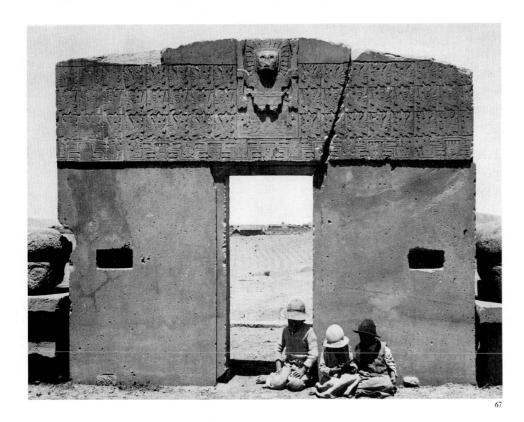

the Aztecs of Tenochtitlán. The Incas had no writing, and their vast empire was held together by an extraordinary system of oral communication, messages being delivered by runners in short and frequent relays, making it possible for a message to travel one hundred and fifty miles in a day—as compared to the twelve to fifteen days required by the later Spanish system of post-horses. The Spaniards were astonished to find themselves everywhere expected. In the absence of writing, the Incas made relief models of areas of their mountainous empire to aid them in moving subject peoples from one region to another in order to forestall revolt. In Andean architecture we find many of the familiar features we have encountered in Mexico-platforms, step-pyramids, gridiron cities. Mining was extensively practiced, and the smelting, casting, beating, and chasing of metals done with the utmost skill. It cannot be claimed, however, that Andean art often reached the level of Mayan art at its best.

Andean carvings were generally incised on stone in patterns of great complexity, but not further carved save for reduction of the background. One of the most fascinating Andean reliefs is the Raimondi Monolith (fig. 66), datable about 500, from Chavín de Huántar in northern Peru. This was probably a ceiling decoration, intended to be read in either direction. At first sight one distinguishes a chunky personage, with claws on his feet, in the lower third of the relief; his short arms and massive hands extend to hold two richly carved scepters. His face is a mask, displaying a grinning mouth, full of square teeth, and saucer-shaped depressions for nostrils and eyes. The upper two thirds of the relief appears to be filled with a towering headdress from which feathers sprout on either side; when one turns the picture around, the upper sections become a series of masks, each hanging from the jaws of the one above. The magical intensity of the complex pattern renders it extremely attractive to modern eyes.

Few remains of Andean buildings can compete in splendor with those of the Central American cultures. Yet the so-called Gateway of the Sun (fig. 67) at Tiahuanaco is a majestic creation in its own right; located in the lofty plateau region surrounding Lake Titicaca, a site now in northern

- 64. Lintel relief, from a Maya house, Yaxchilán, Mexico. c. A.D. 692-726. British Museum, London. Maudslay Collection
- 65. Siege Operations During a Battle, painting from the south wall, inner room, upper Temple of the Jaguars, Chichén Itzá. Maya Toltec culture, 13th century A.D. Peabody Museum, Harvard University, Cambridge, Massachusetts
- 66. Raimondi Monolith, from Chavín de Huántar (Ancash), Peru. c. A.D. 500. Stone, height 72". Museo Nacional de Antropología y Arqueología, Lima
- 67. Gateway of the Sun, Tiahuanaco, Bolivia. Tiahuanacan culture, shortly after A.D. 300. Height 9'

Bolivia, it dates shortly after A.D. 300. Two monolithic jambs, each nine feet high, support a huge lintel that at first appears to be decorated with three superimposed strips of floral or foliate ornament above a lower border of a meander pattern suggesting those common in ancient Greece and throughout the decorative art of China. In the center, over the doorway, is a sharply stylized frontal relief showing the sun god holding a bow in his right hand and two arrows in his left. From his masklike countenance emerge gigantic rays. On closer analysis the strips of ornaments resolve themselves into registers of eight running figures, thus forty-eight in all, each holding two arrows and wearing a feather crown. Those in the upper and lower rows have human heads in profile directed straight forward, while the upturned heads of those in the central row display open bird beaks. All have staring eyes, some round, some square, and all these minions of the sun god are propelled by wings lifted behind them. Into the openings in the meander pattern are inserted other sun-masks in wigwag style, now up, now down. As in the Raimondi relief the combination of powerful vertical and horizontal rhythms with an elusive balance between apparently floral but actually animal representations produces an almost dizzying effect.

At the opposite pole from this very nearly abstract art, with its probable religious significance and ritual purpose, the same region of northern Peru in which the Raimondi relief was carved, at roughly the same period, produced strikingly naturalistic pottery intended for daily use, in which the entire pot was turned into an image of a human head. The Mochica potters experimented with different types of facial expressions until they were able to produce natural, spontaneous, and infectious ones, an example of which is shown in the Laughing Man (fig. 68), whose features are irradiated with a wide and happy grin and whose eyes are almost closed in laughter.

The grandest productions of the short-lived Inca Empire, which governed an enormous Andean area from its capital at Cuzco in southern Peru, are its cities, built of masonry that has been sculptured to fit, stone against stone, so that literally (as is almost too widely known) the blade of a knife cannot be inserted between them. The city of Machu Picchu, most of whose buildings are datable about 1500, is probably the most fantastic of all early American cities known to us (fig. 69). Its extensive ruins stand on a crag that towers among other crags about two thousand feet above a misty valley.

The culture of the Spanish Renaissance, however, ended the indigenous art of the ancient American civilizations in the sixteenth century and imposed its own European styles on the conquered inhabitants, along with its languages and religion.

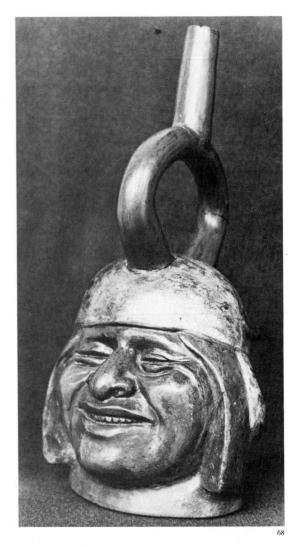

68. Vessel representing a laughing man. Mochica culture, c. A.D. 500. Museo Nacional de Antropología y Arqueología, Lima

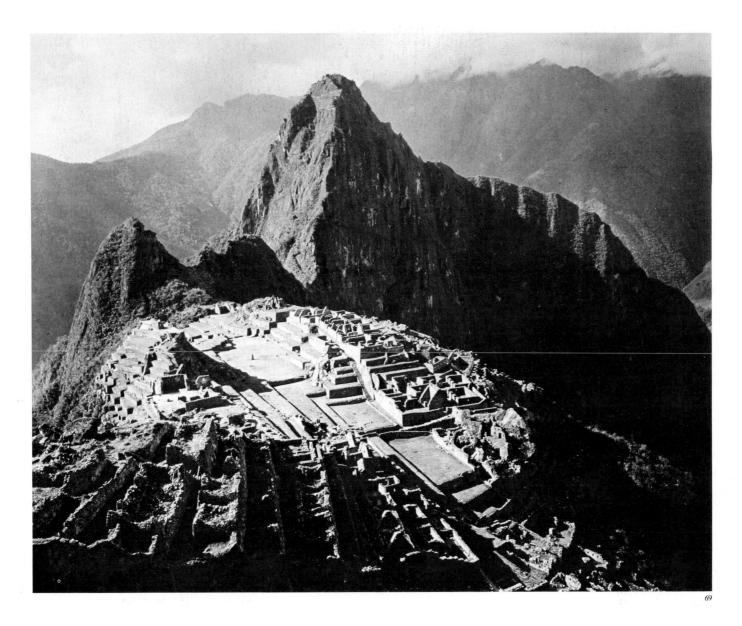

These few objects we have seen represent only a small selection from the immense riches of ethnic art, which has at once perpetuated many of the modes of creation found in the earliest arts of humanity and brought the raw power of preliterate art closer to our own times, often under a high degree of intellectual control. For twentieth-century artists, ethnic art has served as a reservoir of emotional energy as well as of forms and designs and a reminder that magic and unreason are far from dead. They live deep in the subconscious of all "civilized" peoples and provide more strength in our lives than we will perhaps admit.

69. Aerial view of Machu Picchu, Peru. Inca culture, c. A.D. 1500

TIME LINE I

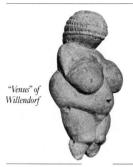

Wounded Bison

Ritual Dance. Addaura (detail)

Plastered Skull, Jericho

Environment

30,000 B.C.

Upper Paleolithic Period Alternate cold and mild phases Franco-Cantabrian region is western boundary of Eurasian Ice Sheet

20,000

Mongoloid migrations from East Asia to North and South America Expansion of Paleolithic man into North Europe

and Asia Mesolithic Period

10,000

Post Glacial Period; birch forests and parkland appear in North Europe and Asia Hunters in North America migrate south and east;

lakeshore settlements in Europe

Human Activity

"Blade" cultures develop in Eurasia and Africa

Stone toolmaking becomes commonplace Increased specialization of stone tools Invention of bow and arrow, spear-thrower, and chisel

Hunting-fishing-fowling cultures prevail Increase in tool repertory; development of bone harpoon, fish traps, heavy adzes and axes Domestication of the dog

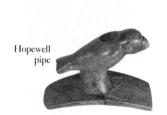

Cliff Palace, Mesa Verde

Queen Olokun

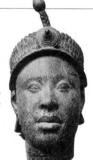

Leopard from Benin

8,000 B.C.

Neolithic Period Steady rise of average temperatures Rise in sea levels Increased foresting of land

4,000

2,000 Stabilization of climatic conditions

1,000

A.D. 1100

Climatic optimum: worldwide warm spell

Mongoloid and Melanotic settlements in Oceania

1800

Irrigation, plant cultivation, and animal husbandry gain sophistication Pottery; ground and polished tools Start of mining and quarrying Jericho develops farming and hunting Diffusion of farming to Crete, Sicily, South Italy Bronze Age; Tigris-Euphrates civilizations flourish

Metallurgy spreads from Near East to Egypt, Mediterranean; Iron Age

ART BEFORE WRITING/LATER ETHNIC GROUPS

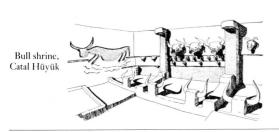

entrance slab, Tarxien

Stonehenge

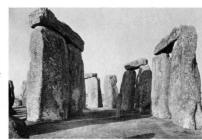

PAINTING, SCULPTURE, ARCHITECTURE

"Venus" of Willendorf Woman's Head from Grotte du Pape **CHAPTERS**

Art Before Writing Paleolithic

30,000 B.C.

"Venus" of Lespugue

Painted caves at Lascaux; Bison and Reclining Woman, La Madeleine Bison, Altamira; Two Bison, relief at Le Tuc d'Audoubert Chamois from Le Mas d'Azil Ritual Dance, Addaura

Hunting Scene (copy), El Cerro Felío

Mesolithic

10,000

20,000

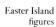

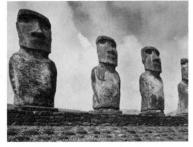

Colossal Olmec head

Machu Picchu

Stone fortifications, Jericho; Plastered Skull, Jericho Çatal Hüyük: houses, Bull Sanctuary, Shrine with wall paintings Goddess Giving Birth from Catal Hüyük

Temple, Tarxien; trilithon portals, Malta

Corbel vault from tomb chamber, Maeshowe Stonehenge Hopewell pipe; Great Serpent Mound Easter Island figures; Raimondi Monolith; Olmec head Cliff Palace, Mesa Verde; The Caracol, Chichén Itzá Queen Olokun; "Princess," Leopard, and bronze reliefs from Benin Adobe pueblos, Taos; Tlingit screen; Haida mask; nobility blanket Yoruba door from Ikerre; Bakota guardian figure; Yoruba mask; Simo mask of Nimba War shield from Sepik River; "soul boat" from New Ireland

Neolithic

8,000 B.C.

Later Ethnic Groups 4,000 2,000

1,000

A.D. 1100

1800

THE ANCIENT WORLD

TWO

For many thousands of years, Neolithic humans were able to produce and preserve food and thus develop permanent settlements, yet they depended entirely on memory for records, communications, and the preservation of history, religion, and literature. No matter how highly developed, memory is notoriously fickle. No large-scale systematic enterprise, whether political, economic, or religious, was possible in the absence of reliable and enduring records. How humans first hit on the idea of setting down information in visible form, thus arriving at a system of writing, we do not know, but this essential change seems to have taken place a little more than five thousand years ago, in Mesopotamia and Egypt, on both sides of the land bridge connecting Asia and Africa. In both of these civilizations the earliest writing was pictographic, but soon the little images became codified and developed connections with syllables and words independent of their original derivation. Egypt, which possessed both quantities of hard stone and swamps from whose reeds a paper-like material called papyrus was fabricated, long retained the pictorial shapes the Greeks named *bieroglyphs* ("sacred writing," because its use was a prerogative of the priesthood). Mesopotamia, however, relied on soft clay as a writing surface, and there the pictographs were rapidly codified into groups of impressions made with the wedge-shaped end of a reed stylus—a form of writing we call *cuneiform* (from the Latin word for "wedge").

Records and communications facilitated commerce and systematic agriculture as well as the development of governmental authority. Cities grew to considerable size. Monarchies arose and extended their sway to ever wider regions by the subjugation of neighboring states. By the middle of the second millennium B.C., three powerful and prosperous empires had developed: in Egypt, in Mesopotamia, and in the islands of the Aegean Sea. The end of the second millennium, however, was a time of great upheaval for the ancient world, and none of the major powers escaped unscathed. From the ensuing chaos arose the glorious, if partial and short-lived, democratic experiment of the Greek city-states. But despite the enormous influence of Greek culture on the future, the separate Greek political systems could not resist the march to power of Rome. By the end of the first millennium B.C., all the states of the Mediterranean world and many of the still tribal polities of northern, central, and eastern Europe were either absorbed or on the road to absorption by the Roman Empire. Political unification prepared the ancient world for religious unification as well, and the religions surviving from the ancient states proved no match for the universal claims of Christianity or, a few centuries later, of Islam.

Along with writing and the new attitudes and systems it made possible, there arose entirely new modes of intellectual activity based on writing and aimed at the intellectual and physical control of the environment and of humanity itself. History and epic and religious poetry were put in writing in Egypt and Mesopotamia. The sciences of zoology, botany, anatomy, and medicine made remarkable progress.

Numbers, considered apart from enumerated objects, became transferable to any object, or became subject to abstract analysis. Arithmetic and geometry, including principles still valid and methods still taught, were discovered. Optics, perspective, and astronomy made remarkable beginnings, and scientific calendars were devised. Speculation and abstract reasoning followed observation, and under the Greeks and Romans the major branches of philosophy were established. New scientific attitudes began to replace mythological systems with a cosmology based on scientific method.

The adoption by the Greeks of the Phoenician alphabet about 750 B.C. facilitated the codification of language and the establishment of regular grammar and syntax. Recorded literature included not only the preliterate oral poetry of the Greeks, which could at last be set down, but newly composed dramas and lyrics and a systematic attempt at accurate history. Fortunately enough, in one way or another Greek and Latin have remained accessible, but in the case of the twin colossi of the pre-Greek world, Egypt and Mesopotamia, not only their languages but even their systems of writing had seemed hopelessly lost. Only a combination of lucky accident and tireless investigation in the nineteenth century has enabled us at last to read the writing in which their civilizations were crystallized, and thus to reconstruct a remarkable proportion of their history and religion. These writings have also helped us to understand the purpose and meaning of thousands of works of art.

Ancient music, now almost entirely lost, was based on scales and mathematical principles still in use today; it apparently reached great heights. But along with the earliest steps in the evolution of science, and before any presently known achievements of philosophy, literature, and music, the mental attitudes born of writing made possible entirely new purposes, standards, and practices for the visual arts. For the first time, in Egypt and Mesopotamia, emphasis in figural art was transferred from animals to humans, individually or in groups, described with accuracy and analyzed with understanding, and set upon a continuous groundline or within an increasingly complex spatial environment. Compositions could be measured and controlled. Empirical Neolithic building methods gave way to a rational architecture composed of regular and regularly recurring modular units and spaces, often mathematically interrelated, and constructed with so accurate an understanding of physical stresses that, if they had been kept in repair, most ancient masonry structures would be standing today. Not only buildings but whole cities were laid out according to regular plans and provided with systematic water supply and drainage.

In all fields of human endeavor, reason is the triumphant discovery of the ancient world. The best works of ancient art, founded upon reason, are of a quality that has seldom since been equaled and never surpassed. Indeed, none of the other great conquests of the ancient world in any field—practical, intellectual, or spiritual—could have been achieved without reason. Professionals in all fields, whose activities were based on systematic exploitation of every facet and consequence of the reasoning process, were highly regarded in all ancient civilizations, and as we shall see, especially in Egypt and Greece, they sometimes attained high positions. As far as we can tell, from pictures and from literary evidence, these professionals were always male, except for an occasional woman poet (such as the matchless Sappho, in Greece in the sixth century B.c.) and a handful of later Greek portrait painters. This situation was entirely due to the social restrictions placed on women. In Egypt women could become dancers, but this was not a highly regarded profession. In recompense, however, powerful female patrons, like the Egyptian queen Hatshepsut or the Roman empress Livia, must have imposed their own ideas of style on some of the greatest monuments of the ancient world.

Ancient humanity was still haunted from every side by the irrational, embodied and given legal force in the form of state religions, the violation of whose codes could bring death, as it did to even a figure as universally admired as the philosopher Socrates in Athens in the fifth century B.C. The hidden purposes of ancient deities could be divined only by specially gifted persons (priests or oracles), and their favor was won by sacrifices. Dangerous as these irrational forces might become if not propitiated, it was still to

them that some of the most impressive structures of antiquity, with all their works of art, were consecrated. We might even say that in the ancient world *irrational* content (devotion to unpredictable and vengeful divinities, sometimes part animal and often free from any commitment to morality in their own behavior) provided the animating spirit within the *rationally* organized works we now respect. At some moment, especially in conventions imposed by religious purposes but systematically carried out, rational and irrational can be said to coalesce. It is from this very equipoise between reason and unreason that ancient art derives much of its excitement.

The social upheavals following the dissolution of the ancient empires were responsible for the destruction of much of humanity's early artistic achievements. Tragic as are our losses—most of the productions of ancient visual art and literature and all of ancient music but for a few tantalizing fragments—archaeology has won back countless works of art from what had seemed impenetrable darkness. To the High Renaissance of the sixteenth century in Italy, archaeology was a humanist scholar's impracticable dream, but in the eighteenth century it became a reality, and whole buried cities were dug up. Since then archaeology has developed a scientific theory and a rigorous methodology. In most countries this science has also inspired a determined and often successful attempt at legal control of excavation, whose validity has been recognized internationally by resolutions of the United Nations. The majority of the works of art illustrated in this section, "The Ancient World," were either once buried under the continually rising level of the earth or sunk in the sea. They owe their resurrection to archaeology. The discoveries continue. In recent years, many splendid works of art have come to light, including the two powerful bronze statues illustrated in figs. 217 and 218.

Alas, not all excavation has been disinterested. Temples and tombs have been robbed of their treasures for private gain, and many of the results of such depredations, often involving the ruin of what was left in place or underground, fill museums in every country. It is an experience of unforgettable sadness to visit, for example, the majestic rock-cut temples at Lungmen in Northern China and witness the pitiful remnants of beheaded figures, or the scars left by statues clumsily hacked from their bases. But in spite of violence and cupidity, what is left of ancient art, no matter how scarred or brutally torn from its original setting, remains a supreme intellectual and spiritual heritage—and inspiration—for us today.

EGYPTIAN ART

ONE

The antiquity and continuity of Egyptian civilization were legendary, even to the Greeks and Romans. In fact, the period of roughly three thousand years during which Egyptian culture and Egyptian art persisted, unchanged in many essential respects, is longer by half than the entire time that has elapsed since the identity of Egypt was submerged in the larger unity of the Roman Empire. Although the rival cultures of the Near East, especially Mesopotamia, had a somewhat earlier start, and even influenced to a limited extent some of the early manifestations of Egyptian art, the Mesopotamian region did not enjoy natural barriers like those that protected Egypt. Consequently, group after group of invaders overwhelmed, destroyed, or absorbed preceding invaders throughout Mesopotamia's stormy history. Moreover, with few observable outside influences, the Egyptians rapidly developed their own highly original forms of architecture, sculpture, and painting earlier than any comparable arts in Mesopotamia, and it is Egyptian rather than Mesopotamian art that provided norms for the entire ancient world. It seems preferable, therefore, to commence our story of the ancient world with Egypt.

The dominating reality of Egyptian life has always been the gigantic vitality of the Nile River. For nearly a quarter of its four thousand miles, it flows through Egyptian territory. The Nile Valley, nowhere more than twelve and a half miles wide, forms a winding green ribbon between the barren rocky or sandy wastes of the Libyan Desert to the west and the Arabian Desert to the east. During the fourth millennium B.C., the valley was inhabited by a long-headed, brown-skinned ethnic group, apparently of African origin, while the Nile delta to the north was the home of a round-skulled people originally from Asia. Remains of Neolithic cultures, including a rich variety of decorated ceramics, abound in both regions.

The chronology of Egyptian history is still far from clear, and most dates are approximate and disputed. But, according to an account set down by a Hellenized Egyptian called Manetho in the second century B.C., the separate kingdoms of Upper (southern) and Lower (northern) Egypt were united by a powerful Upper Egyptian monarch called Menes, founder of the first of those dynasties into which Manetho divided Egyptian history. Menes has been identified by modern scholars as Narmer, the king depicted on the slate tablet in fig. 71. His tremendous achievement—establishing the first large-scale, unified state known to history—took place either shortly before or shortly after 3000 B.C.

The inscriptions that abound on all Egyptian monuments were written in a form of picture writing known as hieroglyphic (examples appear in many illustrations; see figs. 81, 94, 100, 110). Although, for millennia afterward, hieroglyphic was known in Europe and admired for its beauty, it was never understood. In fact, it became the subject for the most fantastic theorizing. Then, in one of the most important discoveries in the history of archaeology, the Rosetta Stone, a fragmentary inscribed slab, was found near the town of Rosetta in the Nile Delta by French scholars who accompanied the armies of General Na-

poleon Bonaparte in his invasion of Egypt in 1799. The slab contained texts in three scripts, Greek (which everyone knew), *demotic* (a late, popular form of Egyptian writing), and hieroglyphic. Although it was immediatedly guessed that the text was the same in all three scripts, not until 1821 did the young French scholar Jean-François Champollion (1790–1832) succeed in deciphering the other two. Ancient Egyptian turned out to be the direct ancestor of Coptic, a now-extinct language spoken by the Egyptians in Early Christian times and thus known to scholars. Champollion, and his many successors, thus had the key for the deciphering of countless inscriptions and manuscripts, a practice that continues to the present day. Egyptian history, economics, social structure, literature, and religion were open to study, and much can be read in translation.

The Egyptian king, or *pharaoh* as he is known in the Old Testament (from an Egyptian word originally meaning "great house"), was considered divine. He participated, therefore, in the rule of universal law that governed the natural life of the entire valley. The sun rose over the eastern cliffs in the morning and set over the western cliffs in the evening. All day the sun sent down its vivifying rays until it was devoured by the night, but one could be perfectly sure that next morning it would be resurrected. In the same way the Egyptians faced death with the certainty that, like the sun, they would live again. Every autumn the river overflowed, spreading over the land the fertile silt brought from central Africa. Even in the almost total absence of rainfall, abundant crops could be produced. The unchanging order of the natural world was personified by a complex and often changing pantheon of nature deities engaged in a continuous mythological drama rhythmically repeated according to the cycles of nature. By these deities the pharaoh was believed to have been generated, and to them he would return after a life spent maintaining in the state an order similar to that which they had ordained for the Nile Valley—beyond which, at the start of Egyptian civilization at least, little was known and nothing mattered.

The Egyptians built their houses, their cities, and even their palaces of simple materials such as palm trunks, papyrus bundles, Nile mud, and sun-dried bricks. Little is left of the palaces beyond an occasional foundation or fragments of a floor or painted ceiling, and almost nothing of the dwellings of ordinary people. But tombs and temples were soon to be constructed of stone, of which there was an abundance in the desert—sandstone, limestone, granite, conglomerate, and diorite, to name only a few. The Egyptians devoted their major artistic efforts to the gods and to the afterlife, not only in architecture but also in sculpture—both of which were often of colossal dimensions, meant to rival the immensity of the landscape and the sky—and in those delightful decorative reliefs and paintings from which we derive most of our knowledge of Egyptian life. As we will see throughout our survey of their art, with rare exceptions the Egyptians' desire for permanence, stability, and order runs through every aspect of their temples, their tombs, their sculpture, and their painting, determining down to the last detail how every structure should be organized and carried out and even how the human figure should be posed and proportioned.

The Archaic Period and the Old Kingdom, c. 3200–2185 B.C.

A striking illustration of the difference between preliterate, predynastic Egypt and the subsequent tightly organized civilization that was to prove so amazingly durable can be seen by comparing the earliest known example of an Egyptian mural painting (fig. 70), made shortly before 3000 B.C., with almost any subsequent works of Egyptian figurative art. The painting comes from the plaster wall of a tomb chamber at Hierakonpolis, a city in Upper Egypt about fifty miles south of Thebes. Not essentially different from Neolithic rock paintings found in the Spanish Levant, the random composition shows three Nile boats, possibly carrying coffins, attended by tiny figures with raised arms who may represent mourning women. Antelope and other animals are scattered about, and men fight animals and each other.

THE STONE PALETTES Within a relatively short time after this improvised mural with its diagrammatic figures—perhaps as little as a century or two—Egyptian art had changed totally, reflecting the character of the monarchy, which had impressed itself on all aspects of Egyptian life. The most striking examples of this newborn Egyptian art are the stone "palettes" carved on both sides with images in low relief and on one side hollowed into a slight depression. The exact purpose of these palettes is unknown, but since they were found in the lowest levels of religious buildings excavated at Abydos and Hierakonpolis, it is doubtful that they had a purely practical purpose. It has been surmised that they

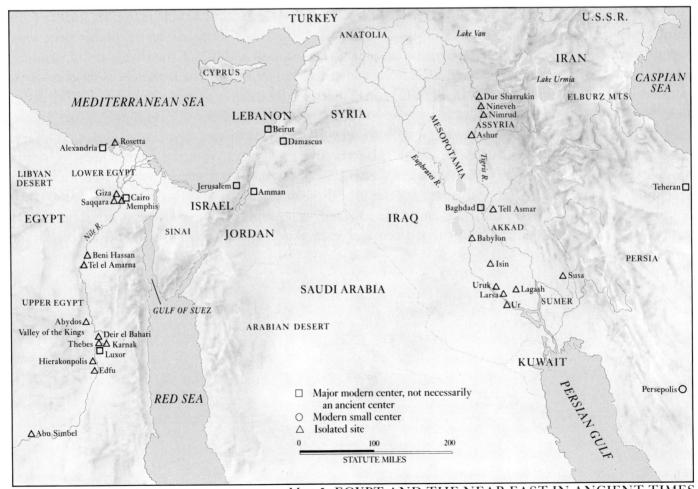

MAP 5. EGYPT AND THE NEAR EAST IN ANCIENT TIMES

70. Tomb painting, from Hierakonpolis, Egypt. Before 3000 в.с. Egyptian Museum, Cairo

were used to mix the paint applied to the eyes of divine images in order to provide the gods with sight. The finest of these palettes is that of King Narmer (fig. 71), whose capital was at Thinis in Upper Egypt. In this work a sense of total order prevails. The king appears in his own right, standing firmly on a definite groundline; adorned with a bull's tail and wearing the crown of Upper Egypt, he grasps his enemy by the forelock with his left hand while his uplifted right hand brandishes a mace. Cow heads (sign of the goddess Hathor) representing the four corners of the heavens flank an abbreviated symbol of a palace bearing the king's name. Behind the king walks a servant with his sandals; the king is unshod as if to indicate the sanctity of the moment (as later with Moses on Mount Sinai). A hawk, symbol of the sky god Horus, protector of the pharaohs, holds a rope attached to a head growing from the same soil as the papyrus plants of Lower Egypt. Below the king's feet his foes flee in terror.

The other side of the palette (fig. 72) is divided into three registers beneath the cow heads at the top. The king, now wearing the crown of Lower Egypt, strides forth, followed by the sandal bearer and preceded by warriors carrying standards, in order to inspect ten decapitated bodies, their heads placed between their legs. As if to emphasize the king's immense strength, his leg and arm muscles are sharply demarcated. In the central register two felines resembling panthers, perhaps representing the eastern and western heavens, led by divinities from barbaric regions to the east and west of Egypt, entwine their fantastically prolonged necks to embrace the sun disk, hollowed out to form a cup for the paint. (The meanings of these early images are often far from certain; the animals can also be interpreted as symbols of Upper and Lower Egypt.) Below, a bull

symbolizing the king gores a prostrate enemy before his captured citadel, its walls and towers represented in plan—the earliest architectural plan known. The naturalism and sense of order that appear for the first time in these reliefs are no more striking than their introduction of a set of conventions that controlled Egyptian representations of the figure for the next three thousand years. Apparently in order to provide the observer with complete information, the eyes and shoulders are shown frontally while the head, legs, and hips are represented in profile. The weight is evenly divided between both legs, with the far leg advanced. Exceptions are made only when both hands are engaged in the same action, as in the agricultural occupations depicted in wall paintings; then the near shoulder is folded around so that it, too, appears in profile.

THE TOMB AND THE AFTERLIFE The Old Kingdom began in earnest with the Third Dynasty and the removal of the capital to Memphis, in Lower Egypt. Now appear for the first time in monumental form those amazing manifestations of the belief in existence beyond death that dominated Egyptian life and thought. Each human had a mysterious double, the ka or life force, that survived his or her death but still required a body; hence the development of the art of mummification. In case the mummy were to disintegrate, the ka could still find a home in the statue of the deceased, which sat or stood within the tomb in a special chamber provided with a false door to the other world and with a peephole through which incense from the funeral rites could penetrate to its nostrils. The deceased was surrounded with the delights of this world to ensure enjoyment of them in the next: the tomb was filled with food, furniture, household implements, a considerable treasure, and sometimes even with mummified dogs and cats. The coffin, in the shape of the mummy, could be made of wood and merely painted with ornamental inscriptions and with the face of the deceased, or, in the case of the pharaoh, made of solid gold. The walls of the tomb were adorned with paintings or painted reliefs depicting in exhaustive detail the deceased's life on earth as well as the funeral banquet at which the deceased was represented alive and enjoying the viands. Once the ceremonies were over and the tomb sealed, all this beauty was, of course, doomed to eternal darkness and oblivion. But not quite all, because the royal tombs were systematically plundered even during the Old Kingdom, perhaps by the very hands that had placed the precious objects in their chambers—an odd commentary on the discrepancy between belief and practice.

The characteristic external form of the Egyptian tomb, doubtless descended from the burial mounds common to many early cultures, is called by the name mastaba (Arabic for "bench"), a solid, rectangular mass of masonry and mud brick with sloping sides, on one of which was the entrance to a shaft leading diagonally to interconnected tomb chambers excavated from the rocky ground of the western desert (fig. 73). The location was important: the tombs had to be placed out of reach of the annual floods that inundated the entire Nile Valley and to the west of the city, where the sun sank nightly into the desert, for that was the direction from which the deceased began their journies into the other world.

The Step Pyramid at Saggara. The earliest colossal stone structure we know, the step pyramid of King Zoser at Saqqara (figs. 74, 75), to the west of Memphis, was originally planned about 2750 B.C. as such a mastaba. However, it occurred to the royal architect Imhotep, the first artist whose name has come down to us, to set six mastabas of constant height

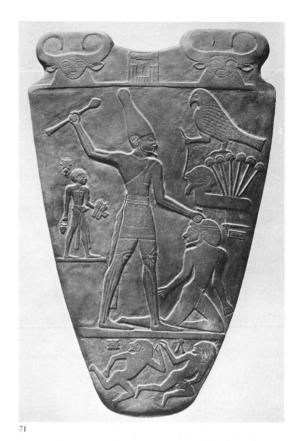

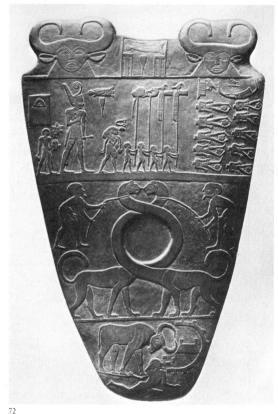

- 71. Palette of King Narmer (front view). c. 3200-2980 B.C. Stone, height 25". Egyptian Museum, Cairo
- 72. Palette of King Narmer (back view)

but diminishing area one upon the other to form a majestic staircase ascending to the heavens. His creation, rising from the desert, is still a work of overwhelming grandeur, and Imhotep was revered by posterity as a god. The funerary temple was far more impressive when its complex series of surrounding courtyards and temples, whose outer walls measure approximately 1,800 by 900 feet, was intact (fig. 76). All of Imhotep's forms were derived from wooden palace architecture, which he imitated

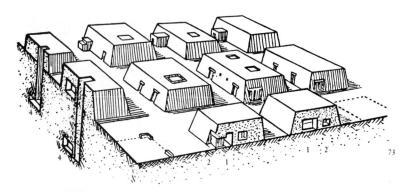

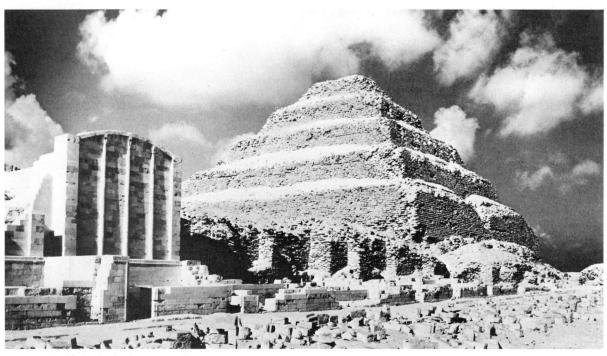

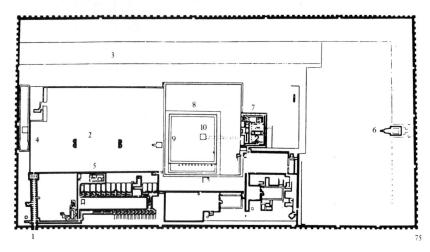

- Group of mastabas (Architectural reconstruction after A. Badawy) 1. Chapel 2. Serdab (statue chamber) 3. Shaft to burial chamber
 Burial chamber
- 74. IMHOTEP. Funerary Complex of King Zoser with step pyramid, Saqqara. c. 2750 B.C. Limestone
- 75. Plan of the Funerary Complex of King Zoser, Saqqara 1. Entrance Hall 2. Courtyard with two stones for king's ritual race (beb sed)
 3. Storeroom galleries 4. Secondary tomb
 5. King's robing room for beb sed 6. Serdab (statue chamber)
 7. Funerary temple 8. Pyramid 9. Mastaba 10. Shaft to burial chamber

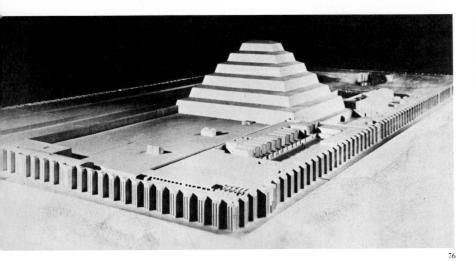

with the utmost elegance in clear golden-white limestone. The surrounding walls, now partly reconstructed, were divided into projecting and recessed members, each paneled. The processional entrance hall, recently partly rebuilt largely from its original stones (fig. 77), had a ceiling made of cylindrical stones in imitation of palm logs, supported by slender columns reflecting in their channeled surfaces the forms of plants, probably palm branches lashed together since the capitals appear to be formalized palm leaves (fig. 78). These are the earliest known columns, and apparently Imhotep did not entirely trust them to bear so great a weight, because he attached them to projecting walls that do most of the work. But the essentials of the Classical column—shaft, capital, and base—are already here.

Similar plant forms of the greatest elegance appear throughout the architecture of the courtyards, in which stood statues of the king and his family, including a colossus, the earliest known, of whom only fragments survive. But one splendid seated lifesize statue of Zoser in limestone, still another first (the earliest known royal portrait) among the achievements of this extraordinary reign, has survived relatively intact. In its majestic pose (fig. 79) we have the prototype of all subsequent seated statues for the rest of Egyptian history. It bears the name of Imhotep on its base. The statue was originally placed in the serdab, or sealed statue chamber, built against the center of the north wall of the step pyramid, with two peepholes through which the king could look forth to the sky. The statue's appearance must have been less solemn when the rock crystal eyes, gouged out long ago by tomb robbers, and the original surface paint were intact. The king wears the "divine" false beard, and his massive wig is partly concealed by the royal linen covering. He is swathed in a long mantle descending almost to his feet. The statue is absolutely frontal, utterly immobile, and perfectly calm. Obviously, it was drawn upon three faces of the block of stone and carved inward till the three sides of the figure merged into one another; its nobility of form arises from the perfect discipline of this procedure, recommended for sculptors as late as the Italian Renaissance.

Later stages of the carving process are illustrated in a Sixth Dynasty relief from Saggara (fig. 80) in which we see two sculptors finishing a statue with mallet and bronze chisel, then polishing it with stone tools. Interestingly enough, while the sculptors are represented with shoulders frontal or folded round according to the necessities of the action, the statue does not conform to the conventions governing living figures, and remains in profile throughout. Immense dignity, if not the majesty of the

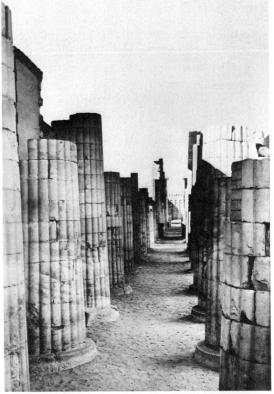

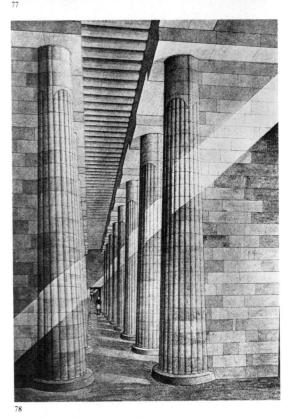

76. Model of the Funerary Complex of King Zoser, Saqqara

- 77. Entrance Hall, Funerary Complex of King Zoser, Saqqara (partly rebuilt)
- 78. Entrance Hall and colonnade, Funerary Complex of King Zoser, Saqqara (Reconstruction drawing by Jean Philippe Lauer)

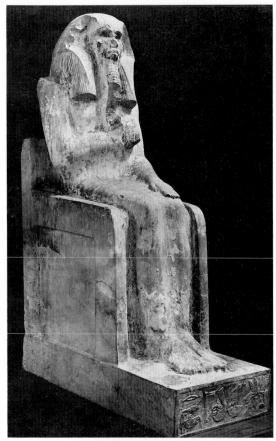

80

divine monarch, is shared by court officials such as Hesira (fig. 81), holding symbols of his authority as well as writing instruments, in a wooden relief from his tomb at Saqqara. Although slenderer than King Narmer, he stands before us in the same manner, with weight evenly distributed on both feet. Convention also invariably and inexplicably gives relief figures two left hands, except when the right hand is holding something, and two left feet (or two right, in the rare instances when they move from right to left). This convention continues in force except for a brief period in the Eighteenth Dynasty when the feet, but not the hands, are shown as in nature (see fig. 94); immediately thereafter the old convention returns. The present impression of beautifully controlled surfaces of wood given by the Hesira relief would be sharply different if it still retained its original bright paint, but it must always have shown the grace, authority, and firm handling of muscular shapes characteristic of Old Kingdom art.

The Pyramids of Giza. The grandest monuments of the Old Kingdom, and the universal wonder of mankind ever since, are the great pyramids of Giza (fig. 82), a few miles to the north of Saqqara. They were built by three kings of the Fourth Dynasty who are generally known by their Greek names: Cheops, Chephren, and Mycerinus (Egyptian: Khufu, Khafre, and Menkure). It is still unclear whether the perfect shape, with its four isosceles-triangular sides (fig. 83), evolved from the step pyramids at Saqqara and elsewhere, or whether it had special religious significance. The earliest of the Giza pyramids, that of Cheops, is also the largest, originally 480 feet high, more than twice the height of the step pyramid

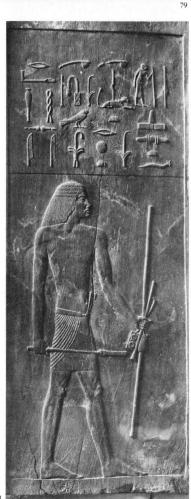

- 79. King Zoser. c. 2750 B.C. Limestone with traces of paint, height 55". Egyptian Museum, Cairo
- Sculptors at Work, from Saqqara. c. 2340–2170
 B.C. Painted stone relief. Egyptian Museum, Cairo
- 81. Hesira, from Saqqara. c. 2750 B.C. Wood relief, height 45". Egyptian Museum, Cairo

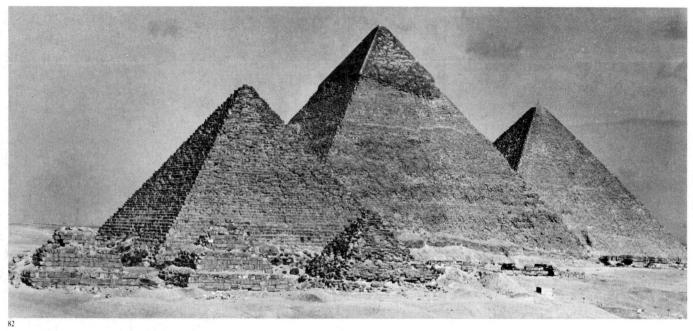

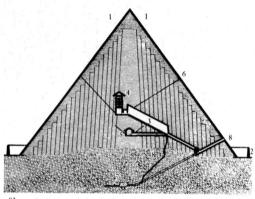

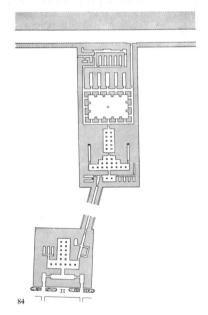

of Zoser. Whether seen from modern Cairo some eight miles distant or across the rocky ledges and sands of the desert or towering close at hand, these amazing structures convey an impression of unimaginable size and mass. Originally, they also had the characteristic Old Kingdom perfection of form, but this, alas, has vanished since the smooth, finely dressed limestone surface was stripped from the underlying blocks for use in the buildings of Cairo. Only a small portion at the top of Chephren's pyramid remains. No elaborate courtyards were ever contemplated. Each pyramid had a small temple directly before it, united by a causeway with a second or valley temple at the edge of cultivation (fig. 84); the valley temple was accessible from the Nile by canal or, during the floods, directly by boat. Flanking the great pyramids were extensive and carefully planned groups of smaller pyramids for members of the royal family and mastabas for court officials. The great pyramids were oriented directly north and south, and the pyramids of Cheops and Chephren were constructed along a common diagonal axis.

The accounts by Greek and Roman writers of forced labor used to build the pyramids are probably legendary. The concept of large firms of contractors and paid labor is more consistent with what we know of Egyptian society, and remains have been found of a considerable settlement that grew up at the edge of the valley to house workers, supervisors, and planners. Brick ramps were built up; on these the limestone blocks, transported by boat from quarries on the other side of the Nile, could be dragged, probably on timber rollers (the wheel was as yet unknown).

Only the valley temple of Chephren can now be seen (fig. 85); in contrast to Imhotep's architecture at Saqqara, all its forms derive their beauty from the very nature of stone. The walls are built of pink granite blocks, the shafts and lintels are granite monoliths, and the floor is paved with irregularly shaped slabs of alabaster. All the masonry is fitted together without mortar and with perfect accuracy, creating an impression of austere harmony. Alongside the valley temple rises the Great Sphinx (fig. 86), carved from the living sandstone; it is not only the earliest colossus to be preserved but also by far the largest to survive. In spite of later damage by Muslims which has almost destroyed the face, this immense lion with the head of Chephren is possibly the most imposing symbol of royal power ever created.

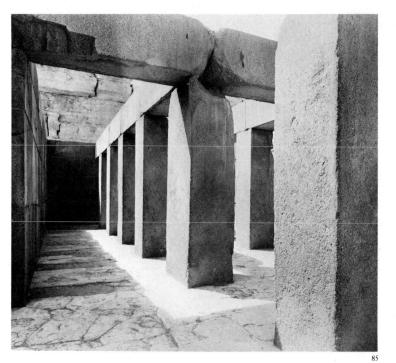

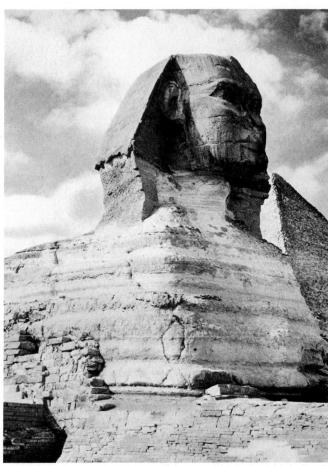

C 0) 02 D 11 CM 1 4 2500

OLD KINGDOM STATUES A statue of Chephren (see fig. 9), which once stood in his valley temple, is luckily almost undamaged. Immobile, grand, unchanging, the pose of the figure derives from that of Zoser (see fig. 79). Seated on a lion throne, the king is clad only in a richly pleated kilt and a linen head covering, horizontally pleated over the shoulders, that completely conceals the customary wig. The lines of this massive headdress are perfectly aligned with the wings of the hawkgod Horus, spread in protection behind the king's head. The broad, simple treatment of the shapes, the grand proportioning of the elements, and the smooth movement of the unbroken surfaces of diorite all culminate in the noble features of the king, whose serene expression bespeaks calm, total, unchallengeable control. In lesser works the systematic method of the Egyptian artists sometimes results in uniformity and mediocrity, but in the hands of the finest Old Kingdom sculptors the method itself exemplifies Egyptian beliefs regarding the divinity of the king and is the visual counterpart of the unalterable law governing earth and sky, life and death. By common consent, the *Chephren* is both one of the supreme examples of ancient sculpture and one of the great works of art of all time.

Somewhat less impersonal than the *Chephren* is the superb group statue showing King Mycerinus, wearing a kilt and the crown of Upper Egypt, flanked by the cow-goddess Hathor and a local deity (fig. 87). Each of the goddesses has an arm around Mycerinus as if to demonstrate his habitual intimacy with divinities. The work is carved from gray-green schist, and although the sculptor has not maintained quite the exalted dignity so impressive in the *Chephren*, he has delightfully contrasted the broadshouldered, athletic figure of the king with the trim, youthful, sensuously beautiful forms of the female divinities, fully revealed by their clinging

- 82. Pyramids of Mycerinus (c. 2500 B.c.), Chephren (c. 2530 B.c.), and Cheops (c. 2570 B.c.), Giza, Egypt. Limestone, height of Cheops pyramid c. 480'
- 83. North-south section of the Pyramid of Cheops, Giza (Drawing after L. Borchardt)
 1. Original fine limestone facing 2. Entrance
 3. Large gallery 4. King's burial chamber
 5. So-called queen's chamber 6. Possible airshafts 7. False tomb chamber 8. Tunnels dug by thieves
- 84. Plan of the Pyramid of Chephren and Valley Temples, Giza
- 85. Valley Temple of Chephren, Giza. c. 2530 B.C.
- 86. The Great Sphinx, Giza. c. 2530 B.C. Sandstone, 65 × c. 240'

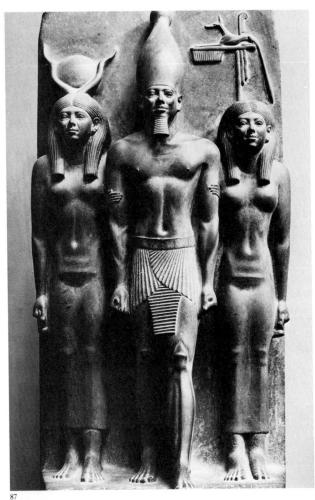

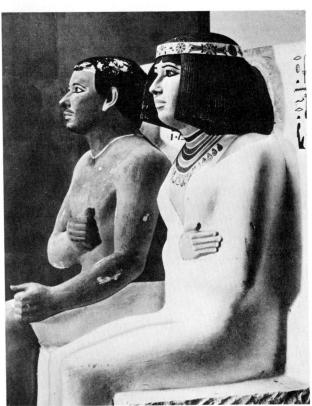

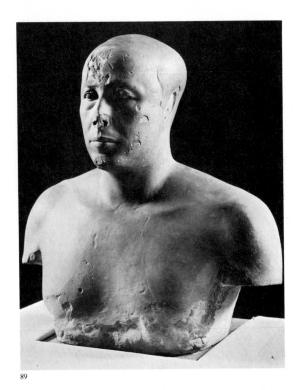

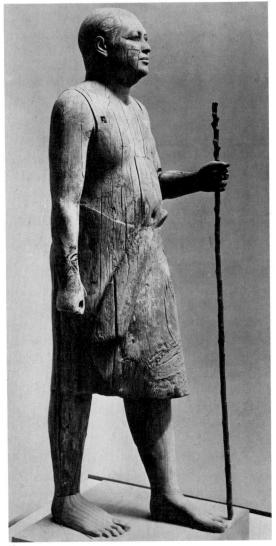

garments. Interestingly enough, while the king stands with legs apart, weight evenly distributed on both feet as in the *Hesira* relief, Hathor takes only a timid step forward and the local goddess keeps her feet together as if rooted to the spot.

While the royal statues are obviously individualized portraits, Old Kingdom naturalism is held in check by the need to emphasize the majesty and divinity of the pharaoh. But even in the more vividly lifelike statues of princes and officials, the dignity, simplicity, and balance characteristic of the Old Kingdom are consistently maintained. Prince Rahotep and His Wife Nofret (fig. 88) is carved from limestone, softer and easier to work than diorite or schist. The pair retain most of their original coating of paint. Rahotep is brown, his wife yellow ocher—the colors used by the Egyptians to distinguish male from female, probably to show that men braved the fierce sun from which delicate female skin was protected. The coloring, combined with the inlaid eyes of rock crystal, Rahotep's little mustache, and Nofret's plump cheeks, gives the pair an uncanny air of actuality that, to modern eyes, contrasts strangely with their ceremonial poses. On a far higher plane is the painted limestone bust of Prince Ankhhaf (fig. 89), son-in-law of Cheops. The aging forms of body and face are clearly indicated, but the whole is pervaded with a mood of pensive melancholy that makes the observer wonder about its origin. This beautiful psychological portrait is unique in its subtlety among the more forthright Old Kingdom figures.

The Fifth Dynasty wooden statue of Kaaper (fig. 90), originally painted, betrays a lower-class allegiance; its uncompromising realism, not sparing the fat belly and smug expression of the subject, has earned the statue the modern nickname of *Sheikh el Beled* (Arabic for "headman of the village"), but the artist has not sacrificed any of the firmness and control typical of the best Old Kingdom work. Another brilliant Fifth Dynasty portrait is the painted limestone *Seated Scribe* (fig. 91), doubtless portraying a bureaucrat, alert and ready to write on his papyrus scroll. The engaging figure is just as intensely real and just as rigid as *Kaaper*.

RELIEF SCULPTURE AND PAINTING Our understanding of life in Old Kingdom Egypt is illustrated with a completeness beyond any expectations by the innumerable scenes—carved in low relief on the limestone blocks of tomb chambers and then painted, or painted directly without underlying relief—that describe in exhaustive detail the existence the deceased enjoyed in this world and hoped would be perpetuated in the next. Only such scenes are represented; the paintings do not tell stories. Within the conventional structure of Egyptian style, these scenes describe in rich detail all the elements of what we know to be taking place, not just the incident as we might see it from one vantage point. Usually the walls are divided into registers, each with a firm and continuous groundline and no indication of distant space. For example, in a relief representing a high official, Ti Watching a Hippopotamus Hunt (fig. 92), the owner of the tomb is represented at least twice the size of the lesser figures, and he merely contemplates, but does not participate in, the events of daily existence. Yet, since the scenes line the walls of the tomb chambers on all sides, they surround us with the illusion of an enveloping space in which we walk among the humans, animals, birds, and plants of 4,500 years ago. In this case the background consists of vertical grooves to indicate the stems of a papyrus swamp. Ti stands in his boat, posed according to the principles of relief representation we have already seen, holding his staff of office, while men in a neighboring

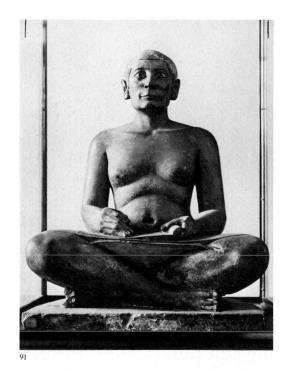

- 87. King Mycerinus Between Two Goddesses, from the Valley Temple of Mycerinus, Giza. c. 2570 B.C. Gray-green schist, height 373/8". Egyptian Museum, Cairo
- 88. Prince Rabotep and His Wife Nofret. c. 2610 B.C. Painted limestone, height 47¹/₄". Egyptian Museum, Cairo
- 89. Bust of Prince Ankhhaf, from Giza. c. 2550 B.C. Painted limestone, height 221/8". Museum of Fine Arts, Boston
- 90. Kaaper (Sheikh el Beled), from Saqqara. c. 2400 B.C. Wood, height 43". Egyptian Museum, Cairo
- 91. Seated Scribe, from Saqqara. c. 2400 B.C. Painted limestone, height 21". The Louvre, Paris

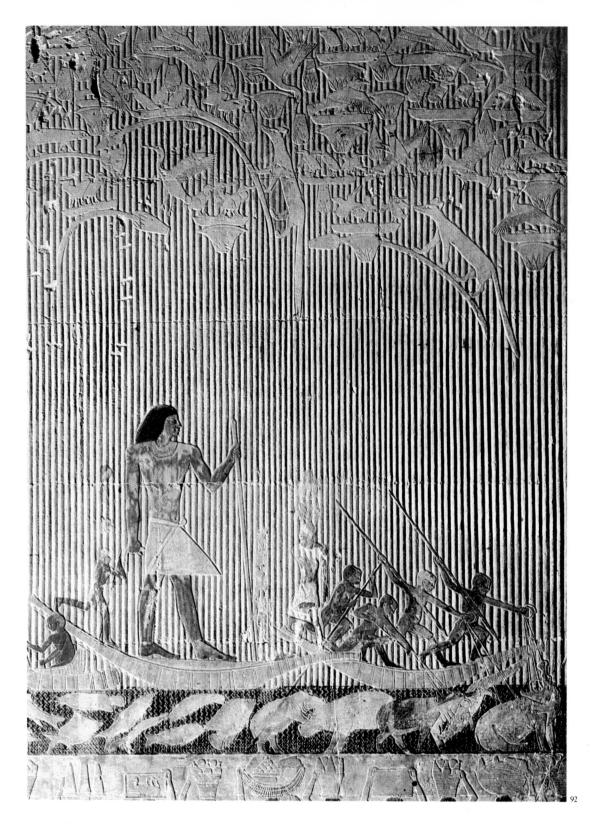

boat spear the hippopotamuses. Toward the top of the relief are scattered papyrus flowers, among which wild animals lurk and birds fly or nest in an amazing variety of beautifully rendered poses. There is none of the random waywardness of the Hierakonpolis mural (see fig. 70). An exact sense of order prevails—even the spears of the huntsmen are drawn parallel to one line of the triangle formed by Ti's kilt. Among the innumerable incidents that line the tomb is a touching scene (fig. 95) in which cattle are being led across a river and a terrified calf, too small to ford the

- 92. Ti Watching a Hippopotamus Hunt, from the Tomb of Ti, Saqqara. c. 2400 B.C. Painted limestone relief, height c. 45"
- 93. Geese of Medum (detail of a fresco). c. 2600 B.C. Egyptian Museum, Cairo
- 94. Preparatory drawing and relief from the Tomb of Horemheb, Valley of the Kings (west of Thebes, Egypt). c. 1334-1306 B.C.

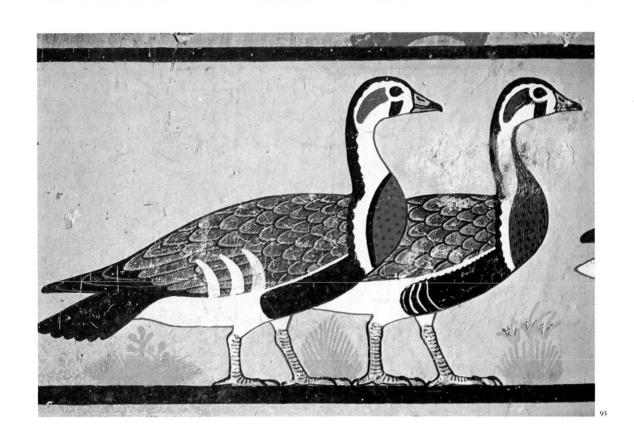

stream, turns its head as it is carried over and cries to its anxious mother. The water is convincingly suggested by parallel vertical zigzags, over which the legs of humans and animals are painted, not carved.

The celebrated Geese of Medum (fig. 93), actually a strip from a continuous series of wall paintings, shows the extent to which the Old Kingdom could carry both its naturalism and its strong sense of form, so fused that the formalization characteristic of almost all Egyptian art seems to be derived effortlessly from the motion of these delightful birds, rather than from outside, as is so often the case with representations of human beings.

Luckily, a few unfinished tomb designs are preserved, left in that state because the deceased, for some unknown reason, had to be buried in haste. An unfinished passage from the later tomb of the pharaoh Horemheb (fig. 94), in the Eighteenth Dynasty, shows us how the reliefs were made. First, as we see in the left-hand figure, the painter did his preparatory drawing on the stone, according to a fixed system of proportions represented by ruled lines. But the artist was clearly very sensitive to nuances of contour and changed his outline two or three times before he was satisfied. Then, either he or a specialized stone carver cut out the shallow relief according to the drawing, down to a uniform background level. Finally, the painter returned to color the figures and objects. Even more revealing is a scene from the tomb of Neferirkara (fig. 96), from the Fifth Dynasty, in which only the preliminary drawing was ever done. Presumably the finished birds would have been drawn and painted with the same precision as the Geese of Medum, but the present airy grace of the descending pigeons comes not only from the astonishing variety of their poses but from the lightness of the brush drawing as well.

Although it was in Old Kingdom Egypt that people first learned to be fully human, our ideas of Old Kingdom art and life are entirely formed on the funerary art through which the Egyptians faced eternity. Their

- 95. Cattle Fording a River (detail of a relief from the Tomb of Ti, Saggara). c. 2400 B.C. Painted limestone
- 96. Birds in Flight, preparatory drawing from the Tomb of Neferirkara, Saqqara. c. 2480-2340 B.c. Limestone
- 97. Model of a troop of Nubian mercenaries, from a tomb at Asyūt, Egypt. 2181–2133 B.C. Painted wood, height 153/4". Egyptian Museum, Cairo
- 98. Funerary Temple of Mentuhotep III, Deir el Bahari, Egypt. After 1990 B.C. (Architectural reconstruction after Dieter Arnold)

houses, palaces, and temples have mostly vanished, leaving hardly a clue. In the very nature of things, the beautiful system that sustained and gave meaning to the life of the Old Kingdom could not last forever. Perhaps the cost of the great funerary temples and pyramids was too heavy to bear. A king who is also a god must be able to act the part. At any rate, the weak kings of the Seventh and Eighth dynasties could not meet these demands, and their reigns were followed by a period of great social disorder during which the real power passed into the hands of provincial rulers and little art worthy of notice was created.

MIDDLE KINGDOM ARCHITECTURE In a prolonged struggle, the kings of the Eleventh Dynasty regained power from provincial rulers and reunited the country, whose capital oscillated between Memphis in Lower Egypt and Thebes in Upper Egypt. Power no longer depended upon the divine authority of the pharaoh but on military force. Tombs often contained remarkable miniature groups in wood, representing every kind of daily activity, including the all-important military ones. A company of forty Nubian mercenaries (fig. 97) advancing toward us is a brutal indication of the changed conditions of the Middle Kingdom. Some small stone-faced brick pyramids were built, and numerous tombs whose

The Middle Kingdom, c. 2040–1650 B.C., and the Empire, c. 1550–1070 B.C.

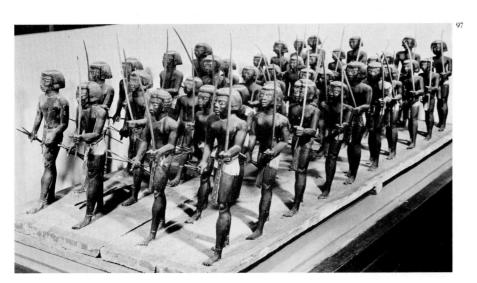

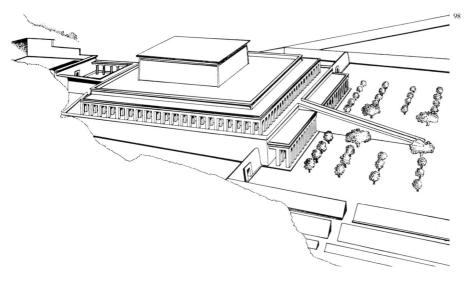

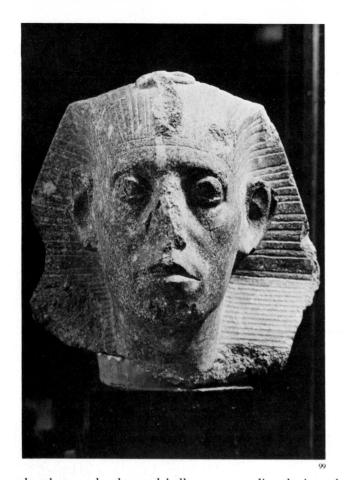

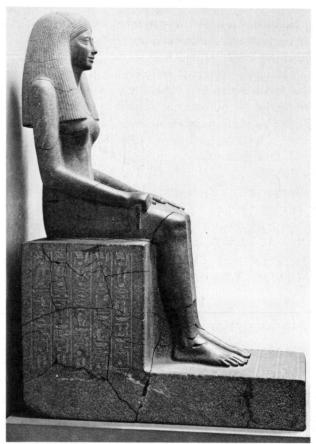

chambers and columned halls were cut directly into the rock, but the most impressive architectural work we know from this period is the funerary temple of Mentuhotep III at Deir el Bahari, across the Nile from Thebes. From what remains of the building, alongside which Queen Hatshepsut was later to build her even more ambitious temple (see fig. 102), we can reconstruct its original appearance (fig. 98). From a grove of geometrically aligned trees a long ramp led to a terrace supported by a row of square piers; from there one entered a second colonnade through a canted doorway and moved into a courtyard from the center of which rose a massive block with canted sides like a huge mastaba outlined against the immense cliffs of the western mountain. According to some reconstructions, the tomb may have been topped with a small pyramid. The

MIDDLE KINGDOM SCULPTURE Some royal portraits reveal with devastating frankness the chronic anxiety in which, according to literary accounts, Middle Kingdom monarchs lived, tormented by the military struggles needed to maintain their rule. Especially intense are the brooding portraits of Sesostris III (fig. 99), whose careworn face shows none of the serene confidence of the Old Kingdom. Against such a background, the exquisite seated statue of Princess Sennuwy, posed like a pharaoh (fig. 100), comes as a delightful surprise. This masterpiece in polished granite shows in its slender forms and softly flowing surfaces a style as sensuous as that of the best Old Kingdom female figures but endowed with a wholly new elegance and grace.

scale, as compared to Old Kingdom tombs, is almost human.

At the close of the Twelfth Dynasty ensued a new period of political chaos, during which Lower Egypt was invaded by Asiatic rulers known as the Hyksos, or shepherd kings. These conquerors imported two com-

99. King Sesostris III, from Medamud, Egypt. c. 1878-1843 B.C. Granite. Egyptian Museum, Cairo

- 100. Princess Sennuwy, from Kerma, Sudan. c. 1950 B.C. Granite, height 671/2". Museum of Fine Arts, Boston
- 101. Queen Hatshepsut. c. 1495 B.C. Limestone, height c. 77". The Metropolitan Museum of Art, New York. Rogers Fund and contribution from Edward S. Harkness, 1929

modities soon to be triumphantly adopted by the Egyptians—the horse and the wheel. After a century of foreign rule, pharaohs from Upper Egypt for the third time regained power, and the Eighteenth Dynasty saw not only the expulsion of the Hyksos and the reunification of the country, with its capital at Thebes, but also the extension of Egyptian power over neighboring lands as well—Syria, Palestine, Libya, Nubia, an area more than 2,000 miles in length.

ARCHITECTURE OF THE EMPIRE The next five centuries, variously known as the Empire or the New Kingdom, constitute a period of unprecedented imperial power and wealth, celebrated by enormous architectural projects, largely in the surroundings of the Theban metropolis—at modern Karnak and Luxor on the east bank of the Nile and Deir el Bahari on the west. Amon, the local deity of Thebes, was promoted to the ruling position among the gods in recognition of his services to the Empire and was identified with Ra, the sun god, thus becoming Amon-Ra. The new temples were often decorated with statues, reliefs, and paintings representing the power and historic exploits of the pharaohs.

The Mortuary Temple of Queen Hatshepsut. Among the earliest of these ambitious builders of the Empire was Queen Hatshepsut, the first great female ruler of whom we have any record. Daughter of Tuthmosis I, half-sister and wife of his weak successor, Tuthmosis II, she ruled first as queen consort, then after her husband's death, supposedly as regent for her stepson Tuthmosis III. In fact, she assumed power as pharaoh and governed peacefully for twenty years (c. 1501–1481 B.C.). A limestone statue of this brilliant monarch (fig. 101), clad in her kingly headcloth and kilt, reminds us of the slenderness and delicacy of the statue of Sennuwy more than four hundred years earlier, yet radiates an air of majesty and quiet power.

Hatshepsut's immense mortuary temple (figs. 102, 103), alongside and to the north of that of Mentuhotep III (see fig. 98) at Deir el Bahri, directly across the Nile from the capital at Thebes, consists of three ascending colonnaded terraces, connected by ramps, and a final colonnaded court, now largely destroyed. The outer colonnades employ simple, square pillars, but the columns of the sanctuary of Anubis (fig. 104), at the right of the second terrace, and also the inner columns of the sanctuaries, are delicately faceted into sixteen slightly concave sides, a form invented during the Middle Kingdom that deceptively suggests the fluted columns of later Greek temples. In the blinding glare of Egyptian sunlight the present effect looks a bit bleak, but was surely sumptuous when the queen's full array of brightly painted statues, not to speak of the rich plantings, were all in place. Alas, her successor, the mighty conqueror Tuthmosis III, obtained his revenge for his long wait by having them all smashed, but many have been put together from the fragments. Hatshepsut was represented as a divine king, with red or yellow skin, blue eyebrows, and false beard. Colossal painted statues of the queen in dark granite knelt at either side of the entrance to the sanctuary, and a row of huge standing statues in limestone, blazing with color, stood before the pillars of the upper terrace, crowning the entire complex and doubtless visible for miles. All in all the queen was shown more than seventy times in superhuman scale; in addition, her head appeared on more than a hundred painted sandstone sphinxes and on twenty-two more in red granite facing each other in a double rank up the center of the lower terrace.

All that is still left in place of this brilliant display of color are the

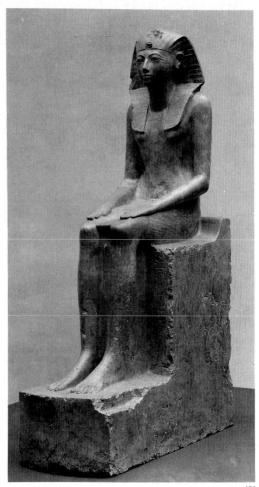

10

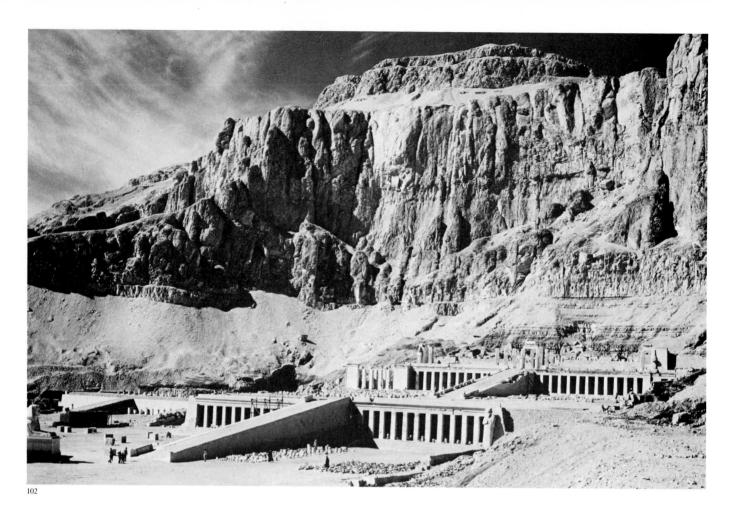

open halls on the right side of the middle terrace (see fig. 104), which contain generally well-preserved reliefs narrating in great detail scenes from Hatshepsut's life, beginning with her supposed divine origin as a daughter of Amon. The terraces were filled with fragrant myrrh trees, highly prized as a source of incense, and the reliefs include representations of the expedition dispatched by Hatshepsut to the distant land of Punt, in modern Somalia near the coast of the Red Sea, to acquire these precious trees. People, dwellings, plants, animals, and birds all appear, and the ruler of Punt is shown next to his magnificently corpulent queen (fig. 105), whose fat piles up in rolls on her swaybacked body, long arms, and stubby legs. There are also a number of tiny portraits of Hatshepsut's architect and chief minister, Senmut, usually shown kneeling at the entrances to various sanctuaries. Senmut may also have been the queen's lover; his tomb, left unfinished at her death, was carved from solid rock

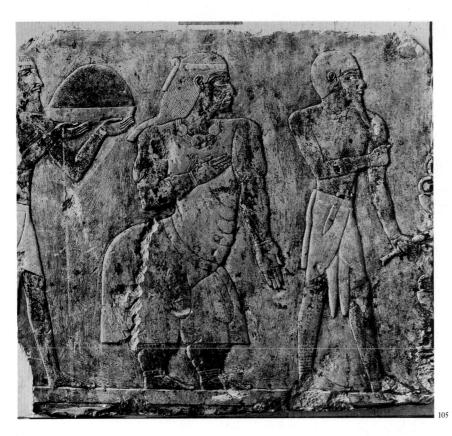

- 102. Senmut. Funerary Temple of Queen Hatshepsut, Deir el Bahari (base of Funerary Temple of Mentuhotep III visible at extreme left). c. 1480 B.C.
- 103. Plan of Funerary Temple of Queen Hatshepsut, Deir el Bahari (After H. Ricke and M. Hirmer)
- 104. Portico, Anubis Sanctuary, Funerary Temple of Queen Hatshepsut, Deir el Bahari. c. 1480 B.C.
- 105. King and Queen of Punt, from Funerary Temple of Queen Hatshepsut, Deir el Bahari. c. 1480 B.C. Painted relief. Egyptian Museum, Cairo
- Colonnaded court, Temple of Horus, Edfu (view toward hypostyle hall). 3rd–1st century B.C.

underneath the temple. A worthy successor to Imhotep of the Old Kingdom, Senmut planned the uppermost courtyard to abut the mass of the cliff into which the sanctuary chamber of Amon is cut, since the sun bark disappeared over the mountain daily. Thus the thousand-foot mass of the living rock of the western mountain substitutes for a man-made pyramid.

The Temples of Luxor and Karnak. A powerful priesthood in Thebes administered the royal temples of Amon, his wife Mut, and their son Khonsu at Luxor and at Karnak. These were originally connected by an avenue of sphinxes more than a mile in length, of which hundreds are still in place. Egyptian temples, unlike those of the later Greeks, offered no unified outer view. They were built along a central axis to enclose a succession of spaces of increasing sanctity and exclusiveness, starting with the entrance gateway, which was flanked by slanting stone masses called pylons. Our illustration (fig. 106) is drawn from the much later Temple of

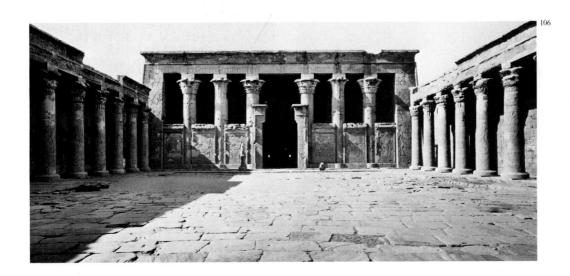

EGYPTIAN ART 91

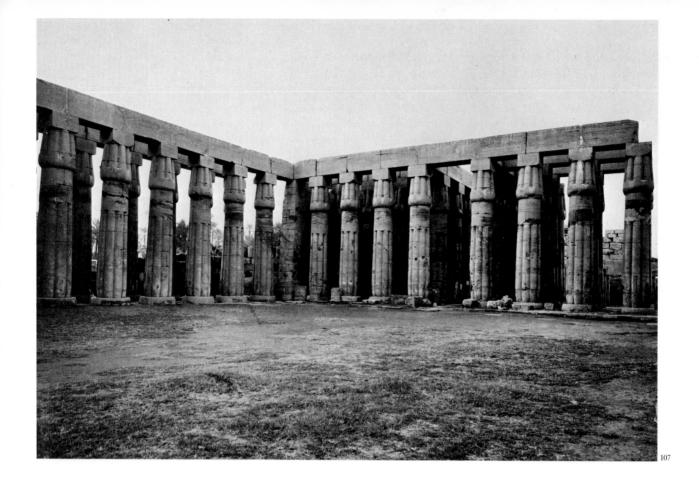

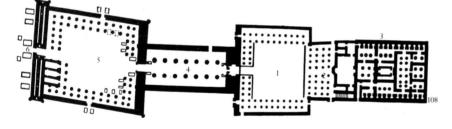

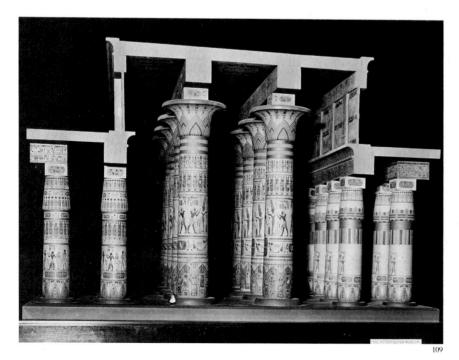

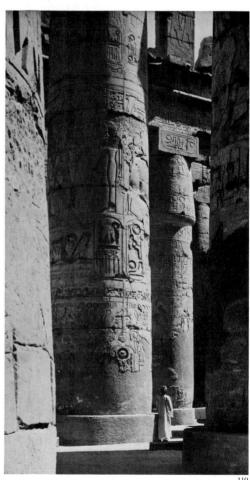

Horus at Edfu, which closely followed the principles and shapes established in the Empire. Through the gateway the worshiper was admitted to a spacious colonnaded court. Then came one of the most characteristic features of Egyptian imperial temples, the hypostyle hall, a lofty room whose stone roof was supported by immense columns. The central section of this structure (see fig. 109) was usually elevated above the sides and was lighted and ventilated by a row of upper windows known as a clerestory. This feature was adopted in Roman architecture as well and was then used constantly throughout the Middle Ages in Europe and the Near East. The strong Egyptian sunlight and great heat were controlled by stone grilles in the clerestory windows. Clerestory, grilles, and all were derived from wooden counterparts in Egyptian houses. After the hypostyle hall came the smaller, more secret, and much darker sanctuaries containing cult statues and the "bark of Amon" (sacred boat), reserved for the priesthood and their rituals.

The Temple of Amon-Mut-Khonsu at Luxor was built by Amenhotep III on this standard principle in the late fourteenth century B.C., but he soon added an impressive entrance hall (fig. 108). Later Ramses II added a second courtyard and a new set of entrance pylons in front, deflecting the axis on account of the curve of the nearby Nile. The immensity of Amenhotep's thirty-foot columns (fig. 107) is far removed from the elegance and purity of Imhotep's forms, but the problems themselves required new solutions. The unknown architect at Luxor built massive freestanding columns of local sandstone rather than of the fine limestone available at Saqqara, and he shaped them according to the conventionalized forms of bundles of papyrus reeds, traditional supports for the more ephemeral architecture of the vanished Egyptian houses and palaces. The columns sustain huge undecorated sandstone lintels that surround the courtyard and continue in the hypostyle hall, where they supported a now-fallen roof of stone slabs. Light came from the clerestory over low walls, so that the center of the hall remained mysteriously dim. The grand proportions of the columns, which seem to continue in all directions, always blocking any clear view, create an effect of majestic solemnity.

The even larger and far more complex temple at Karnak was one of the most extensive sanctuaries of the ancient world, with a perimeter wall about a mile and a half in circumference. The partially ruined temple was constructed piecemeal by so many pharaohs that the overall effect is confusing, yet many of the surviving portions are very beautiful. The hypostyle hall (figs. 109, 110) built by Seti I and Ramses II in the Nineteenth Dynasty was filled with columns so massive that diagonal views are impossible from the central axis. Wherever one looks, the vista is blocked by these immense shapes, decorated by bands of incised hieroglyphics and painted reliefs.

TOMB DECORATIONS Scores of tombs survive from the period of the Empire. Pharaohs and aristocracy alike gave up building monumental tombs, which could not be defended against robbers. The dead were buried deep in rock-cut chambers in mountain valleys, and the entrances carefully hidden. Even the royal tombs in the Valley of the Kings, west of Thebes, were invariably discovered and plundered, but the wall decorations remain. In the splendid Eighteenth Dynasty painted tomb of Nebamun at Thebes (fig. 114), the deceased is shown fowling. Accompanied by his hunting cat, he plays havoc among the brilliantly drawn and painted birds of a papyrus swamp. A fragment from this same tomb

- Court of Amenhotep III, Temple of Amon-Mut-Khonsu, Luxor (view into hypostyle hall)
- 108. Plan of the Temple of Amon-Mut-Khonsu, Luxor, Egypt. c. 1375 B.C. (After N. de Garis Davies) 1. Colonnaded court 2. Hypostyle hall 3. Sanctuaries 4. Entrance hall (addition by Amenhotep III) 5. Colonnaded court (addition by Ramses II) 6. Pylons (addition by Ramses II)
- 109. Model of hypostyle hall, Temple of Amon-Ra, Karnak, Egypt. c. 1290 B.C. The Metropolitan Museum of Art, New York. Bequest of Levi Hale Willard, 1890
- 110. Portion of hypostyle hall, Temple of Amon-Ra, Karnak. c. 1290 B.C. (begun by Seti I and completed by Ramses II)

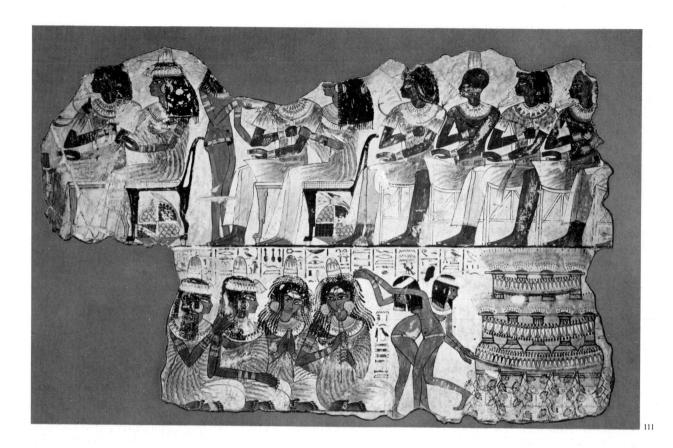

(fig. 111) shows an entrancing banquet scene, at which both the revelers and the musicians wear cones of perfumed unguents on their heads. Delightful female dancers, clad only in jeweled collars and tiny golden belts, clap their hands as they move with exquisite lightness and grace. While most of the figures are shown from the side, two of the crouching musicians unexpectedly face directly outward, and all the crouching figures point the soles of their feet toward us. In such poses, apparently, Egyptian conventions were useless and therefore thrown aside. In the subtle, delicate style of the Eighteenth Dynasty there can also be great pathos, as in the relief of the Blind Harper (fig. 112) from the tomb of Patenemhab at Saqqara, in which the harper gently strums his octave of strings. His song is inscribed on the wall beside him:

Pass the day happily, O priest. . . . have music and singing before you, Cast all ill behind you and think only of joy, Until the day comes when you moor your boat in the land that loves silence.

Characteristic of the arrangement of scenes in superimposed strips is the tomb of Sen-nedjem at Deir el Medineh, from the Nineteenth Dynasty (fig. 113). At the end of the chamber the deceased crosses to the other world in the boat of the dead to be received by the gods, and below are shown the harvest of his grainfields and the rows of his fruit trees. On the right the gods themselves are aligned above his funeral feast. As in the tomb of Ti, scenes like these in registers continuing around the chamber create a special kind of space that, once one accepts the conventions of Egyptian art, becomes surprisingly real and convincing when one actually stands in the chamber, surrounded by the paintings on all sides.

- 111. Banquet Scene, fragment of a wall painting from the Tomb of Nebamun, Thebes. c. 1400 B.C. British Museum, London
- 112. Blind Harper, relief from the Tomb of Patenemhab, Saggara. c. 1552-1306 B.C. Rijksmuseum van Oudheden, Leiden, the Netherlands
- 113. Wall paintings from the Tomb of Sennedjem, Deir el Medineh (Thebes). с. 1150 в.с.

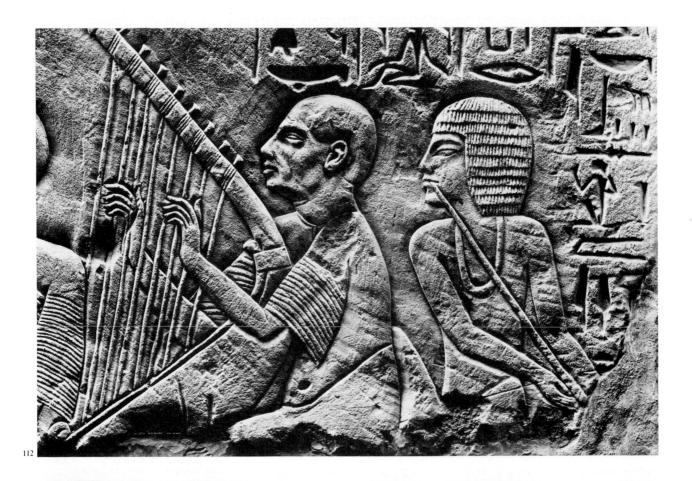

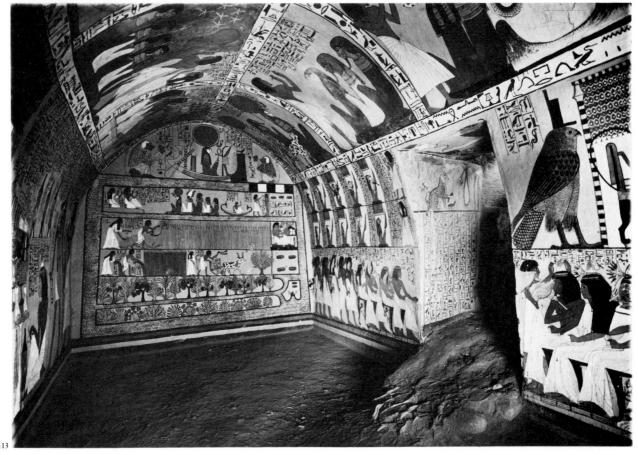

EGYPTIAN ART 95

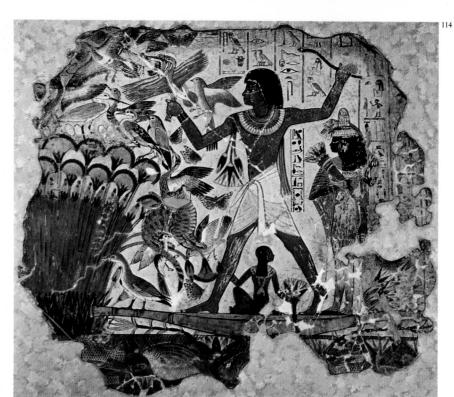

AKHENATEN Just when everything about Egyptian life and art seemed to be safely settled for an indefinite period, an unexpected reformer appeared who tried his best to unravel the entire fabric, and indeed succeeded for a limited time. During the reign of Amenhotep III in the Eighteenth Dynasty (1567-1320 B.C.), there arose at the imperial court a new cult that worshiped the disk of the sun, called the Aten. Amenhotep's son, first his co-ruler and then his successor, changed his name from Amenhotep IV to Akhenaten in honor of the new solar god, of whom he declared himself to be the sole earthly representative. This extraordinary religion, a kind of early monotheism, required the closing of the temples of Amon-Ra and the disinheriting of the priesthood, which had become the true ruling class of Egyptian society. Although Akhenaten built a new Temple of Aten at Karnak, he moved the capital from Thebes to an entirely new site, dedicated to Aten, at a spot now called Tell el Amarna. The insubstantial secular buildings of the Egyptians usually vanished, like those of Çatal Hüyük, under new structures, leaving few traces, but when Akhenaten died his successors were so anxious to wipe out the memory of the heretic that they destroyed the new city of Akhenaten immediately. The plans and even painted floors from the palace and from the houses of state officials have, however, been excavated, and the entire contents of a sculptor's studio were discovered, including casts from life, models for sculpture, and unfinished works.

Something of the character of this royal visionary who neglected the military necessities of empire to promulgate his new religion can be seen from strange statues and reliefs of him and others, which have been found in considerable numbers because they were used as building blocks by later pharaohs. One colossal pillar statue from the Temple of Aten at Karnak (fig. 115) shows his slack-jawed, heavy-lipped features and dreamy gaze and, instead of the athletic male ideal of the earlier pharaohs, an exaggeratedly feminine body with swelling breasts—as if the king in his new messianic role were to embody both paternal and maternal principles. An incised relief (this method, which freed the sculptor from the

- 114. Nebamun Hunting Birds, fragment of a wall painting from the Tomb of Nebamun, Thebes. c. 1400 B.C. British Museum, Lon-
- 115. King Akhenaten, from the Temple of Aten. Karnak (fragment). c. 1360 B.C. Sandstone, height 601/4". Egyptian Museum, Cairo

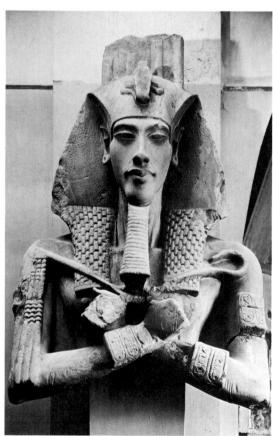

necessity of reducing the entire background, was characteristic of largescale Empire reliefs) shows the king sacrificing to Aten (fig. 116), whose rays terminate in hands that bestow life to the earth, represented by papyrus plants. He is followed by the queen, Nefertiti, whose figure is shaped just like his, though in smaller scale, and by a still smaller daughter.

The famous painted limestone bust of Nefertiti (fig. 117), a work of consummate elegance and grace, shows the queen at the height of her beauty, wearing the crown of Upper and Lower Egypt and decked with the usual ceremonial necklaces. Every plane of her strong cheekbones, perfect nose, firm chin, and full lips, and every line of the heavy makeup applied to her eyebrows, eyes, and mouth, moves with an arresting combination of smoothness and tension. The slender, long-necked ideal is irresistible to twentieth-century eyes, attuned to contemporary fashion. But entranced viewers of this masterpiece, less often of the original than the countless reproductions on sale everywhere, seldom realize that this bust was never intended for public view. It is a model for official portraits of the queen and was found in the studio of the sculptor who made it. It comes as a shock to note that he never finished the left eye (the eye is completed in all the copies)! If we were to see this same lovely head poised above the flat-chested, full-bellied figure visible in all representations of Akhenaten's surprising family, we might be less charmed. Nonetheless, there is something undeniably personal about this astonishing model. We would perhaps be justified in considering it a testament of admiration on the part of a great if unknown artist to the beauty but also to the intelligence and supreme calm of an extraordinary woman.

TUTANKHAMEN Through a happy accident of history, even more is preserved to show the brief life and activities of Akhenaten's successor, known to us by the name Tutankhamen, who died between eighteen and twenty years of age. The young king may have been Akhenaten's younger half brother; his name was forced upon him by the revived priesthood of Amon. His is the only royal tomb that has been found intact; it had been obscured and protected by debris from a later tomb. When discovered in 1922, the chambers contained a dazzling array of beautiful objects, displaying the taste of the imperial court for delicacy and grace. The king's many coffins, one inside the other, were found intact. The innermost, of solid gold, weighs 222 pounds! The cover of the coffin has a breathtaking portrait of the boy king in solid gold, with the ceremonial beard, the eyebrows, and lashes all inlaid in lapis lazuli. But even more beautiful, if possible, is the gold mask that covered the face of the actual mummy (fig. 118). The dead king wears the usual divine beard, and over his forehead appear the heads of the vulture-goddess of Upper Egypt and the serpentgoddess of Lower Egypt. While the brilliant blue stripes on the headdress are glass paste, the other inlays come from semiprecious stones, such as lapis lazuli, turquoise, carnelian, and feldspar. To the effect of splendor produced by the intrinsic value of the materials is added an impression of the greatest poetic sensitivity and gentleness. The wide eyes of the young king seem to be looking through and beyond us; no other work of art from antiquity brings us so close to the personality of a deceased monarch. Among the thousands of objects from the tomb, one of the most beautiful is the carved wood throne, covered with gold and inlaid with faience, glass paste, semiprecious stones, and silver. The charming relief on the back (fig. 119) shows the disk of Aten shining on the young king, who is seated on a delicately carved chair while his queen, Ankhesenamen, lightly touches his shoulder as she presents him with a beautiful bowl.

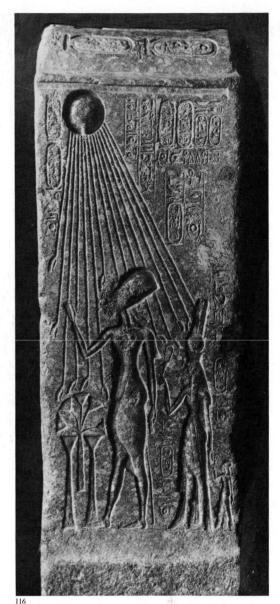

116. King Akhenaten and His Family Sacrificing to Aten, from Tell el Amarna, Egypt. c. 1360 B.C. Limestone relief. Egyptian Museum,

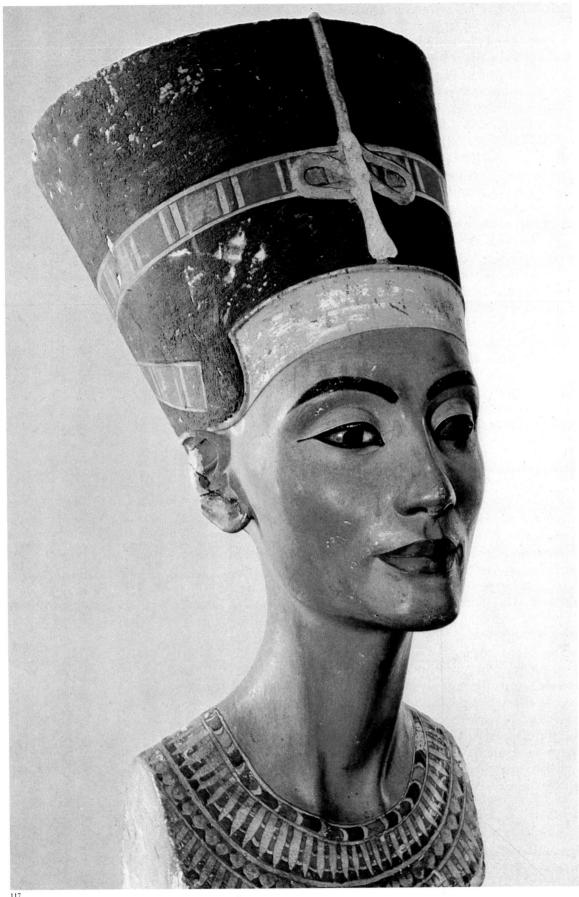

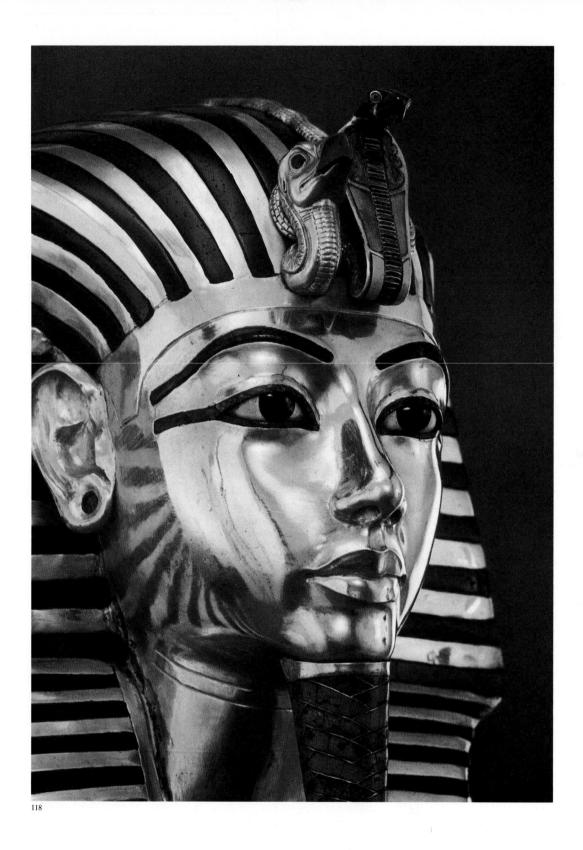

117. Nefertiti. c. 1365 B.C. Painted limestone, height 195/8". Staatliche Museen, Berlin

118. Mask of King Tutankhamen, from the Tomb of Tutankhamen, Valley of the Kings (west of Thebes). c. 1355–1342 B.c. Gold inlaid with blue glass, lapis lazuli, turquoise, carnelian, and feldspar, height 211/4". Egyptian Museum, Cairo

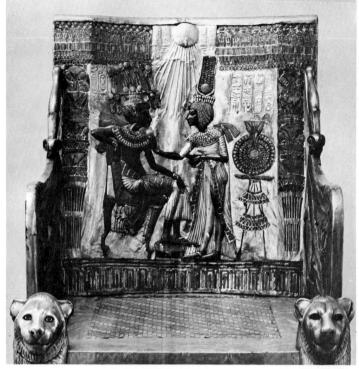

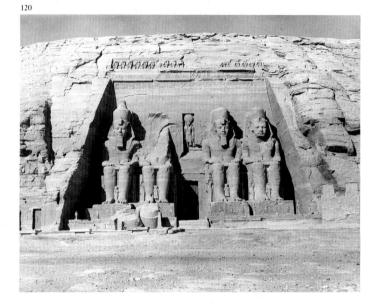

- 119. Throne (rear view) of King Tutankhamen and his queen Ankhesenamen, from the Tomb of Tutankhamen, Valley of the Kings (west of Thebes). c. 1355-1342 B.C. Carved wood covered with gold and inlaid with faience, glass paste, semiprecious stones, and silver; height of throne 41". Egyptian Museum, Cairo
- 120. Entrance façade, rock temple of Abu Simbel, Nubia. c. 1290-1225 B.C.
- 121. Entrance pylons, Temple of Horus, Edfu. 3rd-1st century B.C.
- 122. Last Judgment Before Osiris, from the Books of the Dead, found at the Theban Necropolis. Painted papyrus. British Museum, London

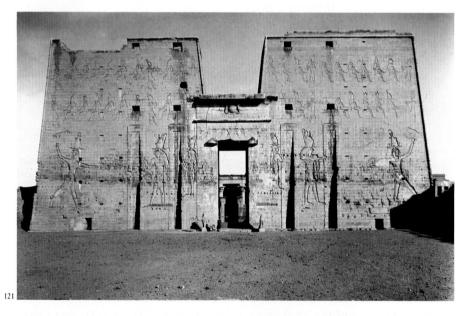

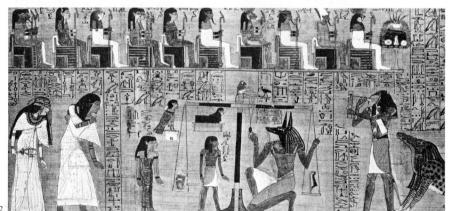

LATER PHARAOHS Succeeding monarchs, particularly the Ramesside pharaohs, were anxious to reestablish symbols of imperial might along with the neglected cult of Amon. Ramses II had himself portrayed in immense statues characteristic of the megalomania of his dynasty, not only between the columns of his forecourt for the Temple at Luxor, but in the four colossal seated figures that flank the entrance to his majestic tomb at Abu Simbel (fig. 120). These have become universally known in recent years through the successful campaign to cut the entire tomb from the rock, statues and all, and raise it to a new position above the rising waters dammed at Aswan.

Even under the Greek rulers of Egypt in the last centuries B.C., the principles of Egyptian architecture, sculpture, and painting continued virtually unchanged. If some of the conviction may have gone out of Egyptian art, the late works, such as the Temple of Horus at Edfu, south of Luxor (see fig. 106), are often impressive. This is the best preserved of all major Egyptian temples, still retaining the stone roof over its great hall. Its traditional pylons (fig. 121), terminated by simple, crisp moldings, are punctuated by recessed shafts for flagpoles and decorated with beautifully incised reliefs showing the (Greek!) pharaoh before Horus.

We cannot leave the Egyptians without a word about another of their inventions, the illuminated manuscript. These illustrated books were written and painted on rolls of papyrus, a surface made from the thin-shaved pith of the papyrus plant, glued together to form a continuous sheet. The most important of these are the so-called Books of the Dead, collections of prayers for the protection of the deceased during their perilous adventures in the other world. The best-known scene in every Book of the Dead is the dramatic moment (fig. 122) when, below a lineup of enthroned gods, the heart of the dead person (who is the little humanheaded hawk just above the heart toward the left) is weighed against a feather. Luckily, it has just balanced, or the deceased would have been thrown to the crocodile-hyena-hippopotamus hungrily waiting at the right.

While the great architectural and figurative achievements of the Egyptians are often considered preparations for those of the Greeks, the Books of the Dead prefigure the illuminated manuscripts that form such an important part of medieval culture, and the weighing of the deceased's heart is a forerunner of the Christian Last Judgment. But we would do better to enjoy the beauties of Egyptian art for themselves. This, indeed, is just what the peoples of other ancient cultures did, for the road that Egyptian artists, despite the severe conventions within which they were obliged to work, opened up for the understanding of nature and its re-creation in visible form was the one soon to be followed by every ancient civilization. Often, as we will see in studying Minoan and early Greek art, the debt is obvious. And at times, as in the early years of the Roman Empire, Egyptian art was nostalgically imitated. It was also revived, almost as a fashion, in the eighteenth and early nineteenth centuries when the first excavations took place. Today's readers will recall the tremendous success of the touring Tutankhamen exhibition; for modern students the excitement of Egypt is inexhaustible.

MESOPOTAMIAN ART

TWO

Roughly parallel with the civilization of Egypt, another, in some ways equally great, historic culture was developing in the region of the Near East known as Mesopotamia, from the Greek word meaning "land between the rivers." Traversed by the almost parallel courses of the Tigris to the northeast and the Euphrates to the southwest, this fertile valley was as attractive to ancient peoples as that of the Nile. But unity, stability, and permanence, the three foundation stones of Egyptian culture, were denied by nature to Mesopotamia. The narrow ribbon of the Nile Valley was protected from all but the best-organized invaders by the natural barriers of the Libyan and Arabian deserts, and the placid Nile itself formed a splendid means of communication between all parts of the realm, facilitating unified control. The broad valley of the two turbulent rivers, on the contrary, was open to invasion from all directions and had no easy means of internal communication. Consequently, the natural shape for human communities to assume was that of a city-state in the middle of supporting territory rather than a unified nation. Mesopotamian cities were under frequent and repeated siege from their neighbors or from foreign invaders and thus had to be heavily fortified. Nevertheless, Mesopotamian texts tell us of the continual destruction of these cities and of the removal of their power to other centers.

The climate itself, as compared to the rainless warmth that favored Egypt, watered only by its friendly river, was often hostile. Mesopotamia is subject to sharp contrasts of heat and cold, flood and drought, as well as to violent storms that parallel in the realm of nature the endemic conflicts between human communities. Not surprisingly, little attention seems to have been paid by Mesopotamian cultures to the afterlife, so important to the Egyptians. Security in this life, which except for intermediate periods of disorder was taken for granted throughout Egypt's long history, could be achieved in Mesopotamia only by strenuous and concerted efforts and was at best unpredictable. Propitiation of the deities who personified the mysterious and often menacing forces of nature was essential. At the opening of recorded history, the city-state was organized around the service of a local deity, who could intervene for its protection in the councils of heaven. The central temple controlled much economic activity, and shops and offices were grouped around it. Writing, laboriously taught in the earliest recorded schools, was accomplished by means of pressing the sharpened end of a reed into clay tablets to make cuneiform ("wedge-shaped") marks. Originally pictographs, these soon became ideographs, paralleling the hieroglyphs of Egypt. The tablets, which have been found by the thousands in Mesopotamian excavations, permit the economic and social life in the early theocracies to be reconstructed down to the minutest details.

Elected rulers rapidly assumed authority in their own right as kings and aspired to the control of neighboring states and eventually of the entire region, even of those outlying areas that produced the raw materials required by the economy of the state. Mesopotamian history is, in consequence, a bewilderingly complex succession of conquests and defeats, of rises and falls, of city-states and eventually of hastily conquered empires with universal pretensions that melted away after a century or so of power, sometimes after only a few decades. Any attempt, therefore, to give an orderly account of the welter of conflicting societies in the Mesopotamian world is sure to be an oversimplification. As in Egypt, the basic ethnic structure of Mesopotamian civilization was not unified. One people, the Sumerians, apparently entered the region from the mountains to the north, but their exact origin is as mysterious as their language, which is not inflected and bears no relation to any other. The Sumerians in turn were conquered by the Akkadians, Semitic invaders from the west, but eventually Sumerian culture was adopted by the conquerors. Regardless of the ethnic origin of any Mesopotamian peoples, however, certain essentials characterize Mesopotamian cities for about three thousand years.

First, the central temple was invariably raised on a platform above the level of the surrounding town. Generally, the temple consisted of a series of superimposed solid structures forming a broadly based tower or artificial mountain known as a ziggurat, on the summit of which propitiatory ceremonies to the gods of nature took place. These ziggurats, the one best known to us being, of course, the Tower of Babel (Babylon), represented an immense communal effort and were visible for great distances across the Mesopotamian plain. They clearly symbolized humanity's attempt to reach the celestial deities and, during heavy weather with low-hanging clouds, may often have appeared to succeed. One should recall that according to the Greeks the gods dwelt on Mount Olympus, and that Moses went to the top of Mount Sinai for his conversations with the Almighty. Even in the later period of empires, the royal palace in Mesopotamia always contained a ziggurat.

Second, there were no local supplies of stone, so architecture in the manner of the Egyptian pyramids, tombs, and temples was out of the question. Mud brick, sometimes reinforced by timber, was the basic material for all Mesopotamian buildings, as it had been for the ephemeral dwellings of the Egyptians. Although Mesopotamian structures were sometimes faced with fired brick, most of them survive only in ground plan or in foundations, when these could be built of imported stone. Even sculpture, forced to rely on materials brought from a distance, was limited to modest dimensions, save for the ambitious palace decorations of the Assyrians, who lived in a northern region closer to a supply of stone. Under such circumstances neither architecture nor sculpture could be expected to function on the exalted level that it did in Egyptian art, with its endless sources of material and its continuous artistic tradition—but Mesopotamia did achieve some brilliant creations of its own.

Third, probably because of the extremes of Mesopotamian climate and the violence of Mesopotamian history, no wall paintings survive in condition remotely comparable to those of Egypt.

The earliest of the ziggurats to survive was built in the land of Sumer at Uruk (biblical Erech, modern Warka) on the banks of the Euphrates in southern Mesopotamia between 3500 and 3000 B.C. and was dedicated to the sky god Anu (figs. 123, 124). It is older than any known Egyptian monument. The building owes its partial preservation to having been enclosed in a far later Hellenistic sanctuary. The mound was so oriented as to direct its corners toward the four points of the compass and was sheathed by sloping brick walls so as to form a gigantic oblong platform, standing some forty feet above the level of the surrounding plain. On this terrace stood a small whitewashed brick temple (nicknamed the White Temple), only the lower portions of which remain. Curiously enough, the entrances do not face the steep stairway ascending the mound, and the altar is tucked into a corner of the interior, possibly for protection from wind. The buttressed walls were reinforced by timber, but it is not known just how the building was roofed. Since the Sumerian name for such

Sumer

- 123. The White Temple on its Ziggurat, Uruk (present-day Warka), Iraq. c. 3500-3000 B.C.
- 124. Plan of the White Temple on its Ziggurat, Uruk (After H. Frankfort)
- 125. Ziggurat, Ur (present-day El Muqeiyar), Iraq. с. 2100 в.с.

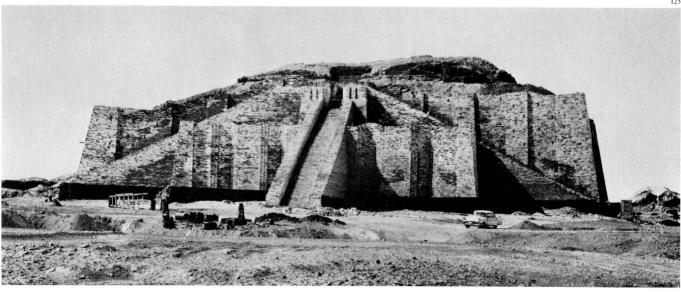

temples means "waiting room," the enclosure may well have provided a setting in which the worshipers could await the descent of the deity.

The better preserved and considerably larger ziggurat at Ur (fig. 125), near the confluence of the Tigris and the Euphrates, was built much later, during the so-called Neo-Sumerian period, when the Sumerians temporarily regained power after the collapse of the Akkadian Empire, about 2100 B.C. Three stairways, each of a hundred steps, converge at the top of the first platform; others ascended a second and then a third level, on which stood the temple. The remaining masses of brickwork, recently somewhat restored, dominate the plain for many miles. The original monument, perhaps planted with trees and other vegetation, must have made a majestic setting for religious ceremonials.

Two pieces of sculpture from Uruk, dating from the period of the White Temple, give us some insight into the character of these ceremonies. A superb alabaster vase (fig. 126) some three feet in height was probably intended to hold libations in honor of E-anna, the goddess of fertility and love. The cylindrical surface of the vase, only slightly swelling toward the top, is divided into four bands of low relief celebrating her cult. In the lowest, date palms alternate with stalks of barley, in the next ewes with rams. The third tier shows naked worshipers bringing baskets of fruit and other offerings, and the fourth the crowned goddess receiving a worshiper whose basket is brimming with fruit. (Nakedness survives in the Christian tradition that all will be naked before God at the Last Judgment; see fig. 532.) Some of the strength of the composition derives from the alternation, from one level to the next, of the directions in which the bands of figures are moving; some derives from the sturdy proportions and simple carving of the stocky figures. Their representation is governed by conventions not unlike those of Egyptian art: the torso seen in three-quarter view, the legs and heads in profile.

E-anna herself may be the subject of the beautiful Female Head (fig.

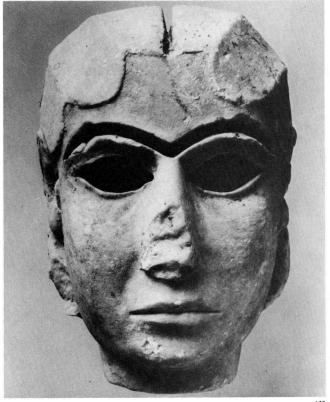

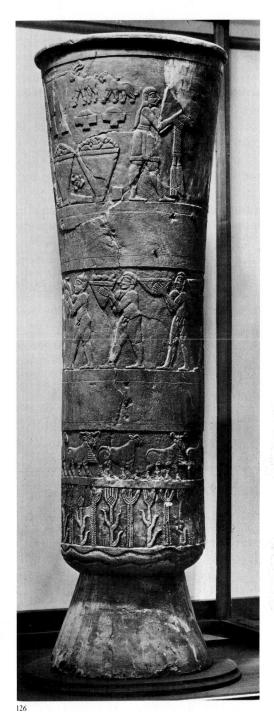

126. Sculptured vase, from Uruk, c. 3500–3000 B.C. Alabaster, height 36". Iraq Museum, Baghdad

127. Female Head, from Uruk. c. 3500–3000 B.C. White marble, height c. 8". Iraq Museum, Baghdad

127) carved from white marble. It was probably intended to surmount a wooden statue. Originally, the eyes were filled with colored material. most likely shell and lapis lazuli held in by bitumen, which would have made the magical stare even more intense. The eyebrows were probably inlaid with bitumen and the hair plated with gold. Even in its present stripped condition, the contrast between the enormous eyes and the sensitively modeled surfaces of the delicate mouth and chin renders the head unforgettable. A much later assemblage of small marble statues (fig. 128) from the sanctuary of Abu, god of vegetation, at Tell Asmar shows the hypnotic effect of these great, staring eyes in Sumerian religious sculpture when the shell and lapis lazuli inlays (in this case, shell and black limestone) are still preserved. Grouped before the altar, the statues seem to be solemnly awaiting the divine presence. It is thought that the largest figures represent the god, whose emblem is inscribed on its base, and his spouse, but more probably they are meant to be the king and queen, since their hands are folded in prayer like those of the smaller figures. Their cylindrical shape, characteristic of Mesopotamian figures, is far removed from the cubic mass of Egyptian statues, which preserve the shape of the original block of stone.

Some of the splendor of a Sumerian court can be imagined from the gorgeous harp found in the tomb of Puabi, queen of Ur (fig. 129). The strings and wooden portions have been restored, but the gold-covered posts and the bull's head, with its human beard of lapis lazuli, are original; so are the four narrative scenes on the sound box, inlaid in gold, lapis lazuli, and shell. The bearded bull is a royal symbol throughout Mesopotamian art. Intensely real, the animal with its wide-open eyes and alert ears seems to be listening to the music. The uppermost scene on the sound box, showing a naked man wrestling two bearded bulls, all of whom stare out at us vacantly, and the lowest, a scorpion-man attended by a goat bearing libation cups, come from the epic of Gilgamesh, the half-historical, half-legendary hero. But the two incidents between are, alas, not so easy to trace. In one a table heaped with a boar's head and a sheep's head and leg is carried by a solicitous wolf with a carving knife tucked

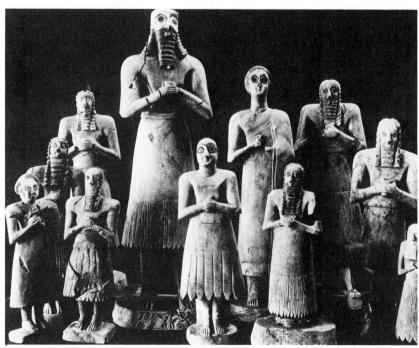

- 128. Statues from the Abu Temple, Eshnunna (present-day Tell Asmar), Iraq. c. 2700–2500 B.C. Marble with shell and black limestone inlay, height of tallest figure c. 30". Iraq Museum, Baghdad, and The Oriental Institute, University of Chicago
- 129. Royal harp, from the Tomb of Queen Puabi, Ur. c. 2685 B.C. Wood with inlaid gold, lapis lazuli, and shell, height c. 13". University Museum, University of Pennsylvania, Philadelphia

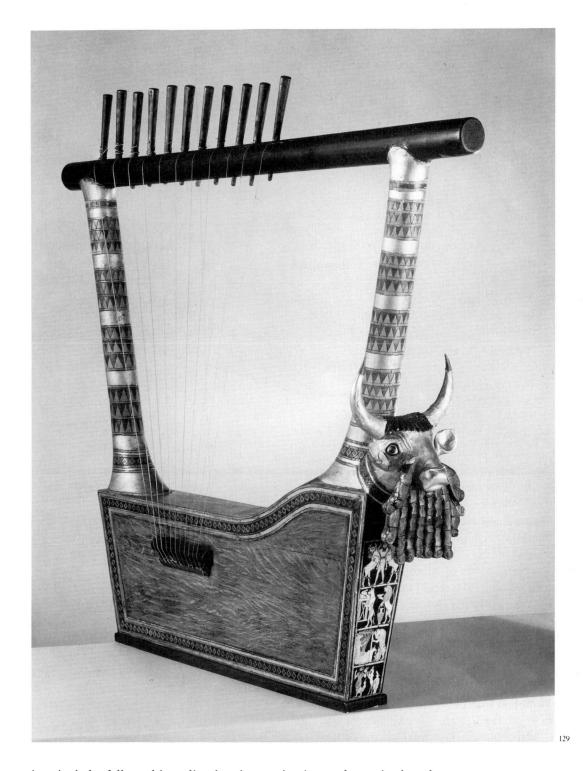

into its belt, followed by a lion bearing a wine jug and cup; in the other a donkey plays a bull-harp while a bear beats time and a jackal brandishes a rattle and beats a drum. Possibly these human-handed beasts come from some Sumerian legend yet unknown, but they suggest with perhaps illusory ease the tradition of animal fables known to us in every era from

the days of Aesop to those of Peter Rabbit.

That such representations may contain a far deeper meaning than we tend to give them is suggested by the splendid goat, made of wood overlaid with gold and lapis lazuli, also found in the royal graves at Ur (fig. 130). We know from contemporary representations on the stone seals used to imprint clay tablets that this is the kind of offering stand customarily

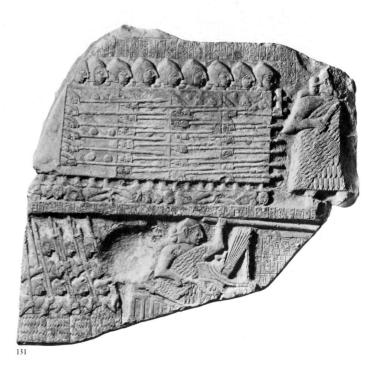

set before the male fertility god Tammuz. The he-goat, proverbial symbol of masculinity, stands proudly erect before a gold tree, forelegs bent, eyes glaring outward with great intensity. The artist has executed every lock and every leaf with crispness and elegance. Descendants of such symbolic animals persist in heraldry even into modern times and are still endowed with allegorical significance.

A grim reminder of the impermanence of Mesopotamian society is given by the *Stele of King Eannatum* (fig. 131), found at Lagash, the modern Tello. This boundary stone is also called the *Stele of the Vultures*. In the upper register the king, conqueror of both Ur and Uruk, leads a phalanx into battle. He is clad in goatskins and carries a mace. The battalion is represented symbolically by a solid block of four shields originally surmounted by nine identical helmeted heads. From each shield protrude six spears, one above the other, each held by a pair of hands; below the shields a steady row of feet tramples a shapeless mass of prone naked bodies. In the broken lower register the king in his chariot, his quiver bristling with arrows, leads light infantry into battle. To modern eyes accustomed to mechanized warfare, this relentless and inhuman attack is all too familiar.

Such endemic warfare was to be followed by something far worse, the virtual collapse of the Sumerian social order under the weight of entirely new conceptions of divine monarchy, like that of Old Kingdom Egypt but maintained wholly by force of arms. A Semitic ruler, Sargon I, usurped the throne of Kish and then ruled for fifty-six years from neighboring Akkad, whose site has not yet been discovered. Sargon founded a dynasty of five kings who aspired to world conquest and in fact controlled the Middle East from the Mediterranean Sea to the Persian Gulf. The

- 130. He-Goat, from Ur. c. 2600 B.C. Wood overlaid with gold and lapis lazuli, height 20". University Museum, University of Pennsylvania, Philadelphia
- 131. Stele of King Eannatum (Stele of the Vultures), from Lagash (present-day Tello), Iraq. c. 2560 B.C. Limestone, height 71". The Louvre, Paris

Akkad (c. 2340–2180 B.C.)

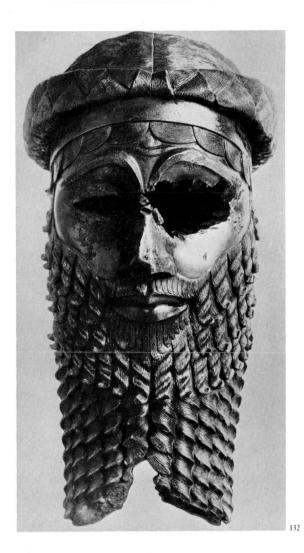

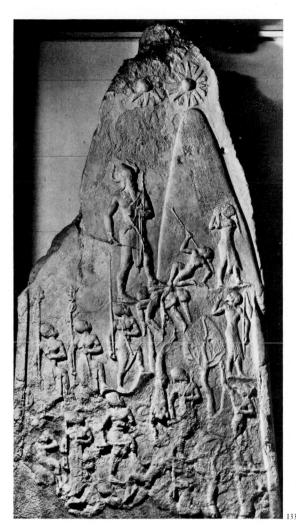

magnificent bronze Head of an Akkadian Ruler (fig. 132) is so great a work of art that it makes us regret that so little survives from the days of these Akkadian monarchs except for the literary texts in which their power and majesty were extolled. Even in the absence of the eyes, gouged out long ago, the head is overwhelming. The hair, braided and bound to form a kind of diadem, is gathered in a chignon on the neck. The face is half hidden in a beard whose two superimposed tiers of curls, each made up of spirals moving in the opposite direction to those in the tier below, exert an almost dizzying effect on the beholder by their blend of formal grandeur and linear delicacy. The great, flaring eyebrows plunge in convergence upon an aquiline nose below which the sensual lips are held quietly in a superb double curve of arrogant power not to be approached again until Greek and Roman sculpture. The identity of this monarch is unknown, but it is hard to believe that the great Sargon looked much different.

The only other work of art of first importance remaining from Akkadian rule also exudes an emotional violence that makes Sumerian art look bland in contrast. The sandstone Stele of King Naram Sin (fig. 133), Sargon's grandson, shows him protected by the luminaries of heaven and about to dispatch the last of his enemies. The king stands proudly beside the sacred mountain, mace in hand. One crumpled enemy attempts in agony to pluck the spear from his throat, another pleads for his life, two others hang over the edge of a cliff down which still another falls headlong. Meanwhile, up the ascending levels of the landscape stride the victorious soldiers of the king. The tremendous drama of this relief, the

- 132. Head of an Akkadian Ruler, from Nineveh (present-day Kuyunjik), Iraq. c. 2300-2200 B.C. Bronze, height 143/8". Iraq Museum, Baghdad
- 133. Stele of King Naram Sin, from Susa (presentday Sush), Iran. c. 2300-2200 B.C. Sandstone, height 78". The Louvre, Paris

strength of the projection of the sculptural figures, and the freedom with which they move at various heights within the landscape space give the stele a unique position in Mesopotamian art.

Akkad, which lived by the sword, perished by it as well. A powerful people called the Guti invaded Mesopotamia from the mountainous regions to the northeast, conquered the Akkadian Empire, and destroyed its capital, only to vanish into history without positive achievements. Ironically, the proud *Stele of King Naram Sin* was carried off as booty.

Only the city-state of Lagash mysteriously escaped the general devastation wrought by the Guti, and its ruler, Gudea, interpreted this deliverance as a sign of divine favor. In gratitude he dedicated a number of votive statues of himself, all carved either from diorite or from dolerite, imported stones of great hardness, as gifts to temples in his small realm. All the Gudea statues radiate a sense of calm, even of wisdom. Holding a plan of a building on his lap, Gudea sits quietly with hands folded (fig. 134). Only the tension of the toes and the arm muscles betrays his inner feelings kept in check by control of the will. The surviving heads (fig. 135), often crowned with what appears to be a lambskin cap, show this same beautiful composure, expressed artistically in the broad curves of the brows and the smooth volumes of the cheeks and chin, handled with firmness and accuracy. While less dramatic than the *Akkadian Ruler*, the modest Gudea portraits achieve real nobility of form and content.

Remarkably enough, Gudea was able to win control by peaceful means over a considerable region of the former Akkadian Empire. In 2111, Urnammu, governor of Ur, usurped the monarchy of Sumer and Akkad and built the great ziggurat at Ur (see fig. 125). Little else of artistic merit survives from his reign, after which Mesopotamia reverted to its former chaotic pattern of conflicting city-states. From the brief Isin-Larsa period (2025–1763 B.C.), so called from the ascendancy of the cities bearing these names, dates a terra-cotta relief of extraordinary power and beauty, the first voluptuous female nude known from antiquity (fig. 136). This creature, at once alluring and frightening, represents the goddess of death, the baleful Lilith, possibly the screech owl of Isa. 34:14. Adorned only with gigantic earrings and the characteristic four-tiered headdress of a deity, she smilingly upholds, behind her head, a looped cord—either the symbol of human life or the instrument with which she brings it to an end. Her great wings are partially spread behind her full-breasted, roundhipped body. Instead of feet she has terrible feathered talons; flanked by staring owls, she perches upon the rumps of two lions back to back. Originally, her body was painted red, one owl black and the other red, and the manes of the lions black. The setting is established by the pattern of scales along the base, a conventionalization of the sacred mountain.

The great king Hammurabi (1792–1750 B.C.) briefly brought all of Mesopotamia under the rule of Babylon and reduced its various and often conflicting legal systems to a unified code; this code is inscribed on a tall stele of black basalt at whose summit Hammurabi, in a simple and noble relief (fig. 137), stands before the throne of the god Shamash, again on a sacred mountain indicated by the customary scale pattern. Wearing the same four-tiered headdress as Lilith and with triple flames emerging from his shoulders, this magnificent being extends his symbols of power, a rod and a ring. At first sight prosaic, this elemental colloquy between man and god becomes grander as one watches; like Moses on Mount Sinai, the king talks familiarly with the deity who sanctifies his laws. The cylindrical figures typical of early Mesopotamian art are conventionalized in pose,

Neo-Sumer and Babylon (c. 2125–1750 B.C.)

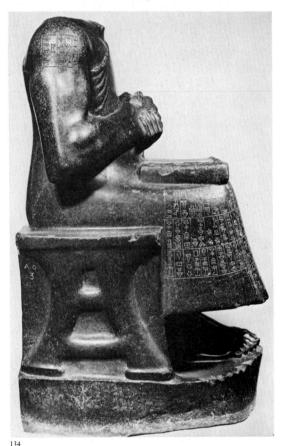

- 134. Seated statue of Gudea with architectural plan, from Lagash. c. 2150 B.C. Diorite, height 29". The Louvre, Paris
- 135. Head of Gudea, from Lagash. c. 2150 B.C. Diorite, height 9". Museum of Fine Arts, Boston
- The Goddess Lilith. c. 2025–1763 B.C. Terracotta relief, height 19%". Collection Colonel Norman Colville, United Kingdom
- 137. Stele with the Code of Hammurabi (upper portion). c. 1792–1750 B.C. Basalt, height of relief 28"; height of stele 84". The Louvre, Paris
- 138. *The Lion Gate*, Boğazköy, Turkey. Hittite, c. 1400 B.c. Stone

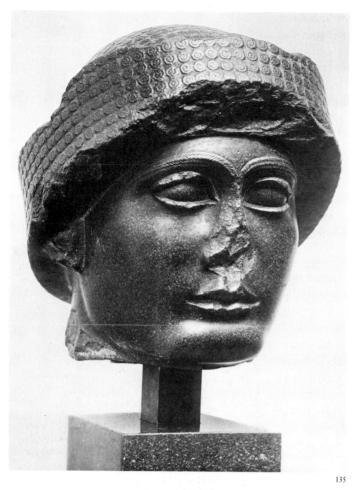

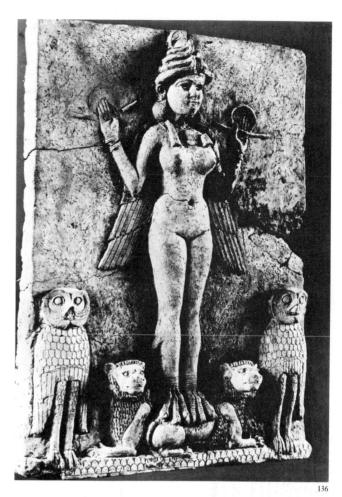

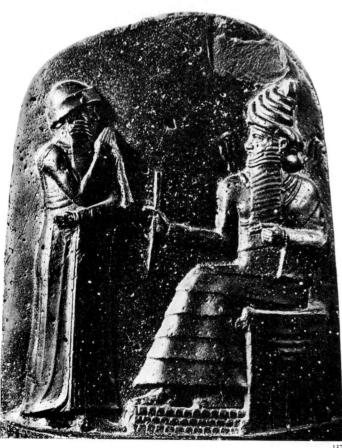

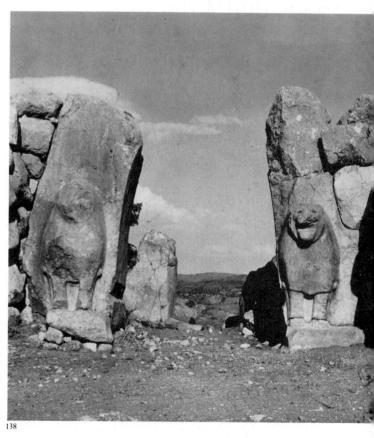

as indeed they are throughout pre-Greek art, so that the torso is shown frontally while the hips and legs, insofar as they can be seen within the enveloping drapery, are depicted in profile. For the first time, however, the eyes are not frontal; the gaze between man and god is unswerving.

About 1595 B.C., the Babylonian kingdom was conquered by the Hittites, a people from Anatolia. The sturdy, virile art of the Hittites is seldom of a quality to compete with the best of Mesopotamian art, but the rude and massive lions (c. 1400 B.C.) that flank the entrance to the gigantic stone walls of the Hittite citadel near modern Boğazköy (fig. 138) are the ancestors of the winged beasts that guard the portals of the palaces of the Assyrian kings. It is interesting that after the death of Tutankhamen, the Hittites were so powerful in the Middle East that Ankhesenamen, the distraught widow of the young pharaoh, besought the Hittite king Suppiluliuma I for the hand of one of his sons in marriage as protection.

In the welter of warring peoples—including the Elamites, Kassites, and Mitannians—who disputed with each other for the succession to Babvlonian and Hittite power, a single warlike nation called the Assyrians, after their original home at Ashur on the Tigris River in northern Mesopotamia, was both skillful and ruthless enough to gain eventual ascendancy over the entire region. In fact, for a considerable period their power extended to the west over Syria, the Sinai Peninsula, and into Lower Egypt, where they destroyed Memphis, and to the north into the mountains of Armenia. The Assyrians gloried in what from their voluminous historical records and their art seems to have been very nearly continuous warfare, mercilessly destroying populations and cities before they in turn were vanquished and their own cities razed to the ground.

The Palace of Sargon II. Only one of the great Assyrian royal residences is known in some detail, the eighth-century palace of King Sargon II at Dur Sharrukin, the modern Khorsabad, which has been systematically excavated (fig. 139). This massive structure was built into the perimeter of a citadel some five hundred feet square, which was in turn incorporated into the city wall. The entire complex was laid out as symmetrically as possible (fig. 140). Above a network of courtyards on either side surAssyria (c. 1000–612 B.C.)

- 139. Citadel of King Sargon II, Dur Sharrukin (present-day Khorsabad), Iraq. c. 742-706 B.C. (Architectural reconstruction by Charles Altman)
- 140. Plan of the Palace in the Citadel of King Sargon II, Dur Sharrukin 1. Central courtyard, accessible from Citadel 2. Courtyard of the Ambassadors, lined with relief sculpture 3. Gate shown in fig. 141 4. Throne Room, lined with mural paintings 5. Royal apartments 6. Ziggurat

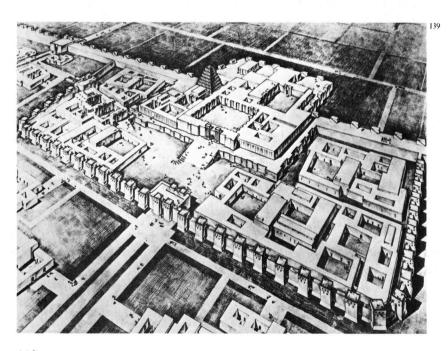

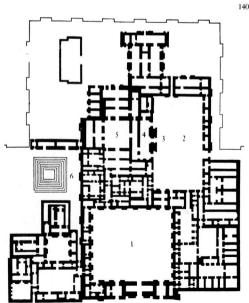

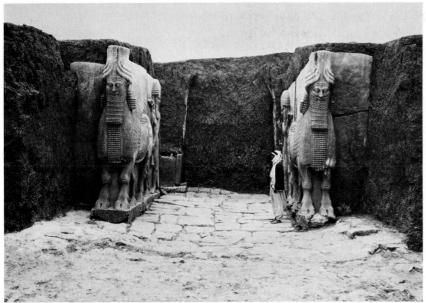

rounded by administrative buildings, barracks, and warehouses rose a platform the height of the city wall. On this eminence stood the palace proper, protruding from the wall into the surrounding plain, so that the king and the court could survey the countryside from its ramparts. It was defended by its own towers. The entire complex was dominated by a lofty ziggurat, descendant of those at Uruk and at Ur (see figs. 124, 125) and doubtless intended for a similar purpose. It was, however, much more carefully formalized. Its successive stages—there may have been seven of these, each painted a different color—were not separate platforms; the structure was ascended counterclockwise by a continuous ramp, a square spiral as it were, so that worshipers always had the paneled wall on their left while on their right they looked out over ever-widening views of the plain.

Like all Mesopotamian buildings, the palace of Sargon II was mostly built of mud brick (although certain crucial portions were faced by baked and glazed brick), which accounts for the ease of its demolition by the next wave of invaders. Considerable use seems to have been made of arches and barrel vaults. Luckily, the Assyrians had access to stone for sculpture, and they were able to flank the entrances to the brightly painted throne room with colossal limestone guardians, in the tradition of the Hittite lions (see fig. 138). Two of these majestic creatures are shown still in place in fig. 141. They were monstrous beings with the bodies of bulls (one recalls the royal bulls of archaic Egyptian palettes, fig. 72), grand, diagonally elevated wings, and human heads with long curly beards and many-tiered divine headdresses (compare figs. 132, 142), doubtless symbols of the supernatural powers of the king. Built into the gates and visible only from two sides, they were really a kind of relief sculpture rather than statues in the round. So that the viewer might see four legs from any point of view, the sculptors generously gave these creatures five.

Sargon II himself can be seen in a superb limestone relief (fig. 142) from the Dur Sharrukin palace, a relief possibly intended to recall the bronze Head of an Akkadian Ruler (see fig. 132) but lacking its calm majesty. There is an almost hysterical intensity about the flare of the eyelids and eyebrows and the cruel set of the narrow lips that is increased by the ornamental curves of the sharply separated forms characteristic of Assyrian relief sculpture throughout its brief history.

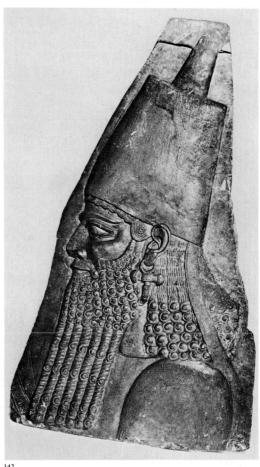

- 141. Gate, Palace of King Sargon II, Dur Sharrukin (during excavation)
- 142. Portrait of King Sargon II, from Dur Sharrukin. Limestone relief, height 35". Museo Egizio, Turin

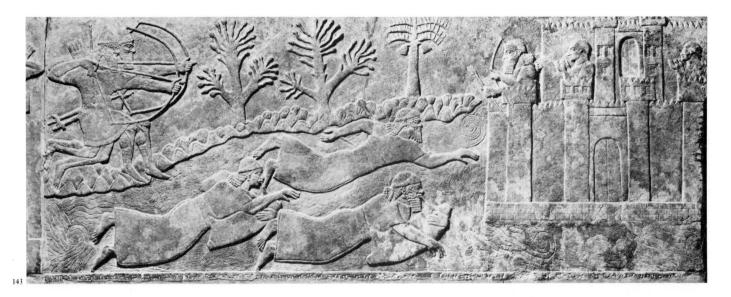

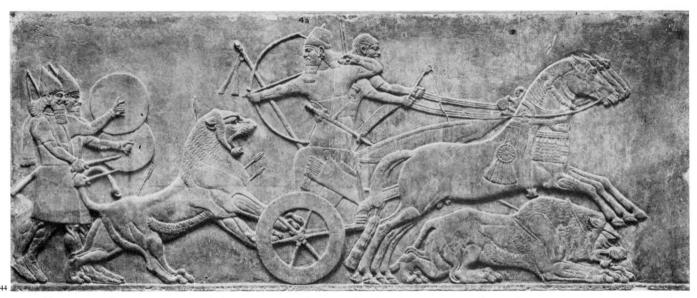

The Palaces of Nimrud and Nineveh. Emissaries of friendly rulers could approach the monarch only through a succession of halls lined with continuous wall reliefs intended to overawe the visitors not only with the king's intimacy with the gods but also with his military exploits and personal courage. These historical reliefs are ancestors of the lengthy political narratives of Roman imperial sculpture (see figs. 352, 353). In strips often superimposed in the manner of Egyptian tomb reliefs, the Assyrians can be seen fighting battles that they always win and cheerfully burning cities, dismantling the fortifications, and massacring the inhabitants. The reliefs were drawn on the surface of alabaster slabs and the background was then cut away to give just a slight projection, as in Egyptian relief. Yet the contours are so bold and so strongly ornamentalized and the proportions are so chunky that they convey an impression of massive volume instead of Egyptian delicacy and elegance. The innumerable scenes of unrelieved mayhem can become monotonous, especially because the quality of the reliefs, which were apparently turned out at some speed, is not uniformly high. But there were great sculptors in the group who could find in their narrative subjects inspiration for an epic breadth of vision entirely new in art. Sometimes the scenes have an unconscious humor, as in *Elamite Fugitives Crossing a River* (fig. 143), from the palace

- 143. Elamite Fugitives Crossing a River, from the Palace of King Ashurnasirpal II, Kalhu (present-day Nimrud), Iraq. c. 883–859 B.C. Alabaster relief, height c. 39". British Museum, London
- 144. King Asburnasirpal II Killing Lions, from the Palace of King Ashurnasirpal II, Nimrud. c. 883–859 B.C. Alabaster relief, 39 × 100". British Museum, London
- 145. Dying Lioness (detail of The Great Lion Hunt), from the Palace of King Ashurbanipal, Nineveh. c. 668–627 B.C. Alabaster relief, height 13¾". British Museum, London

of Ashurnasirpal II at Nimrud. Two Assyrian bowmen shoot from the bank at two fully clothed Elamites who cling to inflated goatskins and at a third who has to rely entirely on his own strength to stay afloat as they swim toward the walls of their little city, defended by Elamite warriors on the tops of the towers. In the manner of Egyptian reliefs and paintings, the swimmers have two left hands. The undulating shapes of the swimmers and the ornamentalized trees on the bank create the strong and effective pattern characteristic of the best Assyrian reliefs.

Strangely enough, while human expressions remain impassive under any conditions, those of animals are represented with a depth of understanding that turns the conflicts between men and beasts into the grandest action scenes in Mesopotamian art—in fact, into some of the most powerful in the entire history of art. Lions were released from their cages, after having been goaded into fury, so that the king could display his strength and courage by shooting down the maddened beasts from his chariot. The best sculptors seem to have been employed for these heroic reliefs, which unleash an astonishing explosion of forces—the swift flight of the horses, the resolute power of the monarch, the snarling rage of the tormented beasts. Not since archaic Egypt have the muscles of humans and animals been shown swelling with such tremendous tension as in the relief depicting Ashurnasirpal engaged in his cruel sport (fig. 144). Almost unbearable in its tragic intensity is the detail of the Dying Lioness from the palace of Ashurbanipal at Nineveh (fig. 145). Pierced by three arrows, bleeding profusely, and howling in impotent defeat, the poor beast drags her paralyzed hindquarters desperately along. After these horrors the relief of a flock of gazelles from the same palace (fig. 146) is totally unexpected in its airy grace. One turns his head in fear, the others plod along, the little ones struggling to keep up, as they flee their archenemy, man. Equally surprising is the device of scattering the animals lightly about the surface of the slab to suggest open space.

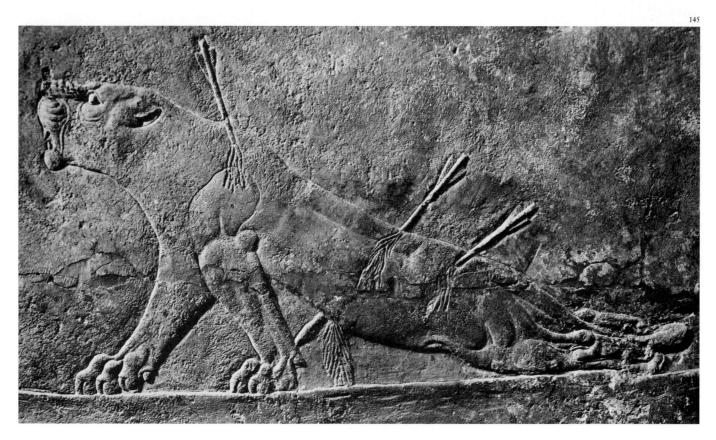

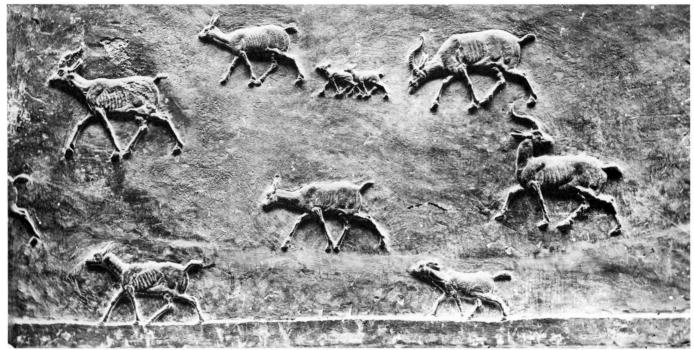

146

The collapse of Assyria in 612 B.C. was brought about by invasions of Scythians from the east and Medes from the north. Order was restored by Nebuchadnezzar II, ruling from Babylon in the south, which had never lost its cultural importance even under Assyrian domination. In the scanty remains of Neo-Babylonian stone sculpture an attempt can be discerned to emulate the style of Sargon I, some eleven hundred years earlier, but the brief revival of Babylonian glory is best known for its architectural remains. For two hundred years or so Babylon had possessed the Hanging Gardens, one of the wonders of the ancient world, a series of four brick terraces rising above the Euphrates, whose waters were piped up to irrigate a splendid profusion of flowering trees, shrubs, and herbs. Nebuchadnezzar added a splendid palace with a ziggurat, which was the biblical Tower of Babel, and built eight monumental arched gates in the fortified city walls. One gate (fig. 147), connected with the inner city by a processional way and dedicated to the goddess Ishtar, was faced with glazed brick. Excavated early in this century, it is installed, with missing portions liberally supplied, in East Berlin, the only place in the world where one can gain any idea of the scale and brilliance of the ephemeral brick architecture of ancient Mesopotamia. The clear, bright blue of the background glaze sets off the geometric ornament in white and gold and the widely spaced, stylized bulls and dragons in raised relief. They are composed of many separately molded and glazed bricks and form a happy postlude to the interminable slaughters of the bloodthirsty Assyrians. Nebuchadnezzar's gorgeous Babylon must have deserved the boastful title he gave it—"navel of the world."

Neo-Babylonia (605-539 B.C.)

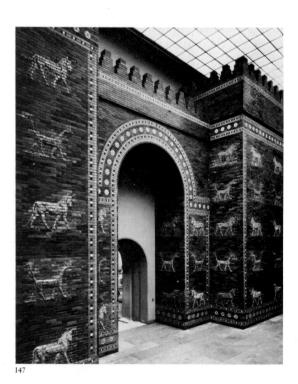

146. Herd of Fleeing Gazelles (portion of a relief from the Palace of King Ashurbanipal, Nineveh). c. 668–627 B.c. Alabaster, height 201/8". British Museum, London

147. The Ishtar Gate (restored), from Babylon, Iraq. c. 575 B.C. Glazed brick. Staatliche Museen, Berlin

Persia (539–331 B.C.)

We obtain a one-sided account of the Persian Empire from the history of the Greeks, to whom the Persians appeared as a juggernaut threatening to crush the cherished independence of the Greek city-states. The tidy administration of the Persians may in fact have come as a relief to the weary peoples of the Near East. Out of the mountainous regions of what is today Iran, northeast of Mesopotamia, came the nomadic Persians under Cyrus the Great; under his successors Darius I and Xerxes I they conquered an empire that was centered on Mesopotamia but included also Syria, Asia Minor, and Egypt on one side and parts of India on the other. Although they set themselves up as kings of Babylon they styled themselves, and quite rightly, kings of the world. Only the Greeks prevented them from extending their rule into Europe, and the Greeks, under Alexander the Great, eventually brought about their downfall. Their orderly and decent government made cruelties like those of the Assyrians unnecessary. The Persian Empire, more than twice as extensive as any of its predecessors, was divided into provinces called satrapies, administered by governors, or satraps, responsible directly to the king. The capital moved about, but its great palace was at Persepolis, near the edge of the mountains above the Persian Gulf, to the east of Mesopotamia.

There Darius commenced his residence, continued and completed by his son Xerxes about 500 B.C.; it was an orderly and systematic complex of buildings and courts surrounded by the inevitable, and now vanished, mud-brick wall (fig. 148). Persian art, perhaps not as imaginative as some that preceded it, included many elements borrowed from the subject peoples; in fact, many of the artisans were Babylonians, and others were Greeks from Asia Minor. The Persians worshiped the god of light, Ahuramazda, at outdoor fire altars for which no architecture was needed, so there were no ziggurats. But the palace was built, like that of Sargon II, on a huge platform, this time of stone, quite well preserved (fig. 149).

- 148. Plan of the Palace of Darius and Xerxes, Persepolis, Iran 1. Great entrance stairway
 2. Gatehouse of Xerxes 3. Apadana, or Audience Hall, of Darius and Xerxes
 4. Throne Hall of Xerxes, or "Hundred-Column Hall" 5. Tachara, or Palace, of Darius 6. Palace, probably rebuilt by Arta-xerxes III 7. Hadish, or Palace, of Xerxes
 8. Tripylon, or Council Hall 9. Restored area of the "Harem" 10. Treasury 11. Section of northern fortifications 12. Royal tomb, probably of Artaxerxes II
- 149. Apadana, or Audience Hall, Palace of Darius and Xerxes, Persepolis. c. 500 B.C.

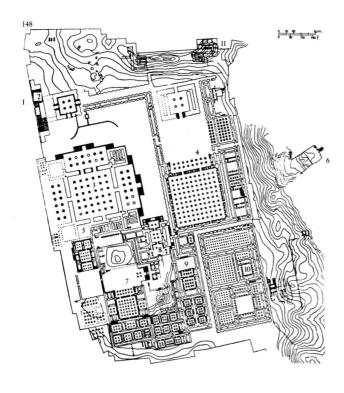

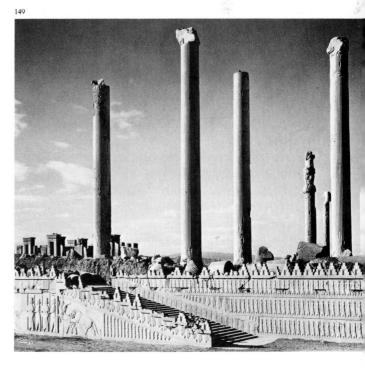

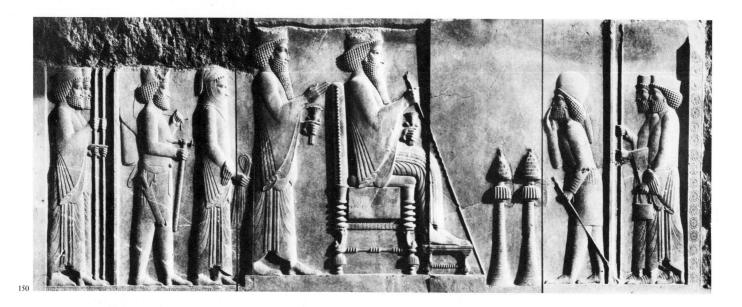

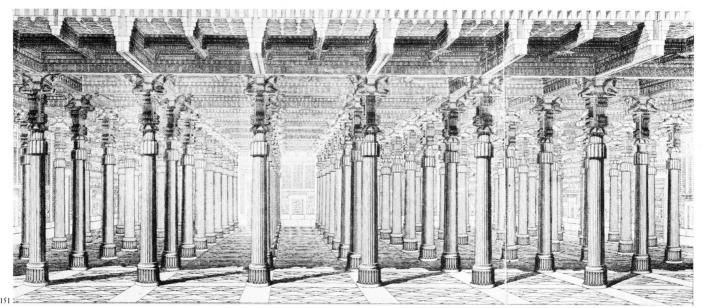

The king had no need to terrify his visitors, so the relief sculpture showed interminable superimposed rows of neatly uniformed bodyguards mounting the steps, as in reality they did, and the great king himself giving audience (fig. 150). For the first time, relief in the Near East was not just surface drawing with the background cut away, but was so carved as to give the impression that actual figures, having cylindrical volume, move on a shallow stage. This idea was derived from Greek art, and the sculptors may have been Ionian Greeks. The statue-like figures are shown in true profile, although the eyes are still frontal. The prim rows of curls in hair and beard are obviously derived from Akkadian and Assyrian forebears, but the drapery folds now have edges that ripple in long, descending cataracts as in archaic Greek sculpture (see fig. 188), and the garments clearly show underlying limbs, as in Old Kingdom Egyptian sculpture (see fig. 87). In a civilization like that of the Persians, individualization was not encouraged, but there is a crisp, fresh elegance of drawing and carving that gives Persian decorative sculpture great distinction. It was doubtless even more striking with its original brilliant colors and gilding.

Persian rooms were characteristically square, and the great hall of Xerxes must have been one of the most impressive in the ancient world

- 150. Darius and Xerxes Giving Audience. c. 490 B.C. Limestone relief, height 100". Palace of Darius and Xerxes, Persepolis
- 151. Throne Hall of Xerxes, or "Hundred-Column Hall," Palace of Darius and Xerxes, Persepolis (Architectural reconstruction by C. Chipiez)

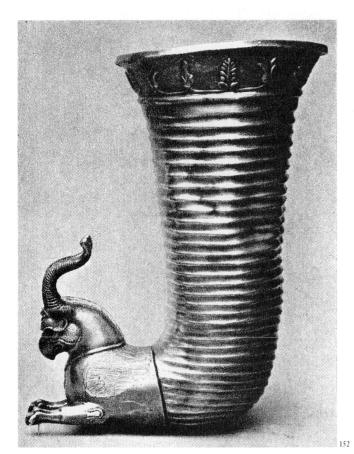

(fig. 151). Its hundred stone columns, each forty feet high (several are still standing) and brightly painted, were delicately fluted and terminated in paired bulls that acted as brackets and helped to support the gigantic beams of imported wood, also painted. No such interior had, of course, existed in the Mesopotamian world, where columns were unknown. Quite possibly the Persians drew their idea partly from the columned porticoes of Ionian Greek temples, partly from the columned temple halls of the Egyptians. The notion of a forest of columns, with no dominant axis in any direction, may have been the origin of the typical plan of many Islamic mosques several centuries later (see figs. 468, 472).

The gold and silver rhytons or libation vessels (fig. 152), with their hybrid animal forms, show the Persian love of elegance, grace, and rational organization of elements. The linear rhythms of the animals themselves still suggest those of prehistoric pottery from Susa, not far from Persepolis, three millennia earlier (fig. 153), not to speak of many characteristic elements of later Mesopotamian cultures, but the alternating palmette and floral ornament on the upper border is already characteristically Greek. Sadly enough, it is upon the Greeks that the responsibility rests for the destruction of the palace, burned by Alexander after a long and violent banquet.

- 152. Rhyton, from the Oxus Treasury, Armenia. Silver, height 10". British Museum, London
- 153. Painted beaker, from Susa. c. 5000-4000 B.C. Height 111/4". The Louvre, Paris

TIME LINE II

Pyramids of Giza

Sesostris III

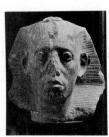

Hatshepsut

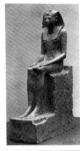

History

5000 в.с.

Sumerians settle in Mesopotamia Narmer-Menes unites Upper and Lower Egypt, c. 3100 Protodynastic period, Sumer, c. 3000-2340

3000

Sumer united by Sargon I of Akkad, c. 2340 Gudea of Lagash controls much of former Akkadian Empire First Intermediate Period, Egypt, 2155–2040 III Dynasty of Ur Middle Kingdom, Egypt, c. 2040-1785

Fall of Ur, c. 2025

Cycladic colonies develop

2000

CULTURE

Pictographic writing, Sumer, c. 3500 Wheeled carts, Sumer, c. 3500–3000 Sailboats, Egypt, after 3500 Potter's wheel, Sumer, c. 3250 Hieroglyphic writing, Egypt, c. 3000 Cuneiform writing, Sumer, c. 2900 First bronze tools and weapons, Sumer Divine kingship of pharaoh, Egypt Theocratic socialism, Sumer

Bronze tools and weapons, Egypt

Stele with Code of Hammurabi

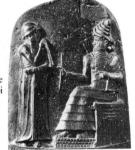

Dying Lioness

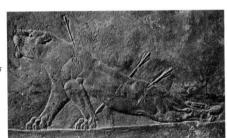

Ishtar Gate

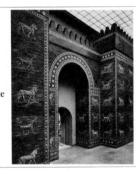

1800 B.C.

Hammurabi brings Mesopotamia under Babylonian rule, 1792–1750 Hyksos rule Egypt in Second Intermediate Period, 1786-1554 Minoan civilization flourishes, 1600-1400 Hittites conquer Babylon Expulsion of Hyksos, expansion of Egyptian Empire, 1554–1080, esp. Amonhotep I, Hatshepsut, Amonhotep III, Akhenaten, Seti I, Ramses II Assyrian Empire, 1000-612

600

1400

Nebuchadnezzar II of Babylon, r. 605-562, Neo-Babylonian Period Persian Empire founded by Cyrus the Great, r. 559-529

Code of Hammurabi, c. 1760

Mathematics and astronomy flourish in Babylon Hittites introduce iron tools and weapons Hyksos bring horses and wheeled vehicles to Egypt, c. 1725

Monotheism of Akhenaten; worship of the disk of the Sun, the Aten, temples of Amon-Ra closed, c. 1360; Tutankhamen restores old religion

Hebrews accept monotheism

Zoroaster (born c. 666)

EGYPTIAN/MESOPOTAMIAN/AEGEAN

Court of Amonhotep III, Temple of Luxor

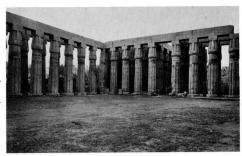

King Akhenaten from Karnak

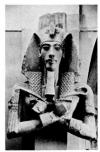

Female Head from Uruk

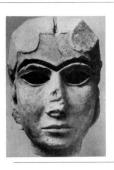

PAINTING, SCULPTURE, ARCHITECTURE

Painted beaker from Susa Ziggurat, White Temple, and sculptured head and vase, Uruk Tomb painting from Hierakonpolis Palette of King Narmer Geese of Medum Step pyramid, Funerary Complex, and statue of King Zoser, Saqqara Statues from Abu Temple at Tell Asmar

Royal harp from Tomb of Queen Puabi; He-Goat; Stele of King Eannatum King Mycerinus, Prince Ankhhaf, Seated Scribe, Kaaper; Tomb of Ti Pyramids, Valley Temples, and Great Sphinx, Giza; King Chephren Ziggurat at Ur

Sculpture portraits of Akkadian Ruler and Gudea Cycladic idol from Amorgos; Lyre Player from Keros Nubian mercenaries, Asyūt; Head of Sesostris III; Princess Sennuwy Funerary Temple of Mentuhotep III, Deir el Bahari

PARALLEL SOCIETIES

5000 B.C.

Sumerian Archaic Egyptian Old Kingdom in Egypt

3000

Akkadian Neo-Sumerian Cycladic Middle Kingdom in Egypt

2000

Palace at Persepolis

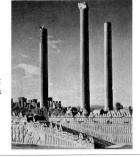

Cycladic idol from Amorgos

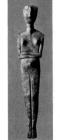

Snake Goddess. Knossos

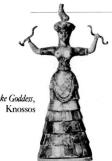

Lion Gate. Mycenae

Stele with the Code of Hammurabi

Palace at Knossos, with mural decorations; frescoes from Thera Octopus vase from Palaikastro; Snake Goddess and bull rhyton from Knossos: Harvester Vase

Citadel of Tirvns; Lion Gate and Treasury of Atreus at Mycenae Three Deities, funeral mask, fresco fragments, and lion dagger, Mycenae Funerary Temple of Queen Hatshepsut, with relief decorations Paintings from tombs of Nebamun and Sen-nedjem Temple of Amon-Mut-Khonsu, Luxor; Temple of Amon-Ra, Karnak Pillar statue and relief of Akhenaten; Nefertiti, Tomb of Tutankhamen Lion Gate at Boğazköy

Reliefs, palaces of Ashurnasirpal II at Nimrud and Nineveh Citadel of King Sargon II at Khorsabad; portrait of Sargon II Ishtar Gate at Babylon

Palace of Darius and Xerxes at Persepolis; "Hundred-Column" Hall Temple of Horus at Edfu

Babylonian Minoan

1800 B.C.

Mycenean

Empire or New Kingdom in Egypt

1400

Hittite Assyrian Archaic Greek Neo-Babylonian

600

Persian Etruscan

AEGEAN ART

с. 3000-1100 в.с.

THREE

Somewhat later than the first manifestations of the splendid cultures that flourished in the Nile Valley and in Mesopotamia, a third artistically productive civilization arose in the islands and rocky peninsulas of the Aegean Sea. The rediscovery of this vanished civilization, like that of the cave paintings and of Sumer and Akkad, has been an achievement of the past hundred years or so. Nineteenth-century scholarship had taken it for granted that the cities and events described in the poems of Homer were largely if not entirely mythical, but the excavations of the German amateur archaeologist Heinrich Schliemann, beginning at the site of Troy in 1870 and continuing later at Mycenae and other centers on the Greek mainland, made clear that the Homeric stories must have had a basis in fact and that the cities mentioned in the poems had indeed existed. Subsequent excavations, beginning with those initiated by the British scholar Sir Arthur Evans in 1900, brought to light a completely unsuspected group of buildings on the island of Crete, containing works of art of surprising originality and freshness of imagination. It has now become clear that there were two distinct cultures. One was centered on Crete and has been called Minoan, after Minos, the legendary Cretan king; the other is known as Helladic, after Hellas, the Greek mainland. The final phase of Helladic culture, and its most interesting artistically, is known as Mycenaean, from its principal center at Mycenae.

Minoan civilization is almost as much of a mystery as that of preliterate humans. The Minoan and Helladic peoples spoke different tongues, and Minoan scripts are still undecipherable. Their language, apparently non–Indo-European, is completely unknown. However, a late form of Aegean writing, found both in Crete and on the mainland, was first deciphered in 1953 and turned out to be a pre-Homeric form of Greek. The now-legible documents, of a purely practical nature and without literary interest, suggest that Minoan civilization eventually succumbed to Mycenaean overlords. Thus our slight knowledge of Aegean history, social structure, and religious beliefs must be gleaned largely from the study of Aegean buildings and other works of art and from the mythology of the later Greeks—however much distorted by the later poetic tradition that culminated in Homer—which seems to have been woven, in part at least, from surviving memories of the Aegean world. Even *Minos* may only be a generic Cretan name for "king."

Approximate dates for Minoan art have been ascertained largely by the systematic excavation of pottery. Minoan and Helladic artifacts have now been traced as far back as 3000 B.C., and some even earlier, but the great artistic periods of both civilizations belong to the second millennium B.C., roughly between the years 1900 and 1200—a period contemporary with the Empire in Egypt and with the Babylonian period in Mesopotamia. Around 1400 B.C. Minoan civilization perished in a catastrophe whose nature is still not certain, but which may have been related to the volcanic eruption which destroyed Thera. Mycenaean culture survived only another three centuries before succumbing to the combined effects of internal dissent and attacks by other Greek invaders.

Even before the rise of the Minoan and Helladic civilizations, there had been another artistically creative culture in the Aegean. Called Cycladic, from the islands where its remains are found, this late Neolithic culture flourished in the third millennium B.C. and has left no trace of writing.

The Cycladic tombs have yielded many stone sculptures, ranging from statuettes to images about half lifesize. The meaning of these figures is not known, but the female ones with their folded arms (fig. 154) seem to be descendants of Neolithic mother goddesses elsewhere (see fig. 30). Interestingly enough, however, their whole character has changed; they are no longer abundantly maternal but touchingly slight and virginal, with delicate proportions, gently swelling and subsiding shapes, and subtle contours. The simplicity and understatement of these Cycladic figures have made them particularly attractive to contemporary artists. It should be borne in mind, however, that the flattened faces originally displayed other features than the sharply projecting noses that are all that now remain. Traces of pigment make clear that eyes and mouths, as well as other details, were originally painted on. Of equal interest are the less frequently found male musicians, such as the Lyre Player (fig. 155), perhaps intended to commemorate a funerary celebration or even to evoke music in the afterlife. The musicians are almost tubular in their stylization, and the forms of body, lyre, and chair enclose beautifully shaped open spaces that prefigure those of some twentieth-century sculpture.

Cycladic Art

- 154. Cycladic idol, from Amorgos. 2500–1100 B.C. Marble, height 30". Ashmolean Museum, Oxford, England
- 155. Lyre Player, from Keros. c. 2000 B.C. Marble, height 9". National Archaeological Museum, Athens

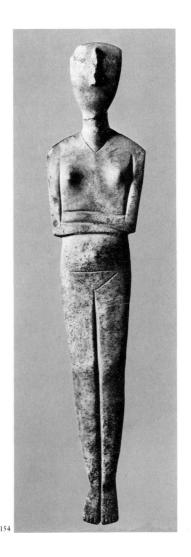

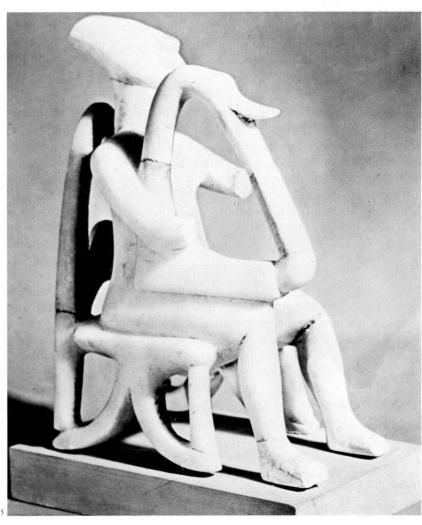

Minoan Art

POTTERY Baked clay pots, produced in abundance by almost all Mesopotamian and Mediterranean peoples for household use, were worthless after breakage and were tossed on the dump heap. Yet pottery fragments are virtually indestructible, and the lowest layers of potsherds in any heap are naturally the earliest, the next later, and so on. Because the shapes and methods of manufacture of these pots and the style of their decoration changed from one period to the next, sometimes quite rapidly, it has been possible for archaeologists to establish a relative chronology for the development of style by recording the potsherds according to the layers in which they were found. Often the Minoan and, later, the Greek pots are supremely beautiful as works of art, in both shape and decoration, and their style is strongly related to that of wall painting and other arts. Thus their chronology is applicable to other works of art as well. Sometimes, also, the circumstances of a find link a dated group of pots to the building in or near which it was discovered.

Since we know so little of their writing, we cannot yet say whether the Minoans themselves accurately recorded dates and specific events. But luckily they were great seafarers and traders. Their pots have turned up in Egyptian sites whose dates can be determined by numerous inscriptions, and the chronology based on the potsherds can thus often be anchored to firm historical knowledge. Approximate dates have, therefore, been assigned to the early, middle, and late periods into which Minoan art has been divided.

Not until the Middle Minoan period, about the nineteenth century B.C., does the art of the potter achieve truly great artistic stature, but objects of the quality of the beaked Kamares jug from Phaistos (fig. 156) would be welcomed as masterpieces in any period. The curvilinear shapes have an extraordinary vitality and are different in style from anything we have previously seen, except perhaps for the ornamental motives of La Tène art (see fig. 486) or the carved decorations of the temple at Tarxien (see fig. 35). Palmlike shapes in soft white quiver against a black ground among curling and uncurling spirals and counterspirals, all beautifully related to the shape of the vessel itself. In Late Minoan, about 1500 B.C., the swirling shapes take on naturalistic forms. The entire front of a vase from Palaikastro (fig. 157), for example, is embraced by the tentacles of an octopus, writhing in menacing profusion. The abstract shapes on the first vase have become naturalistic, but the principle of dynamic curvilinear decoration is the same and reappears in the wall paintings as well.

THE PALACES In Middle Minoan times, after about 2000 B.C., the inhabitants of Crete, previously at a rather modest stage of Neolithic development as compared to their contemporaries in Egypt and Mesopotamia, adopted metals and a system of writing, and rapidly developed an urban, mercantile civilization. Interestingly enough, the Minoans seem to have depended for protection entirely on their command of the sea; not a trace of fortification has ever been found. This reliance may well have proved their undoing. Immense palaces were built at Knossos and Mallia on the north coast of the island, at Phaistos on the south, and elsewhere. Devastated about 1700 B.C., these first palaces were soon repaired or rebuilt. The most extensive and artistically important is the vast palace at Knossos, about which we know more than about any other palace before Persepolis. Although Knossos was again laid waste between 1450 and 1400 B.C., it has been largely—perhaps even excessively—reconstructed from the ruins. A stroll through it affords an insight into the

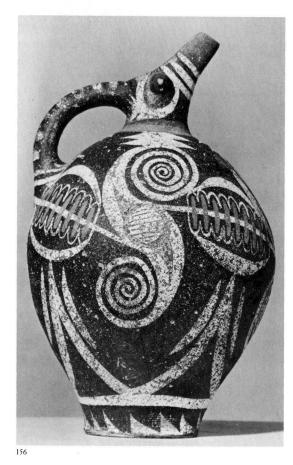

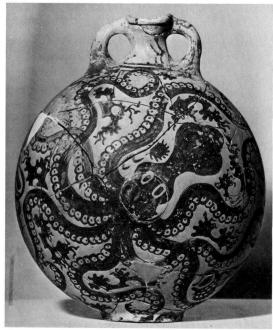

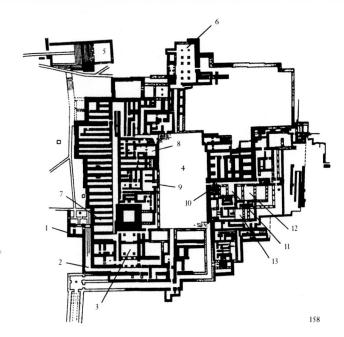

delightful existence of these mysterious people, who seem to have concerned themselves little with religion and not at all with the hereafter (they left no temples, only small hilltop shrines, and few monumental tombs), but entirely with the pleasures of the here and now. From the plan (fig. 158) and from the surviving and reconstructed portions, it is clear that the palace could never have presented the imposing, symmetrical, and ordered appearance of Mesopotamian royal residences. Built around a not perfectly oblong central courtyard (fig. 159), the hundreds of rooms and connecting corridors climb gently up the slopes of the hill in such a haphazard manner as to give color to the Greek legend of the Cretan labyrinth, at the center of which King Minos was supposed to have stabled the dreaded Minotaur, half man, half bull.

Clearly, the Minoan monarchs felt no need to impress visitors with royal might and cruelty. Entrances are unobtrusive; the apartments sprout terraces, open galleries, and vistas at random; even the decorated rooms intended for the royal family are small, with low ceilings and a general air of bright and happy intimacy. The walls are of massive stone masonry; some supports are square piers recalling those in the valley temple of Chephren (see fig. 85), but wooden columns were frequently used. These are now lost, but their form can be reconstructed through representations in wall paintings, from their bases, which are square stone slabs with a socket for the column, and from their cushion-shaped stone capitals, distant ancestors of the Doric capitals of the Greeks (see figs. 192, 194). Strangely enough, the columns tapered downward, a feature that further increased the feeling of lowness and intimacy in the rooms.

PAINTING The mural decorations, painted on wet plaster like the frescoes of fourteenth-century Italy, have survived only in tiny fragments, which have been pieced together; large gaps are filled by modern restorations. The painted interiors must have been joyous. A room at Knossos known as the Queen's Megaron (fig. 161; megaron means "great hall") is illuminated softly by a light well. The doorways are ornamented with formalized floral designs, the columns and capitals are painted red and blue. On one wall we seem to look straight into the sea, as if through the glass of an aquarium; between rocks indicated by typical Minoan free curves, fish swim around two huge and contented dolphins.

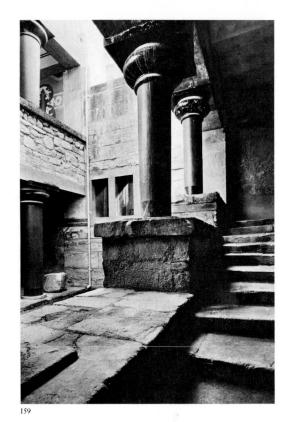

- 156. Beaked Kamares jug, from Phaistos, Crete. c. 1800 B.C. Height 105%". Archaeological Museum, Heraklion, Crete
- Octopus vase, from Palaikastro, Crete.
 c. 1500 B.C. Height 11". Archaeological Museum, Heraklion
- 158. Plan of the Palace at Knossos, Crete.
 c. 1600–1400 B.C. (After J. D. S. Pendlebury)
 1. West porch 2. Corridor of the Procession 3. South Inner Gate 4. Central court 5. Possible theater area 6. Pillar hall
 7. Storerooms 8. Throne room 9. Palace shrine and lower verandas 10. Grand staircase 11. Light well 12. Hall of the Double Axes 13. Queen's Megaron
- 159. Lower section of the main staircase and light well, east wing, Palace at Knossos (reconstruction), c. 1600–1400 B.C.

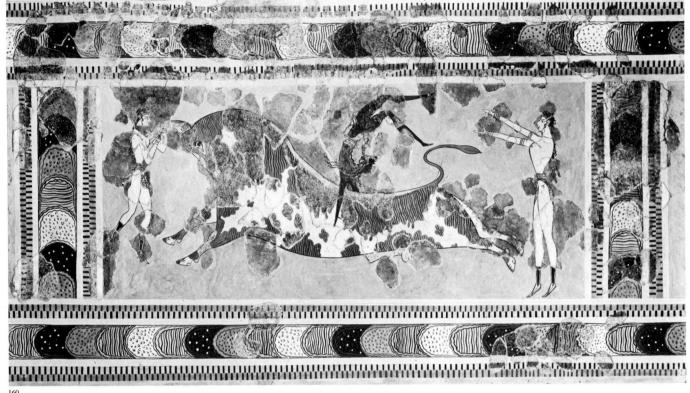

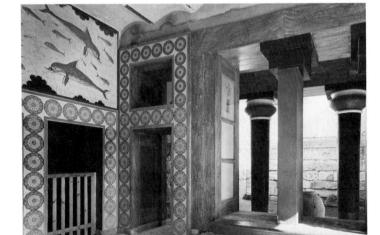

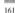

In murals as in ceramics, unfettered rhythmic contours—astonishing when compared to the stratified compositions typical of Egypt and Mesopotamia—are the chief delight of Minoan painting. In the still enigmatic *Bull Dance* from Knossos (fig. 160), these pulsating contours are extremely effective. Unlike the murderous bulls in Egyptian and Mesopotamian art, this resilient creature seems almost to have been trained for his role. He and his attendants are engaged not in mutual slaughter but in some kind of ritual dance. One almost nude girl dancer (painted yellow as in Egyptian art) grasps with impunity the bull's horns; a second waves from the sidelines; and the boy (red-brown) vaults over the bull with the agility of an acrobat. The forward lunge of the bull and the arching movement of the boy are enhanced by the sideward and upward thrust of the conventionalized rocks of the borders. It is believed that the bull ritual we see in

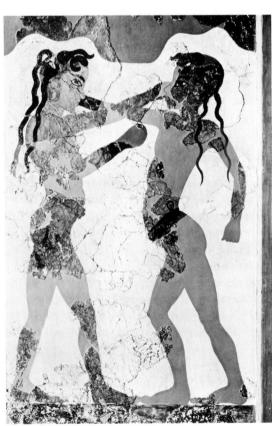

162

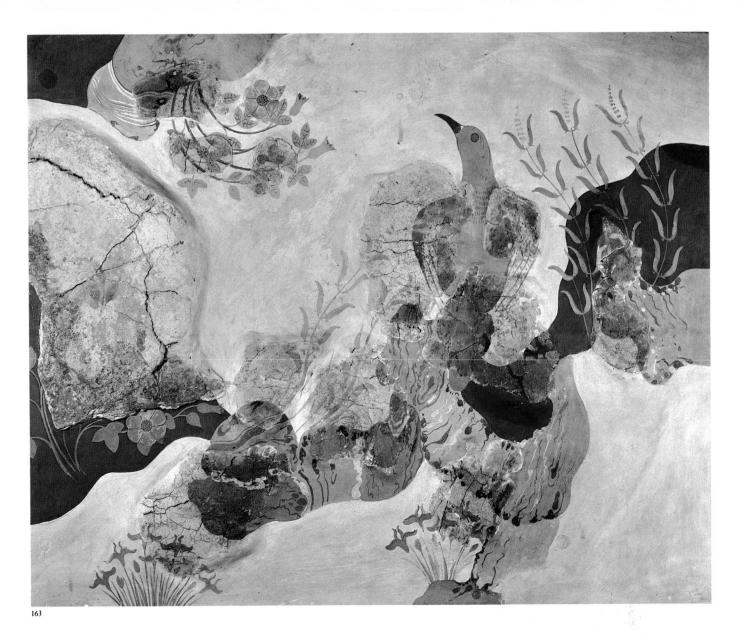

this fresco actually took place in the great court of the palace itself, suitably barricaded and sealed off.

The naturalism of Minoan frescoes, such as the fragment from Knossos showing a bird in a landscape (fig. 163), recalls that of Egyptian paintings, which Minoan merchants must have seen on their visits to the Nile Valley. But the spirit of Minoan art is quite different. Birds fly, animals scamper, plants grow, the very hills seem to dance with a rocking rhythm as if the waves or the sea wind were carrying them along. Some of the most brilliant Minoan paintings have only recently come to light on the island of Thera, part of which sank into the sea in a violent volcanic explosion about 1400 B.C., the rest being buried under volcanic ash. A marvelous room has now been pieced together, with red, violet, and ocher hills and precipices undulating about three walls like live things, asphodel growing from their crests and saddles in dizzying spirals, and swallows fluttering from plant to plant or conversing in midair (see fig. 1). This earliest known European landscape painting is the ancestor of the landscape frescoes of Roman art (see figs. 325, 348) and eventually of such panoramas as those in fourteenth-century Sienese painting. Among the most delightful of the Thera finds is the fresco representing two small boys boxing (fig. 162), with a single pair of gloves between them. Despite

- 160. Bull Dance, fresco from the Palace at Knossos. c. 1500 B.C. Archaeological Museum, Heraklion
- 161. The Queen's Megaron, Palace at Knossos (reconstruction). c. 1600–1400 B.C.
- 162. Boxers (The Young Princes), fragment of a fresco from the Cycladic island of Thera. Before 1500 B.C. National Archaeological Museum, Athens
- 163. Bird in a Landscape, fragment of a fresco from the Palace at Knossos. c. 1600–1400 B.C. Archaeological Museum, Heraklion

the determined expressions in their large, soft eyes, the strongest movement in the fresco is not that of their rather gentle blows but the characteristic pulsation of their fluid contours.

SCULPTURE Monumental sculpture can hardly be expected from a civilization that built no temples and revered no divine monarchs. What little Minoan sculpture survives is small in scale and often uncertain in purpose. Faience statuettes (fig. 164) have been found representing a youthful female figure with bared breasts, a tight bodice, and richly flounced skirt. This impressive personage, who brandishes a snake in either hand, is often called a priestess but is more probably a goddess of the still unknown Minoan religion. In the elegance of her contours and in the softness of her movement, she betrays the same sensibility that distinguishes the wall paintings. Minoan sculpture did just as brilliantly with the wholly nude male figure in action, as we see in the little ivory statuette of an *Acrobat* (fig. 165). This youth, sailing happily through the air with boyish ease, shows in his free contours the same fluid pulsation as the painted *Boxers* from Thera or the bull dancers at Knossos.

Surprising and thus far unique is the upper portion of a small black steatite vase known as the *Harvester Vase* (fig. 166), on which is carved in low relief a crowd of young men, nude to the waist, marching as if in ritual procession but overlapping freely—in contrast to the regimented movement of Egyptian or Mesopotamian figural groups. The harvesters carry long-handled implements, including a pitchfork, and one shakes a sistrum (rattle) with such force that his ribs and rib muscles swell within the skin of his torso; some have their mouths open as if singing in exultation. Never up until this moment have we encountered such freedom

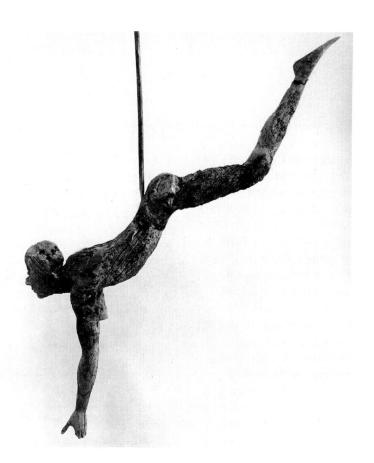

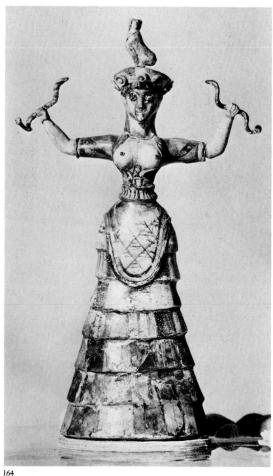

- 104
- 164. Snake Goddess, from the Palace at Knossos. c. 1600 B.C. Faience, height 13½". Archaeological Museum, Heraklion
- 165. Acrobat, from the Palace at Knossos. c. 1550–1500 B.C. Ivory, length 115/8". Archaeological Museum, Heraklion
- 166. The Harvester Vase (detail), from Hagia Triada, Crete. c. 1550–1500 B.C. Steatite, diameter of vase 4½". Archaeological Museum, Heraklion
- Rhyton, from the Palace at Knossos.
 c. 1550–1500 B.C. Steatite with inlaid shell and rock crystal, height of head 12". Archaeological Museum, Heraklion

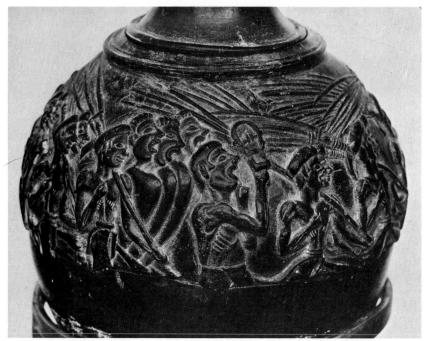

166

of emotional expression in ancient art. The bull, dear to ancient civilizations and possibly sacred to the Minoans, reappears in a splendid black steatite rhyton (fig. 167), with horns and eyes inlaid with shell and rock crystal. The powerful curves of the flaring horns contrast with the delicate, meandering motion of the incised lines indicating locks of hair.

ARCHITECTURE The Greek mainland was inhabited by the Achaeans, an early Greek ethnic group whose commercial and political relations with the Minoans have yet to be thoroughly explored. They were soldiers, and their palaces were citadels utilizing the massive outcroppings of rock that tower above the narrow Greek valleys as natural defenses. The outer walls of such citadels were "cyclopean," built of irregular stone blocks so huge that the later Greeks thought them the work of the Cyclopes, a race of one-eyed giants. Within the wall, however, the palaces were built of sun-dried brick as in Egypt and Mesopotamia. We gain entrance to the palace proper in the thirteenth-century-B.C. citadel of Tiryns (fig. 168) through a columned gateway. Before us rises the columned facade of the royal audience hall, or megaron, whose roof was supported within by four columns around a circular hearth. Traces of rich painted decoration have been found on the plastered floor, and there were numerous wall paintings. The relative positions of gateway and megaron foretell those of the Athenian Propylaia, or entrance gate to the Acropolis (see fig. 240), and the Parthenon in Classical times.

The formidable walls of the citadel at Mycenae, also built of cyclopean masonry, were entered through a trilithon (three-stone) gate recalling the megalithic architecture of the Late Stone Age. The triangle framed by the lintel and the progressively projecting blocks above is occupied by one of the few pieces of monumental sculpture surviving from Aegean times, a massive high relief showing two muscular lions (alas, now headless) placing their front paws upon the base of a typical Minoan tapering column (fig. 169). Clearly the column had a religious significance that required it to be flanked and protected by the royal beasts.

By far the most accomplished and ambitious of these cyclopean con-

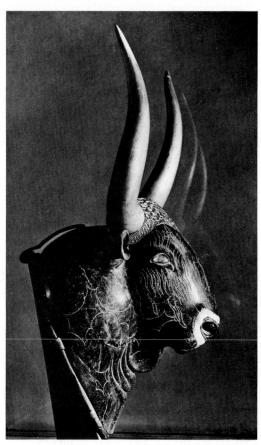

Mycenaean Art

- 168. Citadel of Tiryns, Greece. 13th century B.C. (Architectural reconstruction after G. Karo)
- 169. The Lion Gate, Mycenae, Greece (detail). c. 1250 B.C. Limestone high relief, height c. 9'6".
- 170. Plan of the Treasury of Atreus, Mycenae. 13th century B.C. (After A. W. Lawrence)
- 171. Interior, Treasury of Atreus, Mycenae

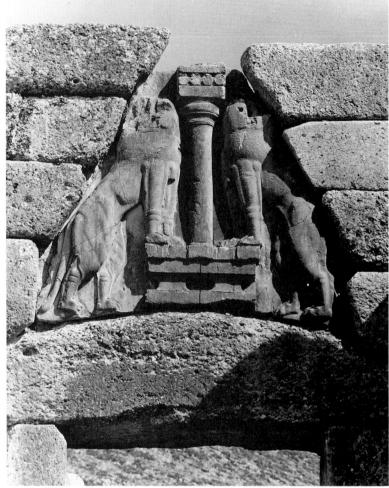

structions is the so-called Treasury of Atreus at Mycenae (fig. 170), actually a thirteenth-century royal tomb, some 43 feet in height and 47½ in diameter. Although all the rich decoration, possibly in precious metals, that once enlivened the interior and the entrance has been plundered, the effect of the simple masonry vault is majestic in the extreme (fig. 171). It is a corbel vault, with superimposed courses of masonry projecting one beyond the other as at Maeshowe in the Orkneys (see fig. 36). The blocks are trimmed off inside to form a colossal beehive shape of remarkable precision and accuracy. This is the largest unobstructed interior space known to us before that of the Pantheon in imperial Rome (see fig. 7).

GOLDWORK, IVORY, AND PAINTING Schliemann's excavations of the royal graves at Mycenae in 1876 yielded a dazzling array of objects in gold, silver, and other metals, some ceremonial, some intended for daily use. A number of masks in beaten gold (fig. 172) were probably intended to cover the faces of deceased kings. Although hardly to be compared with the refinement of the gold mask of Tutankhamen (see fig. 118), their solemn honesty is nonetheless impressive.

The Mycenaean warrior kings attached great importance to their weapons, and superb examples have been found. A bronze dagger blade inlaid with gold and electrum, a natural alloy of silver and gold (fig. 173), shows a spirited battle of men against lions, surpassing anything we have thus far seen in swiftness of movement. One lion assaults lunging warriors protected by huge shields, while two other lions turn tail and flee with inglorious speed, toward the point of the dagger.

Even more beautiful are two golden cups (figs. 174, 175) found at Vaphio in Laconia and datable to about 1500 B.C. These works, to be

- 172. Funeral mask, from the royal tombs, Mycenae. c. 1500 B.c. Beaten gold, height c. 12". National Archaeological Museum, Athens
- 173. Dagger, from the Citadel of Mycenae. c. 1570–1550 B.C. Bronze inlaid with gold and electrum, length c. 9½". National Archaeological Museum, Athens
- 174, 175. *The Vaphio Cups*, from Laconia, Greece. c. 1500 B.c. Gold, height c. 3½". National Archaeological Museum, Athens

172

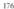

ranked among the masterpieces of ancient art, are covered with continuous reliefs of extraordinary vivacity and power showing the capture of bulls. While the style is clearly Minoan, recalling the movement and expressive intensity of the *Harvester Vase*, these violent bulls are far removed from the graceful creature that appeared in the Knossos fresco. Various methods of entrapment are shown, ranging from lassoing the ankle with a rope, held by a characteristically wasp-waisted, muscular young man, to capture by nets and enticement by a friendly cow. The cups pulsate with the movement of the powerful bodies and flying hooves; the motion subsides only in the romantic tête-à-tête of the bull and the cow.

A little ivory group of unknown purpose (fig. 176) has recently been found near a sanctuary at Mycenae. It shows three deities, possibly Demeter, the earth-goddess, her daughter Persephone, and the young god Iakchos, although this is pure conjecture. The affectionate grouping of the figures, with arms over shoulders and free, playful poses, combined with the fluid movement of the skirts, renders this one of the most poetic works of Aegean art. Little by little, paintings of high quality come to light, including a superb female head under strong Minoan influence (fig. 177).

Under the attacks of another group of Greek invaders from the north, the Dorians, the rich and powerful Mycenaean civilization was overwhelmed and destroyed about 1100 B.C., to be succeeded by a period often known as the Dark Ages. The darkness was deepened by obscurity and neglect. As far as we know, the great achievements of Aegean art were without influence on their Greek successors and remained unknown until our own times.

176. Three Deities, from Mycenae. c. 1500–1400 B.C. Ivory, height 3". National Archaeological Museum, Athens

177. Female Head, fragment of a fresco from My-

GREEK ART

FOUR

Of the three great historic arts we have considered up to this point, that of Egypt alone left a measurable influence on later periods, and even Egyptian influence was only occasionally fruitful or decisive. Splendid though they were, the arts of Mesopotamia and of the Aegean world vanished almost entirely from human sight and memory until very nearly our own times. When we turn to ancient Greece, however, we are dealing for the first time with an art that has never been entirely forgotten. Greek art, like Greek culture in general, influenced in one way or another the art of every subsequent period of Western civilization, including the present, sometimes to an overwhelming degree. Even when later cultures felt they must revolt against Greek influence, each revolt in itself was a tribute to the greatness of Greek achievement. The only other culture that has left a comparable impression on later periods is that of Rome, and this is in large part because Rome was the transmitter, by commerce and by conquest, of the artistic heritage of Greece.

If we attempt to account for the great depth and the astounding durability of Greek influence, we will probably come to the conclusion that they are both due to the primacy of Greek civilization and Greek art in developing rational norms for every aspect of the arts, as distinguished from the rigid conventions imposed by Egyptian society upon Egyptian art. The Greeks derived these norms from human nature and behavior, accessible to Greek thinkers, writers, and artists through their unprecedented powers of observation, inquiry, and analysis. "Man is the measure of all things," said the Greek philosopher Protagoras in the fifth century B.C., and while Protagoras' own subjectivity aroused considerable controversy in his lifetime, his celebrated remark may still be taken as typical of the Greek attitude toward life and toward art. The dignity and beauty of the individual human being and the rich texture of physical and psychological interplay among human beings constitute at once the subject, the goal, and the final determinant of Greek artistic and literary creation.

Both land and climate stimulated the unprecedented concentration of Greek culture on the quality of human life and on physical and intellectual activity. Greece is a land of mountainous peninsulas and islands, separated by narrow, fjordlike straits and bays, with scanty arable land. It is subject to strong contrasts of winter cold and summer heat and to fierce and unpredictable sea winds. Horizons are limited by mountains and rocky islands. Under a sunlight whose intensity is credible only to those who have experienced it, the land takes on a golden color against a sea and sky of piercing blue. Day gives way to night almost without intervening twilight. Against such a background and in such light, forms and relationships are clear and sharp.

In such an environment it was neither easy nor necessary to establish cooperative relationships between communities, separated by mountain walls or by arms of the sea. A living had to be wrested by

force and by intelligence from rocky land and treacherous water. The beautiful but often hostile Greek surroundings fostered an athletic and inquiring attitude toward existence that contrasted strongly with Egyptian passivity and that precluded submission to universal systems of government. Farming was not easy in the rocky soil; grain crops required great expenditure of effort, and the olive tree and the vine needed careful tending. In addition to the limited agricultural class, a trading class eventually arose, and finally a manufacturing class engaged in the production of such characteristic Greek artifacts as pottery and metalwork, which were exported to the entire Mediterranean world. Like the Minoans before them, the Greeks were excellent sailors; like the Mycenaeans, they were valiant soldiers. Greek systems of government were experimental and constantly changing. It is no accident that so many English words for governmental forms derive from Greek—democracy, autocracy, tyranny, aristocracy, oligarchy, and monarchy, to name only a few. Even politics comes from the Greek polis, the word for the independent city-state with its surrounding territory, which was the basic unit of Greek society. All six of the forms of government just mentioned were practiced at one time or another by the Greek city-states on the mainland, the islands, Asia Minor, Sicily, and southern Italy, often in rapid succession or alternation. But even when popular liberties were sacrificed for a period to a tyrant or to an oligarchic group, the Greek ideal was always that of self-government. The tragedy of Greek history lies in the inability of the Greek city-states to subordinate individual sovereignty to any ideal of a permanent federation that could embrace the whole Greek world and put a stop to the endemic warfare that sapped the energies of the separate states and eventually brought about their subjugation. Until the time of Alexander the Great, who borrowed the idea from the Near Eastern cultures he conquered, the notion of a god-king on the Egyptian or Mesopotamian model was wholly absent from Greek history. We can find a special significance in the fact that, while the Egyptians and Mesopotamians recounted their history in terms of royal reigns or of dynasties, the Greeks measured time in Olympiads, the four-year span between the Olympic Games, an athletic festival celebrated throughout ancient Greek history.

The Greeks peopled their world with gods who, like themselves, lived in a state of constant rivalry and even conflict, often possessed ungovernable appetites on a glorified human scale, took sides in human wars, and even coupled with human beings to produce a race of demigods known as heroes. Only in their greater power and knowledge and in their immortality did the gods differ from humans. Just as no single mortal ruled the Greek world, so no god was truly omnipotent, not even Zeus, the king of the gods.

The Greeks were strongly aware of their achievements, and not least of their history, as a record of individual human actions rather than merely of events. Their art is the first to *have* a real history in our familiar sense of an internal development. Egyptian art seems to spring into existence fully formed and can hardly be said to have developed after its initial splendid creations. And certain basic forms and ideas run throughout Mesopotamian art from the Sumerians to the Persians. But Greek art shows a steady evolution from simple to always more complex phases, some of which are for convenience labeled Archaic, Classical, and Hellenistic. Although this development was not steady, nor uniform at all geographic points, it is strikingly visible and has often been compared with that of European art from the late Middle Ages through the Renaissance and the Baroque periods. From start to finish, the entire evolution of Greek art took only about seven centuries, or less than one quarter of the long period during which Egyptian art continued relatively unchanged. The Age of Pericles, often considered the peak of Greek artistic achievement, lasted only a few decades.

Despite the anthropocentric nature of Greek culture, the Greeks were under no illusions about the limitations or indeed the inevitable downfall of human ambitions. One of their favorite literary forms, which they indeed invented and in whose composition they rose to unrivaled heights of dramatic intensity and poetic grandeur, was tragedy (the very word is Greek). In Greek tragedy, human wills pitted against each other bring forth the highest pitch of activity of which men and women are capable; yet these

activities lead to disaster through inevitable human shortcomings. In all of Greek art there are no colossal statues of monarchs like those of the Egyptian pharaohs. With few exceptions, only gods were represented on a colossal scale, and although none of these statues survive, the literary accounts indicate that in spite of their size they were entirely human and beautiful. In contradistinction to the hybrid deities of the Egyptians and the Mesopotamians, in ancient Greece only monsters were part human and part animal. These hybrids were invariably dangerous (satyrs, centaurs, and sirens), often totally evil (the Minotaur).

But while Greek rationality gave rise to arithmetic, geometry, philosophy, and the beginnings of astronomy, zoology, and botany (again the words are Greek), the system had its Achilles heel (another Greek expression). Hellenic society was emphatically a man's world. Women were restricted to homemaking and childbearing and were immured in their special section of the house, the *gynecaeum*. They could not attend the famous *symposia*, or banquets, at which intellectual questions were discussed and were permitted no role in Greek political, intellectual, or artistic life. Only when a woman had lost her "virtue" and became a courtesan could she attend otherwise all-male functions; many of these courtesans achieved a certain power in Greek society. Also, despite the Greek vision of the good life and the perfect state, Greek communal life was actually seldom able to achieve a lasting order. Even in the Classical period the Greek polis permitted both chattel slavery and the disenfranchisement of subject states. Notwithstanding the rationality of Greek philosophers, at no point in Greek history was there any serious or widespread threat to belief in a host of anthropomorphic deities. Yet one of the great charms of the Greeks is the fact that, side by side with the development of the intellect, the life of the passions continued with undiminished intensity, endowing the coldest creatures of reason with an irrational but poetic beauty.

What remains to us of Greek art is of such high quality that it is painful to contemplate the extent of our losses. The survivals constitute, in fact, only a small and irregularly distributed proportion of Greek artistic production. We possess some ancient written accounts of what were considered the greatest works of Greek art, notably the writings of the first-century Roman encyclopedic naturalist Pliny the Elder and the Greek traveler Pausanias of the second century A.D. From these sources we know of many celebrated Greek buildings that have totally vanished; the few that remain standing are all in more or less ruinous condition. Only two statues survive that can be attributed to the most famous Greek sculptors: one, the Victory of Paionios (see fig. 247), is in fragments, and the other, Hermes (see fig. 263), is not universally accepted as the work of Praxiteles. The other preserved Greek original sculptures are either carved by unidentified masters or quite late signed works of secondary importance, such as Laocoön (see fig. 287) and Polyphemos Blinded by Odysseus (see fig. 288), both by the same trio of sculptors from Rhodes. Many Roman copies of Greek statues were made with a mechanical aid, the pointing machine, which transferred adjustable points on a metal frame from the original to the copy, enabling the copyist to reproduce sizes, poses, proportions, and details with some fidelity. Roman copies, therefore, give us a fairly clear idea, however diluted in quality, of the appearance of many lost masterpieces. The general reliability of Roman copies is, of course, susceptible to demonstration when several copies of the same original are checked against each other. But thousands of statues must still lie underground, and a lucky find can always turn up an original of high quality, as has happened even in excavations for buildings or highways.

Monumental painting, to which the Greeks attached the highest importance, is totally and irrevocably lost. Not the smallest piece of any famous Greek painting has ever been recovered, nor, in the nature of things, is any likely to be, for the very buildings on whose walls most of them were painted have long since vanished. Only literary descriptions survive, and occasional "copies," which may not be copies in our sense at all. The local Italian artists who reproduced renowned Greek paintings may never have seen the original works in distant Greece or Asia Minor, but only portable sketches or replicas brought home by travelers. We have, therefore, only the most general idea of what the style of the great Greek painters must have been like, and only now and then are we able to reconstruct the order of figures in one of their

compositions. It is in painting, however, that women make their first appearance in the literature on art, in a passage from the Roman author Pliny, of the first century A.D., which despite its condescending tone is of the utmost importance, for it was known and quoted throughout the late Middle Ages and the Renaissance:

Women too have been painters: Timarete, the daughter of Mikon, painted an Artemis at Ephesos, in a very ancient picture. Eirene, the daughter and pupil of the painter Kratinos, painted a girl at Eleusis, Kalypso painted portraits of an old man, of the juggler Theodoros, and of the dancer Alkisthenes; Aristarete, the daughter and pupil of Nearchos, painted an Asklepios. Iaia of Kyzikos, who remained single all her life, worked at Rome in the youth of Marcus Varro, both with the brush and with the cestrum on ivory. She painted chiefly portraits of women, and also a large picture of an old woman at Naples, and a portrait of herself, executed with the help of a mirror. No artist worked more rapidly than she did, and her pictures had such merit that they sold for higher prices than those of Sopolis and Dionysios, well-known contemporary painters, whose works fill our picture galleries. Olympias was also a painter; of her we know only that Autoboulos was her pupil.

We have, of course, no more evidence of the work of these women painters than of their male contemporaries, but we can glean from this passage that women painted even in Archaic times, that their work was highly valued, that they had male pupils, but that their work was limited almost entirely to portraits—only a single painting of a mythological or historical subject is recorded (see page 189).

Another serious loss is that of color in architecture and sculpture. Under the influence of marble statues and capitals from which the original coloring leached out centuries ago, we tend to think of Greek art—and Greek costumes, too—as white. Nothing could be further from the truth. In early periods the coloring applied to the statues was quite bright, even garish, judging from traces of the original paint still remaining here and there. In the Classical period and in the fourth century, coloring was undoubtedly more restrained but was certainly used to suggest actual life, especially in eyes, lips, and hair. Garments were colored, and certain details were added in gold or other metals in all periods. Limestone or sandstone temples were coated with fine plaster tinted to resemble marble. In all temples, including the marble ones, capitals and other architectural details were brightly painted. Wall decorations from the Hellenistic era survive to indicate that the interiors of prosperous homes were also ornamented in color (see fig. 290). If the well-known Greek sense of harmony and of the fitness of things gives us any basis for speculation, then Greek color must have been harmoniously adjusted and must have formed an essential part of the total effect of works of architecture and sculpture. We must attempt to restore this effect in our imaginations if we are to understand the work of art as the artist intended it. Only the pots, which as we have seen (page 124) are unlikely ever to be totally destroyed, survive in vast numbers and with their coloring intact. In Greek ceramics the color is generally limited to red terra-cotta; black and white slip, baked on; and an occasional touch of violet. But even the pots, made for practical, everyday purposes, were intended to be seen not, as now too often, in superimposed rows in museum cases, but as small, movable accents in richly colored interiors.

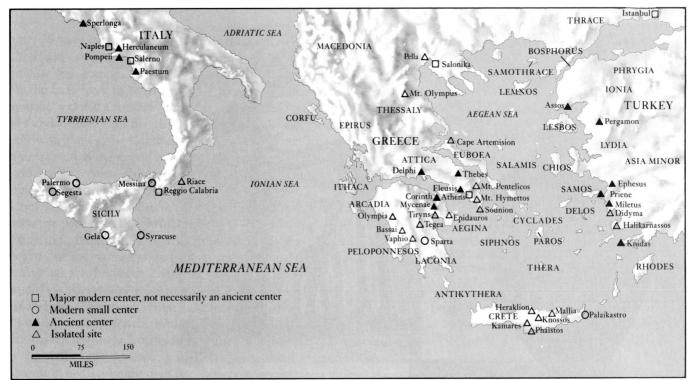

MAP 6. THE HELLENIC WORLD

The three centuries from about 1100 B.C. to about 800 B.C. are still an era of mystery and confusion, often called—by analogy with the later one following the breakup of the Roman Empire—the Dark Ages. The title is intended to suggest not only the dimness of our present knowledge of this era but also the fact that what little has been unearthed about it indicates a fairly low stage of cultural development—indeed, a sharp decline from the splendor of Mycenaean art and civilization. At the beginning of this period tribes from the north, probably the Danube basin, moved south into the areas formerly ruled by Mycenaeans, settling largely in the Peloponnesos, the cluster of peninsulas that makes up southern Greece. Later Greeks called these people Dorians; Sparta, always the most conservative and warlike of the Greek city-states, prided itself on its Dorian origin. Some of the older peoples of Mycenaean derivation fled to the islands of the Aegean and to Asia Minor, where they founded such important centers as Ephesus and Miletus. These tribes, known as Ionians, were, however, not wholly driven out of Greece by the invaders. Some were able to preserve their identity, notably the inhabitants of the peninsula of Attica, with its most important center at Athens.

Understandably enough, architectural remains from this earliest period of Greek art are extremely scanty, although some foundations of temples have been uncovered. But we possess precious evidence as to the modest external appearance of such buildings from two small terra-cotta models (fig. 178) and fragments of another, which can be dated about the middle of the eighth century B.C. by comparison with contemporary pottery. Basically, these temples appear to be direct descendants of the Mycenaean megaron type, such as that at Tiryns (see fig. 168). A single oblong room, sometimes square-ended, sometimes terminating in an apse (semicircular end), was roofed with a gable and preceded by a columned portico. Probably the walls were of rubble or mud brick and the columns of wood; the roof may even have been woven from thatch. These are humble buildings indeed, yet they are the obvious prototypes of the Greek temples of a more splendid era (see figs. 199, 229).

C

c

l

fe

S

b

g

h

p

ri

The finest remains of eighth-century Greek art are certainly the pots,

Geometric period

Geometric and Orientalizing Styles (800–600 B.C.)

178. Model of a temple, from the Heraion near Argos, Greece. c. Middle 8th century B.C. Terra-cotta, length c. 14½". National Archaeological Museum, Athens

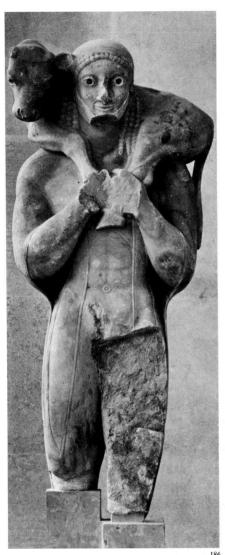

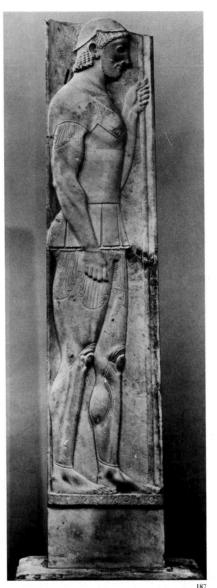

- 186. Calf-Bearer, from the Acropolis, Athens. c. 570 B.C. Marble, height 66". Acropolis
- 187. Aristokles. Stele of Aristion. c. 525 B.C. Marble, height (without base) 96". National Archaeological Museum, Athens
- 188. Hera, from Samos, Greece. c. 565 B.C. Marble, height 76". The Louvre, Paris
- 189. Peplos Kore, from Athens. c. 530 B.C. Marble, height 48". Acropolis Museum

such influence is easier to account for than the as yet unexplained suddenness of its appearance. We still do not know why the Greeks began carving large-scale figures at the end of the seventh century B.C. At first sight the figure, for all its grandeur, seems much less advanced from the point of view of naturalism than Old Kingdom statues dating from two thousand years earlier. But there are telltale differences that suggest the enormous development soon to take place. First, although the Egyptian sculptor thought of his stone figures as freestanding (see the drawings of sculptors at work, fig. 80), in practice he invariably left a smooth wall of uncut stone between the legs and arms and the body (see fig. 87). Apparently, he was trying to avoid fracture in carving with soft bronze tools, on which enormous pressure had to be exerted. Such inert passages of stone must have been intolerable to the Greek artist as restrictions on the mobility and freedom of his figure, and he reduced them to the smallest possible bridges of stone between hand and flank. (He also did away with the kilt of the Egyptian statue to display the male figure in total nudity.) Second, while the weight of an Egyptian figure rests largely on the right (rear) leg, that of the kouros statue is always evenly distributed, so that the figure seems to be striding rather than standing. Finally, the total calm of the Egyptian figure, which never seems to have known the meaning of strain, gives way to an alert look and, where possible, to a strong

suggestion of tension, as in the muscles around the kneecap and especially in the torso, whose abdominal muscle is cut into channels as yet neither clearly understood nor accurately counted. The preternaturally large and magnificent head of the *Kouros of Sounion*, while divided into stylized parts in conformity with a lingering Geometric taste, shows the characteristic Greek tension in every line.

In the *Anavyssos Kouros* (fig. 185), done only some sixty to eighty years later and placed over the grave of a fallen warrior called Kroisos, the stylistic revolution hinted at in the *Sounion Kouros* has been largely achieved. At every point the muscles seem to swell with actual life. Although the full curves of breast, arm, and thigh muscles may as yet be imperfectly controlled, the pride of the figure in its youthful masculine strength is unprecedented. The sharp divisions between the muscles have relaxed; forms and surfaces now flow easily into each other. Even the lines of the still-stylized locks are no longer absolutely straight but flow in recognition of the fact that hair is soft.

A somewhat more mature, bearded figure, the *Calf-Bearer* (fig. 186), of about 570 B.C., shows the transition between the two phases. The sharp divisions of the muscles have softened, and the channels in the abdominal muscle are correctly placed and counted. The now largely destroyed legs originally had the characteristic kouros pose. The meaning of the famous "Archaic smile" that lifts the corners of the mouth still eludes us, but this smile is characteristic of Archaic art throughout the sixth century, after which it soon disappears. While still proclaiming the original surface of the block, the head of the calf the man bears as an offering is modeled with great sensitivity.

A superb funerary stele carved as an idealized portrait of the Athenian warrior Aristion (fig. 187) shows the rich possibilities opened up by Archaic artists. The sculptor Aristokles, who signed this work, was able to control gradations of low relief with great delicacy so as to suggest the varying distance of the left and right legs and arms from the viewer's eye and the fullness of the torso inside its armor. Aristokles' attention to visual effects freed the warrior completely from the Egyptian convention of two left hands and two left feet, and he seems to have delighted in contrasting the smoothly flowing surfaces of the body, neck, and limbs with the delicate folds and rippling edges of the *chiton* (garment worn next to the skin), which escape from beneath the armor and cling gently to the upper arm and the strong thigh.

One of the earliest of the kore figures was found in the Temple of Hera on the island of Samos (fig. 188) and is majestic enough to have been a statue of a goddess. About contemporary with the *Calf-Bearer*, the figure shows a striking change from the "*Lady of Auxerre*" (see fig. 183); the block, as is customary in Samian work, has here become a cylinder. When the missing head was intact, the hair fell over the back. The missing left hand probably held a gift. The *himation* (cloak), looped at the waist, is thrown around the torso and gathered lightly with the fingers of the right hand. The forms of the bosom are at once concealed and revealed by the streaming spiral folds, which contrast strongly with the tiny vertical pleats of the chiton. The profile of the figure, often compared to a column, has much in common with the elastic silhouette of an early amphora (see figs. 179, 181), expanding and contracting, elegant and restrained.

Another sixth-century masterpiece is the *Peplos Kore* from Athens (fig. 189), so named because the figure wears the *peplos*, a simple woolen garment. The statue is somewhat blocky in its general mass and beautifully reticent in its details. The severe peplos falls simply over the noble bosom

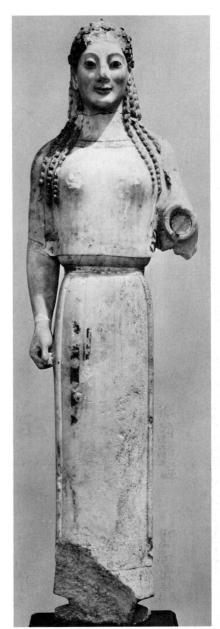

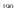

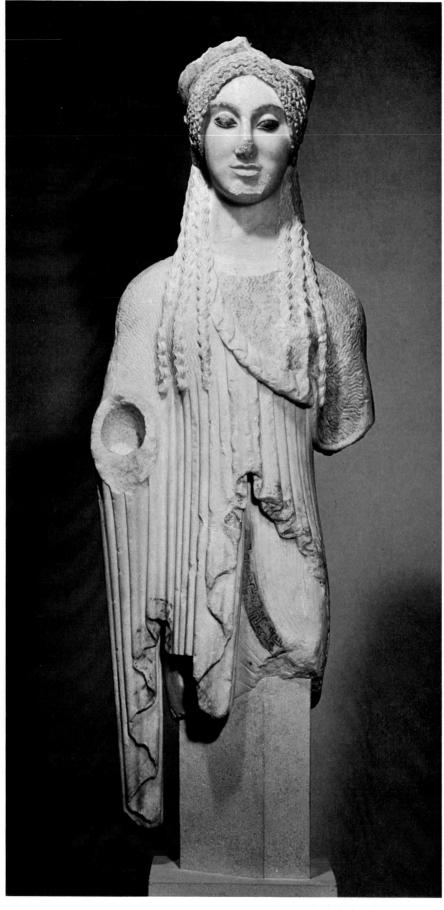

190. *La Delicata*, from the Acropolis, Athens. c. 525 B.c. Marble, height 36". Acropolis Museum

and hangs lightly just above the narrow girdle about the waist. The left arm was originally extended, and thus freed entirely from the mass of the body with a daring we have never before witnessed in stone sculpture. In fact, it had to be made of a separate piece of marble and inserted into a socket, where a piece of it may still be seen. The right arm hangs along the body, the contours beautifully played off against the subtle curve of the hip and thigh, which the heel of the hand barely touches, eliminating the necessity for a connecting bridge. The broad face is unexpectedly happy, almost whimsical in its expression, and the soft painted red locks, three on each side, flow gently over the shoulders, setting off the full forms of the body. The Peplos Kore is datable about 530 B.C. The climax of the Archaic style can be seen in the enchanting kore nicknamed La Delicata (fig. 190), of just a few years later. The corners of the large and heavy-lidded eyes are lifted slightly, and the smile has begun to fade; indeed, the face looks almost sad. The folds and rippling edges of the rich Ionian himation, together with the three locks on either side, almost drown the basic forms of the figure in the exuberance of their ornamental rhythms. Some of the original coloring is preserved, which adds to the delight of one of the richest of all the kore figures. The next steps in the evolution of both male and female figures belong to another era.

ARCHITECTURE AND ARCHITECTURAL SCULPTURE

Great as were the new developments in Greek sculpture in the sixth century, they were at least equaled, perhaps even surpassed, by the achievements of Greek architects. These were not in the realm of private building, for houses remained modest until Hellenistic times. Neither kings nor tyrants, nor least of all, of course, democratic magistrates, built palaces like those of Mesopotamia, which incorporated temples into their far-flung complexes. The principal public building of the Greeks was the temple (fig. 191). Generally in a sanctuary dedicated to one or several deities, some temples were in lowland sites, others set upon a commanding height, like the Acropolis at Athens. Oddly enough, the Greek temple was not intended for public worship, which took place before altars in the open air. Its primary purposes were to house the image of the god and to preserve the offerings brought by the faithful. At first of modest dimensions and never of a size remotely comparable to that of Egyptian temples, it was impressive only in its exterior. Its appearance was dominated by the colonnaded portico, or peristyle, which surrounded all larger temples and existed in the form of porches even in very small ones. In a Greek polis a portico provided shelter from sun or rain and a freely accessible public place in which to discuss political or philosophical principles, conduct business, or just stroll. In fact, in Hellenistic times independent porticoes known as stoas were built for just these purposes. They were walled on three sides and open on the fourth, and were sometimes hundreds of feet long. The walls of early colonnaded temples were built of mud brick and the columns of wood. In the course of time stone was substituted for these perishable materials, but the shapes of wooden columns and wooden beams continued to be followed in their stone successors, just as the architecture of Imhotep at Saqqara (see fig. 74) perpetuated palm-trunk and reed-bundle construction.

Clearly differentiated systems known as orders governed all the forms of any Greek temple. The orders may be thought of as languages, each with its own vocabulary and rules of grammar and syntax, or as scales in music. At first there were only two orders, named for the two major

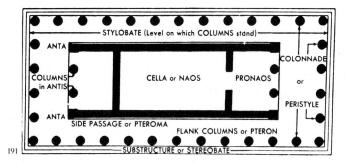

ethnic divisions of the Greeks, the Doric and the Ionic. In the fifth century the Corinthian appeared; this order was seldom used by the Greeks but became a favorite among the Romans, who added two orders of their own, the Tuscan and the Composite. In Hellenistic times individual variants of the Greek orders appeared here and there, but these are occasional exceptions that prove the universal rule.

The column and the entablature, the basic components of the Greek orders (fig. 192), are simply more elaborate versions of post-and-lintel construction. The column was divided into shaft, capital, and base (Greek Doric columns had no base; one was added in the Roman version), the entablature into architrave, frieze, and cornice. The capital (from the Latin word for "head") was intended to transfer the weight of the entablature onto the shaft. The Doric capital consisted of a square slab known as the abacus above a smooth, round, cushion-shaped member called the echinus. The Ionic capital, more elaborate (fig. 193), had a richly ornamented abacus and echinus separated by a double-scroll-shaped member, the volute. The Doric architrave was a single unmolded stone beam, and the frieze was divided between triglyphs and metopes. The triglyph (from a Greek word meaning "three grooves") was a block with two complete vertical grooves in the center and a half groove at each side. The triglyphs derived from the beam-ends of wooden buildings; the metopes were the slabs between the beams. The Ionic architrave was divided into three flat strips called fasciae, each projecting slightly beyond the one below. The Ionic frieze had no special architectural character but could be ornamented or sculptured. The temple was usually roofed by a low gable whose open triangular ends, backed by slabs of stone, were called *pediments*.

Ancient writers considered the Doric order masculine and robust, the Ionic feminine and elegant. In every Doric or Ionic temple the basic elements were the same. The columns were made of cylindrical blocks, called *drums*, turned on a lathe. These were held together by metal dowels and were fluted, that is, channeled by shallow vertical grooves, after being erected. The earliest Doric columns had twenty-four flutes, which increased their apparent verticality and slenderness. Doric flutes met in a sharp edge; Ionic flutes were separated by a narrow strip of stone. Whatever may have been their purpose, the flutes have the effect of increasing the clarity of progression from light to shade in easily distinguishable stages around a shaft. The flutes may possibly be related to the polygonal columns occasionally used in Egypt (see fig. 104).

Unlike Egyptian polygonal and convexly fluted columns, which were always straight, and Aegean columns, which tapered downward, Greek columns tapered noticeably toward the capital. Egyptian cylindrical columns, generally based on plant forms, showed a considerable bulge near the bottom (see fig. 107); Greek columns, instead, had a slight swell, known as the *entasis*, suggesting the tonus of a muscle. They were, moreover, governed by the proportions of contemporary human sculptured figures. As the Greek figure grew slenderer and the head proportionately

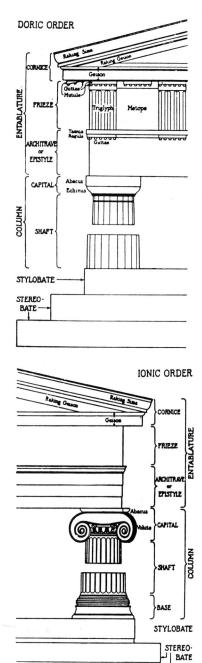

191. Plan of a typical Greek temple (After I. H. Grinnell)

LEVELING COURSE or EUTHYNTERIA

192. The Doric and Ionic orders (After I. H. Grinnell)

smaller, so the column diminished in bulk and its capital in size. On occasion the column could even be substituted by a human figure carrying the architrave (see figs. 198, 246).

Like the parts of the orders, the shapes of the temples were controlled by rules as stringent as those of grammar and music. Small temples often consisted only of a *cella* (the central rectangular structure housing the image of the deity), whose side walls were prolonged forward to carry the entablature and pediment directly and to frame two columns; such a temple was called *in antis*. If the portico ran across its entire front, the temple was *prostyle*; if it had front and rear porticoes, it was *amphiprostyle* (see fig. 242); if the colonnade, known as a *peristyle*, ran around all four sides, the temple was *peripteral* (see fig. 250); if the portico was two columns deep all around, the temple was *dipteral*.

Yet just as sonnets written in the same language or fugues composed according to the same rules will vary infinitely according to the ideas and talents of the poet or the musician, there are a surprising number of individual variations within what appear to be the stern limitations of Greek architectural orders and types. As we have already seen, there was a rapid change in the proportion of the columns corresponding to those of contemporary sculptured figures. The tapering and entasis also changed. The earliest examples show the sharp taper and a very muscular bulge, with sharply projecting capitals, suggesting physical strain in carrying the weight of the entablature. In later columns, along with the increase in height, both taper and entasis rapidly decrease and the projection of the capital sharply diminishes, until the lofty columns of the Parthenon in the middle of the fifth century appear to carry their load effortlessly. The changes in style and taste from temple to temple, subtle though they may at first appear, are distinct enough to enable one to recognize individual temples of either Doric or Ionic order at a glance.

The corner columns invariably caused difficulties. Since there was always one triglyph above each Doric column and another above each *intercolumniation* (space between two columns), either half a metope would be left over at the corner of the building or the corner triglyph would not be over a column. This discrepancy was solved by delicate adjustments of distances, so that a two-faced triglyph always appeared at the corner, with adjacent metopes slightly extended, and the corner column was brought a little closer to its neighbors. In the Ionic order, since the capitals had two scrolled and two flat sides, the problem was again how to turn the corner. This was solved by giving the corner capital two adjacent flat sides, with a volute coming out on an angle for both, and two inner scrolled sides (see figs. 242, 249).

But these adjustments were by no means all. Architects also toyed with the effects of varying proportions. Early temples were nearly three times as long as wide, while the Classical formula of the fifth century provided that the number of columns on the long side of a temple should be twice the number of those at either end plus one. The relatively simple interiors were lighted only by the large door. Numerous methods of supporting the roof beams were experimented with in early temples, including projecting spur walls like those at Saqqara (see fig. 78), and even a row of columns down the center, which had the disadvantage of obscuring the statue of the deity. The sixth- and fifth-century solution was generally two rows of superimposed orders of small columns, each repeating in miniature the proportions of the external peristyle (see fig. 221). Roof beams in early temples were still of wood and tiles of terra-cotta; in the sixth and fifth centuries marble was often used for roof tiles.

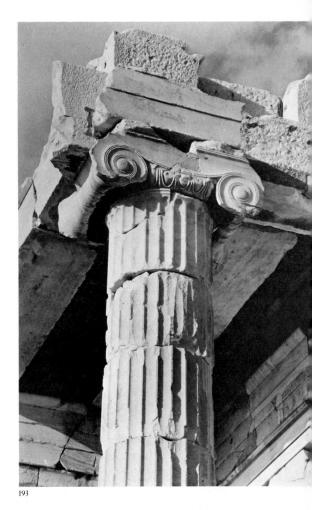

193. Ionic capital on a column in the central passage of the Propylaia, Acropolis, Athens

Sculpture could be placed almost anywhere in Egyptian temples; huge statues could sit or stand before or inside the temples; walls, columns, and pylons were alive with rows of figures carved in the shallowest relief, mingled with hieroglyphics, and painted. From the very start the Greeks made a clear-cut distinction between those sections of a temple that could be ornamented with sculpture and those that could not. Walls and columns were inviolable, save in the rare instances when a sculptured figure could become a bearing member (see figs. 198, 246). But into the empty spaces of a Greek temple sculpture could logically be inserted. Triglyphs were blocks of some size; the intervening metopes made splendid fields for relief sculpture. Naturally, the reliefs had to be of a certain depth in order to compete with the surrounding architectural elements, and there had to be some continuity in content among the metopes running round a large building. An Ionic frieze was also an obvious place for a continuous strip of relief sculpture. The corners of the pediments afforded the possibility of silhouetting sculptures (acroteria) against the sky. And above all, the empty pediments, which needed nothing but flat, vertical slabs to exclude wind and rain, provided spaces that could be filled with sculptured figures of a certain depth, preferably statues in the round. In those regions of Greece that enjoyed good stone for carving, and in those temples that could afford sculptural work, an unprecedented new art of architectural sculpture arose, never surpassed or even equaled until the Gothic cathedrals of the twelfth and thirteenth centuries were built (see Part Three, Chapter Six). For the first time in history, the architectural creations of humanity were in perfect balance with the human figure itself.

The earliest well-preserved Greek temple is not in Greece itself but in the Greek colony of Poseidonia, now called Paestum, on the western coast of Italy about fifty miles southeast of Naples. This limestone building, erroneously called the "Basilica" in the eighteenth century but more probably dedicated to Hera, queen of the gods, has lost its cella walls but still retains its complete peristyle (fig. 194). The temple is unusual in having nine columns across the ends; most others show an even number. The bulky, closely spaced columns with their strong entasis and widespread capitals appear to labor to support the massive entablature. Although the temple has no sculpture, it gives us an idea of how the slightly earlier Temple of Artemis on the Greek island of Corfu must originally have looked (reconstruction in fig. 195). Considerable fragments of one of the limestone pediments remain (fig. 196). This pediment was carved in

194. "Basilica" (Temple of Hera I), Paestum, Italy. Middle 6th century B.C.

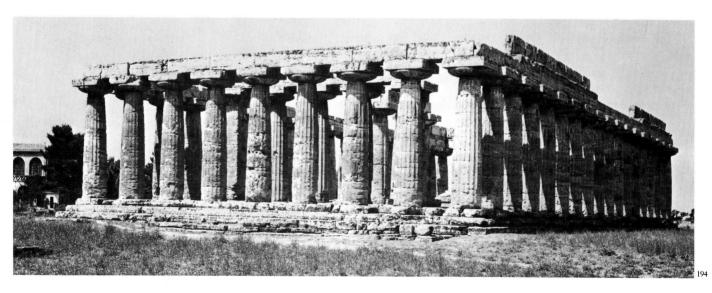

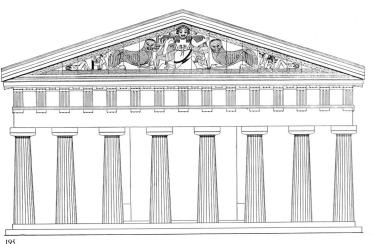

- 195. West façade, Temple of Artemis, Corfu. Early 6th century B.C. (Reconstruction drawing after G. Rodenwaldt)
- 196. *Medusa*, from the west pediment of the Temple of Artemis, Corfu. c. 600–580 B.C. Limestone high relief, height 9'2". Archaeological Museum, Corfu

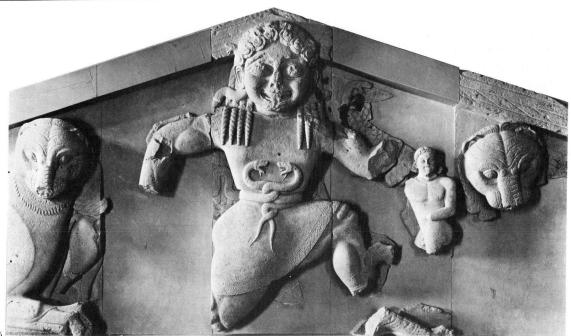

high relief, approaching sculpture in the round. The central figure, so huge that she must kneel on her right knee in order to fit, is the Gorgon, Medusa, grinning hideously and sticking out her tongue. She was probably placed there to ward off evil spirits, and is aided in her task by the two symmetrical leopards that crouch on either side (one thinks of the heraldic lions of Mycenae; see fig. 169). On her left, as an odd anachronism and in smaller scale, appear the head and torso of the boy Chrysaor, who sprang from her neck when Perseus struck off her head; to her right was Pegasus, the winged horse, born in the same way and at the same moment. The modeling strongly suggests that of the Calf-Bearer (see fig. 186). In the empty corners of the pediment were placed smaller, battling figures of gods and giants. So symmetrical a grouping, with fillers at the corners, looks tentative when we compare it to the closely unified pediments that were created later. Nonetheless, the contrast between large and small masses of smooth stone is delightful, and so is Medusa's writhing belt, formed of live, intertwined, and very angry snakes.

A more refined and elegant, as well as more active and complex, use of sculpture appears in the little marble treasury built at the sanctuary of Apollo at Delphi around 530 B.C. by the inhabitants of the Greek island of Siphnos to hold their gifts. The Treasury of the Siphnians has been

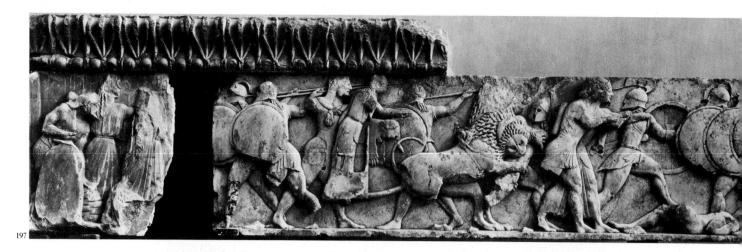

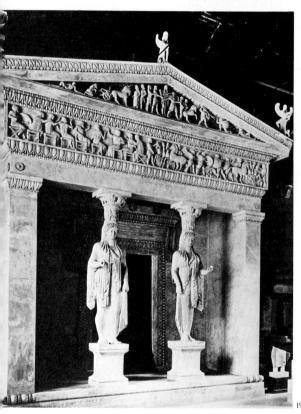

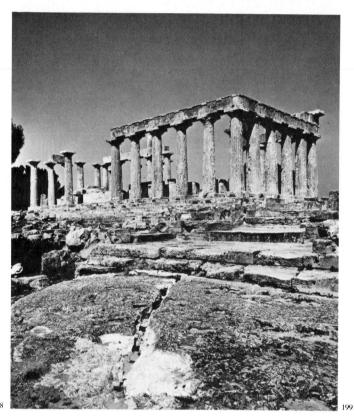

- 197. Battle of Gods and Giants, fragment from the north frieze of the Treasury of the Siphnians, Delphi. c. 530 B.C. Marble, height 26". Archaeological Museum, Delphi
- 198. Façade, Treasury of the Siphnians, Sanctuary of Apollo, Delphi, Greece (partially reconstructed). c. 530 B.C. Marble. Archaeological Museum, Delphi
- 199. Temple of Aphaia, Aegina, Greece. c. 500 B.C.
- 200. Plan of the Temple of Aphaia, Aegina

partially reconstructed from fragments (fig. 198). Here columns are replaced by two graceful kore figures, known as caryatids (strongly resembling La Delicata; see fig. 190), on whose heads capitals are balanced to carry effortlessly the weight of entablature and pediment. The frieze is a continuous relief, largely depicting battle scenes. The Battle of Gods and Giants (fig. 197) shows that the sculptor had a completely new conception of space. No longer does he have to place one figure above another to

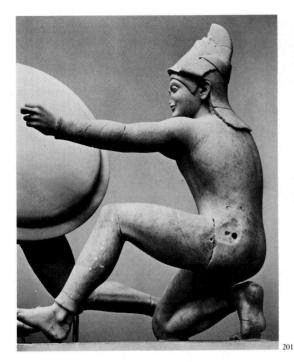

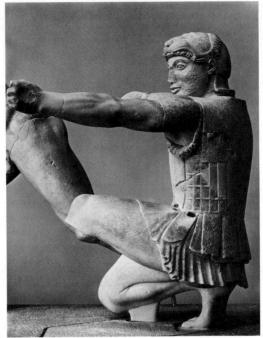

202

indicate distance. All stand or move on the same ground level and overlap in depth. Although none of the figures are in the round—they are all more or less flattened, in keeping with the character of a relief—those in the foreground are sharply undercut. The projection diminishes so that the figures farthest from the eye are only slightly raised from the background. This relief, for the first time in the history of art as far as we know, strives to achieve the optical illusion of space receding horizontally inward from the foreground. This recession is limited to a maximum of three figures (or four horses), but it is revolutionary nonetheless. The pediment contains, again for the first time, actual groups of almost free-standing statues, carved in more or less the same scale, in poses progressively adjusted to the downward slope of the pediment. The intense activity of the reliefs is kept in check only by the severity of the unrelieved wall surfaces below.

The climax of Archaic architecture and sculpture, at the threshold of the Classical period, is the temple of the local goddess Aphaia on the island of Aegina in the Gulf of Athens. The building was constructed about 500 B.C. of limestone stuccoed to resemble marble. Portions of the temple still stand (fig. 199). A plan of its original appearance (fig. 200) shows the outer Doric peristyle, with six columns at each end and twelve on each side. These columns are slenderer, taller, and more widely spaced than those at Corfu or in the Temple of Hera I at Paestum (see figs. 194, 195). For the first time the architect achieved what later became the standard solution of two superimposed interior colonnades. The marble pedimental statues were excessively restored in the nineteenth century, but these restorations have recently been removed. These statues are superb, full of the same vitality visible in the reliefs from the Treasury of the Siphnians (see figs. 197, 198) yet simpler and more successfully balanced. It is interesting to compare the *Oriental Archer* (fig. 201), so called because of his Phrygian cap, from the western pediment, carved about 500 B.C., with the Archer carved some five or ten years later (fig. 202). Nobly poised though the earlier statue is, it is somewhat schematic; one does not really feel the play of muscles. The masses of the later figure are held in position entirely by its beautifully understood muscular movement and tension, which must have been even more effective when the missing bronze bow

- Oriental Archer, from the west pediment of the Temple of Aphaia, Aegina. c. 500 B.C. Marble, height 41". Staatliche Antikensammlungen und Glyptothek, Munich
- 202. Archer, from the east pediment of the Temple of Aphaia, Aegina. c. 490 B.C. Marble, height 31". Staatliche Antikensammlungen und Glyptothek, Munich

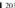

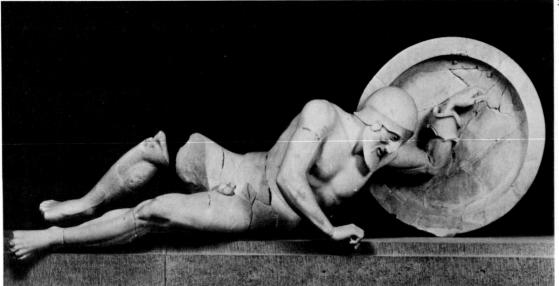

was intact. The Dying Warrior (fig. 203) embodies at long last the heroic grandeur of the Homeric epics in the simple, clear-cut masses of the figure and in its celebration of self-possession and calm even at the moment of violent death. The latest statues at Aegina have, in fact, brought us to the beginning of the Classical period in content and in style.

VASE PAINTING Painting was always considered one of the greatest of the arts by Greek writers, and a splendid tradition of painting on walls and on movable panels surely flourished during the late Archaic period. Yet so little survives that we cannot even form a clear idea of what we have lost. Nonetheless, a few echoes of this vanished art persist in faroff Etruscan tomb paintings (see fig. 305). Given their clear-cut, continuous outlines and flat areas of color, not unlike those of Egyptian painting, and considering also the strict limitations of Archaic sculptures with their smooth surfaces and strong, active contours, we can arrive at some notion of what the style of Archaic monumental painting must have been. Its quality, however, can only be guessed at; in this we are assisted by the beauty of the vast number of sixth-century painted vases still preserved.

The Archaic period saw the climax of Greek vase painting, which reached a high level of artistic perfection, rivaling sculpture and architecture, and which brought art of high quality into every prosperous household. Even more than contemporary sculpture, Archaic vase painting shows the flexibility of the new art, whose brilliant design is based on action and movement. How highly the Greeks themselves valued their vases is shown by the fact that so many of them were signed by the painter. Some were also signed by the potter. Through comparison with signed vases, unsigned pieces can be attributed to individual artists on account of similarities in style. In this way the development of personal styles can sometimes be followed for decades. This is the first moment in the history of art when such distinctions can be made and such evolutions traced. It is a very important consideration, because the art we are analyzing is, after all, one whose very principles of design are based on the interaction of individual human beings—in contrast to the mere alignment of standardized types so common in Egyptian and Mesopotamian art.

Vases were made for both local use and export in several Greek cities, especially Corinth and Athens. In the seventh century, Corinthian vases made of pale, yellowish clay were most popular, but in the early Archaic

- 203. Dying Warrior, from the east pediment of the Temple of Aphaia, Aegina. c. 490 B.C. Marble, 24 × 72". Staatliche Antikensammlungen und Glyptothek, Munich
- 204. KLEITIAS and ERGOTIMOS. François Vase, krater found at Chiusi, Italy. c. 570 B.C. Height c. 26". Museo Archeologico, Florence
- 205. PSIAX. Oriental Between Two Horses (detail of an amphora found at Vulci, Italy). c. 520-510 B.C. Height of amphora 14½". British Museum, London
- 206. Exekias. Dionysos in a Ship (interior of a kylix found at Vulci). c. 540 B.C. Diameter 12". Staatliche Antikensammlungen und Glyptothek, Munich

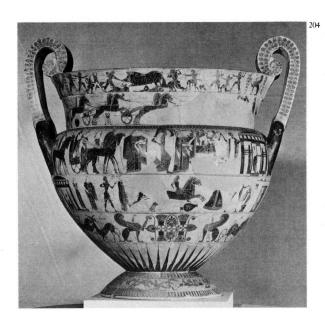

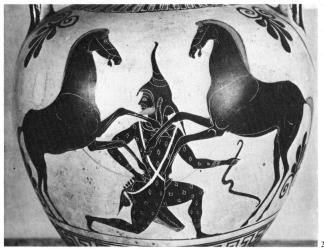

period the orange-red pots of Athens took the lead. The miniature style of the Corinthian painters could no longer compete with the strength, grace, and intellectual clarity of the Athenians.

Many of the finest Greek vases are preserved because they found their way to Etruria, whose inhabitants prized them highly and buried them in the tombs of the dead. The best Athenian vases are masterpieces of drawing and design, operating within a very restricted range of colors. The natural color of the clay was sometimes heightened by a brighter clay slip painted on for the background. The most important tone was black, used for figures and for the body of the vase. Gone is the cluttered decoration of the earlier periods. Within the contours of the black figures, details were drawn in lines incised by a metal tool. The glossy black was also a clay slip, its color achieved by controlling the air intake during the delicate and complex firing process.

One of the most ambitious sixth-century vases, known as the François Vase (fig. 204), of about 570 B.C., was found in an Etruscan tomb at Chiusi in central Italy. It is a krater, a type of vase intended for mixing water and wine, the customary Greek beverage, and was proudly signed by the painter Kleitias and the potter Ergotimos. The grand, volute-shaped handles grow like plants out of the body of the vase before curling over to rest upon its lip. The vase is still divided into registers like the Dipylon Vase (see fig. 179), but geometric ornament has been reduced to a single row of sharp rays above its foot; the handles are decorated with palmettes. The other registers are devoted to a lively narration of incidents from the stories of the heroes Theseus and Achilles. The figures still show the tiny waists, knees, and ankles and the full calves, buttocks, and chests that are standard in the Geometric style, but they now move with a vigor similar to that of the sculptures on the Corfu pediment (see fig. 196), and both men and animals have begun to overlap in depth in a manner foreshadowing the deployment of figures in the frieze of the Treasury of the Siphnians (see fig. 197).

A splendid example of Archaic design based on organic movement is the *Oriental Between Two Horses* (fig. 205) by the painter Psiax, dating from about 520–510 B.C. The Oriental, who seems to be a horse trainer, moves rapidly forward with knees sharply bent, in the style of the Medusa at Corfu, and turns his head to look backward over his right shoulder. The forcefulness of the movement and the angularity of the bent limbs recall

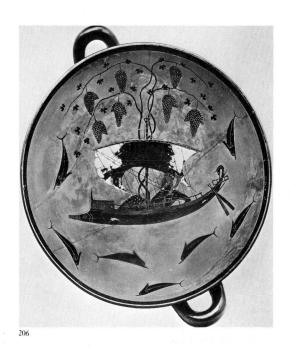

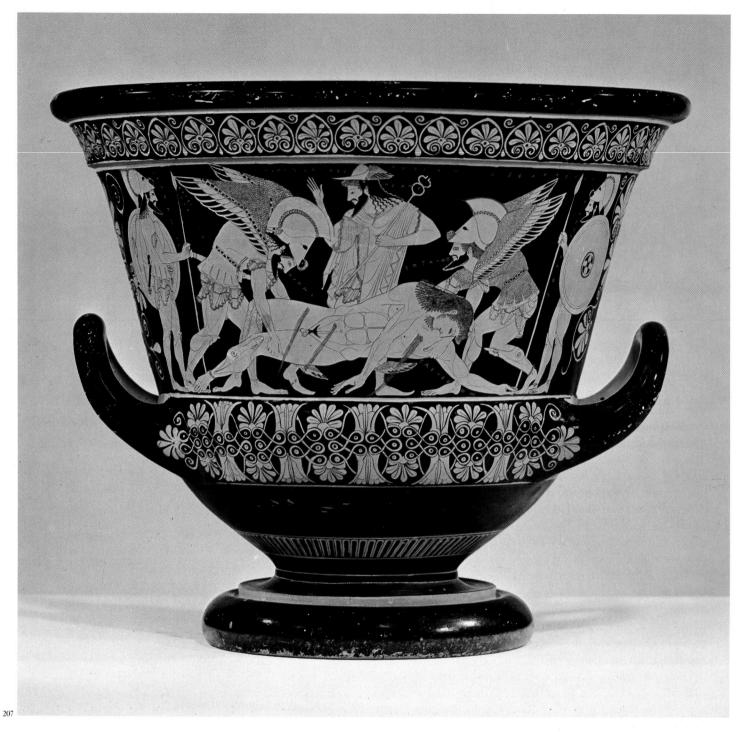

the almost contemporary *Oriental Archer* (see fig. 201) from Aegina. On either side horses rear in a heraldic grouping, their slender legs overlapping the archer's body, their bodies seeming to swell with the expansion of the amphora itself. The incised lines, at once delicate and firm, are left in the red of the background.

One of the most delightful of all Archaic vase paintings is on the interior of a *kylix*, or wine cup, painted by Exekias about 540 B.C. (fig. 206). Dionysos, god of wine, reclines in a ship from whose mast he had caused a grape-laden vine to spring in order to terrify some pirates who had captured him and whom he then transformed into dolphins. The almost dizzying effect of the free, circular composition is, appropriately enough, not unusual in decorations for the insides of wine cups. In this case the feeling of movement is heightened by the bellying sail (originally

207. Euphronios. Sarpedon Carried off the Battlefield (portion of a calyx-krater). c. 515 B.C. Height of vase 181/4". The Metropolitan Museum of Art, New York. Bequest of Joseph H. Durkee. Gift of Darius Ogden Mills and C. Ruxton Love, by exchange, 1972

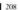

208. The Kleophrades Painter. *Rapt Maenad* (detail of a pointed amphora found at Vulci). c. 500–490 B.C. Staatliche Antikensammlungen und Glyptothek, Munich

all white) and by the seven dolphins circling hopelessly about the vessel. The entire scene, with all its suggestions of wind and sea, is carried off without the actual depiction of even a single wave.

Toward the end of the sixth century, vase painters discovered that their compositions would be more effective and their figures more lifelike if left in the red color of the terra-cotta, with the black transferred to the background, just as in pediments or friezes the figures shone in white or softly colored marble against a darker background of red or blue. At first the change was tentative; some vases even show red figures on one side, black on the other. But once it was generally accepted, the change was lasting. One of the earliest red-figure vases, and certainly one of the finest Greek vases in existence, is a combined kylix-krater (fig. 207) by Euphronios datable about 515 B.C. The principal scene depicts a rarely illustrated passage from the *Iliad*, narrating how the body of the Trojan warrior Sarpedon, son of Zeus, was removed from the field of battle by the twin brothers Hypnos and Thanatos (Sleep and Death) under the supervision of Hermes, so that it could be washed in preparation for a hero's grave. The extraordinary combination of great sculptural force, equaling that of the statues at Aegina, with extreme tenderness of feeling is completely unexpected. The blend is achieved by a line that surpasses almost

anything in Greek vase painting in its tensile strength and descriptive delicacy. From the beautiful analysis of the muscular body of Sarpedon to the knife-sharp wing feathers of Hypnos and Thanatos, even to the slight curl at the tips of the fingers and toes, the movement is carried out with perfect consistency and control. The very inscriptions, usually naming adjacent figures, are not allowed to float freely against the black, but move in such a way as to carry out the inner forces of the composition. *Thanatos*, for example, is written backward to lead the eye toward the central figure of Hermes.

But vase painting did not always remain on the plane of high tragedy; the very fact that so many vases were destined to hold wine tended to promote a certain freedom in both subject and treatment. Among the followers of the great Euphronios, two sensitive masters have been distinguished—one called the Kleophrades Painter because his work is so often found on vases signed by the potter of that name, the other called the Berlin Painter, from the location of his principal work. How free the actual execution of red-figure vases can be is seen in the former's treatment of a rapt blonde maenad (female follower of Dionysos) in fig. 208. The deft, sure linear contours contrast sharply with the sketchy quality of the hair, painted in a different thickness of slip so that it would fire to a soft, light color, and with the garland about the head, even more rapidly brushed in soft violet. The Berlin Painter's bell-shaped krater (see fig. 6)—a triumph of rhythmic grace and poise—shows Ganymede, the favorite of Zeus, holding a rooster in one hand and glancing coyly over his shoulder as he rolls a hoop. The Brygos Painter, another master named for the potter on whose vases his paintings appear, treats an amatory subject with restrained excitement (fig. 209). Two nude men, past their first youth, have begun to embrace two clothed young women. The eye slips happily from nude forms to drapery masses swinging in a controlled abundance of linear movement.

In the early decades of the fifth century B.C., the individualism of the Greek city-states was put to its severest test in a protracted struggle against Mesopotamian autocracy in the form of the Persian Empire, first under Darius I and then under his son Xerxes I. Persia had succeeded in subjugating all the Greek cities of Asia Minor and then insisted on extending

- 209. The Brygos Painter. *Revelling* (portion of a skyphos). c. 490 B.C. Height of vase c. 8". The Louvre, Paris
- 210. Charioteer of Delphi, from the Sanctuary of Apollo, Delphi. c. 470 B.C. Bronze, height 71". Archaeological Museum, Delphi

The Classical Period—The Severe Style (480–450 B.C.) and Its Consequences her domination to European Greece. The resistance to the Persian threat brought about one of the rare instances of near unity among the rival Greek states. In 480 B.C. Xerxes conquered Attica, occupied Athens (which had been evacuated by its citizens), and laid waste the city. Yet in this selfsame year the Greeks managed to trap and destroy the Persian fleet at Salamis, and after another defeat on land in 479, Xerxes was forced to retire. Although the struggle continued sporadically in northern Greece, the Greek states were temporarily safe. Athens, which had led the resistance, embarked on a period of unprecedented prosperity and power.

The new development of the Classical style in the years immediately following Salamis shows above all an increased awareness of the role of individual character in determining human destiny, and it incorporates the ideal of ennobled humanity in a bodily structure of previously unimagined strength, resilience, and harmony. This development was no accident, any more than it was an accident that the Classical belief in the autonomy of the individual was revived in the early Renaissance in fifteenth-century Florence under remarkably similar circumstances. We need only set the new images of heroic, self-controlled, and complete individuals that followed (especially figs. 213, 214) against the standardized soldiers of Persian autocracy in order to realize the extent of the revolution that came to fulfillment in Greek art of the Classical period.

FREESTANDING AND RELIEF SCULPTURE The brief and significant generation between the close of the Archaic period and the height of Classical art in the Age of Pericles shows a remarkable transformation not only in style but also in general tone. The term Severe Style suggests the moral ideals of dignity and self-control that characterize the art of the time and mirror the short-lived Greek resolve to repel the Persian invader. Complex draperies constructed of many delicate folds give way to simple, tubular masses. The face is now constructed of square or rounded forms rather than the pointed features of the Archaic period: the square, broad nose joins the brows in a single plane, the mouth is short, the lips full, the eyes wide open, the chin and jaw rounded and firm. Most important of all, the Archaic smile has given way to an utter and deliberate calm, as if the figure were wearing a mask. (It should be remembered that actors in Greek drama did indeed wear masks, but with set expressions for comedy or tragedy.)

We may well commence our consideration of this period with the earliest of the rare Greek lifesize bronzes to come down to us, the superb Charioteer of Delphi (fig. 210), dedicated by Polyzalos, tyrant of the Greek city-state of Gela in Sicily, to celebrate his victory in the chariot race at the Delphic Games just before 470 B.C. Originally the charioteer stood in a bronze chariot and controlled four bronze horses with their bridles; only fragments of the horses survive. The dignity and calm of the figure remind us that the metaphor of a charioteer was later used by Plato to symbolize man's control of the contrary forces in his soul. The bronze, originally polished, is relieved in the face by inlaid copper lips and eyelashes and by eyes made of glass paste. (We should mentally restore such features whenever they are missing in Greek and Roman bronzes.) The charioteer stands with a resiliency new to Greek sculpture; the folds of his long chiton drape easily across the chest and fall from the high belt in full, tubular shapes as cloth actually does, rather than in the ornamentalized folds of the Archaic period. The figure has at once the verticality and strength of a fluted Doric column and the possibility for action of any nude athlete.

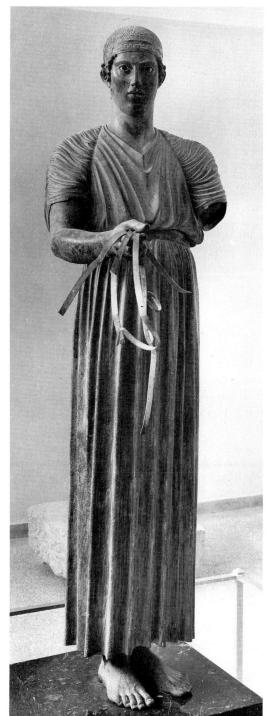

210

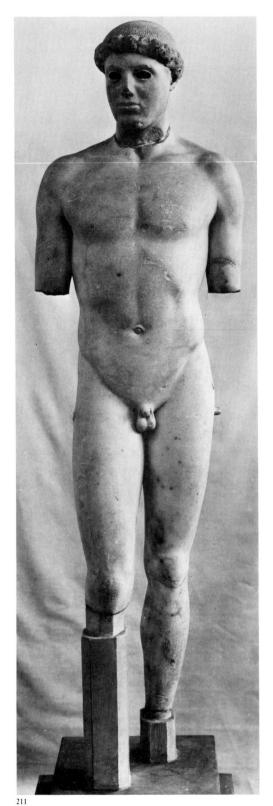

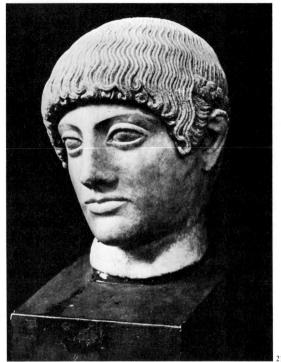

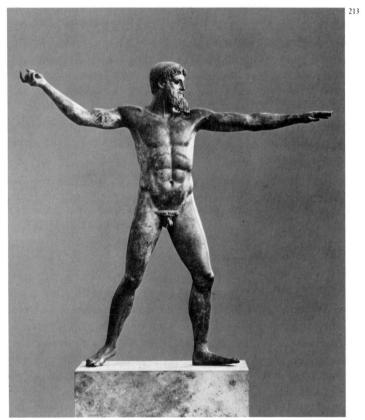

A slightly earlier statue (fig. 211), called the *Kritios Boy* because it embodies what is thought to have been the style of the sculptor Kritios, should be compared with the Archaic kouros figures (see figs. 184, 185) to bring out the scope of the transformation in Greek sculpture. Although the kouros figures are also standing, they appear frozen in a pose derived from walking, with the weight evenly distributed on both legs. In the *Kritios Boy*, the figure stands *at rest*, as people actually do, with the

weight placed on one leg while the other remains free. In consequence the left hip, on which the weight rests, is slightly higher than the right. In recompense, the right shoulder should be higher than the left, but the sculptor does not seem to have noticed this. He has discovered that in a resting figure the masses respond to stresses just as in a moving one, and that rest in a living being is not equivalent to inertia, as in Egyptian sculpture, or to the unreal symmetry of the Archaic, but to a balanced composure of stresses. The fullness, richness, and warmth of the human body, hinted at for the first time in the Anavyssos Kouros (see fig. 185), are now fully realized, as the forms blend effortlessly into each other. The firm beauty of the features and facial proportions preferred by the Severe Style is seen at its grandest in the *Blond Youth* (fig. 212), also dating from about 480 B.C., so called because traces of blond coloring could once be seen in the hair. The irises of the characteristically heavy-lidded eyes still retain considerable color, and the typical pensive, serene expression of the Severe Style is beautifully realized. The hair is still ornamentalized and worn almost like a cap, although occasionally a lock breaks free.

Fortunately, a single original bronze action statue of the Severe Style has come to light, a splendid, over-lifesize figure of the nude Zeus (fig. 213), found in the sea off Cape Artemision. The subject is often consid-

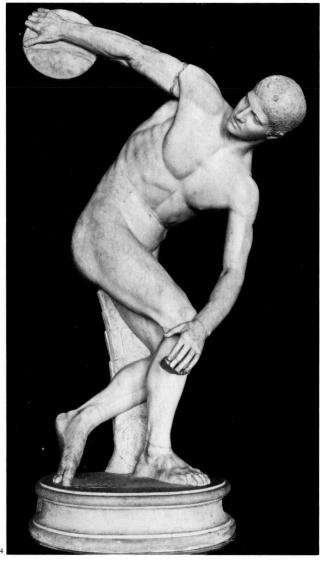

- 211. Kritios Boy, from the Acropolis, Athens. c. 480 B.C. Marble, height 33". Acropolis Museum
- 212. *Blond Youth*, from the Acropolis, Athens. c. 480 B.C. Marble, height 95/8". Acropolis Museum
- 213. Zeus, found in the sea off Cape Artemision (Euboea), Greece. c. 460 B.C. Bronze, height 82". National Archaeological Museum, Athens
- 214. MYRON. Diskobolos (Discus-Thrower). c. 450 B.C. Roman marble copy of bronze original, lifesize. Museo Nazionale Romano, Rome

ered to be Poseidon, god of the sea, but if the trident (three-tined spear) wielded by Poseidon were to be placed in the figure's right hand it would obscure the face; more likely the figure represents Zeus hurling a thunderbolt. In no other remaining example can we see the magnificence of the Greek athletic ideal in the very person of the ruler of the gods. While the hair, bound in by a braid, and the beard and eyebrows are still stylized, the muscles of the body and the limbs vibrate with a new intensity.

The leading sculptors of the period immediately following, especially Myron and Polykleitos, were trained in the Severe Style, of which their work is an immediate outgrowth. Both were chiefly concerned with athletic subjects, which enabled them to exemplify the Classical principles of rhythmic organization derived from the poses of powerful nude male figures. In his bronze Diskobolos (Discus-Thrower), of about 450 B.C., which we know only through Roman copies in marble (fig. 214), Myron chose the moment when the athlete bent forward, in a pose of great tension and compression, before turning to hurl his discus. The composition, operating in one plane like the Zeus of Artemision, is built on the transitory equipoise of the two intersecting arcs formed by the arms and the torso. Like all Classical figural groupings, this one dissolves the moment the action is over; its beauty lies in the lasting grandeur of a geometrical composition abstracted from a fleeting moment of action. The new dynamics of the Severe Style have been concentrated into a single image of extraordinary power.

The ultimate development of the kouros type can be seen in the Doryphoros (Spear-Bearer) by Polykleitos, executed probably between 450 and 440 B.C. Again the lost bronze original is accessible only through a number of Roman copies and ancient literary descriptions. A remarkably successful attempt was made in 1935 to reconstruct in bronze the probable appearance of Polykleitos' masterpiece (fig. 215). The problem of the standing figure, posed in the Kritios Boy (see fig. 211), has now been completely solved. The right leg bears the full weight of the body, so that the hip is thrust outward; the left leg is free; the tilt of the pelvis is answered by a tilt of the shoulders in the opposite direction; and the whole body rises effortlessly in a single long S-curve from the feet to the head, culminating in the glance directed slightly to the figure's right. Regardless of the fact that the figure is at rest—as never before—the dynamism of the pose transforms it into an easy walk and is expressed in the musculature by means of the differentiation of flexed and relaxed shapes, producing a rich interplay of changing curves throughout the powerful masses of torso and limbs. A fragmentary Roman copy in black basalt (fig. 216) shows what must have been the effect in dark bronze of the superb muscular structure of the torso, with its characteristically prominent external oblique muscles and sharply defined, U-shaped pelvic groove. Polykleitos wrote a treatise to explain his meticulous system of proportions as exemplified by this statue, but the book is lost and his system still imperfectly understood. Polykleitos called both the Doryphoros and the book his "Canon" (measuring rod or standard). The Greek interest in arithmetic and geometry manifested in the theories of Greek philosophers, especially Pythagoras, who saw the universe as operating on mathematical systems—was expressed in all the arts, including music. We should keep in mind that the Greek systems of human proportion, like that of Polykleitos, derive from their love of mathematical relationships; such relationships run through Greek architecture as well, down to the last detail.

Our knowledge of Classical sculpture has been dramatically enriched by the discovery in 1972 of two nude, bearded bronze warriors (figs. 217, 218), each well over six feet tall, in the sandy bottom of the Ionian Sea

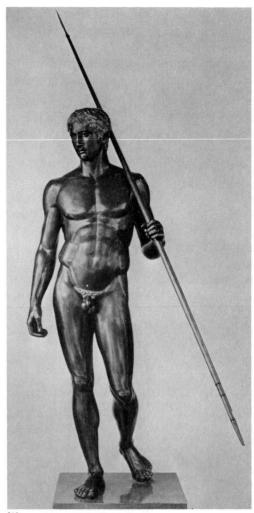

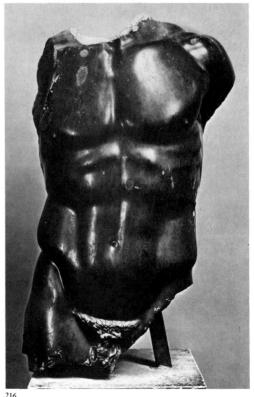

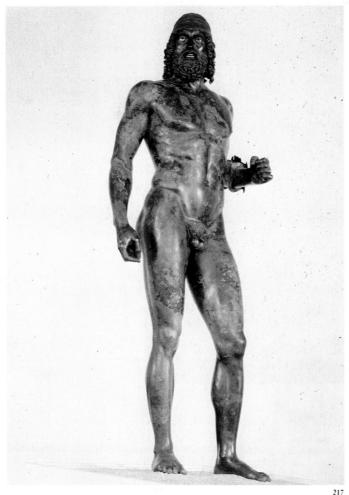

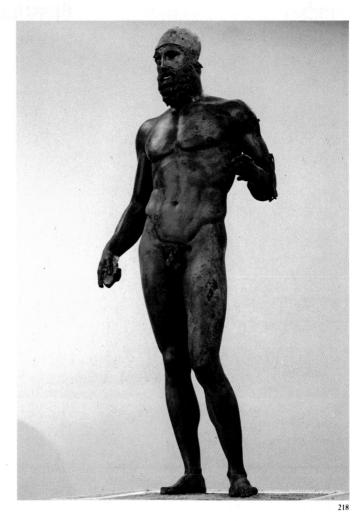

about a quarter of a mile from the village of Riace on the shore of Calabria, the toe of the Italian boot. The statues, thickly encrusted with salt and corrosion, were taken in 1975 to Florence for a lengthy and meticulous cleaning process. Only in 1980 were they placed on exhibition in their full splendor of gleaming bronze muscles. Immediately they were recognized as works of great importance, by scholars and public alike, and created a sensation—in fact, a near riot when they were eventually removed from Florence for exhibition in Rome at the Quirinal Palace, the official residence of the President of the Italian Republic. Each figure originally held a sword or spear in the right hand and had a shield strapped to the left forearm, but these have disappeared along with the helmet that once covered one of the heads. The statues are otherwise astonishingly complete, down to bronze eyelashes, copper lips and nipples, eyes made of ivory and glass paste, and in one case fierce-looking teeth plated with silver. The massive, muscular bodies quiver with life, and the unknown sculptor has been attentive even to the veins appearing through the skin in the groin, in the inner elbows, and on the lower legs, ankles, and feet. The extraordinary power of these figures, their simple, limited poses, and the combination of great naturalism in some details (the veins) with persistent ornamentalism in others (the hair and beards), coupled with the exceptionally high quality of conception and execution, have convinced most but not all specialists that these are indeed Greek works of the middle of the fifth century. Presumably they were tossed overboard to lighten ship by some small vessel caught in a storm near the treacherous Straits of Messina. More important, no one has yet even made a guess

- 215. Polykleitos. Doryphoros (Spear-Bearer). c. 450-440 B.C. Bronze reconstruction. Universität, Munich
- 216. Polykleitos. *Doryphoros* (fragment). Roman copy in black basalt of bronze original. Galleria degli Uffizi, Florence
- 217, 218. Two Warriors, found in the sea off Riace, Italy. c. 460-450 B.C. Bronze, height c. 80" each. Museo Archeologico, Reggio Calabria, Italy

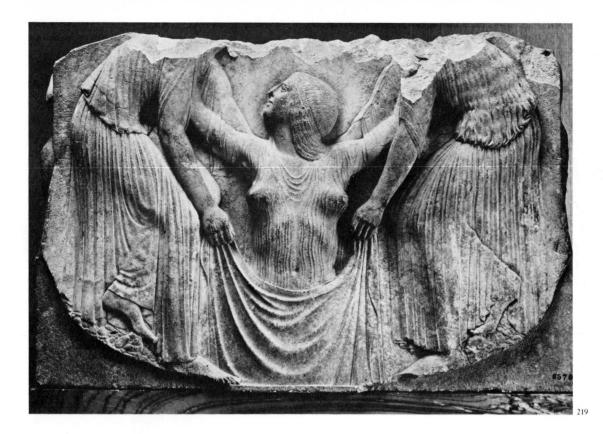

as to where they came from or what purpose these fearless warriors were intended to serve.

An exquisite example of the treatment of the female figure in the Severe Style is the group of low reliefs known as the *Ludovisi Throne*; more probably, these reliefs once formed an altar. Perhaps made in a Greek city in southern Italy, the reliefs nonetheless show early fifth-century sculpture at the height of its perfection. A relief that probably represents the Birth of Aphrodite (fig. 219) delineates full and graceful female figures seen through clinging garments that seem almost transparent. As Aphrodite was born from the sea, the device of sheer garments (often known as "wet drapery") seems appropriate; in any case it was used consistently in fifth-century sculpture to reveal the roundness of female forms even when fully clothed and completely dry. Experiments by the late great archaeologist Margarete Bieber have shown that the kinds of cloth used by the Greeks do not fall in such folds when draped around the body (see fig. 224), so these "wet" folds are a convention, but a very beautiful one.

ARCHITECTURE AND ARCHITECTURAL SCULPTURE

The greatest architectural and sculptural project of the first half of the fifth century was the Doric Temple of Zeus at Olympia, whose construction and decoration may be dated 470–456 B.C. The temple was the principal building of the sanctuary at Olympia, center of the quadrennial games that provided one of the few unifying threads in the chaotic life of the endemically warring Greek city-states. The temple, which has disappeared but for the stylobate and the lowest drums of the columns, has been carefully excavated, and its appearance can be reconstructed with accuracy. It was built of local limestone, coated with a plaster made of marble dust, but the sculpture and roof tiles were of Parian marble. The architect, Libon of Elis, designed a peristyle six columns wide and thirteen long. Something of the grandeur of its original appearance may be

219. Birth of Aphrodite, from the Ludovisi Throne. Early 5th century B.C. Marble low relief, width 56". Museo Nazionale Romano, Rome

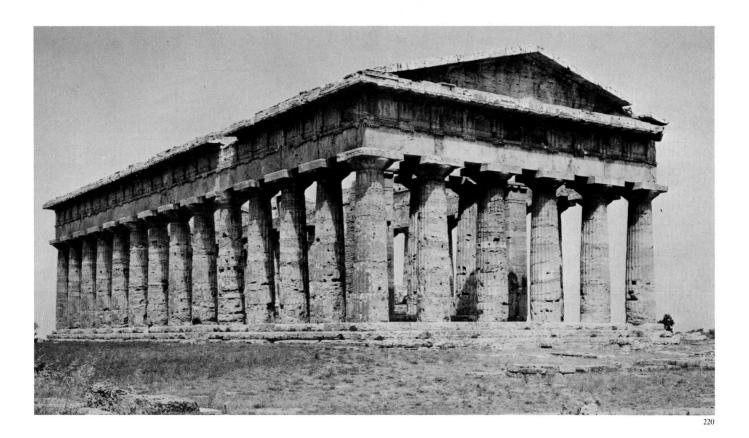

felt in the probably contemporary and somewhat smaller Temple of Hera II at Paestum (fig. 220), despite its more massive proportions and closer spacing of columns due to local taste. Libon's columns are slenderer and more elegant than any we have seen so far, and both their entasis and the

projection of their capitals are slighter and subtler (fig. 221). Both interiors utilized the double row of superimposed columns we saw at Aegina.

The sculpture, much of which is preserved, ranks among the noblest Greek architectural sculpture. Neither the name of the sculptor nor the city of his origin is known, but a single leading master and a host of assistants must have been at work to produce so rich a cycle of sculpture in so short a time. The mythological subjects were chosen to symbolize the civilizing effect of the Olympic Games, held under divine protection. The two pedimental groups are fairly well preserved, but since the exact order and location of the statues are not clear, several conflicting attempts at reconstruction have been made. The west pediment deals with the Battle of Lapiths and Centaurs (fig. 222), a frequent subject in Greek art. The centaurs, half man and half horse, descend on the wedding feast of the Lapith king Peirithoös, and there they taste wine for the first time. Under its influence they attempt to carry off the Lapith women, whom Peirithoös and his friend Theseus strive to rescue. Apollo, god of light and, therefore, of order and reason, presides over the subjugation of the centaurs. The scene is possibly an allegory of the effect of the Olympian sanctuary on the struggles between Greek states, since all such hostilities had to be laid aside before contestants could enter its sacred gates.

However the statues were arranged, the poses were carefully calculated for the raking cornices, and the pedimental composition was more closely unified than any of its predecessors. The stupendous figure of Apollo (fig. 223), standing erect and with his right arm outstretched, commands the centaurs to desist in their depredations. In spite of heavy damage to the statue of a Lapith woman, her pose may be mentally reconstructed. She struggles in the embrace of a centaur's forelegs, pushing

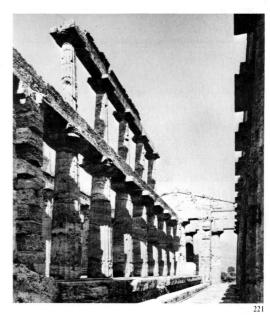

220. Temple of Hera II, Paestum. c. 460 B.C.

221. Interior, Temple of Hera II, Paestum

GREEK ART 163

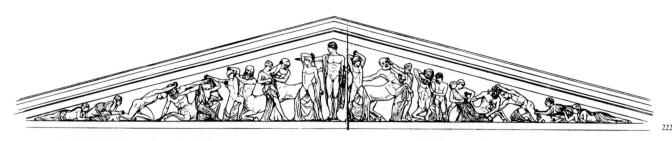

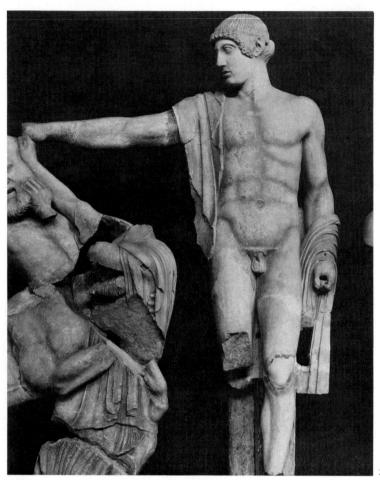

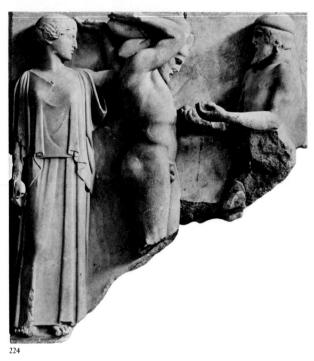

him off with her hands. While the stern Apollo figure shows—naturally enough, given his commanding role in the action—none of the relaxation of the Doryphoros (see fig. 215), the structure and definition of the musculature are in keeping with the principles of the Severe Style. So indeed is the beautiful face, with its nose descending in a straight line from the forehead, its full jaw and rounded chin, and the caplike mass of ornamentalized hair. Despite their freedom of movement, the drapery folds are proportioned to harmonize with the fluting of the columns below.

The metopes of the outer peristyle were left blank, but as observers ascended the ramp before the temple they could see between the outer columns the frieze above the two columns of the inner portico in antis at either end of the cella, each end having six metopes representing the Labors of Herakles. The high reliefs, almost statues in the round, were kept austerely simple, their broad, full masses contrasting with the flat slab behind. One of the finest (fig. 224) shows Atlas bringing back to Herakles (who has temporarily relieved him in his task of supporting the heavens) the Golden Apples of the Hesperides. The goddess Athena gently assists the hero. Garbed in her simple Doric peplos, she is one of the grandest

- 222. Battle of Lapiths and Centaurs, reconstruction drawing of the west pediment of the Temple of Zeus, Olympia, Greece. c. 470-456 B.C. (After G. Treu)
- 223. Apollo with a Centaur and a Lapith Woman, fragment from the west pediment of the Temple of Zeus, Olympia. c. 470-456 B.C. Marble, height of Apollo c. 10'2". Archaeological Museum, Olympia
- 224. Atlas Bringing Herakles the Golden Apples, fragment from a metope of the Temple of Zeus, Olympia. c. 470–456 B.C. Marble high relief, height 63". Archaeological Museum,

female figures of the century, and Herakles is sculptured with a reticence and dignity typical of the Severe Style. Some of the breadth of treatment of the Aegina sculptures remains here, but with a new roundness of shape and smoothness of transition from one form to the next.

PAINTING Vase painting continued throughout the Classical period, but a sharp decline in quality is notable, as if the painters had lost interest, perhaps because of the sudden increase in scope offered by the great commissions for wall paintings. One of the leading vase painters of the Severe Style is known as the Niobid Painter, after a vase depicting the slaughter of the children of Niobe by Apollo. He is less important in his own right than because his paintings may tell us something about the vanished works of mural art, particularly those of Polygnotos, the most celebrated painter of the age and, in many ways, a pictorial counterpart of Polykleitos. According to ancient literary descriptions, Polygnotos gave his figures the nobility we have found in the sculpture of the Severe Style and of Polykleitos, as well as a new quality of emotional expression. He

225. *The Diver*, fresco from a Greek tomb at Paestum. c. 470 B.C. Museo Archeologico Nazionale, Paestum

was also able to paint transparent or translucent draperies, through which could be seen the forms of the body (like those in the *Ludovisi Throne*; see fig. 219). While he did not use shading, and was thus constrained to rely on line to indicate form, Polygnotos was in one respect a great innovator: he scattered his figures at various points in space, freeing them for the first time from the groundline to which they had previously been confined. He also indicated such landscape elements as rocks and trees. One of the finest works by the Niobid Painter, a calyx-krater found at Orvieto in central Italy and dating from about 455-450 B.C., shows on one side a still unidentified subject that includes both Herakles and Athena and possibly Theseus (fig. 226). The noble, relaxed figures remind us of the sculpture of the Severe Style, and they correspond to the descriptions of Polygnotos' art. Even more striking is the free placing of figures at various points to indicate depth. Each is standing on a separate patch of ground, and all are united by a single wavy line running from one to the next. Another indication of the new interest in actual visual experience, freeing the painter from age-old conventions, is that, for the first time in art, the eyes of profile figures are drawn in profile rather than in full face.

There the story would have stopped had it not been for the extraordinary discovery in 1968 of a painted Greek tomb, datable about 470 B.C., in a cemetery outside the city of Paestum. The boxlike tomb was formed of six slabs of stone—for the ends, sides, top, and bottom—and all but the bottom slab were painted in fresco, that is, pigment on wet plaster. A layer of coarse plaster was first spread over the slab, and preparatory drawings were made on that. Then smooth plaster was laid on, which had to be painted rapidly so that the colors would amalgamate with the plaster before it dried. This technique was later used widely throughout Etruscan and Roman wall painting, and was revived in the later Middle Ages and the Italian Renaissance.

On the four side slabs of the Paestum tomb were painted figures playing and listening to music and drinking wine (fig. 227), while on the

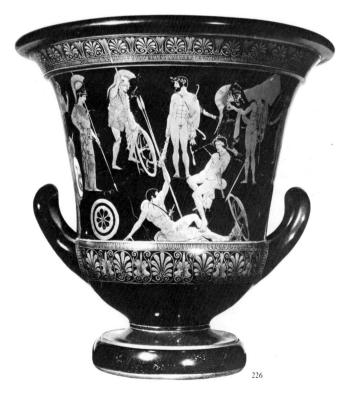

- 226. The Niobid Painter. Calyx-krater found at Orvieto, Italy. c. 455–450 b.c. Height 211/4". The Louvre, Paris
- Banqueting Scene, fresco from a Greek tomb at Paestum. c. 470 B.C. Museo Archeologico Nazionale, Paestum

227

inside of the lid appeared an unexampled scene—a nude figure in early manhood diving from a kind of springboard into the sea (fig. 225). This may represent a scene from real life, or perhaps its significance is allegorical—the soul plunging into the waters of the Beyond, in which it is purified of the corruption of the body. There are neither texts nor images to support either interpretation, but an allegory of the future life would seem probable for an image on the interior of a coffin. Whatever their significance, all the figures show a new suppleness of line, used to describe the fullness of muscular forms as well as a wide range of expressions; between the contours the solid areas of brown flesh tones contain no hint of shading. The eye is shown, as in the work of the Niobid Painter, in profile rather than full face. Schematic landscape elements appear, also for the first time in Greek painting; a tree is represented, as well as the waves of the sea. All this is in keeping with what we read about Polygnotos' paintings.

If a provincial painter, decorating the tomb of an unknown youth with images destined for eternal darkness, could draw and paint like this, what must have been the lost masterpieces of Athens?

The culmination of the Classical period in architecture and sculpture in Athens coincided with the greatest extent of Athenian military and political power, and with the peak of Athenian prosperity—also, unexpectedly, with the height of democratic participation in the affairs of the Athenian polis. This was no accident; the vision and vitality of a single statesman, Pericles, brought Athens to her new political hegemony, and it was Pericles who commissioned the monuments for which Athens is eternally renowned. And with the inevitablity of an Athenian tragedy, it was the long and disastrous war begun by Pericles that brought about the defeat of Athens in 404 B.C. and the end of her political power. Had Pericles not died in 429 the end might well have been different. Nevertheless, in some twenty dizzying years Pericles and the great architects and sculptors who worked under his direction created a series of monuments that have been the envy of the civilized world ever since, perhaps because they first proclaimed the new ideal of a transfigured humanity, raised to a plane of superhuman dignity and freedom. The sublime style of the Age of Pericles, as this transitory period should properly be called, was in many respects never equaled; it can be paralleled only by the even

The Classical Period—The Age of Pericles (450–400 B.C.)

briefer period of the early sixteenth century in central Italy, the High Renaissance, also dominated and inspired by a single political genius, Pope Julius II. It is instructive to remember that with Egypt and Sumeria we thought in millennia and with Archaic Greece in centuries, while with Classical Greece we must think in decades.

THE ACROPOLIS AT ATHENS AND ITS MONUMENTS The massive limestone rock dominating Athens had been in Mycenaean times the site of the royal palace, and in the Archaic period it contained the principal sanctuaries of the city. When the Persians attacked in 480 B.C., they succeeded in capturing the fortress and in setting fire to the scaffolding around a great new temple to Athena, patron deity of Athens, which was then rising on the highest point of the Acropolis. When the Athenians returned to their city the following year, they vowed to leave the Acropolis in its devastated condition as a memorial to barbarian sacrilege. Nonetheless, they utilized marble fragments, including unfluted drums from the first Parthenon and many Archaic statues, as materials for new fortifications. By 449 B.C. the Athenians seem to have repented of their vow, for in that year they embarked on one of the most ambitious building programs in history. Money was, apparently, no object. But it could not be provided by the rudimentary system of taxation then in effect. Pericles' solution was simple. After the victories of 480-479 B.C., Athens had led an alliance of Ionian states, known as the Delian League because its meeting place and treasury were on the island of Delos, against the Persian invaders. For years Athens had kept the smaller states in line, and imperceptibly and inevitably the Delian League had been transformed into a veritable Athenian Empire. States that attempted to secede were treated as rebels and severely punished. Ostensibly for greater security, the treasury was moved to Athens in 454 B.C. Before many years passed, its contents were used for the rebuilding of the Acropolis and its monuments, not to speak of other splendid buildings in Athens. Pericles was sharply criticized, but the work went on with astonishing rapidity.

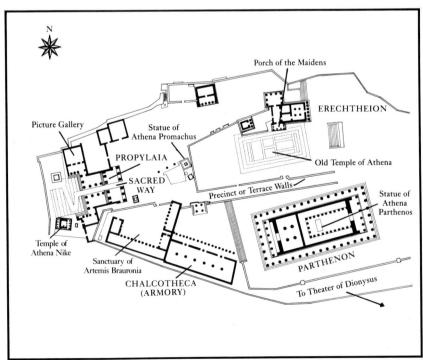

MAP 7. THE ACROPOLIS, ATHENS

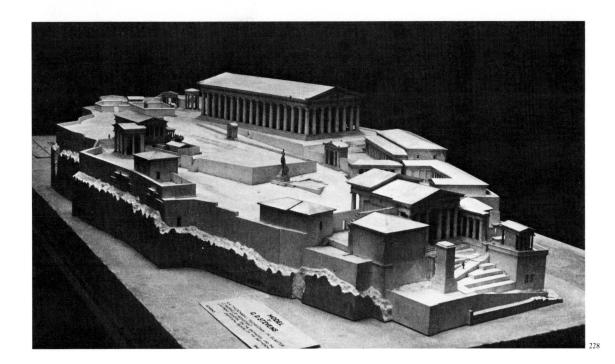

228. Model of the Acropolis, Athens (By G. P. Stevens)

Given the Greek ideals of harmony and order, one might have expected the newly rebuilt center of Athenian civic pride and state religion to have been organized on rational principles at least as highly developed as those that were so successful in Egyptian temples and in Mesopotamian palaces. Nothing could be further from the truth. Only an imperial autocracy, apparently, could impose a sense of order on all the disparate elements of such a traditional center. In fact, no Greek sanctuary before the Hellenistic period was organized along symmetrical lines, or for that matter along any rational principles save those of ready accessibility. The greatest of all Greek sanctuaries, that of Zeus at Olympia, was at any moment in its history a jumble of temples large and small, shrines, altars, colonnades, and throngs of statues, each erected without the slightest consideration for its neighbors. The Temple of Zeus itself was not even centrally placed.

The Parthenon: Architecture. When Pericles rebuilt the Acropolis, he erected the temples on ancient, sacred sites, and where he could he utilized foundations remaining from older buildings, with the result that the Parthenon, the principal structure on the Acropolis and by general acclaim the supreme monument of Greek architecture, could never have been seen in ancient times in any harmonious relation to neighboring buildings. It was once thought that the view of the Parthenon from the Sacred Way, which passed through the entrance gate (see p. 176), would have been partially blocked by several intervening constructions. In fact, the small, columned structure visible in the model (fig. 228) directly in front and to the right of the Parthenon is a propylon or gateway, and its actual form and size are still in doubt. Even more important, recent archaeological investigations by John J. Dobbins and Robin F. Rhodes have shown that the projecting wing of the Sanctuary of Artemis Brauronia, whose eastern wall is shared by the Chalcotheca (Bronze Storeroom), as seen on both model and plan (map 7), constitutes the final architectural phase of the sanctuary, built after the construction of the Parthenon. So even if the projecting wing blocked the view at some later date, it did not when the Parthenon was built. The initial view of the Parthenon, to worshiper and casual visitor alike, from the northwest corner, would have been as

clear and open as it is now. The great structure, seen in all its cubic majesty from front and side at once, would have seemed to grow naturally from its rocky pedestal. The slight leaning of the outer columns inward, which lessens nearer and nearer to the center of the west front, has the effect of increasing the apparent height of the building above us as we approach from the considerably lower entrance gate, and we may presume that this is just what the architects intended. Phidias' colossal bronze statue of Athena Promachos—cast from the melted-down weapons of the defeated Persians, armed with gilded helmet, breastplate, shield, and spear, and visible to ships far out at sea—would have seemed to flank and protect this sanctuary of the patron deity of the Athenians.

From a modern point of view the other aspects of the Parthenon were not quite so happily situated. The south colonnade was too close to the rampart to afford comfortable visibility, but even this fact would have had the advantage of directing the glance of anyone skirting the temple to the south upward toward the frieze around the cella wall. The north colonnade was favored by a broad, open area, but the space before the east front, the principal entrance, was too restricted to afford what we would call a good view (the small round temple visible in fig. 228 is a Roman addition). Clearly the Greeks were able to conceive to their satisfaction a mental image of a building in its entirety even from fragmentary views. But the crystalline architectural shapes of the Periclean buildings, even in their present ruinous condition, tower in unexampled majesty above the city and the narrow plain; as if set down on the great rock by a divine hand, they vie with the surrounding mountains, without recognizing the limitations of nature, except here and there to exploit them.

Most of the smaller structures of the Acropolis are known today only through excavations, and the statues that once adorned it are lost without a trace. But the Parthenon was preserved for centuries as a religious building. It was converted successively into a Byzantine church, a Catholic church, and a mosque, in which latter phase it sported a minaret. Although the interior had been repeatedly remodeled, the exterior remained intact with all its sculptures in place until 1687. The Turks, at that time at war with the Venetians, were using the temple as a powder magazine. A Venetian mortar shell struck the building, and the resultant explosion blew out its center. The Venetians carried the destruction a step further in an ill-fated attempt to plunder some of the pedimental statues, which fell to the rocky ground in the process of removal and were dashed to pieces. In 1801–3 Thomas Bruce, Lord Elgin, a British diplomat, saved most of what remained of the sculptures from possible destruction in the disordered conditions then prevailing in Athens by removing many statues and reliefs to London. In the present century the north colonnade has been carefully set up again, almost entirely with the original drums, and work has begun on the south colonnade.

Pericles is believed to have placed the Athenian sculptor Phidias in general charge of all of his artistic undertakings. It is noteworthy that he did not choose either of the great sculptors of the single athletic figure, Myron and Polykleitos, who were in their prime. The principal designer of the Parthenon appears to have been the architect Iktinos, working in a still imperfectly understood partnership with Kallikrates. Construction began in 447 B.C. and was finished in the extraordinarily brief time of nine years, save for the sculpture, which was all in place by 432 B.C. Iktinos utilized and extended the foundations of the older temple of Athena for his new structure, which was not called the Parthenon (parthenos, meaning "virgin," referring to Athena) until much later; originally, the

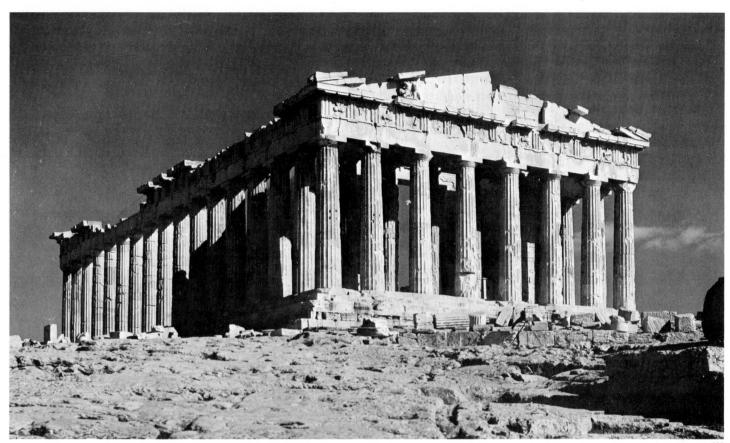

229

title was applied only to the treasury. While the dimensions of the "great temple," as the inscriptions call it, are not much larger than those of the Temple of Zeus at Olympia, it must have looked far larger. It is a regular Doric temple (figs. 229, 230), but differs from most of its predecessors in having eight rather than six columns across the front, and seventeen rather than thirteen along each side. The columns are far higher in proportion to their thickness than earlier Doric columns, and this greater slenderness is matched by a decrease in entasis and in the projection of the capitals, as well as in the mass and weight of the entablature. A glance at the Temple of Hera I (see fig. 194) at Paestum shows how much Greek architecture evolved in little more than a century. The wonderful sense of unity, harmony, and organic grace experienced by visitors to the Parthenon derives largely from the infinite number of refinements in the traditional elements of the Doric order. For example, the stylobate is curved upward several inches in the center to avoid the appearance of sagging, the columns lean progressively inward as we approach the corners (see page 170 for a suggested explanation), and the intercolumniations are progressively narrower toward the ends. Few of these refinements are immediately visible, but a great many have been measured, and even the most minute ones play their part in the total effect of the building. The whole structure, even the roof tiles, was built of Pentelic marble.

The Parthenon: Sculpture. The decoration of the Parthenon was by far the most ambitious sculptural program ever undertaken by the ancient Greeks. The east and west pediments were filled with over-lifesize statues; the ninety-two metopes were sculptured in high relief; and a continuous frieze in the Ionic manner, uninterrupted by triglyphs, ran right round the building along the top of the cella wall for a total length of 550

- 229. IKTINOS and KALLIKRATES. The Parthenon, Acropolis, Athens (view from the west and north). c. 447–438 B.C.
- 230. Plan of the Parthenon, Acropolis, Athens1. Reflecting pool 2. Statue of Athena Parthenos 3. Treasury

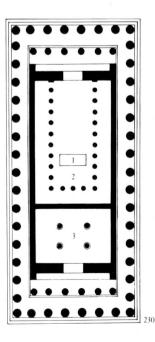

feet. The backgrounds of the pediments were painted bright blue, those of the metopes and friezes red. Many ornaments were added in metal. Hair and eyes were painted, and the capitals were decorated with ornament in bright colors. The whole building must have shone with color.

The interior of the cella, entered only from the east, was intended to house the colossal statue of Athena by Phidias. We do not know what the ceiling was like, but it was certainly supported by two superimposed Doric colonnades like those still in place in the Temple of Aphaia at Aegina and the Temple of Hera II at Paestum (see figs. 199, 220). No access existed between the cella and the treasury, which was entered from the west and was apparently the principal treasury of the city. Its ceiling was supported by four Ionic columns, the first in any Athenian temple.

The magnificent array of sculptures for the Parthenon was produced in only twelve years. The belief that they were all executed under the general supervision of Phidias—or at the least show aspects of his style and artistic intention—is supported by a remarkable unity of taste and feeling that runs through the entire series. But the scope of the undertaking and the speed of its execution must have required an army of artists; some of these were clearly sculptors of great ability, others were stonecutters, presumably executing ideas sketched out by the major masters in clay models or perhaps working from drawings on papyrus. That all of these preparatory studies could have been made by Phidias himself, who was then busily occupied in work on his statue of Athena, is unlikely. The surviving statues for the two pediments, in spite of the heavy damage they have sustained, are among the most majestic in the whole history of art. The east pediment represented the Birth of Athena, the west the Contest Between Athena and Poseidon. From the individual statues, as well as from sketches made by a French traveler when they were still in place (fig. 231), it is clear that the compositions were not symmetrically organized on either side of a static central figure in the manner of the Olympia

231. JACQUES CARREY. Contest Between Athena and Poseidon (drawing of the west pediment of the Parthenon, Acropolis, Athens). 1673. Bibliothèque Nationale, Paris

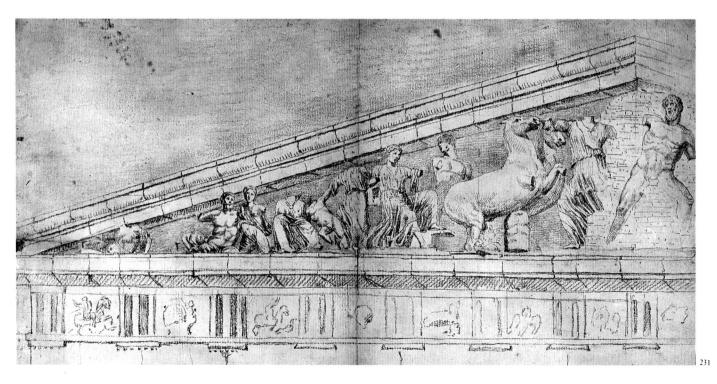

pediments (see figs. 222, 223), but were at every point based on action, which came to its climax toward the center.

Some of this movement runs through the *Three Goddesses* (fig. 232) probably Hestia, Dione, and Aphrodite—who recline nobly in a group that sloped along with the downward movement of the raking cornice of the east pediment. Aphrodite rests her elbow and shoulders against her mother, Dione, while Hestia turns toward the center of the composition. The intricate drapery folds cling to the figures and reveal rather than conceal the splendid masses of the bodies and limbs. As may be expected, the folds no longer show a trace of the ornamental drapery forms of the Archaic, but neither does the drapery fall into the simple, naturalistic folds of the Severe Style. It seems to be endowed with an energy of its own, and to rush around the figures in loops and even in spirals, as if communicating to the very corner of the pediment the high excitement of the central miracle, the birth of Athena from the head of Zeus. From this moment onward drapery movement becomes a vehicle for the expression of emotion, not only in Greek art but also in that of most subsequent civilizations.

The swirling lines of crumpled drapery have still another function. Like the Diskobolos of Myron (see fig. 214) on a smaller scale, indeed like any Classical composition, the Parthenon pediments crystallize for eternity a moment of dynamic action, this time the interaction of many figures. Their compositions will dissolve once this moment has passed. The drapery lines serve as lines of energy, letting us follow the trajectory of all the interacting forces. Finally, speeding around the figures, the drapery folds allow us to grasp the fullness of their majestic volumes. But action and emotion are exercised by the poses and drapery folds alone: wherever preserved, anywhere in the sculptures of the Parthenon, the faces maintain a complete calm, as masklike as those of the Severe Style.

A splendid male figure, perhaps Herakles (fig. 233), leans back on one

232. Three Goddesses, from the east pediment of the Parthenon, Acropolis, Athens. c. 438–432 B.C. Marble, over-lifesize. British Museum, London

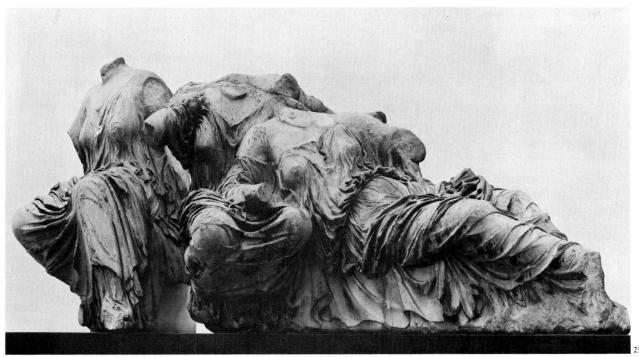

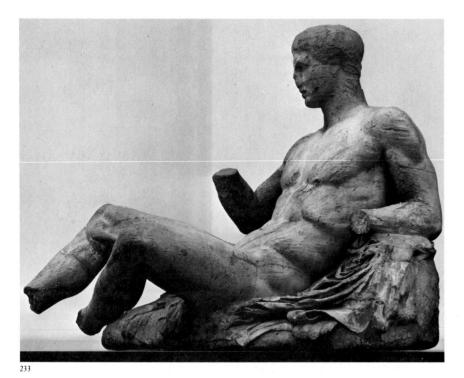

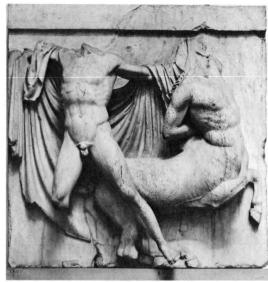

elbow in lordly ease in the opposite corner of the pediment (most of the intervening figures are lost). He is as powerful as any of the nudes of the Severe Style, if less ostentatiously athletic. New and unexpected is the beautiful relaxation of the abdominal muscles below the rib cage, which seems almost to expand with an intake of breath. In consequence of the restful pose, new and smoother transitions carry the eye from one muscular or bony form to the next. No nobler embodiment of the Greek ideal of physical perfection and emotional control can be imagined.

The metopes all depicted battle scenes—Greeks against Trojans, Greeks against Amazons, gods against giants, Lapiths against centaurs. Like the pedimental compositions, and in contrast to the static figural groups of Olympia, the metopes are dynamic scenes, each crystallizing in a composition of perfect balance a single moment of interaction. In the interests of legibility from the ground more than forty feet below, and in order to fit into the ninety-two restricted spaces, the narratives were mostly broken into pairs of figures in hand-to-hand combat, which "our side" does not invariably win. Incredible richness of invention characterizes the many variations on this single theme. One of the finest (fig. 234), in spite of the destruction of the heads, shows a Lapith in a proud action pose, charging toward his right, with his head turned over his left shoulder, as he drags a centaur backward by the hair. The tension of the composition, in which the figures are pulled together by the force of their own opposite movements, is expressed in curves of the greatest beauty; these are amplified by the broad sweep of the Lapith's cloak, which falls into crescent-shaped folds decreasing steadily in curvature as they move upward.

The frieze around the top of the cella wall (fig. 235) represented the Panathenaic Procession—an annual festival in which the youth of Athens marched to the Acropolis to pay homage to the city's patron deity and in which, every fourth year, a new peplos was brought to clothe her ancient wooden image in the nearby Erechtheion. The procession, of necessity, was not represented as if taking place at one moment but as a cumulative experience, because the observer moving around the building could see only one section at a time. Some of the most impressive parts of this long

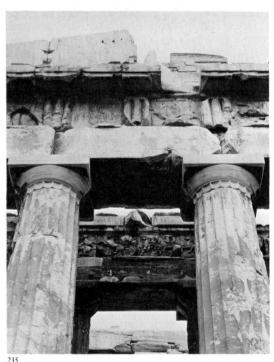

- 233. Male figure (perhaps Herakles), from the east pediment of the Parthenon, Acropolis, Athens. c. 438-432 B.C. Marble, over-lifesize. British Museum, London
- 234. Lapith Fighting a Centaur, fragment from a metope on the south side of the Parthenon, Acropolis, Athens. c. 440 B.C. Marble, height 56". British Museum, London
- 235. West entrance of the cella of the Parthenon, Acropolis, Athens, showing a portion of the Panathenaic Procession. c. 440 B.C. Marble

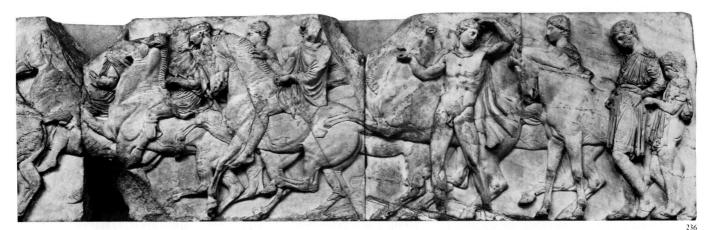

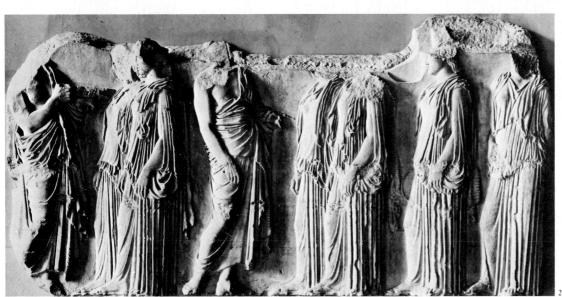

composition are those representing riders on horses and youths leading horses in a splendid flow of overlapping figures suggesting great depth (fig. 236). In order to maintain uniformity of scale throughout the frieze, the sculptors adopted a convention, followed throughout Greek relief sculpture, of reducing the size of the horses as compared with the riders. Very beautiful is the passage (fig. 237) originally over the east doorway to the cella, where the procession converges from both sides of the building. The standing figures show all the new ease and grace of posture and are clothed in drapery that flows with all the new rhythmic beauty. Admittedly the frieze, in the only location permitted by the rules of the Greek orders, was not placed in the best position for perfect visibility, being some thirty feet above the stylobate and under the shadow of the peristyle ceiling. Nonetheless, it was hardly as difficult to view as some writers maintain. At most moments of the day, the strong Greek sunlight, reflected upward from the marble stylobate and (on the south side) from the cella wall, must have cast a soft, diffused light into the shadow under the marble ceiling beams and slabs. Moreover, the heads and shoulders of the figures were carved in a higher projection than the lower portions; and, finally, the red background set off all the figures with considerable sharpness.

Once inside the cella the observer stood in the awesome presence of Phidias' forty-foot-high statue of Athena, dimly illuminated, since the only light in the windowless temple came from the east door and was, of

- 236. Mounted Procession Followed by Men on Foot, fragment of the Panathenaic Procession, from the north frieze of the Parthenon, Acropolis, Athens. Marble, height 41¾". British Museum, London
- 237. Maidens and Stewards, fragment of the Panathenaic Procession, from the east frieze of the Parthenon, Acropolis, Athens. Marble, height c. 43". The Louvre, Paris

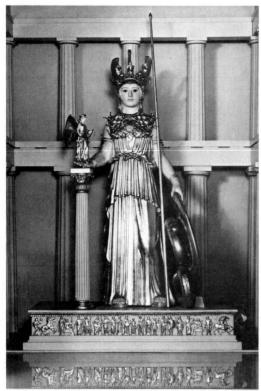

course, at its strongest in the morning. From literary accounts of the statue and from tiny, ancient replicas, a remarkable small-scale model has been made (fig. 238). With this as a basis, and with a good deal of poetic imagination, one can form some idea of what must have been the grandeur of the original. Thin plates of ivory and sheets of gold attached to plates of wood were arranged on a framework of great complexity so that it looked as though all the flesh portions were solid ivory and all the drapery solid gold. A shallow basin of water in the floor before the statue served as a humidifier to protect the ivory in the dry climate of Athens and also, doubtless, as a pool to mirror the majestic goddess and as a source of reflected light to play upward on her features. No large-scale copy remains to suggest how her face may have looked, but we do have a convincing Roman marble copy of the head of the destroyed Lemnian Athena by Phidias (fig. 239), also once on the Acropolis. Although this work was much smaller and thus more informal in pose than the hieratic Athena Parthenos, we can glean from its calm, clear, harmonious features at least a hint of the beauty we have lost. Athena's left hand sustained a shield above the folds of the sacred serpent, and on her extended right hand stood a golden statue of Victory six feet tall. So enormous was the Athena Parthenos that splendid reliefs by Phidias decorated both sides of the shield, the pedestal, and even the thickness of the soles of the goddess' sandals. According to ancient literary sources, Phidias also executed an even finer gold-and-ivory statue of the enthroned Zeus for the Temple of Zeus at Olympia. It was so tall that if Zeus had risen to his feet his head would have burst through the temple roof.

Although we possess not a scrap of sculpture that we can with certainty attribute to Phidias' own hand, the work done under his direction and possibly from his models on the Parthenon is consistent with the architecture of the building and with the literary accounts of Phidias' style. He invented new ways of combining figures on foot and on horseback into free action groups; he was responsible for a new majesty of proportions and harmony of movement; he was the first to use drapery in order to reveal the masses of the figure, increase the impression of movement, and express the drama of the subject; he was responsible for a new dynamic harmony between figural compositions and architecture. Clearly, we are confronted by a universal genius, the first in history, the only one in the visual arts in the ancient world, and probably one of the greatest who ever lived. It is sad to record that Phidias, like so many of the great men of Athens (one recalls Themistocles, who was exiled; Socrates, who was forced to drink poison), met an ignominious end. He was imprisoned (or perhaps exiled) on trumped-up charges of impiety by jealous citizens of the very city to whose lasting glory he had contributed so much.

The Propylaia. The Acropolis was entered through a monumental gateway called the Propylaia, constructed—doubtless under Phidias' supervision—by the architect Mnesikles from 437 to 432 B.C., while the sculptures of the Parthenon were being completed. The problems posed for the erection of a suitable gateway were not easy. One could approach the site only by means of the Sacred Way, a ramp not zigzagging steeply up the rock as it does today but ascending sharply from the west (then the city center) and turning from about eighty meters out, for a dramatic rise straight to the entrance. A formal entranceway was clearly needed. The solution was a central pedimented Doric portico of six columns facing west, flanked by two smaller and lower Doric porticoes at right angles (figs. 240, 241). Pedestrians could climb steps on either side, but a ramp

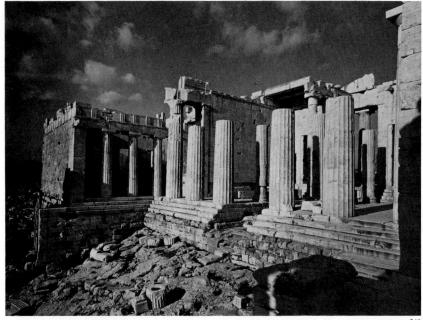

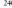

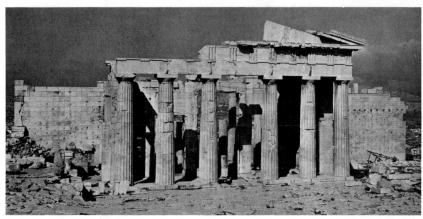

24

was required for horses and sacrificial animals, and to accommodate this the central intercolumniation was widened by one triglyph and one metope—not an ideal solution, perhaps, but the only one consistent with the strict principles and limited vocabulary of the Doric order. Inside the building the roadway was lined with Ionic columns, three on each side, and the inner gateway was again a pedimented Doric portico. This inner gateway was to have been flanked by two halls, whose prospective use is not known; construction was halted by the outbreak of the Peloponnesian War, and the halls were never built. Whether seen from below as one toils up the ramps, or from the higher ground within the Acropolis, the exterior of the Propylaia is noble and graceful; the columns are similar in their lofty proportions and elegance of contour to those of the Parthenon. The small flanking structure to the north (on the south only the portico was built) was a picture gallery, the earliest one on record, erected to accommodate paintings on wood to be set around the marble walls below the windows.

The Temple of Athena Nike. About 425 B.C., four years after the death of Pericles, the tiny Temple of Athena Nike (Victory) was constructed, presumably by Kallikrates, co-architect of the Parthenon, on the bastion flanking the Propylaia to the south in celebration of the victories of Alci-

- 238. Phidias. Athena (reconstruction), from the cella of the Parthenon. c. 438–432 B.C. Wood covered with gold and ivory plating, height c. 48". The Royal Ontario Museum, Toronto
- 239. Phidias. *Lemnian Athena*. c. 450 B.C. Roman marble copy of the bronze original, height 171/4". Museo Archeologico, Bologna
- 240. MNESIKLES. The Propylaia, Acropolis, Athens (view from the southwest). c. 437–432 B.C.
- 241. The Propylaia, Acropolis, Athens (view from the east)

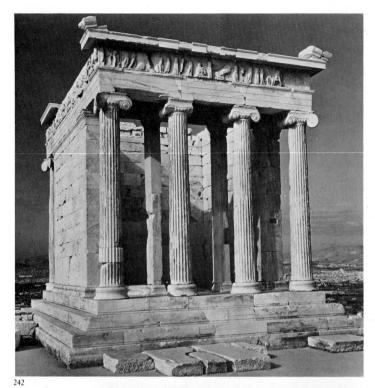

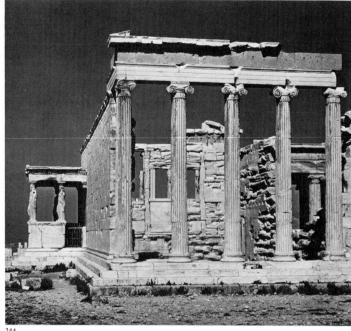

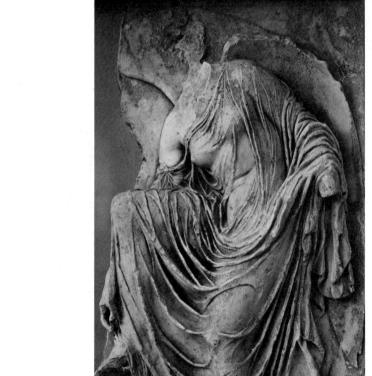

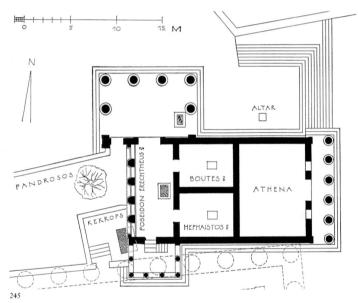

- 242. Kallikrates. Temple of Athena Nike, Acropolis, Athens. c. 425 B.C.
- 243. Victory Untying Her Sandal, from the parapet of the Temple of Athena Nike, Athens. c. 410 B.C. Marble, height 42". Acropolis Museum
- 244. The Erechtheion, Acropolis, Athens (view from the east). c. 421–405 B.C.
- 245. Plan of the Erechtheion, Acropolis, Athens
- 246. Porch of the Maidens, the Erechtheion, Acropolis, Athens
- 247. PAIONIOS. *Victory*, from Olympia. c. 420 B.C. Marble, height (including base) 85". Archaeological Museum, Olympia

biades, which brought about a temporary lull in the catastrophic Peloponnesian War. The amphiprostyle temple has four Ionic columns on each portico (fig. 242). The proportions are unusually stocky, possibly so as not to contrast too strongly with the Doric columns of the Propylaia. The little structure was dismantled by the Turks and its stones used for fortifications; it was reassembled only in the nineteenth century. The finest sculptures carved for this temple originally decorated the parapet and showed personifications of Victory either separately or before Athena. These reliefs were apparently carved by masters trained initially under Phidias in the sculpture of the Parthenon. The loveliest is the exquisite Victory Untying Her Sandal (fig. 243), in which the transparent drapery of the Phidian style is transformed into a veritable cascade of folds bathing the graceful forms of the Victory. It has been suggested that the taste of the sculptor Kallimachos, credited with the invention of the Corinthian capital, is responsible for this refined, late phase of fifth-century style, which, however ingratiating its melodies may be, has certainly lost the grand cadences of Phidias.

The Erechtheion. The final fifth-century building on the Acropolis, the Erechtheion, built from 421 to 405 B.C., was named after Erechtheus, a legendary king of Athens; it contained the ancient wooden image of Athena and possibly sheltered the spot where the sacred olive tree sprang forth at Athena's command. Rarely for a Greek temple, and presumably because of the now not entirely understood requirements of the religious rites for which it was designed, the Erechtheion is strikingly irregular. The four rooms culminate in three porches of sharply different sizes facing in three separate directions (figs. 244, 245). Yet from any view the proportions are so calculated that the effect is unexpectedly harmonious. Two porticoes are Ionic, with extremely tall, slender columns and elaborate capitals; the taller portico had four columns across, the smaller six (see fig. 242; one column is lost). On the third portico (fig. 246), instead of columns, six korai uphold modified Doric capitals and an Ionic entablature, in the manner of the caryatids in the Treasury of the Siphnians at Delphi (see fig. 198). Despite disfiguring damage, the figures stand so calmly that the masses of marble above them seem almost to float. Anyone who has ever watched Mediterranean women carry heavy loads on their heads without the slightest apparent effort will recognize the pose.

MASTERPIECES FROM THE AGE OF PERICLES Perhaps the most spectacular outgrowth of the Phidian style was Paionios' *Victory* (fig. 247), a marble statue set up at Olympia about 420 B.C., on a tall shaft, triangular in cross section, with its apex presented to the spectator so that in most lights it would almost disappear. The impression was thus given that the Victory—with arms and wings (now lost) extended, tunic pressed by the breeze against her full body, and her drapery billowing behind in the wind—were really flying. Although the experiment was daring, one misses the grandeur of the Phidian style, whose absence from this work makes it seem a bit pretentious.

The deeper aspects of Phidian style seem to have been better understood by modest artisans, such as the sculptors of the grave stelai carved in great numbers in Athens; these were often for export and uniformly of high quality. An especially touching example is the *Stele of Hegeso* (fig. 248), which shows the deceased seated in a chair holding a piece of jewelry (painted, not carved) and accompanied by a standing girl, perhaps a daughter. The gentle melancholy of the group is not achieved by expressions—as usual in the fifth century, the faces are almost blank—but rather

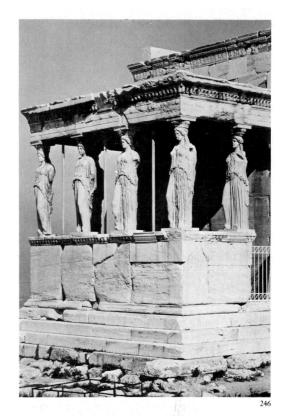

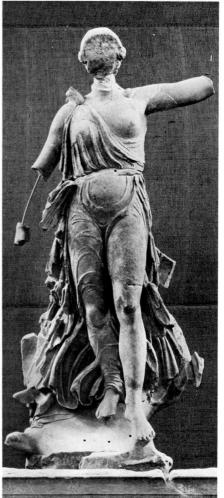

247

by the rhythm of their poses, especially the bowed heads suggesting resignation. The sculptor, who may well have been among the host of stonecutters trained on the Parthenon, has an unusual command of space. He has placed his two figures so that the back of the standing woman and the chair of Hegeso overlap the frame, causing them to emerge into our space. Yet the veil over Hegeso's head is so slightly projected from the marble background as to indicate an airy space within the frame.

Although the principles of the Doric and Ionic orders as applied to temples were by now firmly established, experimentation was still possible. One of the most striking variants, dating from around 420 B.C., the Temple of Apollo at Bassai in the wilds of Arcadia, has been attributed to Iktinos himself. The peripteral exterior is not exceptional (fig. 250); in fact, it shows fewer refinements than the Parthenon. The dramatic effect of the interior, however, is utterly new (fig. 249). The cella was lined with Ionic columns, engaged to the walls by projecting piers, supporting capitals with three equal faces. At the west end stood at least one, perhaps three, Corinthian columns, the earliest known. The abacus of a Corinthian capital (see fig. 254) resembles that of the Ionic, but the volutes are rudimentary; the distinguishing feature is the profusion of carved acanthus leaves (the acanthus is a Mediterranean plant of the thistle family) enveloping it, in at first one row, later two, and giving a rich and splendid appearance. The frieze above the columns made the cella interior even more exciting. It was carved in high relief with the typical subjects of battles between Lapiths and centaurs, Greeks and Amazons (fig. 251), but with unusually energetic poses and sharp exaggerations of movement and gesture-still in the Phidian tradition, but with a touch of wildness unexpected after the equilibrium of the Parthenon metopes.

Another large Doric temple at Segesta (fig. 252), in Sicily, commenced possibly by Attic builders for a local community in the process of Hellenization, was abandoned for unknown reasons in an unfinished condition; the cella was, in fact, not even started. We have, therefore, the privilege of seeing the columns already set up, preparatory to being fluted in place, and the stones of the stylobate retain the bosses left to provide holds for the tackle used in transporting them to this wild, lonely spot.

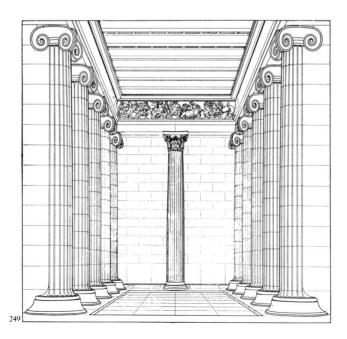

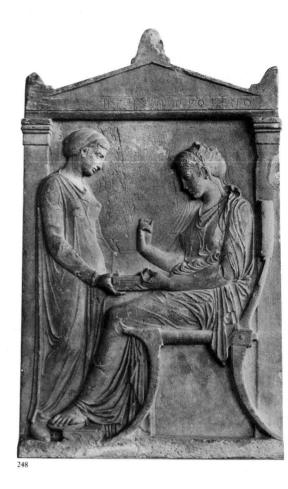

248. Stele of Hegeso, from Athens. c. 410-400 B.C. Marble, height 59". National Archaeological Museum, Athens

249. IKTINOS. Interior, Temple of Apollo, Bassai, Greece (Architectural reconstruction after F. Krischen)

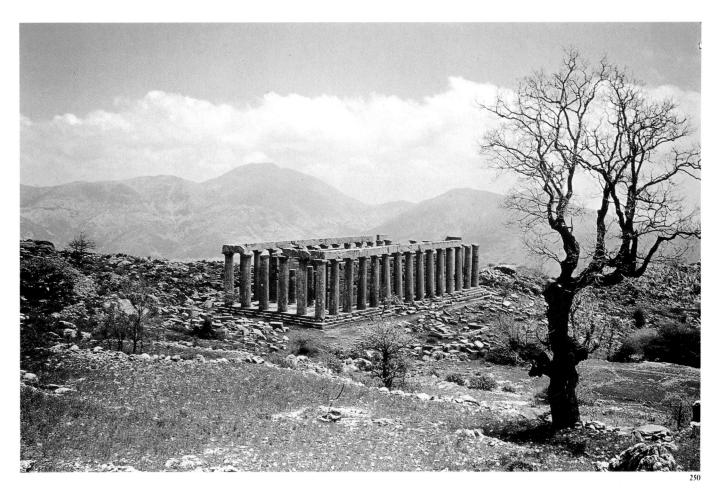

250. IKTINOS. Temple of Apollo, Bassai. c. 420 B.C.

Ancient literary accounts have much to say about the advances made by painters in the second half of the fifth century, especially a new realism in depicting everyday life and a new ability in rendering the expression of intense emotion. Even more important, the masters of the period are credited with having invented the means of painting light and shade in order to give form its full roundness and set it into depth. No Classical paintings showing these new achievements have yet come to light. Their effect on vase painting seems to have been to weaken even more the firm linearity and the attachment of flat design to the vase surface, which had been the delights of Archaic vase painting, and to lure the best masters away from that limited art to more exciting new fields. Only faint hints of the new pictorial freedom can be detected in the white-ground lekythoi (vases made to contain oil or perfume). In these, a painted white background could be used because they were intended as funeral gifts and would never be washed. In the enchanting Muse on Mount Helikon (fig. 253) by the Achilles Painter, we can see a new softness of form and a wavering, sketchy line which suggests space and light.

Looking back at the meteoric development of Greek art in the fifth century, it is sobering to reflect that an Athenian born toward the end of the Archaic period could have watched during a long lifetime the entire evolution of the Classical style.

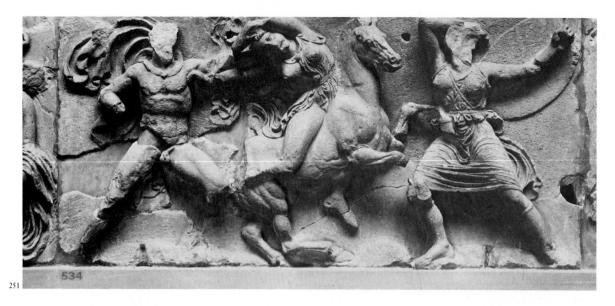

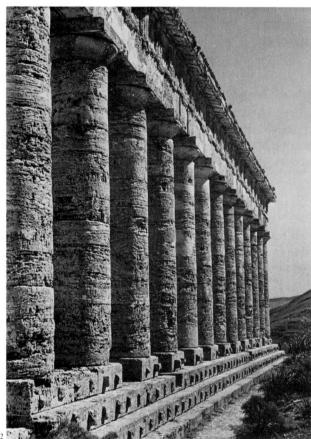

- 251. Battle of Greeks and Amazons, portion of a frieze from the cella of the Temple of Apollo, Bassai. c. 420 B.C. Marble high relief, height 251/4". British Museum, London
- 252. Unfinished temple, Segesta, Sicily. c. 416 B.C.
- 253. The Achilles Painter. *Muse on Mount Helikon* (portion of a lekythos). c. 440–430 B.C. Height of lekythos c. 14½". Staatliche Antikensammlungen und Glyptothek, Munich

Toward the end of the fifth century B.C. a succession of military disasters stripped Athens of her imperial role and left the city a prey to severe social disorders. First Sparta, then Thebes exercised leadership among the Greek city-states in the first half of the fourth century, except for the Ionian cities of Asia Minor, which submitted to Persian rule. By the middle of the century the final threat to Greek independence had appeared. Philip II, king of Macedon, ruler of a land just to the north of Greece which had previously been considered outside the sphere of Hellenic civilization, established Macedonian primacy over the Greek mainland. His son, Alexander III (the Great), in a series of lightning military ventures absorbed and then attempted to Hellenize the entire Persian Empire, carrying his domination even into India. Alexander adopted Persian dress and court customs, claimed Zeus as his father, and had himself worshiped as a god in the manner of Mesopotamian and Egyptian monarchs. Despite her diminished political power, Athens remained the center of Greek intellectual life. The foundations of Western philosophy were laid in this period in the work of Plato and Aristotle, who first submitted traditional standards to the questioning test of reason. Under the changed circumstances, the balance, integration, and control of the Classical style so largely a product of Athenian nationalism—were sure to be dissolved in the expanded world of Alexander's conquests, to be replaced by wholly new interests in space, movement, and light.

ARCHITECTURE Clearly, the fourth century was not to be a period of ambitious building programs in mainland Greece, but some splen-

The Classical Period— The Fourth Century

- 254. Polykleitos the Younger. Tholos of Epidauros (reconstructed section). c. 360 B.C.
- 255. Monument of Lysikrates, Athens. c. 334 B.C.

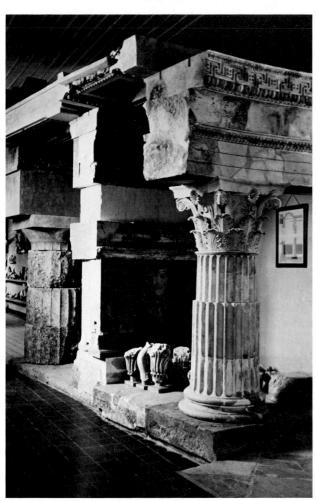

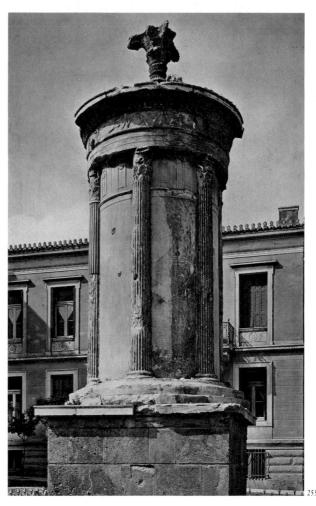

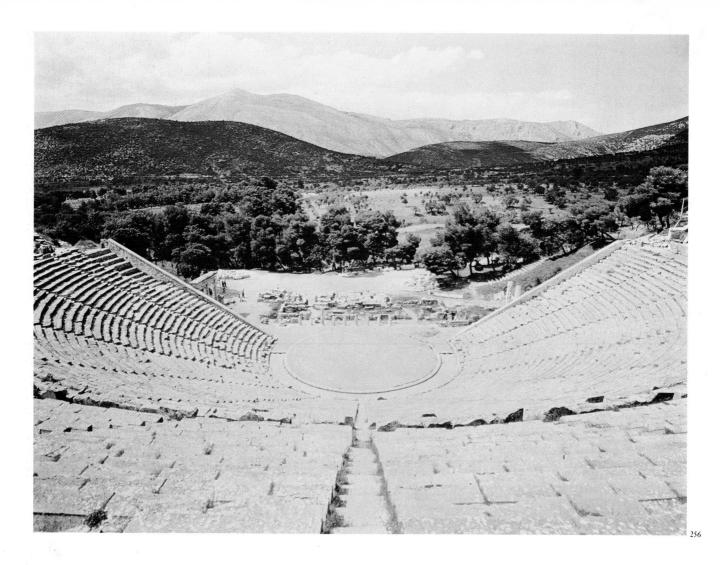

256. POLYKLEITOS THE YOUNGER. Theater, Epidauros. c. 350 B.C.

did new structures did make their appearance. One of the handsomest must have been the tholos (circular building), dating from about 360 B.C., at Epidauros. The tholos plan, derived from the round huts and tombs of Helladic times, could be devoted to a variety of purposes. For example, a fifth-century tholos in Athens served as a dining hall for the city administration. The Tholos of Epidauros, designed by Polykleitos the Younger as a place for sacrifices, consisted of a cylindrical wall surrounded by an outer Doric peristyle supporting a conical roof. The inner colonnade was composed of Corinthian columns—the first such colonnade we know. Sections of this tholos have been recomposed (fig. 254) and show extreme elegance and refinement of carving. The Corinthian capital already appears in very much the form later adopted by the Romans and revived in the Italian Renaissance, with two superimposed, staggered rows of acanthus leaves. The volutes are undercut, and so is each leaf, curving over at the tip with a jagged contour of great technical virtuosity. The earliest example we know of a Corinthian peristyle on the exterior of a building is the Monument of Lysikrates at Athens (fig. 255), a charming little structure intended to support the tripod Lysikrates won in 334 B.C. when he provided a chorus for the theater in Athens. The Corinthian columns are really only half columns, engaged to the central cylinder, which although hollow has no entrance; the conical roof, a single block of marble, supports an acanthus pedestal resembling a somewhat overblown Corinthian capital.

A new type of building that appeared in the fourth century is the

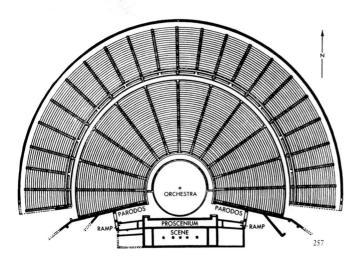

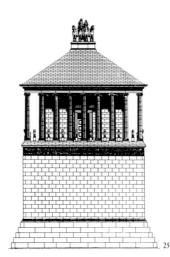

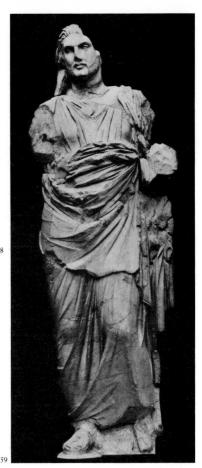

monumental outdoor theater. The largest and finest of these—so considered even in antiquity—is the well-preserved theater at Epidauros, designed, like the Tholos, by Polykleitos the Younger (fig. 256). During the great age of Greek drama in the fifth century, theaters had consisted of mere rows of wooden benches on a hillside, grouped roughly around the *orchestra* (meaning "dancing place"), a circular area where the chorus and the actors—never more than three at a time—sang and spoke. This idea is monumentalized at Epidauros in the form of a half cone of some fifty rows of marble benches separated by radiating aisles (fig. 257), still built around slightly more than half the orchestra circle. Originally, the theater had no stage; the building behind the orchestra circle supported temporary scenery. For all its simplicity, the harmony and grandeur of the space are as impressive as its acoustics. A word uttered in the orchestra circle can be clearly heard in the farthest reaches of the vast space.

The traditional elements of Greek architecture were forced to perform new functions in buildings erected outside of Greece. The most spectacular of these was the Mausoleum at Halikarnassos; the familiar name derives from its function as the tomb of Mausolus, prince of Caria in Asia Minor, who died in 353. Work began during his lifetime and continued after his death under the direction of his widow, Artemisia. The tomb, some 150 feet in height, was demolished by the Knights of St. John in the Middle Ages, and the pieces incorporated in their castle in the present-day port of Bodrum. Only fragments of sculpture and architecture have been recovered. Ancient literary descriptions, unfortunately, were incorrectly copied, so that it is now impossible to tell exactly what the building looked like (fig. 258 is one of several possible reconstructions). We do know that the Mausoleum had a lofty pedestal supporting a peristyle of thirty-six Ionic columns, each forty feet high, either in a single or a double row, surrounding the burial chamber. The whole was surmounted by a pyramid, in imitation of the Egyptians, culminating in a great marble chariot with four horses, presumably driven by Mausolus and Artemisia. At several still uncertain locations on the tomb, perhaps in the customary and inconvenient position at the top of the base, ran friezes representing the traditional battle subjects, carved by four of the most prominent Greek sculptors of the age.

In order really to understand the Mausoleum's sculpture preserved in the British Museum and the bare lines of the various architectural reconstructions, we must keep in mind the landscape for which the immense structure and its decorations were designed. Little is visible at the excavation today, but the site is a saddle between two hills, about three hundred

257. Plan of the Theater, Epidauros

- 258. Mausoleum, Halikarnassos (present-day Bodrum), Turkey. c. 353 B.C. (Architectural reconstruction after F. Krischen)
- Mausolus, from Halikarnassos. c. 353 B.C. Marble, height 9'10". British Museum, London

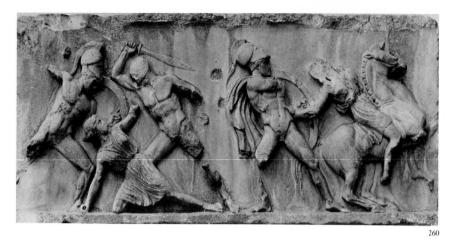

feet above the port, looking down the long harbor, flanked by hills on either side, to the distant sea. The immense space is filled with light, including that reflected from the water below, and all must have come to a dramatic climax in the towering pyramid with its culminating chariot against the sky. We do not know for certain the name of the master who executed the grand statue of Mausolus (fig. 259)—it may have been Bryaxis—but clearly it is animated by the new dramatic spirit of the time. While this realistic portrait, one of the earliest known, lacks the sense of majestic control visible in all Athenian sculpture of the fifth century, the movement of the drapery, the depth of the carving, and the intensity of the expression produce a great sense of excitement. It is instructive to compare this swaying, windblown charioteer with the serene Charioteer of Delphi (see fig. 210), of little more than a century earlier.

SCULPTURE The most eminent of the Halikarnassos sculptors was Skopas, born on the island of Paros but trained in Athens, known in antiquity for his ability to render movement and to convey drama. He may have been responsible for the Battle of Greeks and Amazons (fig. 260), in which the free movement of the figures in space is carried even beyond the stage of the frieze at Bassai (see fig. 251). In the section illustrated here, two Greek warriors are about to slay an Amazon who has fallen to her knees and cries for mercy, while a third Greek pulls an Amazon from her horse. The impression of speed is produced largely by the wide spacing of the figures, which leaves considerable areas of blank background to be traversed. Despite their mutilation, fragmentary heads from the Temple of Athena Alea at Tegea (fig. 261) show how Skopas revealed new depths of passion by means of an exceptionally deep eye cavity, thus producing a powerful shadow around the eye and intensifying the expression of wildness. Even the surging rhythms of the ornaments on the helmet are used to heighten the excitement of the moment.

A complete contrast to Skopas is furnished by the Athenian Praxiteles, whose fame was based on the grace and softness of his style. His most celebrated work in antiquity was the marble statue of Aphrodite in her sanctuary at the city of Knidos in Asia Minor, which we know only from Roman copies (fig. 262). This is the first nude statue of the goddess, and one of the earliest Greek statues of a female nude, which in itself indicates a sharp change in the status of women, increasingly liberated from the gynecaeum. Compared to the partially nude female figures of the fifth century, and in spite of faulty restorations (the head comes from another statue, and the hands and feet are new), the copy shows a greater fullness of forms and an almost imperceptible transition from one form to the next. The result is a wholly new sense of warmth and life.

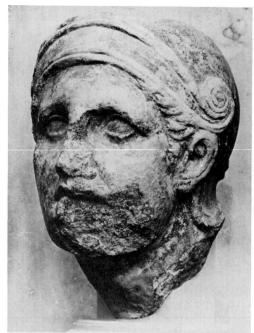

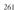

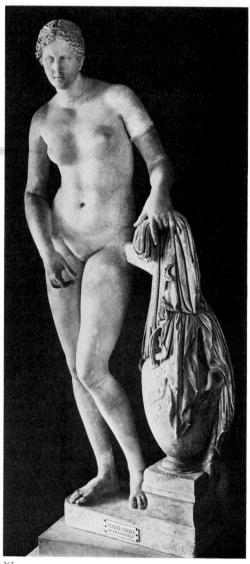

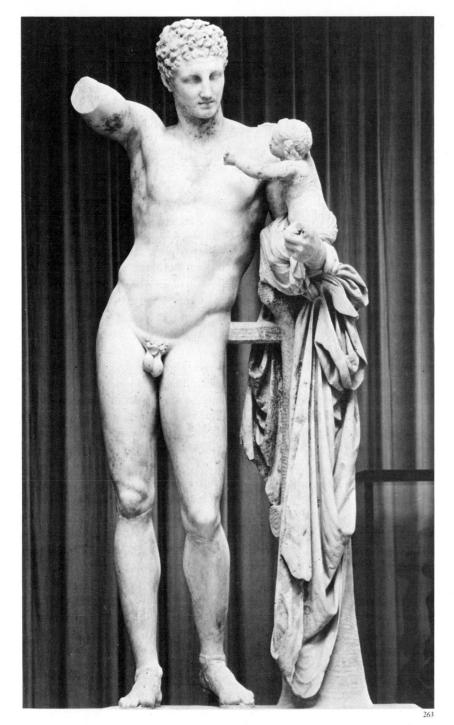

In recent years the beautiful *Hermes with the Infant Dionysos* (fig. 263) at Olympia has been dismissed as a Hellenistic or even Roman copy of a lost original by Praxiteles, but the quality of this statue is so much higher than that of any ancient copy known to us that this judgment is hard to accept. The least that can be said of the *Hermes* is that no other surviving ancient work approaches its consistent pitch of refinement in the treatment of surface. Apparently, Praxiteles was one of the first to become fully aware of the crystalline and translucent nature of marble, and to discover a way of exploiting its special quality by softening and veiling all transitions, abrading and polishing them until sharp edges could no longer be seen. Eyelids, for example, and the edges of lips are deliberately blurred, as is the transition from muscle to muscle in the soft and glowing torso and limbs of the god. Shadows play gently over the fluid

- 260. Battle of Greeks and Amazons, portion of a frieze from the Mausoleum, Halikarnassos. Middle 4th century B.C. Marble, height 35". British Museum, London
- Skopas. Head, from the Temple of Athena Alea, Tegea, Greece. c. 350–340 B.C. Marble, height c. 113/4". National Archaeological Museum, Athens
- PRAXITELES. Aphrodite of Knidos. c. 350 B.C. Roman marble copy of marble original, height 80". Vatican Museums, Rome
- 263. Praxiteles. Hermes with the Infant Dionysos, from Olympia. c. 330–320 B.C. Marble, height 85". Archaeological Museum, Olympia

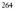

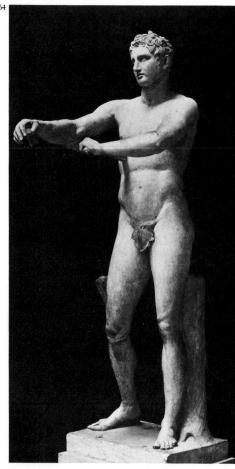

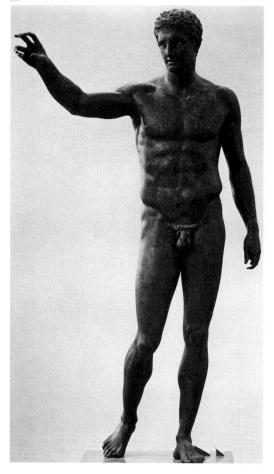

surfaces, and light is reflected from within the crystalline structure of the marble. Even the curly locks of the god's hair are softly sketched in the marble, particularly when compared to the still clear-cut definition of hair in the fifth century. The subject itself, far from the majestic themes of the fifth century, has a quality of gentle, aesthetic dalliance. Hermes dangles a bunch of grapes to tease the infant Dionysos; a dreamy half smile plays about his luminous features. In many ways this kind of attitude and treatment seem to have more in common with the nature of painting than with sculpture, and is thus often called "pictorial." Soon such pictorial ideals were to be pursued in a spectacular manner by Hellenistic and Roman sculptors, and later they were revived briefly in the Florentine Renaissance and triumphantly in the Italian Baroque.

The third great sculptor of the fourth century, Lysippos, took up again, but from a new point of view, the athletic themes of Myron and Polykleitos. If one judges from the surviving Roman copies, his lost bronze Apoxyomenos (fig. 264) showed a subject visible wherever athletes gathered—a young man scraping dust and sweat from his body with an Sshaped terra-cotta instrument called a strigil. Again according to the Roman copies, Lysippos employed a new system of proportion in keeping with the increased slenderness, height, and grace of Greek columns after the middle of the fifth century. The head is smaller, the torso and limbs longer and lither, the divisions between the muscles less strongly marked (in common with Praxiteles) as compared with fifth-century sculpture in general. More important, the arms are raised in such a way as to make use of the space in front of the body, thereby finally breaking through the invisible frontal plane to which even such vigorous action figures as the Diskobolos (see fig. 214) and the Zeus of Artemision (see fig. 213) had been restricted. How a Lysippan bronze statue would have looked may perhaps better be seen in the wonderful figure of a youth (fig. 265) found in the sea off Antikythera, in the wreck of a Roman vessel presumably laden with works of Greek art. Originally, the bronze did not have the greenish patina we now admire, but must have been polished to a luminous brown to suggest the deep tan of a Mediterranean youth who constantly exercised in strong sunlight. The inlaid eyes and copper lips are, luckily, still preserved. The brilliant naturalism of the work takes us across the centuries straight into a Greek palaestra.

PAINTING For no moment in the history of art, perhaps, do we mourn the disappearance of painting so keenly as for the fourth century. According to voluminous and graphic literary accounts, painters had made almost incredible strides since the not-too-distant days when Polygnotos was content to define form with line and to fill in the areas between contours with flat color. The names of many painters are known, and their styles were described in great detail. The leading master was apparently Apelles, whose studio was visited by Alexander himself. Artists no longer chiefly painted monumental murals on commission. Instead they specialized in panel paintings done on easels in the studio, working to satisfy themselves and hoping for sales to the wealthy and powerful. Painters employed either *encaustic*, using colors dissolved in hot wax and painting while the wax was still soft, or tempera, utilizing colors mixed with egg yolk. Both techniques were fairly laborious, but the effects the artists achieved were totally new. Most important, they had discovered the full meaning of light for the first time in the long story of the art of painting. They were able to indicate the source of light and follow its effects in diffusion, transparency, reflection, and cast shadow. So many of these

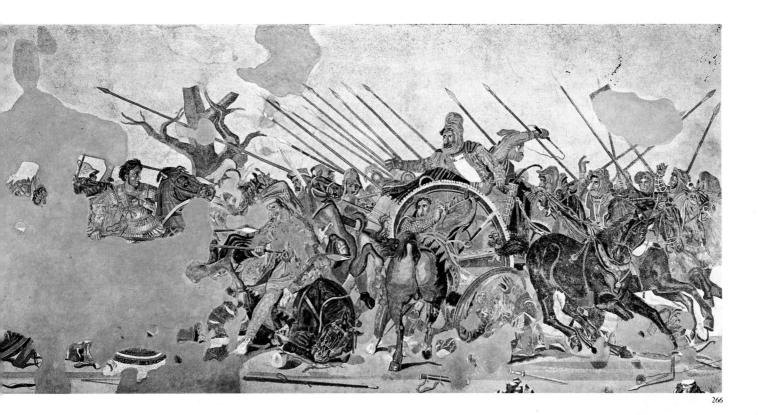

light effects turn up as common practice in the Roman paintings done at Pompeii and Herculaneum (see figs. 290, 323, 324) by anonymous provincial artists three centuries later that the literary accounts are more than believable. Furthermore, these effects correspond to those that the sculptors were seeking to achieve in marble and in bronze. The painters were also able to indicate depth, especially by means of foreshortening objects placed at an angle to the picture plane; and finally they were greatly interested in human character and emotion. Many portraits are described and many dramatic scenes in which passion was represented with great success. One extremely important device discovered by fourth-century masters was glazing, or covering the surface of a painting with a quickdrying, transparent coating (which could be a varnish) in which small amounts of color had been dissolved. This gave otherwise very brilliant tones an effect of greater depth and resonance, much like the soft colors transmitted by sunlight at certain times of day.

We do at least possess occasional attempts, however halting, to reconstruct fourth-century paintings. One is a mosaic (a technique of building up a pictorial image by combining small pieces of hard, colored material: in Classical times stone was used) found at Pompeii. This mosaic appears to be a Roman copy of the Victory of Alexander over Darius III (fig. 266), painted about 300 B.C. by Philoxenos for King Cassander of Macedon. The original has been attributed, without firm evidence, to a painter called Philoxenos, although Pliny the Elder, who died at Pompeii, believed it to have been the work of a woman, Helen of Egypt. Despite the difficulty of translating a painting into such a picture-puzzle technique, and the heavy damage that has destroyed most of the left side of the mosaic copy, we can still experience the grandeur of a very noble composition. The artist has not tried to show the whole battle, but to sum up its central action in a selected grouping of figures and accessories. He has represented very effectively the impact of Alexander's cavalry on the routed army of Darius, who turns in his chariot with a gesture of intense compassion for his fallen bodyguard, run through by the Macedonian king.

- 264. Lysippos. *Apoxyomenos* (*Scraper*). c. 330 B.C. Roman marble copy of bronze original, height 81". Vatican Museums, Rome
- 265. Youth, found in the sea off Antikythera, Greece. c. 340 B.C. Bronze, height 77". National Archaeological Museum, Athens
- 266. Victory of Alexander over Darius III. Roman mosaic copy of a painting possibly by Philoxenos or by Helen of Egypt. c. 300 B.C. Height 10' 31/4". Museo Archeologico Nazionale, Naples

Tides of battle surge through what is clearly deep space within the picture, even though the background is a flat white. The horses turn and twist in depth, some foreshortened from the front, others from the back; still others are seen diagonally. A sheaf of long Greek spears shows that Darius is almost surrounded, but the spears also serve as a compositional device pointing to Alexander, who can be seen over the damaged area, reining in his rearing horse. The ground is littered with weapons. Light, as we have never seen it represented before, gleams on Alexander's armor, on the tree, the shields, and the glossy bodies of the horses, and casts strong shadows on the ground. A fallen Persian is reflected in the polished surface of his shield. Anguish contorts the faces and dilates the eyes of the defeated. Certainly the great fourth-century discoveries—light, space, and emotion—appear to an extraordinary degree in this picture, which opens artistic vistas leading to modern times.

During the Archaic and Classical periods Greek culture had spread, through a steady process of colonization, as far west as the Mediterranean coast of Spain. The conquests of Alexander produced almost overnight a veritable explosion of Hellenism throughout the entire eastern Mediterranean region as well, including Egypt, and throughout all of western Asia extending to the Indus River. Ironically enough, the propelling energy for this new burst of Hellenism came from the ruler of Macedon, a country previously considered to lie on the fringe of the Greek world; yet so durable were the effects of Alexander's conquests that Greek remained the principal language spoken in Lower Egypt and in the eastern Mediterranean region, even under the Roman Empire. Throughout the conquered countries Alexander founded new Greek cities, some of which grew rapidly to enormous size; meanwhile, the older Ionian centers in Asia Minor, freed from Persian domination, enjoyed a new period of great prosperity. After Alexander's death in Babylon in 323 B.C., at only thirty-three years of age, his generals divided his empire among them and ruled as kings. Among the major divisions were Macedon itself under the Diadochi, the kingdom of the Seleucids in Asia Minor with its capital at Antioch in Syria, and the kingdom of the Ptolemies who ruled Egypt as pharaohs from the new Greek capital at Alexandria. Antioch and Alexandria eventually became the first cities of the ancient world with populations of a million or more.

The riches of the eastern kingdoms contrasted sadly with the poverty and relative impotence of the Greek city-states, left with only a semblance of their former autonomy to carry on their usual fratricidal warfare, except when interrupted by one or another of the Hellenistic kingdoms. Athens was respected for its distinguished history and cultural achievements, but it had slight commercial or political importance. As the city-states declined so did their old cults; religious feeling became intensely personal, and the individual sought direct and often ecstatic contact with the gods in such Oriental religions as the worship of Cybele, the mother-goddess, or the cult of Isis, imported from Egypt. Learning flourished, not only in Athens but also in the great new cities, especially Alexandria, with its Mouseion, or gathering place of philosophers, scientists, and scholars, and its library, the largest in the ancient world. The newly Hellenized populations, with their mystery religions, provided an insatiable demand for an art that could carry the discoveries of the fourth century regarding space, light, movement, and above all emotional drama to extremes of sensuality and violence that would have shocked the Athenians of the Classical period. Yet the artists themselves were Greek, and The Hellenistic Period (323–150 B.C.)

without the discoveries of their fifth-century predecessors they could have done little.

TOWN PLANNING Not all Greek cities grew up higgledy-piggledy like Athens, with bits of rational planning inserted here and there. But to build a planned city requires either starting from scratch, as Akhenaten did at Tell el Amarna, or tearing down a preexisting town. Seldom in Classical Greece could either of these be done. Straight streets intersecting at right angles do appear, as in those outlying sections of Miletus, a Greek city in Asia Minor, planned by a local architect, Hippodamos, around 470 or 460 B.C. But the Hellenistic cities, especially the new princely capitals, required planning on a grand scale. Their straight streets intersecting at right angles, open spaces, and public buildings were necessary for all the varied activities of metropolitan life within a rational system.

A beautiful example of late Classical and early Hellenistic town planning is Priene, situated across from Miletus, on the other side of what is now a broad plain but was then an immense bay. High above the port, a perfect Hippodamian plan was superimposed about 320 B.C. on a sloping hilltop, with the result that all the straight streets tilt sharply according to the terrain (fig. 267), affording spectacular views of the bay and landscape and of distant Miletus. A highly irregular fortification wall, exploiting the most defensible positions, surrounded the city. Fortunately for us, Priene contained within its territory the principal sanctuary of the Ionian League of Greek cities, so the Romans deliberately neglected it and spared us later remodeling. The city has been largely excavated, and although few walls are standing more than ten feet or so in height, we can serenely walk (or climb!) the straight streets today and gain a wonderful idea of how a Hellenistic city worked. At the lower edge of the reconstruction we see the stadium, used for athletic events and activities. At the center is the *agora*, an open square to be found in all Greek cities; surrounding the agora is that most typical of Hellenistic buildings, the stoa, essentially a continuous colonnade, closed by a wall behind, intended for the transaction of business or just for strolling, and generally

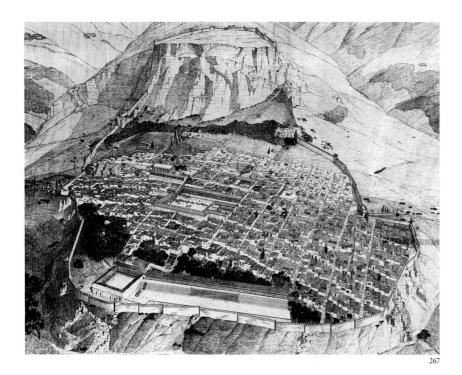

View of the city of Priene, Turkey (Reconstruction drawing by A. Zippelius)

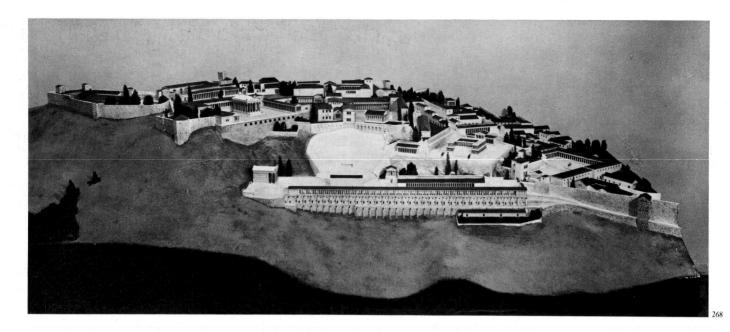

connected with shops and markets. To the upper left, at the highest point in the city, stands the Ionic Temple of Athena, and at upper center the theater, a gem of a building, still almost intact, with a columned stage so planned that painted scenery panels could be inserted between the columns. The Acropolis, not visible in the illustration, is a mighty crag soaring 1,000 feet above the port.

Town plans were designed to be as regular as possible, even when, as at Pergamon in Asia Minor, the rocky slopes of the terrain made planning extremely difficult. A restored model shows some of the principal buildings of this splendid city (fig. 268), even more dramatically situated than Priene. The large temple in the center of a square at the upper left is Roman and should be disregarded in this context. In the center is the theater, higher and narrower than that at Epidauros, because it was not built around an orchestra circle; in fact, only a semicircle was planned, and the action took place on a stage dominated by a high building for the support of scenery. Above the theater every attempt was made—in contrast to the free arrangements of the Classical period—to impose the appearance of regularity on the mountainous terrain. At the extreme right of the model is the usual agora, in the center foreground the stadium, above the right end of which rises the Altar of Zeus (see fig. 284), a monumental structure in itself. Higher up and just behind the theater, at right angles to one of its aisles, is the Temple of Athena; it is isolated and clearly visible from all sides in a plaza, formed by a two-story stoa, not in exact alignment but handled as if it were. The second story of the stoa, towering above the exact center of the theater, gave access to the royal library, second only in importance to that of Alexandria.

An agora of the Pergamene type at Assos in Turkey (reconstruction in figs. 269, 270) had handsome stoas, divergent but treated as if parallel, along both sides, a temple at one end, and at the other the bouleuterion (council hall). With their long, straight colonnades such complexes must have made magnificent spatial impressions. The traditional orders were still used, although Doric columns are often as tall and slender as Ionic, and Doric entablatures are correspondingly light. Generally, in two-story buildings the lower story is Doric, the upper Ionic. A superb bouleuterion of about 170 B.C. (reconstruction in fig. 271) at Miletus was preceded by an enclosure, entered through a Corinthian portico resembling a small temple. The courtyard was surrounded on three sides by a Doric colon-

- 268. Model of the city of Pergamon, Turkey. Staatliche Museen, Berlin
- 269, 270. The Agora, Assos, Turkey (Architectural reconstruction after A. W. Lawrence)
- 271. The Bouleuterion (Council House), Miletus, Turkey. c. 170 B.C. (Architectural reconstruction after A. W. Lawrence)
- 272. The Arsinoeon (with roof in section), Samothrace, Greece. Before 270 B.C. (Architectural reconstruction after A. W. Lawrence)

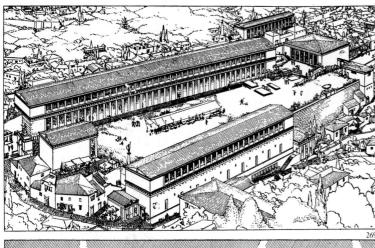

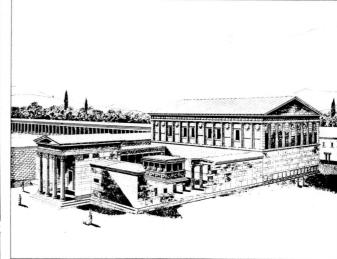

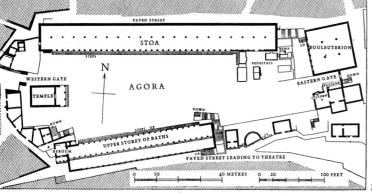

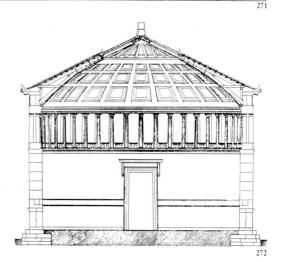

nade, in the center of which was an open-air altar. The fourth side was formed by the lower story of one long side of the council hall itself, whose upper story was an engaged Doric colonnade, with a pediment at either end. The Doric columns are more widely spaced than in the Classical period, with three rather than two triglyphs per column. Windows admitted light to the interior.

Large Hellenistic public buildings posed new problems for which the Greeks, thinking always in terms of post-and-lintel construction, had no organic structural solutions. Generally, interiors were roofed with wood, with sloping beams upheld in a stoa by a central row of taller columns, or sometimes in a bouleuterion by four interior columns so placed as least to obstruct the view. An ingenious device was employed at Samothrace, in a tholos called the Arsinoeon (reconstruction in fig. 272). Its cylindrical wall was surmounted outside by an engaged peristyle of Doric pilasters, inside by engaged Corinthian columns, supporting a wooden roof with a conical inner ceiling of wood, elegantly coffered (divided into recessed panels). Here is an early approach to the problem of the centralized interior without inner supports, which was solved later by the Romans through new and more imaginative construction methods (see figs. 1, 358) and taken up again in the great domes of the Byzantine (see figs. 427, 429) and Renaissance periods.

Hellenistic temples, when compared with those of the Archaic and Classical periods, represent a strong departure from what archaeologists have liked to consider "good taste." Nonetheless, if we are willing to forget for a moment preferences based on Classical style, and see these buildings in the context of the overriding Hellenistic concern with space and light, we must agree that they were very dramatic structures. A completely original example was the so-called Didymaion, the Temple of Apollo at Didyma, near Miletus, begun about 300 B.C. by the architects Paionios

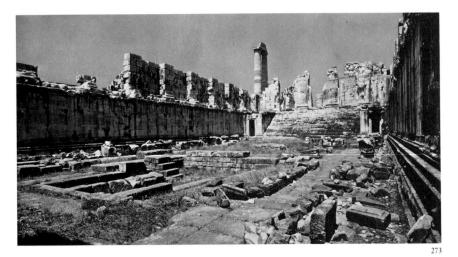

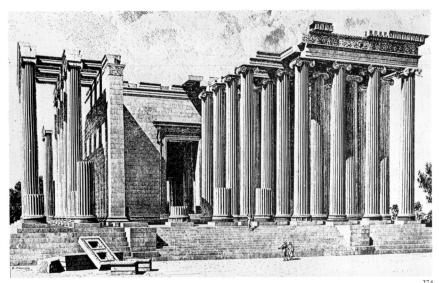

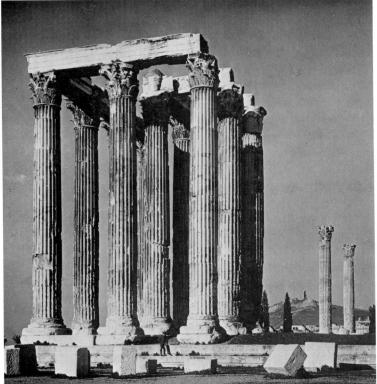

- 273. Paionios of Ephesus and Daphnis of Miletus. Temple of Apollo, Didyma, Turkey (view of the inner courtyard looking east; ruins of sanctuary in foreground). c. 300 B.C.
- 274. Temple of Apollo, Didyma (east front; architectural reconstruction by H. Knackfuss)
- 275. Cossumus. Temple of the Olympian Zeus, Athens (view from the east). c. 174 B.C.–2nd century A.D.

27

of Ephesus and Daphnis of Miletus (figs. 273, 274). Like a number of earlier temples in this region, the Didymaion was dipteral (with two peristyles, one inside the other). The structure was gigantic—358 feet long by 167 feet wide, with 110 columns. These were the tallest of all Greek columns, sixty-four feet in height, and there were ten across each end and twenty-one along each side; the entrance porch, with no pediment, was five columns deep. The central doorway, whose threshold was raised to make it inaccessible to the public, was used only for the promulgation of oracles. By means of a dark, barrel-vaulted passageway the few who were admitted to the sanctuary emerged not into the expected dim interior, but into a giant courtyard blazing with Apollo's sunlight and lined with pilasters, whose capitals carved with griffins correspond to no conventional order. At the end of the court stood the sanctuary proper, an elegant Ionic temple approached by a flight of steps erected over a hot spring, from which arose the fumes that inspired the oracles. Not only the dimensions and the enormous number of columns but also the stages in approach to the sanctuary and the general air of mystery remind us of the great temples at Luxor and Karnak (see figs. 107, 110). The immense building was so ambitious that its construction dragged on for centuries; a number of columns are still unfluted and their capitals and bases uncarved.

Temple architecture intended to produce a similar overwhelming emotional experience appeared in the second century in Athens itself, the center from which the intellectual style of the Classical period had emanated. The Temple of the Olympian Zeus (fig. 275), begun in 174 B.C. by the architect Cossutius (a Roman citizen working in Greek style) and commissioned by Antiochos IV, king of Syria, belongs to the same dipteral type as the Didymaion, which it almost equaled in scale. It is the first major Corinthian temple, and was so elaborate that it was not finished until the second century A.D. under the Roman emperor Hadrian. The small sections still standing, with their towering columns and rich capitals, hint at the majesty of the entire building, especially when it was surrounded by its original immense walled precinct.

SCULPTURE The sculptors of the Hellenistic age must have been almost embarrassed by the richness of their Classical heritage. Through the teaching of the innumerable followers of the great fourth-century masters—Skopas, Lysippos, and Praxiteles—Hellenistic sculptors were enabled to master the entire repertory of Classical virtuosity; they could represent anything in marble or bronze, from the vibrant warmth of nude flesh in the sunlight to the soft fluffiness of youthful hair. There are, in fact, works in which Hellenistic sculptors strove consciously to emulate their predecessors, even those of the sixth and fifth centuries, and since the great artistic conquests had already been made, it is not possible to follow in Hellenistic sculpture the steady evolution so clearly visible in earlier periods of art. Consequently, unless we have inscriptions or external evidence, Hellenistic sculpture is extremely difficult to date. Strikingly new in Hellenistic sculpture are an increased interest in naturalism and a new dimension given to drama, which violates at times all previous boundaries and standards, in keeping with the new geographic frontiers of this period and with the new spaces and light of its architecture.

Distinct schools of sculpture grew up at Athens, at Alexandria, on the island of Rhodes, and at Pergamon, to name four of the most important. It is appropriate to begin with a second-century portrait of Alexander himself (fig. 276), who was the motive force behind the new era and its art. The head was found at Pergamon, and it once formed part of a

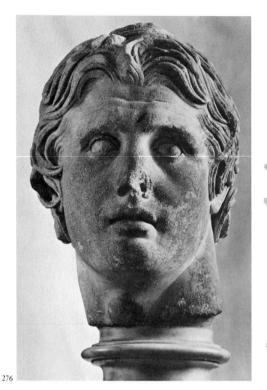

now-lost, larger-than-lifesize statue of the brilliant young monarch. Although done long after his death, it is a convincing portrait of the strange hero—part visionary, part military genius—driven by the wildest ambition, stranger to no physical or emotional excess, restrained by no moral standards (he ordered his own nephew executed and murdered his closest friend in a wild debauch). The rolling eyes, the shaggy hair, the furrowed brow, the already fleshy and sagging contours of cheeks and neck, all betray the character of this astounding man. As in all sculptures of the Pergamene school, the master—one of the most gifted sculptors of his time—has maintained a carefully controlled system of exaggerated incisions and depressions in eyes, mouth, and hair in order to increase light-and-dark contrasts and to achieve a heightened emotional effect.

A different kind of portraiture—more searching perhaps and less dramatic, but equally influential on the later art of Rome—must have characterized the lost original bronze of the archenemy of Macedon, the Athenian orator Demosthenes. This work is known from several Roman copies (fig. 277; the hands and forearms are an accurate modern restoration). The sculptor has embodied with great success the quiet intensity of the pensive, aging statesman, enveloped in his worn cloak; no realistic detail is spared. Hellenistic sculptors, in fact, shrank from no representations of decay or deformity in their attempt to present an intense and

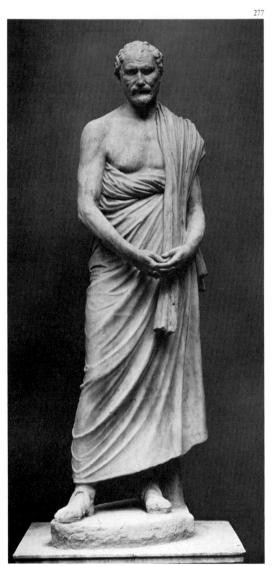

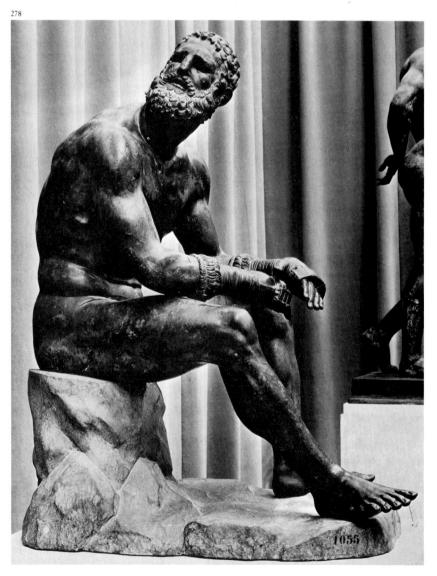

196 THE ANCIENT WORLD

convincing picture of human life. A tragic example of human degradation is shown in the bronze Seated Boxer (fig. 278), probably dating from about the middle of the first century B.C., about a hundred years after Athens had lost its independence to Rome. The sculptor controlled the entire repertory of anatomical knowledge and bronze technique known to Polykleitos and Lysippos, but instead of a graceful athlete in serene command of his own destiny, he preferred to show us a muscle-bound, knotty boxer, with broken nose, cauliflower ears, swollen cheeks, and hands armed with heavy leather thongs to do as much damage as possible. Blood oozes from the still-open wounds on his face. What is left of a human soul seems almost to ask for release in the expression of the stunned face, possibly even more harrowing when the inlaid eyes were preserved.

Mythology itself was seen from the point of view of the new naturalism; the satyr, a happy and irresponsible denizen of the glades in Archaic and Classical art, is shown heavy with wine (fig. 279) in an excellent Roman copy of a lost Hellenistic original from about the middle of the third century B.C. The bestially sensual anatomy and the brutal face disturbed by dreams in its drunken stupor radiate the same sense of tragic imprisonment so impressive in the Seated Boxer. The dreamy, languorous naturalism of Praxiteles lingers on throughout the Hellenistic period, even in representations of divinities, who never radiate the impersonal grandeur of the fifth century. The Aphrodite of Cyrene (fig. 280), found in a bath in that North African Greek city, is an exquisite work of the early first century B.C. The curving surfaces and soft, warm flesh of the goddess, who has just risen from the sea (in emulation of the Aphrodite of

- 276. Portrait of Alexander, from Pergamon. 1st half of 2nd century B.C. Marble, height 161/8". Archaeological Museum, Istanbul
- 277. Demosthenes. c. 280 B.C. Roman marble copy of bronze original, height 791/2". Nationalmuseet, Copenhagen
- 278. Seated Boxer. Middle 1st century B.C. Bronze, height 50". Museo Nazionale Romano,
- 279. Satyr. c. 220 B.C. Roman marble copy of Greek original, over-lifesize. Staatliche Antikensammlungen und Glyptothek, Munich
- 280. Aphrodite of Cyrene, from Cyrene, North Africa. Early 1st century B.C. Marble, height c. 56". Museo Nazionale Romano, Rome

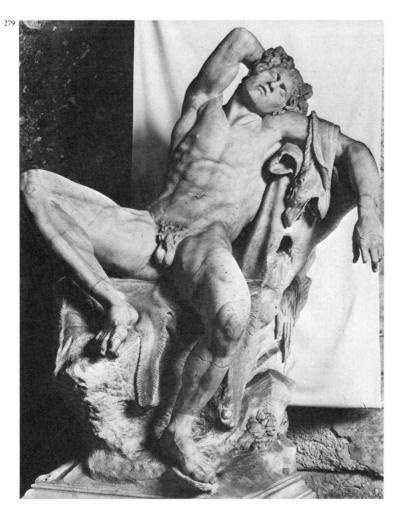

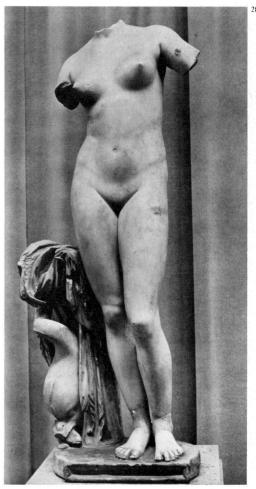

Knidos of Praxiteles, see fig. 262), contrast with the beautiful curves of the dolphin and with the delicate folds of the garment beside her. In the Head of a Girl (fig. 281), probably of the third century, from the island of Chios, Praxitelean style is carried to its furthest extreme. The marble head was doubtless inserted in a statue made of another kind of marble, part of which was carved into drapery covering the girl's head. The upper lids melt into the brows, so soft has definition become, and the lower lids are hardly represented at all. The face is a masterpiece of pure suggestion. through luminous surfaces of marble and tremulous shadow.

In the magnificent Nike of Samothrace (fig. 282), we have an echo of Paionios' famous statue at Olympia (see fig. 247), but this time the unknown Hellenistic sculptor has won; his statue is far more dramatic than its Classical prototype. It was originally erected in the Sanctuary of the Great Gods at Samothrace by the Rhodians in gratitude for their naval victory over Antiochos III of Syria about 190 B.C., and it stood upon a lofty pedestal representing in marble the prow of a ship. The right hand, discovered in 1950, shows that the fingers originally held a metal victor's fillet; the head is turned partly to the left. The sea winds whip the drapery into splendid masses, producing a rich variation of light and shade. The contrast between the tempestuous movement and the power of the outstretched wings renders this one of the grandest of ancient statues.

The most dramatic of all the Hellenistic schools of sculpture flourished at Pergamon, which in the third century B.C. was attacked by tribes of Gauls from the north. The victory of King Attalos I over the invaders was celebrated in a series of bronze statues and groups, known through Roman copies. A strikingly naturalistic example, the Dying Trumpeter (fig.

- 281. Head of a Girl, from Chios, Greece. c. 3rd century B.C. Marble, height 141/8". Museum of Fine Arts, Boston
- 282. Nike of Samothrace. c. 190 B.C. Marble, height 96". The Louvre, Paris

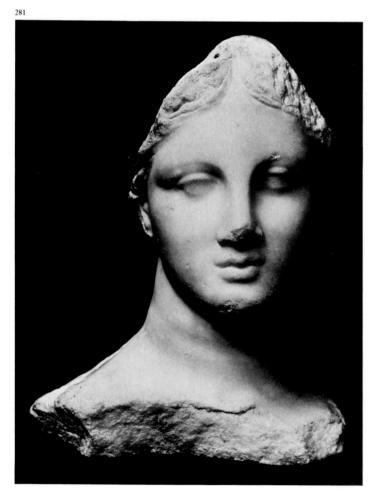

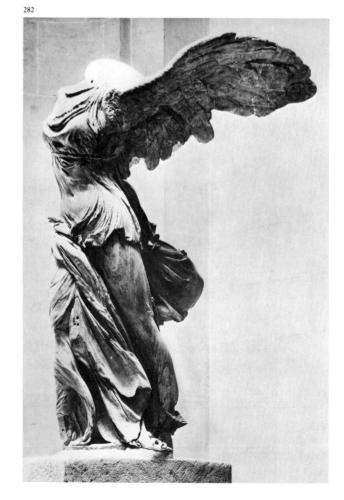

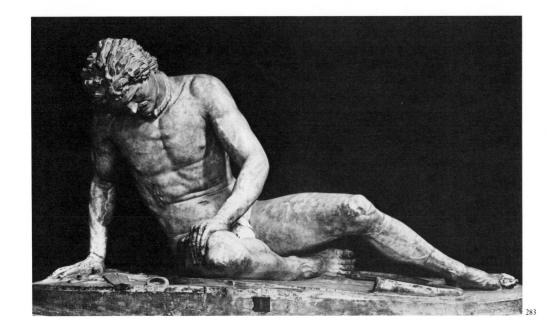

283), is obviously a descendant of such works as the *Dying Warrior* of Aegina (see fig. 203). But the beautiful reticence and geometric clarity of Late Archaic sculpture should not blind us to the accomplishments of Pergamene art here in representing the collapse of the barbarian, from a wound in his side streaming blood, with a deep and unexpected sympathy of the victor for the vanquished.

The triumph of the Pergamenes is celebrated allegorically in the huge Altar of Zeus (figs. 284, 285) built between 181 and 159 B.C. and partially reconstructed in Berlin. Appropriately enough for the king of the gods, it was erected as an altar in the sky, looking over a vast landscape and out to sea (see fig. 268 for its position in the city). It stood on a raised platform, in the manner of a ziggurat, in the center of a court, and was accessible by a steep flight of steps. Around the altar were two peristyles, the outer one of widely spaced Ionic columns, with wings projecting on either side of the staircase. Around the entire base ran a frieze more than seven feet high, representing the *Battle of Gods and Giants* (symbolizing, of course, the triumph of the Pergamenes over the barbarian hordes), second only to the Parthenon frieze as the largest sculptural undertaking of antiquity. But the great artist who designed the frieze changed the customary place

- 283. *Dying Trumpeter*, from Pergamon. c. 230–220 B.C. Roman marble copy of bronze original, lifesize. Museo Capitolino, Rome
- 284. Altar of Zeus, from Pergamon (northern projection). c. 181–159 B.C. Pergamonmuseum, East Berlin
- 285. Plan of the Altar of Zeus, Pergamon

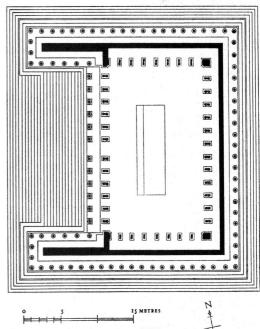

for such a decoration from the top of a high wall or entablature (Treasury of the Siphnians, Parthenon, Temple of Apollo at Bassai, and possibly the Mausoleum at Halikarnassos), where it could be read only with difficulty, to a position only just above eye level, where the larger-than-lifesize figures, almost entirely in the round, seem to erupt from the building toward the spectator; some have even fallen out of the frieze so that they are forced to support themselves on hands and knees up the very steps that the worshiper also climbs.

No pains were spared to achieve an effect of overwhelming power and drastic immediacy. The fragile architecture is borne aloft, as it were, on the tide of battle. So dense is the crowding of intertwined, struggling figures as at times to obscure the background entirely. Figures of unparalleled musculature lunge, reel, or collapse in writhing agony. To our left Zeus has felled a giant with a thunderbolt aimed at his leg (fig. 286), and the giant bursts into flames; to our right a giant with serpents for legs beats against the thundering wings of Zeus' eagle. Projections and hollows, large and small, were systematically exaggerated so as to increase both the expressive power of the work and the changes of light and shade as the sun moved around it (the intense light from the sky, the valley, and the sea, reflected upward from the marble steps, would have eliminated the black shadow we see in the photograph, taken in the Berlin Museum). The sculptures must have been experienced like forces from the surrounding sky and clouds. Compared to this wild surge of violence, the battle reliefs of the fifth and fourth centuries look restrained, governed by laws of balance and measure which here are swept aside. The reliefs bear several sculptors' signatures; unfortunately, we do not know the name of the master who designed the entire work and who also may well have carved the giant head of Alexander (see fig. 276), which has so much in common with this relief.

By analogy with the art of the seventeenth century A.D., the style of

- 286. Zeus Fighting Three Giants, from the Altar of Zeus, Pergamon. Marble, height 90". Pergamonmuseum, East Berlin
- 287. HAGESANDROS, POLYDOROS, and ATHENODOROS. Laocoön and His Two Sons. 2nd century B.C.—1st century A.D. Marble, height 96". Vatican Museums, Rome
- 288. HAGESANDROS, POLYDOROS, and ATHENODOROS. Head of Odysseus, part of Odysseus Blinding Polyphemos, from Sperlonga, Italy. 2nd century B.C.—1st century A.D. Marble, lifesize. Museo Archeologico Nazionale, Sperlonga
- 289. HAGESANDROS, POLYDOROS, and ATHENODOROS. *The Wreck of Odysseus' Ship* (detail), from Sperlonga. 2nd century B.C.—1st century A.D. Marble, lifesize. Museo Archeologico Nazionale, Sperlonga

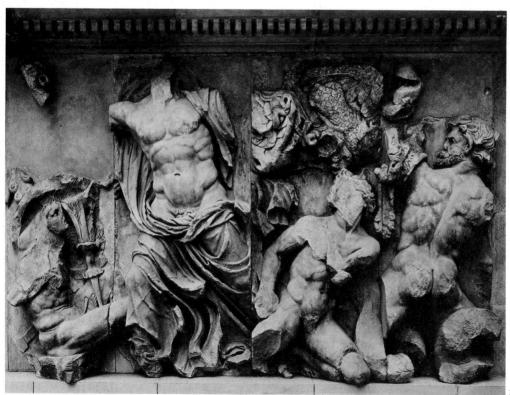

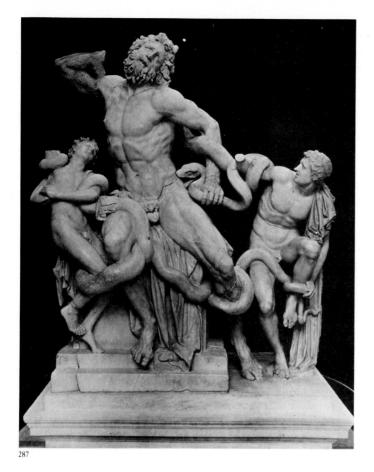

the Altar of Zeus has often been called the "Pergamene Baroque." It continued throughout Hellenistic times and was revived repeatedly in the art of the Roman Empire. One of the most extraordinary examples of the style is the group representing Laocoon and His Two Sons (fig. 287), generally identified with the group mentioned by the Roman writer Pliny. The Trojan priest Laocoön was assailed by sea serpents sent by Poseidon and was strangled before the walls of Troy. The group is the work of three sculptors from Rhodes—Hagesandros, Polydoros, and Athenodoros but we do not know when it was created. Its customary dating in the second century B.C. has recently been upset by an extraordinary find at Sperlonga on the coast of Italy, about halfway between Rome and Naples. Fragments of five huge sculptural groups, like the Laocoön depicting themes from Homer, were discovered placed around the interior of a cave that had been turned into a pleasure grotto by some wealthy Roman, only to be later systematically smashed, presumably by early Christians. One of these groups, repeating the old Homeric subject of Odysseus Blinding Polyphemos (see fig. 181), was signed by the same three Rhodian sculptors. It has recently been suggested that both the Laocoon and the Sperlonga sculptures may have been done as late as the first century A.D., possibly for the Emperor Tiberius, and should thus be considered under Roman art. Even so, the sculptors were Greek and the style, whatever its date, is a direct descendant of the Pergamene Baroque. The head of Odysseus, who was probably helping to hold the burning pike (fig. 288), shows strong similarities to that of Laocoön—the same cutting of the marble, the same wildly rolling eyes, and the same treatment of hair and beard. The legs of Polyphemos are those of a figure about twenty feet high. In contrast to the intense light that bursts upon Pergamon for most of any year, the five groups must have struggled mysteriously in a dim grotto lighted only by oil lamps.

GREEK ART 201

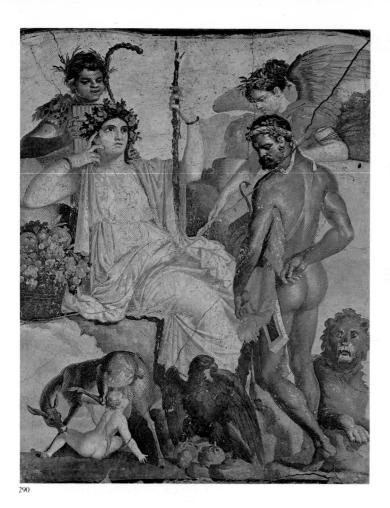

The sharp impact of the moment of dramatic action and the utter freedom from conventional restraints typical of Hellenistic sculpture may be seen again in the fragment of another group, The Wreck of Odysseus' Ship (fig. 289), which depicts in detail the stern of the vessel from which the helmsman, every muscle tense with the disaster, falls forward before our astonished eyes. Although the expert rendering of muscular strain, and even swelling veins, in the *Laocoön* may seem forced to us, in comparison to the Altar of Zeus, it was a revelation to the Italian Renaissance when the group was unearthed near Rome in 1506.

PAINTING AND DOMESTIC DECORATION Unfortunately, we possess few more original paintings from the Hellenistic period than we do fourth-century ones, but many of the finest Roman paintings preserved at Pompeii and Herculaneum are believed to reflect lost Hellenistic originals. A fresco of Herakles and the Infant Telephos from Herculaneum (fig. 290) even repeats a composition carved in the interior of the Altar at Pergamon. The sensuous richness of the style appears at its height in the painting of Herakles' deeply tanned body, in the shadows on his fierce lion, and in the range of light and shade on the doe suckling Herakles' infant son, Telephos. Hellenistic pictorial style can be clearly seen in a number of pebble mosaics used for floors, especially the beautiful third-century series unearthed at Pella in Macedon, the birthplace of Alexander. Even through the difficult medium of colored pebbles, the artist has been able to show the movement of light and shadow across the nude bodies and flying cloaks of two youths engaged in a Stag Hunt (fig. 291). Each pebble is treated as if it were a separate brushstroke, and the blue-

- 290. Herakles and the Infant Telephos, fresco from Herculaneum, near Naples. Roman copy of a Greek painting. 2nd century B.C. Museo Archeologico Nazionale, Naples
- 291. Stag Hunt, from Pella, Greece. Pebble mosaic. 3rd century B.C. Archaeological Museum, Pella
- 292. Amphora with sculptured handles, from Panagyurishte, Bulgaria. c. 300 B.C. Gold, height c. 10". National Archaeological Museum, Plovdiv, Bulgaria

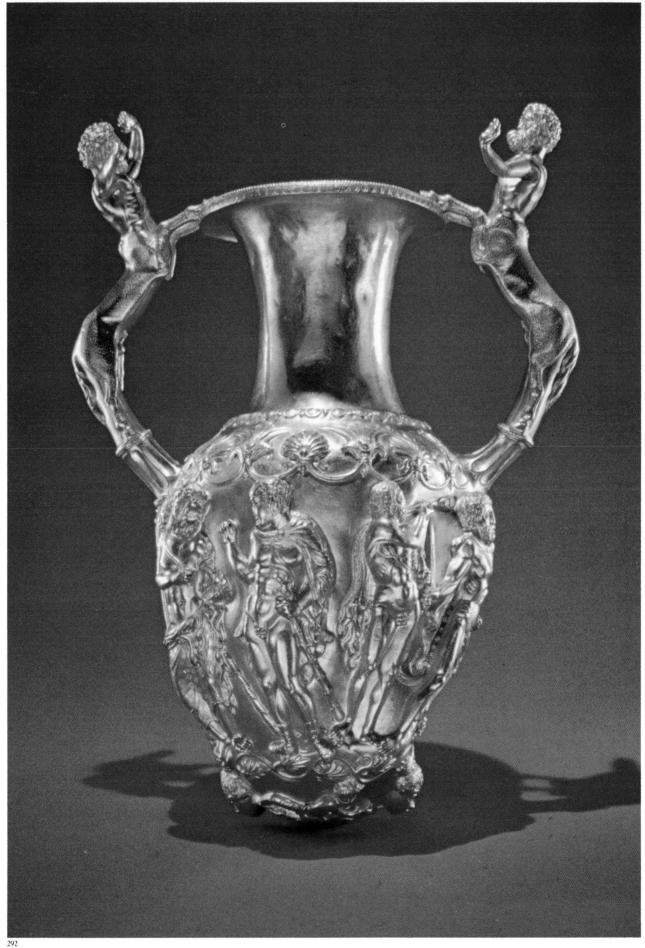

gray background accentuates the play of light. The motion is enhanced by the rhythmic surge of the vinescrolls framing the scene and is played off against the wave pattern in the border.

A final word should be said about the Hellenistic houses lavish enough to have such floors. Throughout Greek history up to this moment the private residence had been meanly simple—rough stone or mud-brick walls, supporting a tiled roof around a central court whose pillars were mere wooden posts. Demosthenes writes that in his time, the end of the fourth century, houses in Athens were becoming larger and richer, and during the wealthy Hellenistic period every city could boast entire streets of luxurious residences. These houses were invariably blank on the exterior and flush with the street, but once the visitor entered the interior through a hallway (L-shaped to keep out prying eyes), he found himself in a handsome courtyard graced at least on the north side, and sometimes on all four, by a peristyle, and giving access to a splendid dining room (fig. 293). Other rooms opened off the court, and the houses were often two stories high. The walls were decorated with an elaborate system of panels painted to resemble marble slabs (the so-called incrustation style taken up later by the Romans). Figural paintings appeared here and there, as if hanging on the wall.

Hellenistic palaces, temples, and prosperous private houses must have been sumptuously furnished with objects making lavish use of luxurious materials and precious metals. We are aided in forming a mental picture of such vanished splendors by a treasure comprising eight wine vessels of pure gold, dating from about 300 B.C., which was discovered by accident at Panagyurishte, near Plovdiv, Bulgaria. Probably intended for ritual use, these wine vessels were produced at Lampsacus, a Greek city on the Asiatic shore of the Dardanelles, the strait dividing Europe and Asia; the measurements of wine indicated on them use the units of that city. The technique, known as repoussé (pressed outward), consisted of hammering the gold plates from the reverse before they were joined together. The central object of the group is a superb amphora (fig. 292). The handles produced as if by chance—are formed by sprightly, youthful centaurs whose forehoofs overlap the rim and whose arms are uplifted in delight at the sight of the wine within. Traditional ornament is restricted to four bands widely scattered so as not to compete with the refulgence of the smooth, gold surfaces in the neck of the vessel and in the human and animal figures. The body of the amphora is covered with a vigorous relief, whose figures, mostly nude, enact still-unidentified mythological scenes. On the side illustrated a nude youth carrying a staff converses with an older man, possibly Herakles. In the youth's lithe and supple figure, relaxed and resplendent, as well as in those in violent action on the other side of the vessel, the unknown craftsman has shown himself in full command of all the resources of Hellenistic monumental sculpture, reduced to the scale of an object that can be held in the hand. He has translated into smooth surfaces of flashing gold the luminary values that are the essence of Hellenistic art in every medium and at any scale.

293

In many ways Greek art may be regarded (along with Greek literature, Greek philosophy, and perhaps Greek music) as the greatest triumph of the ancient world. Unlike the arts of Egypt, Mesopotamia, and the Aegean, Greek art never really died. The Romans stole it by the shipload and adopted and adapted Greek artistic ideas, even employing Greek artists. The Greek sense of beauty and order gave structure to Christian imagery in the art of the Byzantine (Greek) society. Even in the darkest moments after the barbarian invasions of Western Europe, Greek culture was never wholly forgotten. Greek forms and principles have been revived repeatedly throughout the Middle Ages, the Renaissance, and modern times, and the Greek analytical approach to the phenomena of a dynamic, ever-changing world has formed the basis of human thought and vision ever since.

293. Section of a house at Delos, Greece, showing-mural decoration. c. 2nd century B.C. (Architectural reconstruction after A. W. Lawrence)

TIME LINE III

Model of a temple

"Lady of Auxerre"

Calf-Bearer

Treasury of the Siphnians

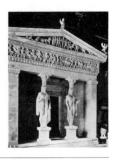

History

1200 B.C. 800 Dorians invade Greece Ionians resettle in Asia Minor Mycenae destroyed First Greek colonies established in Southern Italy and Sicily

700 600

Draconian laws in Athens Athenians expel Hippias and establish democracy

500

Persian Wars, 499–478; Battle of Marathon, 490; Persians destroy much of Athens, 480 Battle of Salamis, 480; Delian League, 479-461 Periclean Age, 460-429

CULTURE

Phoenicians develop alphabet, c. 1000; Greeks adopt it, c. 750

First Olympic Games, 776; begin time-reckoning by Olympiads

Epic poems by Homer (fl. 750–700) collected to form Iliad and Odyssey, 750-650

Coinage invented in Asia Minor, c. 700–650, soon adopted by Greeks

First tragedy performed at Athens by Thespis, 534; Aeschylus (525–456)

Pythagoras (fl. c. 520)

Sophocles (496–406); Euripides (d. 406) The Persians by Aeschylus performed; Socrates (469–399); *Oresteia* by Aeschylus (458) Hippocrates (b. 469)

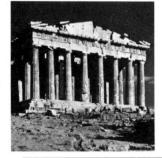

Hermes by Praxiteles

Stag Hunt mosaic, Pella

450 B.C.

400

300

Peloponnesian War, 431-404 Death of Pericles, 429 Oligarchic revolution in Athens, 411 Sparta defeats Athens Philip of Macedon (r. 359–336) defeats allied Greeks at Battle of Chaeronea, 338 Alexander the Great, King of Macedon (336–323) occupies Egypt and founds Alexandria, 333 Battle of Issus, 333; Battle of Arbela, 331 Fall of Persian Empire; death of Alexander, 323; five monarchies develop out of his empire

The "Sophist" Protagoras in Athens, 444 Antigone by Sophocles, 440 Plato (427–347) founds Academy, 386 Trial and death of Socrates, 399 Aristotle (384–322) Epicurus (341–270); Zeno (336–264)

Theophrastos of Athens, botanist (fl. c. 300) Euclid (fl. c. 300–280) Archimedes (287–212) Eratosthenes of Cyrene measures the globe, c. 240

GREEK

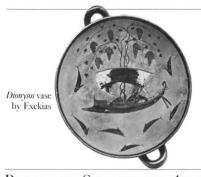

Temple of Hera II at Paestum

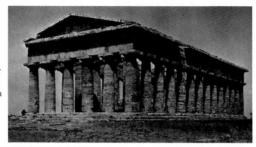

Apollo from Olympia

Painting, Sculpture, Architecture

Dipylon amphora; amphora from Eleusis; *Chigi Vase* "Lady of Auxerre"; Kouros of Sounion; Medusa, Temple of Artemis, Corfu Black-figure vases by Psiax and Exekias Anavyssos Kouros; Calf-Bearer; Stele of Aristion by Aristokles

Hera of Samos; Peplos Kore; La Delicata

"Basilica" at Paestum; Treasury of the Siphnians, with relief sculpture Red-figure vases by Euphronios, Kleophrades Painter, Berlin Painter,

Niobid Painter, Achilles Painter; painted tomb at Paestum Temple of Aphaia at Aegina, with pedimental sculpture Blond Youth; Charioteer of Delphi; Zeus of Artemision Temple of Zeus at Olympia, with pedimental and relief sculpture Temple of Hera II at Paestum

PARALLEL SOCIETIES

Empire in Egypt 1200 B.C.
Greek: Geometric and 800
Orientalizing
Assyrian
Greek: Archaic 700
Neo-Babylonian 600

Persian Etruscan

Greek: Classical

Celtic tribes

500

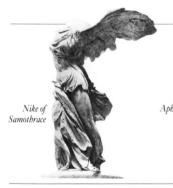

house at Delphi

Aphrodite of Cyrene

Diskobolos by Myron; Doryphoros by Polykleitos; Riace Bronzes

Parthenon at Athens, with pedimental and relief sculpture

Herakles and Telephos

Laocoön

Greek: Age of Pericles

450 B.C.

Etruscan

400

300

Hellenistic

Roman: Republican

Propylaia; Erechtheion and Temple of Athena Nike, with sculpture Athena Parthenos and Lemnian Athena by Phidias Victory by Paionios; Monument of Lysikrates
Temple of Apollo at Bassai; unfinished temple at Segesta Tholos and Theater at Epidauros
Mausoleum at Halikarnassos; Temple of Apollo at Didyma
Head by Skopas; Apoxyomenos by Lysippos; Hermes by Praxiteles
Originals of Victory of Alexander over Darius III and Herakles and Telephos Alexander; Demosthenes; Dying Trumpeter; Seated Boxer; Nike of Samothrace Laocoön and Odysseus by Hagesandros, Polydoros, and Athenodoros
Altar of Zeus, Pergamon, relief sculpture of Battle of Gods and Giants
Cities of Priene and Pergamon
Agora at Assos; Bouleuterion at Miletos; Arsinoeon at Samothrace;

ETRUSCAN ART

FIVE

Beyond the borders of the coastal Greek city-states of southern Italy, the hinterland was inhabited by less developed, indigenous peoples. To the north, in the region between the Tiber and the Arno rivers, flourished an extraordinary and still-mysterious culture, that of the Etruscans. Herodotus, the Greek Classical historian, reported that the Etruscans came from Lydia in Asia Minor, and there is a good deal of evidence to support his contention. Another ancient tradition, however, causes some modern scholars to believe that the Etruscans inhabited Italy from prehistoric times. This view is difficult to reconcile with the fact that the Etruscans spoke a non–Indo-European language which, as ancient authors noted, had nothing in common with the other tongues current in ancient Italy, not even with their roots. On account of this linguistic discrepancy the Etruscans were, in fact, sharply isolated from their neighbors. The discovery on the Aegean island of Lemnos of an inscription in a language resembling Etruscan adds weight to the arguments for an Eastern origin.

Regardless of how the debate may eventually be settled, the fact remains that for about four hundred years this energetic people controlled much of central Italy, the region of Etruria, which has retained the name of Tuscany (from the Latin *Tuscii* for "Etruscans") until the present day. They never formed a unified nation, but rather a loose confederation of city-states, each under the rule of its own king. Many of these cities are still inhabited, among them Veii, Tarquinii (Tarquinia), Caere (Cerveteri), Perusia (Perugia), Faesulae (Fiesole), Volaterrae (Volterra), Arretium (Arezzo), and Clusium (Chiusi). Although presently populated centers are generally impossible to excavate, others, since abandoned, such as Populonia and Vetulonia, have been systematically uncovered. We often know more about Etruscan cemeteries, which have been excavated, than about Etruscan towns.

During the sixth and fifth centuries B.C., the Etruscan states colonized an ever-expanding domain in central Italy, including Rome itself, which was ruled by a succession of Etruscan kings until the founding of the Roman Republic at the end of the sixth century. In fact, Etruscan rule spread into Campania in the south, and into the plain of the Po River to the north, as far as the foothills of the Alps. Etruscan commerce in the Mediterranean vied with that of the Greeks and the Phoenicians, both of whom had reason to dread Etruscan pirates. From the fifth century onward, the expanding military power of Rome doomed the Etruscan hegemony, and eventually even Etruscan independence. During the fourth century, constant warfare against the Romans attacking from the south and the Gauls from the north forced the Etruscans to develop the urban fortifications for which they were renowned. During the third century, Roman domination destroyed Etruscan power forever, and in the early first century B.C. the Etruscan cities were definitively absorbed into the Roman Republic.

Etruscan literature is lost; we know of no Etruscan philosophy or science, nor can it be claimed that the Etruscans developed an art whose originality and quality could enable it to compete with the great artistic achievements of the Egyptians, the Mesopotamians, or above all the Greeks. In many respects Etruscan art follows, about a generation behind, the progress of the Greeks, whose vases the Etruscans avidly collected. Yet many works of Etruscan sculpture and painting are very attractive in their rustic vigor, and every now and then in museums of Etruscan art we encounter a real masterpiece.

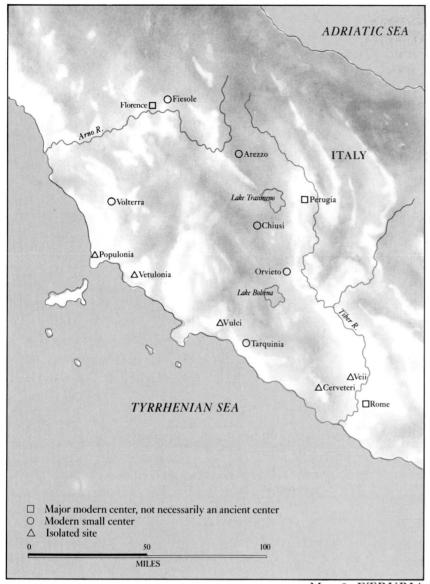

MAP 8. ETRURIA

Little Etruscan architecture is standing, even in fragmentary condition, although recent excavations have disclosed very original plans of early date. A detailed prescription for an Etruscan temple based on examples visible in his day is given by Vitruvius, a Roman architect and theoretical writer of the first century B.C. If we judge from Vitruvius, a typical Etruscan temple was roughly square in plan (fig. 294) and placed upon a high podium of stone blocks, often tufa (a volcanic stone which was handy and easy to cut). Access was provided by a flight of steps in the front, unlike the continuous, four-sided platform of the Greek temple. The mudbrick cella occupied only the rear half of the podium; the rest was covered by an open portico; the low-pitched wooden roof had widely overhanging eaves to protect the mud-brick walls. Early columns were of wood, with stone capitals and bases; later examples were of stone throughout. Vitruvius thought that all Etruscan columns were unfluted, with molded bases and capitals close to those of the Doric order, including both echinus and abacus; he therefore postulated a fourth or Tuscan order. However, surviving examples show that the Etruscans did on occasion flute their columns, and did imitate, however roughly, both Ionic and Corinthian capitals. The heavy roof beams and protecting tiles left little room for pedimental sculpture. But the Etruscans were extremely adept at terra-

Architecture

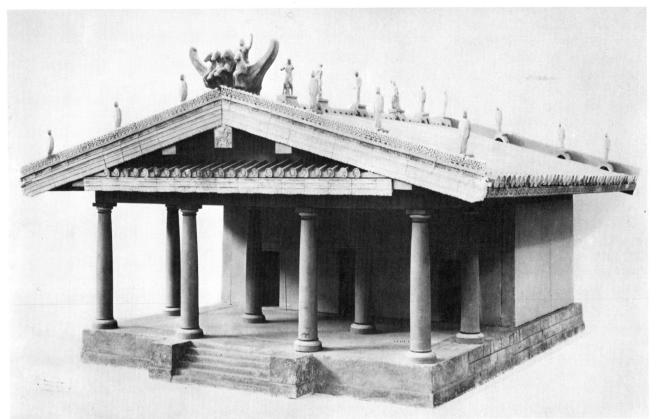

294. Typical Etruscan temple as described by Vitruvius (reconstruction)

295. Porta Marzia, Perugia, Italy. 3rd or 2nd century B.C.

cotta (baked clay) work, having learned the technique from the Greeks to the south, and their roof lines and ridgepoles often bristled with a sizable terra-cotta population.

The appearance of an Etruscan temple, with its squat proportions and crowded roof, could scarcely rival the elegance and harmony of Hellenic proportions, but the Etruscan examples were, nonetheless, the basis for the Roman experience of a temple. Several existed in Rome itself, and a very large one, 175 feet by 204 feet, with a triple cella and columns con-

294

tinuing along the sides, was dedicated in 509 B.C. on the Capitoline. Although this great temple burned down in 83 B.C., it was rebuilt in 69 B.C. with lofty marble columns on the Greek model. This very circumstance tells us much about the double derivation of Roman architecture, with Greek elements grafted, so to speak, onto Etruscan trunks.

The Greeks knew the arch but used it very rarely, mostly in substructures. One of the few Greek arches above ground is in the city wall of Velia, a Greek town south of Paestum. Borrowing the idea from their Greek neighbors, the Etruscans embellished and elaborated it. Like the Babylonians, they displayed the arch proudly, at the major entrances to their cities—places which had special religious meaning. The gates of Perugia—for example, the Porta Marzia (fig. 295; originally open, later filled in with brick)—are true arches, composed of trapezoidal stones called archivolts, each of which presses against its neighbors so that the structure is essentially self-sustaining. The arch proper is flanked by pilasters of two different sizes, in rather clumsy imitation of Greek originals; nonetheless, these are important early examples of the combination of the arch with the Greek orders that later typified Roman architectural thinking.

Etruscan sculpture, most of which we know from funerary examples, shows from the beginning the typical Etruscan facility in terra-cotta. The material was modeled with the fingers, and the fine details added with the use of tools, which were probably wooden. Many terra-cotta statuettes of the deceased have been found; small terra-cotta urns, made to hold incinerated remains, were widely used. A seventh-century urn of hammered bronze from Chiusi (fig. 296) is surmounted by a staring terracotta head of great expressive power, and the whole is set upon a bronze model of a chair. The Etruscans developed a new kind of funerary sculpture in painted terra-cotta that shows the deceased, singly or in couples, relaxing happily on the left elbow on a couch, in the pose of banqueters. The finest of these is from Cerveteri (fig. 297). These delightful images,

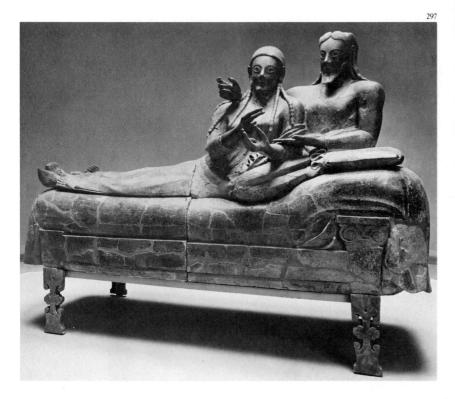

Sculpture

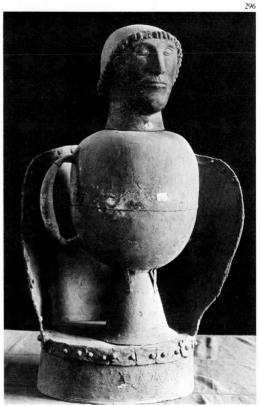

296. Cinerary urn, from Chiusi, Italy. 7th century B.c. Hammered bronze with terra-cotta head, height c. 33". Museo Etrusco, Chiusi

297. Sarcophagus, from Cerveteri, Italy. c. 520 B.c. Painted terra-cotta, length 79". Museo Nazionale di Villa Giulia, Rome

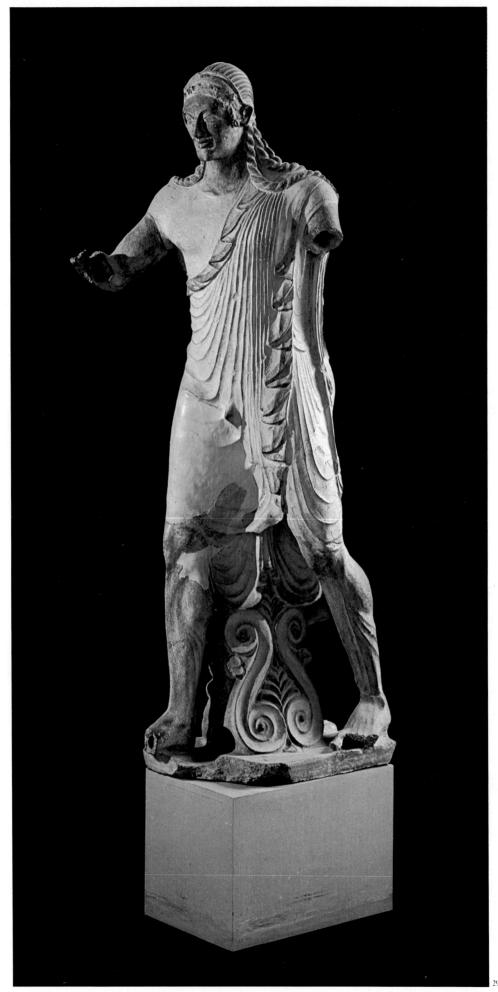

whose smooth bodies, braided hair, and Archaic smiles remind us of Greek sculpture, seem to show a very happy view of the future life, in keeping with the festive paintings (see below, pp. 216-18) that decorate the interiors of the tomb chambers. But the most imposing Etruscan terra-cotta works were such rooftop statues as the famous Apollo of Veii, which still retains some of its original coloring (fig. 298). This figure was part of a group showing Herakles carrying off the sacred hind, with Apollo in hot pursuit. Provincial though he may appear in comparison with such contemporary Archaic Greek works as the earliest sculpture at Aegina (see figs. 201, 202, 203), the athletic god, with his grand stride and swinging drapery, shows a freedom of motion which in Archaic Greek sculpture is generally restricted to reliefs; the borrowed Archaic smile and stylized folds seem almost anachronistic. This statue helps us form an idea of the terra-cotta statue of Zeus once in the Etruscan temple on the Capitoline

298. Apollo of Veii. с. 515-490 в.с. Painted terracotta, height c. 70". Museo Nazionale di Villa Giulia, Rome

^{299.} She-Wolf. c. 500-480 B.C. Bronze, height 331/2". Museo Capitolino, Rome

^{300.} Wounded Chimaera, from Arezzo, Italy. Early 4th century B.C. Bronze, height 311/2". Museo Archeologico Nazionale, Florence

(see above, pp. 210-11), whose sculptor also came from Veii, a town eight miles north of Rome.

The fierce bronze *She-Wolf* (fig. 299), a symbol of the origins of Rome because a she-wolf suckled Romulus and Remus, the legendary founders of that city, is an Etruscan work of about 500 to 480 B.C., but the bronzecaster may have been a Greek. Its crisp and brilliant detail was incised in the bronze after casting. The sculptor was clearly interested in representing a fierce and defiant animal as a symbol of Rome, newly released from Etruscan tyranny, and perhaps for that reason substituted the mane of a lion, rendered in stylized Archaic curls, for the thick coat of a wolf. An equally impressive if more fantastic animal is the Chimaera (fig. 300), from the late fourth century, found at Arezzo. This three-headed beast was adopted by the Etruscans from Greek mythology. The ornamentalized locks of its lion mane and the equally stylized horns of the goat-head rising from its back derive more from sculptural tradition than from any naturalistic observation, but the ferocity of the expression and the tension of the muscles and rib cage display the power of Etruscan art at its best. A similar precision of detail and intensity of expression are still seen in the impressive portrait of a Bearded Man (fig. 301), dating from the third century, whose air of strong resolution has given it the nickname of Lucius Junius Brutus, the leader of the Roman revolt against the last Etruscan king. The head may have belonged to a lost equestrian statue.

Bronze Implements

An entirely different aspect of Etruscan taste is seen in the lovely incised images on Etruscan bronze implements, especially the backs of bronze mirrors (the fronts were highly polished for reflection). In a fairly Archaic example (fig. 302) found at Praeneste—the modern Palestrina (see p. 225)—dating from around 490 B.C., a remarkably chunky Aphrodite is being clothed by two nude small boys, who have been identified as Eros and Himeros (Love and Desire). Her shoes are winged, and enormous wings

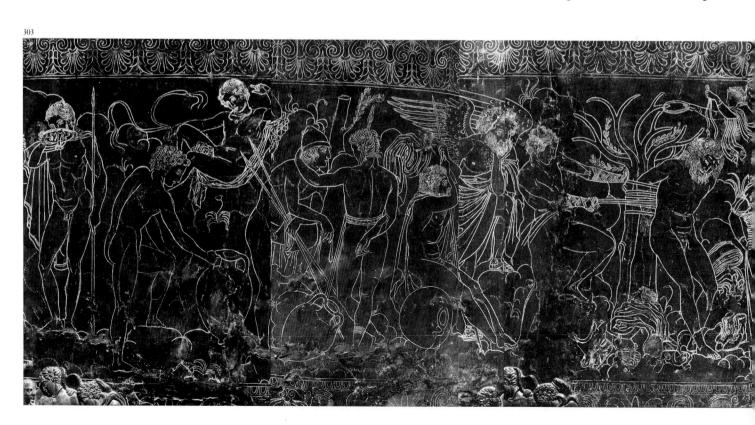

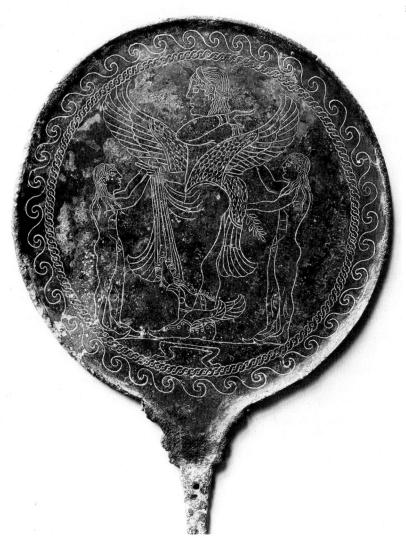

- 301. Bearded Man (Lucius Junius Brutus). Head, с. 300 в.с. Bronze, height 12¾". Palazzo dei Conservatori, Rome
- 302. Mirror back, from Praeneste (present-day Palestrina), Italy. c. 490 B.C. Engraved bronze. British Museum, London
- 303. Novios Plautios. *The Argonauts in the Land of the Bebrykes*, frieze from the *Ficoroni Cist*, from Praeneste (Palestrina). Late 4th century B.C. Engraved bronze, height of cist c. 21". Museo Nazionale di Villa Giulia, Rome

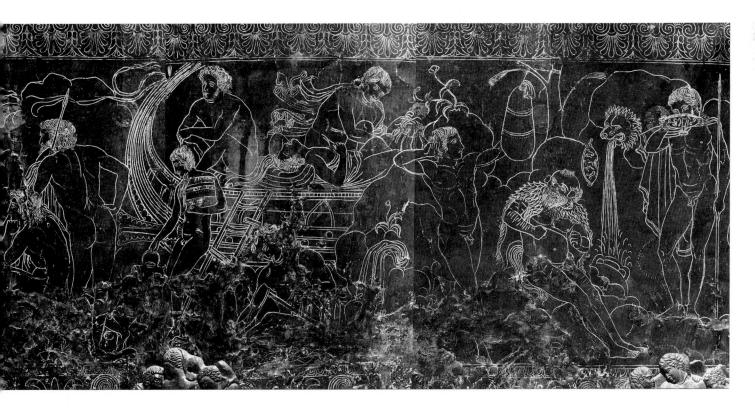

sprout not from her shoulders as we would expect but from her fertile loins. The line flows with a delicate ease we would hardly predict after the intensity of the preceding sculpture in bronze, an ease not only in the bodies and wings but in the ornamental border, especially the wave pattern indicating the sea from which the goddess was born.

The Etruscans commissioned many cists, bronze vessels which were intended to hold objects used in the rituals for the worship of Bacchus and Demeter and were decorated with linear images like those on the mirrors. The most elaborate cist yet found is a splendid example also from Praeneste, the so-called Ficoroni Cist (fig. 303), datable in the late fourth century B.C. The cylindrical body of the cist, topped by three bronze figures on the lid, is best seen in a photograph that unrolls the story like a scroll, reading from right to left. The Argonauts, needing fresh water, have landed in the territory of Amykos, who will permit no one to drink from his spring who cannot beat him in boxing. We see the lion-headed mouth of the spring, with a figure drinking from a kylix, then the hero Pollux practicing with a punching bag, the lofty stern of the ship Argo in the background with reclining Argonauts, but alas, no boxing match. Athena stands in the center, while Pollux vigorously binds Amykos to a tree, and Victory flies overhead. At the left Pollux, now hatted again for the journey, chats affectionately with his twin Castor, while other Argonauts fill their amphorae. The exquisite mastery of the nude body in the flowing contours is matched by the representation of rocks and even mountains in the landscape background. The signature Novios Plautios indicates that the artist was a Greek (not a Roman, as often mistakenly supposed), probably a freed slave of the Roman family of the Plautii. He indicates that he made the work in Rome for a Praenestan patroness, and it has been suggested that he copied the design from a now lost but then famous painting of this subject by the Greek master Kydias, a work known to have been in Rome in the first century B.C. and presumably earlier. This is a fascinating documentation of the complex interrelations of Greek, Etruscan, and Roman cultures.

- 304. Dancing Woman and Lyre Player, wall painting, Tomb of the Triclinium, Tarquinia, Italy. c. 470–460 B.C.
- 305. *Hunting and Fishing*, wall painting, Tomb of Hunting and Fishing, Tarquinia. c. 510–500 B.C.

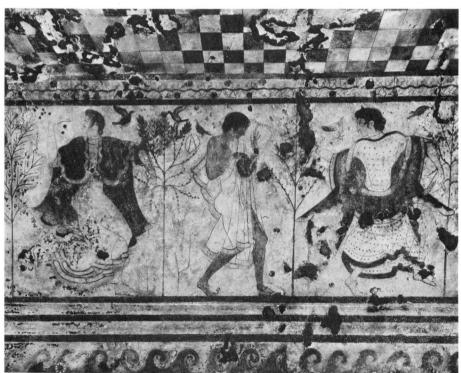

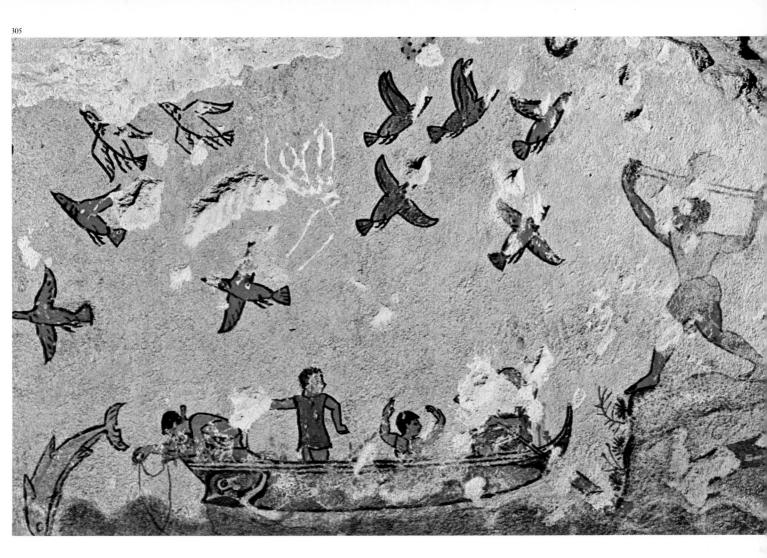

We know the most about the Etruscans from their innumerable tombs, of which hundreds have been explored and thousands more still lie unexcavated, a prey to tomb robbers. Most of the Greek pottery so far recovered has been found in these tombs. Typically, the Etruscan tomb was covered by a simple conical mound of earth, or tumulus, whose base was often held in place by a plain circle of masonry. Some tomb chambers were also circular with corbel vaults like that of the so-called Treasury of Atreus at Mycenae (see figs. 170, 171). More often they were rectangular, rock-cut rooms, which at Tarquinia and other cities contain some of the richest treasures of ancient wall painting we know. Early fifth-century tombs, such as the Tomb of the Triclinium at Tarquinia (fig. 304), were sometimes painted with scenes of daily life; at other times, the funeral feast was shown, as in Egyptian tombs. In the absence of firm knowledge of Etruscan religion, it is impossible to say whether these wall paintings were meant to comfort the deceased or to indicate the existence that awaited them in the afterlife. Their energetic contours and flat surfaces betray the influence of Greek vase painting, especially in the handling of the drapery, but also show a typically Etruscan vigor of movement, as in the depiction at Tarquinia of the dancers frolicking happily outdoors among the trees. The most spectacular of these paintings, representing hunting and fishing (fig. 305), derives from such Greek originals as the Diver from Paestum (see fig. 225). Interestingly enough, both the dolphin and the red and blue birds joyously elude capture, taking refuge in the billowing sea or the endless air.

Tombs

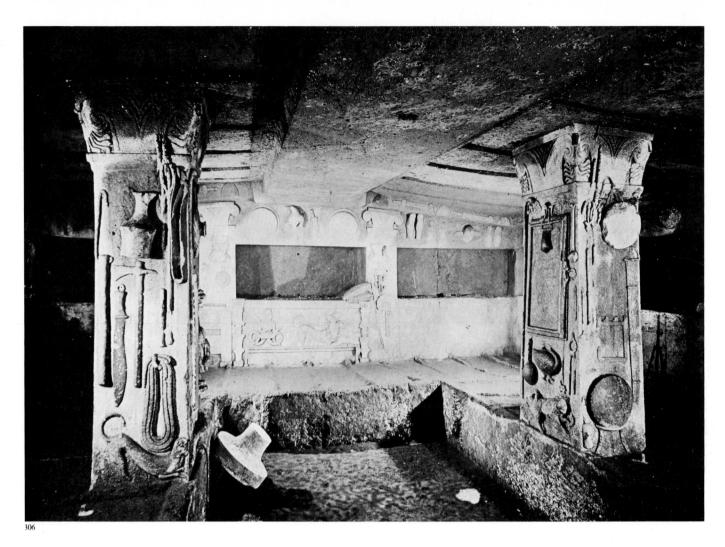

Later tombs, such as the burial chamber in the Tomb of the Reliefs at Cerveteri (fig. 306), take a more gloomy view of the other world. The rock-cut pillars, whose capitals are derived from Greek sources, are supplied with stucco reliefs of household instruments, weapons, and even a small dog, all for the use of the deceased, but a demon of death appears at the end of the chamber, with snaky legs like those of the giants at Pergamon (see fig. 286), and he is accompanied by Cerberus, the threeheaded dog who guarded Hades. The tomb has become an image of the underworld; the earlier joyous vitality has been forgotten.

The Etruscans and their art were eventually submerged in the larger life of the Roman state, and like those of the Egyptians, the Etruscan tombs were not seen again until relatively modern times. But Etruscan art was certainly a major ingredient in the rich artistic mix of Roman culture. And the descendants of the Etruscans still lived on in Tuscany in the Middle Ages and the Renaissance. It was these descendants who produced not only some of the most original and imaginative works of medieval art but also the Renaissance of the fifteenth century A.D.

306. Burial chamber, Tomb of the Reliefs, Cerveteri, Italy. 3rd century B.C.

ROMAN ART

SIX

The culminating phenomenon of ancient history was the rise of a single central Italian city-state from total obscurity to imperial rule over most of the then-known world. Far-reaching as were the effects of Alexander's rocket-like trajectory, they can scarcely be compared to the steady, inexorable expansion of Rome. At the start the Romans were chiefly concerned with maintaining their autonomy against their aggressive neighbors. In 510 B.C. they threw off the Etruscan yoke, yet in 386 B.C. the invading Gauls were strong enough to sack and burn Rome itself. Then the tides reversed; in the third century B.C. Rome, in constant warfare with her African rival Carthage, first dominated, then absorbed all of Italy, Sicily, and most of Spain. In the course of the second century B.C., she conquered the Balkan peninsula including Macedon and Greece, destroyed Carthage and annexed its territory, and expanded into Asia Minor and southern Gaul (modern France). In the first century B.C., the rest of Gaul, Syria, and Egypt fell into Roman hands; in the first century A.D., Rome conquered Britain and much of Germany; in the second, Dacia (modern Romania), Armenia, and Mesopotamia.

At the death of the emperor Trajan in A.D. 117, the Roman Empire extended from the Tigris River in Mesopotamia to the site of the Roman wall built by his successor Hadrian across Britain, close to the present Scottish border, and from the banks of the Elbe to the cataracts of the Nile. This incredible expansion, which not even the Romans could have foreseen, was partly forced upon them by their enemies, especially the Gauls and the Carthaginians, and partly engineered by well-disciplined armies and ambitious generals operating at great distances from any political control. Wherever the Romans went, they took with them their laws, their religion, their customs, and their extraordinary ability to organize. Moreover, on these lands they also imposed the Latin language, with its rigorous grammatical structure and its capacity to express complex ideas. This process of Romanization did not extend to Greece or to the Hellenized East, whose people continued to speak Greek and to preserve many elements of Greek culture. Given the universal extent of Roman power, the history of Roman art is really the history of Mediterranean and European art for half a millennium—so rich, so complex, and so many-sided that only a few of the principal types and historical phases can be treated carefully in a general account.

Quite early in the expansionist career of Rome, two developments became manifest which were destined to have profound artistic consequences. First, the almost continuous process of imperial growth led to a rapid increase in the population of Rome itself and of most of the cities under its control; this growth of population was accompanied by such inevitable problems as mass unemployment and poverty. As a result, not only the prosperous productive classes but also a numerous, idle proletariat required food, water, housing—and entertainment. New types of public buildings—especially vast interior spaces—were needed on an unprecedented scale, and the traditional emphasis of Mediterranean architecture and decoration was thus transformed. Second, the conquest of the Hellenic world—and to a more limited

extent that of Egypt and Mesopotamia as well—opened Rome to the influence of cultures that far surpassed its own in their antiquity, intellectuality, and aesthetic achievement. Parallels to the Roman gods were found in Greek religion and mythology, so that Zeus became Jupiter, Hera Juno, Athena Minerva, and so on. Borrowed artistic elements were superimposed on the practical inventions of the Romans, and foreign artists, especially Greek, were often employed to carry out typically Roman projects. Thus, Rome found itself in the odd position of becoming the vehicle through which Greek forms and ideas were conveyed to western and northern lands that had previously had little or no contact with Hellenism.

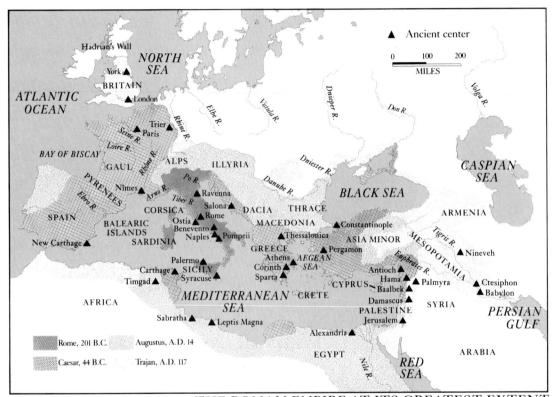

MAP 9. THE ROMAN EMPIRE AT ITS GREATEST EXTENT

If we judge from Roman literary accounts, we must conclude that the Romans of the early Republic were a resolutely anti-aesthetic people. Scornful of what they considered the luxurious ease of their chief competitors in Italy, the Etruscans and the Greeks, the early Romans prided themselves on their austere virtues, frugal life, and military valor. Oddly enough, at first they do not even seem to have paid much attention to town planning—in spite of the example of the Greek cities in southern Italy and Sicily, which were laid out on regular plans, and the planned Etruscan towns in the plain of the Po River. Rome itself was the last Roman city to receive a plan. After its destruction by the Gauls in 386 B.C., the town was rebuilt along the same disorderly lines. During the Republic and the first years of the Empire, Rome was a pell-mell collection of structures, often rebuilt to the height of several stories, with the most slipshod methods, in order to accommodate its ever-increasing population. Contemporary descriptions record vividly the discomforts and hazards of life in the metropolis. Public buildings, such as the great temple The Republic (509–27B.C.)

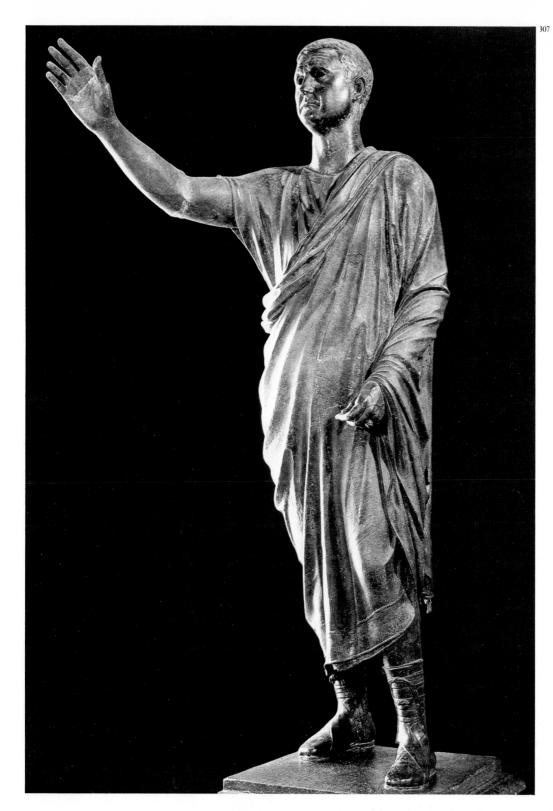

on the Capitoline Hill (see above, page 210), were rebuilt from time to time, however, according to new and imported Greek principles of style. The rectilinear layout of Roman military camps, on which the Romans prided themselves and which they later adapted for their colonial cities, was borrowed from the Etruscans. From them, in fact, the Romans appear to have received their first lessons in building fortifications, bridges, aqueducts, and sewers, in which practical undertakings they took a great deal of pleasure and found—and were able to communicate—a special kind of austere beauty.

307. L'Arringatore (portrait of Aulus Metellus), from Sanguineto, near Lake Trasimeno, Italy. 90–70 B.C. Bronze, height 71". Museo Archeologico, Florence

SCULPTURE Significantly enough, the most impressive witnesses to the formative period of Roman Republican art that have come down to us are the portraits of these sturdy Romans themselves. We have already seen the bronze Etruscan portrait from the third century, whose subject may be a Roman (see fig. 301). Another splendid example in bronze, the so-called Arringatore (Orator), dates from the first century B.C. (fig. 307). Found at Sanguineto near Lake Trasimeno in southern Etruscan territory, the statue bears an Etruscan inscription which includes the Roman name Aulus Metellus, the subject of the portrait. Whether the sculptor himself was Roman or Etruscan is almost beside the point, since the work was done at a period when the territory had already been Romanized; Aulus Metellus may have been a Roman official. The directness and force of the representation show a new and characteristically Roman attitude toward portraiture. The simple stance, with some weight on the free leg and the hand thrust forward in an oratorical gesture, has nothing to do with the tradition of organic grace that runs through even the most naturalistic poses of the Hellenistic period. The subject himself, with close-cropped hair, wrinkled forehead, and tight lips, is represented with an uncompromising directness that makes no concessions to Hellenic beauty.

The Greeks never accepted the idea of the separate portrait head or bust because to them a separate portrait bust made the head appear to have been decapitated. But as we have seen, such heads were in the Etruscan tradition (see fig. 301). In Roman Republican times, exact portrait masks of the deceased were made of wax and were preserved in a wooden cabinet in the home, to be carried by relatives at later funeral ceremonies. This custom reflects a kind of ancestor worship, by means of which the old patrician families preserved their identity. The artistic result was uncompromising realism. A statue of a Patrician Carrying Two Portrait Heads (fig. 308) embodies this atavistic tradition with a brutal directness that would have horrified the Greeks and, incidentally, illustrates several stages in the early development of Roman portraiture. The heads, which show a strong family resemblance, represent wax images that in the right hand an original of about 50-40 B.C., that in the left done around 20-15 B.C. Both show stern, bleak Romans, but the statue itself, with its elaborately draped toga (the outer garment worn in public by male citizens), can be dated in the early years of the Empire, about A.D. 15. By an irony of fate, the statue's original head is missing and was replaced in recent times with an unrelated one dating from about 40 B.C.

The typical Roman Republican portrait strove to render the subject with a map-maker's fidelity to the topography of features, in keeping with the air of simplicity stoutly maintained by even the most prosperous citizen. A striking example is the portrait bust (fig. 309), dating from the mid-first century B.C. and possibly representing the dictator Sulla, which shows an irredeemably homely man in late middle age, whose bald forehead is creased by a frown. His cheeks are slashed by deep wrinkles, his lower lip crumpled in the middle, and above his bulging eyes one of his heavy eyebrows is punctuated by a huge wart. In contrast to such brutal Roman honesty, an unexpectedly subtle Republican Head of Pompey (fig. 310) dating from around 55 B.C., although thought by some to be an early imperial copy, was almost certainly carved by a Greek sculptor. This master had at his fingertips all the traditional devices of Hellenistic art for the differentiation of the textures of the full cheeks, the wrinkled forehead, the bulbous nose, the sharp eyelids, and the short, crisply curling locks of hair, and for the manipulation of the play of light over marble surfaces. Yet if we compare this head to the *Portrait of Alexander* (see fig.

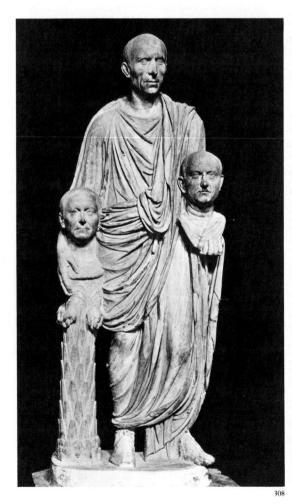

308. Patrician Carrying Two Portrait Heads. c. A.D. 15. Marble, lifesize. Museo Capitolino, Rome

276), we can see that the Roman subject is treated with a psychological reserve respected by men who placed ultimate value on decisive action.

But the influence of Greek art on Roman culture was by no means limited to the importation of Greek artists; beginning with the sack of Syracuse in 212 B.C., actual works of Greek art—sculpture, painting, and minor artifacts of all sorts—arrived in Rome in great numbers. Stripped from their original settings, these works, often intended for religious or political purposes, became to the Romans only objects of adornment. In the homes of wealthy Roman patricians, extensive collections of Greek art were rapidly built up by plunder or by purchase. When no more originals were available, copies were manufactured by the thousands, often in Athens and in other Greek centers as well as in Rome, to satisfy the voracious market.

ARCHITECTURE It is significant that, although Roman literature gives us admiring accounts of Greek art and artists, doubly precious to us in the absence of the original Greek works, the Romans had little to say about their own art; they seldom recorded the names and never discussed the styles of the many artists—some of them great—who carried out ambitious Roman projects. Most of the few recorded names are Greek. The profession of painter or sculptor had little social standing, and the necessity of making numerous quasi-mechanical copies must have lowered the artists' own self-esteem. In consequence no distinct artistic personalities comparable to those known to us from Greek art emerge from the thousands of preserved Roman works. In its anonymity and in its collective character, Roman art can be more easily paralleled with that of Egypt or Mesopotamia. Only in the field of architecture—in the writings of the first-century-B.c. architect Vitruvius—do we find much interest in theory, and even here it is largely applied to the codification of an already accepted body of architectural knowledge, for much of which Vitruvius was obliged to resort to Greek terminology.

In the absence of extensive knowledge about the magnificent Temple of Jupiter Optimus Maximus, rebuilt on the Capitoline Hill in 69 B.C., with lofty marble columns imitated from Greek models and bronze roof tiles covered lavishly with gold leaf, we have to rely on comparatively modest examples for an idea of Republican architecture. One of these is the well-preserved second-century building known as the Temple of Fortuna Virilis (fig. 311; a misnomer—the building was probably dedicated to Portunus, the god of harbors), near the Tiber in Rome. Elements of Etruscan derivation are immediately visible—the podium, the flight of steps at the front, and the deep portico. But equally obvious is the attempt to Hellenize the building. The slender proportions were derived from Greece, as was the Ionic order (see figs. 193, 242). A compromise is apparent in the way in which the peristyle was carried around the sides and back of the temple only in engaged columns rather than in the freestanding columns generally preferred by the Greeks. Also, when compared to Hellenic architecture, there is something cold and prim about this little building; the capitals, in particular, lack the organic fluidity of Greek models.

Even more illuminating for the future of Roman architecture was the circular so-called Temple of the Sibyl (fig. 312) at nearby Tivoli. Although this Corinthian structure may derive ultimately from Roman circular huts, some of which were religiously preserved on the Palatine Hill

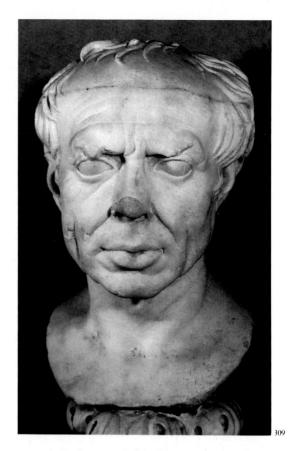

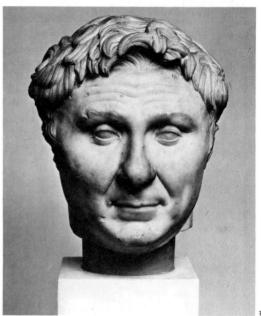

309. Head of a Roman with a Wart over His Eye. c. middle 1st century B.C. Marble, height 373/8". Vatican Museums, Rome

310. *Head of Pompey*. c. 55 B.C. Marble, height 97/8". Ny Carlsberg Glyptothek, Copenhagen

into imperial times, it owes its immediate formulation to the Greek tholos type (see fig. 170). The round temple at Tivoli has one remarkable feature. Instead of the coursed masonry characteristic of almost all Greek historic architecture, the cella is built of concrete. Roman concrete was not the semiliquid substance in use today, but a rougher mixture of pebbles and stone fragments with mortar, poured into wooden frames or molds. While the concrete was being formed, wedge-shaped stones (and later flat bricks) were worked into its sides, thus forming an outer skin that both protected the concrete and served to decorate the surface when it was exposed. This technique, used occasionally by the Greeks for fortifications in Asia Minor as early as the third century, was adopted by the Romans for architecture on a grand scale. They were thus freed from the limitations of the post and the lintel—which had governed architecture since the days of the Egyptians—and were able to enclose huge areas without inner columnar supports. They could for the first time sculpture space itself, so to speak. Rapidly in Roman architecture the column became residual, an element of decoration to be applied to the rough concrete walls, like the marble paneling or stucco with which the concrete was often veneered. Most Roman ruins, stripped of their gorgeous coverings, look grim; to gain a true idea of their original effect, we must resupply them in imagination with their missing decoration.

As early as the second century B.C., the Romans appear to have discovered how to exploit the new opportunities given to them by concrete by establishing an architecture based not on straight colonnades but on open spaces of constantly changing size and shape. They also learned how to combine their new discoveries with a dramatic conquest of landscape itself. In this respect the great civic centers built by the Hellenistic monarchs in Asia Minor were pioneers. However, Hellenistic spaces were limited by the convention of the straight colonnade, and irregular terrain could prove embarrassing, forcing an unwanted asymmetry on the architects. The flexibility of concrete construction gave Roman architects new

- 311. Temple of Fortuna Virilis (Temple of Portunus), Rome. Late 2nd century B.C.
- 312. Temple of the Sibyl, Tivoli, Italy. Early 1st century B.C.

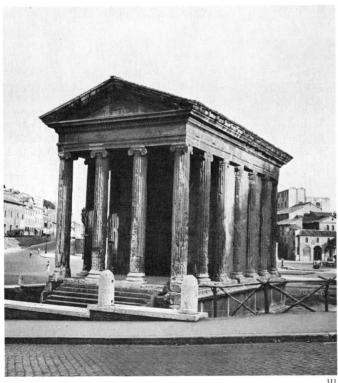

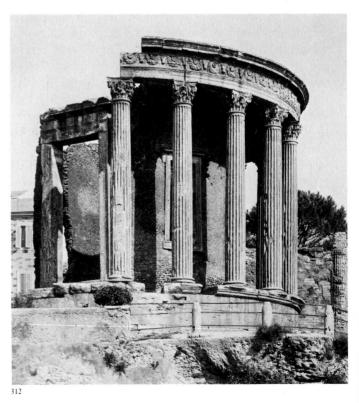

freedom of action, and they pressed home their advantage with imaginative boldness.

A striking early example of such planning is the sanctuary of the goddess Fortuna at Praeneste—the modern Palestrina—long thought to be a work of the early first century B.C. But the date has been pushed back well into the second century by newly discovered evidence. The city on the plain was connected with the temple of the goddess some three hundred feet above by an elaborate system exploiting to the maximum the dramatic possibilities of the steep slope. A destructive air raid in World War II stripped from the Roman ruins the medieval buildings that had covered them for centuries, and made visible the underlying concrete constructions (fig. 313). A model of the sanctuary as it originally appeared (fig. 314) shows that worshipers entered by means of two covered ramps, which converged on either side of a central landing, affording an immense view of the new city, the surrounding plain, and the distant sea. From this landing a steep staircase led upward to four terraces of different sizes and shapes. On the first a remarkable vaulted colonnade, punc-

313. Sanctuary of Fortuna, Praeneste (present-day Palestrina), Italy. 2nd century B.C.

^{314.} Sanctuary of Fortuna, Praeneste. Museo Archeologico Nazionale, Palestrina (Architectural reconstruction)

tuated by two semicircular recesses called exedrae, protected a continuous row of barrel-vaulted rooms (now clearly visible; see fig. 313). On the second similar rooms were enclosed by an engaged colonnade—one of the earliest appearances of the arch embraced by columns and entablature, a motive that became standard in Roman imperial architecture and was revived enthusiastically in the Renaissance. The third terrace was a vast, open square, surrounded on two sides and part of a third by Lshaped colonnades reminiscent of Hellenistic stoas, terminating in pediments. Finally came a theater-like structure, apparently intended for religious festivals, surmounted by a lofty colonnaded exedra, also terminated by pediments. Almost hidden behind the exedra was the circular Temple of Fortuna. This series of ascending and interlocking masses and spaces of constantly changing character shows a new kind of architectural thinking, made possible only by the sculptural freedom afforded by concrete. Such thinking later found its grandest expression in the forums (open civic centers) which were the chief architectural glory of imperial Rome.

A vast number of Roman town houses are known, many from recent excavations in all parts of the Roman Empire but the majority from the southern Italian cities of Pompeii and Herculaneum, which were buried by the eruption of Vesuvius in A.D. 79. The excavation of these two cities, begun in the middle of the eighteenth century, disclosed not only the houses themselves but furniture, implements, and even food in a sufficiently good state of preservation to enable a detailed reconstruction of the daily life of their inhabitants. In fact, by pouring plaster into holes in the hard-packed ash, it has been possible to rediscover the long-dissolved forms of humans and animals in their death agony.

Pompeii and Herculaneum were designed according to a grid plan imitated from their Greek neighbors (for Greek city-plans, see p. 191), although in the case of Pompeii the plan is somewhat irregular (fig. 315), since a grid had to be imposed on preexisting streets. Both cities were inhabited by a mixture of Greeks and Italians, among whom the Samnites, an indigenous people related to the Romans, were predominant. Both cities were brought under Roman rule by the dictator Sulla in 80 B.C. Pompeii was badly damaged by an earthquake in A.D. 62; some of its public buildings were under reconstruction, but others were still in ruins when Vesuvius buried the city for good seventeen years later. Among these were the structures surrounding the Forum (fig. 316). Characteristic of all Italic settlements, this central gathering place usually barred to all but pedestrian traffic was the result of haphazard growth in many cities, including Rome. But in Pompeii the Hellenized Samnites had designed an impressive layout, which was later adopted throughout the Roman world. The design resembled the Greek agora, such as that at Assos (see fig. 270), but with colonnades lining both the long sides and the south end. The long, relatively narrow space was dominated by the temple of the Capitoline triad (Jupiter, Juno, and Minerva) at the north end.

Toward the south end stood the Basilica, dating from about 120 B.C. (fig. 317), the earliest known example of a type of building destined for a long and honorable history. The word is of Greek origin, but the building was developed in Italy for the same purpose as the stoa, for gatherings of businessmen and eventually for law courts. Generally a basilica was built with a long, narrow central space, or *nave* (from the Latin word for "ship"), supported by colonnades, which separated the nave from the side aisles and which were customarily carried across both ends as well, forming a division before the spaces where judges held court (the *apses*). The side aisles often supported colonnaded galleries. Light came through the windows

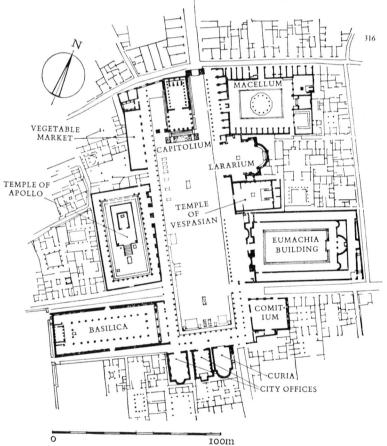

in the galleries and from a *clerestory* of windows in the walls above the galleries, which were roofed separately from the nave. Until the fourth century, basilicas were always roofed with timber, protected by tiles. The nave, side aisles, and galleries should be imagined as crowded with businessmen, clients, and scribes, the apses with plaintiffs, defendants, and attorneys. (The Basilica at Pompeii has neither clerestory nor apse.)

The basic plan of the private house, called by the Romans the domus

- 315. Plan of the city of Pompeii, Italy (aerial view)
- 316. Plan of the Forum, Pompeii, under reconstruction in A.D. 79

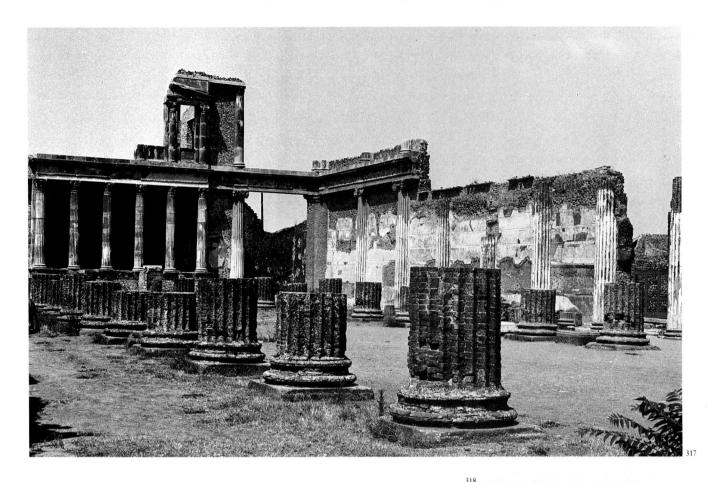

(from which the English word domestic is derived), seems to have been common to the Etruscans, the Samnites, the Romans, and other Italic peoples. As often in Italian town houses even today, the street entrance was flanked by shops. A corridor led to a central space called the atrium, bordered by smaller, generally windowless rooms. The atrium roof sloped toward a central opening which let rainwater into a basin in the floor, at first of tufa or terra-cotta, later of marble, whence it drained into a cistern. At the far side of the atrium was the tablinum, a shrinelike room for the storage of family documents and wax portraits. By the second century B.C. every fine domus was also provided with a peristyle court, entered through the tablinum and remarkably similar to the contemporary Hellenistic examples at Delos (see fig. 293). In the center of the court might be a garden with fountains and statues. The family living and sleeping rooms were entered from the peristyle. The House of the Silver Wedding at Pompeii (fig. 318; see also the plan of the House of the Faun, fig. 319) is one of many such residences, more luxurious than the palaces of the kings at Pergamon. The corners of the atrium were sustained by stately Corinthian columns of marble; the open tablinum provided a delightful view of the garden in the peristyle court. Plaster casts of the holes left by roots in the earth have made it possible to identify the original flowering plants, and these have been replaced today.

The earliest known Roman apartment houses were also discovered at Pompeii. Careful examination has determined that these were formed in the later decades of the Republic, probably by real-estate operators who bought up numbers of domus houses, joined them together, and built second or even third stories on top—not to speak of rooms on balconies jutting into the street—all erected sloppily enough to justify the bitterest complaints of ancient writers regarding similar dwellings in Rome.

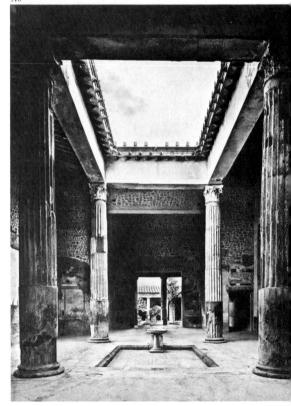

317. The Basilica, Pompeii, c. 120 B.C.

318. Atrium, House of the Silver Wedding, Pompeii. Early 1st century A.D.

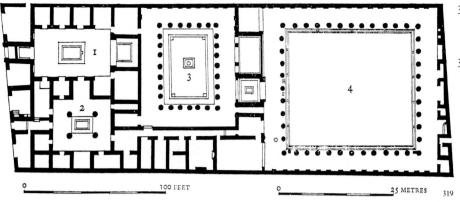

- 319. Plan of the House of the Faun, Pompeii. 2nd century B.C. 1. Atrium 2. Atrium tetrastylum 3. Peristyle 4. Peristyle
- 320. Room in the House of the Centaur, Pompeii, with First Style decoration

PAINTING Late Republican houses glowed with color. The interior walls were often decorated, as in contemporary second-century houses at Delos (see fig. 293), with painted and modeled stucco panels imitating marble incrustation. The stucco was mixed with marble dust, like that used for the exteriors of Greek temples (see p. 162), and was smoothed to give the appearance of marble. Panels of rich red, tan, and green were enclosed by white frames modeled in stucco, as in a room from the House of the Centaur at Pompeii (fig. 320). This method has been called the First Pompeiian Style, although late examples date from just before the

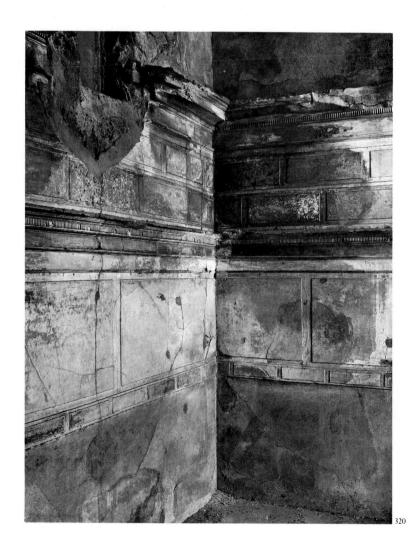

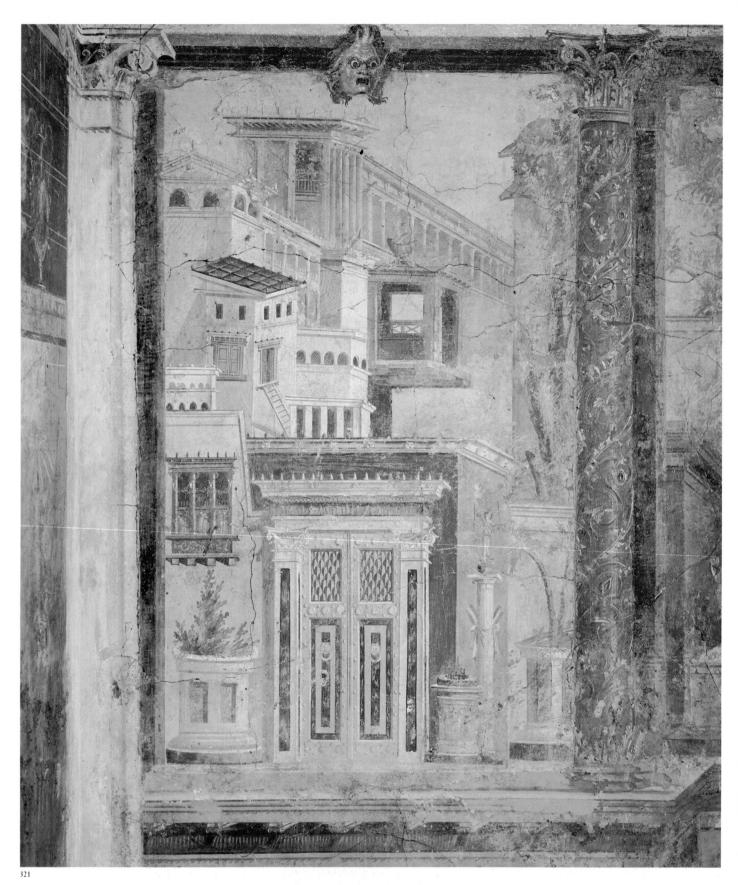

eruption of Vesuvius. The Second Pompeiian Style, which appears to be roughly contemporary with Julius Caesar (c. 80-15 B.C.), is far more imaginative; instead of being paneled, the wall was transformed into an architectural illusion by paintings, often of amazing skill. In a delightful little room from a villa of the late first century B.C., found at Boscoreale near Naples (fig. 321), the walls have been simply painted away. Rich red porphyry columns, entwined with golden vinescrolls and surmounted by gilded Corinthian capitals, appear to support the architrave, to which is attached a superbly painted mask. Through this illusionistic portico we look into a sunlit garden, then out over a gilt-bronze gate framed by a marble-encrusted doorway into a view of rooftops and balconies rising in the soft, bluish air and culminating in a grand colonnade, somewhat on the principle of the view up the hillside to the sanctuary at Praeneste (see fig. 314). For all the apparent naturalism of the painting, which shows such details as a balcony room accessible only by a ladder, it is evident that the painter felt no responsibility to depict the entire scene as it would appear from a single viewpoint at a single moment in time. Disconcertingly, some buildings are seen from below, some from head on, and some from above. Both artist and patron were apparently content with an arrangement that stimulated without ever quite satisfying a desire to explore distant space. To our eyes the evident contradictions contribute a dreamlike quality of unreality, which is enhanced by the absence of even a single person in this magical city.

The Second Pompeiian Style could also utilize the illusion of a portico as a springboard into a mythological world of the past, as in the landscapes with scenes from the *Odyssey* (fig. 322) discovered in the nine-

- 321. Architectural View, Second Style wall painting from a villa at Boscoreale, near Naples. c. 50–40 B.C. The Metropolitan Museum of Art, New York. Rogers Fund, 1903
- 322. The Laestrygonians Hurling Rocks at the Fleet of Odysseus, wall painting from a villa on the Esquiline Hill, Rome. Middle 1st century B.C. Vatican Museums, Rome

teenth century in a villa on the Esquiline Hill, and datable about the middle of the first century B.C. Although the painters may not have been Greek (there are errors in the occasional Greek inscriptions), it is now believed they were working on the basis of Greek originals of the second century B.C., possibly Alexandrian or southern Italian. The square piers, bright red with gilded Corinthian capitals, form a shadowed portico through which one looks happily, as from a tower, into a far-off land of sunny rocks and blue-green sea, toward which Odysseus and his companions escape in their ships from the attacks of the fierce Laestrygonians. The landscapes were painted with ease and speed in a fluid style contrasting deliberately with the uncanny precision of the architecture.

A grand room still in place in the Villa of the Mysteries at Pompeii (fig. 323) shows another aspect of Second Style illusionism. The actual walls have been transformed by painted architectural elements into a sort of stage on which gods and mortals sit, move, converse, even turn their backs to us, their attitudes ranging from quiet, classical serenity to occasional and startling terror. Apparently, the subject—still not entirely understood—was drawn from the rites attending the worship of the Greek god Dionysos, one of several competing mystery cults brought to Rome from various parts of the Empire. The nobility of the broadly painted, sculptural figures, almost lifesize, is heightened by contrast with the brilliance of the red background panels, green borders and stage, vertical black dividing strips, and richly veined marble attic.

- 323. *Dionysiac Mystery Cult*, wall painting, Villa of the Mysteries, Pompeii. c. 60–50 B.C.
- 324. Still Life, wall painting from the House of Julia Felix, Pompeii. 1st century B.C.—early 1st century A.D. Museo Archeologico Nazionale, Naples

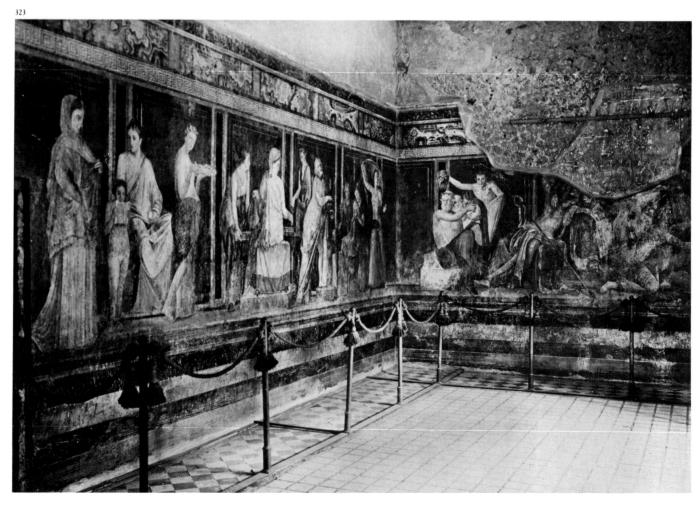

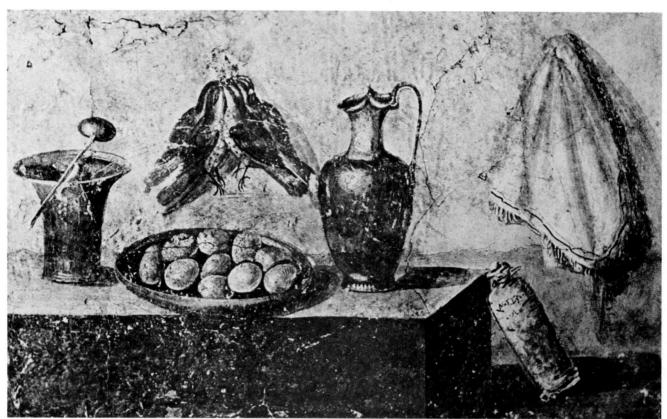

324

Often the illusionistic skill of the Second Style painters, doubtless deriving from Hellenistic tradition, could be dazzling, as in the frequent still lifes painted on the walls of Roman houses. An example of such virtuosity repeated in the later (Fourth Style) House of Julia Felix in Pompeii (fig. 324) shows a corner in a kitchen, with dead birds, a plate of eggs, metal household instruments, and a towel, all arranged in a strong light from a single source, which not only reveals forms and casts shadows, but conveys beautifully reflections in the polished metal. An even more spectacular illusionistic work, in fact unparalleled in all of ancient art, is the garden room from a villa at Prima Porta which once belonged to Livia, the third wife of the emperor Augustus, possibly before their marriage (fig. 325). All four walls disappear, in a manner attempted more modestly long before in the Minoan landscape room at Thera (see fig. 1). A fence and a low wall are all that separate us from an exquisite garden, half cultivated, half wild, in which no earthbound creature can be seen; only fruit trees and flowering shrubs compete for the attention of the songbirds which perch here and there or float through the hazy air. Our vision roams freely around this enchanted refuge which, however, encloses us so entirely as to exclude all but the blue sky. The poetic delicacy of the conception and the consummate skill of the rapid brushwork make this a masterpiece among the world's landscape paintings.

For more than a century, it had been apparent that the traditional political machinery of the Roman city-state—the popular assemblies, the patrician senate, and the two consuls chosen annually—was inadequate to cope with the problems posed by a vast and expanding empire and a set of freewheeling armies, often separated by weeks or even months of travel

The Early Empire (27 B.C.-A.D. 96)

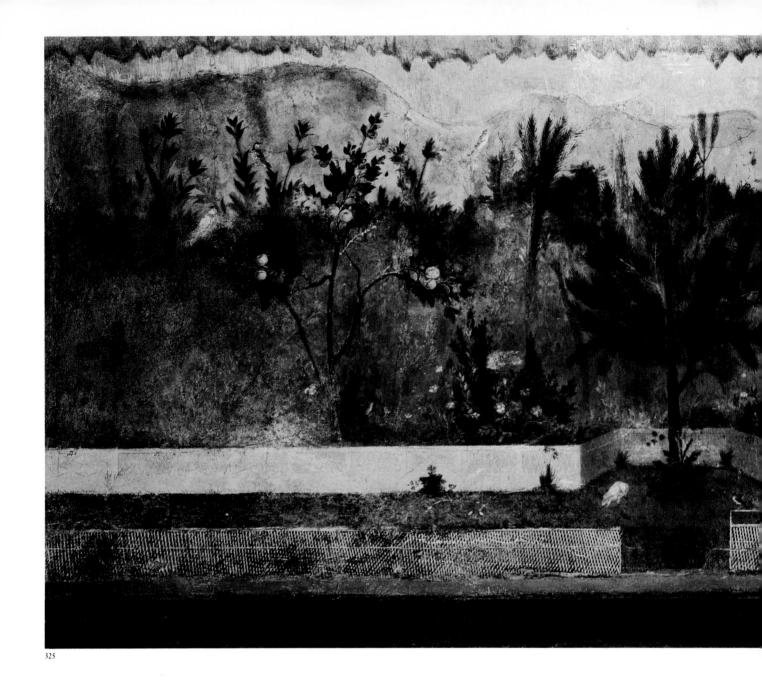

from any decree that might be issued in the capital. In several periods of bloody civil warfare, the armies competed with each other for power. Only briefly, under the dictatorships of Sulla (82–79 B.C.) and Julius Caesar (49–44 B.C.), could any form of stability be maintained. In 31 B.C. Octavian, Caesar's great-nephew and adopted son and heir, defeated Antony and Cleopatra in the Battle of Actium, sealing the fate of both the Roman Republic and the Hellenistic world. Cleopatra was the last independent Hellenistic monarch; after her defeat Egypt became Roman. Four years later, in 27 B.C., the Roman senate voted Octavian the title of *Augustus*, and he became in effect the first legitimate Roman emperor.

Augustus ruled as emperor for forty-one years, a period of unprecedented peace and prosperity. The façade of republican government was piously maintained, but power was in fact exercised by Augustus and his successors, who controlled all military forces and appointed governors for the important provinces. The title *Imperator* meant "army commander"; nonetheless, the emperors, who rarely held office in the obsolete but well-nigh indestructible framework of the Republic, in truth gov-

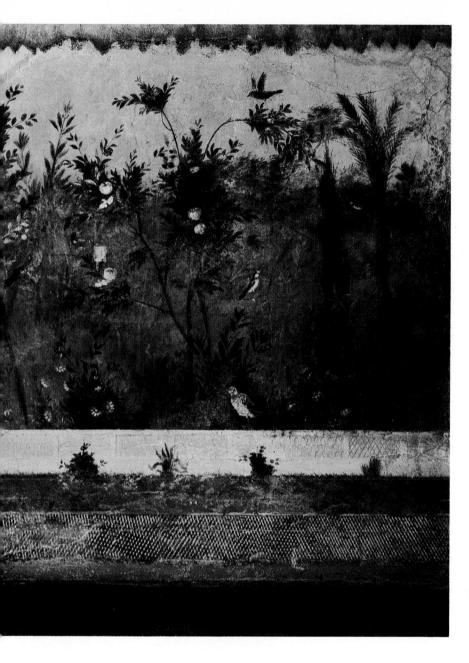

325. Garden Room, wall painting from the Villa of Livia, Prima Porta, near Rome. Late 1st century B.C. Museo Nazionale Romano, Rome

erned as monarchs. Augustus' hybrid compromise survived for more than four centuries. With predictable immediacy the emperors were deified after death; Augustus erected a temple to Julius Caesar, and some of his successors demanded worship as gods while still alive, in the manner of Egyptian and Mesopotamian divine monarchs.

SCULPTURE Now that the Romans had had time to digest their avidly devoured diet of Greek culture, they were able to profit by it and to bring forth a new art of their own. It was to be expected that its Etruscan and Greek sources would at first be plainly visible. Equally predictable was that the new art would deal less with religion and mythology, the primary concerns of the Greeks, than with transforming the often brutal facts of Roman military and political life into partly mythologized images for public consumption. In the celebrated statue of Augustus from the imperial villa at Prima Porta (fig. 326), the new ruler is seen as *Imperator*, in a grand pose easily recognizable as a blend of the *Doryphoros* (see

fig. 215) and the Arringatore (see fig. 307) in equal proportions. The statue was probably a replica carved immediately after Augustus' death (otherwise, he would have been shown wearing military boots, which, as a god, he did not need), but the emperor is represented as a young man. The head is a portrait, belonging to an official type known in all parts of the Empire through its appearance on coins. Yet the features have been given a distinct Hellenic cast, idealized and ennobled. The figure stands easily, as if the oratorical gesture of the right arm grew from the very stone below the left foot. The cloak seems to have fallen accidentally in coldly Phidian folds from the shoulders to drape itself around the waist and over the arm, thus revealing a relief sculptured on the armor, narrating the return by the Parthians, about 20 B.C., of the military standards they had captured from the Romans.

A deliberate contrast is offered by the statue of Augustus as Pontifex Maximus (the pontifex maximus was the Roman high priest; fig. 327), in which the emperor is shown about to perform a sacrificial rite, his head veiled in a fold of his toga. Unbelievably, the statue must have been made when the emperor was more than seventy years old; all signs of advancing age have been blurred by an almost Praxitelean softness in the handling of the marble. The still-recognizable face radiates a godlike wisdom and benignity.

In a detailed account of the achievements of his reign, Augustus boasted that he "found Rome of brick and left it of marble." Although this could scarcely be said to apply to the multistory tenements inhabited by the populace, Augustus energetically continued the building program initiated by Julius Caesar and constructed innumerable public buildings on his own. He desired first of all to celebrate the Pax Augusta (Augustan peace) with buildings in which the new imperial power was to be dignified by the cadences of an imitated Attic style.

Chief among these monuments was the Ara Pacis (Altar of Peace; fig. 328), commissioned by the Senate in 13 B.C. and finished in 9 B.C. Although the monument suggests in form the Altar of Zeus at Pergamon (see fig. 284), it is on a far more intimate scale and is in every respect less dramatic. The altar itself is surrounded by a marble screen-wall, visible as a square block divided by delicate pilasters. These and the lower half of the wall are covered with a tracery of vinescrolls of the utmost delicacy and elegance. Above a meander pattern are a series of reliefs, some illustrating events from Roman history and religion, some showing contemporary events. The emperor himself, his head veiled for sacrifice, leads the numerous and recognizable members of the imperial family (fig. 329). In the rhythmic movement of the drapery, the frieze recalls that of the Parthenon (see fig. 237) and was doubtless intended to. But there are instructive differences: first, the Panathenaic Procession was represented on the Parthenon as a timeless institution, while the scene on the Ara Pacis shows a specific historic event, probably that of 13 B.C., when the altar was begun; second, the figures on the Ara Pacis are far more closely massed, as undoubtedly they would have been in reality; finally, the background slab of the frieze seems to have moved away from us, allowing room for figures behind figures, with progressively reduced projections. One of the reliefs flanking the east doorway shows Mother Earth with a personification of Tellus (Earth) accompanied by Air and Sea (fig. 330); all are portrayed as gracious, very Hellenic-looking goddesses, seated respectively on a rock, on a swan, and on a sea monster. The delicately observed landscape elements come from Hellenistic sources, and the same type of billowing, parachute-like veils over the heads of Air and Water

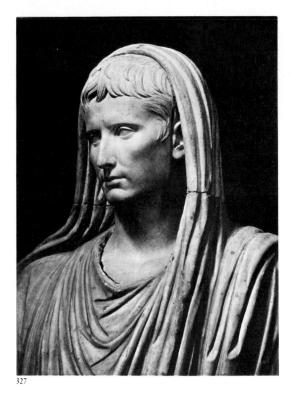

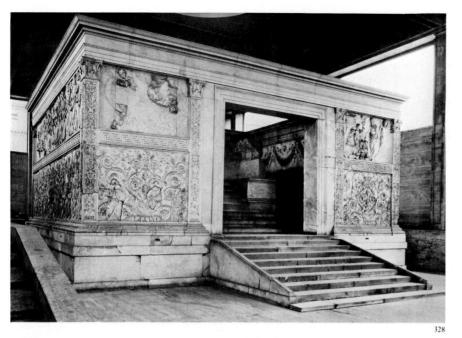

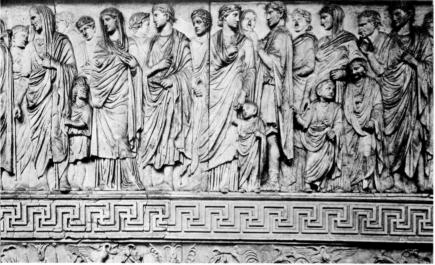

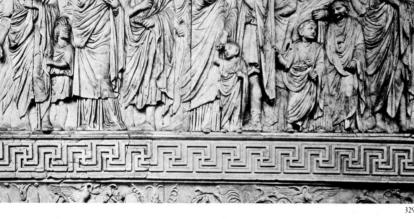

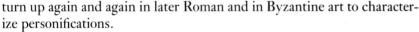

In a marvelous cameo, the Gemma Augustea (fig. 331), probably cut for Augustus' son-in-law and successor, Tiberius, the seminude emperor shares a benchlike throne with the goddess Roma, made to resemble a Greek Athena; he is attended by relatives and by allegorical figures, one of whom is about to place a laurel wreath on his head. Above Augustus is his zodiacal sign, Capricorn. In the lower zone two barbarians, male and female, crouch disconsolately while Roman soldiers erect a trophy, a pole carrying armor stripped from the barbarian; two other barbarians are pulled in by the hair. With consummate skill and grace, the artist has worked the intractable semiprecious stone into a delicate relief, constantly suggesting space in the foreshortening of the human figures, the chariot, and the horse. In its allegorical version of history and in its exquisite refinement, this work sums up the ideals of the early Empire.

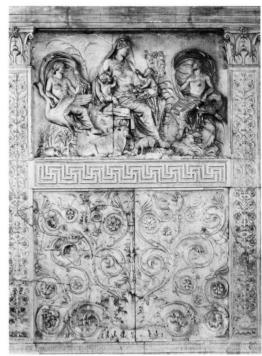

- 326. Augustus of Prima Porta. c. A.D. 15, probably after original of c. 20 B.C. Marble, height 80". Vatican Museums, Rome
- 327. Augustus as Pontifex Maximus. 1st-century-A.D. replica of original of c. 20 B.C. Marble, height 81½". Museo Nazionale Romano, Rome
- 328. Ara Pacis. c. 13-9 B.C. Marble, width of altar c. 35'. Museum of the Ara Pacis, Rome
- 329. Imperial Procession (detail of the Ara Pacis frieze). Marble relief, height c. 63"
- 330. Earth, Air, and Sea Personified and Vinescroll Ornament (details of the Ara Pacis frieze). Marble reliefs

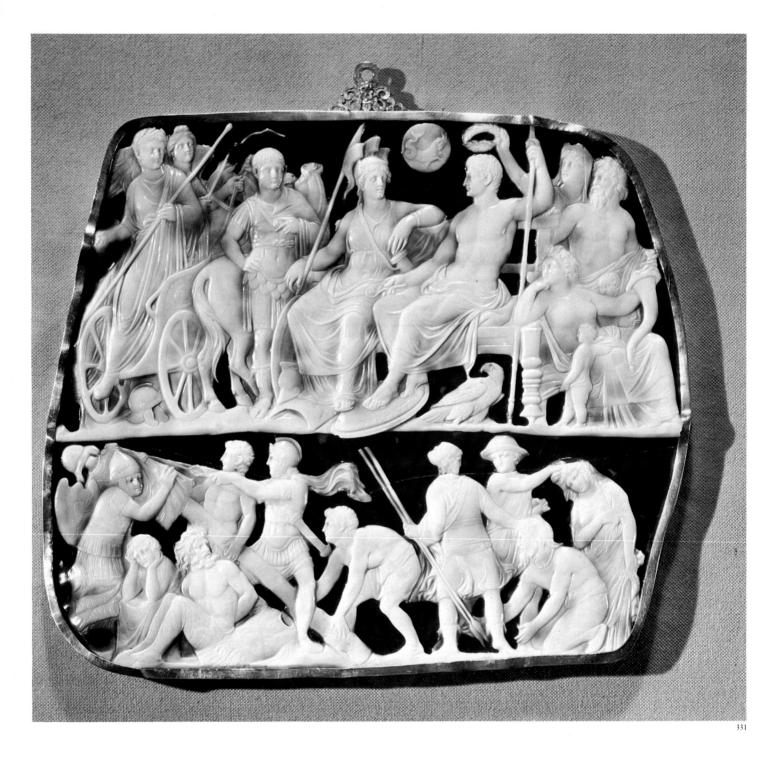

ARCHITECTURE Unfortunately, no Augustan temple survives in Rome in sufficiently good condition to enable us to appreciate the qualities of style the emperor desired. Luckily, this gap can be partly filled by an Augustan temple at Nîmes in southern France; nicknamed the Maison Carrée (fig. 332), it was begun about A.D. 1–10 and was based on the Temple of Mars Ultor (see below). This little structure can claim to be the best preserved of all Roman buildings. We recognize the familiar podium, front steps with flanking postaments, deep porch, and shallow cella of the Etrusco-Roman tradition. The temple, moreover, revives the Republican system of ornamenting the cella wall with an engaged pseudoperistyle. But the Corinthian order, henceforward the favorite in Roman buildings, is far richer than the austere Ionic of the Temple of

- 331. *Gemma Augustea*. Early 1st century A.D. Onyx cameo, $7\frac{1}{2} \times 9^n$. Kunsthistorisches Museum, Vienna
- 332. Maison Carrée, Nîmes, France. Begun c. A.D. 1–10

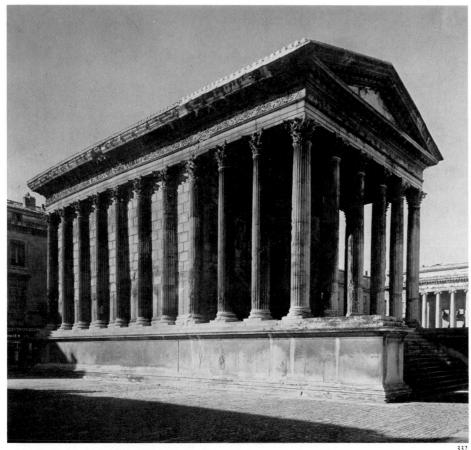

Fortuna Virilis (see fig. 311), and its frieze, no longer blank, is enriched by the kind of delicately carved vinescroll we have seen in the Ara Pacis.

It is with all these aspects of Augustan art in mind that we should attempt to reconstruct mentally the vanished magnificence of the ruined Forum of Augustus, which met the Forum of Julius Caesar at right angles (plan, fig. 333; reconstruction, fig. 334). The Temple of Mars Ultor (Mars the Avenger; fig. 335), of which four side columns remain standing, stood at the end of the Forum of Augustus on the usual podium, like that of the Capitoline Jupiter at Pompeii. Its back abutted an enclosing wall 115 feet high, which described an exedra on either side of the temple, cut off the view of surrounding buildings (including a slum), and protected the forum from the danger of fire. The eight lofty Corinthian columns across the front formed part of a freestanding peristyle that continued on both sides as well, but ended at the enclosing wall. In front of the exedrae and along either side of the rectangular plaza in front of the temple ran a row of smaller Corinthian columns, upholding an attic story which was ornamented with a row of caryatid figures, mechanical copies of the maidens of the Erechtheion porch (see fig. 246). The white marble columns shone against back walls paneled in richly colored marbles, producing on a grand scale an effect as brilliant as that of the Gemma Augustea.

Not all of Augustus' successors shared his concern with maintaining the public-spirited "image" he desired for the Julian-Claudian dynasty (the family relationships were often tenuous). Nero, last of the line, was known for the most extravagant abode of antiquity, the famous Golden House, of which only fragments remain. This residence was, in effect, a country villa in the heart of Rome, stretching from the Palatine to the

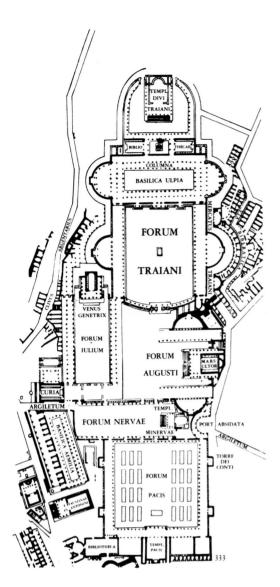

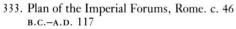

- 334. Reconstructed view of the Temple of Mars Ultor and part of the Forum of Augustus, Rome
- 335. Temple of Mars Ultor, Forum of Augustus, Rome. Late 1st century B.C.
- 336. Reconstruction of an insula, Ostia, Italy. 2nd century A.D.
- 337. Pont du Gard, near Nîmes. Late 1st century B.C.

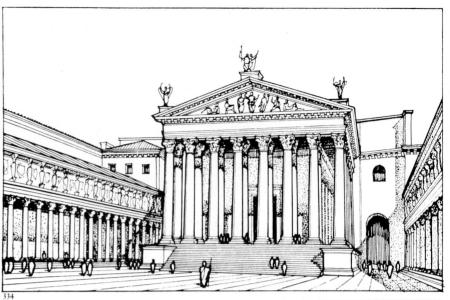

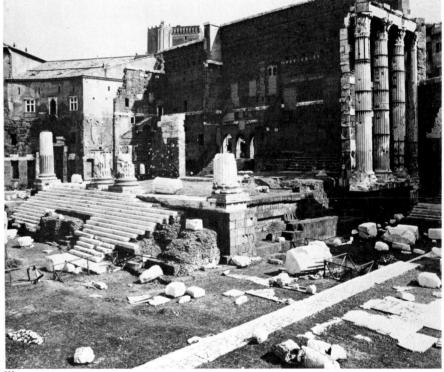

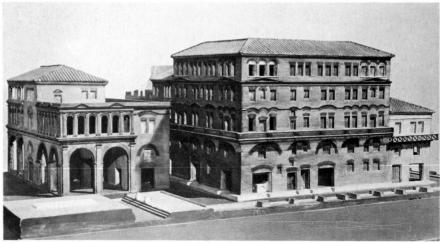

336

Esquiline, with gardens that enclosed an artificial lake. The delights of the villa included a banqueting-room ceiling that showered perfumes upon guests, a statue of Nero more than one hundred feet high, and a dome that revolved so guests could follow the motions of the heavenly bodies.

The caprices of Nero should not blind us to the fact that, after the well-nigh inevitable fire of A.D. 64 (for which he has often been unjustly blamed), he promulgated a building code designed to prevent recurrences of such disasters. Streets were widened, excrescences limited, building materials controlled, and structures rebuilt in stronger form and along more rational lines. The eventual outgrowth of Nero's code was the blockshaped apartment house known as the insula (island), strikingly similar to those built in Italy almost up to our own times. These insulae were massive buildings (fig. 336), four or five stories in height and made of brick or stuccoed concrete. Many are partially preserved at Ostia, the port of Rome. The ground floor usually contained shops, including perhaps a tavern, and common latrines. Staircases led from a central court to the apartments. Exterior balconies were provided for some of the lower suites, which were the most desirable. Every effort was made to give these insulae a monumental character and to avoid uniformity.

An extraordinary witness to Roman ability to deal with utilitarian structures in monumental terms is provided by the aqueducts erected by the Romans. These aqueducts were essential to the growing cities of the Empire; some still extend for miles in partially ruined state across the rolling plains outside Rome. One of the most daring is the Augustan aqueduct called the Pont du Gard (fig. 337) in southern France, constructed in the late first century B.C. by Augustus' lieutenant Agrippa to carry the water for Nîmes across a river gorge. The arches were built from unadorned, giant blocks of masonry, beautifully proportioned, in three stories; four smaller arches of the third story correspond to each single arch of the lower two. The majestic effect is, if anything, enhanced by the frankness with which the architect left blocks of stone protruding here and there as supports for scaffolding to be erected when repairs were necessary. Once an aqueduct reached a city, however, a richer treatment was appropriate, as can be seen in the Porta Maggiore at Rome (fig. 338),

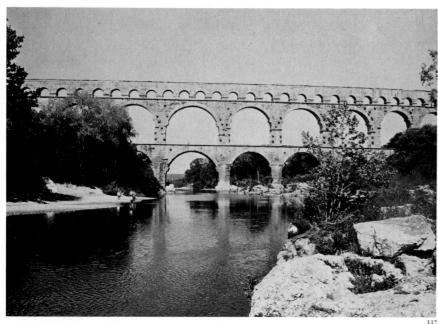

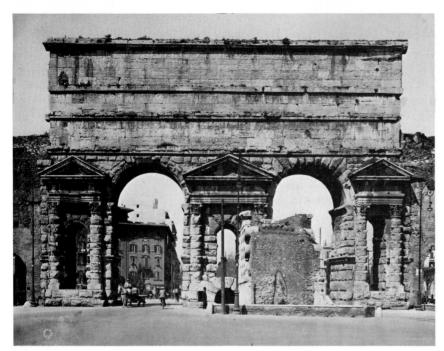

a double archway of travertine erected by Claudius, the fourth emperor of the Julian-Claudian dynasty, to carry water across two major Roman streets. The piers supporting the arches are adorned by Corinthian aediculae (small shrines) with pediments, but interestingly enough all the stones save those of the capitals, bases, and pediments were left untrimmed, as if to indicate the basically utilitarian nature of the enterprise and to convey a sense of rude power. This treatment, known as rustication, was revived extensively in the Italian Renaissance.

FLAVIAN ARCHITECTURE Following the suicide of Nero in A.D. 68 and the year A.D. 69, in which three emperors succeeded each other, the soldier and farmer Vespasian founded the Flavian dynasty, which set about to erase the memory of the self-indulgent Nero and to reestablish Augustus' imperial system. On the site of the artificial lake of Nero's Golden House, Vespasian commenced the largest arena ever built before the enormous stadiums of the twentieth century. The Colosseum (fig. 339), as this building is generally known, was dedicated in A.D. 80 by Vespasian's son and successor, Titus. It belongs to a new type of structure invented by the Romans and built throughout the Empire except, significantly enough, in the Greek world now reduced to Roman provinces. Its purpose was to house the spectacles with which vast audiences, including the jobless proletariat, were amused. These buildings were known as amphitheaters (double theaters) because, in order to bring the greatest number of spectators as close as possible to the arena, two theaters were, in effect, placed face to face. The resultant shape is always elliptical, and an earlier example, the amphitheater at Pompeii, c. 80 B.C., is the first elliptical building known. While the kind of spectacle in which Roman audiences delighted—gladiatorial combats, mock naval battles, fights between wild beasts, and contests between animals and humans—hardly bears contemplation, the remains of the Colosseum enable us to see that it was one of the grandest of ancient structures. The now-vanished marble seats were supported on multilevel corridors of concrete and masonry, providing for rapid handling of as many as fifty thousand spectators, each of whom entered by a ticket numbered to correspond to a specific gate. 338. Porta Maggiore, Rome. c. A.D. 50

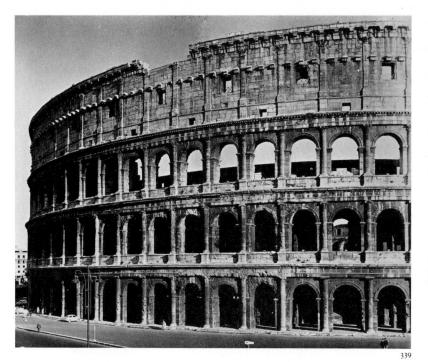

The exterior is composed of blocks of travertine, the somewhat porous, warm tan stone preferred also by Renaissance and Baroque architects for Roman church and palace façades. (Unhappily, these architects used the Colosseum as a quarry for their buildings.)

The arcades were decorated by columns that no longer served any structural function but acted only as a means of dividing the surface harmoniously and as a bridge between the otherwise bleak arches and the spectator. Three major orders stood one above another: Tuscan (probably used in place of Doric because the triglyphs would have been aesthetically troublesome), Ionic, and Corinthian. Above the uppermost order was a lofty wall, articulated by Corinthian pilasters; sockets at its summit were used for the insertion of masts, from which gigantic awnings were stretched across the arena to protect spectators from the sun. Windows in this fourth story alternated with applied shields of gilded bronze.

The corridors were covered with concrete, both in the familiar barrel vault and the groin vault (fig. 340), the latter formed by two barrel vaults intersecting at right angles, thus directing all weight to the four corners. The groin vault, like the barrel vault, was known to the Greeks, but they never used it for monumental buildings. Eventually (see page 269), the groin vault became extremely useful to the Romans as a means for covering vast spaces. The vaults of the Colosseum, now bare, were originally enriched with an elaborate surface decoration of stucco.

The Flavian emperors pulled down much of the Golden House of Nero, erecting on part of the site the now-vanished Baths of Titus, one of the earliest examples in Rome of a type of monumental building extensively built by later emperors throughout the city and the Empire (see below, pp. 269–70, and see fig. 378) as a means of providing useful public services for growing populations. Having thus converted to public use much of the land Nero had enclosed for his private pleasures, the Flavians built their own extensive imperial residence on the Palatine. Now visible only in stripped condition, from which little idea of its original magnificence can be gained, the Flavian Palace contained grand-scale vaulted audience halls in which the emperor could be seen in fitting splendor, and it was thus in a sense a public building; the Flavian Palace remained the official imperial residence until the late Empire.

339. The Colosseum, Rome. c. A.D. 72–80

340. Interior (second story), the Colosseum

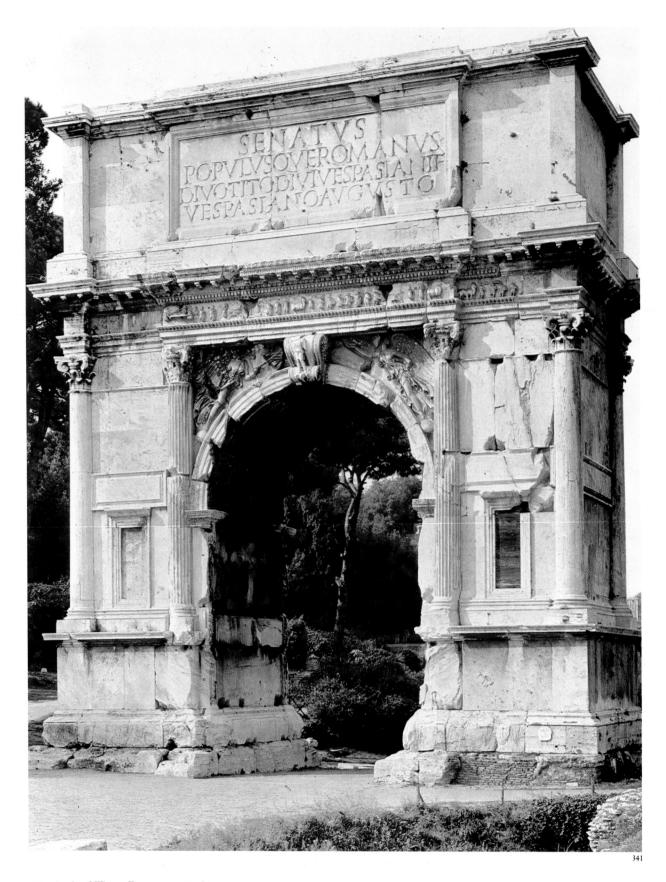

341. Arch of Titus, Rome. c. A.D. 81

342. *Triumph of Titus*, Arch of Titus, Rome. c. a.d. 81. Marble relief, height 79"

To commemorate his brother Titus' capture of Jerusalem in A.D. 70 and destruction of the Temple, the emperor Domitian dedicated, eleven years later, a white marble triumphal arch at the summit of the Sacred Way, the street which connected the imperial forums with the Colosseum. The Arch of Titus (fig. 341) was a permanent version of the kind of temporary arch customarily built by Roman commanders to celebrate their triumphal return to the capital at the head of armies bearing the spoils of war and leading fettered prisoners. By the end of the Roman Empire, some sixty-four marble triumphal arches adorned Rome, and others were scattered throughout the Empire. The Arch of Titus, built of Pentelic marble around a concrete core, is a relatively simple structure (for a more elaborate version, see the later Arch of Trajan at Benevento, fig. 355). A single arch between square piers is crowned with an attic story, undoubtedly once supporting a bronze, four-horse chariot driven by the emperor. The applied decorative (or "screen") architecture is formed of paired columns upholding an entablature with a sculptured frieze. Two special innovations are apparent: first, the capitals are no longer strictly Corinthian, but Composite, an even richer fifth order mentioned by Vitruvius and distinguished from the Corinthian in that the volutes have been enlarged to the scale of those in the Ionic; second, the entablature is no longer continuous, but broken so that it projects over the lateral columns, recedes close to the massive piers, and projects again over the central columns and the connecting arch. Thus screen architecture is now being molded with the same liberty as the underlying architecture of concrete, in the interests of freedom of shape and the movement of light and dark. The last shackles of the post-and-lintel system, with its endless, straight horizontals, have been thrown off.

FLAVIAN SCULPTURE The spectator passing along the Sacred Way in Rome was addressed by two reliefs in the inner surfaces of the piers of the Arch of Titus, one depicting the *Triumph of Titus* (fig. 342) and the other the *Spoils from the Temple at Jerusalem* (fig. 343), in which

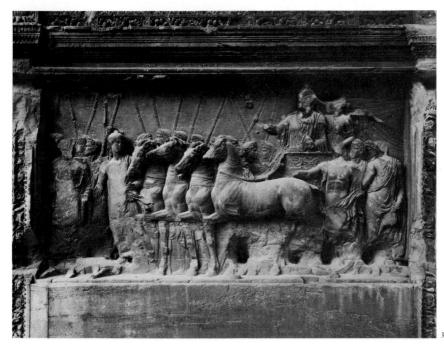

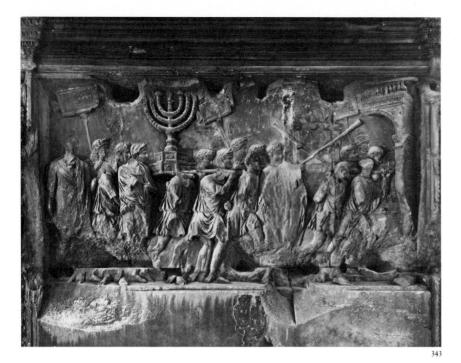

Roman legionaries are seen carrying off the trumpets, the seven-branched candlestick, and the golden table. These reliefs were, if anything, more revolutionary than the architecture. For the first time Roman historical relief came into its own. Memories of the Ara Pacis still linger, but the Attic stateliness of Augustan relief has been swept away by a new dynamism in keeping with that of the architecture. We are reminded less of the Parthenon than of Hellenistic Baroque—although those relatively small reliefs lack the grandiloquence of the Altar of Zeus at Pergamon (see fig. 290). The relief space is much deeper than that of the Ara Pacis, and several devices have been utilized to increase its apparent depth. At the right, an archway has been placed at an angle to the spectator so that it dissolves into the background. Even with the loss of much of the relief, it is clear that the figures exploit their newly gained space, moving freely at various levels in depth as if passing before us on a stage. Some are so sharply projected that they are almost freestanding—and thus have suffered the most damage—while others, deeper in space, are represented in slight projection. As in the varying levels in depth of the surrounding architecture, light and shade have been utilized to enrich the drama.

In Flavian portraiture this new dynamism of form and new interest in light and shade were richly explored. A superb Portrait of Vespasian (fig. 344) shows that lessons from Praxitelean and Hellenistic sculpture have been applied to bring out in marble the full play of light and dark across the weather-beaten face of the old general. The eyeballs are no longer fully carved; they are actually slightly recessed so that the shadow of the eyelids can give the impression of the colored iris. The folds of flesh are rendered with the same pride in ugliness we found in Republican portraiture (see figs. 309, 310), and the subject seems to be caught in a transitory moment between reflection and speech. A brilliant example of a standard type of Flavian female portraiture is a beautifully poised young matron (fig. 345), whose elegant and sensitive features are almost overpowered by a lofty Flavian coiffure of curls. The contrast of the rich shadows in the headdress with the translucency of the features suggests the actual coloration of hair and flesh, and again a slight depression hints at the color of the eyes. The Flavian portrait style is often characterized

3.

as coloristic, which is a very expressive term for the range of tonal values embodied in each head.

PAINTING In the late Augustan period, the illusionistic achievements of the Second Style were overlapped and eventually succeeded by paintings in the Third Style that show an unexpected combination of pure architectural fantasy with prim refinement, such as in a painted wall from the house of M. Lucretius Fronto at Pompeii (fig. 346). The lower two thirds of the wall, painted glossy black or red, is divided by columns prolonged into spindles; against the side panels stand equally attenuated lamps, on which appear to be suspended tiny panel paintings showing views of villas by the sea, and a mythological painting is "hung" against the center panel. Above the wall one looks out into an array of fantastic structures, reduced to toylike slenderness—columns like reeds, open pergolas—all in a perspective that takes us deep into unreal space, but is exactly repeated in reverse on the opposite side. Undeniably, this style shows some of the mannered elegance and grace of official Augustan art.

Most fantastic of all Pompeiian art is the Fourth Style, which flourished after the earthquake of A.D. 63 and was terminated at Pompeii and Herculaneum only by the eruption of Vesuvius in A.D. 79, a period corresponding to the last years of the reign of Nero and the first decade of the Flavian dynasty. A new and wildly imaginative manner appeared, with architectural vistas even more fantastic and far more convincingly lighted and painted in an astonishing array of rich colors (fig. 347 shows a fine example from Herculaneum). Curtains, masks, broken pediments, and simulated bronze statues are irradiated with a sunlight as warm as that which charmed us in the Second Style.

- 343. Spoils from the Temple at Jerusalem, Arch of Titus, Rome. c. A.D. 81. Marble relief, height 94"
- 344. Portrait of Vespasian. c. A.D. 75. Marble, lifesize. Museo Nazionale Romano, Rome
- 345. *Portrait of a Lady.* c. A.D. 90. Marble, lifesize. Museo Capitolino, Rome
- 346. Architectural View and "Panel Paintings," wall painting from the House of M. Lucretius Fronto, Pompeii. Middle 1st century A.D.

- 347. Architectural View, wall painting from Herculaneum, near Naples. c. A.D. 63–79. Museo Archeologico Nazionale, Naples
- 348. Sacred Landscape, Fourth Style wall painting from Pompeii. c. A.D. 63–79. Museo Archeologico Nazionale, Naples
- 349. Landscape with Figures, from an Augustan house near the Farnesina Palace, Rome. c. 19 B.C. Stucco relief, 181/8" high. Museo Nazionale Romano, Rome

Especially beautiful are the Fourth Style landscapes (fig. 348). In these views of an imagined nature, the artists exploited every device then known in order to render sunlight and atmosphere. Rapid brushstrokes sketched in a delightful dream world of mountains and glades, shrines, Etruscanlooking temples, cattle, and lakes and bridges, all dissolved in light and air in a manner that has often been compared with nineteenth-century Impressionism. Interestingly enough, the whole subject matter of Roman landscape painting could be modeled in stucco, with remarkably convincing effect and without any color whatever, in the reliefs often appearing

on Roman ceilings. Stucco dries rapidly and requires a working speed comparable to that of the sketchy paintings so impressive in the Second, Third, and Fourth styles. A typical example, from an Augustan house near the Farnesina Palace in Rome (fig. 349), shows the usual shrines, trees, little figures, animals, and rocks so arranged and so treated as to suggest distance, light, and air.

The assassination in A.D. 98 of the tyrannical Domitian, last of the Flavian dynasty, resulted in the rule of a new and stable succession of six emperors, the first five of whom have become known—in contrast to their immediate predecessor and several of their appalling successors—as the "good emperors."

The Second Century (A.D. 96-192)

TRAJAN The first, the aged Nerva, lived only two years before he was succeeded by his adopted son, the brilliant general Trajan, born in Spain—the first non-Italian emperor. Under Trajan the Roman Empire reached its greatest expansion, and his achievements were fittingly commemorated by the dedication in A.D. 113 of the grandest of all the imperial forums (fig. 350; see also fig. 333). The Forum of Trajan, in fact, covered more ground than those of Julius Caesar, Augustus, and Nerva together. To design this project Trajan called on a Greek architect from Syria, Apollodorus of Damascus, whose imagination was equal to the grandiose ideas of his imperial patron. Apollodorus combined elements from Roman tradition with others, eventually tracing their ancestry to the bygone architecture of Egypt. The axial plan of the forum, in certain aspects, recalls strikingly the general layout of Egyptian temples, although there could have been no direct influence. A vast colonnaded plaza, similar to the Egyptian peristyle court, contained a bronze statue of the emperor on horseback. Beyond was the Basilica Ulpia—corresponding in its position to the Egyptian hypostyle hall—a columned space which the visitor must traverse before arriving at the Temple of the Divine Trajan, erected by his successor Hadrian. We do not know what kind of structure was originally destined for this position. The plaza and the basilica were each flanked by semicircular spaces; exedrae, like those of the Forum of Augustus, rose behind the colonnades at either side of the plaza; apses closed off either end of the basilica; in the center of a single huge exedra stood the temple. As was by now the universal custom, the exedrae were built of concrete and faced with brick, but details were made of travertine; beyond the east exedra of the plaza is Trajan's market.

The Basilica Ulpia (fig. 351), named after Trajan's family, was the largest of Roman basilicas, some four hundred feet in length. Two earlier basilicas stood near it in the great complex of Republican and imperial forums; the Basilica Ulpia seems to have differed from its predecessors only in size and magnificence. Two aisles on each side of the nave were supported by a forest of monolithic columns carved of gray Egyptian granite. The roof was concealed by a coffered ceiling, covered with plates

of gilded bronze.

On leaving the Basilica Ulpia, visitors found themselves in a small court between Trajan's Greek and Latin libraries. Through the columns they could look out to the final exedra with its temple, if their attention could be distracted from the extraordinary monument in the center of the court (fig. 352), a marble column that, together with its podium, rose to a height of 125 feet and was topped by a statue of Trajan in gilded bronze (destroyed in the Middle Ages and replaced in the sixteenth century by a statue of Peter). The podium was decorated with captured weapons carved in low relief; a golden urn containing the ashes of the emperor was placed within it after his death in A.D. 117. The column base was carved into a giant laurel wreath. In a spiral around the column winds a relief some six hundred and fifty feet long, on which are narrated events from Trajan's two successive Dacian campaigns.

No precedent for this extraordinary idea has ever been found, but it is noteworthy that the column was placed between two libraries. Ancient books did not have pages; they were *rotuli* (scrolls) wound between two spindles (see Part Three, Chapter One). The reader saw a column of text at a time—sometimes with an accompanying illustration—then wound it away to read the next column. Just under the Doric capital of the Column of Trajan, a glimpse of fluting appears above the scroll-like relief. It has been suggested that the idea of the historiated column was derived from rotuli with endless narrative illustrations, but the only such rotuli known are much later (see fig. 440) and were influenced by the Column of Trajan and other monuments imitating it, rather than the reverse. The originality of the idea—and we do not know whether to attribute it to Apollodorus or to an artist working under his supervision or even to the emperor himself—lies in the idea of the continuous narrative, unfolding with cinematic power in more than one hundred and fifty incidents. Through camps, sacrifices, harangues, embassies, sieges, river crossings, pitched battles, routs, tortures, suicides, and mass slaughters, the story of the campaigns is told. In contrast to the battle reliefs of Assyria, which spring constantly to mind, the Trajanic narrative possesses an impressive objectivity. Nowhere is the enemy underrated, and the Romans must put up a good fight for their victories. In the reliefs of the Column of Trajan,

- 350. APOLLODORUS. Forum of Trajan, Rome. Dedicated A.D. 113
- 351. Basilica Ulpia, Rome. Dedicated A.D. 113 (Architectural reconstruction after Canina)

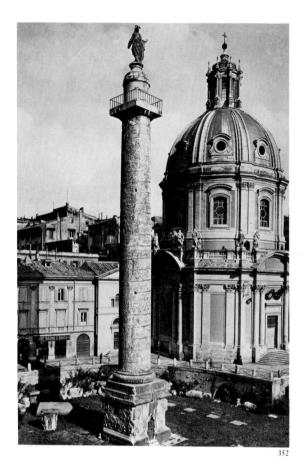

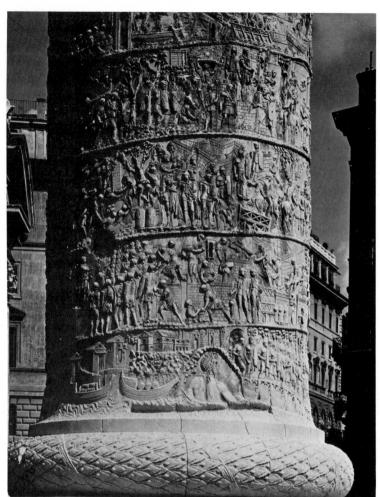

Roman sculpture at last came into its own; these creations owe no debt to any previous period. Doubtless the work, like that of the sculptures adorning the Parthenon, was executed by many different assistants. But the breadth and dignity of the narration—which has been compared with Caesar's literary account of his Gallic wars—the power of the individual scenes, and the overall uniformity of accents and design show the conception of a single great master, whose name, unfortunately, is unknown.

In fig. 353, several incidents can be read. At the bottom, a personification of the Danube River, represented as a bearded giant, rises from the waves in amazement as the Roman legions issue forth from a city gate onto a bridge of boats to cross the river. In the second level, Roman soldiers carry blocks of stone to reinforce a fortification. In the third, Roman cavalry emerges from the gate of a walled camp and crosses a wooden bridge over a moat to embark on a patrol. In the fourth, the emperor stands upon a high podium to address his troops. As in almost all Classical reliefs, the sculptures on the column were painted to bring out the figures and the details of the narrative with greater clarity.

Four major differences, however, separate this continuous narrative from the illusionistic reliefs on the Arch of Titus (see figs. 342, 343). First, because deep carving such as that on the Arch of Titus would have destroyed the integrity of the column and created ragged contours, the work on the Column of Trajan was carried out in low relief. Second, concern with narrative legibility caused its sculptors to give every figure an almost uniform degree of accentuation. Third, the figures are displayed as if on a steeply mounting terrain, providing a panoramic view,

- 352. Column of Trajan, Rome. Dedicated A.D. 113. Marble, height 125'; length of spiral low relief 650'
- 353. Column of Trajan, Rome (detail)
- 354. Market of Trajan, Rome. Dedicated A.D.
- 355. Arch of Trajan, Beneventum (present-day Benevento), Italy. Marble. c. A.D. 114-17

rather than overlapping in depth. Finally, just as in the Parthenon frieze (see fig. 236), a different scale was adopted for the horses from that of the figures; buildings are also shown relatively small, while city walls are the same height as people. Since these principles were by no means uniformly followed in other Trajanic reliefs, it must be assumed that they were adopted here because of necessity. The difficulty of reading the upper episodes was overcome to some extent by increasing the scale slightly as the spiral mounted. Legibility would have been enhanced, in all probability, by viewing the upper portions from the terraces above the libraries and from the roofs of the Basilica Ulpia and the connecting colonnade. Even so, the topmost levels must have been very difficult to distinguish.

Nothing of the Temple of the Divine Trajan is now above ground, but we know that it had a portico even higher than that of the Temple of Mars Ultor, with a peristyle of monolithic columns in the same gray Egyptian granite that was used for the Basilica Ulpia. A handsome utilitarian structure connected with the Trajanic complex still stands on the slope of the Quirinal Hill—a two-story market (fig. 354), whose concrete, groin-vaulted central nave is flanked by barrel-vaulted shops, built of concrete faced with brick; each travertine opening, serving as entrance and shop window, was surmounted by a window to provide ventilation for the mezzanine story, where the shopkeeper or his clerk resided. Traditional wooden centering was supplemented in the construction of the groin vault by forms molded in terra-cotta.

Entrance to the entire Trajanic complex was afforded by a triumphal arch, which has disappeared. However, a noble marble arch built by Trajan in A.D. 114–17 at Beneventum (modern Benevento) in southern Italy, to celebrate the opening of a highway, still stands in remarkably good condition (fig. 355). The general shape of the relatively modest Arch of Titus is here enriched by a series of panels sculptured in high relief, which fill every surface not occupied by the commemorative inscription. Large, rectangular panels alternate with narrower strips. The public deeds

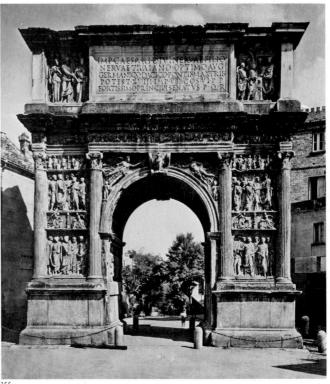

of the emperor are shown here, rather than his military exploits; the folds of the togas are obviously scaled to harmonize with the fluting of the Composite columns. The relation between architecture and sculpture here can only be characterized as symphonic, in the bewildering variety of accents and cross-accents grandly sustained by the columns, bases, and entablature. This arch is unquestionably the finest example of balance between architecture and sculpture remaining to us from the Roman world.

HADRIAN Trajan was succeeded by his nephew Hadrian (ruled 117– 38), an administrator who had little interest in military conquests—he, in fact, let some unruly border provinces slip from Roman grasp. Hadrian was, however, deeply concerned with cultural activities and artistic monuments, especially those of the Hellenic world, with which he felt a strong kinship. He undertook several long tours of his vast empire, embellishing provincial centers with new buildings and doing his utmost to support the continuing intellectual life of Athens. Hadrian seems to have had little interest in the epic themes of Trajanic sculpture, and sculpture surviving from Hadrian's reign reflects the emperor's Hellenism. Several medallions made for a Hadrianic monument but later incorporated into a new triumphal arch in the fourth century by the emperor Constantine. who had the imperial heads recarved to portray himself, vibrate with echoes of Classical and Hellenistic sculpture (fig. 356). In the muscular horses and the free drapery rhythms of the Wild Boar Hunt, memories of the Parthenon frieze and the Temple of Apollo at Bassai (see figs. 235, 251) are very clear; in the soft treatment of the nude and in the gentle drapery folds of the Sacrifice to Apollo, the graceful tradition of Praxiteles and Lysippos is quoted. Interestingly enough, although the horse in the Sacrifice emerges from a space clearly indicated as behind that of the attendant, the horses and riders of the Hunt, to show that they are behind the wild boar, appear above it. Illusionism is at an end, and the artist's

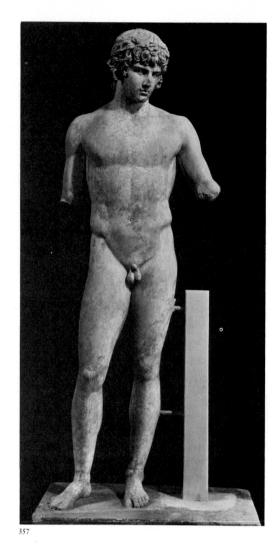

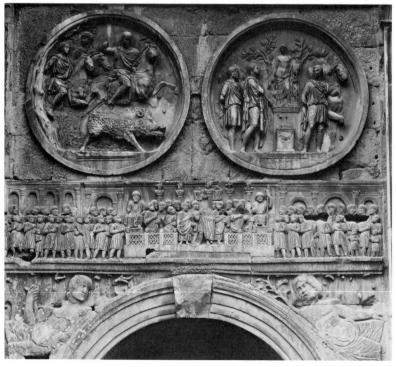

- 356. Wild Boar Hunt and Sacrifice to Apollo (details of the Arch of Constantine, Rome). Medallions c. A.D. 131–38; frieze c. A.D. 312–15. Marble, height of frieze c. 40"
- 357. Portrait of Antinoüs. c. A.D. 131–38. Marble, height 701/8". Archaeological Museum, Delphi, Greece
- 358. The Pantheon, Rome. c. A.D. 118-25
- 359. Plan of the Pantheon, Rome

devices are directed toward informing the observer rather than describing a visual situation.

Perhaps the most Hellenic of all Hadrianic sculptures is the *Portrait of Antinoüs* that Hadrian gave to the sanctuary of Apollo at Delphi (fig. 357). The emperor had showered statues of his favorite throughout the Empire; these works are recognizable by the portrayed youth's slightly aquiline nose, full lips, and deep chest. Most of these statues show a figure at least partly draped, but this example is connected with an older Roman tradition in which realistic portrait heads were superimposed on idealized nude bodies copied from Greek statues. Generally, the results were grotesque. In the *Antinoüs* of Delphi, however, a Greek sculptor working for Hadrian was able to treat this unlikely combination with convincing unity. Revivalist though it is, the statue achieves great success in its contemporary adaptation of a Classical Greek concept.

Interestingly enough, Hadrianic architecture in Italy owes little to Hellenic tradition, but in fact sums up authoritatively the most progressive spatial tendencies of Roman building. The grandest of all Hadrianic monuments is the rebuilt Pantheon in Rome (figs. 358, 359), which owes its extraordinary state of preservation to its rededication as a church in the early history of Roman Catholicism. The Pantheon has exercised an incalculable influence on all the architecture of the Middle Ages, the Renaissance, the Baroque period, and modern times. The building must be imagined in its original state, approached by parallel colonnades flanking a central plaza, and elevated on a podium now concealed by the sharp rise in the level of the surrounding terrain. Viewed from below, the circular cella (derived, of course, from the tholos tradition), which is the remarkable innovation of the building, would have been sensed rather than seen. The Corinthian columns of the portico are monoliths of pol-

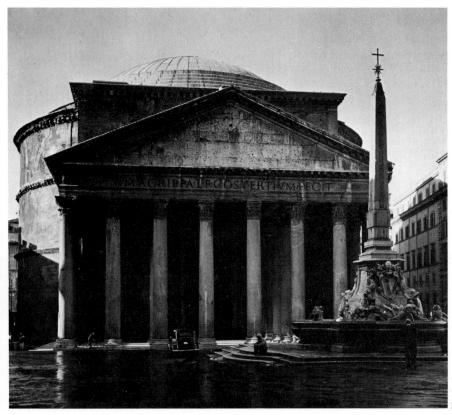

358

ished granite; the cella is built of formed concrete, faced with fine brickwork. The roof was covered with gilded tiles. The crowning dome is an exact hemisphere of concrete 143 feet in diameter, at the top formed of lightweight materials and very slight in thickness. Farther down, the shell becomes both thicker and heavier, and it is supported not only by the walls of the cylindrical drum but by relieving arches within the walls and invisible from the interior. The height of the drum is equal to its radius, which is identical to that of the dome.

Once one enters the Pantheon its revolutionary character becomes apparent—it is one of the few truly overwhelming spatial experiences in architecture, so grand in fact that it cannot be represented convincingly by photographic means. We must have recourse to a painting done in the eighteenth century (see fig. 7). The interior of the Pantheon conveys the effect of a colossal sphere, whose perfect beauty is untroubled by excrescences. The continuous entablature is upheld by paired, fluted Corinthian columns of softly colored marble in front of eight recesses, alternating with eight flat wall surfaces encrusted with colored marble from which project aediculae, once containing statues of the gods, framed by unfluted columns of polished granite. The now-bare concrete coffering of the dome was originally painted blue; each coffer contained a rosette of gilded bronze. A single great circular opening at the apex is the sole and abundant source of light, and it allows the eye to move freely out into the sky above. The effect of this vast, spherical space, whose enclosing wall is softened by the fluid colors of the marble, can only be described as sublime. No interior before or after the Pantheon has achieved quite this impression. A long tradition in ancient times associated architectural domes with the Dome of Heaven, the sky itself, a tradition also appropriate for a building dedicated to the worship of all the gods, as was the Pantheon. The breathtaking interior space of this great building arouses in us a sense of liberation analogous to what we feel when we gaze into the open sky.

The most imaginative architectural achievement of Hadrian's reign was the villa he constructed near Tivoli (fig. 360); to modern eyes it suggests nothing so much as the pleasure dome of Kubla Khan as described in Coleridge's poem. Several square miles of gently rolling countryside were adorned with a rich array of buildings and gardens. In contrast to

360. Hadrian's Villa, Tivoli. c. A.D. 125-35. Museo della Civiltà Romana, Rome (Architectural reconstruction by I. Gismondi)

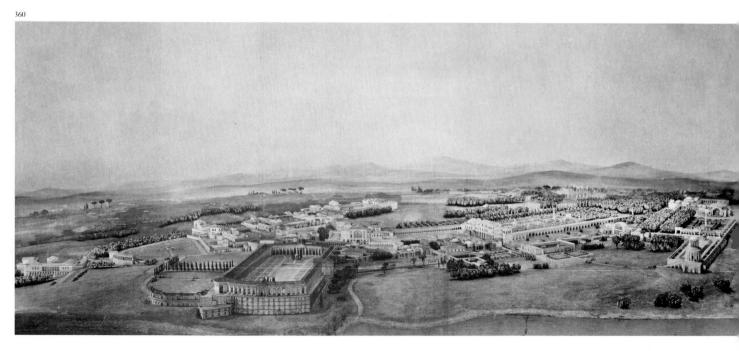

the rigorous axial planning of the imperial forums, the constructions and spaces of Hadrian's Villa were freely scattered in groups in order to take advantage of varied levels, exposures, and vistas. Within each group, however, the buldings were arranged with close attention to harmonious and generally symmetrical relationships. The individual spaces were seldom large but almost infinitely complex, exploiting all the freedom of shape offered by Roman concrete architecture. Some interiors contained not a single straight line, only alternating convex and concave forms.

The villa had several elaborate nymphaea (fountain buildings), Greek and Latin libraries, a theater, baths both large and small, courtyards, plazas, and temples. A circular colonnaded pool was adorned with a central island, attainable by bridges on wheels, on which stood a tiny, selfcontained abode. Many reproductions—more symbolic than accurate of sights that Hadrian had seen on his travels throughout the Empire were constructed at the villa. These included the Grove of Academe and the Stoa Poikile (painted porch), both of Athens, and the Canopus of Alexandria (fig. 361), a long canal culminating in a temple to the Egyptian god Serapis. This temple was also a nymphaeum, and it was ornamented with Egyptian sculptures preserved today in the Vatican Museums. The end opposite the temple was colonnaded, and the entablature seems to have been bent into arches as if made of clay. When intact, Hadrian's Villa offered an unimaginable richness of forms, spaces, and colors to excite the senses and to enshrine the intellectual life of the imperial hedonist, who unfortunately died before its completion.

THE ANTONINES The uneventful reign of Hadrian's successor, Antoninus Pius, was appropriately memorialized by an undecorated column of pink marble, erected after the emperor's death in A.D. 161. The cubic base, which is all that remains, is a powerful work of art in itself. On the front face is shown the flight of the emperor and the empress to heaven; on either side is represented the ceremonial circular gallop of the cavalry around groups of armored infantrymen holding standards at the imperial funeral (fig. 362). Surprisingly, the hard-won illusionistic space of the Hellenistic tradition, already compromised by the devices of Trajanic narrative style, has been completely dismissed. Although the distinction has been preserved between near figures in high relief and those

361. The Canopus of Alexandria, Hadrian's Villa, Tivoli. c. A.D. 125–35 (Reconstruction)

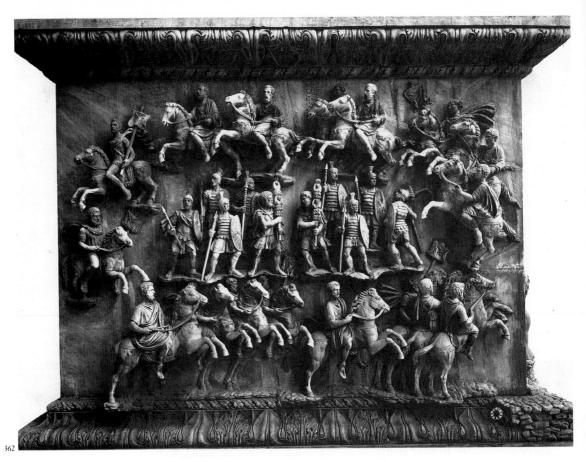

362. Ceremonial Circular Gallop of the Cavalry, from the base of the Column of Antoninus Pius. Marble relief, 8' 11/4" × 11' 11/8". c. A.D. 161. Vatican Museums, Rome

363. Equestrian Statue of Marcus Aurelius. c. A.D. 161–80. Bronze, over-lifesize. Piazza del Campidoglio, Rome

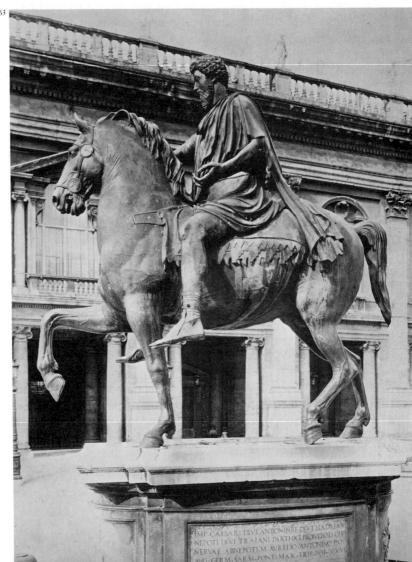

farther from us in low relief, all that remains of the traditional setting is a few patches of ground under the feet of men and horses. The figures seem to float in a free space, unregulated and unenclosed, in front of the neutral marble background. What is behind is now represented as above, as if in reversion to the far-off days of Polygnotos.

The new abstract conception of space and the new carving techniques were employed in the relief sculpture on the column of Antoninus' successor, Marcus Aurelius. As an emperor, Marcus Aurelius was an extraordinary blend of an efficient general, on the model of Julius Caesar and Trajan, with a Stoic philosopher. Marcus Aurelius loathed war, and he fought only defensive actions aimed at preserving the Empire from incursions of Germanic tribes, particularly in the Balkans. For him duty was man's highest goal and only reward; his own duty was to administer the Empire as a brotherhood of man under the rule of an all-pervasive God, which involved the sacrifice of his own well-being in favor of the unity of the state.

One of the most memorable works of art from Marcus Aurelius' reign is his noble equestrian statue in bronze (fig. 363), originally in front of the Lateran Palace in Rome, in which the emperor was born, but transferred to the Capitoline unwillingly by Michelangelo in 1536 at papal command. The statue owes its preservation to the mistaken belief that it represented Constantine, the first imperial protector of Christianity, and is the only well-preserved ancient equestrian statue in bronze to come down to us; needless to say, it has been imitated countless times from the Renaissance almost to our own day. The statue shows the emperor unarmed, his right arm outstretched in the characteristic Roman oratorical gesture (see figs. 307, 326) and his left guiding the now-vanished reins of his spirited horse. As we have seen in relief sculpture, the rider here is also represented in a larger scale than the horse. The bearded emperor (the beard was a Hadrianic innovation, in imitation of the Greeks) looks out calmly on the world; the rich curls of his hair and beard, in contrast to the smooth parts of his face, show a revival of Flavian colorism, which precludes the traditional device of inserting eyes made of glass paste. The horse is superbly modeled, revealing extensive knowledge of the proper position and function of bones, muscles, tendons, and veins.

One of the most significant and lasting of all Roman achievements was the foundation throughout the Empire of hundreds of towns and cities, many of which are still inhabited, and the extensive rebuilding of Hellenistic cities in Greece and Asia Minor. Where possible, the typical Roman town followed the foursquare Hippodamian plan, with straight perimeter walls leading to major thoroughfares, oriented north and south, east and west, and crossing at right angles in the center, and minor streets also intersecting in a grid. (Such a plan was out of the question in Rome itself, because of its haphazard prior growth on an irregular, hilly site; see fig. 364 for the appearance of the center.) Such self-contained, crystalline plans were, of course, fairly rigid, leaving no room for expansion. Later growth outside the square inevitably betrays the suburban sprawl all too familiar in our own world. Most cities had a central capitol dominating a forum, temples to Roman and indigenous deities, a basilica, a bath or two, a theater, and an amphitheater. The latter was rare in Greek provinces, which resisted the Roman gladiatorial combats until very late; only three amphitheaters were built in all of Asia Minor.

But these architectural undertakings were by no means uniform in style at any one moment in all parts of the Empire. For example, urban complexes and country villas in Britain, Gaul, and Germany were far

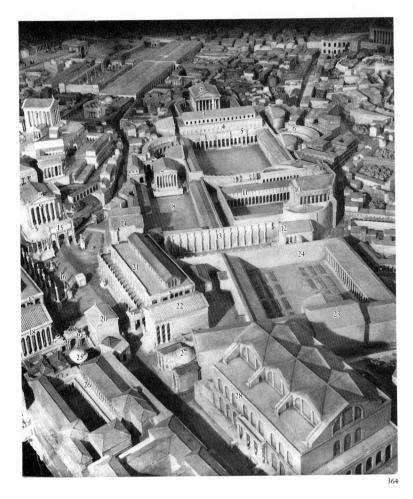

364. The Republican and Imperial Forums, Rome. c. A.D. 310. Reconstructed in a model of ancient Rome. Museo della Civiltà Romana, Rome (Starred numbers are works mentioned in this book) *1. Temple of Capitoline Jupiter *2. Temple of Trajan *3. Column of Trajan *4. Basilica Ulpia *5. Forum of Trajan *6. Market of Trajan 7. Temple of Venus Genetrix 8. Forum of Julius Caesar 9. Temple of Concord *10. Temple of Mars Ultor *11. Forum of Augustus 12. Temple of Minerva 13. Forum of Nerva 14. Curia (Senate Chamber) 15. Arch of Septimius Severus *16. Roman Forum 17. Basilica Julia 18. Temple of Castor and Pollux 19. Arch of Augustus 20. Temple of Julius Caesar 21. Basilica Aemilia 22. Temple of Antoninus and Faustina 23. Temple of Peace 24. Forum of Peace 25. Temple of Vesta 26. House of the Vestal Virgins 27. Temple of Romulus *28. Basilica of Maxentius and Constantine

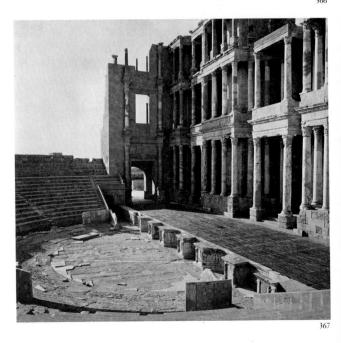

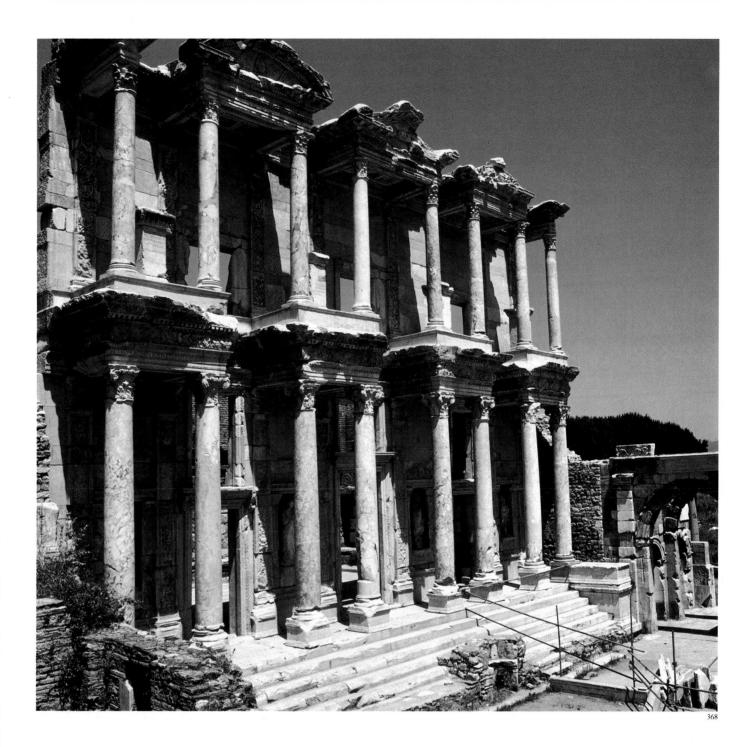

less sumptuous than those designed for provinces that still cherished a Hellenistic tradition of architecture and decoration. The most dazzling provincial centers were perhaps those in Asia Minor, such as Ephesus, Miletus, Aspendus, Side, and Perge; in Syria, such as Baalbek and Palmyra; and in North Africa, especially Leptis Magna, Sbeitla, and Timgad (fig. 365), large portions of which are still standing. A vista (fig. 366) down the central colonnaded street of Timgad toward a late-second-century gateway erroneously known as the Arch of Trajan gives some inkling of the splendor of these North African and eastern Mediterranean cities in the time of Marcus Aurelius. The great central arch for horse-drawn traffic is flanked by two smaller ones for foot passengers, embraced by columns designed to culminate the colonnaded walkways rather than to re-

- 365. Plan of the city of Timgad, Algeria
- 366. Colonnaded street with arched gateway, Timgad. Late 2nd century A.D.
- 367. Theater (partial reconstruction), Sabratha, Libya. Late 2nd century A.D.
- 368. Façade, Library of Celsus, Ephesus, Greece. c. A.D. 135

371. Portrait of a Graeco-Roman Egyptian, from a mummy case found at El Faiyûm, in the Nile Valley. 3rd quarter of 2nd century A.D. Encaustic on panel, 175/8 × 9". Staatliche Museen, Berlin

and have Hell glad of th (fig. histo 342, their mans victo ing c ment and groui like t 352). peare ity of T still o of Ph was n and b scribe first-c phasis

though his unsparingly rendered effete expression and slight physique are completely incongruous. As throughout Antonine sculpture, the locks of hair and beard, roughened and deeply undercut to suggest their color, are contrasted with the transparent pallor of the face. The eyes too are now rendered coloristically, the irises and pupils actually carved, a device that frees sculpture entirely from applied pigment and allows it to function pictorially in its own right. The serpentine complexity of the shapes, as disturbing as the portrait itself, reminds one of the nervous forms and patterns used in the sixteenth century in an Italian style known as Mannerism. In A.D. 192, members of Commodus' household conspired to have him strangled by a wrestler inappropriately named Narcissus. So ended the Antonine line, in a manner that prepared the way for the near chaos of the third century.

Little second-century painting remains, except a numerous series of portraits discovered at El Faiyûm in the Nile Valley. These images of the deceased were substituted for the traditional masks in mummies, which the Egyptians continued to make. They are the only ancient paintings in the encaustic, or hot wax, technique that have been discovered. Many are strikingly expressive, rendering with great vividness the members of the multiracial society of the Roman world. A Graeco-Roman Egyptian (fig. 371) looks at us with utter candor from superbly painted brown eyes, showing that in the rendering of light on flesh and hair the painters of the second century A.D. still retained the knowledge gained from half a millennium of Hellenic tradition. These paintings also admit us to the very presence of a sensitive and graceful people, in whom are summed up the traditions of more than three thousand years of continuous civilization.

The assassination of Commodus inaugurated a period of almost unbelievable deterioration in Roman life and, consequently, in that of the entire Mediterranean and European world, culminating in a loss of Roman and even Italian preeminence and power in the Empire at large. For the next ninety-two years one brief imperial reign followed another. Except for those of Septimius Severus (ruled 193-211) and Claudius II surnamed Gothicus (ruled 268–70), each reign was terminated by violence, usually assassination by troops or by the Praetorian Guard. This bodyguard of the emperor was the single agency in the Empire still strong enough to make and unmake emperors. With provincial and uneducated soldiers serving as emperors, the vast structure of the international and intercontinental imperial state tottered virtually leaderless; only the administrative bureaucracy maintained a semblance of order. Coinage was rapidly and alarmingly debased; inflation followed; agriculture and trade stagnated. The sole uniting factor was the all-pervasive fear of invasion by Germanic tribes to the north and by Parthians to the east.

SCULPTURE In imperial portraiture the penetrating frankness of the portraits of Commodus had already opened up new and unpleasant psychic vistas. Three third-century imperial portraits lead us even further into this hitherto unexplored realm. Caracalla (ruled 211–17), the brutal son and successor of the energetic Septimius Severus, appears so frighteningly his true self (fig. 372) that we hardly need to be told that he caused the murder of many persons, including his own brother Geta. The fea-

The Third Century (192–284)

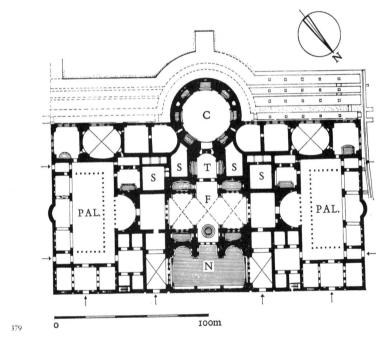

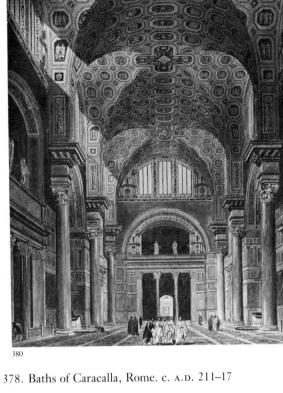

- 379. Ground plan of the Baths of Caracalla, Rome C Caldarium; T Tepidarium; PAL. Palaestra; S Services; F Frigidarium; N Na-
- 380. Tepidarium, Baths of Caracalla (Restoration drawing by G. Abel Blonet)
- 381. Temple of Venus, Baalbek, Lebanon. 1st half of 3rd century A.D.

under the arches of the groin vaults, which were coffered, stuccoed, painted, and gilded; the walls, floors, and columns were sheathed in colored marbles. The interior must have made an impression not only of great spatial openness but also of constantly changing light and color.

The most extraordinary structure of the third century is the little Temple of Venus, which was added to the vast second-century Roman sanctuary of the Syrian deity Baal at Baalbek (now in Lebanon; fig. 381). The portico is conventional enough, but the cella behind it is circular. The peristyle is carried around it, supported on free-standing Corinthian columns. Here the architect had his most brilliant idea, making the podium and entablature curve inward from each column to touch the cella, and then outward again to the next column, producing a scalloped shape.

374)

furti and

deba

nost

niqu

plan

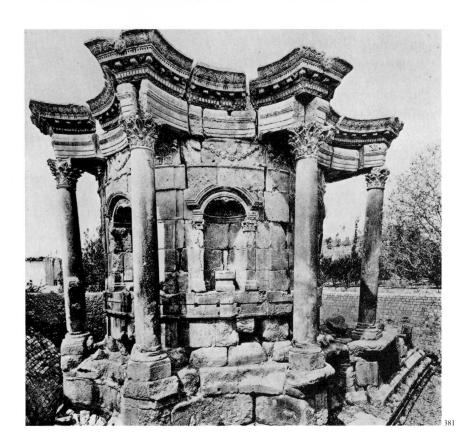

This flow of outer concavities against inner convexity produces a free architectural fantasy as astonishing as some of the painted examples in the Fourth Pompeiian Style. The Temple of Venus at Baalbek has often been proclaimed an ancestor of the highly imaginative architectural inventions of the Italian Baroque. At this moment, it is almost more useful to regard it as one of the last examples of such fantasy before it was terminated by the rigidity of the later Empire.

Under the "barracks emperors" of the third century, the government of the Empire degenerated into a situation bordering on anarchy and was frequently rent by civil war among rival claimants to imperial power. A rugged general of peasant stock from Illyria (modern Yugoslavia), the emperor Diocletian (ruled 284–305), attempted to put an end to disorder and in so doing imposed upon the Roman world a system that can only be compared with the despotism of Mesopotamian rulers. Even the shadowy authority still cherished by the Senate was set aside; personal rule was directly exercised by the emperor through an elaborate system of administrative levels, military and governmental, that functioned better in theory than in fact. Since the days of Septimius Severus, the imperial person had been considered sacred, a notion that contrasts bitterly with the ease with which individual emperors were murdered. Debasement and consequent collapse of coinage had led to economic breakdown and reversion to barter. A wealthy landowning class, precursors of the medieval nobility, had arisen throughout the Empire. Agricultural workers were increasingly attached to the land and workmen to their trades. Communications throughout the Empire had deteriorated.

The rigidity of Diocletian's system was a formal expression of an economic and political paralysis that was beyond any then-known cure. Because of the difficulty of governing the entire imperial territory from a

The End of the Pagan Empire (284–323)

single center—and Rome had largely given way to Milan as the seat of administration in Italy—Diocletian divided power between two theoretically coequal emperors, each known as Augustus, one ruling in the West, the other in the East. Each Augustus took on a deputy and successor with the title of Caesar. This short-lived experiment was known as the tetrarchy (government of four rulers), and it heralded the inevitable breakup of the Empire, whose numerous political subdivisions were already infiltrated with barbarians. Under emperors as different as Nero and Marcus Aurelius, Christianity had long been recognized as a danger to the state, in that the Christians refused to burn incense before imperial statues and to render military service. Sporadic persecutions of Christians became intense; the last was ordered by Diocletian in 303. Two years later he abdicated and retired to a palace he had built in Split, near his birthplace.

A rapid succession of tetrarchies only perpetuated the anarchic situation that had existed before Diocletian. After a six-year struggle one tetrarch, Constantine the Great (ruled 306–37), seized sole imperial power

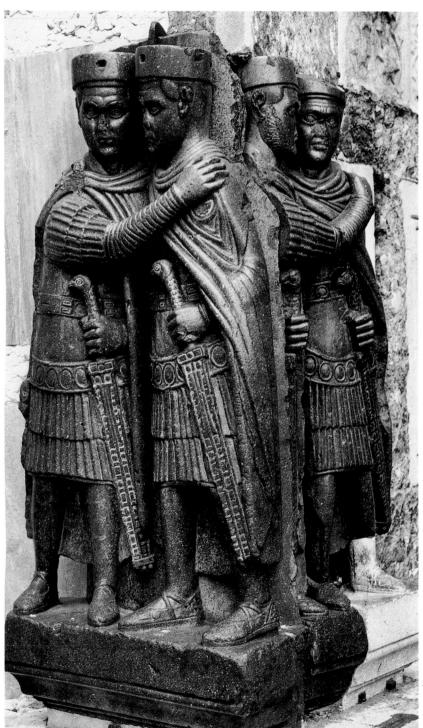

382. *The Tetrarchs*. c. A.D. 305. Porphyry, height c. 51". Façade of S. Marco, Venice

383. Arch of Constantine, Rome. c. A.D. 312-15

after defeating his rival Maxentius at the Milvian Bridge over the Tiber River in 312, reportedly after a dream in which an angel appeared to him bearing the Cross and saying, "In this sign thou shalt conquer." In the Edict of Milan in 313, Constantine proclaimed toleration of Christianity. which had become the single most powerful spiritual and intellectual force in the Empire; in the same year Diocletian died in retirement. In 325 Constantine called and participated in the Council of Nicaea, which considered questions essential to the new religion. But Helleno-Roman polytheism did not rapidly die out; it was necessary in 345 to decree the death penalty for adherence to pagan cults. A short-lived attempt was made to restore paganism under Julian the Apostate (ruled 361-63), but at his death Christianity rapidly triumphed. In point of fact, however, the ancient gods were never entirely forgotten, but lived a subterranean existence in folklore as well as in the literary heritage. They were to surface at unexpected moments in the Middle Ages, and on occasion they triumphed in the Renaissance.

SCULPTURE An astonishing, in fact rather touching, red porphyry group, about half-lifesize (fig. 382) and formerly attached to a column, represents four tetrarchs—we are not sure which ones, but probably Diocletian and his colleagues. Each Augustus embraces a Caesar with his right arm, and each figure firmly grasps the hilt of a sword. The style would have impressed Gudea of Lagash as archaic (see fig. 134). Nothing remains of the naturalistic tradition in the representation of the human body, which had evolved in Egypt, Mesopotamia, and the Hellenic world throughout more than three thousand years. The figures have been re-

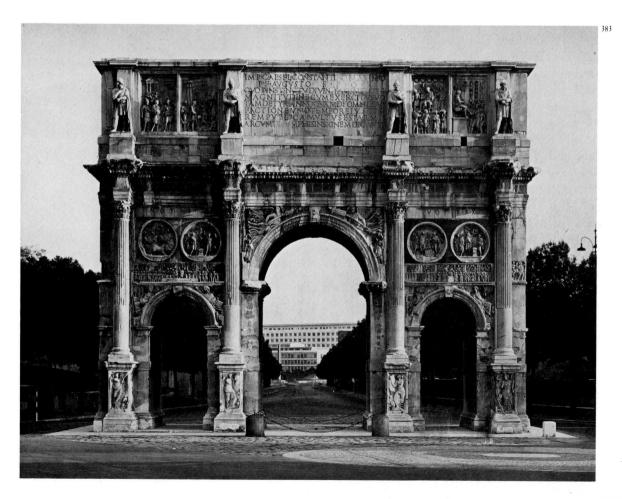

ROMAN ART 273

duced to cylinders, their legs and arms to tubes, their proportions to those of dolls, and their faces to staring masks. But if freedom and beauty of face and body have been sacrificed, anxiety has not. The figures clutch each other like lost children, and an art that no longer cares to analyze features cannot forget frowns. In fact, only the individuality of their frowns differentiates these figures.

The grand triumphal arch that Constantine erected in Rome from 312 to 315 to celebrate his assumption of sole imperial power owes much of its splendor to its predecessors (fig. 383). The three-arched shape was used earlier in the Arch of Septimius Severus in the Roman Forum, and most of the sculpture was lifted bodily from monuments built by Trajan, Hadrian, and Marcus Aurelius, whose heads were recarved into portraits of Constantine and his generals. The sculpture contributed by Constantine's artisans (see fig. 356) is startling. Tiny figures with huge heads, stiffly posed, are aligned on either side of the emperor as he addresses the people from the rostrum in the Roman Forum, whose buildings have been reduced to toys in the background. A few channels made by the drill suffice to indicate what had been the glory of Roman ceremonial sculpture, the melodic cadences created by the folds of the togas. Only here and there in faces and gestures can one distinguish a trace of the Hellenic tradition. Figures and architecture have been locked into an embracing structure of pattern allowing for no independent movement.

Technical inadequacy may account for part of the change; no official relief sculpture had been made in Rome for eighty years, and only artisans were available to Constantine. But the renunciation of the Classical tradition seems to have been deliberate. A new and impressive Constantinian style was rapidly formed, to be carried out by better-trained artists. One gigantic remnant is the marble head of a colossal statue of the emperor (fig. 384), which once was enthroned in the apse of his basilica. Head, arms, and legs were of marble, and the drapery probably of bronze plates over a masonry core. It is hard to keep from thinking of an august predecessor—the Zeus of Phidias at Olympia. No accusation of technical decline can be leveled at this magnificent head. The features and the neck muscles are superbly modeled, showing a full understanding of Hellenistic tradition—with one significant and disturbing exception: the eyes are enlarged beyond all verisimilitude. Carved with all the colorism of Antonine sculpture, even to the extent of a tiny fleck of marble having been left in each eye to represent the reflection of light in the transparent cornea, they stare above and beyond us as if we could never reach their owner, as if his godlike gaze were fixed upon eternity. This enormous enlargement of the eyes as an indication of sanctity or of inspiration became a convention in Early Christian and Byzantine art.

ARCHITECTURE Two structures of great size and importance from this brief transitional period between the ancient world and the early Middle Ages still remain partially standing. One is the gigantic palace which Diocletian began to build in 293 for his retirement near his birthplace at Salona. Much of the present-day city of Split is built inside the palace walls, but its original appearance has been reconstructed in a model (fig. 385). The plan (fig. 387) and appearance of the palace reflect the changed conditions of the Empire. A free arrangement of structures like Hadrian's Villa at Tivoli (see fig. 360) was no longer possible in this unstable portion of the Empire, and so close to the sea. The complex had to be defended, and it was thus laid out on the plan of a Roman camp, with the main streets intersecting in the exact center. The palace was sur-

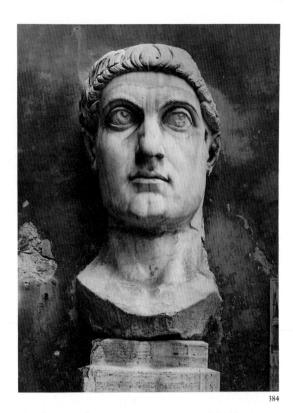

384. Constantine the Great. c. A.D. 315. Marble, height 96". Palazzo dei Conservatori, Rome

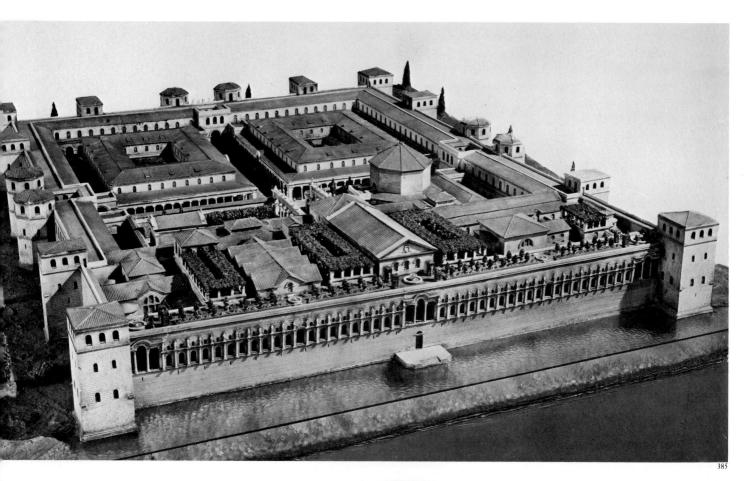

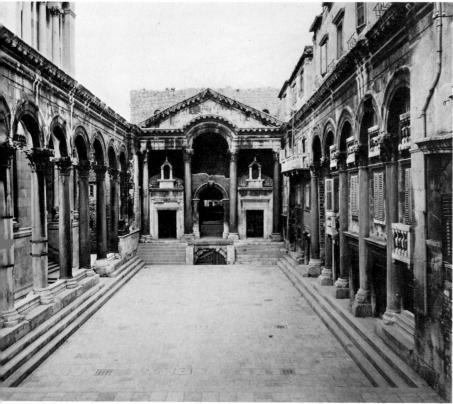

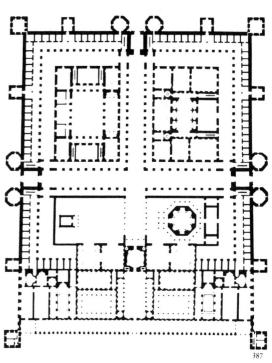

385. Palace of Diocletian, Split, Yugoslavia. c. a.d. 293. Museo della Civiltà Romana, Rome (Architectural reconstruction by E. Hebrard)

- 386. Peristyle court, Palace of Diocletian, Split
- 387. Plan of the Palace of Diocletian, Split

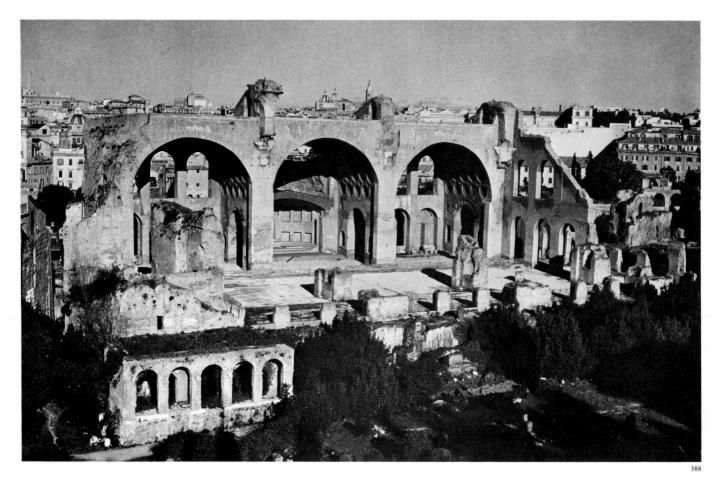

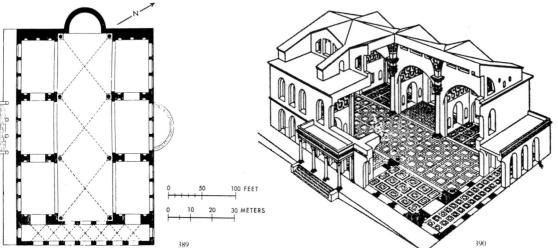

rounded by walls and towers except on the south side, which overhung the sea and could be approached only by boat; the imperial apartments ran along this side, with arched windows embraced by an engaged colonnade. An octagonal structure visible toward the right side of the model was designed as the emperor's mausoleum; it is in good condition and is now in use as a cathedral. A peristyle court, now forming the principal square of Split (fig. 386), gave access to the mausoleum on the left and the imperial apartments at the end through a sort of triumphal arch once crowned with the customary bronze group of a four-horse chariot driven by the emperor. In the center of this arch the Emperor made his formal appearances. The most remarkable feature of this court is the complete change in the customary relationship of column and arch since the first

- 388. Basilica of Maxentius and Constantine, Rome. c. A.D. 306–13
- 389. Plan of the Basilica of Maxentius and Constantine, Rome
- Basilica of Maxentius and Constantine, Rome (Architectural reconstruction after Huelsen)
- 391. Basilica of Trier, Germany. Early 4th century A.D.

century B.C. Under the central pediment the entablature is bent upward to form an arch, as we have previously seen at Hadrian's Villa (see fig. 361). But the monolithic Corinthian columns in gray granite along both sides of the court no longer *embrace* arches; for the first time in Roman architecture, the columns *support* the arches directly. This decisive step prepares us for the structural innovations of Early Christian architecture in the mid- and late fourth century.

The other great pagan structure of the early fourth century is the basilica started by Maxentius in 306 and terminated under Constantine in 313 (figs. 388, 389, 390), a massive section of which still dominates the imperial forums in Rome. Curiously enough, the architect decided to relinquish the traditional basilican plan as we have seen it in the Basilica Ulpia (see fig. 351), with its long nave, side aisles, twin apses, and timber roof, in favor of the groin-vaulted form of hall used in the tepidaria of Roman baths, such as that of Caracalla (see fig. 380). The downward thrust of the heavy groin vaults upon the eight colossal Corinthian columns and the piers behind them must have been to a certain extent abutted by the six massive, octagonally coffered barrel vaults running at right angles to the nave; these replaced the usual side aisles of a basilica. The grandeur, simplicity, and openness of the interior seem to us so easily adaptable for religious use that it is hard at first sight to realize why the building was not adopted as a model for Early Christian churches. The answer (see Part Three, Chapter One) tells us much about the nature of early Christianity. Equally important is the fact that this mighty ruin was universally believed in the Renaissance to have been a temple.

A strikingly austere brick basilica (figs. 391, 392) of the early fourth century still stands at Trier, now in Germany but then one of the major cities of northern Gaul. Constantius, one of the tetrarchs, selected Trier as his capital in 293, and it remained the center of the whole western Empire until the removal of the administration to Milan. Interestingly enough, the basilica is still used as a church, and it forms a remarkable link with Early Christian architecture. The nave is an exact double square in plan, 100 by 200 Roman feet (95 by 190 modern feet), ending in a

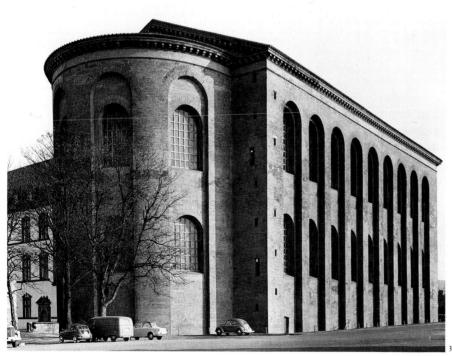

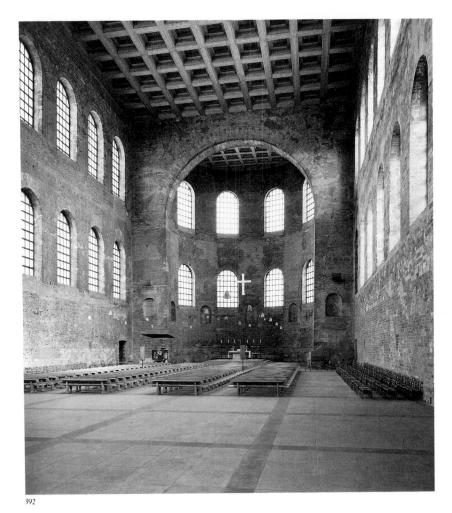

392. Interior, Basilica of Trier

393. Exploits of Hercules, detail of a floor mosaic at the Imperial Villa, Piazza Armerina, Sicily. Early 4th century A.D.

plain arch through which one looks into a semicircular apse. The equally plain walls are pierced by two superimposed stories of arched windows. Neither the interior nor the exterior shows ornamentation of any sort, not even columns, although the exterior windows are embraced by a blind arcade. By a clever optical device, the apse is made to look deeper than it really is: the window sills at both levels are about four feet lower than those in the nave, and the central windows are narrower. The effect of the blank walls and vast spaces is majestic.

MOSAICS In a final glance at the dying pagan tradition, we might note its survival, well into the fourth century, in floor mosaics in North Africa and in Syria, where these decorations have been discovered in great numbers. But the most spectacular find of all has been the villa, excavated since World War II, at Piazza Armerina in Sicily. In striking contrast to the fortified palace of Diocletian, this country residence, which may have been designed for the contemporaneous retirement of Diocletian's colleague Maximian, is freely arranged on the slope of a hill in a manner recalling the improvised plan of Hadrian's Villa at Tivoli. The complete series of late imperial mosaics that enliven the pavements of all the interiors of the villa at Piazza Armerina must have been done by a workshop from North Africa over a considerable span of time. Among the most striking is the group representing *Exploits of Hercules*, seen as separate episodes scattered over a white background. A nude warrior, sprawled over his dead horse and with one leg in the air (fig. 393), plunges

his sword into his breast. The powerful masses of his muscular body recall the Pergamene style of half a millennium earlier (see figs. 283, 286), and the rich changes of light, shade, and color which play over his tanned skin and establish the volumes of his body and limbs in depth show that even at this late date Hellenistic colorism was very much alive. In the next part of this book, we shall see this colorism employed not in the rendition of violence and bloodshed but in the depiction of hitherto unsuspected aspects of spiritual experience.

The heritage of Hellenism, preserved, transformed, and expanded by the systematic nature of Roman civilization, not to speak of the enormous original contributions of the Romans themselves, was to form the basis for the art and thought of all succeeding periods. Roman art blends almost imperceptibly into that of early Christianity, and the great monuments of Roman civilization, many of them in better condition than they are now, remained as a source of wonder and inspiration for the Middle Ages, the Renaissance, the Baroque, and modern times. Subsequent European and Near Eastern art, in any field, is unthinkable without the Roman contribution.

TIME LINE IV

She-Wolf

Apollo of Veii

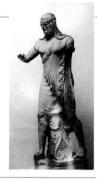

HISTORY

Model of

Etruscan temple

> 800 B.C. Rome under Etruscan domination: overthrows Etruscans to establish Republic, 509 Gauls sack Rome, 387

> > Rome extends rule to southern Italy, Sicily,

300 Sardinia, Corsica

> Rome defeats Carthage in First Punic War, 264–241; expels Carthaginians from Spain, invades Africa, 202-201

Rome victorious over Macedon, 168, extends rule over Macedonia, Asia Minor, Egypt Sack of Athens, 86

Sulla becomes dictator, 82-79

First triumvirate (Pompey, Caesar, Crassus), 60

CULTURE

Invention of paper, China Vast quantities of Greek sculptures brought to

Rome in triumph after victory over Macedonia Earliest water mills

Golden Age of Roman Literature: Cicero, Catullus, Virgil, Horace, Ovid, Seneca

Colosseum

Pantheon

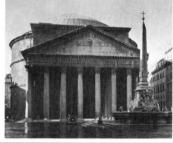

50 B.C.

Arch of Titus

100

Caesar assumes power, 49; assassinated, 44 Second triumvirate, including Octavius, 43

A.D. 1 Octavius first Emperor as Augustus Caesar, 27 B.C.-A.D. 14

Principal later imperial reigns:

100 Julio-Claudians (Tiberius, Claudius, Nero), 14-68; Flavians (Vespasian, Titus, Domitian), 69-96

Trajan, 98-117; Hadrian, 117-38

Antonines (Antoninus Pius, Marcus Aurelius, Commodus), 138–80

Septimus Severus, 193–211; Caracalla, 211–17

300 Diocletian, 284-305 (Tetrarchy, 293) Constantine the Great, 324–37

Vitruvius completes his ten books on architecture, De Architectura

Jesus Christ (c. 3 B.C.-A.D. 30)

Invention of glassblowing; Pliny the Elder, Natural

Paul (d. 65) spreads Christianity to Asia Minor, Greece, and Italy

Tacitus (55?–after 117)

Ptolomy, astronomer (d. 160)

Galen, physician and anatomist (d. 201) Plotinus (d. 270)

ETRUSCAN/ROMAN

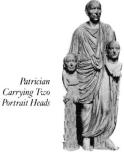

Temple of the Sibyl, Tivoli

House of the Silver Wedding, Pompeii

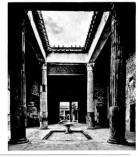

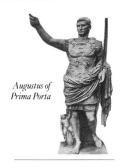

PAINTING, SCULPTURE, ARCHITECTURE

Etruscan temple as described by Vitruvius Cinerary urn, Chiusi; sarcophagus, Cerveteri; Apollo of Veii Hunting and Fishing and Dancing Woman and Lyre Player, Tarquinia Tomb of the Reliefs, Cerveteri She-Wolf; Wounded Chimaera; Bearded Man (Lucius Junius Brutus?)

Bronze mirror and Ficoroni Cist from Praeneste

Porta Marzia, Perugia

Temple of Fortuna Virilis, Rome; Temple of the Sibyl, Tivoli Patrician Carrying Two Portrait Heads; Head of a Roman; L'Arringatore Head of Pompey

Forum, Pompeii

Wall paintings: from the *Odyssey*, Rome; Villa of Mysteries, Pompeii *Garden Room*, Villa of Livia, Rome

Still Life, House of Julia Felix, Pompeii Architectural View, from Boscoreale

PARALLEL SOCIETIES

Persian Greek: Archaic Etruscan

Gauls

Roman Republic

100

300

800 B.C.

Marcus Aurelius

Constantine the Great

Palace of Diocletian

Statues of Augustus; Ara Pacis

Forum of Augustus, with Temple of Mars Ultor

Pont du Gard; Maison Carrée

Gemma Augustea; houses of Silver Wedding and Faun, Pompeii; wall paintings: House of M. Lucretius Fronto, Pompeii; Architectural View from Herculaneum; landscapes, Rome and Pompeii

Porta Maggiore; insulae at Ostia

Flavian portrait sculpture; Arch of Titus, with sculpture; Colosseum Forum of Trajan with Basilica Ulpia, Column, and Market; arches and streets of Trajan

Hadrian's Villa, Tivoli; Pantheon; Portrait of Antinoüs

Base of Column of Antoninus Pius; statue of Marcus Aurelius; *Commodus* Library of Celsus at Ephesus; Theater at Sabratha; Faiyûm Portrait;

Family of Vunnerius Keramus

Caracalla; Philip the Arab; relief of Gordianus III; Ludovisi sarcophagus Temple of Venus, Baalbek; Palace of Diocletian; Tetrarchs; mosaics at Piazza Armerina

Portrait and Arch of Constantine; Basilica of Maxentius; Basilica, Trier

Roman Empire

50 B.C.

A.D. 1

100

Early Christian

300

THE MIDDLE AGES

THREE

Two overriding circumstances separated the Middle Ages from the ancient world. The first was the gradual dissolution of the Roman Empire into a wide variety of successor states. Some of these retained or revived imperial pretensions, while others frankly proclaimed their ethnic basis; however, all achieved only limited territorial jurisdiction, thus preparing the way for the modern nation-state. The second was the dominance of two religions with universal claims, first Christianity and then, in competition with it, Islam. Each religion demanded total allegiance on the part of the worshiper, sometimes to the point of active judicial and military hostility to other faiths—as seen in religious executions and holy wars. Each ordered the worshiper's ethical standards and daily life. In ultimate decisions each valued revelation above reason, that supreme goal of ancient thinkers. Each prepared the worshiper in detail for an afterlife.

Both circumstances were to have profound consequences for art. The first resulted in a far greater repertory of artistic forms, corresponding to the necessities of individual states and regions, than was possible even under the large tolerance of the Roman Empire. The second demanded a religious architecture that could handle ceremonially vast masses of people, and whose interior spaces, therefore, tended to determine the character and appearance of their external forms. Equally important, the emphasis of religion on an otherworldly goal tended to weaken interest in naturalistic representation of the spaces and objects of this world. It also prohibited outright the depiction of the nude human body, the pride and glory of Helleno-Roman art, save when required by a specific religious or historical subject; even in such an instance, no beauty is discerned in the body. Explicit Scriptural support for this attitude is unfindable, but it may derive from the shame of Adam and Eve at recognizing their nakedness and from Saint Paul's distrust of all sexuality. Early in the period, therefore, representations of even the clothed human figure betray a lack of knowledge of or interest in the underlying structure of the body. As an inevitable corollary of religious antinaturalism, schemata inherited from one generation to the next were inexorably substituted for the active pursuit of visual reality which, in one form or another, had occupied the attention of Mediterranean artists for more than three millennia.

At the same time, the emphasis on faith and the consequent transcendence accorded to the inner life opened up for artistic exploration rich areas of human experience hardly touched by the visually oriented art of the Helleno-Roman tradition. Formalized shapes, patterns, and color relationships, whether based on nature or wholly abstract, had been permitted only an ornamental role in ancient art. In the Middle Ages such elements took on extreme importance as vehicles for feeling and imagination. In certain aspects of Celtic and Islamic art, in fact (see figs. 11, 466), abstraction entirely replaces elements derived from observation. Paradoxically enough, in the service of otherworldly religions, engineering science took enormous strides in the Middle Ages. Such brilliant achievements as the lofty domes on pendentives, which

crown Byzantine churches (see figs. 429, 447); the interlacing arches, which opened up new possibilities for mosques (see fig. 472); and the soaring ribbed vaults sustained by external buttressing, which roof Gothic cathedrals (see figs. 585, 597), were feats beyond the imaginings of Roman architects.

The dividing line for both the political and the religious determinants fell within the reign of the emperor Constantine (A.D. 312–37). The breakup of the Empire was heralded by his removal of the capital from Italy (where Milan had for decades replaced Rome as the chief administrative center) to Byzantium, on the shores of the Bosporus, which he rebuilt and renamed Constantinople. The direct result of this move was a new and eventually permanent division of the Empire under Constantine's successors along more or less the same lines as the tetrarchy. The Eastern Roman (or Byzantine) Empire survived for more than a thousand years, although constantly diminished by foreign inroads, until Constantinople was conquered by the Turks in 1453. The Western Roman Empire was repeatedly invaded during the fifth century by Germanic tribes, who twice succeeded in sacking Rome. These tribes had already eaten away at the outlying provinces, and had infiltrated the very administration of the Empire; many had become Christianized. The deposition in 476 of the last Western Roman emperor, Romulus Augustulus, by the Gothic king Odoacer merely gave formal expression to what had long been a fact, the take-over by Germanic tribes of the whole of the Western Empire as a series of separate kingdoms.

Possibly the religious policy of Constantine, beginning with his promulgation of the Edict of Milan in 313 along with his co-emperor Licinius, would have been inevitable no matter who sat on the throne. The number of Christians in all parts of the Empire, even in the imperial administration and in the imperial family, had become too great either to persecute or to ignore. Constantine's later activities as sole emperor—for example, his presiding role at the Council of Nicaea in 325—reinforced the new importance of the Christian religion. His transfer of the capital to the most heavily Christianized region of the Empire made the supremacy of Christianity all but inevitable.

Christianity rapidly replaced Roman and other forms of polytheism as the official, indeed the only legal, religion of the entire Mediterranean world. Adherence could be enforced by the full machinery of Roman imperial government, and by almost all the successor states for many centuries. Poor at its humble beginnings, the Church was now rich. Thus began a wholly new era in human history, in which political and religious phenomena were inextricably mixed, not within national boundaries, as often in the ancient world, but on an immense scale, with worldwide claims. Even after the West had been overrun by barbarians, who set up their own monarchies, the title of the Roman Empire was revived by Charlemagne in 800 and maintained until extinguished by Napoleon in the early nineteenth century. The Emperors were still called "Caesar"—the origin of the German Kaiser and the Slavic czar. Although their capital was mobile, and the emperors were almost uniformly Germanic, their authority over lesser sovereigns was not firm until they had gone to Rome to be crowned. For the bishop of Rome had come to be recognized as pope (from the expression for "father"), supreme head of the Christian Church—in the West, at least—and however little his person might at times be respected, divine authority was considered to be in his hands. The language both of the Church and of all official documents and learned writing throughout most of the Middle Ages in the West remained Latin. In the largely Greek-speaking East papal preeminence was not recognized, nor was there any equivalent to papal authority among the patriarchs holding sway over the regional divisions of the Eastern, or Orthodox, Church.

Gradually, under the dominance of interlocking church and state authority, a new phenomenon perhaps too easily characterized as the "medieval mind" came into being. In sharp contradistinction to the generally unfettered intellectual life of Greek and Roman antiquity, all knowledge in the Middle Ages was subordinated to the transcendent belief in divine revelation through Scripture and Church tradition. Accepted theological principles known as *dogma*, belief in which was considered necessary to salvation, were adopted at Church councils, proclaimed by popes, and refined by theological writers. Deviation was

considered *beresy*, a crime punishable in theory and too often in fact by the most painful forms of death. Yet heresies arose and spread, sometimes throughout entire regions, until they were suppressed, occasionally with a ruthlessness that might have startled the pagan persecutors of the gentle early Christians. Surprisingly, the greatest of the theologians were well read in Greek and Latin literature and philosophy, and while rejecting pagan deities as demons, they systematically incorporated ancient wisdom and scientific knowledge into the structure of Christian faith. Many, indeed, maintained that there was no conflict between faith and reason. We owe most of our knowledge of Classical writings to the Church's practice of copying ancient manuscripts for preservation in their libraries. Still more unexpected, a great deal of scientific investigation in the Islamic world permeated Christendom, partly because of the Crusades designed to rescue the Holy Land from its Arab conquerors.

A special feature of Christianity in East and West was the new institution of monasticism. In the troubled conditions of the later Empire, invaded and dismantled by the barbarians, and throughout the Middle Ages, thousands of men and women sought refuge in a total renunciation of worldly life, including marriage, by founding communities of single persons known as monasteries (from the Greek word for "one"). Many monks and nuns, especially in the East, were hermits, living a life of perpetual penance, meditation, and prayer in complete solitude, in caves, huts, or eventually groups of separate structures, and coming together only for corporate services. In contrast to these *eremitic* groups, there arose organized cenobitic orders (from the Latin word for "dining place"), who inhabited separate cells in larger structures, ate together—in silence, while listening to sacred readings—and celebrated all liturgical rites in common. Both monks and nuns were often trained as scribes, and one of their principal duties was to copy the Bible, liturgical books, and theological writings as well as those works of pagan authors considered worth preserving. The monasteries, therefore, became the main centers of learning before the year 1000. In the convents for women, the first all-female communities we know except for such tiny Roman groups as the nine Vestal Virgins, the role and authority of women were vastly enriched. Although they still needed male priests to celebrate Mass, women ruled their own convents and indeed governed whole orders of nuns, subject to the often distant authority of a bishop. Women in the convents, just as men in the monasteries, painted the illustrations for the manuscripts they copied. Thus for the first time in human history we have works of art indisputably created, and sometimes signed, by women; such works often also illustrate theological writings by women authors (see figs. 569, 620).

In the largely illiterate world outside the monasteries, cities had shrunk to a fraction of their original size or had even disappeared. Barbarian chieftains, soon Christianized, ruled as local or regional lords, with their practice of hereditary tenure of land giving rise to the concept of a "noble" class, foreign to the ancient world. The *feudal system* (based on a Latin word for "oath") gradually arose and held sway throughout most of the Middle Ages. The peasant held his land from his local lord, who had sworn loyalty to a higher regional nobility, who in turn had taken an oath to a national king; over all, in theory, ruled the emperor. Marriages often generated conflicting loyalties through the inheritance of lands pledged to different overlords. And in point of fact regional nobles, throughout the Middle Ages, ruled with slight regard for royal power, just as the kings, supreme only in their own immediate territory, obeyed the emperor only when he could enforce his wishes. But imperial secular authority was held to be worldwide, corresponding to the universal spiritual authority of the pope. The system was formalized and justified in the thirteenth century by the great Italian poet and humanist Dante Alighieri in his *De Monarchia* (On Monarchy).

Not long after the year 1000 a disruptive element made its appearance within the feudal system—the rise of cities. Often these were revived Roman centers, but sometimes important towns, such as Florence, grew up on sites that were mere villages in antiquity. Owing their growth and rapidly increasing prosperity to manufacture, finance, and trading with each other and with the monarchies on a surprising scale, by land and sea, these cities were ruled by a new class of bourgeois merchants, unwilling to recognize the

authority of kings and nobles, but often unable to defend their rights. In most of Italy and parts of northern Germany the cities established themselves as wholly independent republics, recalling vividly the city-states of ancient Greece. And they were often able to extend their rule over considerable regions and even disenfranchise the nobles. In the later medieval cities, whether or not they were independent, the *cathedrals* (churches containing the bishop's *cathedra*, or chair of authority) assumed a new importance and eventually colossal size, as symbols of civic dignity within the church-state structure. In the cities the universities rapidly replaced the monasteries as repositories of knowledge and incubators of new thought and, since any qualified male could attend, provided some social mobility within the system.

The theologians and philosophers of the Middle Ages, through the universities, necessarily had to work in harmony with Christian dogma, and they were eventually able, after many centuries of constant thought and writing, to erect a philosophical system that corresponded intellectually to the codified church and state governing their world at every level. *Scholasticism*, as the system came to be known, was perhaps the most characteristic expression of the "medieval mind." Every observable phenomenon of the natural world and human existence could be set in its proper place in this towering structure, justified by Scriptural authority, theological argument, and the reasoning of ancient philosophers. By the thirteenth century, in the *Summa* of Saint Thomas Aquinas, the system attained its peak of complexity and logical interrelationship of elements, reaching from the mysteries of heaven to the tiniest aspect of life on earth to the certitude of human destiny. Unlike the companion system of political and ecclesiastical authority, beset by all the frailties of human nature, Scholasticism worked very well indeed and proved all of its points to its own satisfaction. No one could have foreseen that free human observation and inquiry beginning in the Renaissance would eventually bring Scholasticism down, just as the example, at least, of the independent republics was to undermine both feudalism and the Empire and as the new emphasis on individual conscience was to split the Western Church.

It is sometimes maintained that Early Christian art and Byzantine art are in reality continuations of tendencies that had begun under the later pagan emperors and that they should be treated, therefore, as a final phase of ancient art. But there is a fundamental change between the conceptions of the human figure and surrounding space—and indeed the very nature and purpose of architecture, sculpture, and painting—prevalent in Greek and Roman art and those strongly evident in the new art of Christianity. This change was felt by the early Christians themselves, who used pagan buildings as quarries for materials and architectural elements, and destroyed pagan statues and paintings as idolatrous and sinful, without regard for artistic value. The attitude of the early Christians toward the past contrasts strongly with that of the Romans, who protected their own earlier buildings wherever possible and cherished the statues and paintings of the Greeks. It would be more significant for us to consider the surprising developments of third-century pagan art as already partly medieval. In any event, the new appreciation of both the antinaturalistic art of the late Empire and that of the Middle Ages is an intellectual reconquest, dating from the Romantic period of the later eighteenth century and strongly reinforced in modern times.

EARLY CHRISTIAN AND BYZANTINE ART

ONE

The earliest Christians had no practical need for art of any sort. Jesus himself, and after him the Apostles, preached and taught in houses, on hillsides, from ships, in streets and squares, and even in the Temple. Persecutions of Christians were by no means as continuous and thorough as is popularly believed. Between persecutions Christianity flourished and spread in its own quiet way. The new religion had its competitors, of course, among the mystery cults which had abounded even in the days of the Roman Republic—the religions of Dionysos, Isis, Cybele, Attis, and Mithras were the most important. But it would be a mistake to regard early Christianity as in any way comparable to these cults. True, they all promised salvation in an afterlife through the intervention of a particular divinity. But, unlike Christianity, they either culminated in orgiastic rites or included sanguinary ceremonies. For example, votaries of Mithras, the god of the favorite mystery cult of the Roman soldiery, lay on couches surrounding an altar before which a live bull was sacrificed and then drank his warm blood.

Early Christianity was nonviolent in essence. Would it had remained so! Alone save Judaism among the religions of the Roman Empire, it proclaimed a system of ethics that governed the entire behavior of the worshiper in all aspects of daily life, and alone save Judaism it possessed written authority embodied in a rich library of Scriptures, whose authenticity was generally accepted despite disagreement on specific elements and interpretations. And even Judaism, always an ethnic religion, could not vie with the universal claims of Christianity. Thus, Christianity held not only a promise of individual salvation, but it also rapidly became a corporate religion, which created a counterculture inside the Roman state. Enthusiasts of the mystery cults had no objection to participating in the largely perfunctory aspects of Roman state religion, which included burning incense before the statue of the divine emperor. To the Christian such rites were anathema, and thus the very strength and pervasiveness of the Christian faith were interpreted as threats to the stability of the Empire. A tribute to the extraordinary success of early Christianity is that the two most systematic persecutions, those of Decius in 249–51 and Diocletian in 303–5, came so shortly before the Edict of Milan in 313, which marked, if not the final triumph of the new religion, at least its liberation from fear.

During the later first and second centuries, Christian communities remained small, and believers worshiped in private houses. The basic ceremony, doubtless simple, was the communal meal, celebrating the Last Supper, which began with the breaking of bread and concluded with the drinking of wine, in ritual perpetuation of Christ's sacrifice. The ceremony included prayers, the reading of passages from the Gospels and the Epistles, discourses on the part of successors to the Apostles, and sometimes "speaking in tongues," which is today so mysterious an aspect of early Christianity. A dining room was essential, and

the early Christians used the Roman triclinium (a dining room with a three-part couch extending around three sides of a table). In the crowded cities of the Eastern Empire, the triclinium was often located on an upper floor—the "upper room" mentioned in the Gospels and in Acts. Christianity was at first a religion chiefly for the lower classes, whom it sought to wean from the bloody spectacles of the arenas. Often, therefore, religious meetings took place in humble apartments in tenements, such as the insulae of Rome and Ostia (see fig. 336). By the third century the structure of the Mass—the word derives from the Latin missa, meaning "sent" or "finished"—had become clear; it was presided over by episkopoi (bishops; literally, overseers), whose qualifications are listed in 1 Tim. 3. A clear distinction was maintained between the Liturgy of the Catechumens, consisting of the reading of Epistles, Gospels, prayers, and hymns (today the Ordinary and Proper of the Mass), which those under instruction could attend, and the Liturgy of the Faithful, the actual Eucharist—from a Greek word for "thanks"—or sacrifice of bread and wine (today the Canon of the Mass), to which only baptized Christians were admitted. The catechumens were required to leave before the Eucharist, and could only hear but not see the Liturgy from an adjoining room. No altar was used, only a table brought in for the Eucharist and another table to receive offerings.

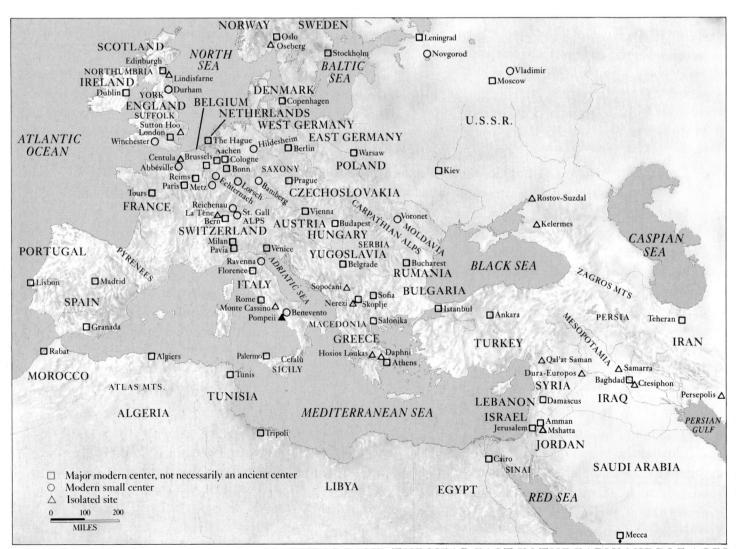

MAP 10. EUROPE AND THE NEAR EAST IN THE EARLY MIDDLE AGES

The Earliest Christian Art

THE DOMUS CHURCH A special sort of house devoted exclusively to the observance of the Eucharist—a domus ecclesia (house of the church, from which the Italian duomo and the German Dom, both words for cathedral, were derived)—became the first type of church building. The earliest known, dating from just before 231, was found at Dura-Europos in Syria (fig. 394). It is an ordinary Greek peristyle house, somewhat remodeled for Christian use, with a separate room for the catechumens, a library, and a vestry. It could not have accommodated a congregation of more than sixty and can scarcely be said to have had any pronounced architectural character; if it contained works of art, they have perished. This building had a dais for a bishop's chair, and thus it can be regarded as a cathedral. The baptistery at Dura-Europos, however, did contain very modest wall paintings. The earliest Christian churches, like early synagogues, generally were inconspicuous; their sites were selected in popular quarters near the city walls. There is, however, evidence for the erection of one substantial Christian meeting hall in Rome just before the issuance of the Edict of Milan. The existence of many others, in cities throughout the Empire before the persecution by Diocletian, is mentioned by Eusebius of Caesarea, fourth-century bishop and historian.

THE MARTYRIUM A second kind of structure, the martyrium, was built over a martyr's grave or employed as a cenotaph to commemorate a martyr whose body was interred elsewhere. The earliest such structure known, dating from around A.D. 200, is a simple aedicula, or shrine, recently excavated under Saint Peter's in Rome (fig. 395). Inscriptions show that at that time the Christians believed it was the tomb of Peter.

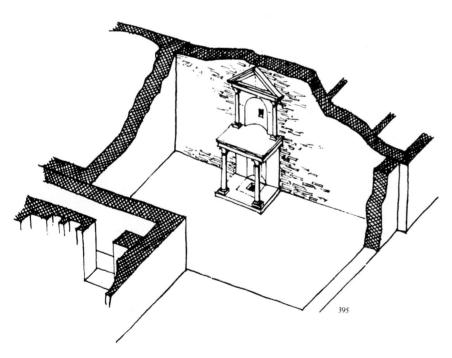

CATACOMB PAINTING The early Christians also dug catacombs. Since Christian belief in the resurrection of the body then prohibited cremation, the Christians could not use the columbaria (dovecotes) cemeteries of lower-class Roman burial societies, where urns were kept in little niches, many tiers high. Also the Christians felt the necessity of segregation from pagan burials. Like other Roman citizens, they could and did acquire property—as, for instance, their church buildings—and

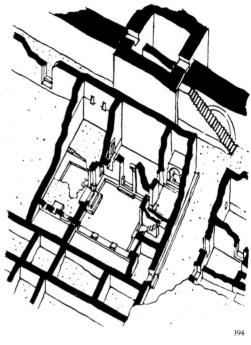

394. Christian community house, Dura-Europos, Syria. Shortly before A.D. 231

395. Shrine of Saint Peter, Rome. Late 2nd century A.D.

they bought land outside many cities, choosing sites where it was possible to excavate passages in the rock. Often these catacombs took advantage of local quarries as starting points. From these, tunnels were dug systematically according to plans; to conserve space, the catacombs were sometimes excavated four or five levels deep. Superimposed niches for sarcophagi, and from time to time small chapels for funeral feasts and for commemorative services, were hollowed out.

The earliest known works of Christian figurative art have been found in these chapels. These simple paintings on plaster, spread over the rock surface, were executed by modest artisans working by lamplight in the dark, dank, and probably odoriferous surroundings. Most of these paintings were on ceilings, a position that required the painter to work with his head tilted. One of the earliest, on the underside of an arch in the Catacomb of Saint Priscilla, Rome (fig. 396), dates from the time of the Antonine emperors in the late second century. Four men and three women are seated—they no longer recline—around a table on which only plates of bread and a small pitcher are visible. The central figure is shown in the act of breaking the bread, which represents the culminating moment of the Eucharistic sacrifice. The style is a sketchy version of Roman illusionism, but is adequate to convey deep excitement, transmitted from face to face by earnest glances revealing the exaltation of the participants.

A somewhat less intense ceiling fresco (fig. 397), probably painted in the early fourth century, in the Catacomb of Saints Peter and Marcellinus, Rome, is interesting chiefly from the symbolic standpoint. The circular design, like a miniature Pantheon dome, was doubtless intended to suggest the Dome of Heaven. Four semicircles are arranged about the central circle and are united by bands forming a Cross to show that this universal Christian symbol both embraces and reveals Heaven itself. In the central medallion, flanked by resting sheep, is the figure repeated countless times in Early Christian paintings and sarcophagus sculpture, the Good Shepherd. These are the earliest images of Christ and, of course, were not intended to inform us about his actual appearance (about which we know nothing). The youthful, beardless shepherd, with a lamp over

396. *Breaking of Bread* (detail of a fresco, Catacomb of Sta. Priscilla, Rome). Late 2nd century A.D.

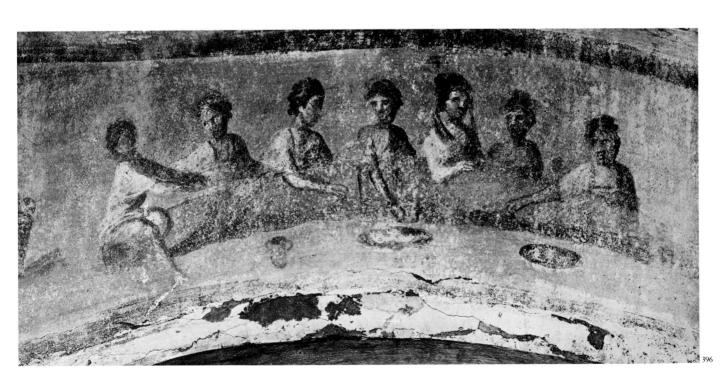

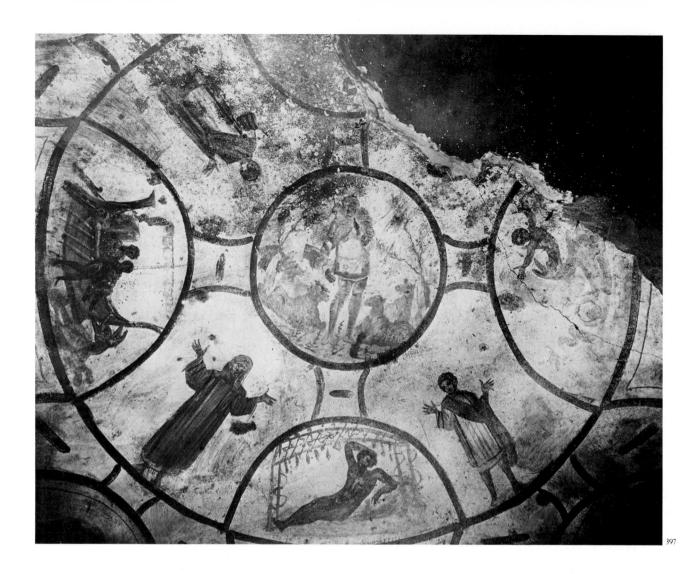

397. The Good Shepherd, ceiling fresco, Catacomb of SS. Pietro e Marcellino, Rome. Early 4th century A.D.

his shoulder, is a symbol of Christ, who said, "I am the good shepherd; the good shepherd giveth his life for the sheep" (John 10:11). One semicircle is lost, but the remaining three tell in simple imagery the story of Jonah, tossed from his ship at the left, swallowed by the whale at the right, and at the bottom reclining below the gourd vine. Here again we are instructed by Christ's own words, "and there shall no sign be given to it, but the sign of the prophet Jonas: For as Jonas was three days and three nights in the whale's belly; so shall the Son of man be three days and three nights in the heart of the earth" (Matt. 12:39-40). Thus, as always in Christian thought, the Old Testament is interpreted in the light of the New; in the apparent death and miraculous deliverance of Jonah are prefigured the Crucifixion and Resurrection of Christ, and through faith in him, the salvation of the true believer. The "sign of the prophet Jonas" is the Cross, between whose bars stand figures in what is known as the orant pose, the arms-wide gesture of prayer in Early Christian times, still used by the celebrant at certain moments in the Mass.

The only biblical wall paintings of truly monumental character that have come down to us from this early period are, however, not Christian but Jewish; they form a remarkable series and originally decorated the entire interior of a synagogue at Dura-Europos. However provincial in execution, these paintings are impressive in the solemn directness with which they set forth the biblical narratives. In Haman and Mordecai (fig.

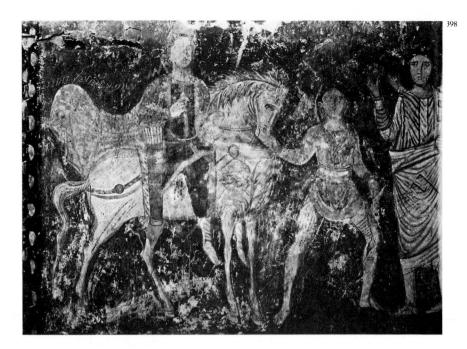

398. Haman and Mordecai (detail of a wall painting from the Synagogue, Dura-Europos). c. A.D. 250. National Museum, Damascus, Syria

398) these two figures move against a flat background with no indication of groundline, reminding us of the floating figures on the base of the Column of Antoninus Pius (see fig. 362). Mordecai stands in a Roman speaking pose, his right arm outstretched and his body enveloped in the folds of a cloak that strongly recall those of a toga. We can only surmise that Christian counterparts to this large-scale Jewish painting existed; none have yet been found.

The Edict of Milan brought about immediate and far-reaching transformations in the life of the Church through the new relationship between church and state it established. Given the strong interest and active role of Constantine, Christianity became to all intents and purposes an official religion, inheriting the splendors of the dethroned Roman gods. Although no complete colossal statue of the emperor is still preserved, the solemn Colossus of Barletta (fig. 399), a bronze statue probably representing one of his successors in the fifth or sixth century, clearly indicates the majestic and superhuman authority accorded to the person of the emperor in early Christian times. No longer divine, he was nonetheless sacred—the Unconquered Sun, the Vicar of Christ on earth.

THE EARLY CHRISTIAN BASILICA The newly official religion, encouraged as an effective arm of imperial administration, soon took on imperial magnificence. It could no longer aim at small and intimate congregations bound together by no other ties than those of Christian love. Huge crowds of worshipers had now to be accommodated and given access to sacred places and to the sacraments of the Church. Enclosed and roofed spaces were needed in great numbers. In rapid succession and under direct imperial patronage, scores of churches rose throughout Rome and other great cities of the Empire, especially Milan and Constantinople, and at sacred sites in the Holy Land.

A model for these new buildings was needed. Although the Christians had no compunction about utilizing architectural elements taken The Age of Constantine

from pagan structures, the temples themselves, even when not too small for the crowds of worshipers, were manifestly unsuitable; their very sites were regarded with abhorrence. The obvious solution was the Roman basilica, or meeting hall, which existed in every inhabited Roman center. As we have seen, there was no strict uniformity of plan for these meeting halls. Many Roman basilicas, some quite large ones, were simple halls with no side aisles; most were entered along one side, and had apses at either end. One apse soon proved convenient for the installation of the clergy and the enthronement of the bishop, but the entrance had to be placed at the opposite short end. The early portable communion table was replaced by a fixed altar, which had to be visible from a considerable distance and accessible to all worshipers at Communion. The long row of columns on either side of the nave played a double role in dramatizing the approach of the faithful to the altar and in segregating, by means of curtains hung between the columns, the catechumens from those who could witness the Mass of the Faithful.

The colonnades characteristically supported a lofty wall pierced by a clerestory. The roof was usually of an open timber construction, as was the case in so many ancient buildings. The large number of churches begun in the reign of Constantine required columns in great numbers and at great speed. It may be fairly doubted whether, in Constantinian Rome, it was possible either to produce so many or to order them from other regions. However, temples and other monuments of the Roman past offered an inexhaustible supply. Borrowed columns were thus uncritically installed in the new basilicas, with little or no regard for consistency of style, color, or size. Granite and marble columns, Corinthian and Ionic capitals, were placed side by side; capitals were sometimes set on columns they did not fit.

Saint Peter's was the largest and grandest of the Constantinian basilicas, in fact the largest church building in all Christendom (fig. 400, illustrating a fresco painted when the apse and part of the nave had already been destroyed, but much was still standing). It differed from most other basilicas not only in its stupendous size—an inner length of 368 feet but also in its very nature as a combined basilica and martyrium. The apse enshrined the tomb of Peter under a marble canopy supported by four spiral columns (later used by Bernini as a model for his colossal construction in the seventeenth century). In order to accommodate the crowds of visitors to the tomb, a large hall—the transept—was erected at right angles to the nave between the nave and the apse (figs. 401, 402). Before the transept came the so-called triumphal arch, a common feature of Early Christian basilicas. The altar, at the head of the nave, was probably movable. The columns of the basilica were either Corinthian or Composite and of many different materials, including green marble, yellow marble, red granite, and gray granite. They were closely spaced, and supported a continuous, straight entablature. As in the Basilica Ulpia, Saint Peter's had double side aisles; the colonnade separating them supported arches. The building was not completed when Constantine died in 337 nor for some time thereafter. It is not known what wall decorations were originally planned; the frescoes covering the nave walls between the colonnade and the clerestory were painted in the fifth century, but the half-dome of the apse was filled with an immense pictorial composition in mosaic (see page 299 and figs. 407, 408).

Initially, there was certainly no suggestion that the transept plan symbolized the Cross, as it did in later times. The plan of Santa Sabina, erected in Rome from 422 to 432 (fig. 403), is more typical of Early Chris-

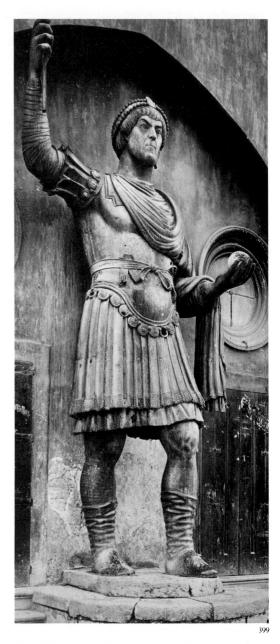

399. Colossus of Barletta. c. 5th or 6th century A.D. Bronze, height of original part (head to knee) 11' 73/4". Barletta, Italy

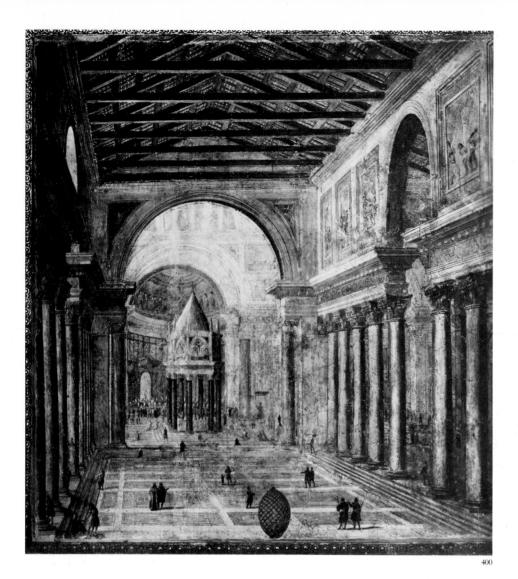

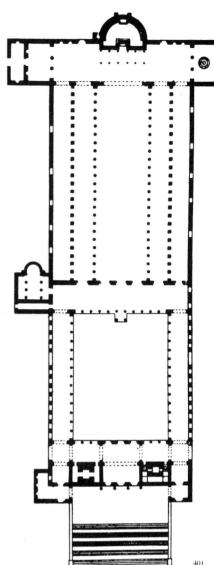

- 400. Old St. Peter's, Rome, fresco, S. Martino ai Monti, Rome. 16th century A.D.
- 401. Plan of Old St. Peter's, Rome. 1st half of 4th century A.D.
- 402. Isometric view of St. Peter's, Rome. c. A.D 400 (Dotted lines indicate conjectural outline of atrium and entrance portal)

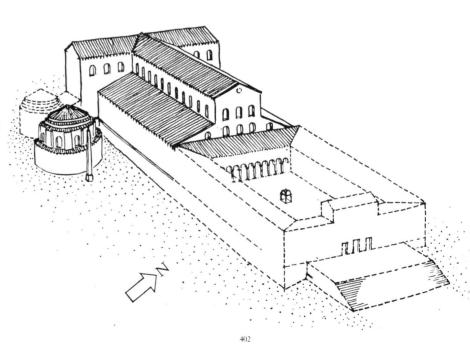

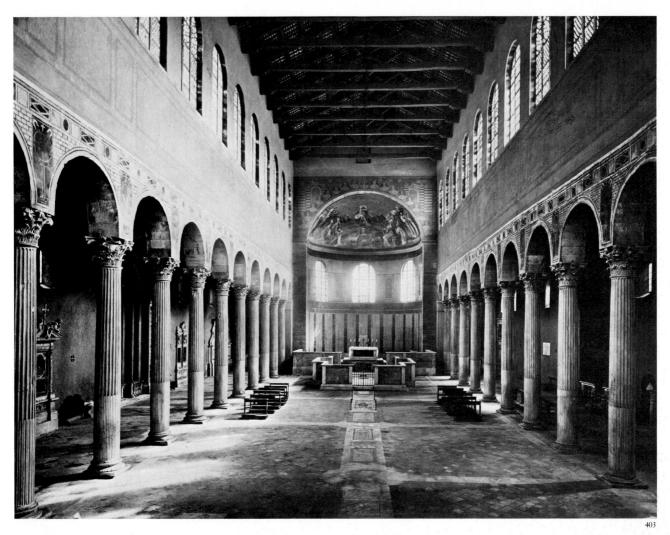

403. Interior, Sta. Sabina, Rome. A.D. 422-32

tian churches. It was built without a transept so that the triumphal arch embraced the apse directly. Throughout the Early Christian period, the apse was used only by the clergy, and often it contained a throne for the bishop. Arches were substituted for straight entablatures, as at Santa Sabina, in the course of the fifth century. None of the Constantinian basilicas survive in their original state. Saint Peter's, in fact, was demolished section by section in the Renaissance, to be replaced by a new building. The beautifully restored interior of Santa Sabina is almost the only one that still conveys the appearance of an Early Christian basilica in Rome, but it is unusual in having carefully matched Corinthian columns—purloined as usual.

All Early Christian buildings were devoid of external decoration, presenting unrelieved brick walls of the utmost simplicity (as in the Basilica at Trier, fig. 391; see also figs. 411, 418). The pilgrim to Saint Peter's (see fig. 402), for example, arrived at the blank, outer wall of an atrium—in reality a large peristyle court—then proceeded to the narthex or vestibule, and finally emerged into the richly colored nave with its splendid columns and bright frescoes, scores of hanging lamps, jeweled altar cloth, gold and silver vessels of the Mass, and clergy in gorgeous vestments—a far cry from the simplicity of the first centuries of Christianity. The processional principle on which the church was laid out has often been compared with the basic plan of the Egyptian temple, but it should be remembered that a similar processional principle governed the alignment of spaces and structures in the Roman forum as well, especially that of Trajan (see fig. 350).

THE CENTRAL PLAN A considerable number of variations could occur in the basilican plan, depending on the purpose of the building and on local traditions and requirements. An entirely different arrangement, the circular plan, was also widely used (fig. 404). A handsome early example is the Church of Santa Costanza (fig. 405), built in Rome about 350. Circular churches, unsuitable for celebrating Mass before large congregations, were almost always erected as martyria; this one was destined to contain the tomb of Princess Constantia, daughter of Constantine. Basically, of course, the circular plan is that of the Greek tholos type (see fig. 170) and of its lineal descendant, the Pantheon (see fig. 358), but the Early Christian circular church was usually enveloped by a circular side aisle, known as the ambulatory, which was intended for pilgrimages and for ceremonial processions. In cross section such a church, with its elevated clerestory, would suggest a basilica, save only for the central dome. In Santa Costanza the rich mosaic decoration is still preserved in the barrel vault of the ambulatory, although that of the central portion of the church has disappeared. The coupled Composite columns in granite create an impression of outward radiation from the central space, which is enhanced by the swelling, convex frieze of the entablatures.

Any number of variations were eventually possible in the circular plan, such as its expansion into radiating apses and chapels in the sixth century (see fig. 419). A circular martyrium could also be combined with a basilica, as in the great church commissioned by Constantine for the

- 404. Plan of Sta. Costanza, Rome. c. A.D. 350
- 405. Interior, Sta. Costanza, Rome

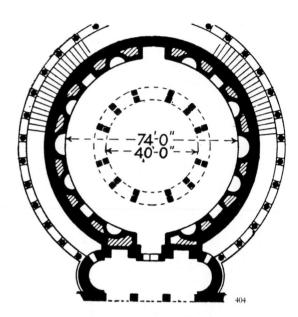

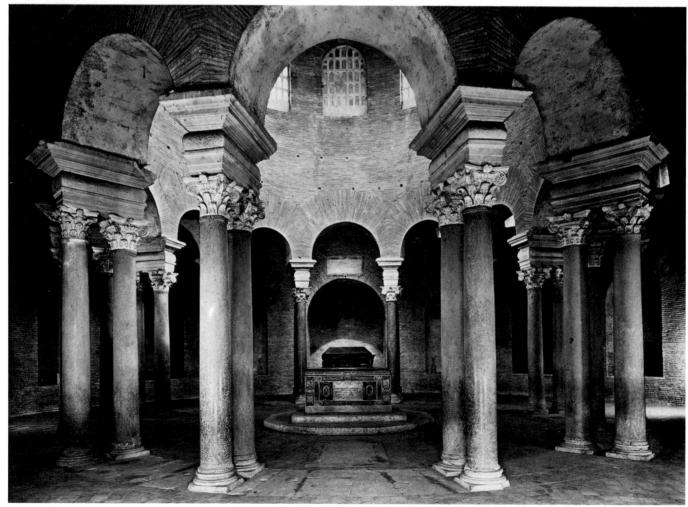

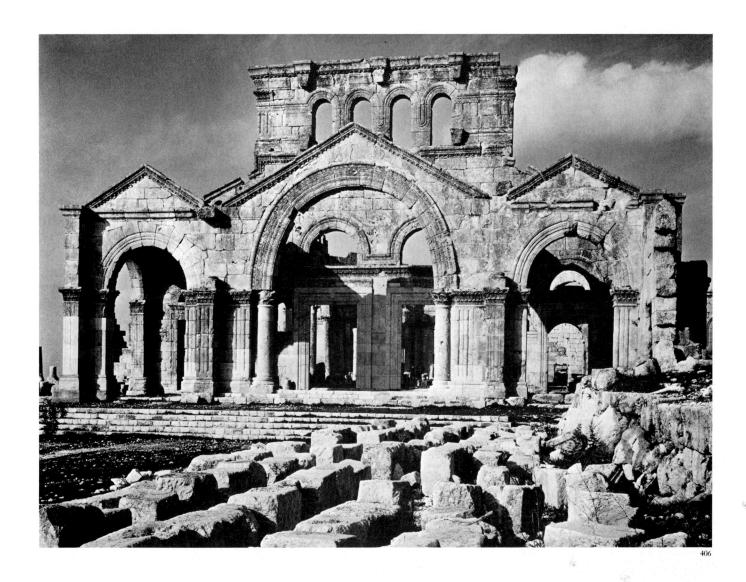

406. St. Simeon Stylites. c. A.D. 470. Qal'at Saman, Syria

Holy Sepulcher in Jerusalem. Perhaps the most spectacular fusion of a central martyrium with the basilican plan was the Church of Saint Simeon Stylites (fig. 406), built about 470 at Qal'at Saman in Syria. This consists of four distinct basilicas, three with splendid entrances and the fourth with three apses, radiating outward from a central octagon, which enshrined under an octagonal timber roof the pillar on the top of which Saint Simeon spent the last three and a half decades of his life. Syrian architecture is far richer in carved elements than its Early Christian counterparts in the West. Its buildings were constructed in the old Hellenic tradition of large, rectangular blocks of stone. The corners of the octagon are supported by piers, flanked by sixteen freestanding, monolithic, and rather stumpy columns of granite, with acanthus capitals derived from Corinthian models; the richly molded entablature sweeps up to form arches, which lead into the four basilicas and into four small chapels fitted into the reentrant angles. The general appearance of Syrian churches is squat and massive as compared with the lofty, brick-walled basilicas of the West; the treatment of moldings and other architectural members is extremely free and imaginative.

MOSAICS The new churches completely renounced the screen architecture so dear to the Romans and had little use for monumental sculpture. A series of lifesize silver statues of Christ and the Apostles, long since disappeared, once stood below a colonnade across the apse of San Giovanni in Laterano, but they were an exception. These churches possessed no pediments or acroteria for statues, no metopes for relief, and when friezes existed, they contained no sculpture. This art, so crucial to the Greeks and Romans, was continued in Early Christian times on a grand scale only in the imperial portraits, arches, and columns erected by the emperors in Constantinople. The Christians, on the other hand, relegated sculpture almost entirely to the more modest position of sarcophagi and ivory carvings (see below, pages 307–8). The wall surfaces of Early Christian churches may have been deliberately kept flat so that they might be adorned in brilliant colors with complete narrative illustrations of the new religion for the instruction of the faithful.

Where these wall decorations consisted of frescoes, as, for example, the narrative cycles in the nave of Saint Peter's, they have perished, with few exceptions. Luckily for posterity, however, Early Christian artists had another and more durable alternative, the medium of mosaic, which Hellenistic and Roman artists had habitually used where wear or water required it, that is, for floors and for fountains and pools.

The Romans had generally employed colored stones for their mosaics, which certainly made for a resistant floor covering but presented severe limitations in the range of available colors. Both Hellenistic and Roman floor mosaics (see figs. 266, 291, 393) often restrict the background to a single color plane so as to preserve the integrity of a surface intended primarily for walking. Early Christian artists, however, seem to have pre-

407. Apse mosaic, St. Peter's, Rome (fresco copy)

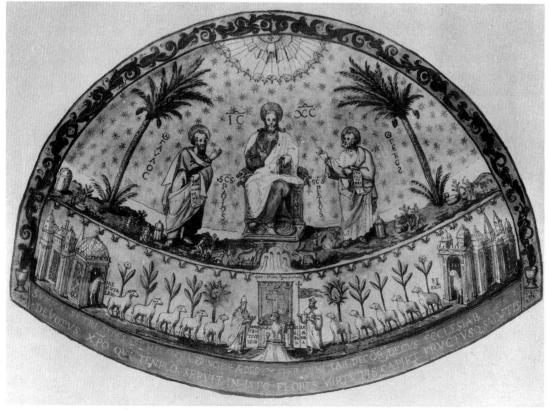

407

ferred an abstract background, at first a radiant sky-blue and later gold, for its transcendental effect in many large-scale wall mosaics. When landscape or architectural elements are required, they are either reduced to vague suggestions or else sharply schematized. Yet the techniques of pictorial representation inherited from Roman art are not forgotten, but float like severed but still green branches on a tide of essentially nonintellectual religious experience.

The earliest large-scale Christian mosaic was probably the one that filled the semidome of the apse of Saint Peter's in Rome, apparently using marble tesserae (cubes) as in pagan Roman work. The original was lost in the destruction of the basilica in the sixteenth century, but its composition is preserved in a fresco copy (fig. 407), which shows it to have been the ancestor of many other apsidal mosaics. Christ is enthroned in the center, blessing with his right hand and holding the Gospel book with his left. He is shown with long hair and beard, as usual in East Christian art, and since one set of inscriptions is in Greek, the artist may well have come from Constantinople. The scalloped semicircle above Christ symbolizes the tabernacle, or tent, of Heaven, and on either side grow palm trees, signifying the Christian victory. Below the throne flow the four rivers of Paradise, from which stags, symbols of the human soul, are drinking (Psalm 42 in the King James Version, 41 in the Douay Version). On either side of the lower register appear two cities, labeled Jerusalem and Bethlehem, from which twelve sheep, meaning the twelve Apostles, proceed toward a central throne on which rests the Lamb of God. The two cities were reworked in the thirteenth century under Pope Innocent III, who added figures of himself and of the Roman Church, and a set of inscriptions in Latin. A single, noble fragment of the original survives (fig. 408) and corresponds closely, even to details of the drapery folds, to the figure of Saint Paul in the fresco. The roughly matched gold-glass tesserae of the background must have been substituted in the thirteenth century for the original, doubtless a resounding deep blue as in other Early Christian mosaic backgrounds in Rome. But the figure, of exactly fitted marble tesserae like those of Roman floor mosaics, helps us to reconstruct in our imaginations the lost original mosaic, which must have been a magnificent work, and forms a precious witness to its remarkably Classical style and appearance. Saint Paul's bald forehead and straight Greek nose are beautifully modeled in tone, and his hair, beard, and drapery are executed in patches of clear, bright color that preserve in the fourth century all the radiance of Pompeiian illusionism.

Later on, the early Christians used glass tesserae, which instantly opened up a whole new world of glowing colors. Moreover, they exploited gold lavishly, not only for the representation of golden objects but also for that of light and even of illuminated surfaces, and with splendid effect. Entire backgrounds came to be made of gold, on a grand scale, particularly in the Eastern Empire, and the practice was perpetuated for the next millennium and longer in the gold-leaf backgrounds characteristic of Byzantine icons and early Italian painting. The glass tesserae were pressed into soft plaster, laid a section at a time over minutely planned preparatory drawings on the wall surfaces. The tesserae were never exactly leveled off, so that each one presented a slightly varied surface to the light; thus, observers, as they move, behold a constantly changing sparkle across the surface. The technique of gold glass—gold leaf applied behind clear glass cubes—was not exact, so that the gold mosaic backgrounds have a shimmering appearance rather than the hard uniformity of more precise modern imitations.

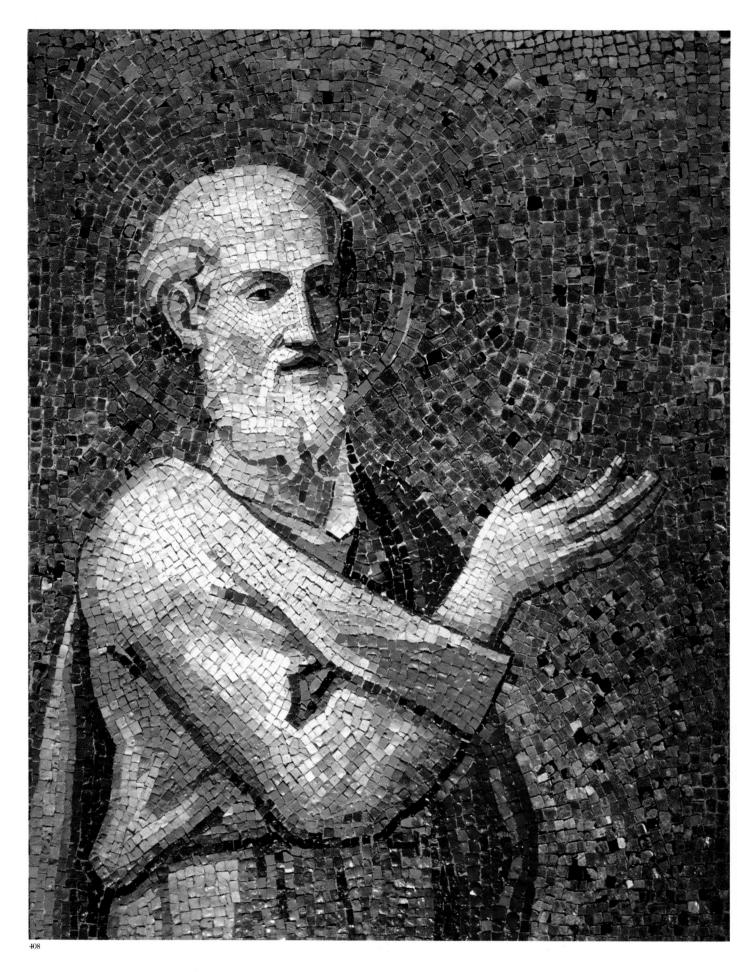

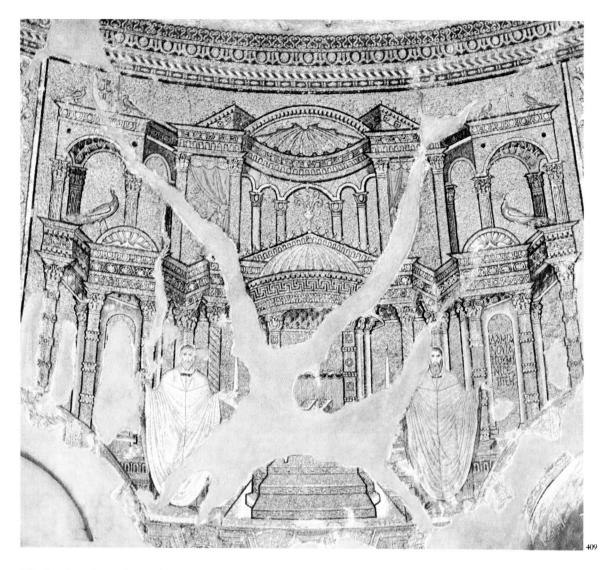

Hagios Georgios. One of the earliest preserved series of Early Christian mosaics (fig. 409 shows one section) ornaments the dome of Hagios Georgios (originally a mausoleum, later transformed into a palace chapel) in Salonika in northeastern Greece. In direct imitation of the towering, fantastic architecture of late Roman stages and other ornamental façades (see fig. 347), a visionary architecture, whose two stories are composed of richly interlocking columns, arches, broken pediments, niches, and coffered groin vaults, rises before us in illusionistic space. The architecture, like the background, is entirely of gold glass, but brown tesserae are used to indicate shadows; these shadows have been so subtly deployed as to convey an illusion of light reflected from below into the coffered groin vaults at either side. Shades of brilliant blue were used for curtains and to pick out such details as arches, shell niches, and the crosses at either side, the latter each accompanied by three blue-green peacocks, symbols of eternal life. Some columns are spirally fluted, others embraced here and there by collars studded with jewels. Under the dome of the tiny central tholos can just be seen an altar bearing a book with a jeweled cover. Before the structure stand Saints Cosmas and Damian, the two physicians, in orant poses, dressed in white chasubles whose soft shadows repeat the palest blue of the architecture.

Santa Maria Maggiore. A series of mosaics radiating imperial grandeur survives in the Roman Basilica of Santa Maria Maggiore, dating from

- 408. Saint Paul, from the apse mosaic, St. Peter's,
- 409. Dome mosaic, with Saint Cosmas and Saint Damian. c. A.D. 400. Hagios Georgios, Salonika, Greece

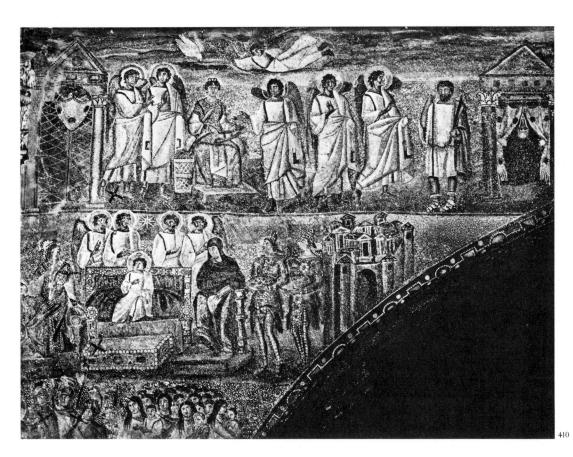

410. Annunciation and Adoration of the Magi. Mosaics, Sta. Maria Maggiore, Rome. c. A.D.

432 - 40

about 432–40. Instead of the architectural framework, which in Roman wall painting tied the images to the structure of the room, the triumphal arch is sheathed in mosaic. As so many Early Christian and Early Byzantine interiors show, this practice has the effect of seeming to dissolve the underlying architecture so that it is superseded by a new world of pictorial imagination. The entire left side of the arch is occupied by the first subjects drawn from Gospel narrative to be used in art, the Annunciation and the Adoration of the Magi (fig. 410). According to Christian doctrine, the Annunciation—the announcement to the Virgin Mary that she is to become the Mother of Christ—is the moment of the conception of his human body, brought about by the Divine Word (the Logos, or Second Person of the Trinity), conveyed by the Archangel Gabriel. Mary is seated upon a throne, robed and crowned exactly as an Augusta (empress) of the fifth century, in all the splendor due her since the Council of Ephesus in 431 had officially proclaimed her the *Theotokos* (Mother of God). She is regally attended by four white-robed angels, not mentioned in the biblical text (Luke 1:26-36). She listens with one hand lifted in surprise, while Gabriel flies above her like a Roman Victory, and the white dove, which in Christian art symbolizes the Holy Spirit, descends upon her according to Gabriel's words: "The Holy Ghost shall come upon thee, and the power of the Highest shall overshadow thee." What we witness, therefore, is the moment of the Incarnation, one of the most sacred in Christian belief. At the left appears a closed gate, symbol of Mary's virginity; at the right, by a little aedicula whose hanging lamp indicates night, a majestic angel announces the momentous tidings to Joseph (Matt. 1:20). The background behind both scenes is a wide plain whose horizon fades off into the sky and strips of cloud.

In the lower register the Christ Child, later usually shown on Mary's lap since he was, at the time of the Three Magi's visit, only twelve days

old, appears as a boy of six or seven years seated on an imperial throne and attended by four angels, while the star of Bethlehem shines over his head. Mary is barely visible, standing to Christ's right; the woman to his left may be a personification of Holy Wisdom. Christ and the angels, but oddly enough not Mary in either scene, are endowed with the golden halos used henceforward in Christian art to distinguish sacred figures. Two of the Three Kings from the East stand on one side of Christ; dressed in that fantastic Oriental garment, trousers, they present their gifts. Bethlehem is represented in the manner of one of the cities on the Column of Trajan as a little nugget of walls, temples, and roofs.

Twenty-seven smaller mosaics, immediately under the clerestory windows of the nave, tell stories from the Old Testament. Fig. 412 shows two superimposed scenes from the Book of Joshua. Above, Joshua commands the priests to bear the Ark of the Covenant across the Jordan River, which is shown piling itself "upon a heap" as the text states; the twelve men commanded by Joshua to bear stones from the Jordan to their lodging place have been reduced to four for the purposes of the scene. Below, Joshua sends out two spies to Jericho, this town also represented like those on the Column of Trajan. In both scenes Joshua is dressed as a Roman general, and the parallels with the Column of Trajan in poses, attitudes, and groupings are compelling. Distant space is suggested by hills of several colors, and the sky is striped with gold clouds against the blue-and-white tesserae. The construction of the almost cylindrical figures suggests the Tetrarchs (see fig. 382), but the use of color to build up these and the masses of the landscape is prophetic of the devices employed by Cézanne in the later nineteenth century rather than of the Impressionists of whom illusionistic Roman paintings reminded us.

The Tomb of Galla Placidia. The finest and best-preserved ensemble of fifth-century mosaics is that which decorates the interior of the tiny mausoleum built at Ravenna, on the Adriatic Coast of northern Italy, by the empress Galla Placidia about 425-26 for members of her family. The administrative capital of the Western Empire had been moved to Ravenna from Milan in 402 by Galla Placidia's half-brother, the emperor Honorius. In the following century the Empire reached its height under the

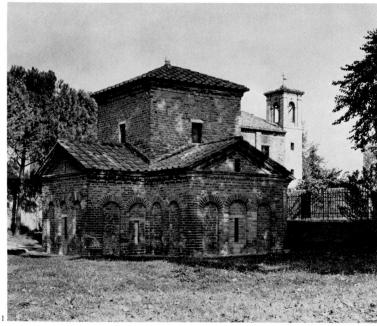

411. Mausoleum of Galla Placidia, Ravenna. c. a.d. 425-26

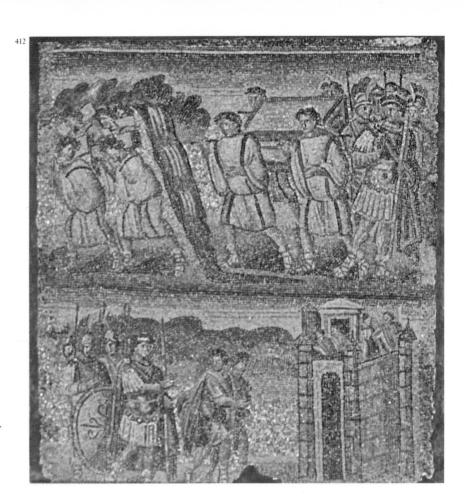

- 412. Scenes from the *Book of Joshua*, mosaic, Sta. Maria Maggiore, Rome. c. a.d. 432–40
- 413. *The Good Shepherd*, mosaic, Mausoleum of Galla Placidia, Ravenna. c. a.d. 425–26

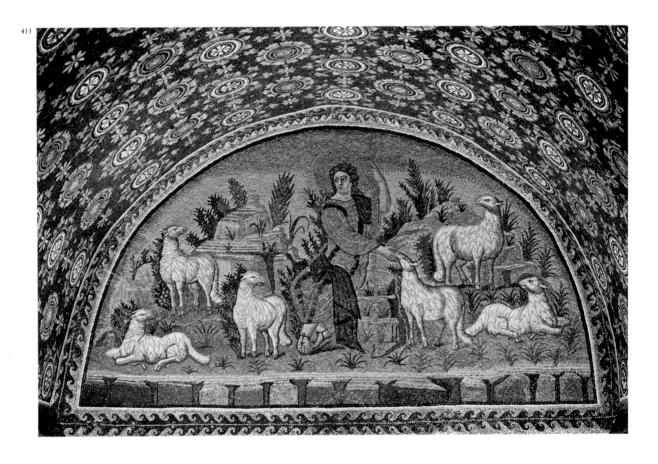

Gothic kings and the Byzantine emperors. The customary simple brick exterior of the mausoleum (fig. 411), ornamented only by a blind arcade and an entablature, gives no hint of the splendors within. The walls are sheathed in smooth slabs of soft gray veined marble. The barrel vaults, the lunettes, and the walls and vault of the central lantern almost disappear under their continuous covering of mosaic. In spite of the alabaster slabs in the windows that now yellow the light, the interior is one of the most beautiful in the history of art, its effect impossible even to suggest in photographs. The dominant color in all the mosaics is a deep sky-blue, which in the barrel vault of the nave is studded with white, blue, and gold floral patterns in medallions that float like magic constellations in some perfect heaven.

The lunette above the portal (fig. 413), framed by a delicate wave pattern in blue and gold, shows the Good Shepherd seated among six of his sheep in a rocky landscape, which derives from those of Roman painting. His graceful pose becomes almost a spiral, as he holds the cross-staff with his left hand and with his right reaches to feed a sheep. Conventionalization of the rocks has begun, but each one contains a gamut of colors, ranging from gold in the lights to violet and gray in the shadows. The gold of Christ's tunic and the violet of his mantle are echoed in the distant rocks, but in softer and paler values. Rocks of about the shape shown here, but always more and more stylized, remained in the standard repertory of landscape settings throughout the millennial history of Byzantine art, after which they were taken over by early-fourteenth-century Italian painters.

THE ILLUMINATED MANUSCRIPT In addition to mural decoration, a second extremely important field for paintings was the "illumination" (illustration) of manuscripts, which were the only form of books made in Europe until the importation of printing from China in the fifteenth century. Egyptian manuscripts had been written on long rolls of papyrus (see above, page 101; see fig. 122), and such rolls, known as rotuli, were adopted from the Egyptians first by the Greeks and then by the Romans. The rotulus was wound between two spindles, and only two or three vertical columns of text were visible at any one moment. Greek and Roman rotuli were illustrated only when necessity demanded, as, for example, diagrams to explain scientific matters; to avoid flaking, these illustrations were usually drawn in line and colored, if at all, with thin washes. The Hebrew Bible was written on rotuli; the scroll form of the Torah, although it is no longer written on papyrus, is a still-surviving example. But the Christians were above all the People of the Book; they needed to be able to refer immediately to any verse in the Bible for authority and to move from one section to another to verify prophetical relationships and Gospel correspondences. They also required books for their increasingly formalized, complex, and uniform Liturgy.

An individual rotulus could only be wound to about thirty feet in length before becoming unmanageable; thus, each Greek or Roman literary work had to be divided into a number of rotuli, or "books"; the Bible required scores of them. Even in antiquity the difficulty of using rotuli for ready reference gave rise to the copying of key passages on thin wooden tablets, hinged together at the back. These were the ancestors of the familiar *codex* (paged volume), which became a practical reality only when parchment came into general use. This material, whose name is a corruption of Pergamon, where it was invented in the second century

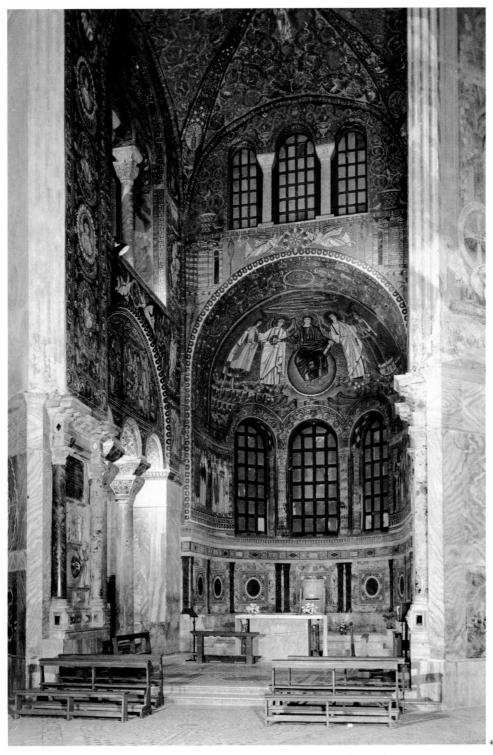

the outer walls are truly octagonal. The central space is enveloped on the ground story by an ambulatory and on the second by a gallery. At the eight inner corners of the ambulatory stand large piers, sustaining eight great arches, which embrace the smaller arcades of ambulatory and gallery. Instead of being flat, as we would expect, these arcades are concave with respect to the central space, expanding from it to form, as it were, seven transparent apses; the eighth is replaced by the chancel with its central altar. Even the crowning lantern is not octagonal; its corners are rounded off by tiny arches, called squinches, between the windows, which cut the drum in the interior into sixteen sides. The squinches are difficult to make out through the later decoration.

422. Chancel, S. Vitale, Ravenna

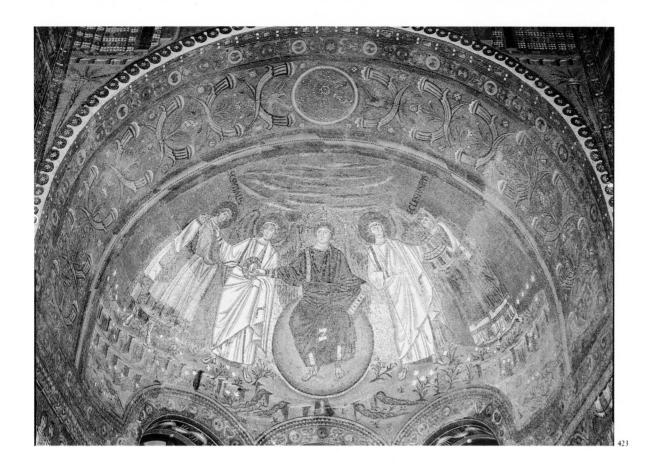

423. Christ Enthroned Between Angels and Saints, mosaic, S. Vitale, Ravenna. c. A.D. 525-47

Entering the church through the narthex, whose odd angle deflects the presbytery and apse from the east-west axis and is as yet unexplained, the worshiper proceeds through the ambulatory and then into the central octagon, with its expanding spaces, filled with light from the eight arched windows of the lantern. The impression of dazzling spatial complexity is enhanced by the colorism of the interior. The columns are of veined marble, and richly colored marble sheathes each pier up to the springing point of the smaller arches. The very capitals have been transformed (fig. 421); no longer is there the slightest reference to any of the Classical orders with their elegant articulation of parts. These capitals resemble baskets, and their smooth sides mask a subtle transition of shape from a square at the top to a circle at the bottom; instead of acanthus leaves, sculptured in depth, they are covered with a continuous interlace of vinescrolls drawn on the surface, incised, and then painted to make them appear even more intricate. All the marble work was imported from the East, where Theodoric, who died in 526, had spent ten years as a hostage.

The entire chancel—apse, side walls, lunettes, jambs, arches, and crowning groin vault—is clothed with a continuous garment of mosaics in gold and other bright colors (fig. 422). Most of the subjects were drawn from the Old Testament, and chosen so as to prefigure the Eucharistic sacrifice. For example, as one looks across the chancel before the altar, one sees in the lunette of the arch, below two soaring angels carrying the Cross in a golden medallion, two scenes from the story of Abraham. On the left Abraham brings to the three angels—whose appearance to him was considered by theologians a revelation of the Trinity (see fig. 607) a meal believed symbolic of the Eucharist. On the right he prepares to sacrifice his son Isaac, an event believed to foreshadow the sacrifice of Christ. Christ appears in the semidome of the apse (fig. 423) as a youthful, short-haired, and beardless figure, robed as usual in West Christian art in imperial purple and gold, and enthroned upon the orb of the heavens. From the rocky ledges below him gush the four rivers of Paradise. On either side stands a white-robed angel; one presents Saint Vitalis, to whom the church is dedicated and who holds forth hands veiled by his gold-embroidered cloak to receive from Christ a jeweled crown; the other angel introduces Bishop Ecclesius, who commenced the construction of the church, of which he holds a charming if inaccurate model. Rocks, flowers, rivers, even the figures are strongly conventionalized: no hint of bodily structure underlies the thick, tubular folds of their drapery; their feet seem hardly to rest upon the ground. In ostensible conversation with each other, these solemn figures exchange not a glance; they gaze outward, above and past us. But none of the conditions of the real world apply any longer to this symbolic and timeless realm. Christ does not really sit upon his orb, but floats in front of it; nor does the orb rest upon the ground, but is divided from it by a strip of gold. Most of the work was completed before the Byzantine conquest in 540.

On the side walls of the chancel are two imperial mosaics. To the left of the altar is the emperor Justinian, flanked by high officials, soldiers, and priests (fig. 424), and, to the right, the empress Theodora (fig. 425), even more richly crowned than her husband, among the ladies of her court. Both figures, robed in imperial purple, stare calmly at the observer; without looking up Justinian presents a golden bowl, and Theodora a golden chalice, to Christ in the semidome above. Attempts have been made and disputed to connect these scenes with moments in the Liturgy, especially the processional offering of bread and wine at the altar. But Theodora never took part in such processions in Constantinople, going straight from the palace to the gallery reserved for women, and although she appears here before a shell-niche flanked by two different kinds of curtains and next to a small fountain, Justinian and his attendants stand on plain green, against a gold background. Clearly one symbolizes the palace, the other the outer world. Moreover, both bowl and chalice are conspicuously empty. And finally, neither Justinian nor Theodora ever saw Ravenna.

More likely the two mosaics, in keeping with the rest of the cycle, are symbolic. Emperor and empress, confirming their power, status, and new patronage of the church started by Theodoric, present rich liturgical gifts to Christ, just as the Three Magi are doing on the border of the empress's pallium (interestingly, only two are visible, both holding bowls resembling that of Justinian). If anything, these figures are more completely rigid and immobile than those of the apse mosaics, oddly enough since the faces are strongly characterized portraits, doubtless copied from models sent from Constantinople. Both Justinian and Theodora wear golden halos with red borders, like that of Saint Vitalis, startling enough considering Theodora's early life as an entertainer of easy virtue. (As empress, it should be mentioned, she carried on a determined campaign to stamp out prostitution as a degradation of women.) The emperor appears as Vicar of Christ on earth, the empress as his divinely ordained helpmeet. Haunted as Justinian was by his dreams of revived Roman glory, his anxiety-ridden countenance is quite as believable as the steady gaze of his astonishing wife. We might also recall that it was Theodora's courage fifteen years earlier that saved the day (see page 317) when Justinian was about to flee for his life before his enemies. "Purple," Theodora announced to the vacillating emperor and his generals, "makes a fine shroud." Sadly enough it did, the year after the probable date of this mosaic.

- 424. Emperor Justinian and Attendants, mosaic, S. Vitale, Ravenna. c. A.D. 547
- 425. Empress Theodora and Attendants, mosaic, S. Vitale, Ravenna. c. A.D. 547

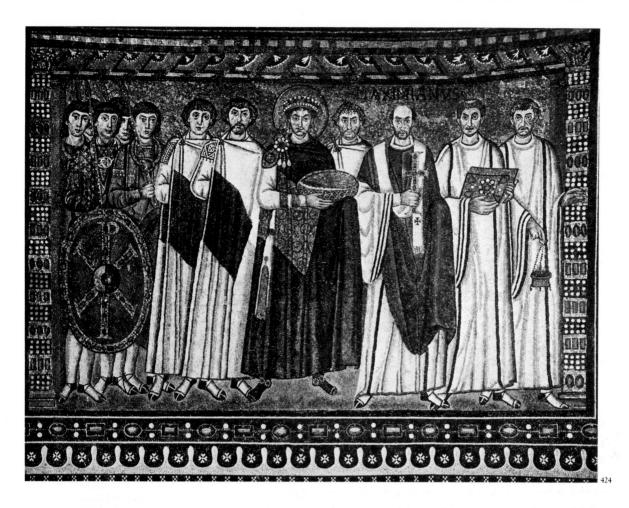

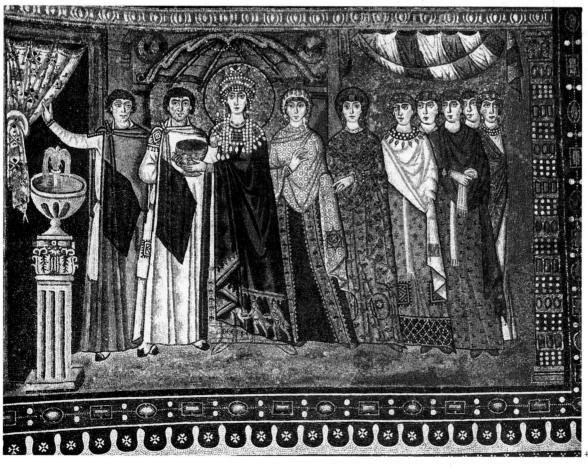

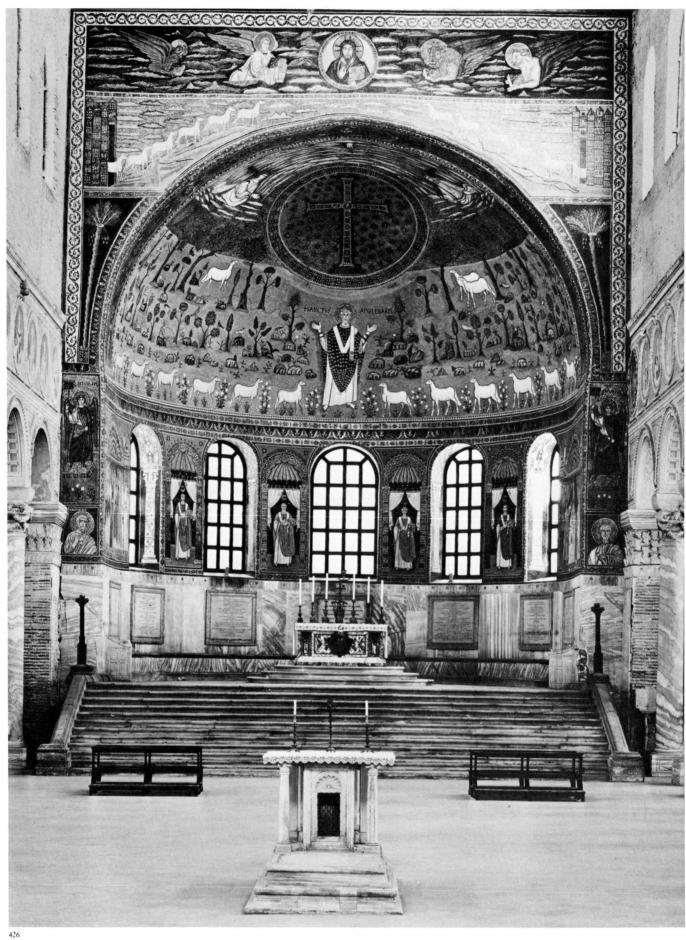

Theodora died of cancer in 548, leaving Justinian desolate and, for a while, completely unnerved. In the midst of all this splendor, other portraits must be accurate as well, especially that of Bishop Maximianus, during whose episcopate the church was consecrated, which depicts even the gray stubble on his cheeks and chin. What we witness in these mosaics is the transformation of a highly developed, naturalistic art into a transcendental and symbolic one, which still retains traces of the old Helleno-Roman illusionism in the treatment of light and surface.

A wholly symbolic representation, executed in mosaic between 533 and 549, fills the apse of Saint'Apollinare in Classe (fig. 426), located at the site of the old Roman port of Classis, a few miles outside Ravenna. As in the Basilica at Trier (see fig. 391), the exterior walls are of unadorned brick. Curtains part in the little aediculae between the windows to reveal deceased bishops of Ravenna in orant postures (several are buried in the church). The half dome is partly filled with a green pasture, at the bottom of which twelve sheep, symbolizing the Twelve Apostles, march in single file on either side of the orant Saint Apollinaris. Above him, against the gold background, a circle of jewels encloses a disk of blue sown with gold stars, on which floats a golden cross studded with gems, as if appearing to the saint in a vision. On either side of the disk Moses and Elijah, depicted to the waist only, are surrounded by clouds to show that they, too, are visionary apparitions, while below them among the trees three lambs look upward. These figures in the upper part of the apse symbolize the Transfiguration and portray that moment when Christ, who had climbed to a mountaintop with Peter, James, and John, was suddenly transfigured in raiment "white and glistening" (Luke 9:29) and Moses and Elijah were miraculously revealed in conversation with him. Christianity, no longer a new religion, has created its own language of symbols in which it can address the faithful with complete confidence that it will be understood. The mosaics of the triumphal arch, which show sheep emerging from Bethlehem on one side and from Jerusalem on the other before Christ flanked by the symbols of the Four Evangelists, were added in the seventh or eighth century.

CONSTANTINOPLE After a catastrophic revolt in 532, in which half the city was destroyed and Justinian nearly lost both his crown and his life, the emperor embarked on an ambitious program of rebuilding the churches of his devastated capital, including the Constantinian Basilica of Hagia Sophia (Holy Wisdom), which had burned to the ground. He dreamed of an entirely new kind of church bearing slight relation to the accepted basilican form. Instead of entrusting his bold idea to an experienced architect, he called in two noted mathematicians, Anthemius of Tralles and Isidorus of Miletus. They carried out the emperor's bidding faithfully; despite its many later vicissitudes, Hagia Sophia is an utterly original and successful structure, which makes surprising departures from the Roman tradition of building and—save for the imitations built by the Turks a thousand years later—remains unique.

Its plan (fig. 428) combines the longitudinal axis typical of a basilica with a centralized arrangement of elements. At the corners of an area one hundred Byzantine feet square (a perfect proportion of perfect numbers) rise four piers, each seventy feet high, upholding four great arches (fig. 427). The arches are connected by pendentives, which may best be described as triangles with concave sides drawn upon the inner surface of a sphere. The upper edges of the pendentives join to form a continuous

^{426.} Apse mosaic, Sant'Apollinare in Classe, Ravenna. c. A.D. 533–49

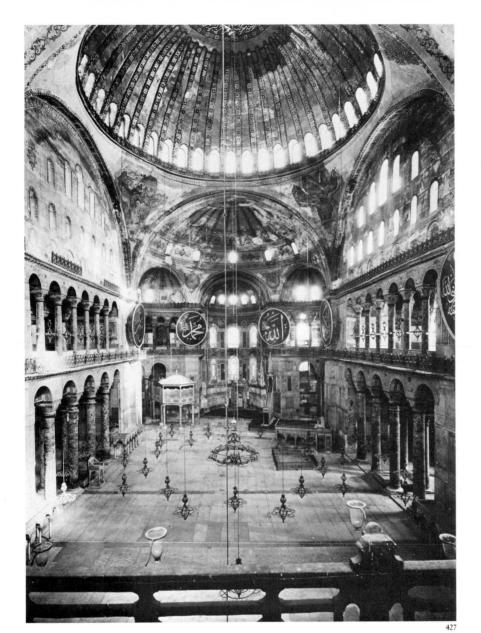

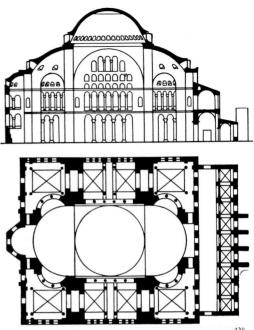

427. Anthemius of Tralles and Isidorus of Miletus. Interior, Hagia Sophia, Istanbul (Islamic medallions are later)

428. Section and plan of Hagia Sophia, Istanbul. c. a.d. 532–37 (Section after Gurlitt; plan after V. Sybel)

circle on which a dome may be erected. Not only do pendentives provide a more graceful transition from a square or polygonal base to a round dome than is possible with the use of squinches, but they also permit the covering of a far greater area of floor space than is allowed by a circular base. The origin of pendentives remains unknown, but they were used for the first time on a large scale in Hagia Sophia. Henceforward, they were employed exclusively to support large domes in Byzantine architecture, and later in the Renaissance, the Baroque period, and modern times. The pendentive was undoubtedly the greatest Byzantine contribution to the technique of building. The dome of Hagia Sophia is somewhat less than a hemisphere, and is composed of forty ribs meeting at the center. The web of masonry connecting the ribs is slightly concave, so that the shape has been compared to that of a scallop shell. On the east and west sides the central square is prolonged by half circles, culminating in semidomes, each of which embraces three smaller semidomes, crowning three apses. Such a structure would probably have been impossible to build employing the concrete construction techniques of the Romans. Anthemius and Isidorus achieved their domes and semidomes by means of ma-

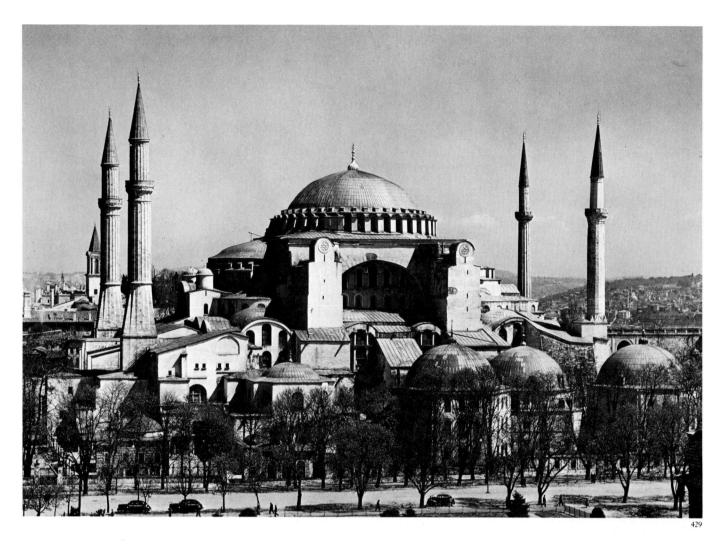

sonry constructed of bricks set edge-to-edge and only one brick deep forming a mere shell.

The building is entered from a groin-vaulted narthex, twice the length of the central square, through a portal directly opposite the eastern apse, which sheltered the altar. The arcaded side aisles and the arcaded galleries above them are roofed by groin vaults. The cornice of the galleries marks the springing point of the pendentives and of the four arches.

Great efforts were made to support the dome. To absorb the thrust of its immense weight, and to keep it from pushing the corner arches out, huge buttresses (masses of solid masonry) were erected, clearly visible on the exterior (fig. 429). Beautiful as they are, the four minarets, built when the church was transformed into a mosque by the Turks after the capture of Constantinople in 1453, change considerably the appearance of the building. The reader should cover them up in the photograph in order to gain an idea of how this enormous pile of semidomes and buttresses culminating in the great central dome, towering 184 feet, originally looked.

The enclosing membrane of masonry is pierced by arched windows and by arcades in careful numerical arrangements—seven arches in the galleries above five in the side aisles, five windows above seven in the lunettes, and forty windows in the dome above five in each semidome. Since the side walls are nearly flush with their enclosing arches, the piers are hardly visible; the whole immense structure with all its shining windows and dark arches, with great domes embracing smaller ones, seems to be floating in light, an impression that must surely have been even stronger when the original decoration of gold mosaic, covered over by

429. Anthemius of Tralles and Isidorus of MILETUS. Hagia Sophia, Istanbul (Minarets are later)

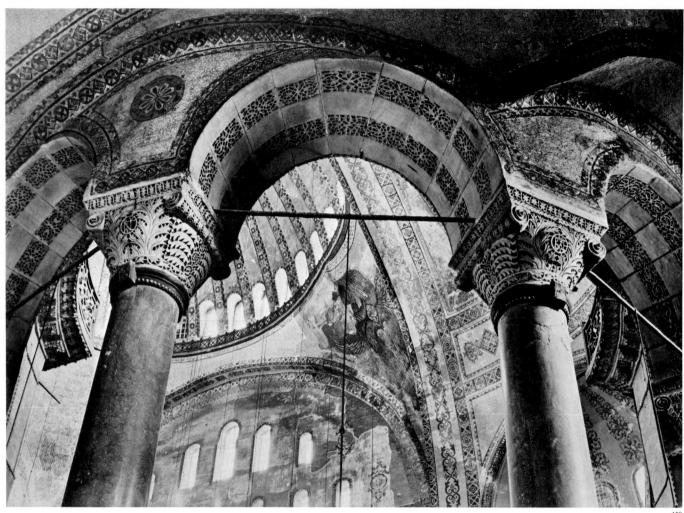

430

the Turks, delicately harmonized with the richly colored marble and porphyry of the columns and piers, and when the windows, originally more numerous than now, retained their colored glass. In fact, the chronicler Procopius wrote that the structure "seems not to rest upon solid masonry, but to cover the space with its golden dome suspended from Heaven."

The meaning of the heavenly light of Hagia Sophia can be understood only in symbolic terms. The Gospel of John (1:4-9) had defined Christ as the "light of men," shining in darkness, and Christ in the same Gospel proclaimed himself to be "the light of the world" (8:12). The Nicene Creed, adopted in 325 and still in use in Orthodox, Catholic, Anglican, and many other churches, declares universal belief in Christ as "God of God, light of light." The building itself was dedicated to Divine Wisdom, which was believed manifest in the Virgin Mary, Mother of God, in the words of the Book of Wisdom (7:26–29, omitted from Protestant Bibles): "For she is the brightness of eternal light . . . for she is more beautiful than the sun, and above all the order of the stars. Being compared with light she is found before it." In the apse over the altar the colossal shining mosaic image of the Theotokos reminded worshipers of this mystical identification, eternal light made visible. Nor did the emperors as Vicars of Christ renounce their share of supernal splendor; one went so far as to unite pagan and Christian light by setting up a Greek nude bronze statue of the sun god Apollo in the principal square of Constantinople, substi-

430. Hagia Sophia, Istanbul (view from the galleries)

tuting his own portrait for the original head, surrounded with a sunburst whose rays formed nails like those of Christ on the Cross.

The glorious impression of harmoniously blended space and light we receive in the interior today should be supplemented in imagination by visualizing the majestic processions of the Byzantine emperor and his court to the imperial enclosure at the right of the sanctuary in the south side aisle, the gleaming vestments of the patriarch and the clergy, and the incense and chanting that accompanied many of the rites. The congregation, restricted to the aisles, could witness only a small portion of the Liturgy, which took place, as it does to this day in Orthodox churches, behind an enclosure. The clergy emerge only at specified times, for example, for the reading of the Epistle and the Gospel and for the rite of Communion. Women and catechumens, confined to the galleries, could obtain only a fragmentary view of the vast interior (fig. 430), but it was a wonderful one, with the forms of the arches—curved in plan—playing against the half-seen, half-imagined spaces of the colorful nave. They could also delight in a closeup view of the new and special beauty of the Byzantine capitals—far more delicately designed and carved than those of Ravenna—out of whose undulating ornamented surfaces remnants of Classical shapes protrude like half-sunken ships.

The colossal structure, by far the largest of the several major centralplan churches with which Justinian embellished his rebuilt capital, was finished in 537, after only five years' work (and a huge expenditure of money and effort). One can hardly blame Justinian for his supposed boast: "Solomon, I have vanquished thee!" However much Anthemius and Isidorus knew about conic sections, they were certainly less familiar with coefficients of safety, since their dome soon started to push its pendentives out of line and indeed collapsed in 558. The original dome was certainly lower than its replacement, completed in 563, and it perhaps continued the shape of the pendentives, forming a giant sail. The present dome has also had its mishaps, but it has been repaired, and Justinian's church has taken its place as one of the most imaginative architectural visions in the entire history of mankind.

SINAI The other-worldly light symbolism of Justinianic art comes to its climax, appropriately enough, in a mosaic on Mount Sinai, where Moses saw the Lord in the light of the Burning Bush. This sole surviving mosaic composition commissioned by Justinian outside of Ravenna has come to general attention only very recently because of the almost inaccessible position of the church in which it is located. The fortified Monastery of Saint Catherine lies more than five thousand feet above sea level on the desert slopes of the sacred mountain. This mosaic, done after 548 and probably before 565, and recently cleaned, restored, and photographed, fills the apse of the monastery church with a representation of the Transfiguration (see page 317), a New Testament equivalent of the luminary revelation to Moses, stated in terms of unearthly abstraction and heavenly radiance (fig. 431). The Transfiguration (known as the Metamorphosis, or Transformation, in Greek) is depicted as at once sudden and eternal. The real world has shrunk to a mere strip of green at the bottom, as in the Justinian mosaic at San Vitale; all the rest of the surrounding space is gold. Blessing with his right hand, and staring over and beyond us, Christ stands at the center in an almond-shaped glory, an early appearance of the mandorla (the Italian word for "almond") that surrounds him in countless representations in the later Middle Ages. Seven

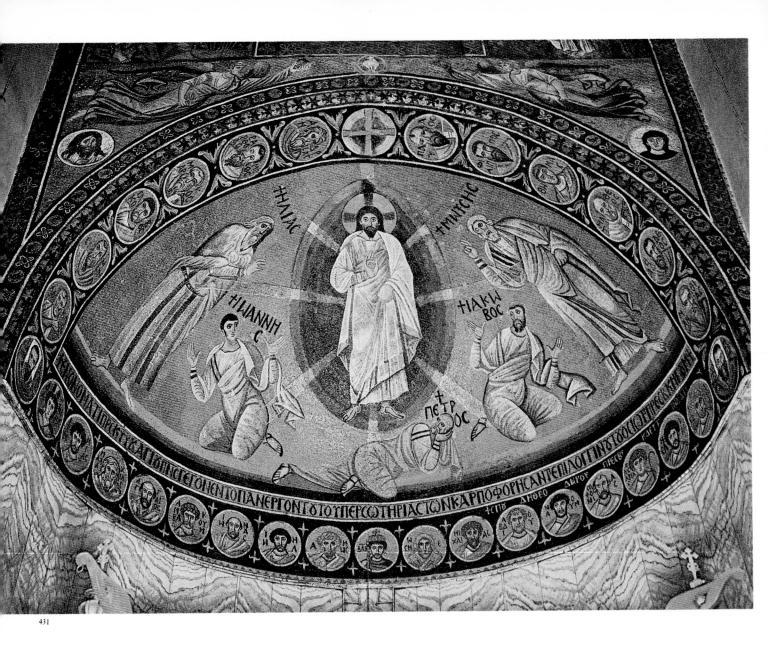

rays of light stream from his raiment. The Apostles appear locked in the kneeling or prone positions into which the force of the miracle has thrown them, yet turn to look backward at the wondrous light with open eyes. The mandorla seems to weigh upon the back of the kneeling Peter. James and John float against the gold, while Moses and Elijah, who in the biblical text are apparitions, stand with their toes touching the green.

Faces, bodies, and drapery are reduced to hard, clear, almost geometric shapes, sometimes defined by heavy contours, showing a sharp change in style during the later years of Justinian's long reign. But if the great artist who designed the mosaic treated earthly forms as unreal, he rendered with minute precision the effects of the heavenly light, which reveals Christ's divinity to the Apostles and to Moses and Elijah. Against the four shades of sky-blue into which the mandorla is gradated, Christ's glistening raiment stands forth in a pearly hue over which play magical tones of velvety white. As they cross the zones of the blue mandorla, the seven rays turn a shade lighter in each zone; they become stripes of white and cream as they traverse the gold; the rich mauves, tans, lavenders, and grays of the garments of the Apostles and Prophets are bleached out as

- 431. Transfiguration, mosaic, Monastery of St. Catherine, Mount Sinai, Egypt. c. A.D. 549 - 64
- 432. The Virgin and Child Enthroned Between Saint Theodore and Saint George. c. 6th century A.D. Panel painting, 27 × 187/8". Monastery of St. Catherine, Mount Sinai

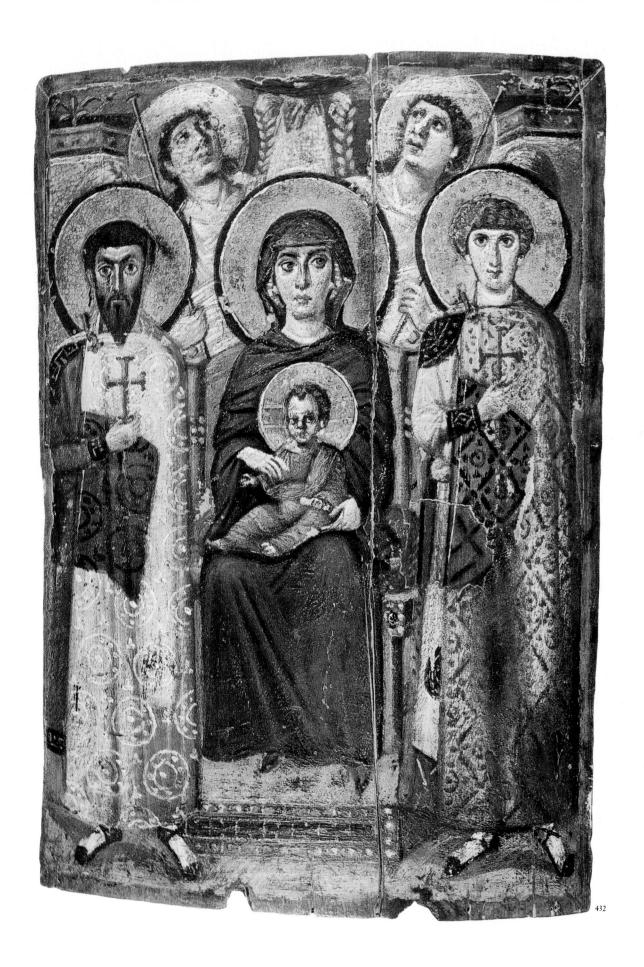

the rays pass over them. No more compelling vision of the actual effects and spiritual meaning of light survives from the early Middle Ages.

A similar contrast between abstraction in the statement of form and naturalism in the rendition of light appears in a picture in encaustic, which is at once one of the oldest-known Christian panel paintings and one of the earliest surviving examples of that favorite among all themes in the late Middle Ages and in the Renaissance, the Virgin and Child (fig. 432). This icon (image), also in the Monastery of Saint Catherine at Sinai, probably dates from the sixth century. Throughout human history, as we have seen, many peoples have tended to consider images to be in some way magical (the tomb statues of the Egyptians, the images of deities of the Greeks, the emperor portraits of the Romans) and to venerate them, usually on account of the subject. However, in Christian art icons began rapidly to be endowed with miraculous powers in themselves; innumerable stories have been told throughout Christian history of the wonders performed by sacred images, and many are firmly believed to this day. As early as the sixth century, chroniclers reported accounts of suppliants kneeling before images, and the icon preserved at Saint Catherine's may well have been intended to inspire such reverence. The Virgin and Child are shown royally enthroned between the warrior saints Theodore (bearded) and George, dressed as officers of the imperial guard. Behind the throne two angels look up to an arc of blue, representing the heavens, in which appears the Hand of God (the typical method of showing God the Father in Early Christian art), from which a band of white light descends toward the figures on the throne. The Virgin appears in an almost exactly frontal pose, and the Christ Child extends his right hand in teaching while his left holds a scroll, very nearly as in the work of the Italian painter Cimabue, who was brought up in the Byzantine tradition, some seven centuries later. The saints stand as rigidly and frontally as the imperial attendants at Ravenna (see figs. 424, 425), and the four gold halos are so aligned that they can be read, together with the Hand of God, as a cross. Even though the principal figures are so locked within this pattern that they can move only their eyes, the play of light is unexpectedly rich and the brushwork free. Variations in flesh tones, the dark circles under Mary's eyes, and the shimmer of the damasks are beautifully represented. Illusionist vision and technique, then, survive in the rendering of the play of light, while the grouping of the figures has been subjected to new laws of symbolic rather than naturalistic arrangement.

Another, and in many ways more impressive, early icon at Mount Sinai (fig. 433) depicts a long-haired, bearded Christ against an architectural background reduced to the mere suggestion of a niche. His right hand is lifted in blessing and his left holds the customary Gospel book, adorned with massive, jeweled gold covers and clasps. Probably sixthcentury, although an eighth-century date has also been proposed, this may be the earliest icon of Christ to come down to us and is certainly the earliest pictorial image of the *Pantocrator* (all-ruler) type known. In later Byzantine art the Pantocrator reappears in colossal size and majesty at the center of domes or semidomes, as once in Hagia Sophia, gazing down at the awestruck worshiper (see figs. 445, 450). The Sinai icon might be a copy of the Christ Chalkites, a famous icon greatly venerated by the populace and improbably believed to have been set over the entrance gate by Constantine himself. Indeed some aspects of the painting suggest knowledge of Classical Greek and Roman practice, especially the clear, sculptural modeling of the eyelids and nose, reminding us of the mosaic fragment from St. Peter's (see fig. 408). Above all, however, the subject,

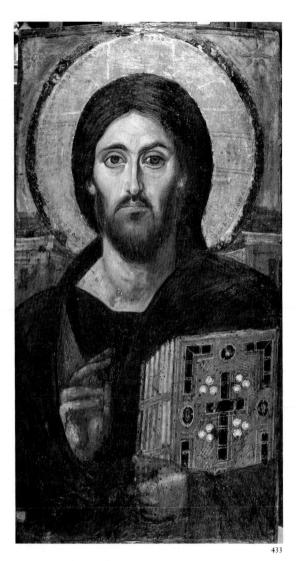

433. Christ icon, Monastery of St. Catherine, Mount Sinai. c. 6th-8th century A.D. Courtesy the Michigan-Princeton-Alexandria Expedition to Mount Sinai

with his pallid countenance, solemn, clear, wide-open eyes, and expression of one who has suffered—"a man of sorrows and acquainted with grief" (Isaiah 53:3)—strikes to the very heart of the observer. Instead of the terrifying images of the later mosaics the Christ Icon conveys an impression of overpowering humanity and compassion. It is certainly one of the deepest expressions of the spirituality of Early Byzantine art.

MANUSCRIPTS AND IVORIES The earliest preserved Christian illuminated manuscripts seem to have been made for the imperial court. In contrast to the utilitarian character of Classical books, this group of codices is written in letters of gold or silver on parchment dyed imperial purple. The finest of them is a sixth-century fragment of the Book of Genesis, now in Vienna (fig. 434); in reality it is a picture book, for the illustrations appear at the bottom of each leaf with just enough text to explain them written above. These little narratives move along at a lively pace on the foreground plane, like scenes on an imperial column (see fig. 353) without any enclosing frame or any divisions between the separate incidents, on a continuous strip of ground. No more background is represented than exactly what the story requires. For example, when Jacob tells Joseph to join his brothers where they feed the flock in Shechem (Gen. 37:13–17), there is no setting except a wayside pillar to indicate the journey and a hillside when Joseph actually finds his brothers and the flock in Dothan. Otherwise, we see only the little figures themselves, shimmering in fresh and lovely colors against the parchment, which becomes by suggestion a kind of purple air. Doubtless by direction, the artist has added an element here and there. These include a touching farewell between Joseph and Benjamin, which is not in the text any more than is the angel shown accompanying Joseph on his journey.

Somewhat less luxurious is a Gospel book whose text was copied by the monk Rabula in a monastery in Syria in 586. The codex contains several full-page illustrations of great dramatic power. One of the earliest representations of the Crucifixion (fig. 435) shows Christ crucified between the two thieves; he wears a long garment—a survival of the Near Eastern tradition that nakedness was shameful (even Ionian kouroi in Archaic times were clothed). We can distinguish a Roman soldier with a sponge filled with vinegar on the end of a reed and another with the lance that pierced Christ's side, the repentant thief turning his head in a beautiful motion toward the dying Saviour, Mary and John at the left, the other Marys at the right, and in the center below the Cross the soldiers playing dice for the seamless robe. Above, over the blue hills, hang the sun and moon, which were darkened at the Crucifixion. Below, in another register, can be seen the empty tomb, with the guards sleeping before it; on the left the angel tells the two Marys that Christ is risen; on the right Christ himself appears in the garden to the Marys, prostrate before him. Even the zigzag chevrons of the border play their part in heightening the excitement of the narrative. The bold sketchy style recalls in some ways the handling of the Miracle of Ascanius in the Vatican Virgil (see fig. 414).

A considerable number of ivory panels survive from Justinian's time, notably diptychs (two panels hinged together), made to be coated with wax on one side for writing and to be carved into representations on the other. These diptychs were customarily given as presents to high officials on their assumption of office. A splendid example (fig. 436) shows on one leaf the Virgin and Child enthroned between two angels, and on the other Christ enthroned between Peter and Paul; in the first the Christ Child

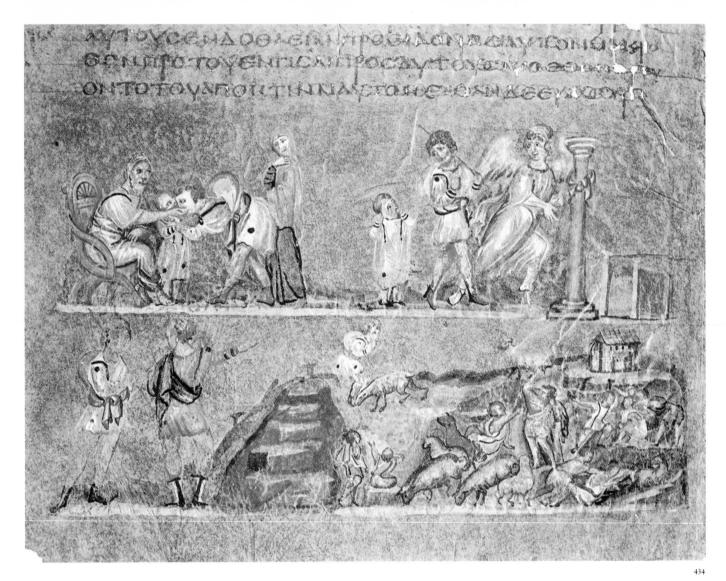

carries a scroll to indicate his Nativity as the fulfillment of Old Testament prophecies, and in the second the adult Christ displays the codex of the New Testament. In the background of both, architectural space survives only as remembered fragments, beautifully carved, yet without any real suggestion of depth. The majestic figures seem to float before their thrones rather than to sit upon them. Mary is a full-featured young matron; the angels who turn their heads with such grace still retain the beauty of the Hellenic tradition. In the strange representation of the adult Christ, shown with an unusually long beard, he seems to have assumed the dignity we associate with God the Father. The drapery folds, as often in Justinianic art, no longer describe the behavior of actual cloth, but begin to develop an intense existence of their own as abstract patterns.

Justinian had overextended himself; the Byzantine forces could not continue to hold all the territory he had reconquered. But in sections of Italy and in Asia Minor the Empire continued (it held sway in the Balkans for nearly nine hundred years longer), a treasure-house of Classical Christian culture and a fortress against the onslaughts of Islam from the east and the Slavs and Bulgars from the north.

434. Joseph and His Brethren, illumination from the Vienna Book of Genesis. Antioch or Constantinople, early 6th century A.D. Österreichische Nationalbibliothek, Vienna

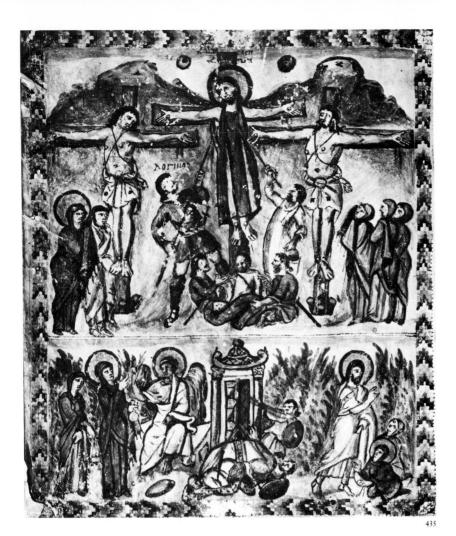

- 435. The Crucifixion and The Women at the Tomb, illumination from the Rabula Gospels. Zagba on the Euphrates, Syria, c. A.D. 586. Biblioteca Laurenziana, Florence
- 436. Christ Enthroned Between Saint Peter and Saint Paul and The Virgin Enthroned Between Angels. Ivory diptych, height c. 12". Middle 6th century A.D. Staatliche Museen, Berlin

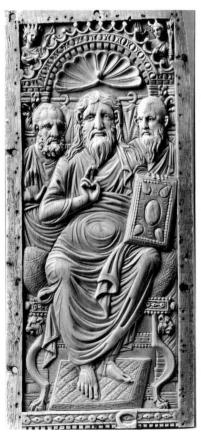

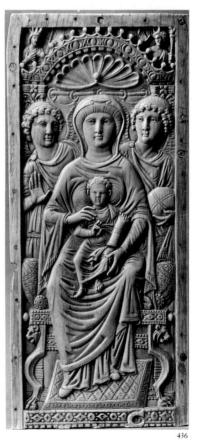

EARLY CHRISTIAN AND BYZANTINE ART 327

In 1944 a stroller in a dense forest of fairly young trees just west of the heavily traveled road connecting Milan with the Lake of Como came upon a small, rudely built, and totally unknown church near the village of Castelseprio; this church contained a series of small-scale frescoes of scenes from the Infancy of Christ, freely painted in an extraordinarily fresh and spontaneous style, reminiscent in some respects of the Hellenistic qualities of Pompeiian painting. In the Appearance of the Angel to Joseph, for example (fig. 437), one of the frescoes in this church, the figures, the draperies, the foliage, the rocks, and even the wayside pillar with its votive scarf must have been set down with great freedom, though on closer examination the schematic patterns in the brushwork betray that the style was not derived from observation of nature but from repeated, learned methods of rendering the effects of light. It is worthwhile noting, in this connection, that as recently as the early nineteenth century a visitor to a Greek monastery on Mount Athos watched a Byzantine master sketch an entire scene, full-scale, on a wall prepared for fresco in one hour without the aid of any drawing or model whatsoever. This combination of inherited compositions and techniques with great manual freedom runs through the entire course of Byzantine painting.

A controversy over the date of the Castelseprio frescoes arose soon after they became generally known at the close of World War II. Although their date remains uncertain, one early in the eighth century now seems probable. Apparently, a Greek painter was traveling through northern Italy, then controlled by the barbarian Lombards, painting wherever he could find work. Isolated though this single incident may seem, it is symptomatic of a Western need that later became endemic; when Western patrons wanted paintings or mosaics of a high quality, they often sent to Constantinople for competent artists brought up in a pictorial tradition that, from Archaic Greek times through the successors of Justinian, had remained virtually unbroken.

It is all the more tragic, therefore, that the Byzantine pictorial tradition, which for centuries constantly recharged the depleted batteries of the West, was itself menaced and for a while almost extinguished by a violent internal controversy that broke out about 726 at the court, led by the emperor himself, who deeply disapproved of the increasing attribution of miraculous powers to icons as a form of idolatry. At the height of the controversy, the possessors of images were tortured, blinded, mutilated, even executed, and representations of all sorts, including the figured mosaics that once adorned the interior of Hagia Sophia, were systematically destroyed. All the great pictorial art of the age of Justinian perished in this campaign, save only that in Byzantine Italy and in such remote fastnesses as Sinai (see figs. 431–33). For more than a century the struggle raged between the *Iconoclasts* (image breakers), who would permit only the Cross and ornament based on animal and plant forms in church decoration, and the *Iconodules* (image venerators), who hid their icons at great personal risk.

Although the triumph of Orthodoxy and the Iconodules was celebrated in 843, it was not until 867 that the patriarch Photios could preach a sermon in Hagia Sophia mourning the loss of the mosaics that had been scraped off the church's walls and rejoicing that the image of the Theotokos could now be restored to its former glory and that the restoration of the images of the saints would soon follow. Photios was doubtless referring to the mosaic of the *Virgin and Child Enthroned* (fig. 438), which still appears in the apse of Hagia Sophia, although today in somewhat damaged condition because of the Turkish whitewash that covered it for

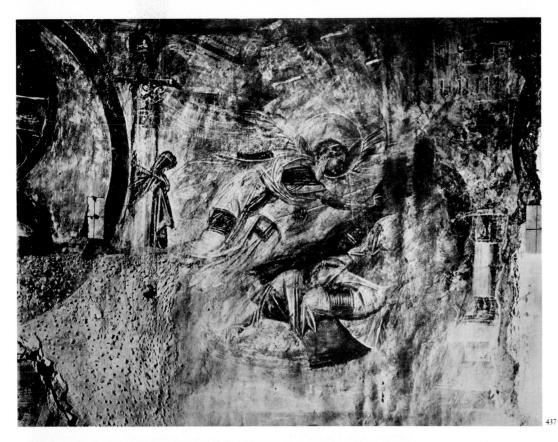

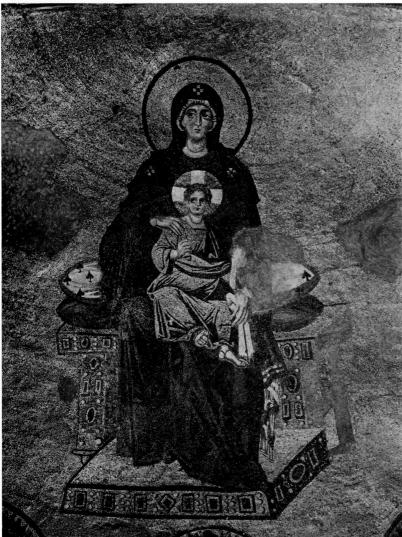

- 437. Appearance of the Angel to Joseph, fresco, Sta. Maria Foris Portas, Castelseprio, Italy. Early 8th century. A.D.
- 438. Virgin and Child Enthroned (detail of the apse mosaic, Hagia Sophia, Istanbul). Before A.D. 867

centuries. The figures are three times lifesize, but the dimensions of Hagia Sophia are so vast that the image seems tiny and is best appreciated through binoculars. It is tempting to see in the grave beauty of the Virgin's oval face and in the depth of her great eyes traces of sadness occasioned by the terrible period her devotees lived through before Photios' sermon. We can certainly discern in the grace of her delicate hands, in the precision with which the drapery folds are shown as they appear along the contour, and above all in the clear definition of the masses of the body and limbs under the shimmering blue garments a new artistic ideal of refinement and definition very different from the light-mysticism of the Sinai mosaic or the entranced solemnity of the Sinai icons. The Virgin is remote, almost lost in the immensity of the golden semidome. Within a few years, however, during the latter quarter of the ninth century, many other mosaics were added to Hagia Sophia, the greatest of which was a Pantocrator in the center of the dome with angels in the pendentives. The entire ninth-century cycle has perished either in structural collapses or at the hands of the Ottoman Turks.

The last six centuries in the life of the Byzantine Empire were only intermittently peaceful. The emperors had to wage almost continuous defensive war against invasions of the Turks, Slavs, Bulgars, Avars, and Russians. Time and again invaders appeared under the very walls of Constantinople, and sieges of the capital, frequently imminent from one direction or another, were often protracted and severe. By one means or another, the Byzantines always repelled the invaders, and from time to time they regained portions of Justinian's former empire. Unexpectedly, their pagan enemies (but not the Muslims) were converted to Christianity; after some oscillation most accepted the Eastern Orthodox form. Quite as dangerous as invaders were internal dissensions, which could break out at any moment in the form of palace revolutions, often engineered by members of the emperor's family or entourage. Nonetheless, the person of the emperor was still regarded as sacred, and palace ritual was controlled by an elaborate scenario. For example, the emperor received ambassadors while seated on the Throne of Solomon, which was flanked by bronze lions and gilded trees bearing gilded birds. As the ambassadors prostrated themselves, the lions put out their tongues and roared, the birds sang (each its own tune), and the throne bearing the emperor rose nearly to the ceiling; when it descended, he was wearing a different costume. The number and riches of the palace halls, adorned with marble columns and gold mosaics, were legendary in the West. The Great Palace must have been laid out in informal groupings of chambers and buildings, somewhat on the order of Hadrian's Villa (see fig. 360). Possibly the Alhambra (see fig. 479) reflects some of the character of the Byzantine imperial palaces, whose chambers were interspersed with courtyards, fountains, and pools. When Constantinople was captured by the Crusaders in 1204, the Great Palace, like the rest of the city, was sacked and left a burned-out ruin. Little of its splendor remains.

THE MACEDONIAN RENAISSANCE The Macedonian dynasty ushered in a period of intense cultural activity, especially under Constantine VII (Porphyrogenitos), a scholar and amateur painter who reigned from 913 to 959. Although their dating is still by no means certain, a group of illuminated manuscripts, whose Classicism is even more impressive than that of the works of the Palace School in the Carolingian

^{439.} David the Psalmist, illumination from the Paris Psalter. c. A.D. 900. Bibliothèque Nationale, Paris

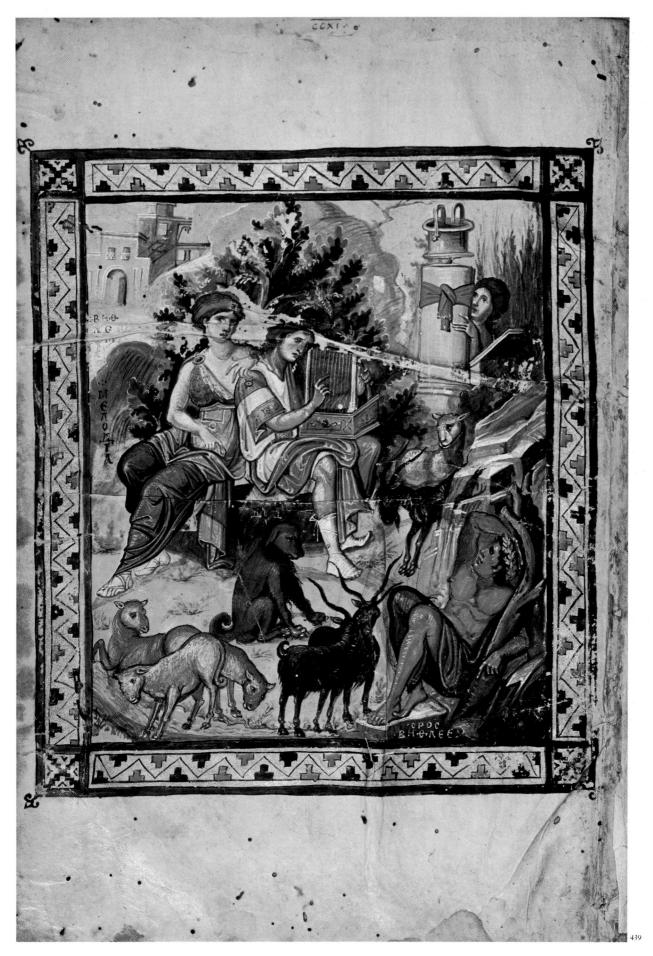

period (see fig. 502), is now attributed by most scholars to the tenth century and to the personal influence of Constantine VII.

The Joshua Roll. A wholly unique work is the Joshua Roll (fig. 440), the kind of continuously illustrated rotulus mentioned in the discussion of the Column of Trajan (see Part Two, Chapter Six; see fig. 352). Undoubtedly, however, the Joshua Roll was influenced by Roman imperial columns, two of which stood in Constantinople. The commissioning of a rotulus to depict the military campaigns of a great biblical hero may well have been prompted by a desire to commemorate allegorically the victories of the Macedonian emperors against the Muslims. In the section illustrated, two Israelite spies are sent out toward distant Jericho, then ride in search of Joshua, and finally Joshua, dressed as a Byzantine general and provided with a halo, leads his army toward the Jordan River.

Landscape elements are depicted much as they were in the Vienna Genesis (see fig. 434) and in the Castelseprio frescoes, but are not restricted to the foreground plane. The illuminator has worked out an extremely effective technique for rendering foliage, rocky hillsides, and distant cities in a soft, golden-brown wash, which suggests great distances and atmospheric haze. Certain details (in one instance Joshua prostrates himself before the angel in the posture dictated by tenth-century court ritual) indicate that the work may not be a copy. But in all certainty the artist studied paintings of the Helleno-Roman tradition with great care. The complex, vivid action poses and the movement of the horses show a firm control of the basic principles of Classical art; the rhythmic movement of the figures through landscape space is totally unexpected.

The Paris Psalter. The brilliant work of this group is the Paris Psalter, which contains several full-page illustrations in color, richly painted in a style so close to that of Pompeiian art (see figs. 323, 346) that it is hard to convince ourselves that we are not looking at a Classical original. David the Psalmist (fig. 439) has all the appearance of an Orpheus charming the animals with his music (they are, of course, David's goats, sheep, and

440. Joshua Leading the Israelites Toward the Jordan River (detail of an illumination from the Joshua Roll). Constantinople (present-day Istanbul), 10th century A.D. Biblioteca Apostolica Vaticana, Rome

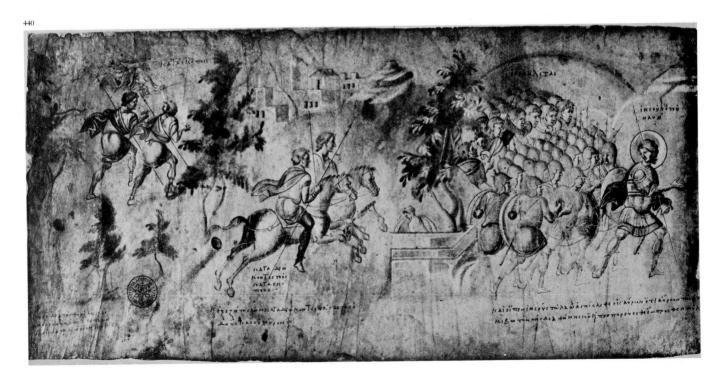

dog). As he plays, he is attended by a lovely Greek female figure labeled Melody; a nymph peeps shyly from behind the usual wayside column; and in the lower right-hand corner a muscular, deeply tanned, superbly painted male figure, clinging to the stump of a tree, is—of all things the divinity of Bethlehem! Classicism could hardly have been carried further. The scene is painted with such grace and luminosity that it is a shock to be called back to chronological reality by the stiffness and mannered quality of the drapery folds and by the parallel striations used to render light. These medieval artists could emulate Classical models, possibly at the behest of the scholar-emperor, and even feel the beauty of the Hellenic style they were learning without clearly understanding the analysis of space and light that had originally given rise to it.

MONASTIC CHURCHES AND MOSAICS When the Macedonian renaissance began, Hagia Sophia and other grand-scale churches already existed in the capital, and the other large cities of the Empire were also graced with elaborate churches. These buildings were well maintained, and there was no need for more of their kind. Eleventh- and twelfth-century builders could devote their efforts to the construction of monastic buildings, intended for communities numbering a few monks, and a profusion of such churches was erected. Despite all their richness of marble paneling and mosaic decoration, therefore, these churches are surprisingly intimate in scale. The basic plan, which had countless individual variations, was the so-called Greek cross with four equal arms inscribed within a square and crowned by a dome. This plan maintained a central axis in that the church was prolonged on the west by a narthex and in that the east wall was broken by one or more apses. The interior was small and designed chiefly for the celebration of the Liturgy by monks.

Hosios Loukas. At the Monastery of Hosios Loukas in Phocis, between Athens and Delphi in west-central Greece, two connected monastic churches were built early in the eleventh century. Both the Katholikon and the Theotokos (fig. 441) were laid out on Greek-cross plans; the

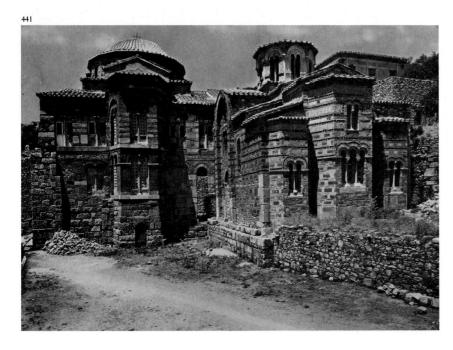

441. The Katholikon and Theotokos (churches), Monastery of Hosios Loukas, Phocis, Greece. Early 11th century A.D.

Katholikon was provided with galleries girdling its interior. In both churches the central dome was lifted on a high drum, pierced by windows. Compared with the austerity of Early Christian exteriors, the churches at Hosios Loukas seem ornate indeed, yet the richness is one of construction, not mere decoration. Courses of stone alternate with courses of brick, set at an angle to provide even greater variety of texture. This kind of construction was used throughout Greece and the Balkans from the eleventh through the fifteenth century.

When compared with the apparently measureless space of Hagia Sophia (see fig. 427), the interior of the Katholikon seems at first cramped (fig. 442); the movement is, however, entirely vertical, and carries the eve aloft into the dome, which is the only part of the central space lighted directly by its own windows. The light in the church is subdued, originating from windows in the galleries, in the corner spaces flanking the sanctuary, in the prothesis and the diakonikon (areas intended respectively for the preparation of the sacred elements of the Eucharist, and for the storage of vessels and vestments, much like the sacristy of a Roman Catholic church), and in the arms of the transept. The dome, interestingly enough, does not spring from pendentives as at Hagia Sophia but rests on squinches as at San Vitale. In all Byzantine churches the bema (sanctuary) is closed off by means of an iconostasis, a screen bearing icons whose subjects and order are largely predetermined by tradition. Tradition also determined the order of the mosaics in a church interior. The Theotokos, invariably enthroned or standing, adorned the semidome of the apse; the Pantocrator looked down from the center of the dome, surrounded by the heavenly hierarchy between the windows and by scenes from the life of Christ pictured in the squinches, vaults, and upper wall surfaces. Figures of standing saints decorated the lower wall surfaces. These soaring interiors, with their rich and subtle variations of spaces and lights, must always be imagined not only with their marble and mosaic decorations but also with their Liturgy, accompanied by clouds of incense and by chanted music whose deep sonorities bear little relation to the sound of Western plainchant.

Daphni. The finest remaining mosaics of the Middle Byzantine period are those in the Church of the Dormition at Daphni, not far from Athens, dating from about 1100. The Annunciation (fig. 443), unfortunately damaged at the right, fills one of the four squinches. The artist has utilized this space so that the angel Gabriel makes his salutation to Mary across the corner; as there is no indication of groundline, the figures seem to float in glittering golden air. Mary is represented in the state of mind indicated by Luke 1:29: "And when she saw him, she was troubled at his saying, and cast in her mind what manner of salutation this should be." The subtlety of the psychological characterization is in keeping with the refinement of the style. Especially beautiful is the harmony between the convex curvature of the angel's wings and the concave line of his arm, and the integration of these curves with those of his himation and tunic. As in Ottonian and Romanesque painting, the light is generalized and the drapery formalized, but at Daphni this formality is always under careful control, so that one is constantly aware of subtle balances and counterbalances of movement.

Although the *Christus patiens* (Suffering Christ) type was chosen for the *Crucifixion* at Daphni (fig. 444), the representation is timeless and symbolic; there are no soldiers, no Apostles, no thieves, only the grieving Mary and John on either side of the Cross, and, originally, mourning angels above the Cross on either side. The emotion is intense, but it is

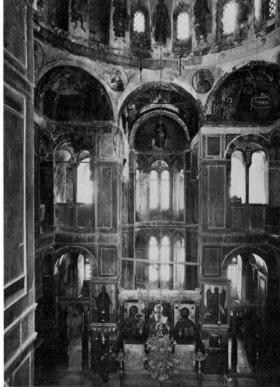

442

43

442. Interior, Katholikon, Hosios Loukas, Phocis

443. Annunciation, mosaic, Church of the Dormition, Daphni, Greece. c. A.D. 1100

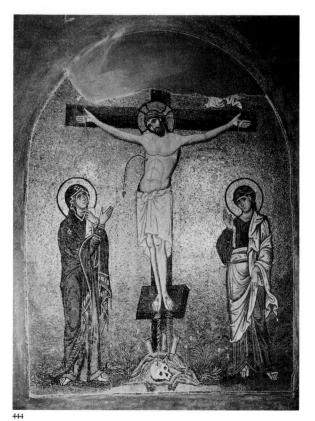

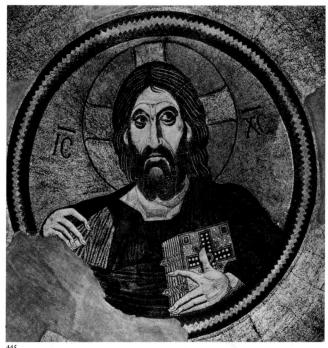

held in check by a reserve comparable to that of the Classical period in Greek sculpture; in fact, the three figures have been disposed with the grand simplicity of those on a metope. Christ hangs upon the Cross, his arms describing a shallow curve, his hips toward his right in a pose repeated in most Crucifixions under Byzantine influence. His head is gently inclined toward Mary as she gazes up at him with one hand slightly extended; John, on the other hand, turns toward us. Formalized though the broad flow of the drapery masses may be in detail, it remains sculptural in feeling. As is characteristic of much Middle and Late Byzantine pictorial art, the modulations of tone are delicate in the extreme. Christ's side has been pierced, and blood accompanied by water spurts from it in a bright arc (John 19:34), symbolizing the sacraments of the Eucharist and Baptism. The streams of blood that flow from Christ's feet strike the skull at the foot of the Cross. Golgotha means "the place of a skull" in Hebrew (John 19:17). Theologians have always interpreted the skull as that of Adam. Paul had said (I Cor. 15:22): "For as in Adam all die, even so in Christ shall all be made alive." As if in fulfillment of Paul's promise, flowers grow from the rocks below the Cross.

From the lyrical Annunciation and the elegiac Crucifixion, we turn with amazement to the revelation of the Pantocrator (fig. 445) at the summit of the dome. We may possibly gain from this image some idea of the vanished mosaic that in the Macedonian renaissance adorned the center of the dome at Hagia Sophia. The light from the windows of the drum illuminates the rainbow circle in which the colossal Christ appears, his face worn and deeply lined by suffering ("Surely he hath borne our griefs, and carried our sorrows," Isa. 53:4). The extraordinary human sensitivity of the great mosaicist at Daphni appears in the drawing of the long, aquiline nose, the flow of brows and cheekbones, the light on the half-open mouth, the streaming lines of the hair, and above all in the incomparable depth and power of the eyes.

444. Crucifixion, mosaic, Church of the Dormition, Daphni. c. A.D. 1100

445. Pantocrator, dome mosaic, Church of the Dormition, Daphni. c. A.D. 1100

THE EXPANSION OF BYZANTINE STYLE In the Middle and Late Byzantine periods, the artistic achievements of Greek masters were carried throughout territory stretching from Russia to Sicily.

The most ambitious of all Byzantine monuments outside the Empire is San Marco in Venice (figs. 446, 447); this state enjoyed strong if not always cordial commercial relationships with Constantinople. The church, now the Cathedral of Venice, was commenced in 1063 as a ducal basilica connected directly with the Doges' Palace. Its plan was imitated from that of the destroyed sixth-century Church of the Holy Apostles at Constantinople, built by Justinian. It is basically a Greek cross, designed on five squares, each surmounted by a dome on a high drum, crowned by a helmet-like structure of wood and copper, which imparts a verticality unknown to Early Byzantine domes. The exterior was greatly modified in the Gothic period by the addition of elaborate pinnacles and foliate ornament along the skyline, but the original Byzantine arches and unusual clustered columns are still visible. The vast interior spaces of the basilica (fig. 448) have much more to do with the spatial fluidity of Hagia Sophia than with the usual compressed Middle Byzantine interiors. The domes, set on pendentives rather than on the insistent squinches of the era's monastic churches, seem to float above their arches.

Powerful barrel vaults separate the bays and abut the thrust of the pendentives; the vaults in turn are supported on massive cubic piers, pierced by arches connecting with the galleries, which are entirely open in contrast to the arcaded galleries of Eastern churches. The nave galleries are sustained by triple arcades supported by modified Corinthian columns. The veined marble columns and the gray marble paneling of walls and piers were, of course, imported from the Byzantine East. Dim at all times, the interior shines with a soft, golden radiance shed by the continuous mosaics that line the domes, barrel vaults, and lunettes and softly veil all architectural demarcations. Mosaic artists were brought from Constantinople, but how much they accomplished is not known; presumably much

446. Plan of S. Marco, Venice

447. S. Marco, Venice. Begun A.D. 1063

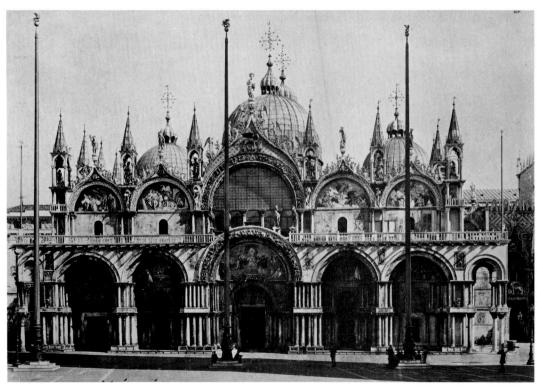

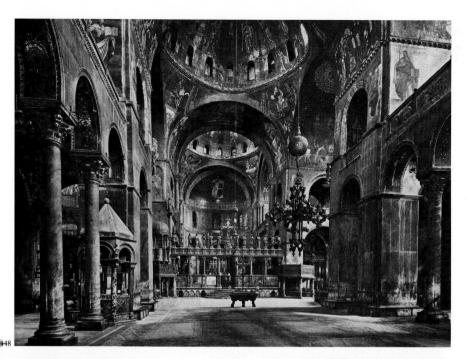

- 448. Interior, S. Marco, Venice
- 449. Pentecost, dome mosaic, S. Marco, Venice. c. a.d. 1150

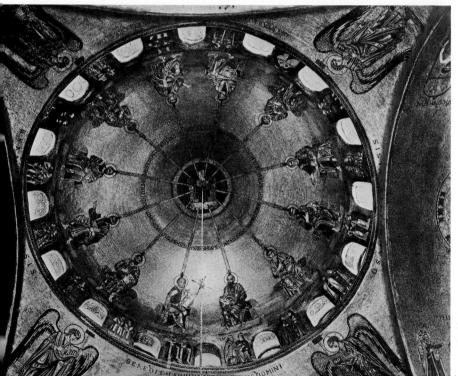

of their work was destroyed in a disastrous fire in 1106. Many of the present mosaics, in Byzantine style but with Romanesque influence here and there, were done by Venetian artisans during the twelfth and thirteenth centuries; several, however, were completely replaced in the late Renaissance or in the Baroque period. Those that remain are important as witnesses to the beginning of the Venetian school of painting, which in the Renaissance became one of the two leading Italian schools.

In the earliest of the five dome mosaics, executed about 1150 in the dome above the nave, the Pentecost (fig. 449) is represented. The Descent of the Holy Spirit upon the Apostles is described in Acts as "a sound from heaven as of a rushing mighty wind." As the Apostles met "there appeared unto them cloven tongues like as of fire, and it sat upon each of them"; they then began to speak in many tongues, which were understood by people from all nations who were in the streets outside. The event is reorganized in conformity with the architecture of the dome. In the center is a throne, on which stands the dove of the Holy Spirit; from the throne rays extend to the Apostles, enthroned in a circle above the windows. Between the windows stand pairs of people from all nations. The design is like a vast wheel, but it contains a startling discrepancy: there are Twelve Apostles over sixteen windows, as if three-four time in music were being played over four-four, each measure being marked by an archangel in one of the spandrels.

Sicily. At the other extreme of Italy, Roger II ruled as the first Norman king of Sicily from 1130 to 1154. Like other monarchs in southern and eastern Europe, he called Byzantine artists to his court to decorate a series of religious buildings and the salon of his palace. The church at Cefalù was raised to cathedral status at the request of Roger II, who intended it as his tomb-church. The team of Greek artists, who finished the mosaic decoration of the apse in 1148 (the later mosaics in the choir are by local masters), had to adapt Byzantine iconographic systems to the architectural requirements of a Western basilica and the desires of a royal patron (fig. 450). In the two lowest registers stand the Twelve Apostles. In the next register the beautiful Theotokos, robed in white with soft blue shadows, extends her delicate hands in orant position between four magnificent archangels, bending their heads as they hold forth scepters and orbs. Above this heavenly court, in the semidome (the church has no dome), appears the Pantocrator, as he does later at Monreale. In contrast to the austere Saviour at Daphni, the Cefalù Christ seems a poet and a dreamer, sensitive and merciful. His right hand is outstretched in blessing; in his left, instead of a closed book as at Daphni, he upholds the Gospel of John, written in Greek and Latin, open at Chapter 8, Verse 12, for all of King Roger's Christian subjects to read: "I am the light of the world: he that followeth me shall not walk in darkness, but shall have the light of life." The light we have learned to expect in Byzantine art shimmers through the Cefalù mosaics with a delicacy that proclaims them one of the finest achievements of Byzantine art—not the radiance of revelation we saw represented at Sinai (see fig. 431), but the light of Paradise, a soft, uniform radiance resulting in the subtlest refinement of gradations in hue and value throughout the drapery masses, the feathers of the angels' wings, and above all in the modeling of faces and hands. Even the ornament sparkles with a new and special brilliance—the decoration above and below the arch, the jewels that stud the cross of Christ's halo, and an entrancing bit of illusionism, the mosaic acanthus capitals crowning the real colonnettes that uphold the arch. Along with the light at Cefalù, line proliferates in amazing multiplicity through the countless strands of Christ's hair and beard and the crinkled folds of the drapery. On the brown tunic appear for the first time sunbursts of gold rays, fusing light and line, soon to be adopted by such Italo-Byzantine painters as Cimabue.

Macedonia and Serbia. An extraordinary series of frescoes (less expensive to produce than mosaics) is still preserved in churches, cathedrals, and monasteries throughout Macedonia and Serbia, in what is today Yugoslavia. At least fifteen major cycles remain, executed from the eleventh well into the fifteenth century, the last of them done barely ahead of the invading Turks. These cycles form the richest and most consistent body of mural painting left from Middle and Late Byzantine art. The finest paint-

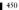

450. Apse mosaics, Cathedral of Cefalù, Sicily. Completed A.D. 1148

ings in each series were almost invariably done by artists from Constantinople or from other Greek centers; some were painted by refugees after the conquest of the capital by the Crusaders in 1204. Many of the signatures on these works are Greek, and some painters can be traced from one cycle to the next. Local, presumably monastic, artists often completed a cycle begun by an artist from Constantinople or elsewhere with frescoes of considerably less interest (usually those farthest from the eye).

An especially impressive cycle covers all of the interior walls of the beautiful little domed church of Saint Pantaleimon at Nerezi, high on a mountainside overlooking the Macedonian city of Skopje; the church was completed in 1164 by a grandson of the emperor Alexius I Comnenus. The styles of several painters can be distinguished in the cycle, which is held together by an overall unity of color—especially the intense blue of the backgrounds—and by its intimacy of scale. The painter who set down the scenes of the Passion with a directness and intensity of emotion not seen in Eastern art since the days of the Rabula Gospels (see fig. 435) was undeniably a master. The Lamentation (fig. 451) shows Christ laid out for burial, his body turned toward us, his eyes closed in death. John holds Christ's left hand to his face, and the Virgin enfolds her dead son in her arms; both faces are contorted with grief. The scene must have been

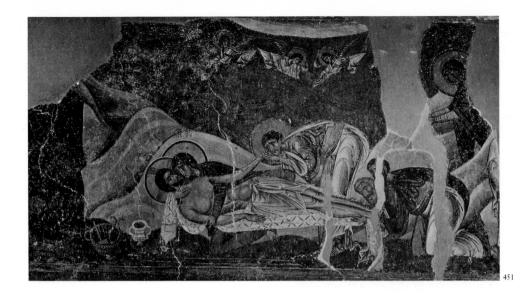

painted at dizzying speed; the authority of the brushstrokes and the brilliant handling of light on the drapery show that Greek painters had lost nothing of their mastery since the distant days of Castelseprio (see fig. 437). The expressive power shown in the Nerezi fresco leads us far in the direction of early Italian art.

The greatness of the Italian debt to Byzantine art is again indicated by the large-scale fresco cycle in the long-abandoned, recently restored Church of the Trinity at Sopoćani in Serbia. This church was one of a series of monasteries built by the Serbian kings (who wore Byzantine dress and imitated Byzantine court ritual) so that monks could celebrate the Liturgy before the royal tombs. In all of these Serbian churches the entire west wall of the interior above the doorway was given over to a vast fresco representing the Dormition of the Virgin, a non-Scriptural scene in which the grieving Apostles, who surround the bier of the Vir-

- 451. Lamentation, fresco, St. Pantaleimon, Nerezi, Yugoslavia. c. A.D. 1164
- 452. Dormition of the Virgin, central section of a fresco, Church of the Trinity, Sopoćani, Serbia, Yugoslavia. A.D. 1258-64

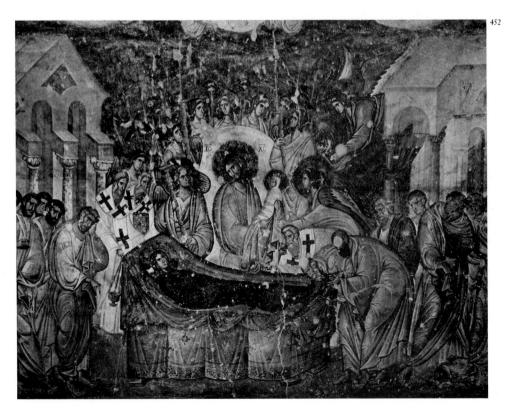

gin Mary, are astonished by the appearance of Christ from Heaven, attended by angels, who takes her soul in his arms in the form of a tiny child. The Sopoćani frescoes must have been done between 1258 and 1264, and although the artist did not go to the same expressionistic lengths as the twelfth-century master at Nerezi, he had quite as much understanding of drama and deployed both figures and architecture with authority. Movement and emotion sweep through the scene with tremendous effect. The coloring is unexpectedly delicate; Christ and Peter, for example, are wrapped in lemon-vellow mantles, and Mary's bier is draped in alternating passages of blue and rose. The illustration (fig. 452) shows only the central section of the fresco, which stretches out at the sides to involve both additional grieving figures and more architecture. The new sense of drama and of scale in the Sopoćani frescoes was accompanied by increasing powers of observation; throughout this scene faces are strongly individualized. Most powerful of all is the new sense of unified modeling in light and shade, of both features and draped figures, as compared to the divided drapery shapes of Middle Byzantine art. The creation of volumes in light has always been credited to Giotto and his immediate predecessors, especially Pietro Cavallini, but it is clear from the Sopoćani frescoes that Greek painters shortly after the middle of the thirteenth century already knew how to bring out a volume in depth by the action of light, even though that light has as yet no single, identifiable source.

LATER BYZANTINE MOSAICS AND PAINTING IN CON-STANTINOPLE In 1261 the emperor Michael VIII (Palaeologus), who had been governing in exile from Nicaea as coemperor, returned to Constantinople and started cleaning up the devastation left by the Crusaders. To the Palaeologan period is generally attributed a very large, fragmentary, but beautiful mosaic in the south gallery of Hagia Sophia (fig. 453) representing the Deësis (Christ Between the Virgin and Saint John the Baptist;

453. Deësis, south gallery mosaic, Hagia Sophia, Istanbul. Late 13th century A.D.

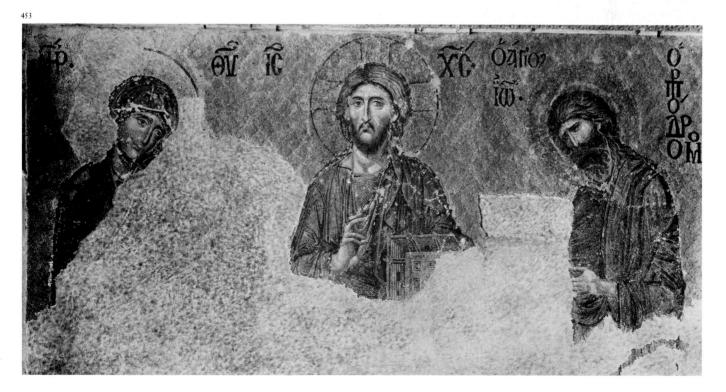

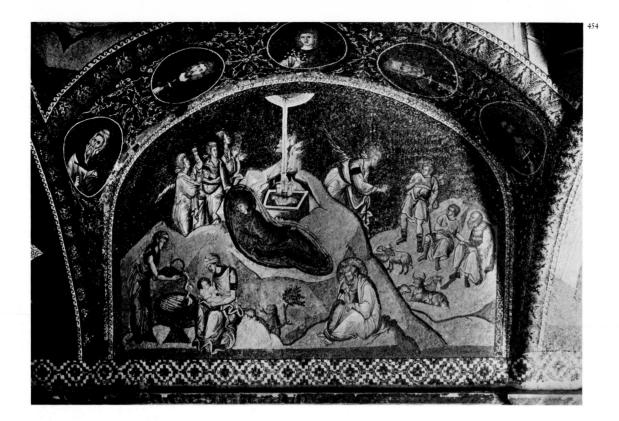

for its later reappearance, see the Ghent Altarpiece by Jan van Eyck). The tenderness of the expressions, the grace of the poses and the linear movement, and the extraordinary sensitivity to light in the rendering of faces, hands, and hair mark a master very different from the bold dramatist at Sopoćani, but, nonetheless, one who had a similar understanding of the role of light in creating volume. In the Deësis mosaic the diffused light, apparently from an external source, is also very different from the allover glow of the Cefalù mosaics.

Church of Christ in Chora. During the reign of Michael's son and successor Andronicus II, the Monastery and Church of Christ in Chora, adjacent to the imperial palace in Constantinople and now known under the Turkish name of Kariye Djami, were rebuilt, the church and its narthex decorated with mosaics, and the parecclesion (an adjacent funerary chapel) painted in fresco. This extensive cycle, which has been dated between 1315 and 1321, was carried out after the creation of Giotto's revolutionary works, and it is just possible that the cubic rocks and massive figures in the Nativity mosaic (fig. 454) were influenced by Giotto's new ideas (see fig. 2). The scene is represented according to Eastern tradition, derived partly from the account in Luke, and partly from the apocryphal stories of the fifth and sixth centuries, which were widely accepted in the East. For example, the cave in the background does not derive from the Gospels, but from one of these later accounts, and is represented throughout Byzantine art (the Church of the Nativity in Bethlehem was later erected over the cave where Christ is believed to have been born). The first bath of the Christ Child, also apocryphal, is depicted at the lower left.

In the startling frescoes of the parecelesion, Late Byzantine style is exemplified in its most vigorous and imaginative phase. The technique of these frescoes has recently been analyzed; they were executed in the method Italian artists call secco su fresco (dry on fresh). The color was suspended in a vehicle containing an organic binding material (such as oil, egg, or wax) and laid on over the still-damp plaster. Paint thus applied forms a contin-

454. Nativity, narthex mosaic, Church of Christ in Chora (Kariye Djami), Istanbul. A.D. 1315 - 21

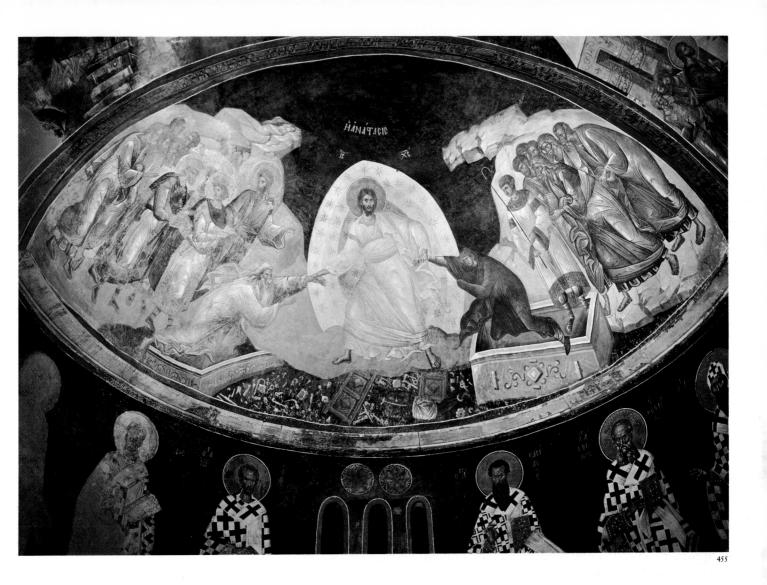

uous and very hard skin. This method also allows free and rapid painting over large areas. This technique differs sharply from the "true fresco" method generally used by Italian artists during the Gothic period and the Renaissance. Probably, the secco su fresco technique was also used in the

Macedonian and Serbian frescoes, but this has not been proved.

The fresco filling the semidome of the apse (fig. 455) represents what the Greeks call the Anastasis (Resurrection). Although the Gospel accounts do not describe this scene, both the Apostles' Creed and the Nicene Creed declare that during the three days when Christ's body lay in the tomb he descended into Hell. Apocryphal accounts, widely believed throughout the Christian world, tell how Christ caused the gates of Hell to burst open before him, filled its darkness with light, commanded that Satan be bound until the Second Coming, and lifted Adam and Eve, followed by all the patriarchs and prophets, from the unhappy realm to which they had been doomed by Original Sin. This theme, known in Western art as the Harrowing of Hell or the Descent into Limbo, is highly appropriate for a funerary chapel, as it sets forth vividly the Christian hope for resurrection. The composition is unusual in that in order to centralize the scene in the apse the artist has shown Christ lifting Adam with one hand and Eve with the other. The unknown painter represented the subject in a style strongly related to that of the vivid frescoes of Sopoćani (see fig. 452) in freedom of movement, in brilliance of color, in naturalism of facial

455. Anastasis (Resurrection), apse fresco, Church of Christ in Chora (Kariye Djami), Istanbul. A.D. 1315-21

expressions, and in the effect of light in modeling volumes. As in the mosaics of Sinai (see fig. 431), Christ is clothed in pearly garments whose white highlights create the impression of blinding radiance. Shadow fills the tombs from which Adam and Eve are drawn up, and the side of Eve's sarcophagus opposite to the source of light in Christ remains deep in shadow. As with the contemporary frescoes of Giotto and his followers in Italy, this apparently naturalistic observation of the effects of light proceeding from a single source is in reality bound up entirely with its religious meaning. The Old Testament kings and patriarchs to the left are led by Saint John the Baptist, who accompanied Christ into Hell, and to the right the prophets are grouped behind Abel. The brilliant colors of the drapery and the creamy, off-white of the rocks shine against the intense blue of the background. Satan, bound, prone, partly across the shattered gates of Hell, is surrounded by a veritable shower of locks, hasps, and bolts.

RUSSIA AND RUMANIA

Russian religious architecture owes its origins to Byzantine models, and throughout its long and rich development, it has retained the central plan for churches because of this arrangement's suitability to Orthodox liturgical requirements. In 989 Vládimir, grand prince of Kiev (who ruled most of the territory now comprising the European U.S.S.R.), married Princess Anna, sister of the Byzantine emperor Basil II, and brought Byzantine craftsmen back with him from Constantinople to build and decorate churches in his newly converted principality as well as to instruct local artisans. In 1037 construction was begun on the magnificent Cathedral of Hagia Sophia at Kiev. This church, in Byzantine style, with five aisles surrounded on three sides by an open arcade, has thirteen domes, representing the number of Christ and the Apostles. Its mosaics date from 1043 to 1046. The apse mosaics have miraculously survived the abandonment and partial ruin of the cathedral in the sixteenth century, its rebuilding in the seventeenth century, and its partial destruction in World War II. A monumental *Theotokos* (fig. 456) in orant position adorns the semidome; her powerful drapery folds recall those at Hosios Loukas. She appears to stand in a golden niche, supporting its arch like one of the maidens of the Erechtheion (see fig. 246). Below her unfolds an extraordinary scene, seldom represented in Western art—the Communion of the Apostles. Christ officiates as priest at the central altar, distributing bread on the left and wine on the right.

Vladímir. Soon local tastes began to modify the Byzantine heritage; artisans imported from Western countries to carry out Russian projects added their own traditions to the amalgam. An early example of Russian hybrid style is the Cathedral of Saint Demetrius (fig. 457), built about 1193–97 at Vladímir in the principality of Rostov-Suzdal, far to the northeast of Kiev and beyond the sway of its metropolitan (archbishop). The square block of Saint Demetrius, showing traces of the inner Greek-cross plan into whose arms the corner blocks housing prothesis, diakonikon, and galleries are fitted, and the central dome on its high drum pierced by round-arched windows are immediately recognizable as Byzantine. The screen architecture, consisting of two-story blind arcades whose arches appear along the roof line and are supported by lofty colonnettes, is also derived from Byzantine churches of the tenth and eleventh centuries. But the elaborate fabric of stone sculpture that fills the arches of the upper story and the walls of the drum with figural and ornamental reliefs of

- 456. Theotokos and Communion of the Apostles, apse mosaics, Cathedral of Hagia Sophia, Kiev, Ukraine, U.S.S.R. A.D. 1043–46
- 457. Cathedral of St. Demetrius, Vladímir, U.S.S.R. c. A.D. 1193–97
- 458. Barma and Postnik. Cathedral of St. Basil the Blessed, Moscow. A.D. 1554–60

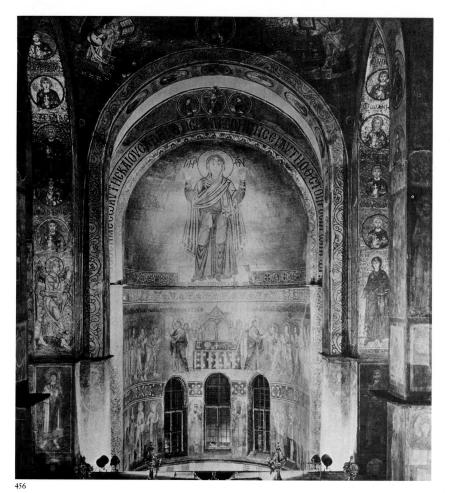

Saint Basil. The domes of many Russian churches built in the following centuries are lifted on drums so high that they look like towers; the need to protect these domes against snow and ice led to the erection of bulbous external shells, generally onion-shaped. The Kremlin at Moscow contains several such churches, some designed by Italian architects in a style combining Renaissance details with Russian architectural tradition. A final expression of pure Russian architectural fantasy, in which Byzantine elements, detached from their original meaning, were multiplied in unbelievable extravagance, is the Cathedral of Saint Basil the Blessed in Moscow (fig. 458). It was built for Czar Ivan IV the Terrible from 1554 to 1560 by the architects Barma and Postnik in what is today called Red Square, adjacent to the Moscow Kremlin. The plan is more rational than the startling appearance of the exterior might lead one to believe. A tentlike octagonal central church (a favorite shape in the sixteenth century in the region of Moscow) is surrounded by eight smaller but lofty separate churches arranged in a lozenge pattern. Each of the corner churches is octagonal and supports a towering onion dome. The architects inserted four even smaller churches, two of which are square and two heart-shaped, all four crowned by onion domes, between the corner churches. The connecting gallery and the conical bell tower, however, are seventeenthcentury additions. The drums of all eight domes are ornamented with innumerable arch-shapes derived from the Byzantine blind arcade but reduced to ornaments, and with gables that become zigzags. The onion domes are fluted, twisted, or reticulated (reminding us of pineapples) and

459

459. Theophanes the Greek. *Stylite* (detail of a fresco, Church of Our Saviour of the Transfiguration, Novgorod, U.S.S.R.). A.D. 1378

painted green and white in stripes that make a vivid contrast to the orangered of the brick.

Russian Painting. The rich tradition of church murals and icon painting in Russia, which began perhaps as early as the tenth century with the importation of Byzantine icons, continued unabated into the nineteenth. Many of the innumerable examples are of extremely high quality, and at least two early painters are major figures, known to us by name. Theophanes the Greek, born between 1330 and 1340, had worked in Constantinople and in other Byzantine centers and brought to Russia the dramatic Palaeologan style we have seen at the Kariye Djami. In 1378 Theophanes was at work in Novgorod, and at the turn of the century in Moscow, then the center of a powerful principality. Theophanes is known to have been able to paint from memory with great rapidity and sureness, and his technique can be appreciated in his few surviving works, such as the wonderful fresco of a stylite (pillar sitter) in the Church of Our Saviour of the Transfiguration at Novgorod (fig. 459). The free, brilliant pictorial style of Castelseprio, with all its echoes of Helleno-Roman illusionism, still continues in the work of Theophanes seven centuries later. However, his brush dashes along at such speed carrying a message of religious mysticism that we are reminded of the great Greek painter El Greco, who worked in Spain in the sixteenth century. The lightning strokes of Theophanes show a personal variant of the Byzantine tradition and vibrate at an intensity that could not be transmitted to a pupil.

In Moscow Theophanes worked in association with a younger and native Russian artist, the monk Andrei Rubley, who painted a fine series of frescoes that still survives at Vladímir but who is best known for his icons. In the fourteenth and fifteenth centuries, the iconostases in Russian churches had been heightened with the addition of upper rows of images, and thus the demand for icons was very great. The style of Russian icons is usually distinguished by flat masses of only slightly modulated color, often of great brilliance, and by a keen sense of the importance of contour. Rublev was content to work within the limitations of this style, but he certainly raised it to its highest level of aesthetic and spiritual achievement. His best-known work is the *Old Testament Trinity* (fig. 460), an icon painted in memory of the Abbot Sergius, who died in 1411. The painting is heavily damaged; almost all of the background is lost and much of the drapery gone, but even in its present state, it is a picture of haunting beauty. The scene is a traditional one in Russian icons, but Rublev did not handle it in the traditional manner. The meeting of Abraham and Sarah with the three angels, who sat down to supper under a tree in the plains of Mamre (Gen. 18:1–15), was interpreted in Christian thought as a revelation of the Trinity. In Russian icons Abraham and Sarah had always been represented, and a lamb's head, symbolic of the sacrifice of Christ, substituted for the textual calf. Rublev goes to the heart of the mystery, showing us only the three angels as if we were Abraham and Sarah experiencing the vision. The relationships among the three angels are treated with the greatest poetic intensity and linear grace; the contours flow from body to body as the glances move from face to face. Throughout the area that now comprises the European U.S.S.R., icons were produced in great numbers long after the fall of Constantinople to the Turks in 1453.

Rumania. The region of Moldavia, the eastern portion of present-day Rumania, preserves a handsome group of monastic churches erected in the late fifteenth and early sixteenth centuries and frescoed not only in

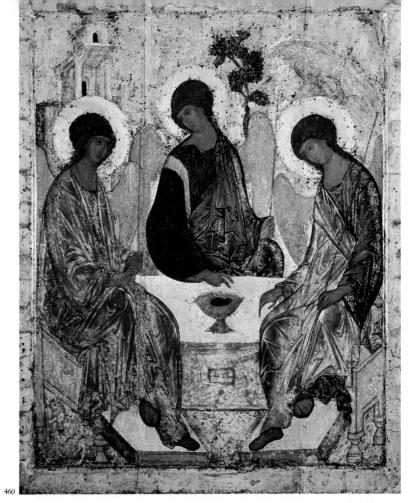

- 460. Andrei Rublev. *Old Testament Trinity*. c. 1410–20. Panel painting, $55\frac{1}{2} \times 44\frac{1}{2}$ ". Tretyakov Gallery, Moscow
- 461. *Last Judgment*, fresco on the west wall of the narthex, Church of St. George, Voroneţ, Rumania. c. A.D. 1550

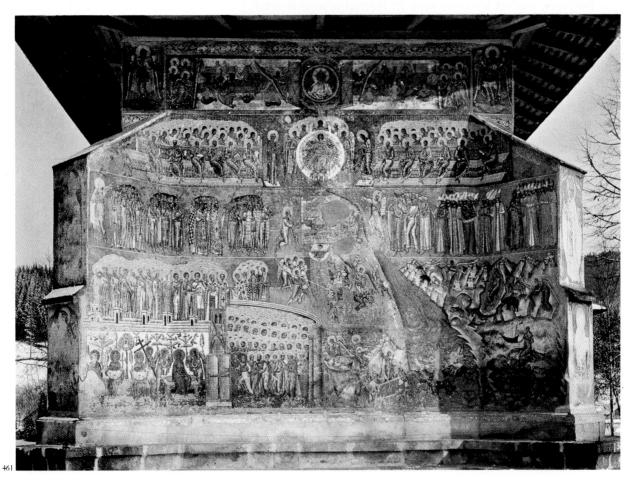

EARLY CHRISTIAN AND BYZANTINE ART 347

the interior but also over all the outside walls, where the frescoes are protected only by wide, overhanging eaves. Unlikely though it may seem in view of the severe winters of this region in the foothills of the Carpathian Alps, the exterior frescoes on all but the north walls are better preserved than those in the interiors; apparently, rain, sun, and wind are not as injurious to paintings as are candle smoke and incense.

Among the best of the Moldavian fresco cycles is that of the *Last Judgment*, which adorns the west front of the former Voroneţ monastery church. The *Last Judgment* (fig. 461), dating from about 1550, covers the entire west wall of the narthex above the entrance. At the top angels roll up the heavens as a scroll (Isa. 34:4; Rev. 6:14). In a circle in the center is God the Father; below him is the Deësis with six Apostles enthroned on each side and angels behind them. In the next tier below, choirs of ecclesiastical saints are grouped on either side of the throne prepared for Christ's Second Coming. A river of fire pours from the throne of Christ and falls upon the damned in Hell to Christ's left, penetrating earth and sea, which give up their dead. On his right Heaven opens up in two tiers of the blessed, whose halos blend into an almost continuous surface of gold.

Counting only from the founding of Constantinople in 330 until its fall in 1453, the Byzantine Empire had lasted longer than any political entity since Egypt. It was, however, in law still the Roman Empire and in fact the continuation of not only Roman but Greek culture, which was by no means extinguished under Turkish rule or outside it. Throughout subject Asia Minor and the Balkans, and as we have seen in Rumania and Russia, Christian communities needed pictorial art to figure forth the structure of their beliefs. Many mural paintings and thousands of icons, often of high quality, continued to be made in Byzantine style into the nineteenth century. Even more important, perhaps, than this astonishing continuity of Byzantine tradition, is the role Byzantine art played for the entire Middle Ages and Early Renaissance in Western Europe as a treasury of Classical forms and ideas.

sion of

nlike their endemic attacks totally. The lightning expansion of Islam political tenacity rivaling that of death of Muhammad, its founder, then aware of the existence of song the Hebrew and Christian holy Islam had reached into Turkestan, west, including Spain, Portugal, western France the Muslims were and Sassanid Persians crumbled bealkans. All the Asiatic and African xception of modern Israel, remain

crabs and to their intense religious. Christianity which took place in untry or region has ever willingly rd, and he directed and personally it the history of Islam, determined, but nonetheless unyielding—in Palestine. In assessing the expangreal material advantages attend-

ing submission to a militarily dominant Arabic culture. But it would be a mistake to assume that this culture, at least in its developed stages, was inferior to those it conquered, particularly in France and in Spain. One of the most surprising aspects of Muslim growth is the rapidity with which Islam assumed the role of conservator and continuator of the Helleno-Roman philosophical and scientific heritages. We owe much of our knowledge of Classical science, especially botany and medicine, and the invention of algebra (and of the very numbers used in this book) to the Arabs. However, Muhammad's prohibition of graven images ruled out sculpture, and his disapproval of representation put painting into an ambiguous position. But under Islam architecture made gigantic progress, and the natural mathematical bent of the Arabs, coupled with their highly developed aesthetic sense, produced an art of abstract architectural decoration that is one of the artistic triumphs of mankind.

Compared with the increasing theological complexity of organized Christianity, in either its Roman

or Eastern Orthodox form, Islam (the word means "submission"—i.e., to the will of Allah) is a remarkably simple and clear-cut religion. It dispensed with priesthood, sacraments, and liturgy from its very start; every Muslim has direct access to Allah in prayers. But its caliphs, at first deriving authority from their degree of family relationship to Muhammad, exercised supreme political power in a theocratic state. Islam's one sacred book, the Koran, embodies the divinely revealed teachings of Muhammad as set down by himself on either palm leaves or camel bones, or as recalled by his companions and edited by his early followers. These teachings include the doctrine of one indivisible God, who has many Prophets (including those of the Old Testament and Jesus), of whom the greatest was Muhammad. Islam posits a Last Judgment, a Heaven, and a Hell, but it makes no clear division between the demands of the body and those of the soul. The good life on earth and the afterlife of Paradise can include many forms of self-indulgence, including a host of concubines, thus strengthening a tendency to view women solely as instruments of pleasure. In contrast to the celibacy imposed upon Catholic clergy of all ranks, and upon Orthodox bishops, no such sacrifice was required of the caliphs or the *imams* (teachers). The duties of a Muslim include circumcision, daily prayer at five stated hours, abstention from certain foods and from alcohol, fasting during the lunar month of Ramadan, charity, and a pilgrimage to Mecca.

Muhammad had no greater need of architecture than had Jesus; he could and did teach anywhere, but much of his discourse was carried on in his own house, which served as the model for building the first mosques. His followers required only a simple enclosure, one wall of which, known as the *qibla*, at first faced Jerusalem, later Mecca. A portico on the qibla side was a practical necessity as a protection from the sun. The sacred well near the Ka'bah in Mecca suggested a pool for ritual ablutions; every mosque has one in the center of its courtyard, which is known as the *sabn*. Soon the qibla was given a sacred niche, called the *mibrab* (see fig. 475), which pointed in the direction of Mecca. To the right of the mihrab stood the *minbar* (see fig. 475), a lofty pulpit from which the imams read the Koran to the assembled faithful and preached the Friday sermons. These simple early mosques always contained the qibla, the sahn, the mihrab, and the minbar, but unfortunately none of the first mosques have been preserved. As in the case of Christianity, and indeed following its example, the taste for splendor soon accompanied success.

Early Architecture

DOME OF THE ROCK As early as 670 the mosque at Kufah in Mesopotamia (located in present-day Iraq) was rebuilt with a roof fortynine feet high, supported by a colonnade in apparent imitation of the Hall of a Hundred Columns at Persepolis (see fig. 151). When Caliph Omar I captured Jerusalem in 638 he left the Christian sanctuaries undisturbed and built on the ruins of the last Temple (which Titus had totally destroyed in A.D. 70) a square shrine of bricks and wood to enclose the rock on which Abraham had attempted to sacrifice Isaac and from which Muhammad had made an ascent to Heaven on a human-headed horse. But toward the end of the seventh century, the caliph 'Abd al-Malik, as a chronicler tells us, "noting the greatness of the Church of the Holy Sepulcher and its magnificence, was moved lest it should dazzle the minds of the Muslims, and hence erected above the Rock the dome which is now to be seen there." 'Abd al-Malik's new building, the earliest preserved Muslim structure, was magnificent from the start (fig. 462). The rich fabric of blue, white, yellow, and green tiles which now clothes the upper portion was added only in the sixteenth century, but it replaces decorative glass mosaics that emulated those in Christian churches and were in fact sheathed in their original slabs of veined marble, in which one may

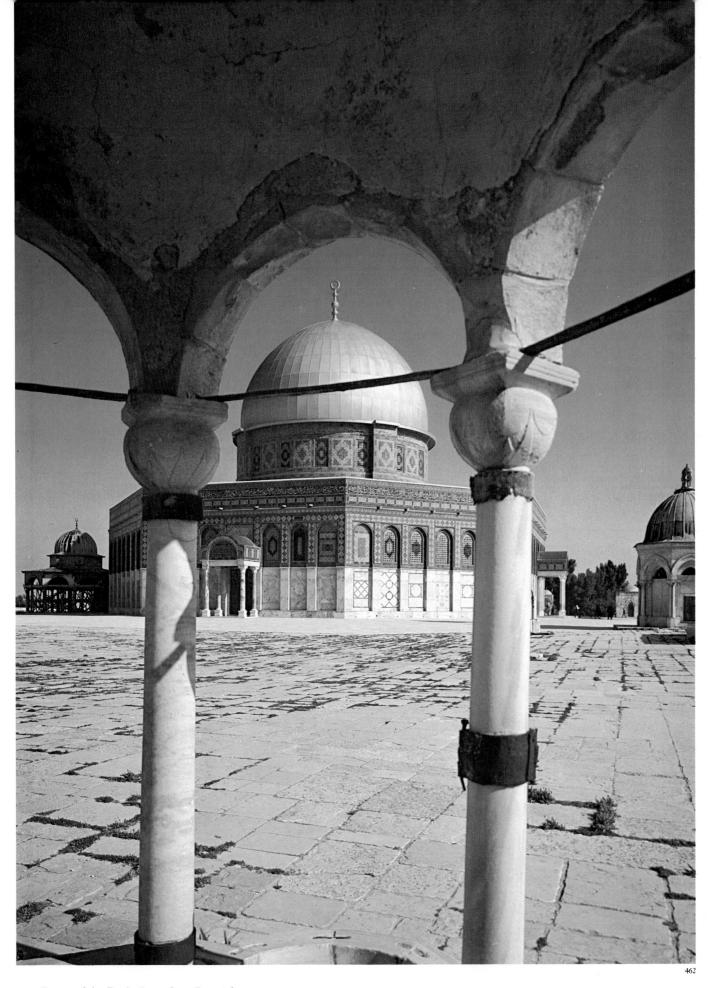

462. Dome of the Rock, Jerusalem. Late 7th century A.D.

note the modest beginnings of the abstract, geometric ornament that became so dazzling in later Muslim architecture. The wooden dome (regilded in 1960, alas, in anodized aluminum!) was covered originally with gold leaf.

The plan is not that of the typical mosque, but derives from the central-plan Christian martyrium because pilgrims were required to walk in procession around the sacred Rock just as the Christians did around a martyr's tomb. A simple octagon is surmounted by a graceful, slightly pointed dome, the idea for which may have been suggested by the almost pointed barrel vault of the palace of the Sassanid Persian monarch Shapur I at Ctesiphon in Mesopotamia (fig. 463), near the later site of Baghdad. The shape is repeated in the delicately pointed arches used throughout the building, in the surrounding courtyard, in the blind arcade and windows of the exterior, and in the two concentric ambulatories around the Rock. The pointed arch offers great advantages over its round counterpart, since it can be designed in almost any proportion, thus freeing the architect from the tyranny of that inconvenient quantity $pi(\pi)$ in working out his calculations. As we shall see, the pointed arch is only one of the many flexible features introduced by Muslim architects in the course of time. The pointed arch later found its way to the West where it was employed in the late eleventh century in Romanesque architecture, as at Cluny (see fig. 528), and where it became the standard shape for arches in the Gothic period. As in most mosques, the windows of the Dome of the Rock are filled with a delicate grille of stone in order to temper the harsh rays of the sun. The Muslims, like the early Christians, pressed into service columns and capitals from Roman buildings, but their sensibility admitted none of the gross discrepancies—between juxtaposed Ionic and Corinthian capitals, let us say—which did not seem to bother the early Christians. The exterior capitals of the Dome came from Roman monuments of the fourth century. The interior, with two concentric arcades around the Rock, is sheathed with veined marble and decorated with glass mosaics.

463. Palace of Shapur I, Ctesiphon, near presentday Baghdad, Iraq. c. 3rd-6th century A.D.

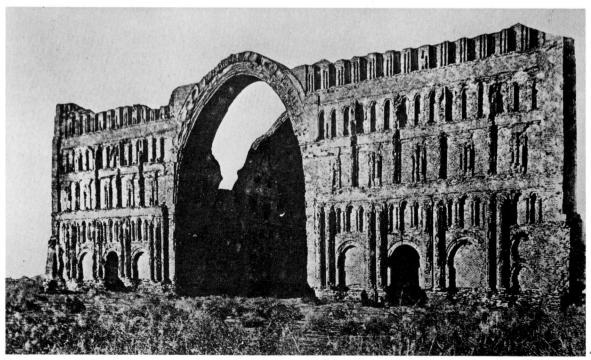

GREAT MOSQUE AT DAMASCUS The earliest Muslim building on a gigantic scale is the Great Mosque at Damascus (fig. 464), built from 705 to 711, inside the fortified outer enclosure of a Roman sanctuary, measuring 517 by 325 feet, originally containing the temple of Jupiter. The Christians had converted the temple into a church, and for decades after their conquest the Muslims left the Christians undisturbed. Then al-Walid demolished everything inside the enclosure, utilizing the salvaged masonry blocks, columns, and Corinthian capitals still in perfect condition for a grand arcade, supported by columns on the short sides and piers on the long; across the south arcade he ran a lofty transept leading to the mihrab. The square corner towers, built for defense, were utilized as minarets, and they are the earliest known. Minarets, still in use today for the muezzin's call to prayer, were not strictly necessary; a rooftop or a lofty terrace could serve the same purpose. But henceforward they became a common if not indispensable feature of the mosque. The present minaret crowning the Roman tower of the Great Mosque is a much later addition. The building has been repeatedly burned and rebuilt; originally, its dome was slightly pointed like that of the Dome of the Rock. Some of the interior mosaic decoration still survives (fig. 465), consisting of dreamlike architectural fantasies in the tradition of Roman screen architecture as we have seen it in early Byzantine mosaics at Salonika (see fig. 409), interspersed with city views like those of the mosaics at Santa Maria Maggiore in Rome (see fig. 410). These mosaics look like a richly designed Islamic textile. The artists who made them were probably Syrian Greeks.

464. Courtyard and façade, Sanctuary of the Great Mosque, Damascus, Syria. c. A.D. 705–11

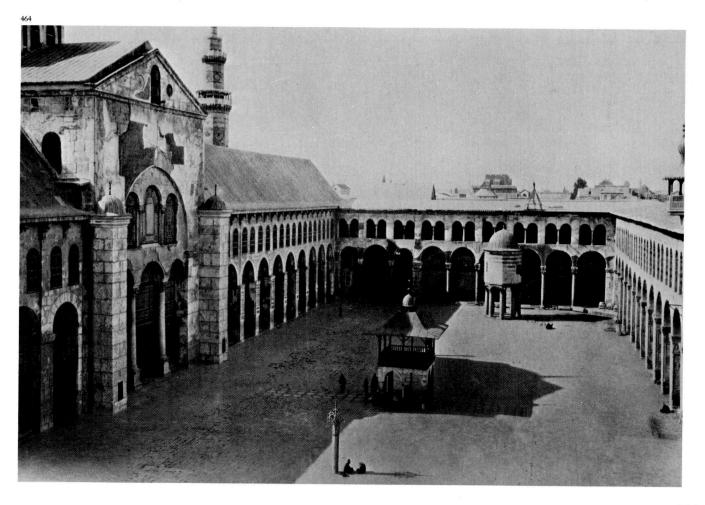

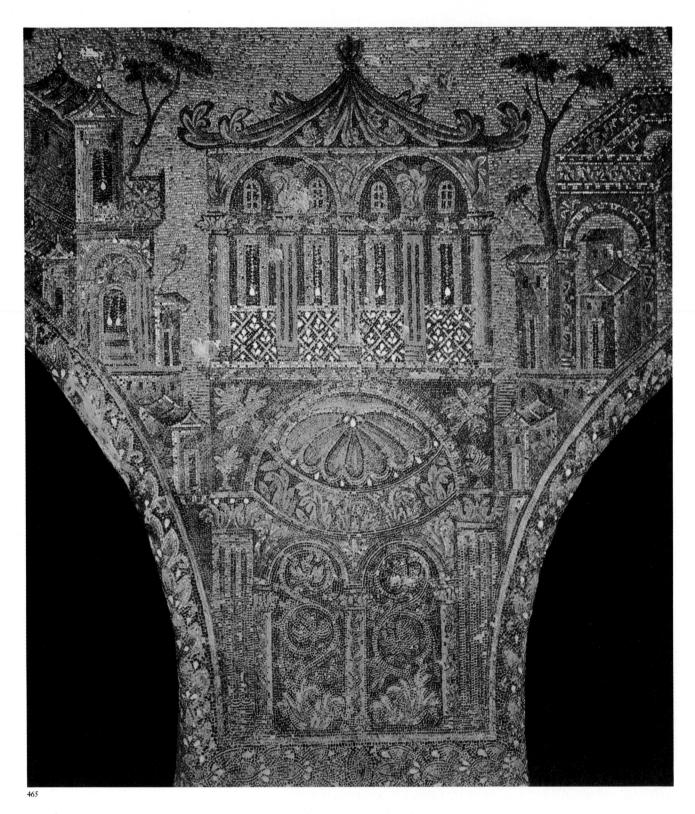

SECULAR MUSLIM BUILDINGS Much of the ornamentation of early Islamic palace architecture gives a similar effect of textile design. For example, the façade of the palace built about 743 in the desert at Mshatta, in what is now Jordan, had a lower zone of almost incredible richness (fig. 466). Here rosette forms and floral interlace derived from later Roman and early Byzantine traditions mingle with confronted winged griffins of Mesopotamian derivation to clothe considerable areas of masonry with a flickering tissue of light and dark. The resultant pattern,

465. Architectural View (portion of a mosaic, Great Mosque, Damascus). c. A.D. 705–11

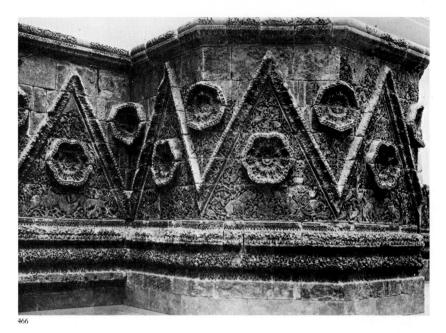

466. Façade, Palace at Mshatta, Jordan (portion). c. A.D. 743. Staatliche Museen, Berlin

known as *arabesque*, is quite as bewildering in its complexity as that of Germanic ornament and Hiberno-Saxon manuscripts, but it is equally disciplined and organized into zones by broad zigzags. The ornamentation at Damascus and Mshatta foreshadowed the Islamic intoxication with the mysteries of pure geometric interlace, which dominates Islamic interiors instead of wall paintings (see figs. 473, 479).

The original Umayyad dynasty of caliphs was succeeded by the 'Abbasids, whose great caliph al-Mansur (reigned 754–75) removed his capital from Damascus to Baghdad on the upper Tigris in Mesopotamia. Here he built a round city, considered unique by Arab historians, but actually derived from the circular camps of the Assyrians and from later Mesopotamian models. It had two concentric circles of walls, four gateways, streets radiating outward from the center like the spokes of a wheel, and in the central area stood a great mosque and the caliph's palace. Unfortunately, al-Mansur's wonderful round city, immortalized by the stories of his great successor Harun ar-Rashid, who developed an unlikely penpalship with the emperor Charlemagne, must remain a dream. Like most Mesopotamian monuments, it was made of mud brick, and when the Mongols swept down in the thirteenth century, they destroyed everything.

SAMARRA Caliph al-Mu'tasim built the city of Samarra upstream from Baghdad after 836. It was twenty miles in length and counted a population of about a million; Caliph al-Mutawakkil built between 848 and 852 a mosque that could accommodate at any one time a considerable proportion of the city's inhabitants. The external rectangle, measuring 784 by 512 feet (fig. 468), forms the largest of all mosques and greatly exceeds the dimensions of any Christian house of worship. The fired-brick exterior walls still stand, but little is left of the 464 mud-brick piers that supported the wooden roof, and nothing remains of the mosaics that once ornamented the interior. The stupendous spiral minaret, of fired brick (fig. 467), towers to a height of 176 feet; it forcefully recalls the principle of the Mesopotamian ziggurat adapted to spiral form.

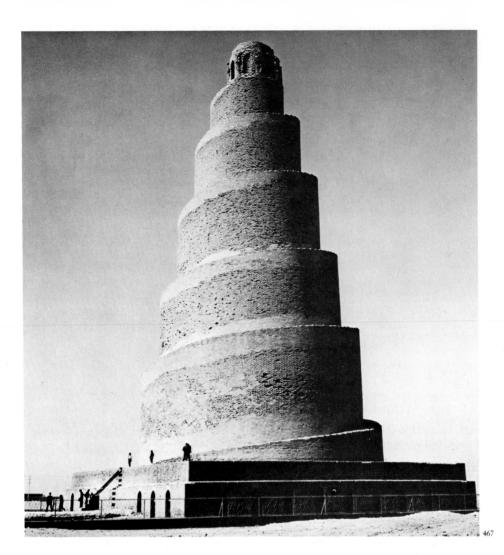

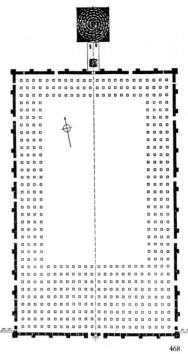

CAIRO Something of the grandeur of the Great Mosque at Samarra, and much of its original character, can be seen in the well-preserved mosque built at Cairo by a former inhabitant of Samarra, Ibn Tulun, from 877 to 879. This new Muslim city rose near the vanished Memphis of the pharaohs, and its surviving Islamic buildings rank second in quality only to the nearby monuments of ancient Egypt. Many of these buildings were of great importance to the medieval architecture of Europe. The Mosque of Ibn Tulun is the earliest (fig. 469). The rectangular structure, measuring 460 by 401 feet, was built on a slight eminence and enclosed by a crenellated outer wall. A double arcade lines the wall on three sides (fig. 470), and a five-aisled portico on the fourth contains the mihrab. As at Samarra the piers are of brick, but here they were protected with a thick coating of fine, hard stucco, which has survived almost intact and which makes the building appear monolithic. The sharply pointed arches, of noble simplicity, are supported by massive rectangular piers of brick, into whose corners colonnettes (little columns) are set, an early example of a device used extensively in Christian architecture of the Middle Ages. The ceiling was originally coffered below the wooden beams; little of the coffering is intact, but the rich floral ornament, carved into the plaster of the arches as if into stone, has survived in splendid condition. Especially remarkable are the smaller arches that pierce the spandrels of the larger ones to no apparent purpose; they produce an impression of lightness and variety, treating the arch—as often in Islamic architecture—as something that can be freely played with.

467. Spiral minaret, Great Mosque of al-Mutawakkil, Samarra, Iraq. Fired brick, height

468. Great Mosque of al-Mutawakkil, Samarra. c. a.d. 848–52 (Plan after Creswell)

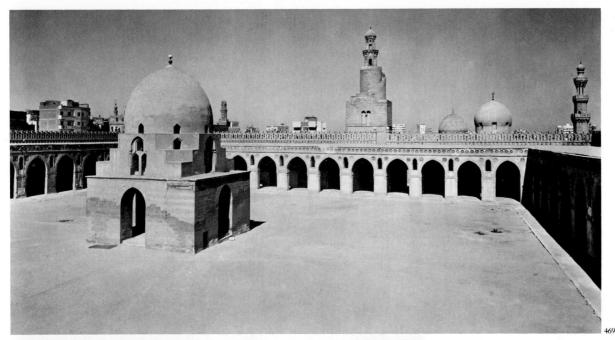

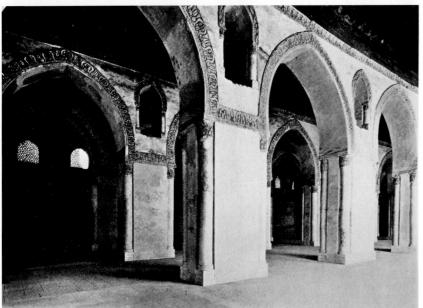

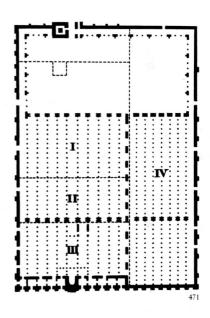

CÓRDOBA One of the most brilliant achievements of Islamic architecture, the Great Mosque (now the Cathedral) of Córdoba (fig. 471), was built in Spain. The original mosque, erected in 786, had all its aisles on the qibla side of the sahn. As necessity required, these aisles were repeatedly lengthened in the late eighth century and again in the tenth; eventually, the location of the Guadalquivir River forbade further lengthening in that direction, so the structure was extended on the east. Unfortunately, in the sixteenth century the canons of the Cathedral (the mosque had been converted into a Christian place of worship long since) built a choir inside it, greatly to the displeasure of the emperor Charles V, who rightly accused them of having ruined a monument unique in the world for the sake of something they could have built anywhere. But from most viewpoints the interior still presents an enthralling spectacle of seemingly infinite extent in any direction (fig. 472)—an endless forest of columns and arches without an axis. The hundreds of marble or granite columns

- 469. Courtyard, Mosque of Ibn Tulun, Cairo. c. A.D. 877–79
- 470. Arcades, Mosque of Ibn Tulun, Cairo
- 471. Plan of the Great Mosque, Córdoba, Spain, showing successive enlargements. c. A.D. 786–987 (Plan after Marçais)

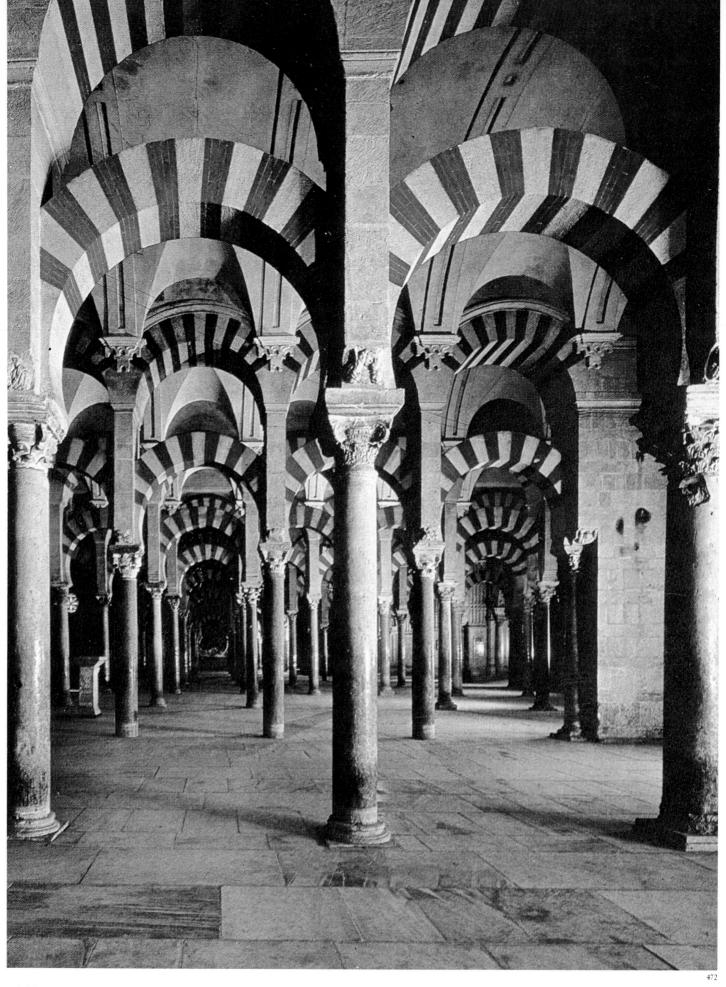

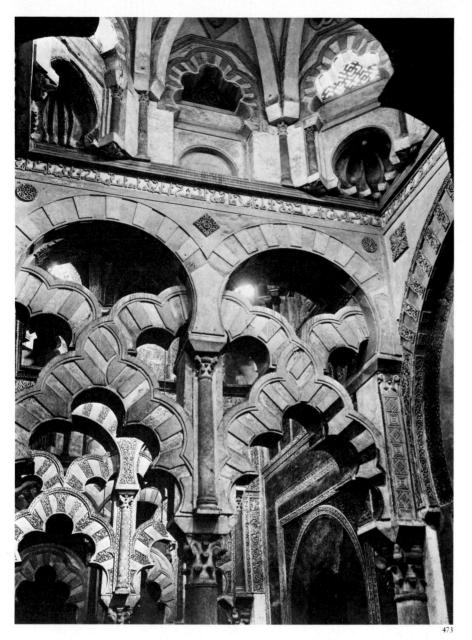

472. Interior, Great Mosque, Córdoba. c. A.D. 786

473. Vestibule of the mihrab, Great Mosque, Córdoba. c. 10th century A.D.

were, of course, cribbed from Roman and Early Christian buildings, but visually they play second to the striped arches, unknown in architecture before Muslim builders employed them. The uniqueness of the Great Mosque of Córdoba demonstrates a principle common to many mosques—that Islamic space, originally at least, was not determined by the requirements of a set ritual as was that of Christian interiors. In the basilica the columns, like the worshipers, unite in obedience to the longitudinal vista extending toward the altar; in the mosque the columns are endless and uniform like the worshipers, who are united only in common prayer.

Another striking feature of the Great Mosque of Córdoba is the introduction of a second set of freestanding arches above the first. These spring from square piers that stand on the Roman columns as though on stilts. These flying arches, intended to uphold a wooden roof (the vaulting was added in the sixteenth century), ingenious as they are, are outdone by the inventions in the mihrab, which was built during the last southward extension of the mosque in the tenth century. The arches here are scalloped and intertwine freely in open space (fig. 473). Other arches soar from the upper corners to cross as ribs for the vault. Here and there, in

the archivolts, in the inner surfaces of the arches, and in the vertical panels, appear passages of pure arabesque; the area that in Classical architecture would constitute the frieze is decorated with passages from the Koran in fluid, richly ornamental Arabic writing.

THE MADRASAH OF SULTAN HASSAN Among the host of splendid religious structures that rose throughout the Islamic world, we must present a completely new type, the madrasab, a building intended for religious and legal instruction (because the two were fused in the Islamic theocracy). The first such combined theological seminary and law school seems to have been built in Persia about A.D. 1000. The architectural requirements were a customary central sahn and separate quarters for each of four schools, each school to be administered by one of the four orthodox Muslim sects. The solution was a series of cells for each school at one of the four corners of the sahn; in the center of each face of the sahn a spacious prayer hall separated one school from its neighbor. These halls, with one side entirely open to the court, were known as iwans; the iwan on the Mecca side, of course, contained the mihrab and the minbar. Apparently, the shape of the iwan was suggested by the giant, almost pointed barrel vault of the open audience hall in the third-century palace of Shapur I at Ctesiphon (see fig. 463), a building that could be easily visited from Baghdad. The arches of the iwans, however, were always sharply pointed, in more or less the shape of the pointed arches of the Mosque of Ibn Tulun (see fig. 469), and their majestic open spaces dominate the sahn. Once established, the madrasah became the model for all large mosques in Persia.

In fourteenth-century Egypt the Mamluk sultans (descendants of Turkish slaves who had seized power) built a number of madrasahs in Cairo. Their size was limited, however, by the existing buildings of the

Later Architecture

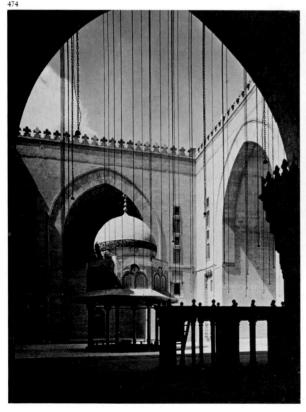

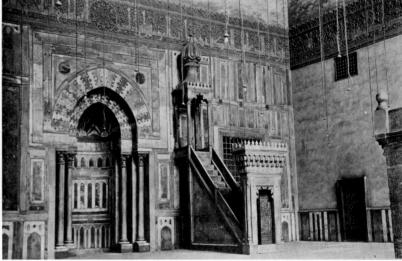

- 474. Courtyard of the Madrasah of Sultan Hasan, Cairo. c. A.D. 1356–63
- 475. The East Iwan containing the mihrab and minbar, Madrasah of Sultan Hasan, Cairo

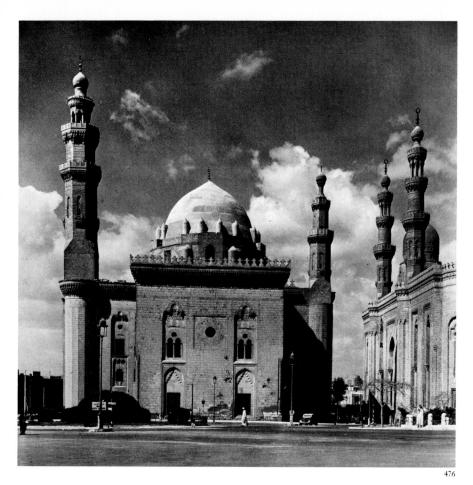

476. Madrasah and Mausoleum of Sultan Hasan, Cairo

metropolis. The grandest example is the madrasah constructed by Sultan Hasan in 1356-63 (fig. 474), whose towering iwans leave little room for windows in the four stories of student cells at the corners of the restricted sahn. With their pointed barrel vaults, the iwans give an overpowering impression of mass and space, increased by the chains of the seventy bronze lamps that still hang in the sanctuary (as once in Early Christian basilicas). The east iwan, richly paneled in veined marble, contains the usual mihrab and minbar (fig. 475), surmounted by a superb arabesque frieze. Behind the gate to the minbar can be seen the bronze grille that gives access to the domed interior of the sultan's tomb, a new type of structure which the Muslims appear to have emulated from Western examples. From the exterior (fig. 476) the two buildings seem almost separated, both blocklike, their walls pierced with pointed windows, some single, others paired with a round window above, in a grouping that may reflect the tracery of French Gothic cathedrals (see Chapter Six, and fig. 583). The tomb is crowned with a handsome pointed dome; the adjacent minaret, square in plan with several superimposed octagonal stories, rises to a height of nearly three hundred feet.

THE OTTOMAN TURKS The achievements of Islamic religious architects, like those of Roman imperial builders, stand throughout North Africa, Spain, the Balkans, and the Near East—and also in northern India, Pakistan, and even western China. The Ottoman Turks, who, in 1453, conquered Constantinople and put an end to the Byzantine Empire, were by no means as inventive as their Arab predecessors, and the capital renamed Istanbul does not offer the infinite surprises that delight the visitor bold enough to brave the dusty and tumultuous alleys of Cairo. Hugely impressed by Hagia Sophia, which along with the other churches

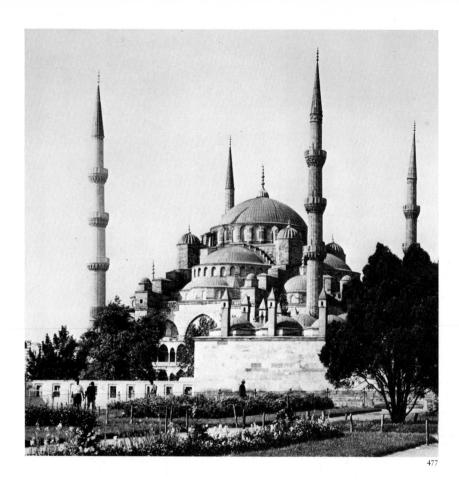

477. Mosque of Ahmed I, Istanbul. c. A.D. 1609-17

of the capital the Turks turned into mosques, the Ottomans confined themselves to producing innumerable variations of Justinian's masterpiece in large, medium, and small sizes. It is thus extremely difficult to pick out from a distance Hagia Sophia itself in Istanbul's romantic skyline of domes and minarets. Although the interiors of the Ottoman centralplan mosques seem heavy when compared with the seraphic lightness of Hagia Sophia, their exteriors, such as that of the Mosque of Ahmed I, built from 1609 to 1617 (fig. 477), often resulted in a considerable refinement and systematization of the free arrangements of domes and semidomes designed by Anthemius of Tralles and Isidorus of Miletus eleven hundred years earlier.

THE TAJ MAHAL The Mogul conquest of India in the sixteenth century brought to power over that subcontinent, with a long and rich artistic tradition, an art-loving Islamic dynasty that built palaces and entire cities of a magnificence rivaling that of imperial Rome. It is no accident, therefore, that perhaps the best known of all Islamic monuments is the Taj Mahal (fig. 478), outside Agra in northwestern India, erected by the Mogul Emperor Shah Jehan from 1623 to 1643 as a tomb for his favorite wife, the beautiful Mumtaz Mahal, and later for himself. Much sentimental legend has gathered about the building. While the emperor was undoubtedly deeply attached to his wife, he was able to console himself for her loss with any number of concubines. It has recently been shown that the inscriptions from the Koran that ornament the building refer neither to the empress nor to Shah Jehan's devotion, but exclusively to the Last Judgment and to the Garden of Paradise, symbolized by the splendid surrounding formal gardens (the present Italianate planting is nineteenth century). The entire park, enclosed by lofty red sandstone walls with

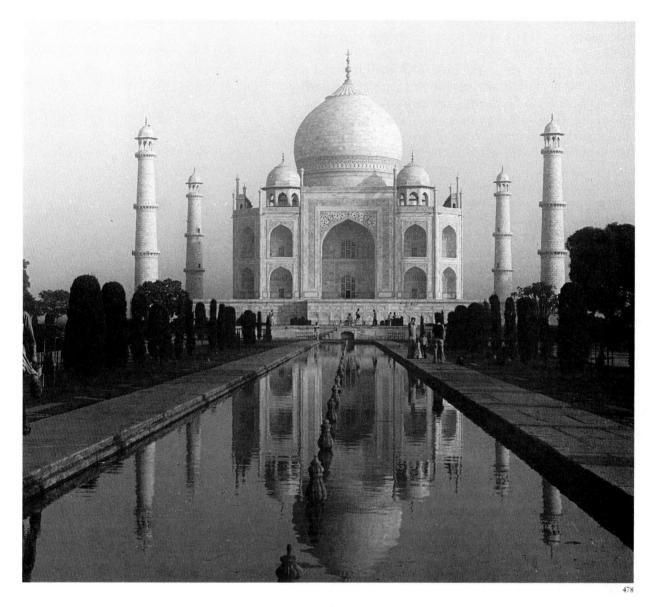

478. Taj Mahal, Agra, India. 1623-43

ornamental gateways inlaid with black-and-white marble, covers an area larger than that of Saint Peter's in Rome and its entire Piazza.

The central mausoleum is flanked by two mosques (not shown in the illustration), also in red sandstone and marble. But the mausoleum itself, including the lofty platform on which it stands and its four delicately tapering cylindrical minarets, immediately suggests a different spiritual realm. All are constructed entirely of snowy marble, smooth but not polished, so that its crystals both absorb and radiate the intense Indian sunlight. While the basic principle—a central block surmounted by a pointed dome—derives eventually from such buildings as the Madrasah of Sultan Hasan, every effort has been made to dissolve the sense of mass. As in earlier Mogul tombs, such as the Mausoleum of Hamayun at Delhi, the four iwans have been transferred to the exterior, opening up the four faces of the block. The corners are cut to provide four new diagonal faces, each of which, as well as the spaces remaining between them and the central iwan, has been pierced by two superimposed smaller iwans—this six for each corner, or a total of twenty-four, creating as much void as solid. The central dome, over 250 feet high, slightly bulbous, and extremely graceful in its swelling curves, is flanked by four smaller domes, surmounting open octagonal pavilions. Similar structures crown the minarets. Thus domes in three sizes and openings in six repeat in solid and void with the

utmost refinement the basic motive of the pointed arch with slight double curvature at the top.

The white marble surfaces are inlaid with floral ornament and Koranic inscriptions in black marble and colored, semiprecious stones, so calculated that every petal can be clearly distinguished with the naked eye from the platform below, and every inscription, increasing in inverse proportion to perspective diminution, read by anyone versed in Islamic script. Even the joints between the white marble slabs cladding the minarets are filled by delicate strips of black marble. The light is reflected upward with such intensity from the white marble terrace that shadows are greatly lightened, and the dome seems to float against the sky like a colossal pearl.

Shah Jehan was confined in his old age by his own usurping son Aurangzeb, but his prison was enviable—the splendid Red Fort of Agra. From an octagonal white marble pavilion set amid delicious gardens cooled by ingenious fountains and artificial waterfalls, the deposed monarch could look out across a broad curve of the Jumna River to the Taj Mahal, where he was eventually to rejoin his departed wife.

THE ALHAMBRA To many the supremely original creation of Islamic architecture will always be the Alhambra, the palace built by the Nasrid kings on a lofty rock above Granada in southern Spain in the fourteenth century, only a century and a half before the Moors were expelled from this last European fortress by Queen Isabella and King Ferdinand. The rich valleys and fertile slopes that surround Granada made the final Moorish kingdom in Spain a paradise during the fourteenth and fifteenth centuries, darkened only by the internal strife that eventually laid the kingdom open to Spanish conquest. The extreme refinement of the scholarly and art-loving court of the kingdom of Granada finds its embodiment in the beauty of the Alhambra. Surrounded on its hilltop by towered fortifications, against a backdrop of snow-covered mountains, the palace seems from the outside to be colossal; on entering, the visitor is all the more surprised at the intimacy, human scale, and jewel-like refinement of the porticoes, vaulted chambers, courts, gardens, pools, and fountains. A view across the Court of the Lions (fig. 479) suggests the disembodied fragility of this architecture, cloudlike in its lightness, flowerlike in its delicacy, but pervaded even in its last refinements by a rigorous sense of logic.

The colonnettes we first saw tucked into the corners of massive piers in the Mosque of Ibn Tulun (see fig. 469) reappear here freed from brute substance, standing singly in twos or threes, upholding vaults whose underlying bricks are covered with hard stucco carved into fantastic shapes—a honeycomb of microvaults, or airy structures made up entirely of arabesque interlace, of arches from which hang stalactites of pure ornament. While the individual elements can all be found in structures in Egypt and throughout North Africa, and especially in Persian buildings of the fourteenth century, nothing like this brilliant combination of them had ever been executed before or ever would be again.

Caught in their last redoubt between the Mediterranean Sea and the Spanish sword, the Nasrid kings lived an existence in which luxury was refined to its ultimate distillation. One could contemplate the arabesques at the Alhambra (see fig. 10) for days on end, and only begin to sample their delights. Such contemplation induces a passivity akin to transcendental meditation, freeing the intellect for the pursuit of the endless ramifications of pure logic. At first it may seem difficult to tarry over such complexities; the Western mind used to literal representation and clear-

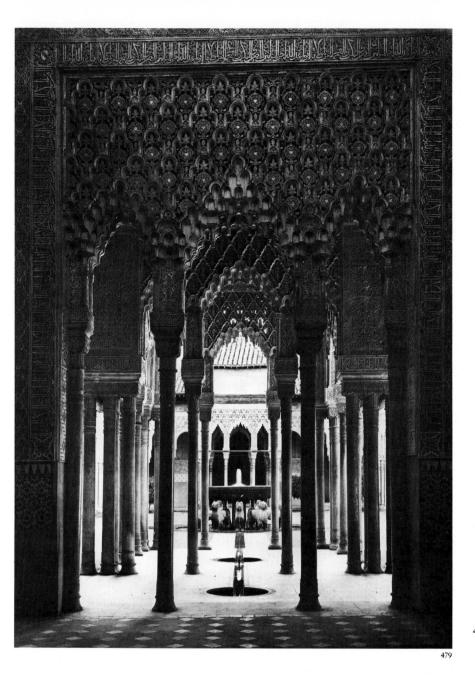

479. Court of the Lions, the Alhambra, Granada, Spain. c. A.D. 1354–91

cut definition turns away frustrated—one has not quite been able to experience it all. But like contrapuntal music, or like the carvings at Mshatta or at Córdoba (or for that matter like the interlace of Hiberno-Saxon manuscripts; see figs. 11, 494), these arabesques of Granada are severely separated into parts and regions, each assigned its own duty in the final intellectual structure.

To Muhammad sculpture was idolatrous by its very nature, and the device of Satan himself; he cleared all of it out of the Ka'bah, and all the paintings, too, for that matter, save one—strangely enough—of the Virgin and Child. Occasionally, sculpture sneaked back into Islamic art, but usually in the forms of decorative animals, like the richly carved lions that support the Alhambra fountain. Painting, while not permitted on a monumental scale, was useful enough for manuscripts—though always secondary to the art of calligraphy. Islam was blessed with a singularly graceful form of writing. The earliest script, a massive style called Kufic, was especially appropriate to carving in stone. A page from a Koran writ-

Painting

481

ten in the ninth century in either Syria or Iraq (fig. 480) shows how bold and harmonious this writing can be in manuscripts as well, with its noble black characters punctuated by red dots and adorned with a broad band of gold leaf used to emphasize an especially important passage. But there is more than at first meets the eye. One watches for a moment, and then the written characters come to life, transforming themselves into Muslims with red turbans, seated, prostrate, or kneeling in prayer, or lifting up their hands to Allah. This form of double imagery was not achieved in Western art until the sixteenth century.

By the thirteenth century lively explanatory or narrative illustrations were common in Islamic manuscripts, usually with the parchment as the sole background and sometimes without borders. Only a summary indication of setting is given, such as curtains or a plant here and there. Under the Mongol conquerors considerable changes appeared later in the century, partly due to Oriental influence—Chinese artists had been imported into Persia. An example of this hybrid art is the disarming *Temp*tation of Adam and Eve (fig. 481) from a manuscript of the Chronology of Ancient Peoples of al-Biruni, painted at Tabriz in Persia in 1307. The Garden of Eden is represented by fruit trees, rocks, and flowers, all ornamentalized in a style derived from Chinese painting. A very Oriental-looking Adam and Eve appear naked (almost unparalleled in Islamic art), except for ineffectual bits of transparent drapery, and with halos which to Christian eyes are undeserved. In fact, even Satan, garbed in a robe shaded in a very Chinese style and shown importuning a coy Eve with a golden fruit, has been provided with a halo. The real explosion of pictorial art in Persia occurred under the Mongol conqueror Tamerlane and his successors toward the end of the fourteenth century. Although converted to Islam, the Mongols paid slight attention to its prohibitions and restrictions against representation, and they covered their palace interiors with figurative mural paintings, of which we possess only mouth-watering descriptions by contemporary writers.

But the manuscripts remain, and they are dazzling. An especially beautiful example is the manuscript of the poems of Khwaju Kirmani by Junaid, one of the leading Persian painters, illuminated in 1396. In *Bibzad in the Garden* (fig. 482), a considerable expanse of landscape has been indicated by means of a division of the page into areas—the smallest being left for the text. The ground in this painting seems to rise like a hillside,

- 480. Page written in Kufic script from a Koran. Syria or Iraq, c. 9th century A.D. Illumination. The Metropolitan Museum of Art, New York. Rogers Fund, 1937
- 481. Temptation of Adam and Eve, illumination from the Chronology of Ancient Peoples manuscript of al-Biruni. Tabriz, Iran. A.D. 1307. Edinburgh University Library

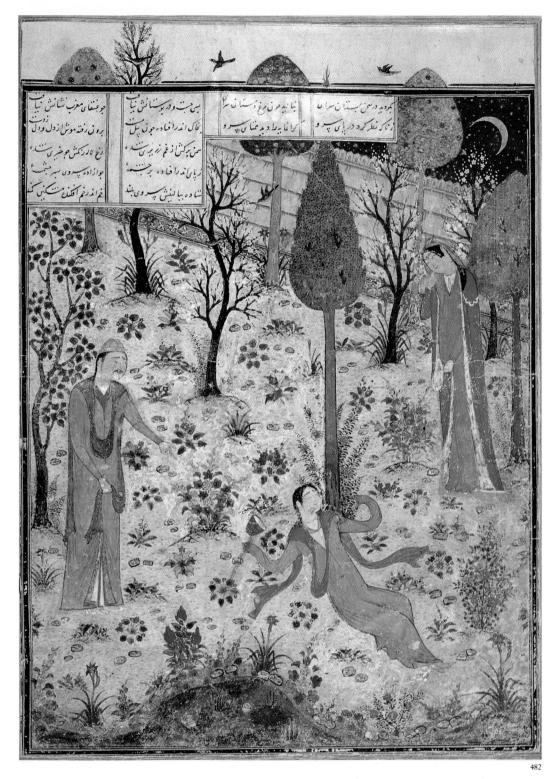

although horizontal extent was clearly intended. At the back a wall encloses the garden from the outside world, and above it one sees only the blue sky dotted with gold stars and a gold crescent moon. Even with the exquisite grace of his representation of foliage, flowers, figures, and drapery in a style that seems utterly relaxed, Junaid was never unaware of the inner rhythmic relationships of motives apparently strewn at random. Nor did he neglect the harmonies of rose, soft green, soft red, pale blue, and gold that make his picture sing. Junaid's joyous rediscovery of the visual world came, significantly enough, in the same century as the rebirth of naturalism in the work of the Late Gothic European masters.

482. JUNAID. *Bibzad in the Garden*, illumination from the manuscript of the poems of Khwaju Kirmani. Persian, A.D. 1396. British Museum, London

The great naturalistic achievements of ancient art in the West were renounced by Islam even more thoroughly than they had been by Christianity. The new religion favored a largely abstract planar art, ruled by the extremely subtle and flexible geometric relationships that appealed to the mathematical tendencies of the Arabic mind, and the resultant linear patterns achieved an unsurpassed richness and beauty. The hostility between the Islamic and Christian civilizations seemed only to increase Western fascination with the creations of Islamic art, which Westerners by the thousands, from every level of society, wondered at as the endemic conflict carried them back and forth across the Middle East, North Africa, Spain, and Eastern Europe. In spite of warfare, commercial and intellectual relationships flourished between the two societies. Islamic artifacts were imported in great numbers to adorn Christian homes, Kufic inscriptions found their way mysteriously into the tooled gold halos of Christian madonnas, and the great innovations of Islamic builders influenced Christian structures as late as the seventeenth century. The shapes and patterns of Islamic art formed ingredients as important to the creativity of the West as did the intellectual heritage of Islam to the philosophic thought and scientific knowledge of the High Middle Ages and the Renaissance.

BARBARIAN AND CHRISTIAN ART IN NORTHERN EUROPE

THREE

Throughout the history of the ancient world and the early Middle Ages, preliterate and literate societies, which we tend to think of as separate stages in human development, were in fact, at almost any given moment, locked in endemic conflict with each other. Ever since the Mycenaean civilization succumbed to the Dorian invaders the patterns of European history in many ways repeated themselves from age to age. Settled, literate, urban cultures in the sunny Mediterranean basin were magnets for wave upon wave of preliterate barbarian tribes (barbarian from the Latin word for "beard"; throughout most of their history the Romans were clean-shaven), from the dark forests, cold mountains, and windy steppes of the unsettled world to the north and east of the Alps, the Carpathians, and the Urals.

Sometimes the attack was completely successful, as with the Dorians in the years before 1000 B.C., in which case the defeated culture was obliterated and the barbarians took over, eventually to bring forth their own civilization. With the later waves of Celtic, Germanic, Mongol, and Slavic invaders the story was more complex. The Gauls, a Celtic people, besieged Asia Minor unsuccessfully in the fourth century B.C., then wandered along the eastern and northern perimeter of the Hellenistic world, to settle in northern Italy and in modern France, which they renamed Gaul. There they were conquered and annexed, like the indigenous peoples elsewhere, by the Romans in the course of their expansion. So were the Celtic Britons who had invaded Britain. Such tribes were first converted to the Roman state religion, then after Constantine to Christianity, but in spite of physical differences they were soon indistinguishable in dress and behavior from other Roman provincial populations; in fact they became Roman citizens and soldiers, assuming their role in defending the perimeter of empire against later waves of invaders.

By the fifth century A.D., in the third great wave of migrations, Germanic peoples, notably the Ostrogoths in Italy, the Visigoths in Spain, and the Vandals in North Africa, conquered both Romans and Romanized populations of whatever origin and again in turn became Romanized and Christianized. After the departure of the Romans from Britain in the early fifth century the Germanic Jutes, Angles (origin of the word England), and Saxons began their slow conquest of the island, driving the Britons into Wales. In the later fifth century another Germanic tribe, the Franks, took over Gaul and gave it their own name. In the sixth the Lombards entered Italy some time after the expulsion of the Ostrogoths and divided the peninsula irregularly and unstably with the Byzantines, who retained most of the ports, and with the popes, who had assumed political as well as spiritual control over Rome and a considerable surrounding area. Both Lombards and Franks were soon Christianized and so, in the later sixth century A.D., were the Anglo-Saxons, although by now Roman culture had been diluted to such a degree that we could scarcely speak of Romanization. Under these last invaders the feudal system grew up as a method of holding society together with ties of tribal loyalty. And finally there were the never-civilized tribes, above all the fierce Huns, Mongols who pushed the others along before them in their westward and southward migrations. The mobility of the barbarians is astonishing in a world without roads or bridges—for example, the transcontinental trajectory of the Gauls or the even more spectacular zigzag of the Vandals from Asia Minor to central Europe to Spain to North Africa, before they disappeared entirely in Justinian's short-lived attempt to revive Western Roman power.

More important than the disappearance of the Roman imperial title in the West were the virtual collapse of Roman administration, economy, manufacture, agriculture, transportation, education, and art and the depopulation of the cities. Only in the Church—especially the monasteries—did learning remain alive. The destruction in the West in two centuries of much of what the ancient world had built up throughout three millennia was by no means compensated for by the Christianization of the invaders. The ensuing era, generally known as the Dark Ages, was not as protracted as historians once believed, as we shall see when we come to the extraordinary figure of the emperor Charlemagne at the end of the eighth century.

In contrast to the monumental architecture of the Early Christian and Byzantine world, on whose inner walls is figured forth in pictorial imagery the full complexity of Christian iconography, the barbarians, as long as they lived in the wilds, had no permanent buildings at all, only structures of timber and wattles. As far as we can discover, the art of painting was unknown to them. The surviving buildings and images created by the invaders once they had settled (with the exceptions of the partially Byzantinized Theodoric and the Visigoths in Spain) are for the most part small, rough, and unpretentious, giving little indication that the Germanic tribes had learned much from the culture they destroyed. Astonishingly enough, few of these examples are comparable in quality to the metalwork, an ancient and highly refined art, that the tribes brought with them and presumably continued to practice.

This metalwork art was generally foreign to Mediterranean culture, but was especially relevant to the needs of nomadic peoples. Its practice was restricted to the manufacture of objects of daily life that the migrants could carry on their wanderings—weapons, personal adornments, and horse gear for the most part, often made of precious metals and studded with precious or semiprecious stones, but also objects of unknown ritual use. It is crucial to consider this barbarian art because both Celtic and Germanic ornament, generally free from all Classical restraint, formed a countercurrent to the humanistic heritage of antiquity throughout European art in the Middle Ages up to the dawn of the Renaissance and was later to burst forth in certain aspects of the art of the twentieth century. How far back these motives go, and how difficult they are to trace, can be seen in a magnificent hammered gold bracelet (fig. 483), of completely unknown ethnic origin, found at Bellye in present-day Hungary. The object, dating from some time in the second millennium B.C., consists of a triple armband ornamented on the inner flanges by an incised scallop pattern; on the outer the scallop becomes tendrils. The back flares into broad scrolls, also ornamented by tendrils. These ornamental motives turn up everywhere in primitive art—the tendrils, for example, appear not only in Tarxien in Malta (see fig. 35) but also in a gigantic burial mound recently excavated at Newgrange in Ireland. The scrolls suggest the volutes of Ionic capitals centuries later. Is it possible that certain forms are endemic in human creativity at any age and in any country?

- 483. Bracelet, from Bellye, Hungary. c. 2nd millennium B.C. Gold. Naturhistorisches Museum, Vienna
- 484. Cult wagon, from Strettweg, Austria. c. 7th century B.C. Bronze, height of goddess 8¾". Landesmuseum Joanneum, Graz, Austria
- 485. Tiara, from Poiana-Cotofeneşti, Rumania. c. 4th century B.C. Gold, height 9½". Museum of History of the Socialist Republic of Rumania, Bucharest

Celtic Art

The Celts, a race of great imaginative powers but, insofar as we know from Classical sources, given to horrifying sacrificial and funerary rites, swept across Europe in the fourth century B.C. and appear to have picked up a number of elements and ideas from settled cultures with which they had already come in contact. For instance, one of the finest examples of Northern European art we possess from the Bronze Age, a small bronze wagon found at Strettweg in Austria (fig. 484), shows contacts with Greece of the Geometric period. A product of the Hallstatt culture, known by the name of the village near which the original finds were made, the wagon probably dates from the seventh century B.C. What religious ritual it was intended to commemorate we do not know. A tall female figure, apparently a goddess, dressed only in a belt, supports a bronze bowl in the center of the wagon; she is followed by pairs of warriors on horseback and on foot, and by pairs of male figures flanking stags. This figure, and others like it, may suggest a leading role for women in some barbarian cultures. It has been shown that the goddess must have been directly imitated from Greek Geometric figures—at that distance from Greece! The animals also suggest Geometric art (see fig. 180), and the bronze work, not hammered but cast by the lost wax method, differs from the usual barbarian art.

Another splendid object of complex derivations (possibly not Celtic) and unknown purpose is the great gold tiara, perhaps a royal or priestly crown, found at Poiana-Cotofenești in Rumania (fig. 485) and apparently dating from the fourth century B.C. Certain motives, such as the shape of the headdress, the stylized curls, and the flaring horns above the eyes, have been traced to a possible derivation in the art of far-away Persia (see, for example, figs. 150 and 152). Giving even more credence to this theory is the figure kneeling on the neck of an animal as he slaughters it, represented in relief on the cheek-piece. But the staring eyes below the horns have just the disturbing effect we like to imagine as barbarian, whatever their original meaning.

In striking contrast to the eclecticism of these works are those identified with the richly productive La Tène culture, named after a site on

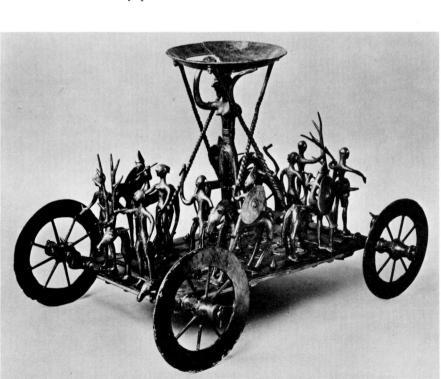

Lake Neuchâtel in Switzerland, where immense numbers of objects of a characteristic style were found in peat bogs, which indicates that they were thrown into lakes, ponds, or rivers. Since many were useless from any practical standpoint (gold swords, let us say), it seems probable that they were made from the start as offerings to water gods. Appropriately enough, all La Tène metalwork is characterized by a beautiful, sometimes bewildering fluidity of style. One of the most complex examples is an openwork ornament in bronze of about the third century B.C., found near a Celtic site at Brno-Malomeřice in Czechoslovakia (fig. 486). The organic shapes well outward and upward, expanding freely to enclose far more open space than solid form; a spatial pattern of surprising elegance and grace centers upon an antelope head with wide-open staring eyes and upward-twisted horns, but ends in delicate hooves. La Tène motives and shapes continue in Celtic art for the next thousand years or so, reappearing in some surprising places.

La Tène monumental art, as in the huge stone shaft-figure from Holz-gerlingen in Germany (fig. 487) of about the second century B.C., shows no comparable proficiency in dealing with stone, which bronze instruments could hack only roughly. The grim, horned figure is two-headed like the Roman god Janus, looking forward and backward, but no one knows its true cult significance.

The most mysterious of Northern metal objects is the *Gundestrup Caldron* (fig. 488), a huge silver bowl made of several pieces soldered together around an inner frame. Found in Jutland, the mainland of Denmark, it has been dated all the way from the second century B.C. to the fifth or sixth A.D. La Tène it is certainly not, but is it even Celtic? No one knows for sure. Its relief, on the outside, inside, and even the bottom, seems to

486. Openwork ornament, from Brno-Maloměřice, Czechoslovakia, c. 3rd century B.C. Bronze, 4½ × 5¾". Moravian Museum, Brno, Czechoslovakia

Figure, from Holzgerlingen, Germany.
 c. 2nd century B.C. Stone, height 79%".
 Württembergisches Landesmuseum, Stuttgart, Germany

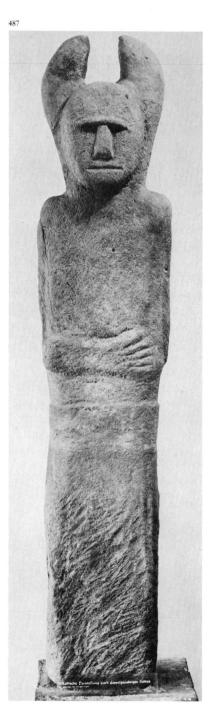

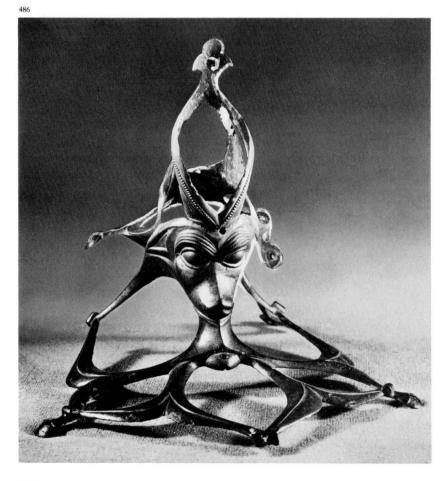

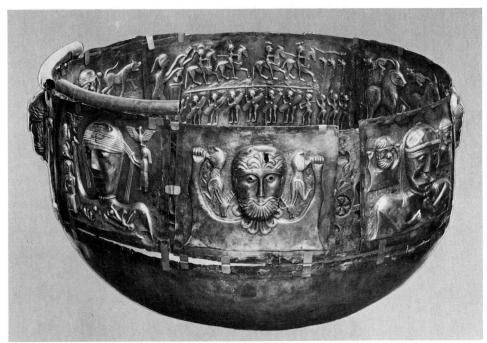

contain an entire world of mythology: raised busts whose extended hands grasp stags by the hind legs or birds with extended wings, warriors on horseback or on foot, elephants, griffins, leopards, winged horses, and seahorses, most of which obviously are not of North European origin. About the expressive and ornamental quality of the work there is no doubt, but the rest is sheer conjecture. The workmanship and some of the motives have been connected with craftsmen near the Black Sea, and it has been suggested that the great bowl was either carried all that distance, or made in Denmark by craftsmen brought along by some powerful chieftain. But the significance of the Gundestrup Caldron transcends even the mystery of its origin, date, and workmanship; it serves as a symbol of the incredibly complex tissue of later medieval art in Western Europe, in which not only all these motives turn up but many more as well.

Copenhagen

488. Caldron, from Gundestrup, Denmark. 2nd

century B.C.-5th or 6th century A.D. Silver,

height 161/2", width 27". Nationalmuseet,

A further ingredient in the medieval mixture was the art of Slavic groups, who apparently never reached Western Europe, although as we shall see, some of their products did make the journey and had decisive effect on the arts of Scandinavia, Ireland, and the islands between Ireland and England. Unlike La Tène art, in which mere portions of animals are occasionally embedded, the very subject of this nomadic art was animals. For this reason the term Animal Style is often applied to it. To find its origin we have to go back to the Scythians, a people who lived in what is today the southern U.S.S.R. They were regarded by the Greeks as archbarbarians, but before they were Hellenized they produced gold objects of great beauty and frightening intensity, such as the crouching panther (fig. 489) of the sixth century B.C., found in a burial mound at Kelermes. No work of twentieth-century sculpture has surpassed the power of the harsh masses and rhythms into which this animal is divided, nor the sheer ferocity of its snarling expression. The paws and the tail of the beast are beaten into the shapes of panthers, and the ears are executed in cloisonné. This technique consists of soldering small strips of metal to the underlying surface so that the small compartments they form may be filled with enamel, glass, or inlaid stones.

The Animal Style

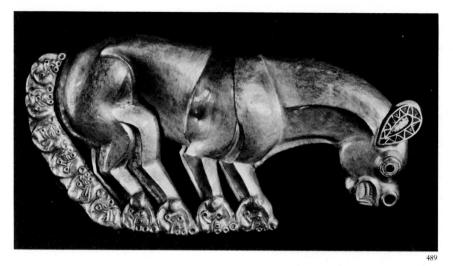

- 489. *Panther*, from Kelermes. Scythian, c. 6th century B.C. Gold, length 111/8". The Hermitage, Leningrad
- 490. Scythian plaque with animal interlace, from the Altai Mountains, Siberia. Gold, $5\frac{1}{8} \times 7\frac{3}{4}$ ". The Hermitage, Leningrad
- 491. Shield ornament, found at Helden, the Netherlands. Scythian(?), c. 1st century B.C.–3rd century A.D. Gilded silver, diameter 85/8". Rijksmuseum van Oudheden, Leiden, the Netherlands
- 492. Animal interlace, from a ship burial at Sutton Hoo, Suffolk, England. c. a.d. 655–56. Purse lid, originally ivory or bone, set with cloisonné plaques. British Museum, London

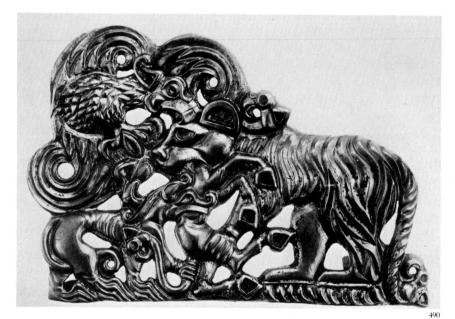

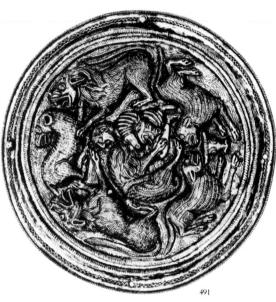

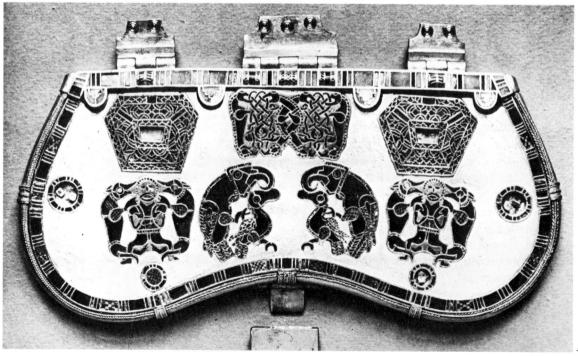

492

Another Scythian gold plaque (fig. 490) apparently came from the Altai Mountains far to the east in southern Siberia, just above the border of Mongolia. After a moment's gaze this seething caldron of destruction resolves itself into a wolf and a tiger that are tearing a colt apart, while an eagle in turn attacks the tiger with beak and wings. The fighting animals have begun to form an interlace, of bewilderingly fluid and complex shapes, whose parallel striations are derived from the stripes of the tiger, the feathers of the eagle, and apparently the shapes of grasses below. An indication of the immense geographic spread of this style may be seen in the discovery of an obviously related gilded silver disk, possibly a shield ornament, at Helden, the Netherlands (fig. 491). It may have been made at any time between the first century B.C. and the third A.D., either by Scythians or under Scythian influence, and was quite possibly carried for thousands of miles. The disk shows at least seven animals, including wolves and lions—not common in the Netherlands—in conflict over a cow, tearing at each other in the form of a spiral.

What eventually happened to this interlace of fighting beasts may be seen in a purse lid (fig. 492) from an Anglo-Saxon royal ship burial at Sutton Hoo in Suffolk, England, dated A.D. 655-56. The lid, originally ivory or bone, is set with cloisonné plaques, of which those at upper right and left are ornamented with purely geometric patterns. The central panel is composed of fighting animals whose jaws are prolonged to form interlaced ribbons. Below are two plaques, each composed of an eagle capturing a duck, while at either side appears that rarest of animals in migrations art, man, highly stylized and standing between two hostile wolves in a configuration that recalls the far-off days of the ancient Sumerians (see fig. 129); in fact, the motive may have been derived from heraldic groupings in Mesopotamian art. Surprisingly—and very important—this polyglot Sutton Hoo ship burial included a beautiful Celtic bronze mirror, with whorls and spirals in pure La Tène style. A final stage in the development of the animal interlace is seen in a fierce animal head in the carved wood of a prow (fig. 493), from a ship burial of Viking seafarers at Oseberg, Norway, datable about A.D. 825. The animal itself is frightening enough, with open mouth and glaring eyes, reminding one of its ancestry in the panther of Kelermes (see fig. 489), but the wood-carver has embellished its head with a rich interlace of crisscrossing and entwined ribbon-like shapes that one would have difficulty tracing back to their probable origins in animal combat.

The Anglo-Saxon pagan conquest of Britain in the fifth and sixth centuries A.D. left Christianized Ireland cut off from easy access to Continental Europe. Under such circumstances it is not surprising that a highly individual form of monasticism flourished in Ireland, a form adapted to the needs of an isolated country without urban centers. What was less to be expected was the rise of an intense Irish missionary activity, directed toward the Continent and toward England. From the sixth through the ninth centuries, Irish monks traveled through northern and central Europe, founding monasteries as far south as Switzerland and Italy. In 633, at the invitation of the king of Northumbria, one of the seven Anglo-Saxon kingdoms, an Irish monastery was established on the island of Lindisfarne, off the northeast coast of England. Quite independently, the Roman missionary Augustine arrived in England in 597 to commence the conversion of the southern Anglo-Saxons to the Roman form of Christianity, from which the Irish by that time had deviated in a number of

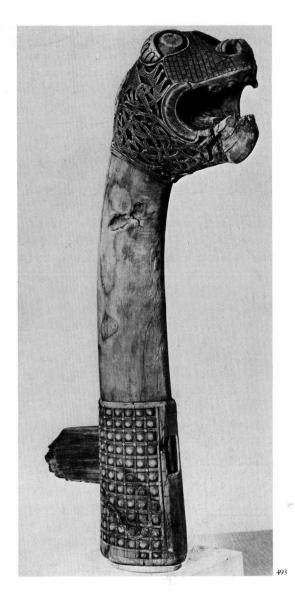

493. Animal head for a prow, from a ship burial at Oseberg, Norway. c. A.D. 825. Wood, height of head 5". University Museum of Antiquities, Oslo

Hiberno-Saxon Art

respects. At the Synod of Whitby in 664 the two missions met head on, not without fireworks. Eventually, the Irish submitted to Rome but continued to maintain a certain independence.

An activity essential to the Irish missions was the copying of religious books, especially the Gospels. For the enrichment of their manuscripts, the Irish drew on established metalwork traditions, both Germanic and Celtic, as well as on examples of Early Christian illumination. The resultant art, carried out in all probability by Anglo-Saxon artists (although this is by no means certain) under Irish inspiration, is best known as Hiberno-Saxon. The transformations of Early Christian originals produced by these artists are interesting, but these pale in comparison with the marvels they turned out in a tradition they knew and understood. For example, one of the earliest of the Hiberno-Saxon manuscripts, the Book of Durrow, done in Northumbria in the second half of the seventh century, contains a brilliant decorative page (see fig. 11) whose ornamentation, surprisingly enough for a work of Christian art, can be traced directly to three of the four types seen in the purse lid from Sutton Hoo (see fig. 492): the animal interlace, the abstract interlace, and the pure geometric, translated from metal into painting. All of it is carried out in a style based on clear contours bounding flat areas of color obviously derived from the cloisonné technique. But a momentous change has taken place. Instead of being freely scattered across the area as in the purse lid, the three types of ornamentation are combined into a unified whole by powerful embracing shapes and movements. Two horizontal panels of animal interlace at the top and two at the bottom are united by smaller vertical panels to bound a square, in which floats a circle containing abstract interlace. Within this interlace are embedded three smaller circles of geometric ornament, arranged in an equilateral triangle. In the center a smaller circle surrounds a cross, composed of four equal triangular elements. This total grouping combines within itself the numbers of the Gospels and the Trinity, and by means of these numbers—the three outer circles, the four corners of the square, and the four horizontal bands, whose widths and lengths are related to each other as one to four—imposes its own proportional unity on the pagan magnificence of the ornament. The animals-biting-animals pattern now proceeds in a beautiful rhythmic motion, which also obeys distinct laws of repetition, alternation, and reversal as well as those of color and shape, all of which may be deduced if one is willing to look long enough.

An even more splendid book, the Gospels illuminated at Lindisfarne from 698 to 721, shows a more highly developed form of this harmony between Christian symbolism and pagan ornamental tradition in a symbolic structure of dizzying complexity and cosmic grandeur (fig. 494). Cross, circle, and square, extended at top and bottom to fit the oblong format, embrace the entire page in a manner recalling the heavenly Cross of the catacomb frescoes (see fig. 397). All three symbols are filled with abstract interlace, so divided into different color zones that at the ends of the crossbars four smaller crosses emerge. Between the crossbars the fields are filled with animal interlace of violent activity. The comparatively serene ornament in the central circle discloses one large and four smaller crosses. Tabs projecting from the four outer corners are formed by animal ornament; on the center of each side is another tab composed of facing birds whose beaks show sharp teeth. Most surprisingly, pure La Tène ornament, whose origins go back a thousand years, fills the corners of the extensions with active whorls.

If the Hiberno-Saxon artists had a Continental model before them,

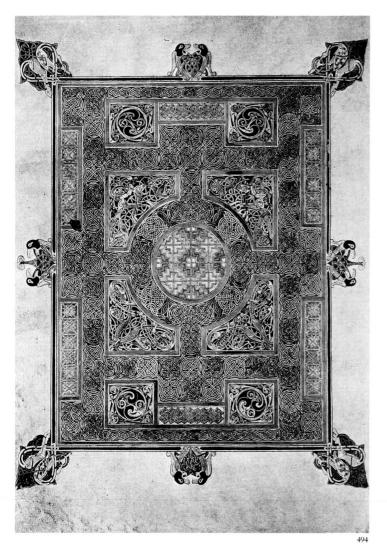

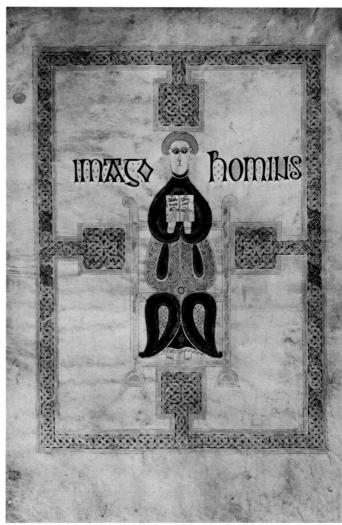

they translated its imagery recognizably enough into a geometrized equivalent, but when they invented their own figures, the result can be startling. The imago hominis (image of man) page from the Gospels illuminated in the first half of the eighth century by a Northumbrian artist at Echternach in Luxembourg (fig. 495) is conveniently labeled, for otherwise we might not know a human being was intended. The little head, with its endearing cross-eyes, appears caught in the mechanism of the cruciform interlace that proceeds from all four sides of the border seemingly to form a vise. The artist, asked to paint the winged man symbolizing Matthew, treated him as a six-winged seraph. Locked in place by the four bars, he completes the form of the Cross.

The freest compositions of the Hiberno-Saxon manuscripts are those that display enormous letters engulfing the entire page. No pagan scribe would have thought of endowing initial letters with exceptional importance. But since the Bible was divinely inspired and therefore sacred, its very letters—and most of all the initials—were regarded as exerting magical potency. What we might call the Baroque phase of the Hiberno-Saxon development is exemplified by the Book of Kells (fig. 496), a copy of the Four Gospels illuminated in southeastern Ireland between 760 and 820. The words Christi liber generationis (the book of the generation of Christ; Matt. 1:1) fill the entire page. The name of Christ, reduced to its Greek contraction XPI, becomes like the Cross an immense celestial apparition

- 494. Cruciform page from the *Lindisfarne Gospels*. Northumberland, England, c. A.D. 698-721. Illumination. British Museum, London
- 495. Imago Hominis (Image of Man), illumination from the Echternach Gospels. Luxembourg, c. 1st half of 8th century A.D. Bibliothèque Nationale, Paris

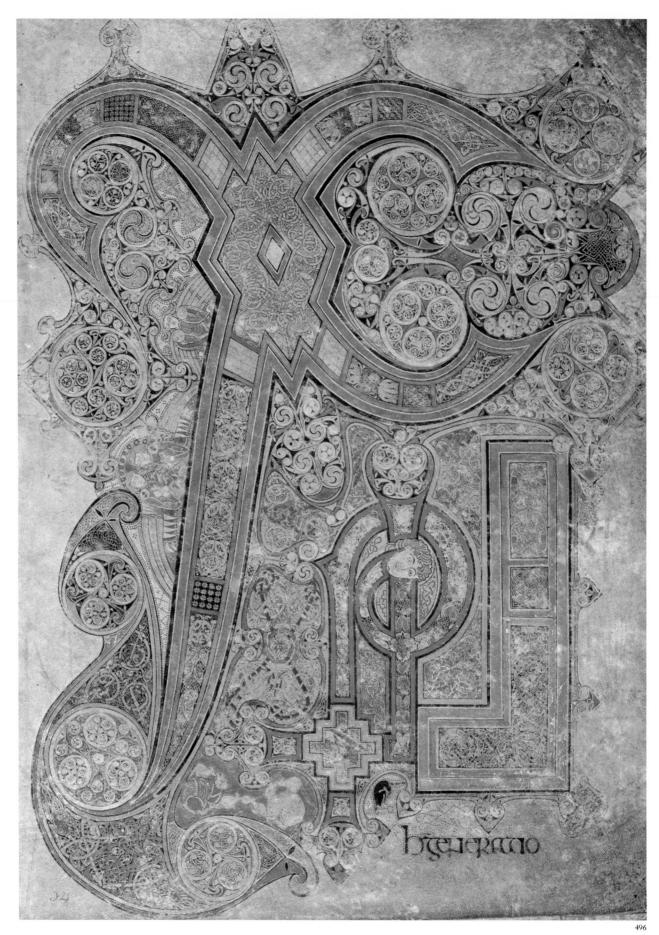

496. *XPI* page from the *Book of Kells*. Ireland, c. a.d. 760–820. Illumination. Trinity College, Dublin

(divided neatly, of course, into successive areas of animal interlace, abstract interlace, and geometric ornament). The powerful diminishing curves, like comets, involve whole galaxies of La Tène circles-within-circles, large and small, filled with vibrant whorls—all going at once. After contemplating this revelation for a while, we are astonished to see emerging from its intricacies the faces and upper torsos of three unhappy little people, trapped among feathers and teeth along the clean outer edge of the mighty X, like the antelope head in the ornament from Brno-Malomeřice (see fig. 486). Stranger yet, in the second spiral from the bottom of the page, at the tail of the same shape, two naturalistic mice appear in a heraldic grouping on either side of a small round object (a piece of cheese?), contemplated by two sleepy cats, each with a mouse on its back.

Barbarian and Hiberno-Saxon artifacts, wherever preserved or whenever excavated, seem always to have been admired, even in periods dominated by realistic standards of representation. Animal fantasy and the animal interlace, reflecting symbolically the realities of barbarian existence in the steppes and the forests, persisted—Christianized only partially if at all—as a major ingredient in the imagination of the illuminators in the Hiberno-Saxon monasteries. For reasons about which we can only speculate, the interlace was not to outlast for long the year 1000, but animal fantasy flourished for the duration of the Middle Ages. Its wildness, ferocity, sometimes even obscenity formed an astonishing countercurrent to the official piety of Romanesque and Gothic church decoration and manuscript art, turning up in the most unexpected places and inundating with a fresh wave of intensity the art of certain Northern Renaissance masters. Living a submerged existence in the folk legends and superstitions of rural regions, this animal fantasy was to surface in a wholly new form in the subconscious symbolism of Surrealism in the first half of the twentieth century.

TIME LINE V

Sarcophagus of Junius Bassus

HISTORY

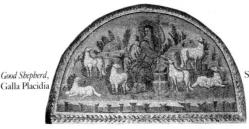

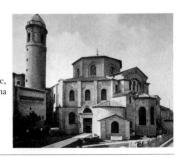

	Histori	
200	Shapur I, Sassanian king of Persia, r. 242–72 Constantine the Great, r. 324–37	
	Constantinople (Byzantium) new imperial capital,	
300	330	
	Theodosius divides Empire: East (Arcadius), West (Honorius), 395	
	Honorius makes Ravenna capital of West, 402	
400	Alaric I, Visigothic king, sacks Rome, 410	
	Galla Placidia regent of West, 423-25	
	Vandals invade North Africa, 429	
	Attila, king of Huns, destroys Milan, 450;	
	Pope Leo persuades him to spare Rome	
	Odoacer takes Empire of West, Ravenna, 476;	

end of Western Roman Empire

Culture

Christian persecution in Roman Empire, 250
Emperor Gallienus grants Christians right to possess churches, 260
Great persecution, 303–05
Constantine proclaims toleration, Edict of Milan, 313
First Council of Nicea, 325
St. Jerome translates Bible into Latin, 382
St. Augustine writes City of God, 412
Council of Ephesus; Mary proclaimed Theotokos (Mother of God), 431
Silk cultivation brought from China
St. Patrick (d. 461) said to have founded Christian church in Celtic Ireland

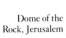

Queen's Chamber, the Alhambra

500	Theodoric founds Ostrogothic kingdom in Italy,
	488-526
	Justinian Emperor of Byzantium
	Byzantine army reconquers Ravenna, 540
	Lombards establish kingdom in Italy, 568
600	Muslims conquer Byzantine provinces in Near
	East and North Africa, 637–40
700	Omayyad caliphate, Damascus, 661–750
	Muslims take Visigothic Spain, 711
	Abbasid caliphate, Baghdad, 750-1256
800	Macedonian Dynasty, 829–976
800	Vladimir I, duke of Kiev, r. 980–1015
	Viadimii 1, duke of Kiev, 1. 900–1019
1000	California battarana Fantana and Wastonniahana
1000-	Schism between Eastern and Western churches

becomes final, 1054

Justinian initiates "Golden Age," 527–65, codifies Roman laws Muhammad, prophet of Islam (c. 570–632), flees Medina (Hegira), 622 Text of Koran established, 651

Iconoclastic controversy, 726–843; Second Council of Nicea rejects Iconoclasm, 787 Macedonian "Renaissance" marks return to Hellenistic ideals Conversion of Russia to Orthodox Church, c. 990

1600

EARLY CHRISTIAN AND BYZANTINE/ISLAMIC/NORTHERN EUROPE

Hagia Sophia, Istanbul

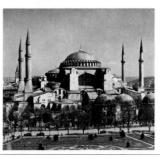

Pantocrator, Daphni

Hosios Loukas, Phocis

Painting, Sculpture, Architecture

Scythian gold objects Gundestrup Caldron Ceiling fresco, Catacomb of Sta. Priscilla "Domus ecclesiae" and Haman and Mordecai, Dura-Europos Palace of Shapur I, Ctesiphon Ceiling fresco, Catacomb of SS. Pietro e Marcellino Old St. Peter's; Sta. Gostanza Mosaics at Hagios Georgios, Salonika Mosaics at Sta. Maria Maggiore Mausoleum of Galla Placidia at Ravenna, with mosaics Sarcophagus of Junius Bassus; The Three Marys at the Sepulcher Vatican Virgil St. Simeon Stylites, Qal'at Saman; Colossus of Barletta

PARALLEL SOCIETIES

Scythian, Celtic	200
Roman Empire	
Early Christian Sassanian Persian	300

400

Scythian Panther

Animal-head prow, Oseberg Ship

Echternach Gospels

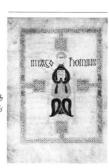

San Vitale and S. Apollinare in Classe, Ravenna, with mosaics
Hagia Sophia; Vienna Genesis; Rabula Gospels; Christ and Virgin diptych
Purse lid, Sutton Hoo; Book of Durrow; Echternach and Lindisfarne gospels
Book of Kells; Oseberg Ship
Dome of the Rock; Great Mosque, Damascus, with mosaics
Great Mosque, Córdoba; frescoes at Castelseprio
Great Mosque, Samarra; Mosque of Ibn Tulun, Cairo
Virgin and Child mosaic, Hagia Sophia; Paris Psalter; Joshua Roll
Churches at Hosios Loukas; Hagia Sophia, Kiev, with mosaics
S. Marco, Venice, with mosaics; mosaics, Cathedral of Cefalù
Lamentation, Nerezi; St. Demetrius, Vladímir
Frescoes, Sopoćani; frescoes and mosaics, Kariye Djami; Stylite,
Novgorod
Alhambra; Madrasah of Sultan Hasan; Bibzad in the Garden
Old Testament Trinity by Rublev
Last Judgment, Voronet; Cathedral of St. Basil, Moscow; Tai Mahal

Lombards Muslims	500
Hiberno-Saxon	
Byzantine	
•	600
	700
Carolingian	700
Ottonian	
Romanesque	800
Gothic	1000-
	1600

THE ART OF THE HOLY ROMAN EMPIRE

FOUR

The victorious advance of the Muslims in Europe was stopped in 732 at Tours, two thirds of the way from the Pyrenees to the English Channel, by Frankish forces under Charles Martel. It is sobering to contemplate how different European history, and consequently European art, might have been had Charles Martel lost this battle. Charles Martel (the word *martel* means "hammer") was a high official under the weak Merovingian kings, and he gave his name to the Carolingian dynasty that, under his son Pepin the Short, replaced them. Pepin entered Italy, in answer to the pope's appeal, to defend the papacy against the Lombards; in 756 he gave Ravenna and the surrounding territory, which rightly belonged to the Byzantine Empire, to the pope, thereby at once strengthening the ties between Rome and the Frankish kingdom and weakening those between the Eastern and the Western Church.

Pepin's son, known to history as Charlemagne (Charles the Great), ruled as Frankish king from 768 to 814, a reign of forty-six years that transformed the cultural history of northern and central Europe. On Christmas Day in A.D. 800 he was crowned Roman emperor in Saint Peter's by Pope Leo III. While it appeared that Charlemagne revived the fifth-century division between East and West, in fact he ruled a region which included modern France, the Low Countries, Germany, much of central Europe, a small slice of northern Spain, and Italy down to a borderline not far south of Rome. He governed this territory from his court in the German city of Aachen (also known by its French name of Aix-la-Chapelle), near the modern border of Germany with Belgium and the Netherlands. Charlemagne actually founded a wholly new institution, a northern dominion known after the thirteenth century as the Holy Roman Empire. For more than a thousand years his successors exercised an often disputed and never clearly defined authority over much of Europe, until Napoleon dissolved the Holy Roman Empire in 1806. In the imagination of the Middle Ages, the emperor exercised in temporal affairs the sovereignty that in spiritual matters belonged to the pope. Since the latter was by now a temporal monarch as well, largely by courtesy of the Carolingian rulers, Pepin the Short had opened a Pandora's box, which none of his successors ever quite succeeded in closing.

Carolingian Art

Abbot Einhard, Charlemagne's biographer, said of him that "he made his kingdom which was dark and almost blind when God committed it to him . . . radiant with the blaze of fresh learning hitherto altogether unknown to our barbarism." If we discount courtly hyperbole, Einhard's claim still contains much truth. We must imagine the Roman cities of Charlemagne's realm as largely in ruins and very nearly depopulated, and there is no indication that he tried to rebuild them. To his court at Aachen, however, he brought Greek and Latin manuscripts, and foreign scholars, especially Alcuin of York, who supervised imperial campaigns aimed at the revival of Greek and Roman learning and the establishment of the correct text of the Bible, which, through constant recopying, had grown corrupt. Such concerns are remarkable in an emperor who retained Frankish dress and who, although he understood spoken Greek and could converse in Latin, never succeeded in learning to write. The emperor's architectural ambitions seem to have been limited to the embellishment of the imperial court and of the monasteries that, under the Benedictines based at Monte Cassino in southern Italy and under the Irish monks who had founded monasteries in much of the territory to which Charlemagne fell heir, had established themselves as Western guardians of Classical Christian culture.

ARCHITECTURE Little of what Charlemagne built is still standing in anything like its original condition; luckily, the chapel of his palace at Aachen is preserved, although it was extended by a Gothic choir in the late Middle Ages and stripped of its splendid decorations. The architect, Odo of Metz, is the first builder known to us by name north of the Mediterranean. The Palatine Chapel of Aachen is an octagon (figs. 497, 498),

108

497. Odo of Metz. Palatine Chapel of Charlemagne, Aachen, Germany. 792–805

498. Plan of the Palatine Chapel of Charlemagne, Aachen (Later additions in fine line)

and a first glance will show that Odo modeled it on San Vitale at Ravenna, a church that Charlemagne must have greatly admired. The next look, however, discloses crucial differences. The flexible, expanding plan of San Vitale (see figs. 418, 419) has been abandoned, possibly because it was unbuildable in stone, possibly because no one knew enough about architectural draftsmanship in 792 to reproduce it; Odo may never have visited Ravenna. Each of the seven transparent apses of San Vitale has been replaced by two superimposed round arches. The upper arch embraces two levels, the lower of which is a straight arcade formed by three round arches, and the upper of which is sheer fantasy—two columns that support the crowning arch at just the point on either side of the keystone where it needs no support, as these lateral archivolts tend to be pushed up, not down, by the pressure of the central keystone. Such a use of Early Christian—in fact, Roman—motives, shorn of their original function and deprived of their true spatial extension, was significant for Carolingian figurative art as well. Needless to say, many if not all of the colored marble and granite columns and white Corinthian capitals were imported from Roman buildings in Italy. The heavy masonry is built of massive blocks of stone, but the cores of the piers are rubble. Originally, the dome was resplendent with a mosaic representing Christ enthroned in Heaven among the four-and-twenty elders rising from their thrones to cast their crowns before his throne, according to the vision of John (Rev. 4:1-10), an appropriate subject for a patron who claimed divine authority for his own imperial rule. (Recently, it has been suggested that the enthroned Christ is a later interpolation, and that the original mosaic showed the Lamb upon the throne.)

Interestingly enough, the customary narthex, set at an angle at San Vitale, is replaced here by a central portal flanked by two circular towers and entered from the main court of the palace. The emperor could thus attend Mass in the gallery as though in a box at the theater, and he could appear at an opening above the portal to the populace in the court outside. Here Charlemagne had set up a bronze equestrian statue of Theodoric (a worthy model, as a Romanized Germanic chieftain), which he had brought across the Alps from Ravenna. The court could hold about seven thousand persons. The design of the Palatine Chapel was so successful that it was repeated several times in different parts of Germany.

Centula. In the still largely agricultural and patriarchal society of the Franks and their Germanic and Gallic subjects, there was no need for new urban churches, but monasteries were essential to Charlemagne's program, and he rebuilt them and founded new ones in great numbers. Only a few remain, largely remodeled, but plans exist that show how crucial these monasteries were for the late Middle Ages. The plan of the now totally vanished Abbey Church of Saint-Riquier at Centula (fig. 499), near Abbéville in northern France, is basically that of a Constantinian basilica with a nave and two side aisles for the congregation, the whole structure roofed with timber. The extensive transept was necessary for processions from the sacristies, where the vestments and vessels for the Mass were kept, to the altar. The apse is separated from the transept by a rectangular space called the choir, intended for the use of the monastic community in chanting the complex music of the Mass and of the Divine Office (the prayers at the seven stated hours). The choir, generally supplied with elaborately carved seats rising in tiers on either side, became a fixture in monastic and cathedral churches from then on. The church plan thus assumed, almost accidentally, the shape of a cross.

At the west end (churches where possible faced east toward Jerusa-

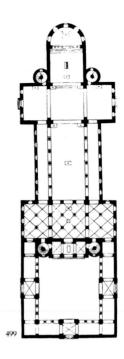

499. Plan of the Abbey Church of St.-Riquier, Centula, France. Late 8th century (After Wilhelm Effmann)

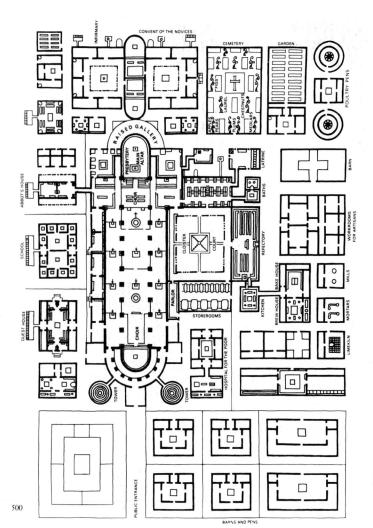

500. Schematic plan for a monastery at St. Gall, Switzerland. c. 819 (Drawing after a 9thcentury manuscript)

lem) is an important addition—a narthex running at right angles to the nave and projecting beyond it, forming in effect a second transept. This addition is known in German churches as the westwork (fine later examples are shown in figs. 509, 550). The westwork was divided into two or even three groin-vaulted stories; the upper levels could be used as chapels for smaller services. Before the westwork is a large atrium, as at Saint Peter's. In the corners of the atrium, on either side of the westwork, are two cylindrical staircase towers, and two more are visible flanking the choir in the angles of the transept. These towers apparently rose to a considerable height. It may fairly be asked what their use could have been. We do not know whether bells were employed in European churches at this time, but if they were, a single tower would have sufficed for this purpose. Four clearly represent an attempt to assert the existence of the church and to render it visible from afar. To make its appearance still grander, Saint-Riquier also sported massive round towers above the crossing points of the nave with the westwork and with the transept. These towers culminated in round lanterns; both corner towers and lanterns had conical roofs. All at once the lofty skyline of the medieval cathedral appears in germ, replacing the low profile of the Early Christian basilica.

Saint Gall. In 816–17 a council at Aachen devised an ideal plan for a monastery, which was sent to the abbot of Saint Gall in Switzerland (fig. 500); although he did not follow it exactly, the plan is revealing in that it shows all the major features of a later Western medieval monastery. The

plan is dominated by the church, whose semicircular westwork is flanked by two cylindrical towers. The customary nave and side aisles of the interior lead as usual to transept, choir, and apse. The buildings to the left of the church include a guest house, a school, and the abbot's house. Behind the apse and to the right is a building for novices. Adjacent to the novitiate and to its right lie the cemetery (frugally used also as an orchard), the vegetable gardens, and the poultry pens. In the position that became customary in all oriented churches, in the southwest corner of the transept—the warmest spot in the monastery—is the cloister, a courtyard surrounded by arcades, under which the monks could walk, write, and converse. Storerooms flank the cloister to the west, the monks' dormitory with connecting bath and latrine lies to the east, and a refectory for meals with a nearby kitchen is to the south. To the right of the refectory are workshops, brewhouse, bakehouse, and other work buildings. A hospital for the poor is adjacent to the southwest tower. The whole was laid out with the same sense of system and order that prevailed in a Hellenistic or Roman civic center, for the monastery was indeed a town in itself.

The Carolingian period is often characterized as a renaissance, since Charlemagne made a deliberate effort to revive Classical antiquity. But each renaissance (that of Augustus or of Hadrian, for example) picks and chooses among the treasures of the past only those it feels it needs. Charlemagne did not revive temples or nude statues; he was interested in establishing in the North a durable Christian society after an interregnum of tribal chaos. He went to considerable trouble to work out an administrative system for his empire, and widespread knowledge was necessary for the fulfillment of his purpose. For the acquisition and diffusion of knowledge, the monasteries, with their libraries and busy scriptoria (rooms for copying manuscripts), staffed by disciplined and devoted monks, were essential. As we have seen, the earliest extant copies of many ancient, even pagan, authors were made in these very scriptoria.

Lorsch. It is interesting, therefore, to see what dignity could be given to the gateway leading to the imperial Abbey of Lorsch, in the central Rhineland (fig. 501). This little building was imitated from the now-vanished triple gateway that gave access to the atrium before Saint Peter's (see fig. 402). Charlemagne has let his gateway stand free like a triple arch of triumph. Undoubtedly, the columns and capitals were culled from a Roman building. But the pilasters above the columns support colored marble zigzags that savor more of Germanic metalwork than of ancient Rome, and the overall effect of the monument, agreeable as it is, is anything but Classical with its flickering background of inlaid colored marble lozenges on the first story and octagons on the second, not to speak of its steep, northern roof.

PAINTING AND LITURGICAL ARTS From contemporary accounts we know that Charlemagne heard evidence on both sides of the iconoclastic controversy then raging in the East (see Chapter One, page 328); he rejected the views of those who would destroy religious images and would forbid the creation of new ones, yet even more firmly he opposed the worship of images. The emperor was deeply interested in the instructional value and the quality of the mural paintings and mosaics throughout his realm; he commissioned an inventory of their subjects (which still survives) and expected periodic reports on their condition. He ordered that paintings done during his reign were to depict Christ

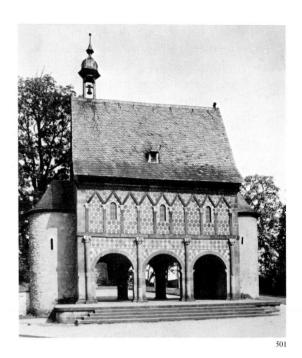

501. Gateway, Abbey of Lorsch (Hesse), Germany. 768–74

and the Apostles, narratives from the New Testament and to a lesser extent from the Old, and the lives of the saints. Military leaders from ancient history could be shown if paralleled with their Christian counterparts (for example, Alexander/Constantine), but Classical deities and Classical personifications were to be avoided in paintings visible to the public. Alas, little but the written accounts remains of the presumably splendid Carolingian art of mural painting, and what does survive is either so provincial or so fragmentary that we can gain no clear idea of how the murals once looked. But illuminated manuscripts from the period are preserved by the score, often in well-nigh perfect condition. They glow with color and gold and are so beautiful that we mourn the loss of the wall paintings all the more.

The manuscripts illuminated for the emperor himself were often written, like those commissioned by Justinian, in letters of gold on purple parchment. Although he could not write, Charlemagne laid great stress on legibility. He caused the often indecipherable script of Merovingian times to be replaced by a new form of letters, more useful than the capitals that the Romans employed exclusively. (In fact, the capitals used on this page are based on those in inscriptions dating from the reign of Trajan, while the small letters descend from the script invented for Charlemagne and taught throughout his dominions.) Schools of illumination were set up at various centers, including the court at Aachen and the bishoprics of Reims, Metz, and Tours. Although the large initial letters often proudly display the complex interlaces of Hiberno-Saxon tradition, the illustrations are figurative, either copied from Early Christian originals (this is a hypothesis, since no such originals are known) or invented anew. Christ and the Evangelists were often given full-page illustrations— Christ as King, the Evangelists as authors. King David, naturally enough, was another favorite of the emperor and was often prominently depicted. Pages were also filled with canon tables (which show the correspondence of passages in the four Gospels), written in under illusionistic arcades.

Coronation Gospels. One of the finest Carolingian manuscripts is the Coronation Gospels, which is said to have been found on Charlemagne's knees when his tomb was opened in A.D. 1000. Like most manuscripts of the Palace School, the Coronation Gospels are illuminated only with canon tables and with full-page portraits of the Evangelists. The Evangelist Matthew (fig. 502) is painted in a manner so Classical that it is hard to realize we are looking at a work done between 795 and 810, rather than five hundred years earlier. The Evangelist, seated on a folding stool, is robed in snowy white and holds his inkhorn above the page with his left hand while his right, grasping a reed pen, is poised as if he were awaiting inspiration. The background landscape, with its rich blue-greens and with rose-andwhite clouds streaking the sky, not to speak of the lights and shadows and the soft brushwork of the mantle, comes straight from the Helleno-Roman illusionistic tradition. This beautiful illustration has often been compared with Roman author representations, especially the *Portrait of Menander*, of the Fourth Style, dating from about A.D. 70, from the House of Menander at Pompeii (fig. 503). But as Meyer Schapiro has pointed out, there is a fundamental difference, which tells us much about the essential character of illuminated manuscripts. Like all authors in Classical art, Menander is shown reading from a rotulus, in a relaxed and patrician manner. Matthew is pictured writing, in a codex, of course. To the Greeks and Romans writing was a manual activity they relegated to slaves, and books were copied quasi-mechanically in shops, which were the ancestors of modern publishing houses.

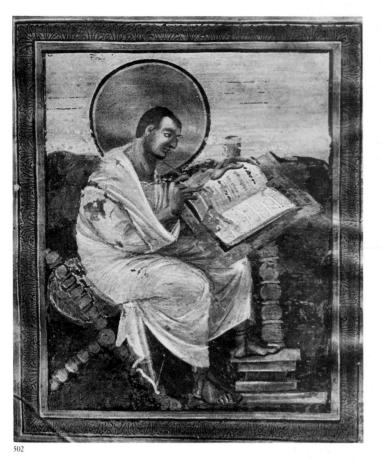

Christians believe that "In the beginning was the Word, and the Word was with God, and the Word was God" (John 1:1). Thus, copying the Word was a sacred duty; how much more elevated, then, the activity of writing under direct divine inspiration! It is to this solemn moment that the Carolingian painter admits us. And, like all medieval artists, he was not really interested in an exact representation of earthly relationships. We look at the portrait through a Classical acanthus frame as though through a window, but one leg of the stool is clearly outside the frame, the other rests on its edge, and the Evangelist's right foot is placed somewhere near the base of the writing desk, not really on it. The question of the homeland of the artist who illuminated the *Coronation Gospels*, at once so serenely Classical and so profoundly Christian, has often been asked but never answered. He may have been an Italian trained in the Byzantine tradition, but in the absence of any paintings of this style in Italy itself, we cannot say.

Ebbo Gospels. A startling transformation of the calm, Classical image takes place in the manuscript of the Reims School, of which the outstanding example is the Ebbo Gospels, illuminated for Ebbo, archbishop of Reims between 816 and 841. The same Matthew (fig. 504), seen through the same acanthus frame, has suddenly been seized as if by the furor divinus. He bends over as he writes, clutching his quill pen, his eyes almost starting from their sockets with excitement, his drapery dashing madly about his form, the very locks of his hair on end and writhing like serpents. Both the figure and the quivering landscape have been so rapidly set down in quick, nervous strokes of the brush that they seem to participate in his

502. Saint Matthew, illumination from the Coronation Gospels. c. 795–810. Weltliche Schatzkammer, Hofburg, Vienna

503. *Portrait of Menander*, wall painting in the House of Menander, Pompeii, Italy. c. 70

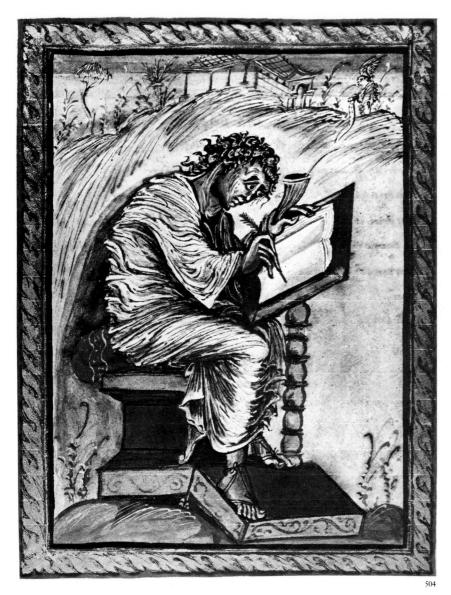

504. Saint Matthew, illumination from the Ebbo Gospels. Reims, France, 816-41. Bibliothèque Nationale, Paris

emotion, recalling the words: "The mountains skipped like rams, and the little hills like lambs" (Ps. 114:4). The tiny structures in the background seem seriously endangered in this cosmic dance, and even the acanthus leaves of the frame run like flames about the edges—left and upper borders together, right and lower borders meeting. The angel, Matthew's symbol, is sketchily brushed in on the right horizon; he brandishes a scroll, the source of the Evangelist's inspiration. We are here confronted with a form of ecstatic mysticism that we shall seldom see again so eloquently expressed before El Greco in the sixteenth century. Free brushwork, till now the recorder of vision, has become a vehicle for inspiration.

Utrecht Psalter. One of the masterpieces of Carolingian art is the Utrecht Psalter, a book of psalms written and illustrated in the Reims School (which comprised several monasteries) at about the same moment the Ebbo Gospels was being illuminated and in a similar passionate style. This psalter was illustrated entirely with quill pen, and in the course of time the ink has turned a rich brown, running from quite dark brown to soft golden tones. The little drawings are frameless, scattered freely about the page between the psalms, some invading the Latin text (still written, by the way, in traditional Roman capitals, without spaces between the words). The compositions may derive from earlier models, and the sprightly drawings in the psalter are the work of several different hands of varying degrees of quality. However, the style is so consistent that one major master must have inspired the unflagging freshness of the scenes and their rapidly moving and gesticulating figures. The illustrations are quite literal. Fig. 505 illustrates both Psalm 82 in the King James Version (81 in the Douay Version), which is written in the central register, and Psalm 83 (82 in the Douay Version), whose text appears on the following page of the psalter. Psalm 82 is pictured in the top register. The illustrations can best be read juxtaposed with the appropriate verses.

Verse 1 God standeth in the congregation of the mighty; he judgeth among the gods.

In the center the Lord, in a mandorla and holding a crossstaff, addresses crowds on either side of him; farther out three angels on each side keep a respectful distance.

Verse 4 Deliver the poor and needy; rid them out of the hand of the wicked.

At the lower left an angel with a sword welcomes the poor, while their tormentors slink

Verse 5 . . . all the foundations of the earth are out of course.

At the lower right a giant (Tellus, the Roman god of the earth, shown nude in this manuscript intended for the elite) shakes the earth gleefully, and things fall to bits.

Verse 7 But ye shall die like men, and fall like one of the princes.

Crowned figures watch while an angel sets fire to a statue on a column; two angels knock a statue down, and two men die at the base of its column.

Psalm 83 (82 in the Douay Version) is illustrated in the bottom register.

Verse 2 For, lo, thine enemies make a tumult: and they that hate thee have lifted up the head.

At the left a confused crowd of armed men lift up their heads.

Verse 12 . . . Let us take to ourselves the houses of God in possession

In the center people fill the arches of a pedimented house; one defies the Lord, who bears shield and spear.

Verse 14 . . . as the flame setteth the mountains on fire; . . .

Right and left, on either side of the Lord, angels set fire to the mountains with torches.

Verse 17 Let them be confounded and troubled for ever . . .

At the bottom an army on horseback retreats rapidly; three of the horsemen are trapped in rope snares.

The artist never loses either the compositional coherence of the entire image, made up of several moments in time with the Lord always pictured in the center, or the speed of a sprightly pen style, which fairly dashes across the page.

Bible of Charles the Bald. After Charlemagne's death his descendants partitioned his domains and proved incapable of continuing his great dream of a newly revived Roman Empire. Nonetheless, the lively narrative and

expressive style of the Reims School continued to influence the development of manuscript painting under Charlemagne's grandson, Charles the Bald, who ruled over a region corresponding more or less to modern France. Charles briefly wore the imperial crown (875–77). The splendid Bible of Charles the Bald, now in Rome, contains a rich series of succinct visual narrations, in brilliant colors, picturing scenes from both Old and New Testaments. One full-page illustration (fig. 506) gives incidents from the ninth chapter of Acts in three registers. At the left of the upper register Saul (not yet Paul) receives a scroll from the high priest on which are written letters for Damascus. At the right, on the way to Damascus, he falls to the ground before the Lord, who appears as the conventional Hand of God, to the astonishment of his companions, who hear a voice but see no one. At the left of the central register Saul is led blind into Damascus. At the right the aged Ananias, asleep on his bed, lifts his hand to the Lord, from whom he receives the command to restore Saul's sight. The miracle, in which Ananias places his hand on Saul's eyes, has been moved out of order to the center of the register and also occupies the center of the page. At the lower left Saul confounds the incredulous Jews; at the right he is let down over the walls of Damascus in a basket.

505. The Last Judgment (above) and Angels of the Lord Smiting the Enemies of the Israelites (below), illuminations from the *Utrecht Psalter*. Reims, c. 820-32. University Library, Utrecht, the Netherlands

The scenes unfold according to the continuous method we have seen in all manuscript narrations so far, a scheme derived ultimately from Roman historical reliefs. But the naturalistic concepts of support and of enclosure have been dismissed. Green earth runs under most of the scenes, with blue sky and white clouds above, but often the feet of the figures in one scene project beyond the ground strip into the clouds of the scene below. Likewise, the simple baldachin on four columns, which does triple duty for the Temple in the first scene, for the house of Judas in which Saul receives his sight in the fifth, and for the locale where Saul con-

506. Scenes from the Life of Saint Paul, illumination from the Bible of Charles the Bald. Rome, c. 875-77. S. Paolo fuori le mura, Rome

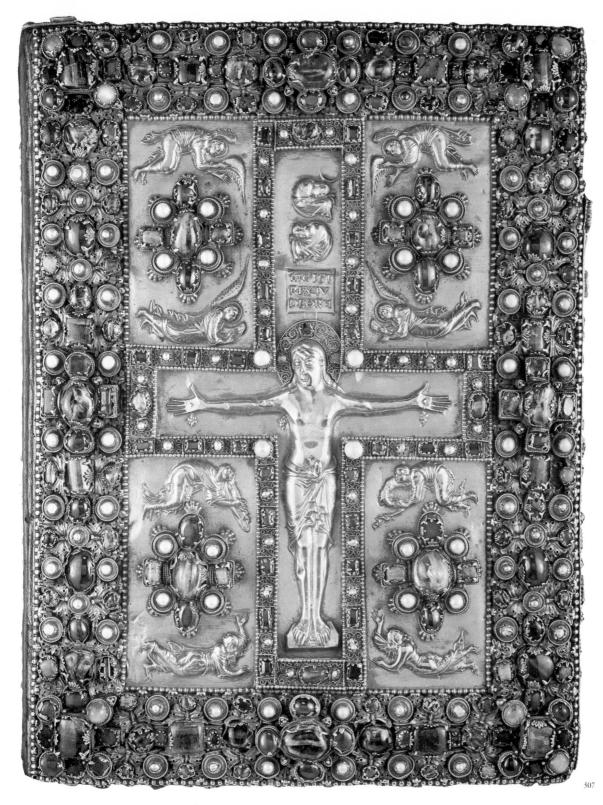

founds the Jews in the sixth, does not enclose the figures, who stand or walk in front of columns they should be behind. The little cities of late Roman and Early Christian art are now toylike. The broad strips of energetic figures and ornamental architecture have been worked into a pattern uniting the whole page, enlivened and reinforced by the systematic distribution of blues, greens, red-browns, rose tones, and lavenders.

How precious the illuminated Christian codex, the work of many months and even years, had become as compared with the utilitarian rotulus of antiquity may be seen in the magnificent covers that protected

507. Front cover of the Lindau Gospels. c. 870. Gold with precious and semiprecious stones, $13\frac{3}{4} \times 10\frac{1}{2}$ ". Pierpont Morgan Library, New York

the painted pages. The back cover of the Lorsch Gospels (fig. 508), probably carved at the court of Aachen in the early ninth century, is made of ivory, as were the Early Christian and Byzantine diptychs from which the style derives. In the central relief a beardless Christ stands under an acanthus arch supported by modified Corinthian columns, as mentioned in Psalm 91 (90 in the Douay Version), Verse 13: "Thou shalt tread upon the lion and the adder: the young lion and the dragon shalt thou trample under feet." A rabbit appears at the right, a very wavy adder at the left, and under Christ's feet the lion and the dragon are being firmly trampled. The arches of the side panels shelter the angels who, in Verse 11, are given "charge over thee, to keep thee in all thy ways." In the upper strip two angels uphold a medallion containing the Cross; in the lower left the three Magi come before Herod and on the right they present their gifts to the Virgin and Child. Clearly, the style is directly imitated from Early Christian or Byzantine originals (see fig. 416, for example); the beardless Christ suggests a source in Ravenna. However, as in the manuscripts, the drapery patterns, still fluttering freely at the edges, are beginning to crystalize into ornamental motives that do not derive from the actual performance of cloth over bodies.

Most dazzling of all the covers are, of course, the ones made of gold and studded with precious and semiprecious stones, whose craftsmanship

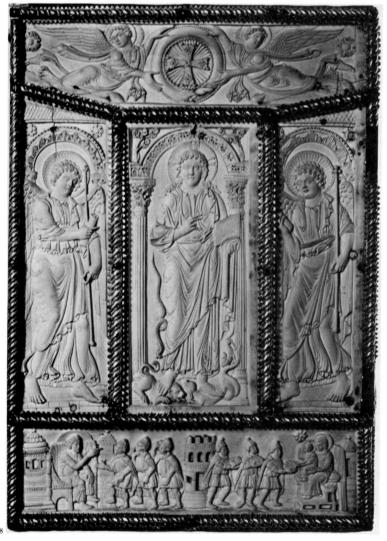

508. Back cover of the *Lorsch Gospels*. Early 9th century. Ivory, 14¾ × 10¾". Vatican Museums, Rome

50

shows that the Germanic tradition of metalwork was by no means extinct. The front cover of the Lindau Gospels (fig. 507), made apparently in the third quarter of the ninth century for a Carolingian monarch, is almost unbelievable in its splendor. Not only the massive acanthus frame but also the interlaced border of the Cross are set with gems, not faceted as is customary today, but smooth and lifted above the gold to receive light from all sides. Christ is represented calmly alive (a type known as the Christus triumphans), seeming to stand on the footrest and to extend his arms voluntarily. He is shown as one who has conquered death. Above his head little half figures representing the sun and the moon hide themselves, and in the upper panels four angels float in beautiful poses of grief. In the panels beneath the Cross, in the style of the flying angels, crouch the figures of Mary, John, and the other Marys. The still-Hellenic delicacy of the floating drapery contrasts strongly with the barbaric richness of the jeweled setting.

Under the uncertain conditions prevailing in northern Europe in the ninth century, the continued maintenance of imperial administration throughout so great an area would have required a dynasty of rulers of Charlemagne's exceptional ability. Unfortunately, his successors divided his empire among themselves and were unequal to the task of repelling renewed waves of invasion. The Vikings made inroads into France, established themselves in Normandy as semi-independent dukes, and became Christianized. In the east the Carolingian kings were menaced by incursions from Magyars and Slavs. As the dynasty disintegrated, the Holy Roman Empire lapsed. Royal power in France passed to Hugh Capet, whose fourteen dynastic successors ruled without interruption until 1328. In Germany the duke of Saxony was elected king as Henry I, but avoided ecclesiastical coronation. His extraordinary son, Otto I (reigned 936-73), was determined to revive imperial power on a Roman scale, but he succeeded only in reestablishing direct rule over Germany and Italy, often by installing members of his family in crucial positions. He set up relatives as dukes throughout Germany; married the widow of Lothair II, king of Italy; and arranged the marriage of his son, later Otto II, to Theophano, daughter of the Byzantine emperor Romanus II, thereby laying claim to Byzantine southern Italy. Otto I also made three expeditions to Italy, had himself crowned king at Pavia, deposed two popes and nominated their successors, and reinforced the imperial claim to the right to approve papal elections. Before Saxon hegemony came to an end in the eleventh century, two descendants of Otto I had occupied the throne of Peter. The five Ottonian rulers (919-1024) brought Germany to the artistic leadership of Europe in the construction of monastic buildings, in painting, and in the revived art of monumental sculpture.

ARCHITECTURE Only a few Ottonian church buildings remain, including the westwork of the Benedictine Abbey Church of Saint Pantaleon at Cologne, consecrated in 980 (fig. 509); the church was especially favored by Archbishop Bruno of Cologne, the brother of Otto I. Although most of the church was transformed in the late Middle Ages, the surviving original fragment shows us something of the grandeur of Ottonian architecture. The two arms of the westwork and the western porch (the latter a modern addition) are of almost equal length, radiating from a square crossing tower with a pyramidal roof. In the angles stand tall towers, which begin square, continue octagonal, and end cylindrical. We

Ottonian Art

509. Westwork, St. Pantaleon, Cologne, Germany. c. 980

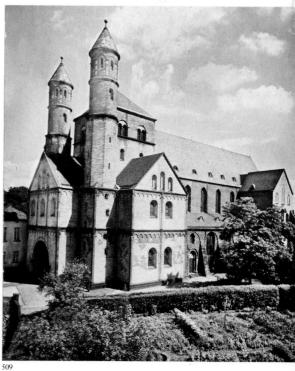

are at once aware of two new traits of style. First, the powerful impression exerted by the exterior is achieved by block masses of heavy masonry rather than by the thin, flat walls used by Early Christian architects. The splaying of the windows, to admit more light, increases the apparent thickness of the walls. Second, the stories are separated by corbel tables (tiny blind arches without supports, upholding a continuous cornice). The establishment of a strong exterior view of the church building, begun in Carolingian architecture, thus culminates in a dramatic massing of clearly demarcated cubes, pyramids, octagons, and cylinders.

One of the most active patrons of the arts during the Ottonian period was Bishop Bernward of Hildesheim, who had been a tutor of Otto III and who had traveled to Rome. The great Church of Saint Michael at Hildesheim (fig. 510), which Bernward rebuilt from 1001 to 1033, was considerably altered in later times and largely destroyed in World War II. It has since been reconstructed so as to reproduce as far as possible its eleventh-century appearance. The exterior view shows the westwork to the right, the choir and apse to the left, and identical square towers over the two crossings. The side-aisle windows are later Gothic additions. The transept towers have been moved from the inner corners to the ends. In the interior the westwork is raised above the level of the rest of the church in order to provide an entrance to a crypt with an ambulatory (fig. 512 was photographed from the level of the westwork). Especially original is the way in which the sometimes monotonous impression of the customary basilican interior is broken up. The massive masonry construction permitted a high clerestory, separated from the nave arcades by an expanse of unbroken wall surface, doubtless intended for frescoes. The nave arcade itself, as in some Eastern basilicas, is broken by a pier after every second column into three groups of three arches on each side, there being twelve columns and four piers in all. It can scarcely have escaped Bernward's attention that he was founding this numerical arrangement on the number of persons in the Trinity, the number of the Twelve Apostles, and the number of the Four Evangelists.

- 510. Plan of St. Michael's, Hildesheim, Germany. 1001–33 (Architectural reconstruction after Beseler)
- 511. St. Michael's, Hildesheim (rebuilt after destruction in World War II to conform to its appearance in the 11th century)
- 512. Interior, St. Michael's, Hildesheim (view from the westwork)

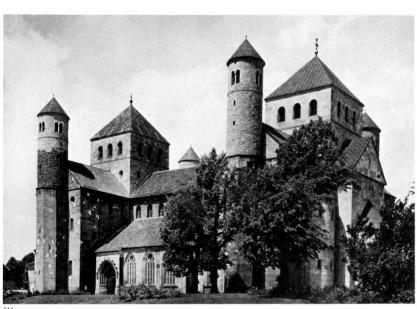

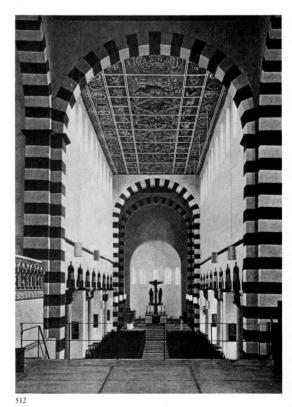

511

SCULPTURE Bernward commissioned for the south portal of Saint Michael's a pair of bronze doors (fig. 513), completed by 1015 and probably before 1035 installed in Hildesheim Cathedral. Bronze doors were traditional in ancient times (the Pantheon had a splendid set), and plain bronze doors without sculpture had been made for the Palace Chapel at Aachen. Bernward is recorded to have been an amateur artist and is generally believed to have supervised not only the iconographic program but also the actual execution of the doors. These massive plates of bronze, about fifteen feet in height, appear each to have been cast in one piece. They begin a long succession of figured bronze doors created throughout

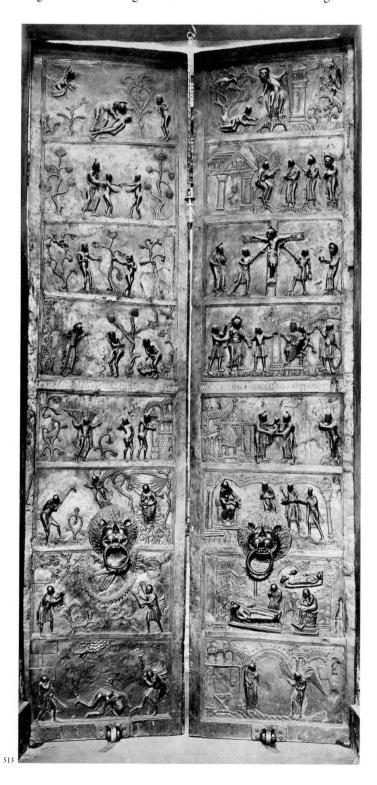

513. Bronze doors with scenes from the Old and New Testaments. c. 1015. Height c. 15'. Cathedral of Hildesheim

the Middle Ages and the Renaissance in Germany, Italy, and Russia, culminating in Ghiberti's masterpieces for the Baptistery in Florence. In sixteen scenes (the number of the Gospels multiplied by itself), the story of man's Fall down through Cain's murder of Abel is told on the left door, reading from top to bottom, and that of man's Redemption through Christ is narrated, reading upward, on the right, a sort of *Paradise Lost* and *Paradise Regained*. Each of the eight scenes on either door is so matched with its counterpart on the other that they complement each other precisely. For instance, in the third pair from the top, the *Temptation of Adam and Eve* (man falls through eating the forbidden fruit of the Tree of the Knowledge of Good and Evil) is opposite the *Crucifixion* (man is redeemed through Christ's sacrifice on the Tree of the Cross). There is little indication of ground, and broad areas of background appear between the figures, so that each scene conveys a strong impression of enveloping space.

The individual narratives are intensely and spontaneously dramatic, and most of them give every sign of having been inspired by a direct reading of the text rather than drawn from iconographic tradition. The fourth scene from the top of the left door, *Adam and Eve Reproached by the Lord* (fig. 514), could hardly be more effective in its staging. An angry God (note that the triune God appears, as often in Creation scenes, in the form of Christ, with a cruciform halo) in a gesture of anger and dismay expostulates with the cowering Adam and Eve, who hide their nakedness with fig leaves. Adam blames Eve, Eve points to the serpent—a dragon-like creature, which in turn snarls back at her. The freely arranged little figures, with their heads almost in the round, contrast strongly with the ornamentalized vegetation, including the fateful tree. Below the scene is a Latin inscription in inlaid silver, added shortly after Bernward's death, which translates: "In the year of Our Lord 1015 Bernward the bishop of blessed memory cast these doors."

A less influential but equally original creation of Bernward's workshop is a bronze column, more than twelve feet in height, which he also gave to Saint Michael's (fig. 515). The crucifix it originally supported is now lost, and the present capital is a nineteenth-century reconstruction. The column itself, obviously derived from the imperial columns of Rome and Constantinople, shows the triumphant deeds of no earthly emperor but of the King of Kings—Christ's earthly ministry in twenty-four scenes, beginning at the bottom with the Baptism in the River Jordan and ending

- 514. Adam and Eve Reproached by the Lord (detail of the doors of the Cathedral of Hildesheim). Bronze, 23 × 43"
- 515. Column of Bishop Bernward. Early 11th century. Bronze, height c. 12'. Cathedral of Hildesheim

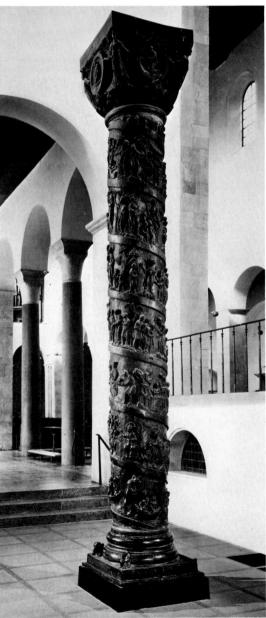

51

with the Entry into Jerusalem. Like each door, the hollow column was cast in one piece, a remarkable technical achievement. The scenes are more densely spaced than on the doors, but quite as dramatic, and may have been the work of the same team of sculptors. The column gains considerable architectural strength from the broad spiral bands that separate the levels.

An unexpectedly powerful example of the new Ottonian art of monumental sculpture is the lifesize wooden *Crucifix* (fig. 516), given to the Cathedral of Cologne by Archbishop Gero between 969 and 976. This is the oldest surviving large-scale crucifix. The Ottonian sculptor, doubtless under ecclesiastical direction, has represented a type not yet seen in the West and apparently adopted from Byzantine art—where, in fact, Christ was never depicted with such intense emotion or such emphasis on physical torment. Instead of the *Christus triumphans* of the *Lindau Gospels* (see fig. 507), the *Christus patiens* (Suffering Christ) is shown, and the viewer is spared little. The eyes are closed, the face is tense with pain, the body hangs from the crossbar, and the lines of tension in arms and legs are strongly indicated; the belly is swollen as if with gas. Christ's hair seems to writhe upon his shoulders. This kind of expressiveness, which achieves its end even by showing the most repulsive physical conditions, is char-

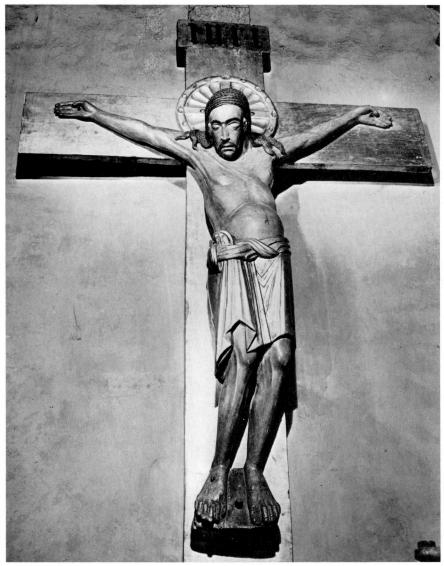

516. Crucifix of Archbishop Gero. c. 969–76. Wood, height 74". Cathedral of Cologne, Germany

517. Doubting Thomas. c. 1000. Ivory plaque, 91/2 × 4". Staatliche Museen, Berlin

518. Otto Imperator Augustus, detached page from an unknown illuminated manuscript. c. 985. Musée Condé, Chantilly, France

acteristic of German art throughout its long history, and reappears again and again at different moments.

A small ivory plaque representing *Doubting Thomas*, made about the year 1000 (fig. 517), raises Ottonian expressionism to the level of spiritual exaltation. The artist has made the relief look higher than it is through the illusion of a niche that encloses and compresses the two figures. In the spandrels appear Christ's words to Thomas, "Reach hither thy finger. . . . " in Latin (John 20:27). Christ lifts his right arm, draws aside his mantle, and bends his head with a look of deep compassion, while Thomas inserts his finger into the wound. Every line of Christ's body and drapery is receptive, and every line of Thomas' pose and garments ascends; Thomas' head is turned backward so that we can see his expression. Master and disciple are bound together in a mystic union of faith and love, in which even the ascending shapes of the framing acanthus leaves seem to share.

PAINTING As so often in the fragmented history of painting from antiquity through the early Middle Ages, we are left with nothing but tantalizing descriptions of the cycles of wall paintings that once brightened the interiors of Ottonian churches. Only in the Church of Saint George on the island of Reichenau in Lake Constance is a fairly complete cycle preserved, and that, like the fragmentary frescoes that survive else-

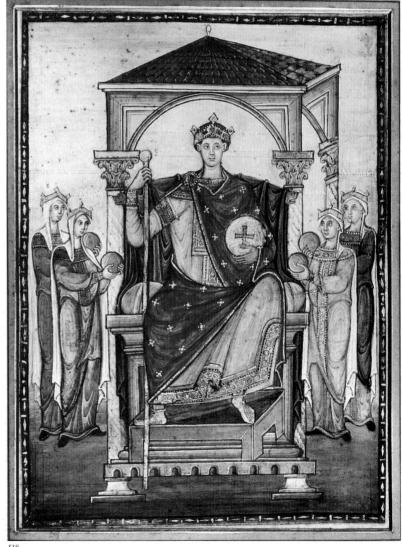

where, is too badly faded for reproduction here. Again we must turn to manuscripts to assuage our loss, and again the consolation is great. The expressive and visionary qualities so evident in Ottonian architecture and sculpture are concentrated in Ottonian manuscripts.

Emperor Otto. In a detached leaf from an unknown volume, we behold a youthful crowned emperor (fig. 518), labeled Otto Imperator Augustus, probably Otto II, majestically enthroned under a baldachin. He holds his staff of office with his right hand and his golden orb of power in his left, while crowned women representing subject countries, optimistically entitled Germania, Francia, Italia, and Alamannia since he ruled only Germany, present him their orbs as well. In the awesome detachment of Ottonian art, naturalism of expression is unaccompanied by concern with real space. Any attempt to deduce the spatial relationships of the columns upholding the baldachin will leave the observer in a quandary. In order not to cut up the noble Latin inscription, the artist represented only three columns; the throne levitates partly within and partly forward of the front columns, being even higher than their bases. But these unreal spatial relationships are part of the magic of Ottonian manuscripts, and if anything enhance their expressive and spiritual depth. Contours are smooth and unbroken, colors richly and subtly contrasted, surfaces strongly modeled, but the Helleno-Roman careful observation of light has now turned into a conventional pattern of strokes of graduated value.

Lectionary of Henry II. The half-real, half-unreal Ottonian style is very grand when turned to narrative purposes, as in the Annunciation to the

519. Annunciation to the Shepherds, illumination from the Gospel Lectionary of Henry II. Reichenau (Lake Constance), c. 1002-24. Bayerische Staatsbibliothek, Munich

Shepherds (fig. 519) from a Gospel lectionary (the Gospel texts arranged in the order in which they are read at Mass) given to the Cathedral of Bamberg by Henry II (reigned 1002–24). The background, partly gold and partly blue, is abstract. On a mountain formed of conventionalized rocks stands a colossal angel, his mantle floating against the gold, ready to announce to the awestruck shepherds the "good tidings of great joy." Yet all seem more overcome with the mystery of the message than by its gladness. The last traces of illusionism have given way to strongly ornamental and unbroken contours; only a few parallel stripes remain to suggest the origin of such strokes in reflections of light.

Bamberg Commentary. The highest attainment of Ottonian art is the series of visions from both Old and New Testaments, represented with an explosive power never seen before in figurative art. As if pervaded by something of the ornamental splendor that had flowered in Hiberno-Saxon art, these illuminations yet overflow with the expressiveness of Ottonian religiosity. The *Vision of Isaiah* (fig. 520), from a commentary illuminated in the late tenth or early eleventh century, should be contemplated along with the text it illustrates, Isa. 6:1–4:

- 1 . . . I saw also the Lord sitting upon a throne, high and lifted up, and his train filled the temple.
- 2 Above it stood the seraphims; each one had six wings; with twain he covered his face, and with twain he covered his feet and with twain he did fly.
- 3 And one cried unto another, and said, Holy, holy, holy, is the Lord of hosts: the whole earth is full of his glory.
- 4 And the posts of the door moved at the voice of him that cried, and the house was filled with smoke.

The Ottonian artist was less literal and more imaginative than the masters who illustrated the Utrecht Psalter (see fig. 505). He has shown the beardless Lord sitting upon and within a fantastic shape composed of an overlapping golden disk and a golden mandorla, both with rainbow borders, with his arms outstretched and eyes gazing forward as if he were in a trance. Nine threefold tongues of gold flame spurt from the mandorla. The smoke, which the text tells us filled the house, is shown as concentric bursts of blue and violet with white edges, like the petals of a gigantic flower. In reciprocal and often double curves, the six-winged seraphim float about his throne, making wonderful patterns of feathers. Below the throne is an altar from which, as related in verses 6 and 7, an angel takes with tongs the live coal he will place upon Isaiah's tongue. And yet with the same surprising disregard for the theme of the principal illustration we found in the Book of Kells (see fig. 496), two unconcerned rabbits in the lower corners gnaw on pieces of fruit. Perhaps a contrast between their blind greed and the beauty of revelation was intended.

Two of the most sumptuous manuscripts remaining from the Ottonian era were ordered by abbesses, who in both Carolingian and Ottonian society were often personages of considerable economic and political influence. In illustrations in both works a special attempt was made to dramatize pictorially the relation of the abbess and her community of nuns to the means of salvation. The two manuscripts, both Gospel books, also reveal strikingly different aspects of Ottonian style.

Hitda Codex. Not dated, but probably executed shortly after the year 1000, the Hitda Codex was ordered by Hitda, Abbess of Meschede, near

520. Vision of Isaiah, illumination from a Commentary. Late 10th or early 11th century. Staatsbibliothek, Bamberg, Germany

521. Abbess Hitda Presenting Her Book to Saint Walburga, illumination from the Hitda Codex.
Germany, Cologne, 1st quarter of 11th century. Hessische Landes- und Hochschul-Bibliothek, Darmstadt, Germany

Cologne in the Rhineland, in northwest Germany, and is considered the masterpiece of the Cologne school of illumination, characterized by a remarkably free and sketchy use of the brush. Among the many brilliant and often intensely expressive illustrations, the most interesting for us is the page which shows the donor herself, labeled *Hitda Abbatissa*, under a symbolic arch above which rises a jumble of monastic buildings—walls, clerestories, gabled roofs, and towers. With an expression of great fervor, the abbess presents the gold-covered book to Saint Walburga, female patron of the abbey (fig. 521). The soft, pictorial touch and the understanding of the play of light have been connected with the influence of the Macedonian renaissance.

Uta Codex. Illuminated for the Abbess Uta of Niedermünster, near Regensburg on the Danube in south-central Germany, between 1002 and 1025, the Uta Codex shows in the density and mathematical complexity of its design the intellectuality of the extraordinary city of Regensburg, known for its philosophical and theological interest. Regensburg was especially devoted to the cult of Saint Denis, whose relics were believed to be enshrined there and who was identified with the mysterious Early Christian philosopher known today as Dionysius the Pseudo-Areopagite (who will reappear in Chapter Six). Saint Erhard, bishop of Regensburg

522. Saint Erhard Celebrating Mass, illumination from the *Uta Codex*. Regensburg, Germany, 1002-25. Bayerische Staatsbibliothek, Munich

about 700, whose relics were venerated at Niedermünster, is shown celebrating Mass (fig. 522) under a ciborium—usually a domical structure supported by four colonnettes—which generally covered altars in both East and West in the early Middle Ages. This time, however, there are distinct references to the Old Testament. It has been shown that the ciborium is constructed according to a linkage principle as directed for the Tabernacle in Exodus 36:18 and that the saint's vestments, while conforming in general to those still required for the celebrant at High Mass, contain elements drawn directly from those of the Hebrew High Priest. He stands with hands extended in orant posture, a deacon on the right as assistant and on the left an altar, of a movable type (altare semifixum), on which can be seen among other objects the missal, the chalice for the wine, and the paten, or plate for the Eucharist.

Above the ciborium the Lamb of God holds an open book, before the Latin inscription "The Spouse of Virgins," obviously meaning the nuns. In the upper right corner of the frame sits Uta herself, labeled "Lady Abbess"; at upper left "Piety," hands crossed on breast; at lower right "Rigor of Discipline," a woman pointing to her closed lips; at lower left "Temperament of Discretion," a woman teaching two children. Below the altar rise the domes, towers, and battlemented walls of the abbey. Clearly the illustration is an allegory, demonstrating in visual terms the

possiblity of bringing Christ in the Mass, by means of portable altar and ciborium, into the lives of the community of women at any proper point in the monastery. The whole is converted into a design of brilliant complexity and geometrical rigor.

The least that can be said of these two powerful abbesses (among their many women contemporaries in similar positions of monastic leadership all over Christendom) is that they stood at the apex of the intellectual, spiritual, and artistic life of their times. Were the scribes and painters of these two magnificent works, whose illustrations correspond so closely to the ideas of Hitda and Uta, actually nuns in the convents of Meschede and Niedermünster? That the question seems never to have been raised is surprising in view of the host of texts recording the training, the achievements, and even the names of many women scribes and illuminators, beginning as early as the sixth century. The biographer of the two eighth-century women painters Harlinde and Relinde expressed wonder that they excelled in "writing and painting, a task laborious even for men." The burden of proof really rests on those who would maintain that Hitda and Uta had to turn to male scriptoria for their manuscripts.

The Classical and Byzantine heritage of Carolingian manuscript painting and ivory sculpture was formalized in the brief Ottonian period and replaced the last remnants of Classical illusionism with a grandly conceived art dominated by linear contours and patterned compositional structure. The innovations of Carolingian architecture were adopted and expanded. Except for Bishop Bernward's brilliant bronze sculpture, which had no immediate followers, Ottonian art formed a bridge to the Romanesque. Its greatest achievements are majestic in form and color, witnesses of an artistic creativity and a profound spirituality unmatched in the rest of Europe.

ROMANESQUE ART

FIVE

The name *Romanesque* was a catchall term coined in the nineteenth century to designate a style that was no longer Roman but not yet Gothic. But *Gothic* itself, as we shall see in Chapter Six, was a misnomer from the start. The word *Romanesque* has other shortcomings as well: originally, it had to cover both Carolingian and Ottonian art, which have assumed distinct identities only in the last hundred years or so; some scholars still so use it. Even worse, it is a term implying transition, inappropriate for a period that has strong positive qualities of its own. Today, the name is so deeply rooted in common usage that it cannot be eradicated. For want of a better term, then, *Romanesque* is now applied to the art of the eleventh and twelfth centuries in western Europe (in France, for special reasons, it is used for the arts only up to the middle of the twelfth century).

For a rarity in this book since the chapter dealing with the Roman Republic, neither headings nor subheadings in the discussion of Romanesque art will contain the name of a single monarch or dynasty. After the year 1000, there were many competing monarchies, and the very institution of kingship had acquired a powerful competitor—a rising commercial and industrial class. No monarchy could any longer enforce claims to universal rule. In the eleventh and twelfth centuries the emperors were, in effect, kings of Germany only. The kings of France ruled as feudal lords a region in north-central France centering on Paris and had next to no control over the rest of the area that makes up modern France, which was governed by several dukes and counts, and even by another king. Norman barons wrested Sicily from the Arabs in 1105 and set themselves up as kings, controlling most of formerly Byzantine southern Italy as well. In addition to the Muslims in the south, at least four Christian kingdoms divided Spain. Under the kings and dukes were feudal lords, ruling from their castles and acknowledging often conflicting feudal allegiances. The system was chaotic in the extreme and constantly shifting; the general disorder often involved the papacy, which found itself at times the football of rival monarchs.

But the towns were growing at a pace that exceeded even that of the monarchies. Cities were still small—medieval Rome and Renaissance Rome, for example, each occupied only a fraction of the center of the ancient city. Yet in France, England, Germany, and the Low Countries, cities devoted to manufacture, trade, and banking demanded and received clear-cut legal rights and charters as corporate persons equal to the feudal lords and sheltered by dukes and kings who depended on them in many respects. In Italy, with the collapse of the remnants of Lombard power in the eighth century and the infrequent visitations of emperors, northern cities became independent communes. At first they were ruled by their bishops, but soon developed republican forms of government with administrations, often chosen by lot among the leading commercial families, succeeding each other for very brief terms. Venice (long a republic), Genoa, Naples, and Amalfi built merchant marines for trade throughout the Mediterranean and navies to protect their commerce from Arab pirates. Venice, in fact, established a commercial empire, with bases in islands and seaports throughout the eastern Mediterranean and a fixed extraterritorial seat

in Constantinople, the capital of the Byzantine Empire. The capture of Sicily and the mass movements of the first three Crusades, the latter culminating in the institution of a Western kingdom of Jerusalem (1099–1187), also assisted in opening Western eyes to the worlds of Byzantine and Islamic cultures.

It is hard to find enough surviving Carolingian and Ottonian churches to illustrate the architectural styles of those periods; in contrast, so many hundreds of Romanesque churches, large and small, most in excellent condition, still stand in Europe, that even a general treatment of Romanesque architecture would require a book as thick as this one. Even more would have been preserved if in the Gothic period many had not been replaced by more sumptuous edifices. An oft-quoted and invariably misinterpreted passage, written in 1003 by the French monk Raoul Glaber, tells us about the new wave of church construction after the year 1000:

Therefore, after the above-mentioned year of the millennium, which is now about three years past, there occurred, throughout the world, especially in Italy and Gaul, a rebuilding of church basilicas. Notwithstanding the greater number were already well established and not in the least in need, nevertheless each Christian people strove against the others to erect nobler ones. It was as if the whole earth, having cast off the old by shaking itself, were clothing itself everywhere in the white mantle of churches. Then, at last, all the faithful altered completely most of the episcopal seats for the better, and likewise the monasteries of the various saints as well as the lesser places of prayer in the towns. . . .

Considering how many years it took to build a Romanesque church, Raoul Glaber's account should be read as a prophecy of what was soon to come about.

But the passing of the millennium and the new growth of cities were not the only factors that spurred the building of churches; the requirements of pilgrimages also had to be considered. Populations in the Middle Ages were surprisingly mobile. Pilgrimages, a feature of many religions, were ostensibly undertaken for religious reasons, but in the fourteenth century the wise Geoffrey Chaucer hinted at other motives as well, once April stirs the blood:

Than longen folk to goon on pilgrimages (And palmers for to seken straunge strondes)
To ferne halwes, couthe in sondry londes;...

Palmers, of course, were those who had been to the Holy Land and were entitled to wear palms (the travel stickers of the Middle Ages) on their garments. Among the *ferne halwes* (distant saints) was James, whose shrine at Santiago de Compostela in the far northwestern corner of Spain attracted pilgrims by the thousands, who had to be cared for along the way, thus encouraging the development of churches along the main routes. (The pilgrimages, of course, could account only for the great *size* of the new churches, far larger than necessary for their monastic or urban communities, but not for their *style*. Some scholars have doubted whether the pilgrimages really were an important factor in Romanesque art.)

Just as dramatic as the great new wave of church building in the Romanesque period was the revival of architectural sculpture. Save for a few scattered examples, monumental sculpture in stone very nearly died out in Europe after the collapse of the Roman Empire. Contemporary accounts relate that some Carolingian and Ottonian church façades were ornamented with sculptures, but no examples have survived; as far as we now know, sculpture connected with church buildings was mostly limited to doors, pulpits, baptismal fonts, and other interior features. But the new Romanesque churches demanded architectural sculpture just as the Greek temples had—not as additions to fill predetermined spaces, however, but as integral parts of the architecture. Romanesque church portals, especially, were enlivened with sculptures so as to present in vivid form essential elements of Christian doctrine in order to excite not

only the piety but also the imagination of the worshiper at the moment of entry into the church. The typical Romanesque portal, which often included a number of reliefs and statues attached to supporting elements, was centered on a large-scale composition that filled the tympanum (the semicircular space bounded by the arch and the lintel). A Romanesque tympanum was not made up of separate statues or groups, as in Greek temple pediments, but was drawn on the surface of the component slabs, then cut deeply to form a kind of relief, and finally painted in brilliant colors. An unexpected field for sculpture was a new type of capital, which appeared at the end of the eleventh century, showing human figures and sometimes narrative scenes. Figured capitals were relatively rare in Roman art and were seldom used before the third century; Romanesque artists, however, produced them in enormous numbers before the taste for them died out in the Gothic period.

As in the Ottonian period, churches were often richly decorated with mural paintings of great size and splendor. We have no records of any women architects, sculptors, or mural painters during the Romanesque period any more than in earlier times, but as in Ottonian days, magnificent manuscripts were written and illustrated by women, whose special contribution seems to have been an unusual and very exciting freedom of imagination.

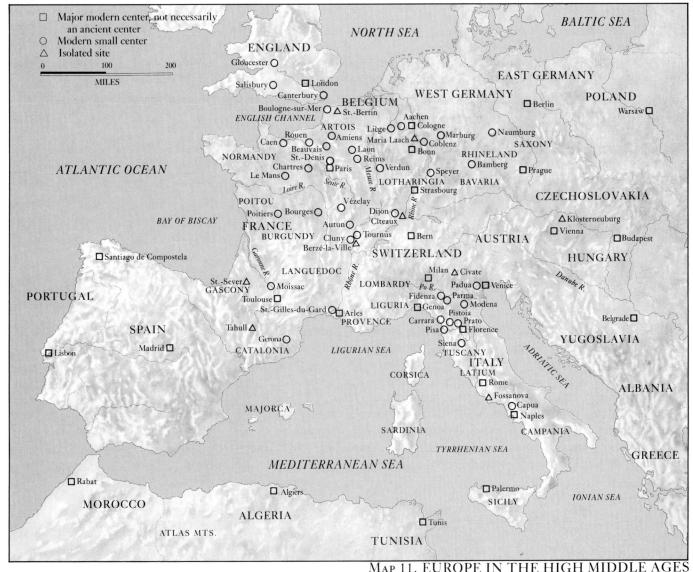

Throughout the old Roman cities of northern Europe and of central and northern Italy (with the exception of Rome, whose basilicas were pilgrimage goals in themselves), many Early Christian, Carolingian, and Ottonian churches gave way to larger Romanesque ones. A prime requirement, based on bitter and oft-repeated experience, especially in France where cathedrals were in urban centers constantly subject to conflagrations, was that the new structures be fire-resistant, therefore vaulted in masonry. For some as yet unknown reasons, the Roman technique of vaulting with concrete seems never to have been considered by Romanesque builders, although a manuscript of Vitruvius, in which he explained the technique, was in the monastic library at Cluny. The new vaults of brick or stone masonry required massive systems of support. As long as the static problems were imperfectly understood-medieval engineering was unequal to the task of calculating stress scientifically—the massive supports for the vaulting could block out the light. A three-way balance among great church size, stable vaulting, and adequate illumination had somehow to be struck; the dramatic changes in the form and appearance of church buildings in the Romanesque and Gothic periods are bound up with many trial-and-error attempts to refine this balance.

Architecture and Sculpture in France

TOURNUS But there was a fourth factor, seldom taken into consideration in modern studies of medieval architecture and yet doubtless the final determinant: the result had to be aesthetically satisfying. One striking instance should be considered, the Benedictine Abbey Church of Saint-Philibert at Tournus in central France. The church was rebuilt after a fire in the early eleventh century. In the course of the eleventh or in the early twelfth century (the date is still in question), the building was vaulted. The impressive interior (fig. 523) would seem to fulfill all practical requirements for a Romanesque church: it is capacious, stone vaulted, and well lighted due to an ingenious constructional system. The nave arcades are sustained by powerful cylindrical columns, without capitals. Engaged half columns are visible in the side aisles. The columns and the half columns provide excellent support for the groin vaults that cover the side aisles. In the nave above each column rises a shorter, engaged column, sustaining a massive arch that bridges the nave. These arches, in turn, support a series of small barrel vaults, which unexpectedly cross the nave at right angles. The weight of the transverse barrel vaults is adequately borne by the arches. But barrel vaults also thrust outward, and this thrust must be abutted. At Tournus this problem was settled by having the transverse vaults abut each other. The outer walls, relieved of all weight, were pierced by clerestory windows admitting ample light. Why, then, was this practical system never again adopted in any other church? The answer seems to be that the effect of the heavy arches, cutting up the ceiling into a succession of separately barrel-vaulted compartments, was unacceptable aesthetically; architects and patrons wanted a more unified look. It is also possible that such a ceiling had a bad acoustical effect, perhaps creating echoes that blurred the chanting of the services.

TOULOUSE The solution utilized on a grand scale for pilgrimage churches erected in the late eleventh and early twelfth centuries may be seen in the Church of Saint-Sernin at Toulouse (fig. 524), the capital of the southern French region of Languedoc. Built about 1080–1120, this structure repeats in many respects the plan and disposition of elements at

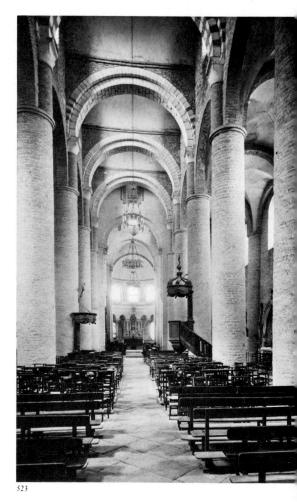

523. Interior, Abbey Church of St.-Philibert. 11th–early 12th century. Tournus, France

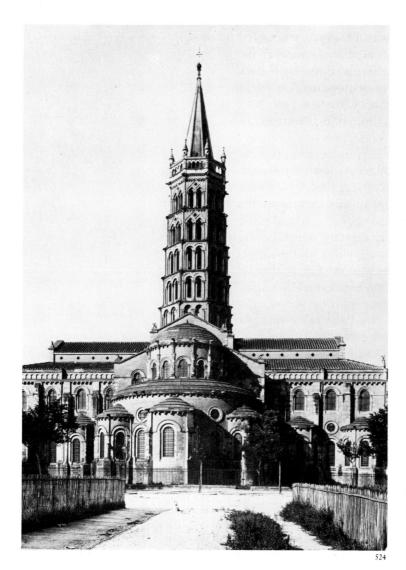

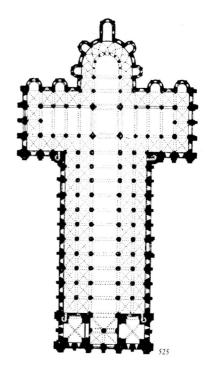

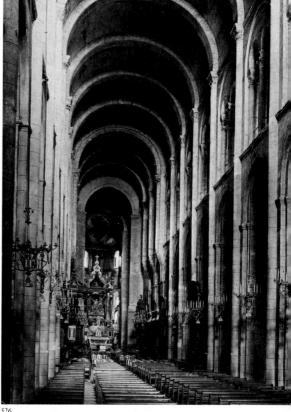

Santiago de Compostela, the goal of the pilgrimages, whose construction began in the 1070s. In contradistinction to Early Christian basilicas, the plan (fig. 525) is unmistakably a cross. The immense nave (eleven bays) is flanked by double side aisles. The inner aisle is continuous, stretching around both ends of the transept and the apse—like the ambulatory in a martyrium—so that crowds of pilgrims could move along constantly and easily. (Medieval sources tell us about the difficulty and danger of handling large crowds in the old basilicas.) Along their way the pilgrims could stop and pray at small chapels, each containing the relics of a saint. The cult of relics was intense in the Romanesque period, and the need for relics to venerate was often satisfied by worse than dubious means. Two chapels open off the east side aisle of each arm of the transept, and five more radiate outward from the ambulatory around the apse. Ambulatory and radiating chapels became an indispensable feature of pilgrimage churches, and were uniformly adopted for cathedral churches in the Gothic period, save only in England and Italy.

The nave, transept, and choir of Saint-Sernin are barrel vaulted (fig. 526); the triumphal arch has vanished, and the apse (now partly obscured by a much later altar) is a half dome at the same height as nave and choir. The downward pressure of this barrel vault, but not its outward thrust, could have been supported by the arches of the usual clerestory; without abutment, the vault would have collapsed. At Saint-Sernin a gallery (which doubtless also accommodated crowds of pilgrims) runs around the build-

524. St.-Sernin. c. 1080-1120. Toulouse, France

- 525. Plan of St.-Sernin, Toulouse (After Kenneth John Conant)
- 526. Nave and choir, St.-Sernin, Toulouse

ing above the side aisles, stopping only at the apse. This gallery is roofed by a half-barrel vault, which rests against the piers of the nave at the springing point of the nave vault and abuts the thrust, directing it back inside the piers to the ground. Unfortunately, the gallery windows light only the galleries; little light filters into the nave. Churches roofed by barrel vaults are inevitably dark. The Abbey Church at Cluny, as we shall see, was an exception.

The continuous barrel vault, however, does have a grand effect. Like a great tunnel, it draws attention rapidly down the nave toward the altar. The barrel vault is crossed at every bay by transverse arches, which have an aesthetic rather than a functional purpose; they seem to support the barrel vault, and may have helped in its construction, but it would stand quite well without them. The arches spring from capitals, which belong to slender colonnettes of entirely unclassical nature, although their capitals preserve Classical elements, looking like those in the Great Mosque of Ibn Tulun (see fig. 470). These colonnettes run two stories in height, from floor level, where they are engaged to the piers that support the nave arcades, up to the transverse arches and down the other side. At Saint-Sernin, therefore, we encounter a basic feature of Romanesque architecture, the compound pier, which replaces the Early Christian column (see fig. 403) and the square pier of Ottonian buildings. As in the Great Mosque of Ibn Tulun, which to be sure utilizes compound piers for a very different purpose and effect, each pier is made up of several elements, each with its own function in the general scheme.

The plan shows that the side aisles, which are relatively low, are groin vaulted (see fig. 525; a groin vault is indicated on a plan by a dotted X). The outward thrust of the groin vaults was met by external buttresses. Each bay of the side aisles is square; the width of the nave corresponds to the width of two of the side-aisle bays, so that each nave bay is an oblong of one to two. This proportion between nave and side-aisle bays was generally maintained in later churches.

From the east end the exterior (the west façade was never completed) shows a superb massing of clearly distinct elements, resembling that we saw in Ottonian churches but far richer and more complex. The transept chapels, radiating chapels, ambulatory roof, semidome over the apse, gallery windows in the transept, gallery roof, transept roof—all culminate in a grand octagonal crossing tower. This tower is Romanesque only in its first three stories; the last two were added in the Gothic period. The clear, rational articulation of the building is carried into smaller elements as well: each bay of the transept is demarcated by a buttress countering the thrust of the vaults within; below each roof runs a sculptured corbel table; each arched window is framed by a larger blind arch, supported in the gallery windows by engaged colonnettes.

CLUNY The grandest of all Romanesque buildings was the third Abbey Church of Saint-Pierre at Cluny in Burgundy, in eastern France; it was the mother church of the Cluniac Order, which, in the eleventh and twelfth centuries, comprised hundreds of monasteries scattered throughout western Europe. Its greatest abbot, Saint Hugh, entrusted the building to an ecclesiastical architect, a retired abbot named Gunzo, known also as a musician. Until the rebuilding of Saint Peter's in Rome in the sixteenth and seventeenth centuries, Cluny was the largest church in Christendom (fig. 527). Construction began in 1085 or 1086 and was virtually completed by 1130. Cluny's dimensions were staggering; the total

- 527. Plan of the third Abbey Church of St.-Pierre, Cluny, France. c. 1085–1130 (After Kenneth John Conant)
- 528. Interior, third Abbey Church of St.-Pierre, Cluny (Reconstruction drawing by Kenneth John Conant and Turpin Chambers Bannister)

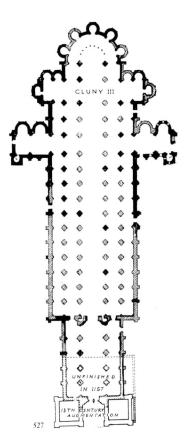

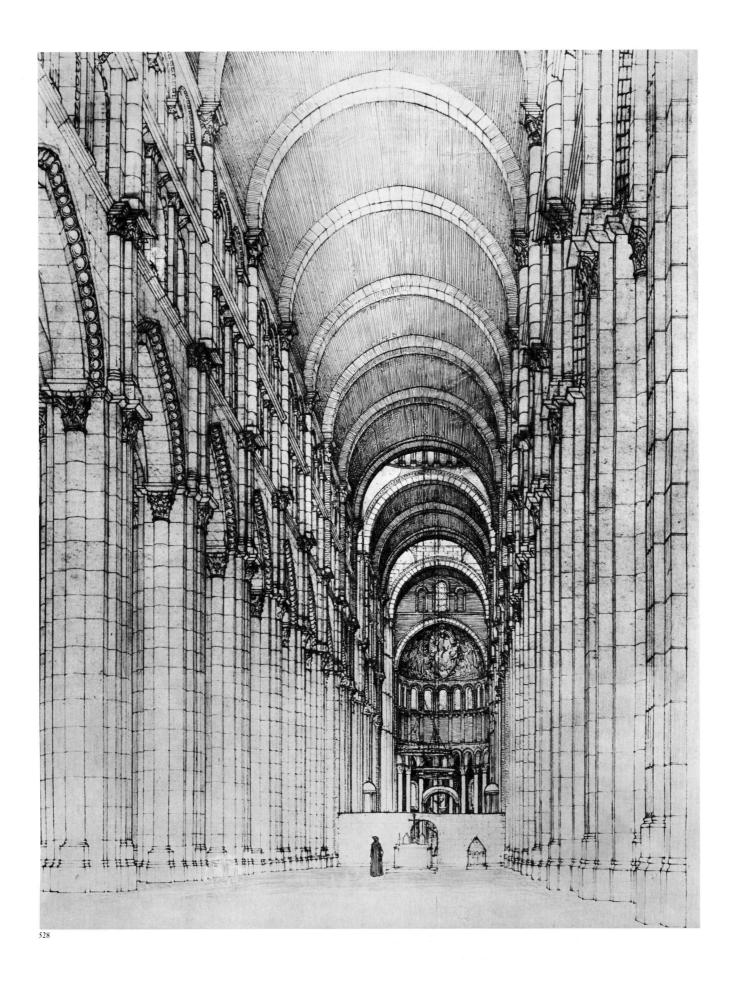

length was 531 feet, the height of the nave vaults above the floor more than 100 feet, and the richly sculptured central portal was 62 feet high. The nave of eleven bays was preceded by a five-bay narthex; there were four side aisles, double transepts, and five large and two small towers. Only portions of one transept remain. The rest of the vast fabric was demolished by a group of real-estate speculators in the years following the French Revolution, and the stone and other materials sold for profit; it took twenty-five years to blow the church up, section by section.

From the remaining fragment it is possible to gain a clear idea of what the church was once like (fig. 528). The barrel vault was slightly pointed to reduce the outward thrust so that the supporting gallery could be eliminated. Unfortunately, this device proved insufficient, and external supports (flying buttresses, which will be discussed in Chapter Six) had to be added later, although no one knows exactly when. Unexpectedly, the church's architectural details were derived partly from Roman, partly from Islamic sources. The compound piers were cruciform in plan. Engaged colonnettes supported the nave arcade and the transverse arches of the double side aisles, which were groin vaulted, but fluted pilasters were attached to the inner faces of the piers, their long, parallel lines increasing the effect of height. All the capitals were imitated directly from Corinthian models. The arches, however, were strongly pointed, somewhat like those of the Great Mosque of Ibn Tulun (see figs. 469, 470).

Above the arcades, in a space measured by the height of the sloping side-aisle roof, was the triforium (so called because it generally has three openings in each bay). The triforium arches, barely visible in the reconstruction, were ornamented all round with little horseshoe-shaped lobes, patterned after Islamic examples. The arches were separated by fluted Corinthian pilasters. Above the triforium was the clerestory, with three windows to each bay, each window framed by a round arch connecting engaged columns. The apse was slightly lower than the three-bay section between the two transepts; its semidome was filled with a gigantic fresco of Christ enthroned in glory. Gunzo's colossal interior was proportioned throughout according to the intervals in medieval music, and contemporary accounts tell us that the barrel vaults carried the chanting beautifully throughout the entire length of the church.

The sculpture of Cluny was of the highest quality. The destroyed tympanum was the largest of all such Romanesque reliefs, about twenty feet in width. Although Kenneth John Conant, to whom we owe our knowledge of the abbey in every stage of its history, has identified and reassembled the fragments of the tympanum, so as to reconstruct its composition, even down to its original coloring, only a few small pieces have been exhibited. Luckily, the ten beautifully carved capitals of the tall, round columns that once stood in the apse are preserved. The Cluny capitals are in most architectural details quite correctly Corinthian. In one of them (fig. 529), against the acanthus leaves, as if suspended, is a beautifully shaped mandorla, hollowed out to contain a figure playing a lyre, the relief representing the Third Tone of Plainsong. The energetic pose recalls the tradition of Carolingian manuscripts, as does the floating cloak, but the sculpture already shows a complete mastery of high relief, being strongly undercut, in fact almost in the round. The drapery lines were treated like overlapping layers rather than folds of cloth and executed with crisp, clean curves.

VÉZELAY A highly original plan and vaulting solution is seen in another Burgundian church, Sainte-Madeleine at Vézelay, constructed be-

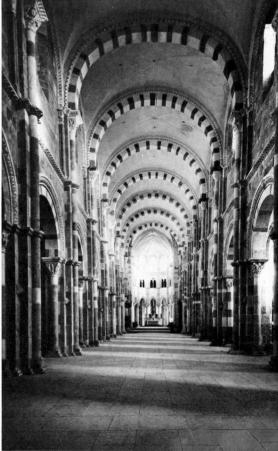

53

tween about 1104 and 1132 (fig. 530); this represents one of the earliest French attempts to roof an entire nave with groin vaults (the choir was rebuilt in the Gothic period). The church has the expected compound piers, almost all of which are enriched with figured capitals; the bays are separated by heavy transverse arches. The eye is immediately struck by a color contrast new to the North, and surely borrowed from such Islamic buildings as the Great Mosque at Córdoba (see fig. 472). The soft golden limestone of which most of the church is built alternates in the arches with blocks of pale pink granite, achieving a brilliant effect further enhanced by the white limestone used for the capitals. The unknown architect did not dare to carry his edifice to the height of Cluny, nor did he quite understand how to support his massive groin vaults. The illustration shows that they have pushed the walls slightly outward, and the vaults would have fallen if in the Gothic period the walls had not been strengthened by external flying buttresses.

The glory of Vézelay is its set of three sculptured portals, opening from the narthex into the nave and side aisles, carved between about 1120 and 1132; the sculpture of these portals is in such high relief that many of the figures are almost entirely in the round. The central portal represents the Mission of the Apostles (fig. 531). Romanesque artists reverted to the archaic system of scale, according to which the size of a figure indicates its importance. A gigantic Christ is enthroned in the center in a

- 529. Capital with relief representing the Third Tone of Plainsong, from the choir, Abbey Church of St.-Pierre, Cluny. Musée Lapidaire du Farinier, Cluny
- 530. Interior, Ste.-Madeleine, Vézelay, France. c. 1104-32
- 531. Mission of the Apostles, tympanum of the central portal of the narthex, Ste.-Madeleine, Vézelay. c. 1120-32

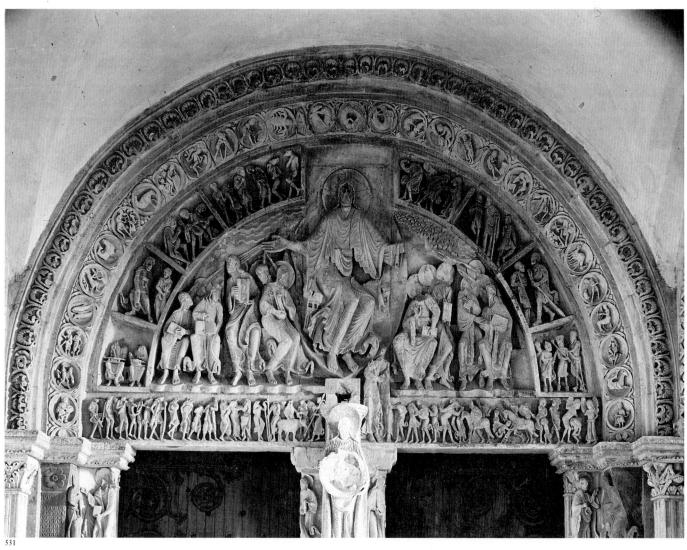

mandorla, his knees turned in a zigzag position, his arms outstretched. From his hands (the left one is missing) stream rays of light to the Apostles, who start from their seats to go forth and evangelize the world. On the archivolts, divided into separate compartments, and on the lintel are represented the peoples of many lands, as described in medieval travelers' tales. All of these people—some with heads of jackals, some with pig snouts, some covered with hair and shading themselves with enormous ears, some so small that one must mount a horse with a ladder—await Christian enlightenment. In spite of the heavy damage suffered by projecting portions, the entire scene radiates intense excitement. Partly this is due to the composition, in which each of the central figures breaks through into the area above it, partly to the use of wavy or swirling lines for the drapery, the clouds on either side of Christ, and the trembling floor below the Apostles' feet. The fantastic whorls of drapery on the right hip and knee of Christ take us back through Hiberno-Saxon manuscripts to La Tène (see fig. 487). When the original brilliant colors and gold were intact, the effect of the portal must have been electric. Scholars have shown that the meaning of this Vézelay portal was closely related to the Crusades, which were intended not only to redeem the holy places but also to carry the Gospel to the infidels, in effect a new Mission of the Apostles; the First Crusade was to have been preached from Vézelay in 1095, the Second actually was (by Saint Bernard) in 1146, and the Third Crusade started from Vézelay in 1190.

AUTUN An equally awesome, if somewhat less energetic, Burgundian tympanum is that of the Cathedral of Autun (fig. 532), probably dating from about 1130 and representing the *Last Judgment*. This work is an early example among the many representations of the Last Judgment

532. GISLEBERTUS. *Last Judgment*, west tympanum, Cathedral of Autun, France. c. 1130

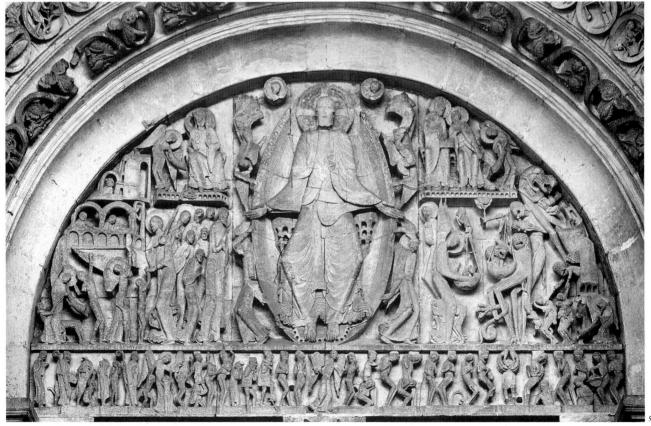

that later appeared in the portal sculptures of almost every Gothic cathedral. Their purpose was to remind Christians of their final destination before the throne of Christ. Again in a mandorla, the huge, impersonal figure of the Judge stares forward, his hands extended equally on either side. In the lintel the naked dead rise from their graves; on the left souls grasp the arms of a friendly angel; in the center the Archangel Michael, wielding a sword, sends the damned to their fate, and their little bodies quiver with terror. In the tympanum fantastically tall and slender Apostles, on Christ's right, superintend the process of salvation, and angels lift the blessed into Heaven, represented as a house with arched windows. On Christ's left a soul's sins are weighed against its virtues, as in the Egyptian Book of the Dead more than two thousand years earlier (see fig. 122). Monstrous demons grasp the damned and thrust them into the open mouth of Hell. The sculptor of this amazing work signed his name, Gislebertus; with Renier de Huy (see fig. 539), he is one of the first figurative artists of the Middle Ages whose name can be connected with a surviving work.

MOISSAC An extraordinary complex of Romanesque sculpture enriches the cloister and the portal of the Abbey Church of Saint-Pierre at Moissac in Languedoc, not far from Toulouse. The corner piers of the cloister were sculptured about 1100 with reliefs showing standing saints. In this relatively early phase of Romanesque sculptural style, the tradition of Byzantine, Carolingian, and Ottonian ivory carving is still evident. An arch supported by slender colonnettes frames a flattened niche, on whose sharply rising floor stands Peter, to whom the church is dedicated (fig. 533). Save only for the head, turned sharply to the right, the figure is frontal; under the garment the legs appear cylindrical, and although the drapery lines are raised in welts from the surface and given an ornamental linear coherence, they flow about the figure sufficiently to suggest its existence in depth. The figure generally appears stable enough, but the right hand is not; in fact, it is turned violently against the forearm and displays the Keys to Heaven, as though they were weightless, by merely touching them with thumb and forefinger. The columns of the cloister, alternately single and double, are crowned with capitals of a radically new design, which taper sharply toward a small band above the column; each is a unique and brilliant work, some ornamented but the majority carved with scenes from Scripture.

The sculptural activity of Moissac flowered between about 1120 and 1125 to produce another masterpiece of portal sculpture. A deep porch with a pointed barrel vault, whose supporting walls are enlivened by splendid high reliefs, leads to the pointed tympanum in which the Heavens open to reveal the Lord upon his throne—the Vision of Saint John (fig. 534), the same scene that had been represented in the mosaic, now lost, of the Palace Chapel at Aachen (see above, page 384; for another treatment of this scene, see fig. 564). A colossal crowned Christ is flanked by the symbols of the Evangelists, twisting and turning in complex poses, and by tall and slender angels waving scrolls. The rest of the tympanum is filled by the four-and-twenty elders in three registers, all of whom turn to gaze at the majestic vision. The relative stability of the cloister relief has now given way to an excitement as intense as that of the later central portal at Vézelay, although produced by subtler, linear means. Wavy lines representing clouds separate the registers; the border is formed by a Greek fret motive treated as if it were an infinitely folded ribbon. Three successive layers of rich foliate ornament of Classical derivation, separated by the slenderest of colonnettes and pointed arches, frame the portal; this is

533. Corner pier with relief of Saint Peter, in the cloister, Abbey Church of St.-Pierre, Moissac, France. c. 1100

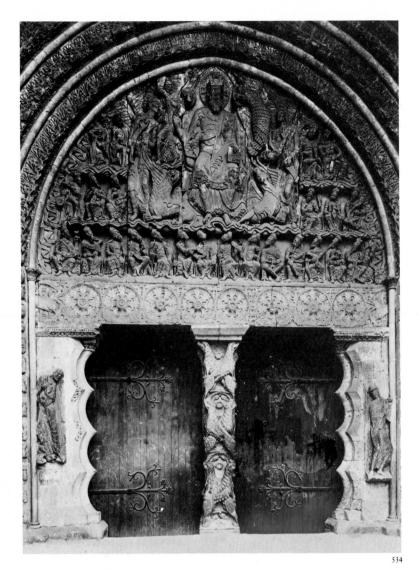

534. Vision of Saint John, tympanum of the south portal, Abbey Church of St.-Pierre, Moissac. c. 1120–25

535. *Prophet*, south portal, Abbey Church of St.-Pierre, Moissac

the first example we have seen of splayed enframement, which became a constant feature of church architecture in the Gothic period.

The lintel is ornamented with recessed rosettes, strangely enough cut at each end by the colonnettes as if disappearing behind them. To our surprise the jambs are scalloped (an Islamic element), and so, as a close look shows, are the colonnettes that border them, as if they were collapsing with the earthquake effect of the vision. The trumeau (central support) is even more startling; it consists of lions and lionesses crossed so that the forepaws of each rest on the haunches of the other—an obvious reminiscence of the old tradition of the animal interlace. On the right side of the trumeau (fig. 535), wedged in against the quivering colonnette and the inner scalloped shape, is one of the strangest figures in the whole of Western art, a prophet (possibly Jeremiah) whose painfully slender legs are crossed as if in a ritual dance, which lifts the folds of his tunic and his cloak in complex linear patterns. He clutches nervously at his scroll of prophecy; his head turns languidly as the long locks of his hair and beard stream over his chest and shoulders, and his long mustaches flow across his cheeks. For all the fervor of his inspiration, the unknown prophet (doubtless his scroll once bore a painted inscription that identified him) seems trapped in the mechanism of this fantastic portal, a situation that would be completely baffling to us if we did not recall its forebears in Hiberno-Saxon illuminations (see figs. 495, 496).

SILOS The mystical style of Languedoc was strongly related to an earlier northern Spanish work, probably dating from about 1085–1100, the cloister reliefs of the Monastery of Santo Domingo de Silos, near Burgos. Under the characteristic arch appears the *Descent from the Cross* (fig. 536), a subject that became popular during the Romanesque period on account of its direct appeal to the sympathies of the spectator. The expressions of the figures are quiet; the carrier of intense emotion is the line itself—the sad tilt of Christ's head, the stiff line of his right arm liberated from the Cross, the gentle line of Mary's head pressed to his right hand, the delicate lines of the drapery, and the looping folds of Christ's garments upheld by two angels. Three more angels emerge from swirling clouds to swing censers above the Cross.

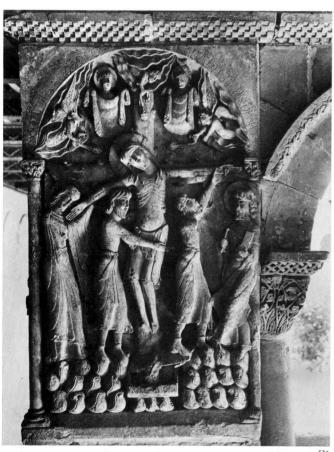

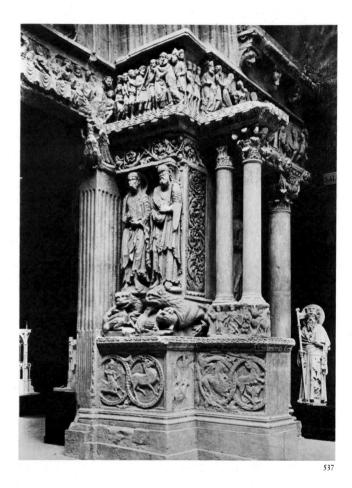

536

SAINT GILLES-DU-GARD A more Classical manner characterizes the sculpture of the region of Provence in southeastern France, rich in monuments of Roman architecture and sculpture. The triple portal of the Priory Church of Saint-Gilles-du-Gard (fig. 537), whose dating has varied enormously but should probably be set about 1130–40, has often been compared to the triumphal arches of the late Empire. The general arrangement, superficially at least, looks Roman, and the details of vinescroll ornament, Corinthian capitals, fluted pilasters, and cascading drapery folds are often directly imitated from Roman originals. More important, when compared with the nervous undercutting of Burgundy and the linear style of Languedoc, the figures at Saint-Gilles do not look as if they had been first drawn on the surface and then cut in to a certain degree, but as if they had been fully three-dimensional in the artist's mind

- 536. Descent from the Cross, relief in the cloister, Monastery of S. Domingo de Silos, near Burgos, Spain. c. 1085–1100
- 537. Triple portal of the Priory Church (detail), St.-Gilles-du-Gard, France. c. 1130–40

from the start. They show the gravity, weight, and richness of form and surface and the constant play of light and dark that betoken either a continuing Classical tradition or an interest in Roman art, or perhaps both.

But the relationship between the various elements is unclassical in the extreme. Two small central columns shorter than those at the sides and jutting out from the jambs in tandem, eagles doing duty for capitals, fierce lions capturing men or sheep, figures moving freely around column bases—all these are unthinkable in a Roman monument. Characteristically Romanesque are the entwined circles on the high socles; these circles, with their enclosed animals, like the lintel rosettes at Moissac (see fig. 534), are not complete within their spaces. The frieze tells the story of the Passion of Christ (the incidents of the last week in his life, beginning with the Entry into Jerusalem) in great detail. Over the central lintel can be seen the richly draped table of the Last Supper, although the figures of the Apostles are badly damaged. Better preserved, in low relief to the right of the central lintel, is the Betrayal, the dramatic scene in which Judas indicates to the Roman soldiers the identity of Christ by an embrace.

POITIERS In western France the tide of sculpture and sculptural ornament broke loose about 1150 and inundated portals, apses, and entire façades, mingling with and almost submerging the architecture, as in the mid-twelfth-century façade of the Church of Notre-Dame-la-Grande at Poitiers (fig. 538). The clustered columns of the lower story of each corner turret appear to—but do not—carry the arcaded second story, whose paired columns, oddly enough, are arranged side by side on the left, tandem on the right. Even more irresponsible are the conical caps, cov-

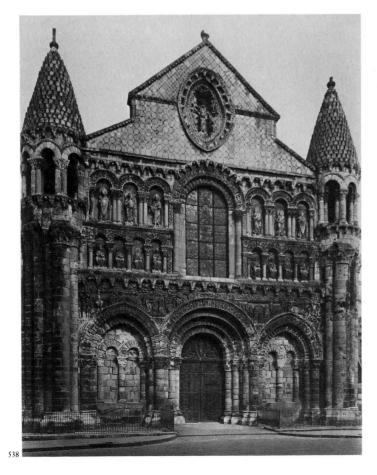

538. West façade, Notre-Dame-la-Grande, Poitiers, France. Middle 12th century

ered with scales imitating Roman tiles, which pointed downward to shed rainwater; these point up but are said to do the job just as well. In the central portion of the façade no register corresponds numerically to that below it, and the arch of the central window even moves upward into the irregularly shaped gable. Time has treated the porous stone unkindly, but the light-and-dark effect of the deeply cut ornament remains dazzling.

RENIER DE HUY We conclude this brief survey with the consideration of a work in a totally opposite style—one of the most classical works of sculpture made in Europe during the Romanesque period, the bronze baptismal font (fig. 539) now in the Church of Saint-Barthélémy at Liège in modern Belgium, done between 1107 and 1118 and attributed in a fifteenth-century document to the master Renier de Huy. The Meuse Valley, in which Liège is situated, was known in the Middle Ages as Lotharingia, after Lothair II, one of Charlemagne's grandsons, and was now under the rule of French-speaking monarchs, now of German. The entire region preserved from the Carolingian period a strong classical tradition derived from the Palace School and the Reims School, and Renier's font is probably the most strongly classical work of Romanesque sculpture made outside Italy. The idea for the font, which appears to be supported on twelve half-length bronze oxen in the round (only ten survive), was drawn from the Old Testament account of Solomon's bronze basin in the forecourt of the Temple. The Baptism of Christ takes place against an impenetrable cylinder of bronze, quite the reverse of the almost atmospheric backgrounds of Bernward's doors (see fig. 513). The figures are modeled nearly in the round, with no hint of the fantastic, visionary styles of Burgundy and Languedoc. The fullness and grace of the figures,

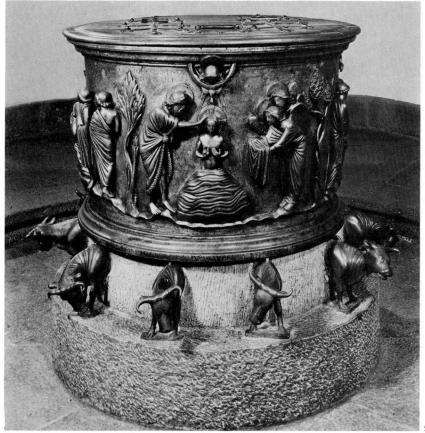

 RENIER DE HUY. Baptismal font. 1107–18.
 Bronze, height 25". St.-Barthélémy, Liège, Belgium

their harmonious balance and spacing, and the sculptor's sensitive understanding of the play of drapery over bodies and limbs are unequaled in any French stone sculpture of the time. The lovely classical figure seen from the back at the left may well have derived from an ancient model; one very like it appears in Ghiberti's famous Gates of Paradise of the Early Italian Renaissance. Renier's figures actually seem to move forward into our space; the head of God the Father (instead of the Hand of God we have seen up until now) leans downward from the arc of Heaven so strongly as to appear foreshortened from above.

Throughout the eleventh and twelfth centuries, the prosperous communes of central and northern Italy and the cities of the kingdom of Naples and Sicily built Romanesque churches on a grand scale. The tradition of basilican architecture had never quite died out in Italy. In addition to the persistence of classical tradition and the presence of many Roman monuments—far more than are standing today—central Italy possessed an unlimited source of beautiful white marble in the mountains of Carrara, to the north of Pisa, as well as green marble from quarries near Prato, just to the west of Florence. While the use and emulation of classical elements and classical details in the Romanesque architecture of Tuscany are so striking as to have caused art historians to speak of a Romanesque renaissance (like the Carolingian renaissance), these classical elements were generally played against an accompaniment of strongly unclassical Romanesque green-and-white marble paneling, in some cases very sprightly and witty in its combination of shapes and intervals.

BAPTISTERY OF FLORENCE The most remarkable Tuscan Romanesque building is certainly the octagonal Baptistery of San Giovanni in Florence (fig. 540). In many communes in central and northern Italy, all children born in the commune were baptized in a centrally located building, which was separate from the cathedral and took on considerable civic importance. The Florentine Baptistery was consecrated in 1059, but it is so classical, in so many ways, that the controversy over the original date of its construction has never been entirely settled. The Florentines of a later era believed that the building had once been a Roman temple dedicated to the god Mars; the foundations of the present edifice are certainly of Roman origin, but the weight of evidence indicates that the building itself dates from the eleventh century. The external decorative work on the Baptistery went on through the twelfth century, and the corners were not paneled in their zebra-striped marbles until after 1293. The interior is crowned by a pointed dome, masked on the outside by an octagonal pyramid of plain white marble.

The classical aspect of the exterior is limited to the blind arcades and pilasters, whose Corinthian capitals are carved with a precise understanding of Roman architectural detail. But nowhere in Roman architecture can one find anything like the vertically striped green-and-white engaged columns or the striped arches. The most vividly anticlassical feature is found in the second story, in the succession of tiny paneled arch shapes too small to connect with the pilaster strips that should support them. Such effects are in the tradition of irresponsible linear activity, which was strong in Romanesque ornament throughout Europe.

Architecture and Sculpture in Italy

SAN MINIATO AL MONTE Somewhat more accurately classical at first sight is the twelfth-century façade of the Abbey Church of San Miniato al Monte (fig. 541). The church was built between 1018 and 1062 high on a hill and commands a superb view of Florence. This building represents a quite successful attempt to integrate the inconvenient shape of a Christian basilica, with high nave and low side aisles, into a harmonious architectural façade by the ingenious device of setting a pedimented, pilastered temple front on a graceful arcade of Corinthian columns. But the triangles formed by the low roofs of the side aisles are paneled in a diagonal crisscross that again recalls the tradition of the interlace. Both the Baptistery and San Miniato were influential in establishing the style of Early Renaissance architecture in Florence, particularly in the work of the great innovators, Brunelleschi and Alberti. But it is instructive to note how these masters always strove to regularize the capricious shapes of the Romanesque marble paneling they imitated.

540. Baptistery of S. Giovanni, Florence. 11th century

tended to abut the thrust of the vaulting but is actually covered only by the side-aisle roofs, which do, however, hide relieving arches. The architects seem to have relied on the immense mass of the piers, pillars, and walls to contain the thrust of the vaults, and their confidence was well placed. Tie rods have never been required. A small, columned clerestory is let into the thickness of the walls at the level of the vaulting, and a catwalk runs behind the conoids of the vaults. These conoids (conelike shapes) are formed by the convergence of the triangular compartments of a groin or ribbed vault on the capital of a colonnette or on a corbel. As twelfth-century builders experimented with this form, they were to discover that they could shape the conoids so as to concentrate all weight on the compound piers or on pillars, thus freeing the walls entirely. As we shall see, the manipulation of the conoids will be one of the major goals of Gothic builders.

CAEN The most influential building for early Gothic architecture. however, was the Abbey Church of Saint-Étienne at Caen in Normandy (fig. 557). Started in 1067 by William the Conqueror, it was completed by the time of his interment there in 1087. The nave does not seem to have been planned for vaulting, but the square double bays (as at Sant'Ambrogio) easily accommodated the daring and very refined system of ribbed vaulting built over the nave about 1115–20 (or perhaps later; the vaults were rebuilt in the seventeenth century). Its thrust is strongly abutted by the vaults of the gallery, which act as a gigantic girdle.

As at Durham a small clerestory was built at the level of the vaulting with a catwalk running behind the conoids (fig. 558). The alternating system was preserved only through the addition of two oblique colon-

- 557. Plan of the Abbey Church of St.-Étienne, Caen, France. 1067-87
- 558. Interior, Abbey Church of St.-Étienne,
- 559. West façade, Abbey Church of St.-Étienne, Caen (Gothic spires added later)
- 560. Crucifixion, nave fresco, Sant'Angelo in Formis, near Capua, Italy. Before 1087

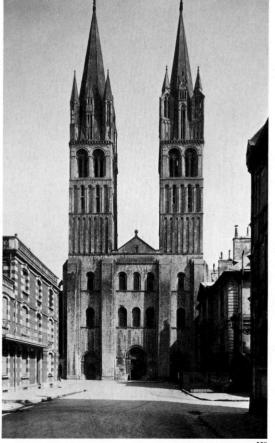

nettes, much slenderer than their counterparts at Sant'Ambrogio, to every second compound pier. The striking innovation at Saint-Étienne was the introduction of a second transverse rib, cutting across the vault from side to side and splitting it into six compartments. The six-part vault may have been thought necessary to sustain the slender diagonal ribs before they could be anchored together by the masonry webs of the vault compartments; in any event, it was adopted in the first cathedrals of the Gothic style. The six-part vaults succeeded, at long last, in creating a far more unified interior appearance than had any earlier technique.

Another decisive feature of Saint-Étienne is the three-part, two-tower façade (fig. 559), which later became standard for all French Gothic cathedrals. The elaborate—and indeed very beautiful—spires were added in the Gothic period; they must be thought away in order to recreate the effect of austere simplicity intended by the original builders. Of crucial importance to our understanding of the symbolic basis of medieval architecture is the division of the façade of Saint-Étienne so as to embody in almost every reading the number of the Trinity. For example, the façade has three stories, each of which is divided into three parts; the church possesses three portals (those at the sides enter the towers); the second and third stories of the central part are each lighted by three windows; finally, the towers themselves are each divided into three stories.

In contrast to Carolingian and Ottonian mural painting, a great deal of Romanesque painting survives, some in fairly legible condition, including complete cycles of high quality. We may, however, mourn the loss of the mosaics done by Greek artists, who were brought to Monte Cassino by Abbot Desiderius in the eleventh century to reform painting, which—in contrast to its achievements in Carolingian France and Ottonian Germany—had sunk to a low ebb in Italy. Desiderius, according to a delight-

Mural Painting

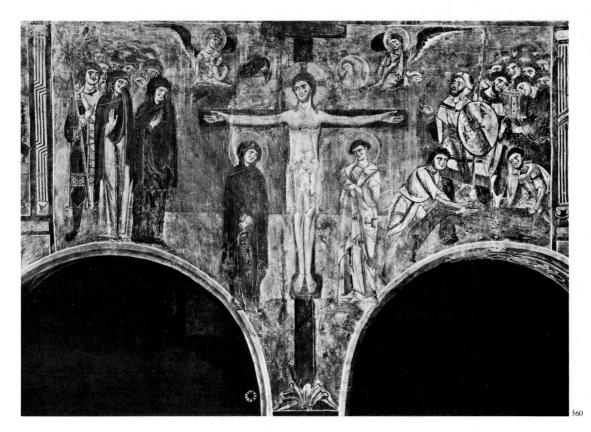

ROMANESQUE ART 433

ful contemporary account by his archivist and biographer, Leo of Ostia, made provision for the Greek artists to train Italian monks and craftsmen in the techniques of religious art. The most impressive example of the Monte Cassino style is the almost complete cycle of frescoes commissioned by Desiderius before 1087 for the interior of the Church of Sant'Angelo in Formis on a mountainside above Capua, north of Naples. As in all such cycles, the cumulative effect of the whole is far greater than the sum of its parts. Although the frescoes have faded sadly in recent years, the succession of biblical narratives and the great *Last Judgment* on the entrance wall still exert a profound emotional effect on the visitor. In spite of the teaching of Byzantine masters, the style of the Sant'Angelo frescoes seems somewhat rough in comparison with the extraordinary refinement achieved by the art of Constantinople. Yet their dramatic and decorative power depends in no small measure on their naïveté.

Especially beautiful among the Sant'Angelo frescoes is the *Crucifixion* (fig. 560), which fills most of the space above two arches of the nave. Christ is represented as alive, triumphant over suffering as in the *Lindau Gospels* (see fig. 507), his perfect serenity in sharp contrast to the grief of the Virgin and John and to the two mourning angels in midair. The forces of the architecture have been allowed to determine the disposition of the elements: the Cross is planted over one of the columns of the nave arcade; on the arch to the left stand weeping women and Apostles; on that to the

561. Christ Enthroned, with the Archangel Michael Battling a Dragon, wall painting, S. Pietro al Monte, Civate, Italy. Late 11th—early 12th century

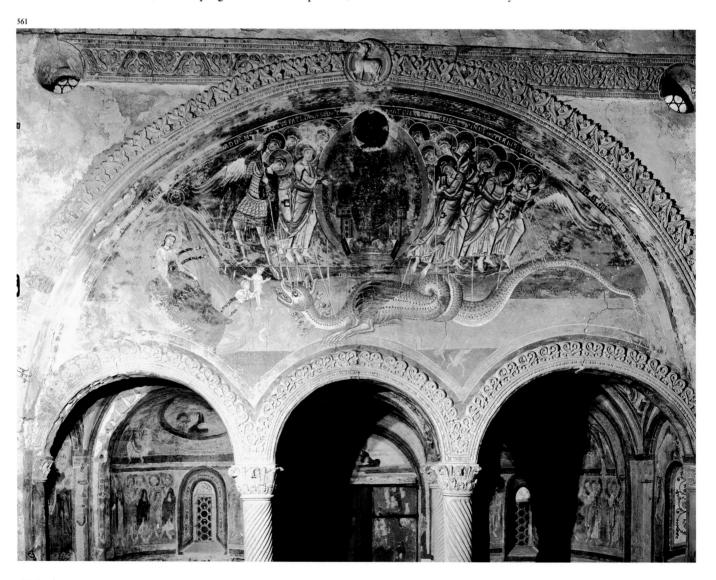

right the Roman centurion, having been moved by the revelation of Christ's divinity, detaches himself from the soldiers' dice game for the seamless robe. The coloring is limited to gray-blue for the background and to terracotta red, tan, oranges, greens, and grays. As in Romanesque sculpture, the drapery is strongly compartmentalized. The simplified faces, with enormous eyes, show startling disks of red on each cheek.

CIVATE A very nearly contemporary cycle of Italian Romanesque painting, dating from the late eleventh or early twelfth century, adorns the simple Romanesque church of San Pietro al Monte in Civate, a remote spot in the foothills of the Alps. The lunette above the triple arcade at the west end of the nave (fig. 561), framed by crisp acanthus ornament in stucco, is filled by the celestial drama related in Rev. 12. Christ is enthroned in a mandorla (unfortunately, his head is lost), and all about him angels led by the Archangel Michael spear a magnificent dragon, who unfolds his scaly coils below the throne. On the left a woman "clothed with the sun" reclines upon a couch, while her newborn child is saved from the dragon. "And there was war in heaven: Michael and his angels fought against the dragon . . ." (Rev. 12:7). The scene floats toward the top of the arch in a mighty involvement of linear curves and stabbing spears, forming one of the most powerful pictorial compositions of the Middle Ages.

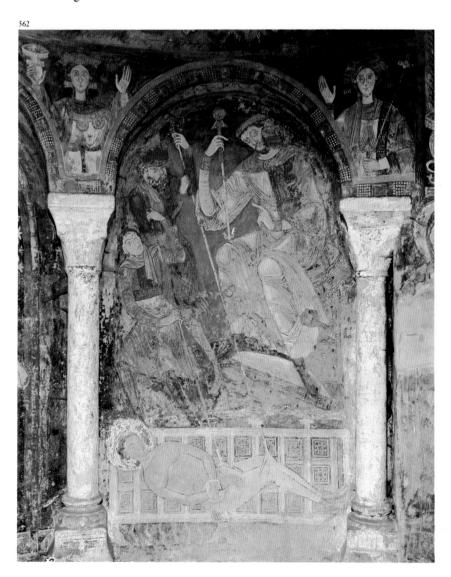

562. Martyrdom of Saint Lawrence, wall painting, Cluniac Priory Church, Berzé-la-Ville, France. Early 12th century

BERZÉ-LA-VILLE A number of Romanesque fresco cycles survive in France in varying stages of preservation; most are very difficult to reproduce adequately. The small former Cluniac Priory of Berzé-la-Ville in Burgundy, whose apse shows a colossal Christ in Majesty imitated from the larger one at Cluny, has well-preserved wall frescoes that include the Martyrdom of Saint Lawrence (fig. 562), a work of immense power. From its coloring we may gain an idea of how the tympanum at Vézelay (see fig. 531) must have looked when its original painted surface was intact. Saint Lawrence lies upon the gridiron, which is arranged schematically parallel to the picture surface, and stylized flames rise from below it. The rest of the arched space is completely filled by the two executioners and the gigantic judge. The diagonal thrust of the two long rods ending in iron forks, which hold the victim on the gridiron, crosses the compartmentalized drapery masses, whose striations show the influence of Byzantine drapery conventions but whose folds move with a fierce energy totally alien to the elegant art of Constantinople. Note also that the French limestone columns flanking the fresco have been painted to resemble the veined marble ones of Byzantine architecture.

TAHULL The Romanesque frescoes that once decorated the great metropolitan churches of Europe have for the most part been replaced by later and more fashionable works of art; the best-preserved group of Romanesque frescoes originally adorned the mountain churches of Catalonia in the picturesque and productive northeast corner of Spain. Almost all of these have been detached from their original walls and are today in museums. A powerful example is the *Christ in Majesty* (fig. 563), painted about 1123 in the Church of San Clemente de Tahull. The style is somewhat less accomplished than that of the Burgundian masterpiece we have just seen, but it is by no means less expressive. Christ's mandorla is signed with the Alpha and Omega (the first and last letters of the Greek alphabet), and he holds a book inscribed (in Latin): "I am the light of the world" (John 8:12), as at Cefalù (see fig. 450). The drapery is rendered in broad, parallel folds, shaded arbitrarily with little elegance and much force. The delicacy of Christ's hands and feet and the portrait quality of his face are therefore the more surprising.

Romanesque manuscript illumination shows as rich a profusion of regional styles as do the churches, the sculptures, and the murals. England in the late tenth century produced a strongly independent style characterized by a freedom recalling that of the Reims School. This energetic art, which flourished especially at Winchester in southern England, was carried across the Channel to France.

GOSPELS OF SAINT-BERTIN An English painter was surely responsible for the illustrations in the *Gospel Book* illuminated at Saint-Bertin, near Boulogne-sur-Mer on the Channel coast, at the end of the tenth century. The first page of the *Gospel of Matthew* (fig. 565) is divided in two vertically; on the right a large initial *L* (for *Liber generationis*) preserves echoes of the old Hiberno-Saxon interlace, but carried out with little interest and already invaded by acanthus ornament. What really fascinated the artist was the figurative side of the page. On a little plot of ground at the top a benign angel gives the glad tidings to two shepherds (the scene is very different from the solemn apparition in the Gospel lectionary of Henry II; see fig. 519). Directly below, Mary is stretched out on a couch, apparently already lonely for her Child, after whom she reaches out her hands. A midwife bends over to comfort her, while Joseph ad-

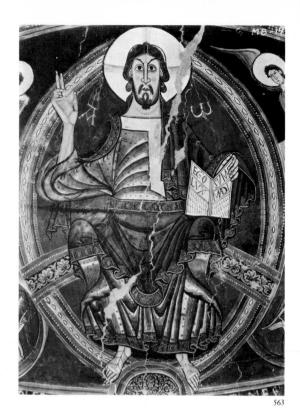

563. Christ in Majesty, fresco from S. Clemente de Tahull, Spain. c. 1123. Museo de Bellas Artes de Cataluña, Barcelona

Manuscripts

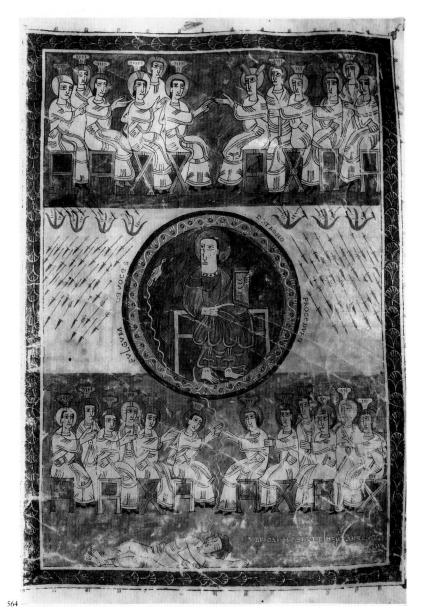

564. Ende. Vision of Saint John, illumination from the Commentary on the Apocalypse by Beatus of Liebana. Monastery of Távara (León), Spain, 975. Cathedral of Gerona, Spain

monishes her vehemently from his seat at the right. At the bottom of the page Joseph bends affectionately over the Christ Child, wrapped in swaddling clothes and lying in a manger, as the ox and ass look on astonished. Above the initial letter the arc of Heaven discloses five delighted angels. The human, narrative style is matched by the sprightly drawing, the delicate and transparent colors, and the rippling drapery folds.

THE BEATUS MANUSCRIPTS A rich treasury of fantasy and imagination was unlocked for artists of the Middle Ages in Spain and later in France by a theological work, the *Commentary on the Apocalypse*, written by the Spanish monk Beatus of Liebana in 786, during the period when the Moors ruled central and southern Spain and when Christian communities were in a state of constant struggle with Islam. The second earliest of the many surviving manuscript copies of Beatus' work, and also one of the finest, was written in 975 in Visigothic script by two priests at the monastery of Távara, in the north Spanish kingdom of León, and was illustrated largely, if not entirely, by a woman painter called Ende, characterized in the text as *pictrix et adiutrix Dei* (woman painter and helper of God). Like most manuscript illuminations Ende's compositions were probably based to some extent on those of earlier illustra-

566

tions, but their special qualities of freedom and buoyancy are her own.

The visions of Saint John, of course, provide exciting material for artists, and Ende exploited them to the full in page after splendid page. In one of the grandest (fig. 564) she depicts a vision that was to reappear in the sculpture of the Romanesque portal at Moissac (see fig. 534)—the heavens opening before Saint John, to disclose the Lord upon his throne among the four-and-twenty elders (Rev., or Apoc. 4:2-5). Ende shows the sleeping visionary at the bottom of the page, and his spirit as a white bird whose wavy path can be followed all the way from the saint's mouth to the throne on which the Lord sits, surrounded by "a rainbow . . . in sight like unto an emerald," holding the usual book in his left hand, and blessing with his right. The elders sit in freely distributed groups of six on either side of the throne, against the upper and lower stripes into which the background is divided. Surprisingly they are beardless, and their "golden crowns" become curious bloops, each with three vertical grooves and three groups of vertical marks. The rainbow is translated as a circular glory, intersecting the lower stripe and floating against the central one, but not quite touching the upper. Seven lamps, "the seven spirits of God," float at the top of the central stripe, and the "lightnings and voices" (labeled in Latin) proceeding from the throne are rendered as showers of alternating arrows and spears. The four beasts, indispensable in later renderings of the vision, are unaccountably omitted. The astonishingly simple facial drawing increases the power of the composition.

Another magnificent Beatus manuscript was illuminated at Saint-Sever in Gascony, in southern France, by a certain Garsia, probably also Spanish. An especially powerful illustration (fig. 566) shows the plague of

565. Initial L and scenes of the Nativity, illumination from a Gospel Book. St.-Bertin, France, late 10th century. Bibliothèque Municipale, Boulogne-sur-Mer, France

566. STEPHANUS GARSIA. *Plague of Locusts*, illumination from the *Commentary on the Apocalypse* by Beatus of Liebana. St.-Sever (Gascony), France, middle 11th century. Bibliothèque Nationale, Paris

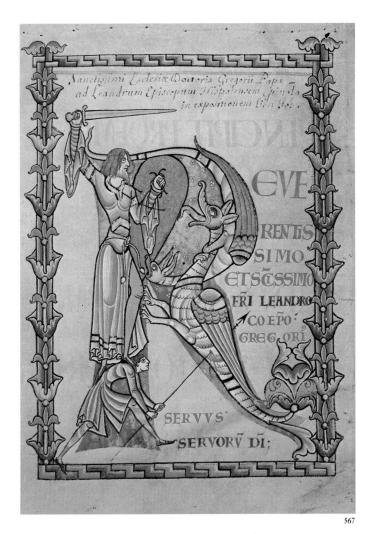

locusts loosened upon the earth to strike men with their scorpions' tails so that they "seek death and shall not find it." So vividly is the passage (Rev., or Apoc., 9:7–11) illustrated that it demands quotation:

And the shapes of the locusts were like unto horses prepared unto battle; and on their heads were as it were crowns like gold, and their faces were as the faces of men.

And they had hair as the hair of women, and their teeth were as the teeth of lions.

And they had breastplates, as it were breastplates of iron; and the sound of their wings was as the sound of chariots of many horses running to battle.

And they had tails like unto scorpions, and there were stings in their tails: and their power was to hurt men five months.

And they had a king over them, which is the angel of the bottomless pit, whose name in the Hebrew tongue is Abaddon, but in the Greek tongue hath his name Apollyon.

The ferocity of the linear style in which these terrible beasts are drawn is intensified by the harsh coloring of the background rectangles: red ocher, brown, green, yellow, and blue.

CÎTEAUX Still another possibility for the Romanesque manuscript style is seen in a highly imaginative illumination from the *Moralia in Job* of Saint Gregory (fig. 567), painted at the very beginning of the twelfth

- 567. Initial R with Saint George and the Dragon, illumination from the Moralia in Job. Cîteaux, France, early 12th century. Bibliothèque Municipale, Dijon
- 568. Frontispiece, Book of Deuteronomy, Bible of Bury St. Edmunds. Abbey of Bury St. Edmunds, England, 1st half of 12th century. Illumination. Corpus Christi College, Cambridge, England

century at the Burgundian monastery of Cîteaux, the mother church of the reforming Cistercian Order. A border of floral ornament at the sides and of zigzag at top and bottom, in delicate tones of orange, lavender, green, and blue, surrounds the initial letters of Gregory's dedication of the book to Bishop Leander. The R (for Reverentissimo) is partly formed by a standing knight, possibly Saint George, whose left leg in blue hose emerges elegantly from his orange tunic. He holds a green shield and brandishes a blue sword high above a delightful dragon, which makes up the rest of the R and which has two heads and green, blue, orange, and gold wings. The knight's pose is actually an unnecessary ritual, because the hapless squire on whose back the knight stands has already taken the precaution of running the dragon through with a spear. Here again are the linear energy and brilliance of design we have seen in Burgundian architecture, sculpture, and painting, accompanied by a wit that could be given free rein only in manuscripts intended for the few. At this point it is interesting to quote from Saint Bernard's famous letter of 1127 on the subject of the impieties of Romanesque art:

. . . what profit is there in those ridiculous monsters, in that marvelous and deformed comeliness, that comely deformity? To what purpose are those unclean apes, those fierce lions, those monstrous centaurs, those half men, those striped tigers, those fighting knights, those hunters winding their horns? Many bodies are there seen under one head, or again, many heads to a single body. . . .

In fact, Saint Bernard, who clearly enjoyed and understood what he was condemning, put an end to all figurative art not only at Cîteaux but also throughout the Cistercian Order—luckily not before the illumination of this and other beautiful manuscripts. It almost seems as if he had correctly traced, whether consciously or not, such animal fantasies to their ultimate source in the art of the pagan barbarians.

THE BIBLE OF BURY ST. EDMUNDS The apex of skill in Romanesque illumination is achieved in the lavishly illustrated *Bible of Bury* St. Edmunds, illuminated in England probably just before the middle of the twelfth century. At the top of an illustration to Deuteronomy (fig. 568), Moses and Aaron reveal the Law to the assembled Hebrews, delightfully individualized in their faces and in their reactions. Moses is pictured with the horns he was given in art according to Saint Jerome's translation of the Hebrew word that also means rays, but that, it has been shown recently, is also connected with a long tradition of horned deities and even with the shape of the Christian miter. In the lower illustration Moses points out the clean and the unclean beasts; two defiant red pigs rejoice in their uncleanness. This style is a very elegant and accomplished one, with its enamel-like depth and brilliance of color and high degree of technical finish. The sparkling perfection of the ornament, the smooth linear flow of poses and draperies, and the minute gradations of value have brought the art of painting about as far as it could go within the conventions of Romanesque style. Marion Roberts Sargent says, referring to this illustration, "The real achievement of Romanesque illumination is the complete domination of two-dimensional space. Figures, border, ornament, architecture, and landscape, even the text, are treated equally in brilliant color, resulting in total mastery of surface design."

SAINT HILDEGARDE OF BINGEN Among all the visionaries of the Romanesque period the most original and unpredictable was Hil-

degarde of Bingen (1098-1179), the first of a long line of influential women mystics throughout the Middle Ages, the Renaissance, and the Baroque. Interestingly enough, considering his attitude toward the fantastic strain in Romanesque art, Saint Bernard firmly championed the validity and importance of Hildegarde's visions. Although the procedures for her canonization were never completed, Hildegarde's name is today officially inscribed among the saints because of her long life divided between mystical revelations of other-worldly powers of light and darkness, which began during her childhood, and intense scholarly activity. In 1136 Saint Hildegarde was elected prioress of her convent, which she then transferred to Rupertsberg near Bingen, on the Rhine. There she wrote books on medicine and history, allegorical sermons, and both the words and the music of canticles and hymns. She even invented a language of her own with nine hundred words and twenty-three letters. Her most important work for our purposes is the *Liber Scivias* (abbreviation of *Scito vias lucis*, "know ye the ways of light"). Whether or not she painted any of the illuminations with her own hand, she certainly directed the work, which was lettered and illustrated by her nuns. Among the twenty-six visions, all of startling beauty and originality, we may choose that of the ball of fire (fig. 569).

569. HILDEGARDE OF BINGEN. Vision of the Ball of Fire, illumination from the Liber Scivias. Rupertsberg, Germany, 12th century (Original destroyed)

Then I saw a huge image, round and shadowy. It was pointed at the top, like an egg. . . . Its outermost layer was of bright fire. Within lay a dark membrane. Suspended in the bright flames was a burning ball of fire, so large that the entire image received its light. Three more lights burned in a row above it. They gave it support through their glow, so that the light would never be extinguished.

Whatever the wonderful visions may have been in the transfigured mind of the saint, it is significant that her nuns set them down in the visual language of the Romanesque—two-dimensional surfaces and ornamental line. It is tragic to record the destruction of the original manuscript in World War II.

THE BAYEUX TAPESTRY One of the largest and also best-preserved pictorial efforts of the Romanesque period is the so-called Bayeux Tapestry. (In point of fact, this is an embroidery, done on eight bolts of natural-colored linen with only two different stitches of wool; in tapestry the design is woven along with the fabric.) Originally somewhat longer, the work now measures 230 feet in length by only 20 inches in height. It was designed and executed to run clockwise around the entire nave of the Cathedral of Bayeux in Normandy, from pier to pier. Especially interesting since Romanesque secular works are rare, the hanging narrates for the populace the detailed story of the invasion of England by William the Conqueror, including the background of political intrigue, from the official Norman point of view and complete with titles in Latin for the benefit of those who could read.

Traditionally the immense project is supposed to have been embroidered by the ladies of Queen Matilda's court. There seems little reason to doubt that the needlework was done by women, who in the Middle Ages made all the gorgeous embroideries for church vestments, altar cloths, altar frontals, and so on-and indeed quite generally still do. Some one of the women seems to have been an Anglo-Saxon, judging from the peculiar forms of some of the letters. The hanging was probably ordered by William's brother Odon, Bishop of Bayeux (also Duke of Kent), for the consecration of his cathedral in 1077. But were the designers of the splendid narrative also women? This seems unlikely, since the actors are exclusively male and the scenes are depicted with close knowledge of military operations and instruments. For example, a ship with others behind it (fig. 570), strikingly like those the Vikings (ancestors of the Normans) had used during their raids in earlier centuries, is beached in a reverse D-Day operation. The mast is being lowered and horses disembarked upon the English beach. But the needlewomen may well have been left free to add their own birds and beasts, sometimes fantastic enough to have irritated Saint Bernard, and even little nudes, in the margins.

Space was required for this continuous method of narration, descending of course directly from Greek and Hellenistic friezes and Roman historical columns—doubtless scattered here and there throughout the Empire—and emulated in Bishop Bernward's column (see fig. 515) and in such rotuli as the *Joshua Roll* (see fig. 440). No excerpt can convey the cumulative force of the *Bayeux Tapestry*. Exhibited today around a single long room, the typically Romanesque figures move with such vivacity that every aspect of the Norman Conquest seems to take place before our eyes, and we easily accept the Romanesque convention of flatness and linearity.

One of the astonishing things about the Romanesque period is its brevity. The great creative moment began at the end of the eleventh century. By 1140 the Gothic style had already replaced the Romanesque in the Île-de-France, and long before the twelfth century was over, the onrush of the Gothic, which was to rule in northern Europe at least for more than three hundred years, had banished the Romanesque to remote provincial centers.

570. The Landing of Horses from Boats, detail of the Bayeux Tapestry. c. 1073–83. Wool embroidery on linen, height 20". Courtesy the City of Bayeux

TIME LINE VI

Ebbo Gospels

Lindau Gospels

HISTORY

Palatine

700

900

Chapel, Aachen

Battle of Poitiers, 732; Charles Martel defeats

800 Charlemagne crowned Emperor at Rome, 800

> Vikings begin raids on England, 835 Charles the Bald, Carolingian king, r. 840–77 Carolingian Empire divided among sons of Louis the Pious at Treaty of Verdun, 843 Charles the Simple cedes Normandy to Vikings,

Otto I, German king, crowned Holy Roman Emperor, 962

Hugh Capet, French king, r. 987–96, founds Capetian dynasty

CULTURE

Alcuin (735–804) begins revision of the Vulgate (Latin Bible) Ebbo, archbishop of Reims, r. 816–35 Carolingian revival of Latin classics Earliest documented church organ, Aachen, 822 Einhard writes Life of Charlemagne, 821 Cluniac Order founded, 910 Gero, archbishop of Cologne, r. 969–76

St. Bernward, archbishop of Hildesheim, r. 993-1033

Capital, Cluny

Tympanum, Vézelav

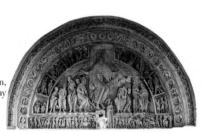

S. Miniato, Florence

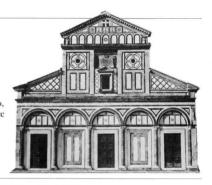

1000 William the Conqueror, Norman duke, r. 1035-87

> Normans begin conquest of Sicily, 1043 Battle of Hastings, 1066; William the Conqueror wins England First Crusade, 1095–99

Crusaders found Latin kingdom of Jerusalem,

1100 Louis IV the Fat of France, r. 1108–37, strengthens monarchy Roger II, Sicilian king, r. 1130–54 Second Crusade initiated by St. Bernard, 1147 Saladin captures Jerusalem, 1187

St. Dominic of Silos (d. 1037) Leif Ericson sails to North America, 1002 Avicenna, 980–1037, chief medical authority of Middle Ages College of Cardinals formed to elect popes, 1059 Pope Gregory VII, r. 1073–83 St. Bruno founds Carthusian Order, 1084 Cistercian Order founded, 1098 Hildegarde of Bingen (1098–1179) Song of Roland composed, c. 1098 Monk Theophilus' De diversis artibus, c. 1100 St. Bernard, abbot of Clairvaux, r. 1115–53 Order of Knights Templars founded in Jerusalem, 1119

HOLY ROMAN EMPIRE/ROMANESQUE

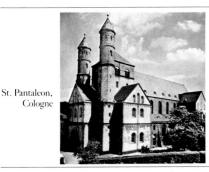

Doubting Thomas ivory

Otto Imperator Augustus

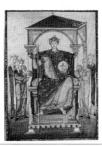

St.-Sernin. Toulouse

Painting, Sculpture, Architecture

Abbey Church of St.-Riquier; Abbey of Lorsch and gateway Palatine Chapel, Aachen; plan for monastery at St. Gall Coronation Gospels; Lorsch Gospels; Ebbo Gospels; Utrecht Psalter; Lindau Gospels; Bible of Charles the Bald Otto Imperator Augustus Vision of Isaiah; Vision of St. John, by Ende Crucifix of Archbishop Gero

Wall paintings, St. George, Reichenau; Lectionary of Henry II Doubting Thomas ivory St. Pantaleon, Cologne; St. Michael's, Hildesheim Bronze doors and Column of Bishop Bernward, Hildesheim Hitda Codex; Uta Codex

PARALLEL SOCIETIES

Franks Byzantine Carolingian Viking Muslim Ottonian

900

700

800

Cathedral, Monreale

S. Angelo in Formis

St.-Étienne, Caen; S. Ambrogio, Milan; Cathedral, Durham

Abbey Church and sculpture, Cluny; St. Sernin, Toulouse

Moralia in lob. Cîteaux

Norman

Italian city-states

French Monarchy

German Monarchy

Durham Cathedral

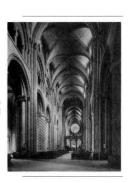

S. Miniato, Baptistery, Florence; Cathedral, Speyer; Cathedral, Pisa

1000

1100

English Monarchy

Frescoes, Civate; fresco cycle, S. Angelo in Formis; Bayeux Tapestry Sculpture, S. Domingo de Silos Ste.-Madeleine, Vézelay, with sculpture; Last Judgment by Gislebertus, Autun; tympanum, portal, and cloister sculpture, Moissac; portal, sculpture, St.-Gilles-du-Gard; Notre-Dame-la-Grande, Poitiers Martyrdom of St. Lawrence, Berzé-la-Ville; Christ, S. Clemente de Tahull Apocalypse of St.-Sever; Gospels of St.-Bertin; Moralia in Job; Bible of Bury St. Edmunds; Liber Scivias by Hildegarde of Bingen Reliefs by Wiligelmo da Modena; King David and Descent from the Cross by Antelami; baptismal font by Renier de Huy Baptistery and Campanile, Pisa; Abbey Church, Maria Laach;

GOTHIC ART

SIX

The term Gothic is used today to designate the style that began in northern France before the middle of the twelfth century and in the rest of western Europe anywhere from a generation to a century later. We now know that the name is a misnomer, for Gothic art has nothing whatever to do with the Goths, who swept down on Roman Italy in the fifth century (see Chapter Three). But the Italians of the Renaissance thought that it had. The medieval buildings surrounding them seemed so barbaric in comparison with the beauty of Roman architecture that they believed this style could have been imported into Classical Italy only by the Vandals, the Goths, the Lombards, and the Huns. Giorgio Vasari, the Renaissance artist and writer who characterized Byzantine pictorial style as "the rude manner of the Greeks," was even more caustic about medieval architecture, which he claimed "was invented by the Goths." The disparaging term Gothic took root; by the seventeenth century the great French dramatist Molière was referring to the "torrent of odious Gothic monsters" that had been unleashed on France. Not until the beginnings of Romanticism in the late eighteenth century did Gothic art begin to catch hold of the imaginations of a cultivated elite as a welcome escape from the rules of Classical art into a past that seemed both natural and intriguingly remote. And only with the historical studies of the early nineteenth century did it become clear that so-called Gothic art was really a phenomenon separated from the Gothic invasions by at least seven centuries. Soon Gothic art became recognized as the refined intellectual and aesthetic achievement of a highly developed society, but there was no longer any possibility of changing the name.

Non-French European regions in the late twelfth and early thirteenth centuries, however, were well aware of the origin of the Gothic style. They referred to it as opus francigenum (French work), and they were right—in the narrow and restricted sense denoted by the term French at the time. The Gothic style was born in that region of north-central France centering around Paris, known as the Île-de-France, which as we have seen (see page 407) was the personal domain of the French kings. Today art historians are in a position to add the birthdate of the Gothic style: shortly before the year 1140, when the first stage of the reconstruction of the royal Abbey Church at Saint-Denis was completed. From the Île-de-France the style radiated outward, winning acceptance in region after region, first throughout northern France, then almost immediately in England, then in Germany, the Low Countries, central Europe, and Spain, and finally in a reluctant Italy—which never fully understood or accepted it and was, as we have noted, the first to brand it barbarous and to rebel against it.

In contrast to the individuality of the local Romanesque schools, their wide diversity of styles and technical methods, and the extreme brevity of their period of full bloom, five outstanding phenomena characterize the Gothic. First, the Gothic is remarkably consistent throughout wide areas of central and northern France; it was carried almost unaltered into Germany, the Low Countries, and Spain; and it was only somewhat modified by local requirements in England. Second, it developed a competitive mo-

mentum; architects, sculptors, and painters were well aware of what was being done elsewhere and were constantly trying to beat their rivals at their own game. Third, the Gothic lasted, although transformed by regional tastes and requirements, well into the sixteenth century (everywhere except Italy, of course). Fourth, the Gothic created structures completely without precedent in the history of art, surpassing in technical daring anything ever before imagined. Finally, after the long interregnum of the early Middle Ages, the Gothic was the first Western art to present a believable image of a complete human being.

We tend to think of Romanesque as the architecture of the monasteries, and to a great extent this is true, but largely because in most Western cities, even some very small ones, the Romanesque cathedrals of the eleventh and twelfth centuries were replaced in the late twelfth or thirteenth by Gothic ones. But the distinction is valid in a general sense because, with the exception of Saint-Denis, which as we shall see proves the rule, it was cathedrals, not monasteries, that required rebuilding. By the beginning of the Gothic period, the great cultural and economic mission of the monasteries had largely come to an end. Their role as conservators of learning was being assumed by the universities, and their economic importance had been superseded by that of the towns. It has long been pointed out by Meyer Schapiro that the Gothic cathedrals were the largest economic enterprises of the Middle Ages. The cathedrals absorbed the activities of architects, builders, masons, sculptors, stonecutters, painters, stained-glass makers, carpenters, metalworkers, jewelers—utilizing materials brought sometimes from great distances—and gave back nothing in a material sense.

Monasteries were generally located in the country; a cathedral, by definition the seat of a bishop, was in a town, and it became a symbol of the town's corporate existence. To a great extent this is still true. A contemporary Florentine will boast of being *fiorentino di cupolone* (Florentine from the great dome [of the Cathedral]); during the air attacks of World War II, Londoners kept watch nightly, risking their lives, on the roofs and towers of Saint Paul's Cathedral in order to extinguish fire bombs as they fell. In the Gothic period communal devotion to the construction of the cathedrals was so great that, according to contemporary chroniclers, not only did the rich contribute financially to the limit of their ability to the building and decoration of the cathedrals, but also rich and poor alike joined with laborers and oxen to pull the carts laden with building materials.

With their soaring height, their immense interiors, their pinnacles, towers, and spires, their innumerable images and narratives in stone, paint, and glass, the cathedrals summed up the knowledge and experience of humanity's brief earthly tenancy in artistic forms and iconographic cycles of astonishing completeness, united in a structure that constituted a comprehensive medieval picture of the universe from the heights of Heaven to the depths of Hell. But we have not defined the Gothic style, and that will not be easy. It is best to illustrate its nature and main lines of development with a few selected works.

The Beginnings of Gothic Style

SAINT-DENIS On June 9, 1140, in the presence of King Louis VII of France and his queen, Abbot Suger consecrated a new façade, with a triple, sculptured portal and two square towers (of which only one was ever completed) on the Carolingian church of the Abbey of Saint-Denis, just north of Paris; on June 11, 1144, the same abbot brought to completion a new choir with ambulatory and radiating chapels that replaced the Carolingian apse. Both additions were necessary to accommodate the crowds of pilgrims who came to venerate the relics of Saint Denis and other saints preserved in the apse. Saint-Denis was not only a pilgrimage monastery but also a royal foundation in which French monarchs were buried. As its abbot, Suger was a person of great political importance, the power behind the thrones of two kings and regent of France (1147– 49) during the absence of one king on the Second Crusade.

Suger intended eventually to replace the Carolingian nave of his church as well. Ironically, when this nave was replaced in the thirteenth century by a Gothic one, Suger's choir was also demolished, except for the ambulatory, which is an extraordinary achievement (figs. 571, 572). At first sight the ambulatory with its radiating chapels recalls Saint-Sernin at Toulouse (see fig. 524), but the ambulatory of Saint-Denis is doubled at the expense of the chapels, which are reduced to hardly more than bay windows, expanding and contracting at regular intervals so as to carry the crowds easily around the high altar with its reliquary shrine.

Suger left a written account, unique in the annals of patronage, explaining his feelings about the work and his reasons for doing as he did, recounting its history (not without miracles), and preserving valuable information about architectural practices in the twelfth century. According to a famous study by Erwin Panofsky (see Bibliography), Suger believed that the writings of an obscure fifth-century Syrian mystic, known as Dionysius the Pseudo-Areopagite, preserved at Saint-Denis, were in fact those of Saint Denis, the patron saint of France and of the abbey (Denis is French for "Dionysius"). The complex Neoplatonic system according to which Dionysius identified light with divinity was seen by Panofsky as the justification for Suger's enthusiasm for the light from the "circular string of chapels, by virtue of which the whole [church] would shine with the wonderful and uninterrupted light of most luminous windows. . . ."

One is tempted to ask why such a theological explanation of light would not refer just as easily to Hagia Sophia, for example, with its rows on rows of windows under and around the floating dome. One notices also that Suger reserved his special raptures for the beauty of the gold used to cover the new doors and for the gold and jewels of the reliquary shrine, without mentioning the design of either. He was so unresponsive, in fact, to the style of his time that he caused a gold mosaic instead of sculpture to be set up in the tympanum of the left portal, although he admitted it was contrary to "modern" practice. One is almost more impressed by what Suger omitted from his account, such as the name of the architect, than by what he mentioned. Suger was also silent about the master's technical and stylistic innovations, but he recounted with admiration the architect's ability to measure the Gothic choir so accurately that when the Carolingian apse left standing inside it was finally taken down, the new choir was found to be in perfect alignment with the old nave. About the columns Suger said no more than that their number corresponds to the numbers of the Apostles and the minor prophets.

So far from being in any way responsible for the new style evolving around him, Suger in his account reveals himself to have been unaware that it was new. Modern studies of the development of ribbed vaults have

571. Ambulatory, Abbey Church of St.-Denis, Paris. 1140-44

572. Plan of the ambulatory, Abbey Church of St.-Denis, Paris (After Sumner Crosby)

shown that for a decade or so before the rebuilding of Saint-Denis, architects—under probable Norman influence—had been experimenting with ribbed vaults in the parish churches of the Île-de-France. Whoever he was, the architect of Saint-Denis was probably of local origin (only the stained-glass makers, Suger tells us, were brought from throughout France). A glance at the illustration (see fig. 571) makes clear what is really new: for the first time we have an architecture not of walls but of supports. Columns or compound piers including colonnettes support the ribs, between which the concave vault surfaces are constructed. Walls tend to be replaced by windows. From this moment walls in French cathedral architecture are residual, and architects will vie with one another to reduce them to a minimum, while at the same time they refine the connection between the supports and slim down the supports to the ultimate. In each of the trapezoidal bays and pentagonal chapels of the ambulatory at Saint-Denis, the transverse ribs are pointed so as to lift the sides of the bays as high as possible, thereby concentrating the outward thrust of the vaults on the columns and piers. The plan shows that this thrust is carried to the exterior of the church where it is met by the buttresses, which appear as black, rectangular projections between the windows.

Architecture at Saint-Denis has become an organic system of interacting supports (columns, colonnettes, ribs, buttresses), both inside the church and outside, enclosing vaulting surfaces above and windows on the sides. Four thousand years of post-and-lintel construction and at least a thousand years of massive vault design have suddenly become obsolete. The only derivation of early Gothic architecture from the past can be found in the ribbed domes of Byzantine architecture, such as that of Hagia Sophia (see fig. 427), but even Byzantine ribs stop at the pendentives and walls remained necessary. Suger recorded his gratitude for divine intervention when the bare ribs of the incomplete choir vaults of Saint-Denis, protected by the outer roof but still without the stabilizing factor of the inner triangles of the vaulting, were shaken by a terrible storm; they vibrated visibly, but remained standing. It would have been more to the point for Suger to congratulate his architect on his extraordinary knowledge and skill.

Like many medieval patrons before him, Suger thought of plundering Rome for marble columns and even worked out the route by which they could be transported. Luckily (again, according to Suger, by miracle) he found an inexhaustible quarry of local limestone. But it was not by accident that in this new organic architecture not only Roman columns but also Roman, Byzantine, and Romanesque capitals have been abandoned. The new capital shapes are based, however schematically, on the growth of actual foliage that the architects had seen rather than on Greek acanthus leaves that they had not. It is worth remembering that several Renaissance writers felt that Gothic architecture had originally been suggested by primitive shelters formed by tying trees together.

CHARTRES One masterpiece of transitional Gothic architecture, sculpture, and stained glass survives intact: the façade of the Cathedral of Chartres (figs. 573, 574), to the southwest of Paris. In 1134 the façade of the eleventh-century cathedral was damaged by fire, necessitating its replacement. The north tower was built first without a spire. Then about 1142 the south tower was erected to its full height, culminating in one of the most beautiful spires of the Gothic period. The simple addition of one element to the next, visible throughout Romanesque structures (see fig. 525), has here given way to a delicately adjusted interconnection.

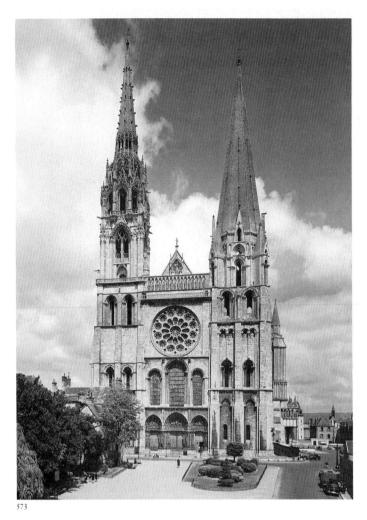

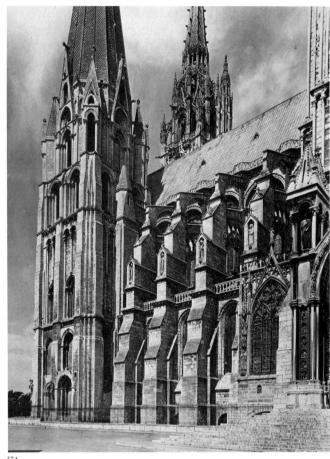

The transition from the square to the octagon, for instance, is prepared as early as the second story by placing the colonnettes of the blind arcade directly on the keystones of the arched windows and by the splaying of the corner buttresses. By the time the eye rises to the fourth story, which is clearly octagonal, the transition has been accomplished almost unnoticeably. The tower rose high above the roof of the Romanesque cathedral at the beginning of the third story; its effect was somewhat diminished by the taller Gothic structure commenced in 1194 (see page 455).

The façade was built to connect the towers at their eastern flanks, so that they would project on either side and appear partly to enclose it. At some undetermined time these plans were changed, and the Royal Portal (fig. 575), dating from about 1140-50, was set up in its present position flush with the towers. The splayed triple portal is completely sculptured, and devoted to a unified theme: the Nativity and scenes from the Infancy of Christ on the right, the Ascension on the left, scenes from Christ's life in the capitals of the colonnettes, and in the center his heavenly apparition according to the Vision of John, as at Moissac, but including the Twelve Apostles (see fig. 534). The freedom of Romanesque sculpture has been abandoned here in favor of a disciplined structure that embraces every element in the portal, and of which Christ himself is the center. In contrast to the rich confusion of the Moissac tympanum, the central lunette at Chartres is immediately legible. Each of the symbols of the Evangelists occupies its predetermined position. Each of the four-and-twenty elders of the Apocalypse in the outer archivolts and the twelve angels in the inner archivolts moves in conformity with the motion of the arch,

- 573. West façade, Cathedral of Chartres, France.
- 574. South tower, Cathedral of Chartres. c. 1142
- 575. Royal Portal, west façade, Cathedral of Chartres. c. 1140-50
- 576. Jamb statues, Royal Portal, Cathedral of

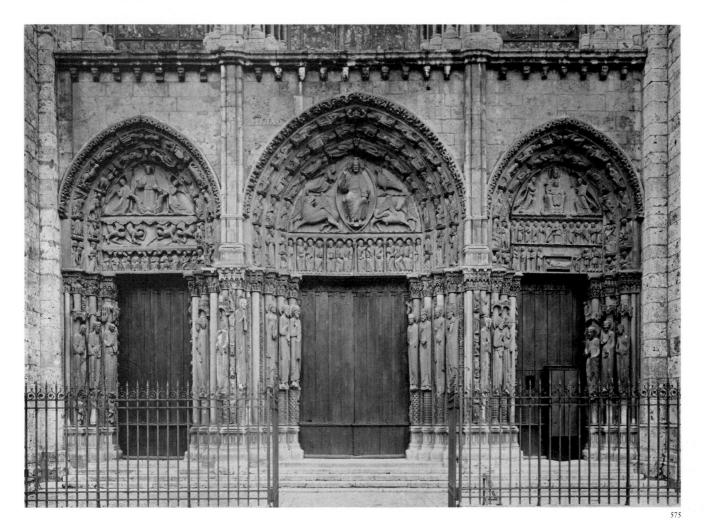

even though that involves tilting over, till they converge at the keystone, where two other angels uphold a royal crown.

The tall, infinitely slender figures on the jambs of the doors (fig. 576) represent in all probability kings, queens, and prophets from the Old Testament. They, too, obey the forces of the architecture to the extent of assuming the shapes of the colonnettes of which they form a part. They stand upon firm pedestals, and the long, taut drapery lines contrast in their severity with the luxuriance of the interlaced ornament between the colonnettes. Paradoxically, the columnar figures support nothing; each usurps the shape of a column, but not its function, in contrast to the maidens of the Erechtheion (see fig. 246), for example, who took over the function of columns without relinquishing their own shapes. Calm has settled over the scene after the wildness of Vézelay and Moissac only twenty years or so before. The figures seem to enjoy their role in a perfect system, which, incidentally, includes among its minor sculptures the seven liberal arts, the signs of the zodiac, and the labors of the months. The figures assume a cylindrical existence in depth, which in Romanesque sculpture had been seen only in Provence (see fig. 537). The delicacy of the parallel drapery lines, recalling those of Archaic kore figures (see figs. 176, 190), is surpassed only by the sensitive delineation of the quiet faces. The serenity of this royal allegory was never again achieved, but the decisive step in the creation of a new architectural sculpture had been taken. Henceforward, the figure could assert its individual existence in harmony with the forces of an all-embracing architecture.

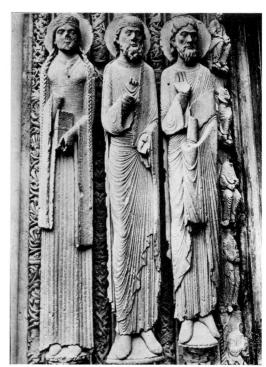

576

The story of French cathedral building in the late twelfth and thirteenth centuries is made more exciting by the element of intense competition. No sooner was a new form or a new device established in one cathedral than it was outdone in another. One architect and sculptor, Villard de Honnecourt, went from cathedral to cathedral drawing the latest architectural and sculptural achievements (fig. 577).

LAON The earliest Gothic cathedral is that at Laon, to the northeast of Paris. The situation is spectacular because Laon itself is a hill town lifted high above an almost flat plain; the cathedral with all its towers may thus be seen for many miles (fig. 578). It was to have had seven towers, one over the crossing between nave and transept, two on the nave façade, and two on each transept. Although even some specialists do not know this, all save the crossing tower—a total of six—were actually completed. During the French Revolution one tower on each transept façade was torn down for its stone, to the dismay of the local population; only four now remain. The number seven had mystical significance, since it was the sum of the Trinity and the Gospels, the number of the Virtues (and the Vices), the number of the gifts of the Holy Spirit, the number of the liberal arts, and the number of the candlesticks in Heaven. No Gothic cathedral ever boasted all seven towers, but many were planned for that number (Chartres was to have had eight). Whether the towers at Laon were also intended to receive spires is uncertain but unlikely; the tiny steeple on one of the transept towers is a much later addition.

The façade, begun about 1190, is unexpectedly dramatic. The triple portal is protected by three porches; above the central porch is an early example of a rose window. Radiating from the center of this circular window is an elaborate network made of separate pieces of stone, known as tracery, one of the great inventions of the Gothic period. Pierced slabs of stone, or grilles, had been used in Byzantine and Islamic windows, and the Gothic rose window derives from this tradition. However, the tracery, intended to hold stained glass, obeys precise geometrical laws. Above the rose and its flanking arched windows runs an open arcade, broken to indicate on the exterior the relation of the clerestory and side aisles within. The façade towers are flanked by superimposed aediculae with pointed arches, square on the first two stories and octagonal on the third. In contrast to the lofty pointed central windows these aediculae create a broken and irregular silhouette. The towers are transparent, skeletal structures, through which the wind blows easily. From the uppermost aediculae protrude statues of oxen, popularly believed to be those who dragged the stones for the cathedral up the steep hill of Laon. For some as-yetunexplained reason, the round apse at Laon, begun about 1160, was replaced only a few years after completion by a square east end on the English model (figs. 579, 580). The present great length of the noble interior—eleven bays for the nave, ten for the choir—is as dramatic as the towers.

In looking at the interiors of Gothic cathedrals throughout Europe we should remember, however, that the vista was originally broken in almost every one by a monumental stone screen running across the entrance to the choir. This screen was provided with a central Crucifixion group, twin pulpits from which the Epistle and Gospel were read at Mass, and sometimes even small chapels. The purpose of these choir screens was to separate the laity's Masses and preaching services, held in the nave, from the Divine Office (prayers at seven stated times) and other liturgical functions, which had to be chanted in the choir by the clergy of the cathedral

The French Cathedral

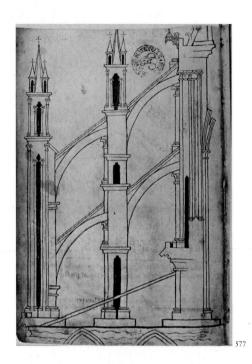

577. VILLARD DE HONNECOURT. Flying Buttresses. c. 1230-35. Pen and ink. Bibliothèque Na-

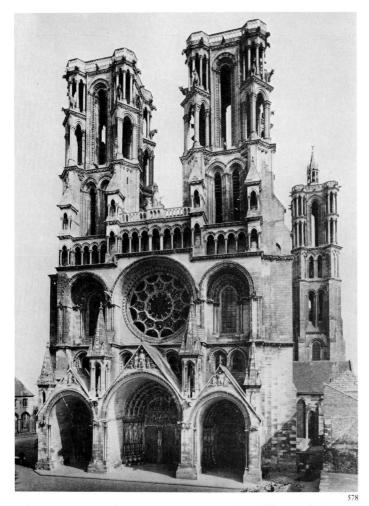

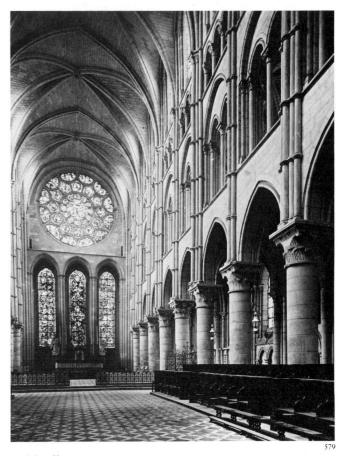

whether or not there was a congregation. These choir screens, with all their precious sculpture, were systematically destroyed in the Baroque period in order to unify the interiors for enormous congregations. Their original effect can be judged by a surviving example at Saint Elizabeth at Marburg in Germany (see fig. 613).

The interior at Laon is four stories high. The nave arcade, supported by heavy cylindrical piers instead of compound square ones, is surmounted first by a gallery with coupled arches under an embracing arch, then by a small triforium, and finally by a clerestory tucked into the vaults. As at Caen (see fig. 558), the vaults are six part, but somewhat less domical. There is an even more significant difference, too often overlooked by art historians, in which resides the secret of Gothic as opposed to Romanesque vaulting: the conoids (the conelike shapes formed by the convergence of ribs and vault surfaces on the capitals of the colonnettes) are sharply pinched together on the side next to the clerestory. This pinching of the conoids frees the diagonal ribs from the clerestory, allowing them to establish their own positions in space. The thrust of the vaults seems to have been contained by the girdle of the gallery, but in the thirteenth century cautious architects added flying buttresses on the exterior (for an explanation of and a look at flying buttresses, see page 455; figs. 577, 591).

NOTRE-DAME AT PARIS The façade of Notre-Dame at Paris (fig. 581) was planned about 1200 and completed about 1250. The dramatic effects of Laon are avoided; the elements are brought under the control

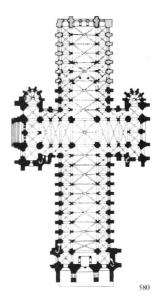

578. West façade, Cathedral of Laon, France. c. 1190

579. Choir, Cathedral of Laon

580. Plan of the Cathedral of Laon. Begun c. 1160 (After E. Gall)

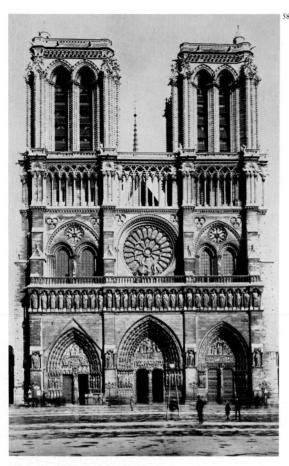

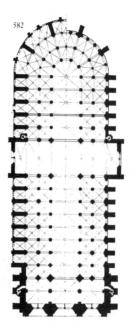

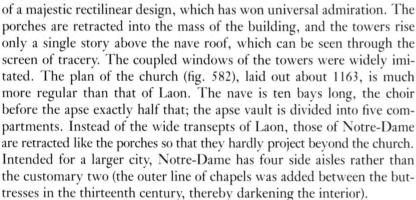

But the interior design of Notre-Dame proved obsolete within sixty years. Only the last bay on the right (fig. 583), next to the crossing, shows the original four-story design of the nave, with a triforium made up of tiny rose windows (the remaining one has been much restored) and a small clerestory. About the middle of the thirteenth century, the original row of flying buttresses in the nave (required to supplement the containing action of the gallery) was replaced by the present ones, and the clerestory was greatly enlarged into tall windows filled with tracery extending well below the springing points of the vaults, influenced by developments at Chartres, Reims, and Amiens. The photograph renders it clear that the pinching of the conoids by the original architect made this "modernization" possible, as it allowed the diagonal ribs to pass freely across the edge of the clerestory windows. Each rib, incidentally, is channeled so that the appearance of a cluster is maintained at all points from the capitals to the vault. The vaults are still slightly domical, but have been carried to a height of 107 feet, 27 feet higher than those at Laon and higher than any Romanesque vaults except those of Speyer Cathedral.

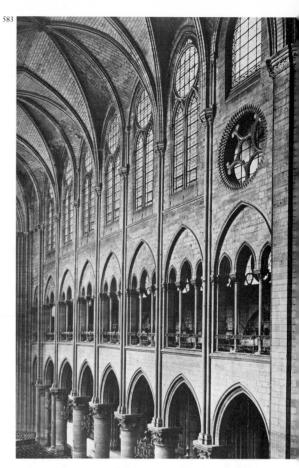

581. West façade, Notre-Dame, Paris. c. 1200-50

- 582. Plan of Notre-Dame, Paris. 1163-c. 1250
- 583. Nave, Notre-Dame, Paris. 1163-c. 1200

CHARTRES The fire of 1194, which consumed the town and the Romanesque Cathedral of Chartres, except for the two towers and the Royal Portal, gave Gothic architects the opportunity to take the next and definitive step, which ushered in the phase known as High Gothic. After the conflagration at Chartres, almost every old cathedral in northern France and some in Germany caught fire when it seemed most opportune to replace them with Gothic ones. The Cathedral of Chartres is the most nearly complete of all in architecture, sculpture, and stained glass, and it demands study as an integrated whole. Smaller than Paris, the town of Chartres needed a cathedral with a nave of only seven bays and a choir of four, and two side aisles (fig. 584). Nonetheless, the vaults rise to a height of 118 feet in one unbroken ascent.

The architect eliminated the gallery, since flying buttresses were, for the first time, planned from the start. Only a small triforium separates the clerestory from the nave arcade (fig. 585). Liberated from the vaults, the clerestory has become almost equal in height to the nave arcade, and now dominates the interior. The cylindrical piers, still inviolate at Laon and at Notre-Dame in Paris, have now been absorbed into the skeletal system; the colonnettes supporting the transverse ribs are coupled to the piers and run straight to the floor. The resulting new type of compound pier became universal. The six-part vault is given up as unwieldy, and the interior thus presents a more unified appearance. In the choir the enlarged clerestory is composed of simple lancet (single pointed-arch) windows, but in the nave the windows are filled with tracery, achieved by piercing the wall of each bay with two lancets under a small rose; this form is known as plate tracery. At the crossing the four supporting piers have been enriched with colonnettes, in the manner of clustered organ pipes, to great effect.

The massive buttresses (see fig. 574) rise in steps to a height far above the sloping roof of the side aisle, to be connected with the clerestory by means of two slanting, superimposed arches joined together by a tiny arcade. These are flying buttresses, which "fly" from the buttresses to make contact with the clerestory at the two points where, so the architects believed, pressure was necessary to counteract the outward thrust of the nave vaults. A third flying buttress, above the other two, added a few years later, was probably intended to help the heavy timber and lead roof over the vaults resist the action of the wind. With the adoption of flying buttresses the concept of skeletal architecture began to determine the exterior as well as the interior appearance of a building; every exterior member corresponds to a necessity created by an interior pressure. The resultant Gothic structural system has been aptly termed an exoskeleton.

Chartres was planned for two western façade towers, two flanking each arm of the transept, and one flanking each side of the choir, or a total of eight; all but the western towers were left unfinished at the height of the vaults. The south transept façade (fig. 586), built about 1215–20, shows a richness of articulation far beyond that of the main façade of Notre-Dame, designed only a few years earlier; slender colonnettes, like those at the crossing, screen the buttresses. The projecting triple porch was an afterthought, added to the portal after the sculpture.

The three portal statues of standing saints to the right (fig. 587) are still columnar, but when compared with those of the Royal Portal, they are partially liberated from the architecture and stand on pedestals more nearly suited to their function; on these pedestals are figures or images alluding to the legend of each saint. The wealth of tiny sculptures above the statues of the Royal Portal has been replaced here by naturalistic foliate capitals, enshadowed by greatly enlarged canopies, which re-

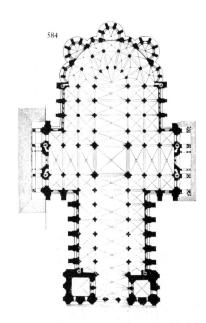

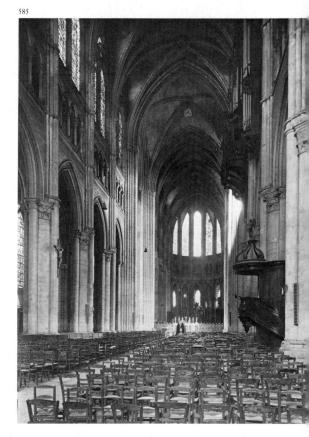

584. Plan of the Cathedral of Chartres. 1194–1220 (After G. Dehio)

585. Nave, Cathedral of Chartres. 1194-1220

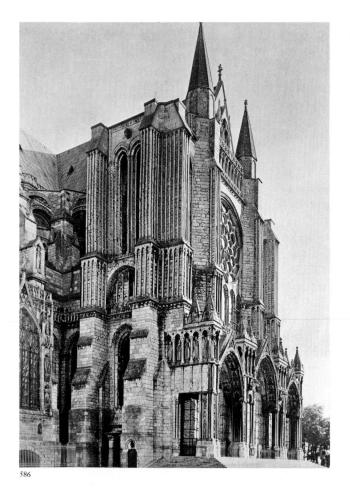

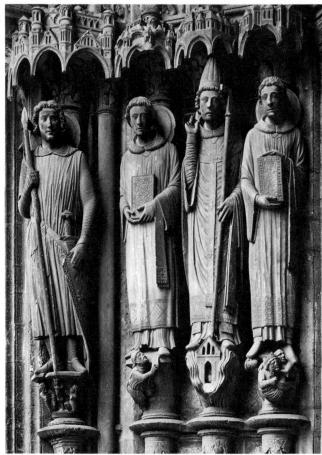

semble little city views with arches, windows, pinnacles, and towers. The portrait-like heads are thrown into stronger light against the shadow, and the figures, wrapped in complete cylindrical envelopes of drapery, are far more strongly projected than those of the Royal Portal.

The statue at the left, probably representing Saint Theodore, was added at the same time as the porch and shows an increased freedom of style. For the first time since Roman art a figure is balanced with the weight largely on the right foot and the left leg at least partially free. Gothic sculpture seems in a way to recapitulate the development of sculpture in Greece from the late Archaic to the Severe Style (see figs. 203, 212), with the crucial difference that in Christian art the movement of the figure must be carried out under voluminous clothing. Once established in the portal figures of Chartres, the freedom of the figure from the architecture increased, as did the freedom of the architectural members themselves from the obsolete concept of the wall. With his knightly attitude, his spear at the ready, and his calm, handsome face, Saint Theodore seems the very ideal of the Christian warrior fostered by the Crusades.

The lightening and heightening of Gothic cathedrals cannot be adequately explained by the desire for illumination—that, as we have seen, could have been handled by a system along the lines of Saint-Philibert at Tournus (see fig. 523). The entire cathedral in the twelfth and thirteenth centuries became a framework to hold stained glass. Stained glass inevitably darkened the interior but had its own indescribable beauty of color and pattern. Much Gothic stained glass has perished, some deliberately destroyed in later times either by Protestant reformers or simply in order to lighten cathedral interiors. Chartres contains the most nearly complete cycle of medieval stained glass, much of it in good condition, from the twelfth-century lancets above the Royal Portal to the thirteenth-century

586. Façade of the south transept, Cathedral of Chartres. c. 1215–20

587. Jamb statues, south transept portal, Cathedral of Chartres. c. 1215–20

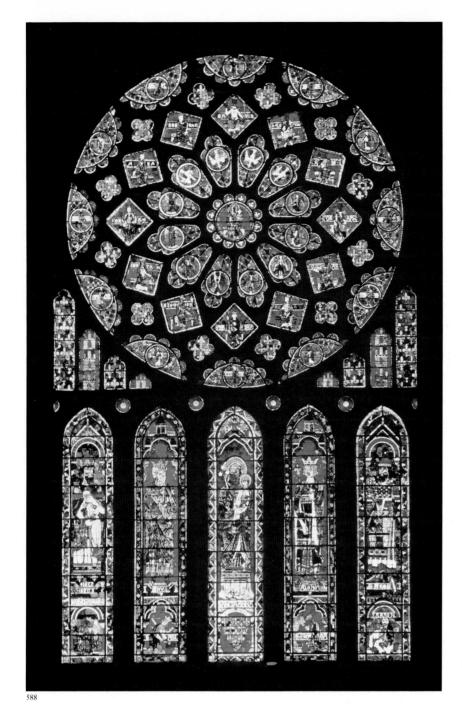

588. Rose window and lancet windows, north transept, Cathedral of Chartres. Stained glass. 13th century

windows girdling the rest of the church. Between the windows, some of which have scores of separate, carefully organized subjects, and the innumerable sculptures on the three triple portals, it takes a studious visitor several days, guidebook in hand, just to identify all the images. One comes away from such an experience with a deep respect for the Middle Ages, because the representations encompass the entire range of medieval knowledge—Old and New Testaments, lives of the saints, fundamentals of Christian doctrine, labors of the months, signs of the zodiac, Virtues and Vices, and the activities of the guilds that contributed to the building of the cathedral.

The gigantic window of the north arm of the transept (fig. 588) is a rose, still in the form of plate tracery, above five lancets. In the central lancet, Saint Anne, mother of the Virgin, holds her child; she is flanked by two kings, David to the left and Solomon to the right. Two high

priests, Melchizedek to the left and Aaron to the right, flank the kings. The rose above, more than forty-two feet in diameter, shows Mary in the center enthroned as Queen of Heaven holding the Christ Child. With the growth of the cult of the Virgin, under the direct influence of Saint Bernard, Mary has now displaced the Romanesque Christ in Majesty and the Byzantine Pantocrator. In the next circle four doves indicating the Gospels proceed toward Mary, and below them eight angels kneel or stand in adoration. Twelve kings from the Old Testament, clearly labeled, all ancestors of Christ, sit in the next circle of twelve lozenges. Finally, in the twelve semicircles around the rim stand prophets. Significantly enough, the twelve quatrefoil (four-leaf) shapes between the kings and the prophets are filled with the golden lilies of the kings of France on a blue field.

Stained glass achieves its effect by the passage of sunlight through it rather than by the reflection of light from it, as in mosaics. Stained glass is, therefore, the most brilliant coloristic medium invented by man before the light sculpture of the twentieth century. It is best to experience the stained-glass windows of Chartres (or any other Gothic church) in the gray weather all too common in northern France, for which this glass was planned; otherwise, the glitter from the south windows not only destroys their unity but also cancels out the glow from the north. In the early morning or in the late afternoon the colored windows float like immense jewels in the dim interior. Medieval theologians saw in the beauty of stained glass a symbol of the sacred mystery of the Incarnation, for as Divine Light, which is Christ (see fig. 431), entered the human body of Mary without violating her virginity and took on mortal flesh, so the light of the sun passes through colored glass without breaking it and assumes its color.

In thirteenth-century glass the predominant colors are red and blue; white, yellow, and green appear, but the red and blue contrast is what one remembers. Unlike mosaics, which are made up of uniform tesserae, stained glass is fabricated from pieces shaped as closely as possible to the contour of a section of face, figure, drapery, or background. First, a full-scale model is made, drawn on wood or later on paper, and the pieces of colored glass are cut to fit. The lines are then painted on the glass with a dark pigment. After this paint dries, a coating of pigment is sometimes applied and scraped away with a stiff brush while still wet, so that what remains in the hollows will increase the sparkle of the underlying color. The pieces are then fired (baked) in a kiln, so that the pigment will harden and at least partially amalgamate with the glass. Finally, the pieces are arranged on the model and joined together by lead soldering strips. Each scene is enclosed in an iron frame, and the frames bolted together within the tracery so that they can easily be taken down for repairs.

In two panels from a twelfth-century window in the façade at Chartres (fig. 589), a *Noli me tangere* ("Do not touch me," the words spoken by the resurrected Christ to Mary Magdalen in the garden) and a *Crucifixion*, the technique can be clearly seen. The lines of the pigment closely resemble those of the drapery and hair of the sculpture in the Royal Portal below (see fig. 576). The lead contours, a bit disturbing in black-and-white reproductions, serve in the colored original to reinforce by contrast the glowing splendor of the glass. The iron frames were often set into an elaborate master design built up of lozenges and circles. Panels of colored glass were known from early Christian times and were certainly used in Constantinian basilicas, as well as later in Hagia Sophia and in other Byzantine churches. They also appeared commonly in mosques. But glass treated in this manner does not seem to have been known before Carolingian times, and only a few fragments that date before the Romanesque

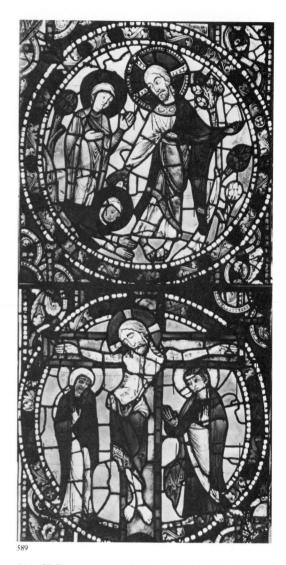

589. *Noli me tangere* and *Crucifixion* (details of a stained-glass window, Cathedral of Chartres). 12th century

period remain. Only in Gothic architecture does such stained glass become universal.

BOURGES The architectural arrangement established at Chartres became the model for most High Gothic cathedrals, but there is a beautiful variant at Bourges in central France, where the Cathedral has four side aisles (fig. 590) as at Notre-Dame in Paris. So that the inner side aisles would not be dark, the architect raised them above the outer side aisles, giving them triforia and clerestories of their own and thereby making them look like complete three-story naves. The nave arcade in turn rises above the inner side aisles, supporting still another triforium and another clerestory. The spatial effect is very open, with views out on every side. The absence of a transept at Bourges affords the eye a clean sweep of arches from façade to apse.

LE MANS The brilliant device at Bourges was seldom repeated in France. In the artistic vocabulary of the High Gothic, the façade with its two towers soon came to compete in interest with the *chevet*—the apse, with its radiating chapels and flying buttresses, crowned by a conical roof. Le Mans Cathedral has the most spectacular chevet in France (fig. 591), in compensation, perhaps, for its low and unobtrusive late Romanesque nave, contrasting with the High Gothic choir, built between 1217 and 1254. As at Bourges, the inner ambulatory has its own clerestory above the radiating chapels, and the windows pile up in three stories. Two flights of flying buttresses carry the thrust of the choir vaults across the intervening ambulatory, and to abut the thrust of the ambulatory

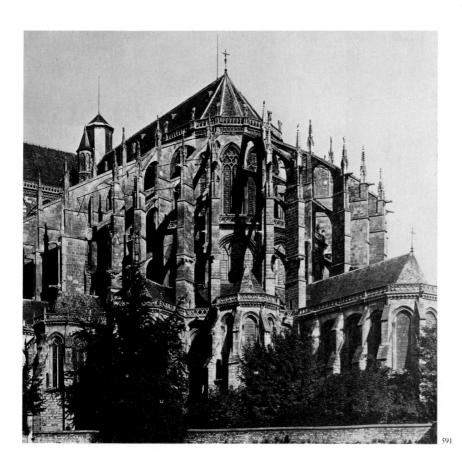

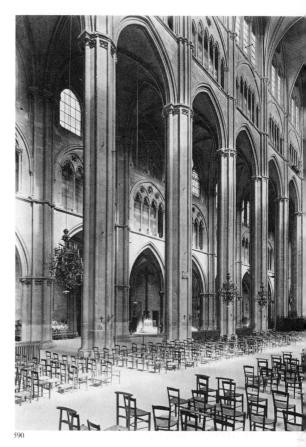

590. Nave and aisles, Cathedral of Bourges, France. 12th–13th century

591. Exterior of the chevet, Cathedral of Le Mans, France. 1217–54

vaults they divide in a Y-shape. The lines have been kept as clean and orderly as those of a flight of wild geese, massing in perfect harmony buttresses, flying buttresses, pinnacles, windows, and conical roof.

REIMS The Cathedral of Reims, in Champagne in northeastern France, was traditionally the coronation church of the French kings. Designed in 1210 (after a fire), probably by Jean d'Orbais, Reims was intended for six towers and a central spire; only the façade towers rise above the roof. At first sight the interior (fig. 592) resembles that of Chartres, with four-part vaults, cylindrical compound piers, three stories, lofty clerestory, and colonnettes rising from floor to vault interrupted only by capitals and rings to mark the stories. The height of the vault has risen to 127 feet, and three additional differences are visible in the illustration. First, the arches are more sharply pointed than those at Chartres, which increases the feeling of verticality. Second, the richly sculptured capitals are composed of naturalistic foliage that seems to follow no predetermined scheme but to grow in place. Finally, a new kind of tracery appears—bar tracery, erected as a linear fabric of slender pieces of stone inside the window opening, preserving only in line the arrangement of two lancets and rose as a framework for the glass.

It will be noticed that in the apse the ribs move so freely and in so

- 592. Nave, Cathedral of Reims, France. Begun 1210
- 593. West façade, Cathedral of Reims. c. 1225-99

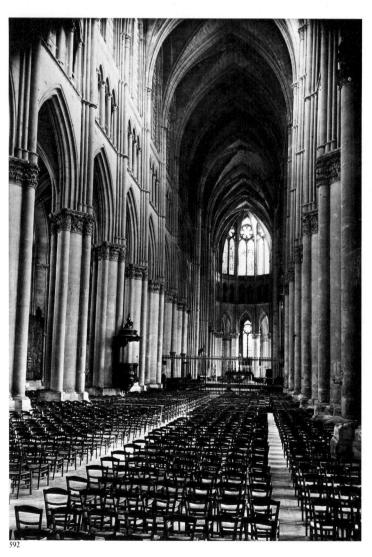

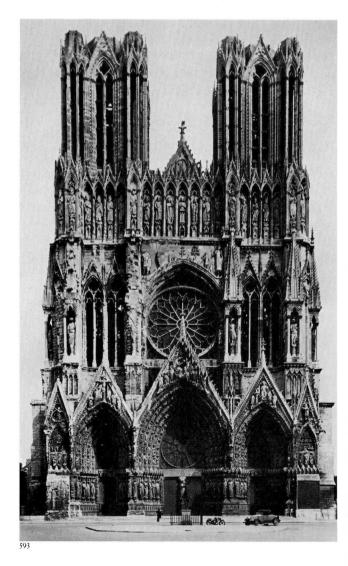

460 THE MIDDLE AGES

sharply pointed an arch that they actually pass in front of the clerestory windows. During World War I some of the ribs fell under bombardment, but the vaults stood, a tribute to the medieval masons. Villard de Honnecourt, as we have seen, made a careful drawing of the flying buttresses at Reims (see fig. 577), in two flights over the ambulatory as at Le Mans, and indicated the points at which they sustain the vaults. The pinnacles are not merely ornamental, but act as counterweights, helping to send the thrust of the vaults harmlessly downward to the ground.

The façade of Reims Cathedral (fig. 593) may have been started as early as 1225 but was under construction until late in the thirteenth century. The general arrangement repeats that of Notre-Dame in Paris, but the differences disclose both the rapid growth of the Gothic style and its organic character. Solid matter has been dissolved into lines moving through air, with the sole exception of the gallery in the third story, which had to be solid in order to hold statues of the French kings (added in the fourteenth century). The very tympana of the portals have given way to windows filled with bar tracery. The porches culminate in gables that move into the second story. The second story is transparent, and one looks through the open tracery of the lancet windows (they have no glass) to see the flying buttresses of the nave. The nave roof appears as a gable above the gallery. Finally, the towers, among the most beautiful creations of Gothic architecture, are entirely made of tracery with no wall surface whatever. The corner turrets, constructed completely of tracery, were intended to support corner pinnacles, whose octagonal bases can barely be distinguished, just as each central section, with its window of bar tracery and its pointed gable, was designed to support an octagonal spire.

The façade sculpture at Reims, dating from about 1225-45, continues the tendency toward freedom from architecture that had begun in the transept sculpture of Chartres, and the humanism of the figures is even more pronounced. Two groups side by side (fig. 594) were obviously made by two sculptors working in strongly individual styles and probably at slightly different times. The group to the right, done about 1225-30, depicts the Visitation, the visit of Mary to the house of her cousin Elizabeth, when the two women rejoiced in each other's pregnancy. The sculptor, while strongly aware of the call of visual reality, responds to it in a classical style. He must have seen and studied Roman sculpture during his travels. The mantles of Mary and Elizabeth sweep about their bodies and over their heads like Roman togas. Mary stands with the grace of a young Roman woman, Elizabeth with the dignity of a Roman matron. But there are differences; these poses do not entirely achieve the balance between the reciprocally tilted masses of the body that was instinctive for all ancient sculptors after about 400 B.C. The faces are only superficially classical. The folds break into more tiny facets than can be explained by the fall of the cloth. Nonetheless, we are clearly confronted with evidence of yet another renaissance of interest in ancient art, of which this is by no means the only Northern example in the thirteenth century (see fig. 615).

In the *Annunciation*, dating from the 1230s or 1240s, a very different style appears, made more apparent by the unfortunate inclusion, in a seventeenth-century restoration, of the wrong angel; he smiles a bit too broadly—though for the first time since Classical antiquity—for his religious function. His figure bends and sways in an accentuated S-curve, and his cloak is a complete and continuous fabric, which can move about his body as cloth will, responding to pressures and tugs and breaking into real folds. In the figure of Mary, shyly waiting, the change in style is

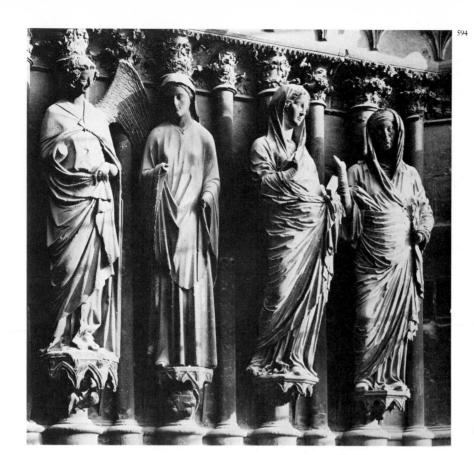

594. Annunciation and Visitation, jamb statues, west façade, Cathedral of Reims. c. 1225-45

even more surprising, because for the first time since antiquity (again) a body really shows through drapery—not just a volume of some undetermined substance, but a warm, human body. Mary's bosom can be clearly seen swelling through the soft garment that enfolds her, much as the bosom of Athena is visible through her peplos in the metope from Olympia (see fig. 224).

Another significant step was taken at Reims by the sculptor who carved, after 1251, the statues in the niches that fill the inside of the west façade. In spite of the fact that the two figures inhabit separate niches, The Knight's Communion (fig. 595; long misnamed Melchizedek and Abraham) forms a unified dramatic and compositional group. The knight, in complete chain mail, spurred, and girt with his sword (the tip has broken off), with mailed hands folded in prayer, looks from his niche toward the Eucharist extended to him from the ciborium (the appropriate vessel) by a priest who has turned toward him from a small altar. The priest, apparently a monk since secular clergy were not permitted to wear beards until the sixteenth century, is robed in a magnificent chasuble (a vestment worn by the celebrant at Mass in commemoration of the seamless robe of Christ) whose billowing folds, obscuring his body, contrast with the severe military dress of the knight. However, the artist was well aware of the proportions and movements of the masses of the body, as can be seen in the way he has handled the figure of the knight, in spite of chain mail and tunic. We have reached a Classical moment in Gothic sculpture, in which figures, fully in the round, are endowed with the capability of movement in space. The sculptor has set forth eloquently the contrast between the earnest, slightly frowning glance of the priest, with his richly curling beard, and the intense expectancy of the knight, receiving Communion presumably just before battle. The foliage of the frame is typical of High Gothic ornament, in its combination of crisp naturalism with easy rhythmic flow.

- 595. *The Knight's Communion*. After 1251. West interior wall, Cathedral of Reims
- 596. Plan and transverse section of the Cathedral of Amiens, France, begun 1220

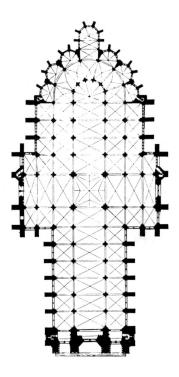

achieved at the Cathedral of Amiens (fig. 596), begun in 1220 by the architect Robert de Luzarches, in Picardy, due north of Paris. The soaring effect of the Amiens interior (fig. 597) surpasses that of any other Gothic cathedral; the vaults leap to a height of 144 feet. The proportions of all the elements are even more slender than at Reims. The last trace of doming is gone from the vaults, whose crown line is level. The triforium openings are filled with bar tracery rather than the continuous arcade of Reims. In the clerestory a momentous step has been taken: the same molding serves as wall rib and window frame, thus canceling out the wall. The nave of Amiens was built first; the two upper stories of the choir show still another step in the direction of dematerialization, probably taken by Robert de Luzarches' successor, Thomas de Cormont, after 1258. The roof covering the ambulatory vaults is no longer sloping, but converted into a succession of pyramidal caps, one over each bay. This change permitted the architect to turn the triforium into a second row of

AMIENS The climax of the High Gothic architectural style was

windows, greatly lightening the interior, which now looks bare without its stained glass. As the photograph of the choir vaults from below clearly shows (fig. 598), the entire cathedral has become a cage of delicate stone members—colonnettes, ribs, tracery—to hold the vault surfaces above and the stained glass on the sides. Mass has been almost totally replaced by linear fabric. This ultimate phase of the High Gothic style in France

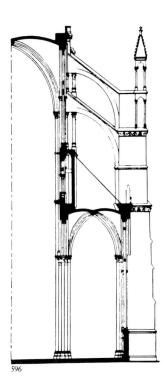

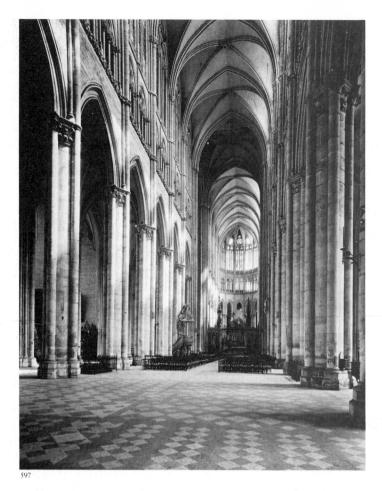

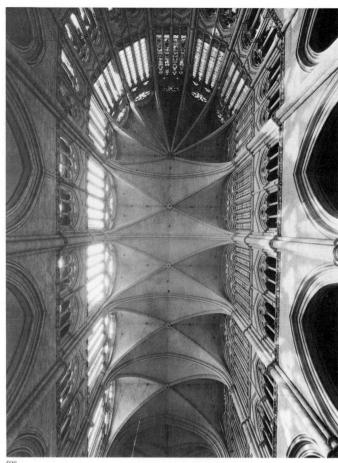

is called the Rayonnant on account of the tracery patterns that in the rose windows expand like rays.

The flying buttresses of the nave at Amiens resemble those at Reims, but those of the choir show a transformation, again probably due to Thomas de Cormont, and teach a striking lesson in the combined imaginative daring and structural logic of Gothic building. The architect has largely dematerialized the very device on which he depends for the support of the building: the flying buttress itself (fig. 599) is composed of bar tracery, connecting an upper strut and a lower arch, which were clearly sufficient to sustain the thrust of the slender vaults. Even the buttresses and their pinnacles have been decorated by a fabric of applied colonnettes and arches, which have no structural function but make the solid masses appear lighter and more vertical. As a final touch, the choir windows, one of which is to be seen at the right of the illustration, are surmounted by false gables made of tracery in order to dissolve the last remaining strip of wall above the window and to break the horizontal line of the cornice molding.

As compared with those of Laon, Paris, and Reims, the façade of Amiens (fig. 600), probably begun in 1220, is not a complete success. The center pinnacle marks the height of the nave roof, almost level with the south tower. From the side view the height of the church is so great as to render towers superfluous. The unity of the façade at Amiens is also disturbed by the much later—and in themselves very fine—rose window and details crowning the towers and the screen, belonging to the Flamboyant phase (see page 469). However, the Amiens portals contain sculpture of great dignity, especially the statue of Christ Treading on the Lion and the Basilisk (fig. 601; compare with the earlier version of the same theme in fig. 508), which stands against the trumeau of the central portal. Stylistically, the figure, with its firm stance and flowing but controlled drap-

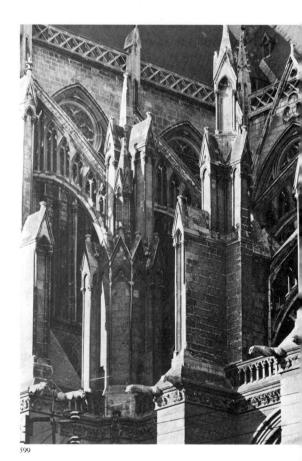

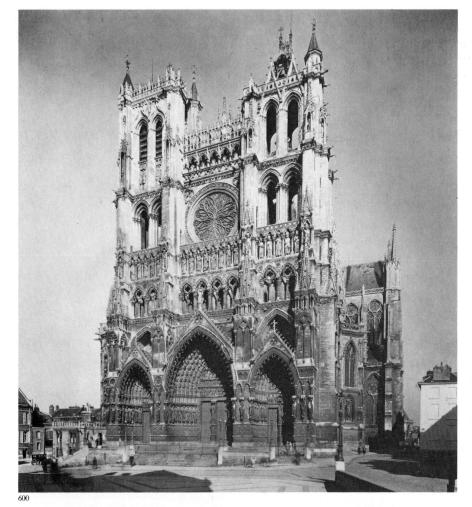

- 597. ROBERT DE LUZARCHES. Nave, Cathedral of Amiens
- 598. Choir vaults, Cathedral of Amiens (view from below)
- 599. View of choir and south transept, Cathedral of Amiens, showing flying buttresses
- 600. West façade, Cathedral of Amiens
- 601. Christ Treading on the Lion and the Basilisk, central portal of the west façade, Cathedral of Amiens. c. 1230
- 602. Signs of the Zodiac and Labors of the Months (detail), reliefs on the portal jamb of the west façade, Cathedral of Amiens. c. 1220–30

ery folds, represents a stage between that of the transept sculpture at Chartres and the highly developed naturalistic and classicistic statues at Reims. Nicknamed locally "le beau Dieu," the image is that of a man in early maturity, with straight nose, broad brow, calm expression, short beard, and flowing hair. With a few striking exceptions, this is the Christtype that has replaced in Western imagination both the Apollonian youth of the Ravenna mosaics and the awesome Pantocrator of Byzantine art. It is a remarkable paradox that Gothic artists should have populated their dematerialized, linear cathedrals with believable, many-faceted, and very solid images of complete human beings, even when it was necessary to portray the second person of the Trinity. The canopy over Christ's head, instead of showing the usual generalized array of domes and towers, is a tiny model of a Gothic chevet, with radiating chapels, possibly a reminder that the apse of a cathedral embraces the Eucharistic Christ of the Mass. The nobility of the Amiens statues contrasts with the vivid naturalism of the little scenes from the Old and New Testaments, and from such allegorical cycles as the Virtues and Vices, the signs of the zodiac, and the labors of the months, which appear in low relief in the quatrefoils on the bases of the portal jambs (fig. 602).

BEAUVAIS The practical limit of the Gothic dream was reached at Amiens. About 1225 the architect who designed the Cathedral of Beauvais (fig. 603), located between Paris and Amiens, tried to surpass it. By 1272 the lofty skeleton of stone, with a glazed triforium as at Amiens, had reached the unbelievable height of 157 feet above the floor. Then in 1284, before the transept could be completed, the choir vault fell, leaving only the apse vault standing. Collapses like this, frequent in the Romanesque period, were rare in the thirteenth century, when architects had, through trial and error, arrived at a system that generally worked. The reason for the disaster at Beauvais is not entirely understood; it may have been a matter of inadequate foundations. In any event the choir was rebuilt, the number of supports and flying buttresses being doubled and old-fashioned six-part vaults being revived for the last time. The building of the transept lagged on into the fourteenth century, with yet another calamity, the fall of a tower, and then the money ran out. From the outside the truncated choir, towering sadly above the Carolingian nave, is a monument to the unattainable, but the effect of the interior, catapulting in one leap from floor to lofty vault, is exhilarating.

THE SAINTE-CHAPELLE IN PARIS In contrast to the Beauvais catastrophe, the small-scale Sainte-Chapelle in Paris is a brilliant achievement of the Rayonnant style. The chapel was built from 1243 to 1248 by Louis IX of France, later canonized as Saint Louis, to enshrine relics of the Crucifixion. Louis met these relics, which were brought to France from Syria and Constantinople, at the gates of Paris and walked barefoot behind them in solemn procession. Although deprived of its surrounding buildings, and badly repainted in the nineteenth century, the chapel is structurally intact. It consists of a lower and rather modest story supporting an upper chapel that represents the utter perfection of the High Gothic (fig. 604), a delicate framework of slender stone elements enclosing stained-glass windows. As there are no side aisles, flying buttresses were not required. Only a small strip of wall remains below the windows, broken at the right by a simple niche. Behind and above the usual location of the altar stands a Gothic shrine in which the relics were

603. Interior, Cathedral of Beauvais, France. c. 1225

604. Interior, Ste.-Chapelle, Paris. 1243-48

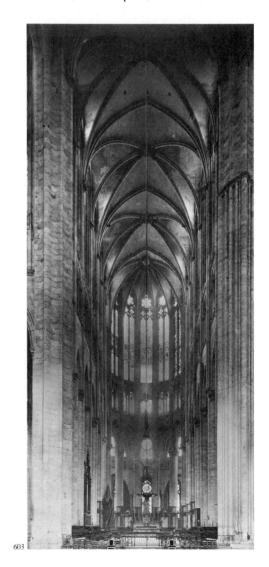

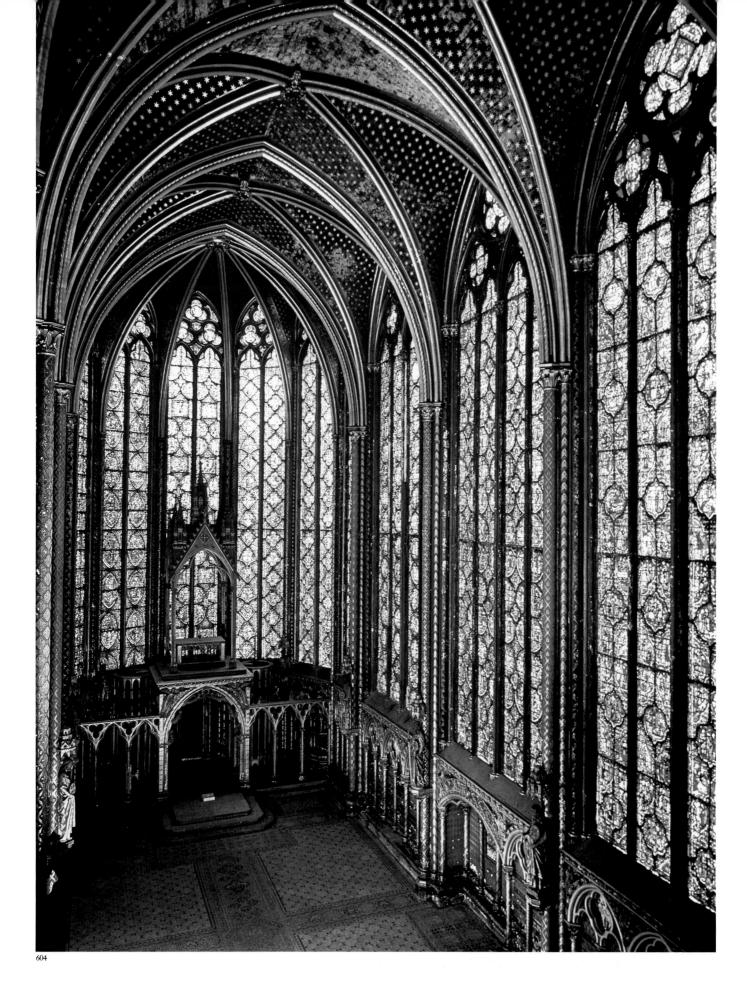

GOTHIC ART 467

kept and from which they could be displayed. For completeness and for quality the stained-glass windows of the Sainte-Chapelle compete only with those at Chartres. Their innumerable scenes organized as parallels between Old and New Testaments are small, and the upper ones are not easy to read from the floor—a problem we have encountered before in the sculpture of the Column of Trajan (see fig. 352). From a slight distance the windows fuse into an indescribable radiance of red and blue.

Never before or again in the history of art was architecture so completely dominant as in the Gothic period in France. Pictorial imagination was directed toward stained glass rather than mural painting, for which few wall surfaces remained in Gothic churches outside Italy. Even illuminated manuscripts, which survive in great numbers from this period, are dominated on every page by architectural concepts. One of the finest is a Bible Moralisée (moralized Bible—a collection of biblical passages and illustrations arranged as parallels between Old and New Testaments, as, for example, in the manner of the windows of the Sainte-Chapelle), probably written and illustrated in the mid-thirteenth century at Reims for Thibaut V, count of Champagne and king of Navarre, and his wife Isabelle, daughter of Louis IX. On one magnificent page God himself is shown as an architect, using that indispensable tool of architectural draftsmanship, the compass, to create heaven and earth, which "was without form, and void" (see fig. 12). The artist has imagined the Deity on such a cosmic scale that the universe is literally in his hand. The border, brilliant in its flashing alternation of patterned red and blue, is insufficient to contain him as he strides through space. The folds of his blue tunic and rose mantle, lined respectively with orange and yellow, are depicted in a free pictorial approximation of the parallel folds of the classicistic sculpture of Reims Cathedral. The artist has imagined the Creation as a moment of intense artistic inspiration; the Lord's eyes are dilated, his mouth slightly open, as he measures the circle containing green and blue waters, dark blue sky with stars, sun, and moon, and a still formless earth, giving it form by a supreme act of creative will. As often in Gothic art, the Lord's appearance is youthful and his halo contains the Cross of Christ, intended to show that not just God the Father but all three persons of the Trinity, under the guise of God the Son, were present at Creation. This unforgettable image should be compared with the totally different view of Creation in the Renaissance.

A dazzling page in the *Psalter of Saint Louis* (fig. 607), made for Louis IX and datable between 1253 and 1270, represents the appearance of the three angels to Abraham and the supper served them by Abraham and Sarah, the two incidents separated by the beautifully ornamentalized oak at Mamre. The excitement of the painting, which vibrates with brilliant color and tense, incisive line, could hardly be more different from the serene icon by Andrei Rublev dedicated to a synthesis of the same subject (see fig. 460). The elegant, swaying figures with tiny hands and feet are embraced, as often in Gothic illumination, by shapes derived from cathedral architecture. The gables and tracery are recognizable as belonging to the period of the choir of Amiens (see fig. 599), and a clerestory can be seen, too. As in stained glass, red and blue, white and green predominate. The border, which Saint Bernard would have hated, repeats the theme of animal interlace, whose origin we have traced to barbarian art.

French Manuscripts

After the thirteenth century, the pace of church building slowed in the domain of the French kings; almost every town that could afford a Gothic cathedral had built one. But in spite of constant warfare with the English, who controlled Normandy and much of western France, the elaborate and expensive process of finishing towers, façades, and gables continued in an always more imaginative style. The latest phase, beginning in the middle of the fourteenth century, is known as the Flamboyant because of the characteristic flamelike shapes of the tracery, based on double curvature rather than on the logical mullions, pointed arches, and circles of the High Gothic. A striking example is the rose window of Amiens Cathedral, done about 1500 (see fig. 600).

SAINT-MACLOU AT ROUEN The climax of the Flamboyant style is represented by the façade of the Church of Saint-Maclou (figs. 605, 606) at Rouen, the capital of Normandy, built in the early sixteenth century, the moment of the High Renaissance in Florence and Rome. The lower portion of the façade bays sharply outward. Of the five apparent portals, two are blind. No inert surfaces remain; transparent, linear shapes of stone merge with each other as they flicker upward, the transparent central gable even passing in front of the rose window. Only the main contours of the flying buttresses, gables, and arches are still apparent, drawn in thin air with lines of stone; the rest is sheer fantasy.

THE HOUSE OF JACQUES COEUR The finest surviving monument of late Gothic domestic architecture is the mansion (fig. 608) built at Bourges from 1443 to 1451 by the wealthy merchant Jacques Coeur, Treasurer to Charles VIII of France during and after the unhappy period when this weak monarch, driven out of Paris by the English, was known disparagingly as the king of Bourges. The house is a freely arranged succession of blocks, with steeply pitched roofs of different heights, the highest being reserved for the owner's private chapel with a Flamboyant window located over the main entrance. Flamboyant ornament is restricted to the balustrades at the eaves, to the panels under the windows, and to the rich staircase tower, ending in an openwork octagonal cap. This delightful, asymmetrical structure, with its inviting appearance of improvisation, should be compared with the rigidly symmetrical palaces being built by the same merchant class in Italy at the same moment. Alas, Jacques Coeur had only two years to enjoy his house before he was falsely accused of attempting to poison the king's mistress and had to flee France.

SCULPTURE AND PAINTING The sculptural style of the four-teenth century does not continue either the classicistic or the naturalistic tendencies we have seen in the sculpture of the great cathedrals. A typical early-fourteenth-century example, the *Virgin of Paris* (fig. 609; originally from the Church of Saint-Aignan), moves with an elegant lassitude that embodies the ultimate in courtly aloofness. The face looks almost Far Eastern in its soft contours and slightly slanting eyes. The folds, despite the sculptor's exact observation of the behavior of cloth, are nonetheless so voluminous that they give little hint of the Virgin's body beneath them. She wears her heavy crown with languid grace, but her pose, one hip sharply moved to the left to support the Child, shows a distinct element of exaggeration. Nonetheless, the sculptor has observed a delicate and

The Later Gothic in France

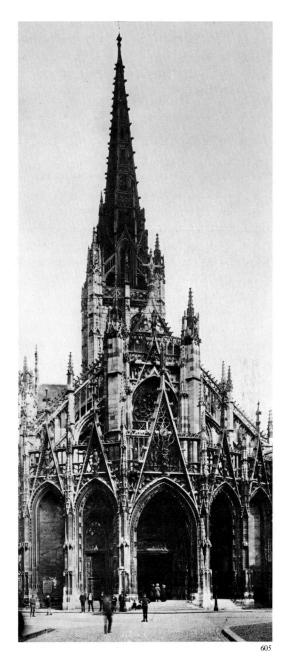

605. West façade, St.-Maclou, Rouen, France. Early 16th century

606. Plan of St.-Maclou, Rouen

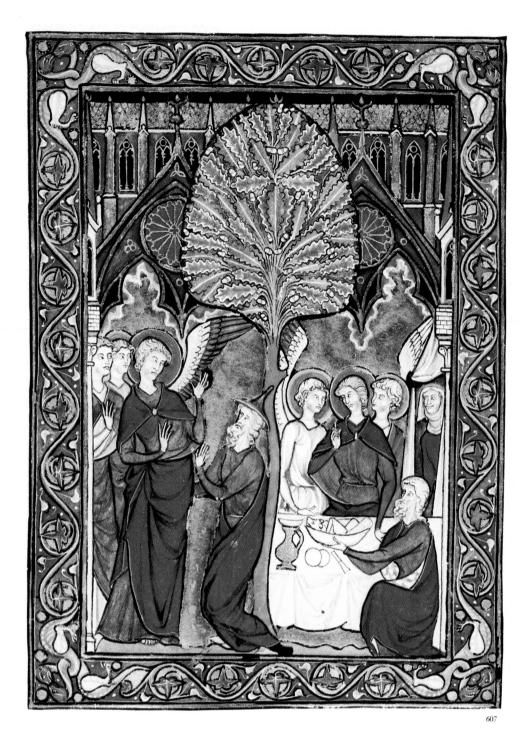

affectionate byplay between mother and Child as the babe holds the orb of power in his left hand and toys with her mantle with his right.

Fourteenth-century painting in France, luxurious and worldly, may be represented by a delightful page from the *Belleville Breviary* (fig. 610), illuminated at Paris about 1323–26 and attributed to Jean Pucelle, a still-undefined artistic personality. The architectural frame of the thirteenth century has been replaced by a delicate border of gold and blue; at the upper left a painting of *David Before Saul* was either executed under direct Italian influence or painted by an Italian artist. At the bottom of the page the French style reappears, in the tiny strip representing at the left Cain killing Abel, in the center the Eucharist offered by a priest to the dove of the Holy Spirit, and on the right Charity as a queen, assisted in her almsgiving by the Hand of God. A breviary is a book containing the

607. Abraham and the Three Angels, illumination from the Psalter of Saint Louis. Paris, 1253–70. Bibliothèque Nationale, Paris

dies mees: et lub lanaa mies anguam nichtlum auce te-Maumotamai uniuala uanuas: omnis tomo inuas Ciaumptamaim ýmagi ne prannue tomo: led t fa an annutanu Dirfantiar: et ignozar cu COMOTOTO HOLD BOTH E councous cit contanto ma nonne commus: Flub Canaa ma ayud cred ju tudo iam mastic as: urnon alinquam is anomo: obplobition ma pigna adila me. m lingua mm. Domoumo ainviam: aum confident prantor ad Comman crnon apam os ualum me. moun: quomam a feath a Domutu Climmulanus moncameplacas mas a fornaidme mannis na fum er futte alometer dolor mais conounties of go afa m marmanans Sonatur or mantinus hobul.undinuntun co meserm meduntone mea th jonuncin-1 grandiat ignus. armixfour fram hairan manthumam eus nau men: nonum fac mucht dimi ama uaur onautacut nconem meun 1 me lome, t nuncum dicumme androrationen mean ounname ar: ur laam guid winnicer appearanonem ine ancaurbs prair la commo or mentiombiles poli

- 608. Palais Jacques Coeur, Bourges, France. 1443–51
- 609. Virgin of Paris, from St.-Aignan. Early 14th century. Stone. Notre-Dame, Paris
- 610. Jean Pucelle. Page of the *Belleville Breviary*. Paris, c. 1323–26. Illumination. Bibliothèque Nationale, Paris

readings for the Divine Offices; yet the patron who ordered the manuscript and the artists who illuminated it had other concerns as well as the strictly religious, as a glance at the border will reveal. The animal interlace has disappeared, but animals, birds, and insects have been revived in very lifelike terms—a beautifully painted pheasant, a dragonfly, a butterfly, a monkey, a snail, a dragon, among which three musicians play a lute, a bagpipe, and a flute. What we witness in these caprices of sculpture and painting, which lingered into the fifteenth century, is the first glimmer of a new and exciting naturalistic style.

COLOGNE CATHEDRAL At first French Gothic was imported directly into the Rhineland, which was already amply provided with massive, apparently fireproof Romanesque double-ended cathedrals. When the Carolingian Cathedral of Cologne burned down in 1248, Bishop Gerhard was ready with complete plans for a Gothic replacement; work started within three and a half months. Building continued into the fourteenth century, then languished, and the choir remained incomplete. Only the lower story of the south tower had been built; unexpectedly, in the nineteenth century a large and detailed drawing for the façade and the towers, dating from about 1320, came to light, and the rest of the Cathedral was then completed with remarkable accuracy.

While the details of the nave and façade betray nineteenth-century handling, the general appearance of the Cathedral (fig. 611) is correct,

Germany

- 611. Cathedral of Cologne, Germany. 1248–1322
- 612. Choir, Cathedral of Cologne

and overwhelming. The interior (fig. 612) is only slightly less daring than Beauvais in its verticality and slenderness, and the glazed triforium may even have been designed earlier than the one by Thomas de Cormont at Amiens. The French would probably never have countenanced the profusion of heavy foliate ornament around the arches of the arcade, but otherwise the interior is French. So indeed are the tracery flying buttresses and the pinnacles veiled in tracery, as well as the gables over the clerestory windows. But French architects had never solved the problem posed by the effect of a lofty church on the design of the towers. The fourteenth-century architect at Cologne made a fresh start, treating the second stories of his towers as extensions of the clerestory, imposing majestic third and fourth stories, and bringing the towers to a brilliant climax in two pointed tracery spires.

SAINT ELIZABETH AT MARBURG The basically French plan at Cologne was not popular in Germany; almost contemporary with it appeared a more influential design, the *Hallenkirche* (hall-church), of which an early example is the Church of Saint Elizabeth at Marburg (fig. 613), dating from 1235 to 1283. In this type, widely followed throughout Central Europe (and, oddly enough, also in southern France), the nave and side aisles are the same height, eliminating the necessity for flying buttresses. Although exterior forms and interior spaces are inevitably less dramatic in the Hallenkirche type, space does flow more freely throughout the church, rendering it especially suitable for preaching. Later German Gothic architecture pursues a course similar to that of the Flamboyant phase of French Gothic, concentrating, however, on strikingly original and purely ornamental solutions of vaulting problems, throughout not only southern Germany but Austria and Bohemia.

NICHOLAS OF VERDUN German thirteenth-century sculpture can scarcely be understood without a consideration of the art of metalwork, highly regarded in the Middle Ages, and without a return to the valley of the Meuse, where in the twelfth century the classicism of Renier de Huy (see fig. 539) held sway at Liège. Another master from the same region, Nicholas of Verdun, had great success in Germany. In 1181 he completed an extensive cycle of gold and enamel scenes for a pulpit at the Abbey of Klosterneuburg, not far from Vienna; these were later remounted to form an altarpiece. The persistent debate as to whether Nicholas' style should be considered Romanesque or Early Gothic should be settled by the characteristically Gothic trefoil (three-lobed) arches of the borders. Nicholas' strong classicism is also Gothic in the sense that all his figures stand or move firmly on the ground, and though the drapery lines still retain some Romanesque ornamental character, the convincing action poses and the thoroughly consistent drapery folds are Gothic. The Sacrifice of Isaac (fig. 614) is presented in terms of physical action; the angel swoops down to withhold Abraham's sword, as he holds Isaac bound upon the altar. The stormy movement brings back memories of Hellenistic sculpture, and perhaps more relevant echoes of Nerezi (see fig. 451). This scene should be compared with Lorenzo Ghiberti's rendering of the same incident at the beginning of the Italian Renaissance.

The Klosterneuburg plaques were followed by the gold figures of the rich Shrine of the Three Kings, made by Nicholas about 1182–90 for the Cathedral of Cologne. The *Prophet Habakkuk* (fig. 615) is surely one of the

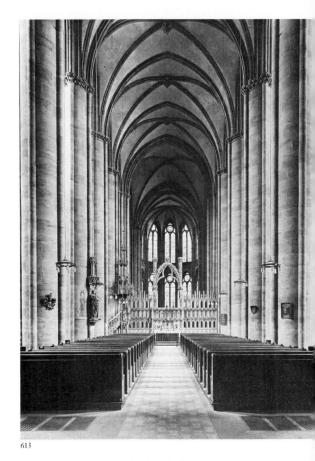

613. Interior, St. Elizabeth, Marburg, Germany. 1235–83

615

most classicistic figures of the entire Middle Ages—even more so than the *Visitation* group at Reims (see fig. 594). The prophet is seated in a strongly Hellenistic pose, his mantle sweeping around him in folds that recall fifth-century Greek sculpture (see fig. 210) as much as they do the togas of Roman sculpture (see fig. 308). His head is turned in an attitude of tense alertness, as if he were listening to divine inspiration. The movement of surfaces has surpassed even that of the work of Renier de Huy, with which it appears in a continuous tradition.

STRASBOURG CATHEDRAL German Gothic sculpture reflects also at the start the classicism of Nicholas of Verdun. Especially impressive is the *Death of the Virgin* tympanum (fig. 616), of about 1220, in the Cathedral of Strasbourg. Today in France, Strasbourg has been throughout most of its history a German city. The ornament of the preexistent arch is Romanesque, and the heads of the Apostles radiate outward from the center as at Vézelay, but the sweep and flow of the drapery are strongly Gothic, as are the delicacy of psychological observation and the intensity of the emotion displayed by the grieving Apostles.

At the same moment a different and vividly original style was developing elsewhere in Strasbourg Cathedral. The trumpet-blowing angels attached to a choir pillar (fig. 617) vaguely suggest French prototypes, but the leg-crossed pose, reminiscent of the *Prophet* at Moissac (see fig. 535), had long been renounced by French Gothic sculpture. Nonetheless, the forthright realism of these Strasbourg angels has no more to do with the visionary quality of the Romanesque than it has with the elegance of French Gothic. The fall of the tunic is easy and natural, the face

- 614. NICHOLAS OF VERDUN. Sacrifice of Isaac. 1181. Gold and enamel plaque, height 5½". Abbey of Klosterneuburg, Austria
- 615. NICHOLAS OF VERDUN. *Prophet Habakkuk* (detail of the *Shrine of the Three Kings*, Cathedral of Cologne, Germany). c. 1182–90. Gold, enamel, and precious stones, height of shrine 67"

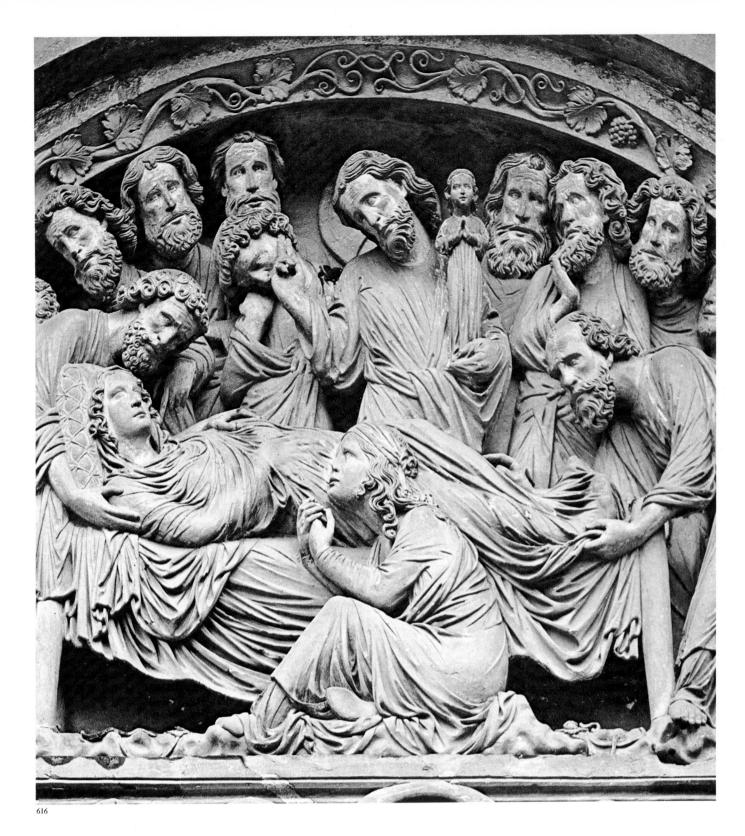

homely and everyday. The wings, with their vigorous abstract curvature, would have been unacceptable in France. But these are the very qualities that make German Gothic sculpture individual.

A legend, given wide circulation in recent years, attributes some of the finest sculpture at Strasbourg to a woman sculptor called Sabina, supposedly the daughter of Master Erwin von Steinbach. Master Erwin (the name Steinbach is also legendary), a brilliant architect in a later, wholly different phase of German Gothic, was actually not recorded at

616. Death of the Virgin, tympanum of the south transept portal, Cathedral of Strasbourg, France. c. 1220

Strasbourg until 1284, sixty years after the date of the sculptural masterpieces, and survived until 1318. Sabina, no relation, whose name does indeed appear in an inscription, was a patron of the work, not a sculptor. There are no records that women in the Middle Ages were permitted to engage in the arduous work of cutting stone.

617. Angels, choir pillar in the south transept, Cathedral of Strasbourg. c. 1220–25

THE NAUMBURG MASTER Massive sculptural cycles like those of the French cathedral portals were apparently not needed in Germany. German thirteenth-century masters, with less compulsion to conform to a "corporate" style, are impressive in their directness. The best of these is an anonymous artist known for his work in the Gothic Cathedral of Naumburg in Saxony (today in East Germany). This powerful sculptor carved a series of statues of nobles from local history who were believed to have been founders of the Cathedral and brought these subjects—about whose actual appearance he knew nothing—to convincing life. The heavyset, pouting Ekkehard (fig. 618), with his hand resting from habit on his sword hilt, is contrasted with his wife Uta, an aloof beauty who gathers up her cloak with her left hand while with her right she draws it closer about her neck.

618. *Ekkebard and Uta*, choir responds, Cathedral of Naumburg, Germany. c. 1250–60

THE BAMBERG *RIDER* Perhaps the most memorable achievement of German Gothic sculpture is the mid-thirteenth-century *Rider* (fig. 619), who stands against one of the Romanesque piers of Bamberg Cathedral in Bavaria, under a French-style canopy that seems both inappropriate to

Germany and inadequate for a man on horseback. The earliest monumental equestrian group to survive since the days of *Marcus Aurelius* (see fig. 363), this work may preserve some memory of the vanished bronze Theodoric that once stood in front of Charlemagne's Palace Chapel at Aachen, but it is in every way unclassical. The horse is hardly to be compared with the fiery steed of Marcus Aurelius; his forefeet are planted side by side, his left hind hoof is lifted to paw the ground. He looks nervous and tense. In contrast to Classical equestrian figures, it should be noted, the Bamberg rider is represented to the same scale as his mount. We do not know the identity of the subject—he may be the emperor Conrad III—but in its calm, dignity, and apparent courage, the statue sums up as nobly as does the *Saint Theodore* at Chartres the qualities essential to the knightly idea.

HERRAD OF LANDSBERG If Sabina von Steinbach turns out to have been a myth, Herrad of Landsberg (1125/30–1195) was a magnificent reality. Abbess of Hohenburg, near Strasbourg, in Alsace, then considered German, Herrad composed between 1159 and 1180 a treatise called the *Hortus Deliciarum* (Garden of Delights) for the instruction of her nuns, who illustrated it under her direction. Some, perhaps many, of the illustrations were drawn and painted by Herrad's own hand. The book, one of the highest achievements of Gothic manuscript painting, was a compendium of medieval knowledge that was based largely on Scripture, but contained many passages drawn from classical learning and from contemporary science, especially the medieval cosmogony, as well as an explication of the Seven Liberal Arts (which, as always in the Middle Ages, included music but none of the visual arts). The author tells us her purpose in touching words:

This book, entitled *Garden of Delights*, I myself, the little bee, composed inspired by God from the sap of diverse flowers from Holy Scripture and from philosophical works, and I constructed it by my love for you [i.e., her nuns] in the manner of a honeycomb full of honey for the honor and the glory of Jesus Christ and the Church.

The last page was a gallery of bust-portraits of the nuns of Hohenburg, sixty all told, each one labeled like a photograph in a high school year-book, all listening intently to an address by Herrad herself—full length.

Tragically, the original manuscript was destroyed by fire in the German artillery bombardment of Strasbourg in 1870, before the photography of illuminated manuscripts had begun in earnest. Outline tracings of most of the illustrations had nonetheless been made, and from these we can now reconstruct the original compositions, although the details, of course, are seen through nineteenth-century eyes. Only one, the *Woman of the Apocalypse* (fig. 620) was copied in color. The complex text of Revelation (Apocalypse) chapters 12 and 13 has been condensed into a single majestic image, the vision of the Woman "clothed with the sun and with the moon under her feet, and on her head a crown of twelve stars." She is attacked at the lower right by the red dragon "having seven heads and ten horns and on his heads seven diadems," his tail drawing "the third part of the stars of heaven," a river coming out of his mouth to carry her away, and the earth opening up *its* mouth to swallow the river; at the lower left the beast from the sea, also with seven heads, ten horns, and

619. *Rider.* Middle 13th century. Sandstone, height 901/2". Cathedral of Bamberg, Germany

620. HERRAD OF LANDSBERG. Woman of the Apocalypse, illumination from Hortus Deliciarum. 1159–80 (Original destroyed)

seven diadems, with the mouth of a lion and the feet of a bear, makes war with the saints. The Woman, given "two wings of a great eagle," has brought forth her "man child to rule all nations," and an angel appears to take him up to God, safe from the two ferocious enemies. In her commentary Abbess Herrad interprets the Woman as the Church, bearing the name of Woman because she is always giving birth to a spiritual race, and goes on to find a symbolic significance in every aspect of the vision. Most important of all, she has succeeded in endowing her vision of Woman with a universal grandeur that survives even the destruction of the original. As artists, Herrad and her nuns control absolutely the sure sense of proportion and the classic flow of surface that are typical of their slightly later contemporary Nicholas of Verdun and that eventually ennobled the sculpture of Strasbourg Cathedral.

French Gothic architecture was also imported into Spain, and the interiors of three major Spanish cathedrals, those at Burgos, Toledo, and León, can hardly be told from their French models (their exteriors have been much reworked in a later phase of Gothic). Nonetheless French Gothic motives were brilliantly reinterpreted in Catalonia in northeastern Spain, especially in the Cathedral of Gerona, whose apse, ambulatory, and accompanying side aisles had already been constructed between 1312 and 1347 in a somewhat simplified version of French thirteenth-century style. In 1369, apparently (roughly contemporary with the Alhambra in Muslim Spain), a daring architect, Pedro ça Coma, proposed continuing the

Spain

building with a single gigantic nave consisting of four bays, with no transept and no side aisles, only lateral chapels, an obvious gesture in favor of improved visibility and audibility for the congregation. The resultant immense width of the nave vault excited the doubts of the authorities and of two successive commissions of architects, a record of whose vehement discussions has luckily been preserved. Not until 1417 did the various councils summon up the courage to proceed with Pedro's grand design, under a later and very enthusiastic architect, Jaime Bofill. The last stone of the giant vault was set in place, still in perfect Gothic style, nearly two centuries later, in 1604!

Although by French standards the height of the Gerona vault (fig. 621), approximately 110 feet, is not exceptional, its 75-foot span makes it by far the largest Gothic vault ever constructed. In comparison the naves at Cologne (see fig. 612) and Milan (see fig. 634) measure respectively 49 and 59 feet in width. In fact among all masonry vaults in history only that of Saint Peter's in Rome exceeds Gerona in width, by a mere ten feet. Relatively narrow windows, for the intense Mediterranean light, and heavy intervening walls, unthinkable in France, have insured the stability of the vault without flying buttresses. The placing of the Cathedral at the highest point of the city, accessible from the front only by a flight of no less than ninety steps, leaves the visitor breathless even before encountering the overwhelming experience of the unified interior space.

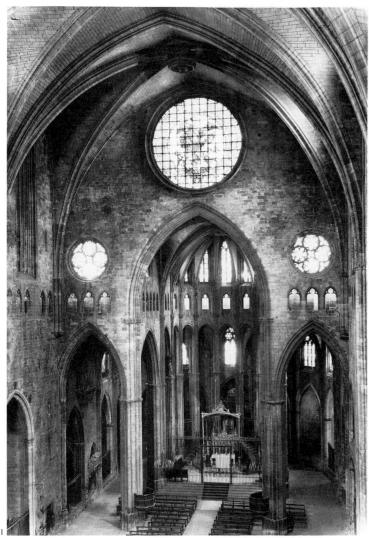

621. Interior, Cathedral of Gerona, Spain. 1312–47, 1417–1604

62

The sweep of the colossal vault cradles as with a giant arm the three-aisled fourteenth-century sanctuary, suggesting the toylike structures in Italian fourteenth-century painting, and further dwarfed by the insertion of a simplified rose window over each side aisle and an oculus just twice the diameter of the roses in the impressively blank wall above the sanctuary arch. Certainly the Gerona vault is one of the great triumphs of Gothic architecture. As in Germany and Central Europe, later Spanish and particularly Portuguese Gothic enjoys a luxuriant final phase comparable to the Flamboyant in France.

Gothic architectural principles were adopted immediately and enthusiastically in England, already prepared to a certain extent by the structural innovations of the Norman Romanesque. It has been claimed—and quite correctly—that in no century since the twelfth has Gothic architecture *not* been built in England. In the last quarter of the twelfth century, the French Gothic architect William of Sens brought the latest French techniques to Canterbury.

SALISBURY CATHEDRAL But the minute French ideas crossed the English Channel they became distinctly English. First of all, the English neither shared the French enthusiasm for height nor renounced their preference for the extreme length of Romanesque churches. The plan of Salisbury Cathedral (fig. 622), begun in 1220 and consecrated in 1258, with its double transept, recalls in that respect the arrangement at Cluny and resembles the layout of no French Gothic building, except that its characteristic square east end recalls that at Laon (see fig. 580). The square east end and lengthy choir of English cathedrals probably correspond to the need to accommodate a larger number of clergy than was customary in France; English cathedrals also have cloisters like those of monasteries (many, in fact, were served by Benedictine monks). Second, the majority of English cathedrals are situated not in the centers of towns but in the midst of broad lawns (originally graveyards) and massive shade trees.

In the interior of Salisbury Cathedral (fig. 623) every effort was made to increase the appearance of length and to diminish what to the French would seem a very modest height. No colonnettes rise from floor to ceiling; those attached to the compound pillars support only the ribs that make up the arches of the nave arcade. The triforium is large, and the clerestory is small—tucked away under the vaults as in French Early Gothic cathedrals. Characteristically English is the use of dark Purbeck marble for the colonnettes and capitals, establishing a color contrast similar to that of Romanesque interiors. In this chaste, unpretentious thirteenth-century style known as Early English, there is no tracery; lancet windows are grouped in threes and fives. The appearance of the interior was doubtless far richer when the stained glass (partly destroyed during the Reformation and partly removed in the eighteenth century) was intact and when the original choir screen and its sculpture were in place.

Compared with the soaring lines of French or German cathedrals, the exterior of Salisbury (fig. 624) looks earthbound. There is no true façade with flanking towers (although these are present in a number of English cathedrals), but a mere screen that extends without supports to mask the angle of the side-aisle roof. In few English cathedrals are there massive sculptural programs in the French manner; statues and reliefs were scattered over the screen façades, but few have escaped the axes of the re-

England

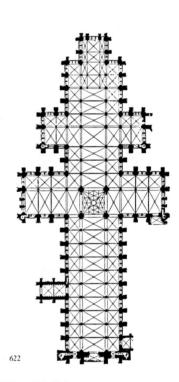

- 622. Plan of Salisbury Cathedral, England. Begun 1220
- 623. Nave and choir, Salisbury Cathedral
- 624. Salisbury Cathedral (view from the northeast)
- 625. Choir, Cathedral of Gloucester, England. Remodeled 1332–57

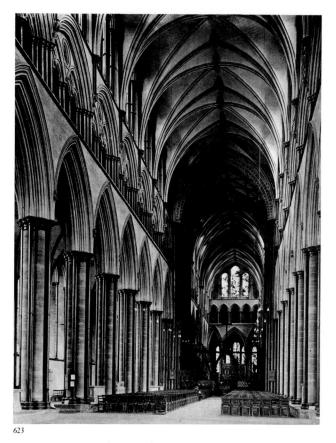

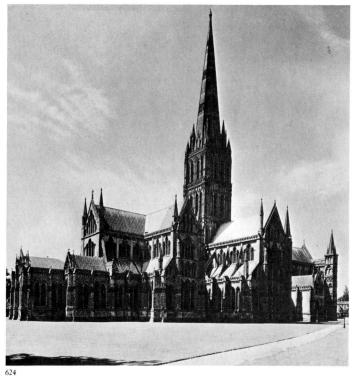

formers. Flying buttresses, in so low a building, did not seem necessary; nonetheless, some had to be added here and there. There is no dramatic chevet; the effects at Salisbury are obtained by the sensitive balancing of elements kept deliberately simple. The square east end is prolonged by the Lady Chapel (a chapel dedicated to the Virgin). The glorious distinguishing feature of Salisbury is the spire over the crossing, a fourteenth-century addition in the second phase of English Gothic, known as Decorated. Although the building was not originally intended for so tall a central tower, the spire, rising to a height of 404 feet, was designed so as to complete the diagonal massing of the exterior composition, and its ornamentation is restrained in order not to conflict with the purity of the Early English building. The effect of this immense weight on the interior was less happy; it required elaborate new supports.

GLOUCESTER CATHEDRAL The most original invention in English architectural history is the style appropriately known as the Perpendicular, which began to appear in the fourteenth century. The choir of the massive Romanesque Cathedral of Gloucester (fig. 625) was remodeled from 1332 to 1357 to enshrine the tomb of Edward II, murdered at the order of his estranged wife, and is a pioneer example of the new style (the Romanesque nave was left intact). The original round arches of the arcade and the gallery may still be made out under the covering screen of Perpendicular tracery. If the English were slow in adopting the idea of tracery, they soon went at it with a will; in this respect the Perpendicular may be considered the English answer to the Flamboyant, whose caprices are countered with brilliant logic. The entire interior of the choir is transformed into a basketwork of tracery, with predominantly vertical

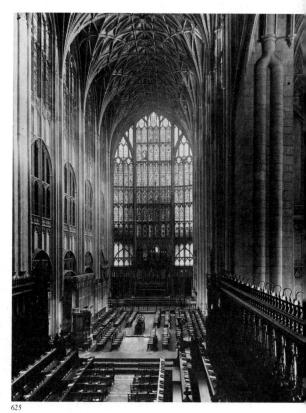

GOTHIC ART 481

members, which form the windows and dissolve into the vault. In this refined stage the ribs have lost any constructional function they may once have had. The triangular compartments are subdivided by additional diagonal ribs, and all the ribs are connected by an intricate system of crisscrossing diagonals. The original Romanesque apse is replaced by an east window 72 feet in height, which not only extends from wall to wall but also even bows slightly outward, doubtless to increase resistance to wind.

THE CHAPEL OF HENRY VII The final development of Perpendicular flowered in the fan vaults of the late fifteenth and early sixteenth centuries, the richest of which are those in King Henry VII's Chapel in Westminster Abbey in London (fig. 626), dating from the first quarter of the sixteenth century, nearly contemporary with Saint-Maclou at Rouen (see fig. 605). The complex shapes are as bewildering at first sight as those of Hiberno-Saxon interlace (see fig. 11) and as open to logical analysis. The vault is made up of tangent cones of tracery, each composed of tiny coupled trefoil arches, surmounted by quatrefoils and enclosed by gables the standard repertory of High Gothic tracery, as compared to the flickering shapes of the Flamboyant. The cones radiate from central pendants; in the interstices between the cones are smaller ones, also culminating in pendants. The larger cones are held in position by cusped tracery arches, springing from between the windows. Tie rods added later indicate that on this occasion the imagination of the Perpendicular architects may have been carried too far.

626. Chapel of Henry VII, Westminster Abbey, London (detail of vault). 1503-19

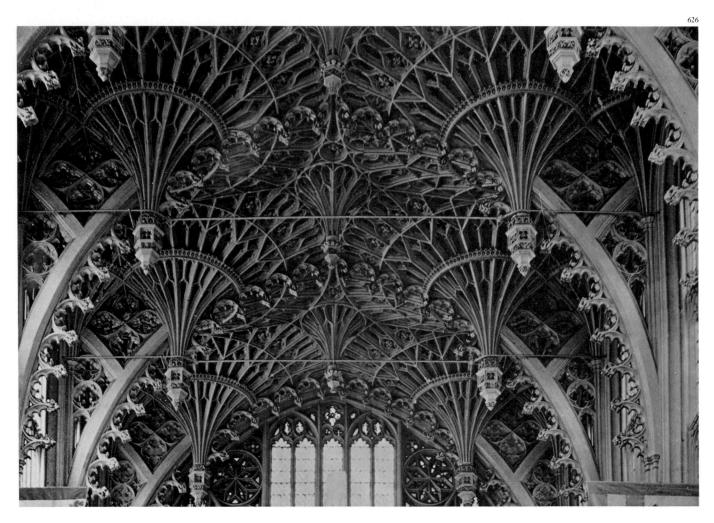

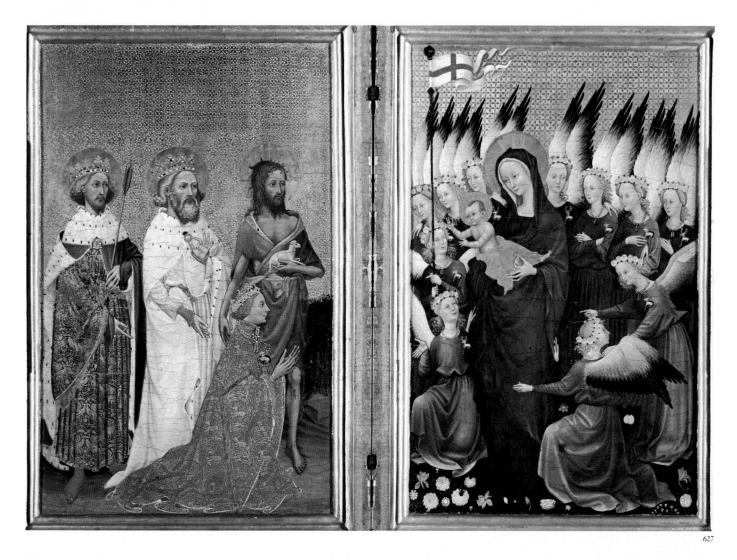

627. Wilton Diptych. c. 1377–1413. Each panel 18 × 11½". National Gallery, London

THE WILTON DIPTYCH Among the rare panel paintings surviving from the Gothic period in England one masterpiece stands out, the Wilton Diptych (fig. 627), a small work painted in the tempera technique. On rocky ground to the left kneels Richard II, represented as a youth and accompanied by his patron saints, John the Baptist and Kings Edward the Confessor and Edmund. Most of the background is gold, tooled in a neat, regular pattern to increase its sparkle, but beside the figure of John the Baptist we look into a deep wilderness. The young king's hands are extended less in prayer than in astonishment at the apparition in the facing panel of the Virgin Mary, holding the Christ Child and attended by eleven rose-crowned blond angels, each wearing the same badge of the white hart as the king wears (he was eleven years old at the time of his coronation in 1377). The sacred figures stand or kneel on a carpet of rich foliage, on which plucked roses and irises are strewn. The rich crimsons of Richard's damasks and the white of the ermines contrast with the skyblues that dominate the right panel, ranging from the deep tones of the tunics in the upper row of angels through the medium value of Mary's mantle and tunic to the pale blues in the foreground; even the angels' white wings are tipped with blue.

The faces, hands, arms, and feet show an unprecedented delicacy of drawing and shading, and accuracy of anatomical observation, held in check by an extreme refinement of taste. This exquisite style is the more mysterious since so little panel painting of the period survives in England. There are many theories regarding the diptych's date (anywhere

from 1377 to 1413) and authorship, but no sure conclusions. The painter was certainly trained in the Italian tradition, and knew Sienese art, especially the work of Duccio and Simone Martini and even more intimately that of Giovanni da Milano. He was also one of the most accomplished painters of the fourteenth century in Europe. But we have no clear indication whether he was from England or the Continent; something in the poetry of the picture suggests England. The least that can be said on this subject is that the painting corresponds to the rarefied taste of the court of Richard II; since his reign was destined for an unhappy end, it is comforting to hope that the unknown master of the Wilton Diptych gave it a beautiful beginning.

France's neighbors, in general, welcomed the new Gothic style and imported French architects and architecture, subject only to modifications in accordance with local taste and customs. In the kingdom of Naples, ruled by French descendants of Louis IX, the existence of French Gothic churches is not surprising. Elsewhere in Italy, however, the only French-style churches are those of the Cistercian Order, itself French and governed from Cîteaux in Burgundy. The austerity decreed by Saint Bernard forbade anything like the splendors of the cathedrals.

ABBEY OF FOSSANOVA The Cistercian Abbey of Fossanova (fig. 628), south of Rome, was commenced in 1187 and consecrated in 1208. Its essentials might as easily be found in Cistercian buildings in France or in England and clearly reflect the bleakness of Saint Bernard's tradition. The east end is square. Massive compound piers support pointed transverse arches and groin vaults over nave and choir. Only the crossing is rib-vaulted. The capitals are French transplants, close to those at Laon and Paris. As there was to be no stained glass, there was no need for the structural refinements of the Early Gothic.

SANTA CROCE IN FLORENCE In the independent republics of central and northern Italy, the Romanesque often continued into the thirteenth century, although many Gothic details were adopted. The major influence on church building emanated from two remarkably different religious figures, Saint Francis of Assisi (1182–1226) and Saint Dominic (1170–1221), both of whom founded orders with innumerable branches, devoted not to a life of work and study apart from the people but to direct preaching before urban masses and to missionary endeavors. The preaching orders revolutionized traditional Italian basilican architecture, for they required simple but very large interiors, usually timber-roofed both for economy and for speed in construction. Santa Croce in Florence (fig. 629), started in 1294, is one of the most imposing. Its octagonal columns, pointed arches, and foliate capitals and its impression of lightness and openness mark the church as Gothic, although at first sight it resembles nothing we have seen elsewhere. As the church was not planned for vaulting, there was no need for the usual French system of colonnettes rising two or more stories. The light and heat of Italian summers would have made large French windows intolerable. The windows at Santa Croce were, however, designed for stained glass, much of which is still in place, although it is very different from French stained glass.

Architecture in Italy

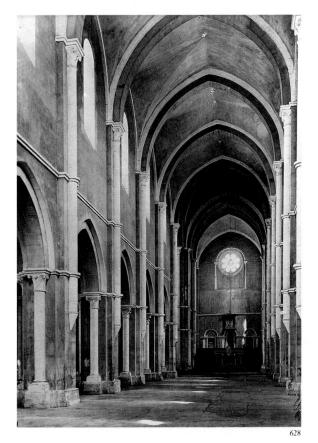

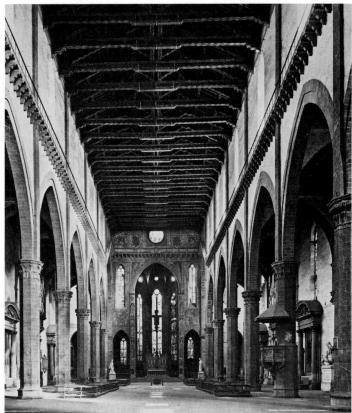

When we look at the choir of Santa Croce, beyond the triumphal arch, we see that the unknown architect (perhaps Arnolfo di Cambio, c. 1245-before 1310) did indeed understand French Gothic principles and adapted them intelligently to Italian requirements. The choir and the five chapels on either side of it, entered from the west side of the transept (two may be seen in the illustration), show a familiarity with the refinements of ribbed vaulting. The tall windows with their bar tracery resemble those inserted into the clerestory of Notre-Dame in Paris in the thirteenth century (see fig. 583). Large wall surfaces were needed in Italy, especially in Tuscany, for the highly respected art of fresco painting; the two chapels to the right of the choir were frescoed entirely by Giotto, and two others by his pupils, while the nave was under construction. The timber roof, recalling that at Monreale (see fig. 544), retains its original Gothic painted decoration.

FLORENCE CATHEDRAL An entirely different problem was presented by the Cathedral of Florence (fig. 630), which has so long and so complex a building history that its final appearance can be attributed to no single architect. A fairly large structure was planned by the architect Arnolfo di Cambio in 1296, with identically shaped apsidal choir and transept arms radiating outward from a central octagonal dome (fig. 631). In the main Arnolfo's plan was followed but much expanded by the architects, chief among whom was Francesco Talenti, who, under the close supervision of a commission, commenced building from the final design in 1368. The colossal interior (fig. 632), is only four bays long, and the impression so simple and bare in comparison with the complexity and mystery of French interiors that it is a surprise to discover that the height of the vaults is approximately the same as at Amiens. The compound

628. Interior, Abbey Church of Fossanova, Italy. Begun 1187

629. Nave and choir, Sta. Croce, Florence. Begun c. 1294

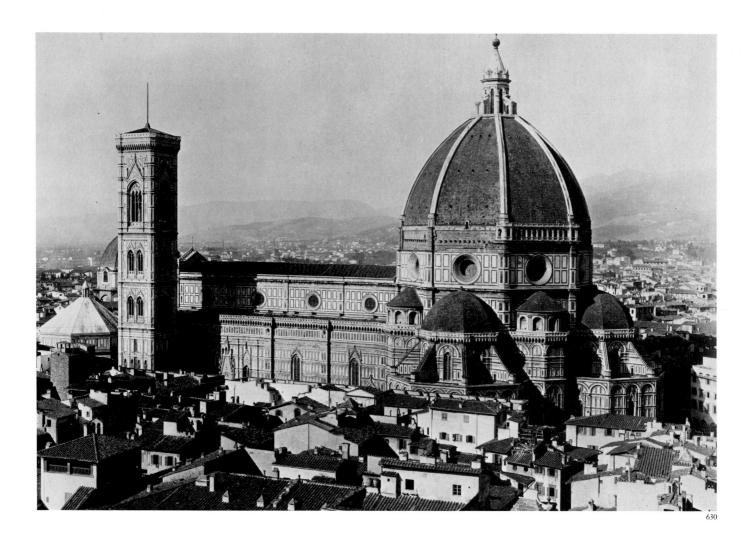

piers are cubic rather than cylindrical as in France, and their foliate capitals are treated as cubes of ornament. Pilasters continue above the giant arches to the catwalk supported on brackets required by the commission of 1368, which also insisted that the vaults spring directly from the level of the catwalk, thus canceling out any considerable clerestory. The interior, therefore, appears as one enormous story, lighted by oculi in the lunettes under the vaults. Walking through the building, one experiences immense cubes of space, which, as soon as their size becomes apparent, are dwarfed by the grandeur of the octagonal central space under the dome, from which the three half-octagonal apses radiate. The vaults are heavily domed and exert strong outward thrust. In the absence of flying buttresses, tie rods had to be installed.

The simple, cubic exterior masses of the nave and the more complex forms of the semidomes surrounding the central octagon were paneled in white, green, and rose marbles to harmonize with the Baptistery. The separate campanile, also paneled in marbles, was commenced by Giotto, who designed only the lower two stories; the much richer upper five stories are the work of Talenti in the middle of the fourteenth century. At the opening of the fifteenth century (so uncertain was the art of building), no one in Florence had the faintest idea how the octagonal central space could be covered. How *that* problem was solved is one of the dramas of the Early Renaissance.

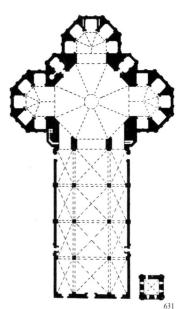

630. Cathedral of Florence. Begun 1368

631. Plan of the Cathedral of Florence (After Arnolfo di Cambio, 1296)

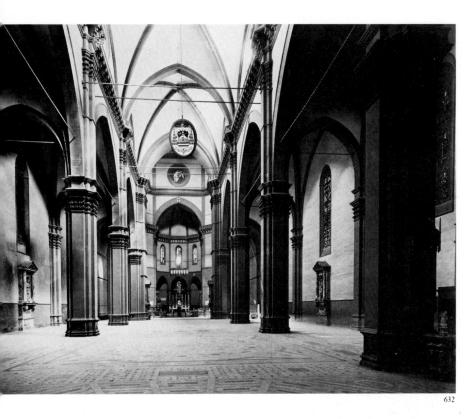

632. Interior, Cathedral of Florence

SIENA CATHEDRAL Perhaps because of the long tradition of Early Christian basilicas in Italy, the two-tower façade, universal in France and common throughout England, Spain, and Germany, was almost never adopted in Italy. In fact, the building of any sort of façade often lagged behind the construction of the rest of the church. Not one of the major churches of Florence received its façade during the period of its original construction; those of the Cathedral and Santa Croce were added only in the nineteenth century. But the Cathedral of Siena, the independent patrician republic forty miles to the south of Florence, was given a dazzling marble façade (fig. 633) in Gothic style that shows certain standard features of Gothic façades in other Italian cities, and gives some notion of what that of the Cathedral of Florence might have looked like had it been completed in the Gothic period. The lower half of the façade was designed—probably in the late 1280s—by Giovanni Pisano, one of the two leading masters of Italian Gothic sculpture.

Giovanni flanked his three gabled portals with rich tracery turrets, whose black-and-white marble bases incorporate the striping of the body of the Cathedral. The splayed jambs, with their alternating white-androse colonnettes, lack the statues one would have expected by French standards. Giovanni has transferred his figures to more independent positions on the turrets, where they appear to issue from shallow niches, in lively attitudes and even in conversation. This new freedom of the human figure from its architectural bonds is not only symptomatic of the role of the individual in the Italian city-republics but also indicative of the emergence of independent personalities among the artists themselves. From time to time we have encountered artists whose names we know and can associate with specific works outside Italy, and a few have even assumed a certain individuality in our minds, but they are exceptions. In Italy such instances become the rule.

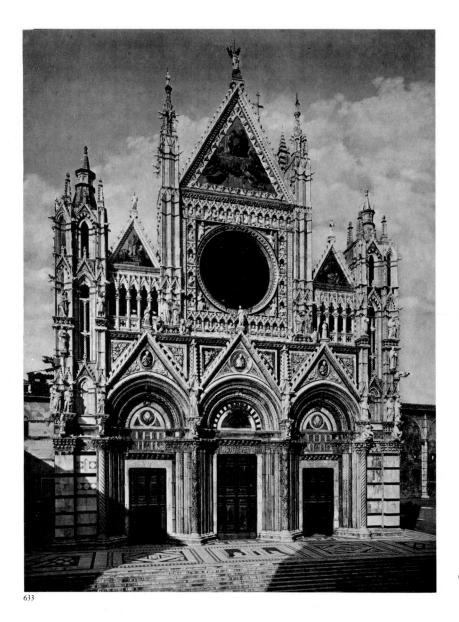

633. GIOVANNI PISANO. West façade, Cathedral of Siena, Italy. Begun late 1280s

MILAN CATHEDRAL In northern Italy the severe architecture of the Lombard Romanesque was replaced in the later fourteenth century by an especially florid phase of Gothic under the domination of the Visconti family, who had made themselves dukes of Milan and had absorbed into a powerful monarchy most of the independent north Italian communes, with the notable exception of the Venetian Republic. The construction of the Cathedral of Milan, one of the largest of all Christian churches, was subject to the committee procedure we have already seen in Florence, carried on, however, not only by north Italian masters but also by builders imported from France and Germany, each of whom brought to bear arguments based on his own national architectural tradition and theory. As in Florence, the colossal project had been commenced (probably in 1386) and the columns partly erected before anyone was certain how high they were going to go or what shape of arches and vaults they would support. The often acrimonious discussions continued, off and on, from 1392 to 1401. An Italian mathematician, Gabriele Stornaloco, subjected the fabric to the governance of an abstract system of expanding equilateral triangles, and one of the French architects, Jean Mignot, summarized his bitter denunciation of Italian methods with the oftquoted remark, "Ars sine scientia nihil est." This should not be taken to mean literally that art is nothing without science, but rather that practice is meaningless without theory. But that Mignot's theory should include appeals to God on his throne surrounded by the Evangelists demonstrates how far medieval builders were from being able to calculate static problems by what we would recognize as engineering science. The resultant interior (figs. 634, 636) resembles partly the arrangement at Bourges (see fig. 590) with its four side aisles of diminishing heights and partly that at Florence (see fig. 632) with its single colossal story dwarfing a tiny clerestory under the vaults. The clustered columns are surmounted by outsize capitals intended for a host of statues—eight to a column—in the gathering gloom of the arches. The four-part vaulting is based on French High Gothic examples. The exterior (fig. 635) shows the characteristic Italian desire to keep the whole structure within the limits of a block, so that the flying buttresses are invisible from street level. That they were also insufficient is betrayed by the telltale tie rods in the interior. The forest of pinnacles, intended from the beginning, was actually added in the eighteenth and nineteenth centuries. The gigantic Flamboyant windows would have been totally unacceptable to severe Florentine taste.

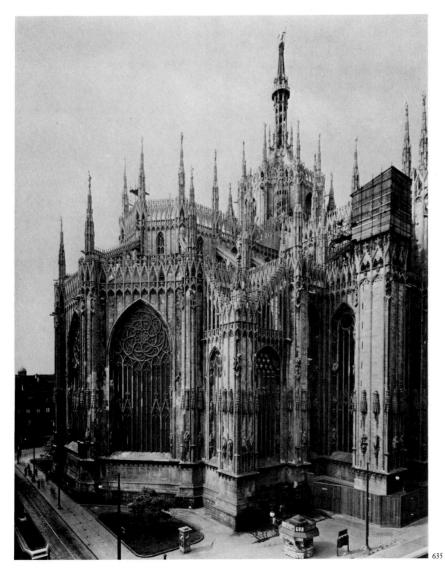

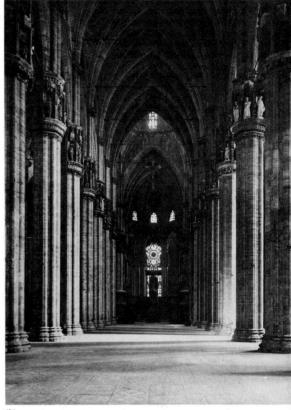

634. Interior, Cathedral of Milan. Begun 1386

635. Exterior of choir, Cathedral of Milan

636. Plan of the Cathedral of Milan

GOTHIC ART 489

THE PALAZZO VECCHIO IN FLORENCE Italian communes demanded impressive civic centers, fortified against the chronic disorders of the period. The grandest example is the Palazzo Vecchio at Florence, built in an astonishingly short time, from 1299 to 1310; the Priori (council or cabinet members) were actually installed in the building as early as 1302. Its castle-like appearance (fig. 637) carries into large-scale civic architecture the roughly trimmed stone used for town houses in medieval Florence. This technique had a Classical precedent in the rustication of such Roman civic buildings as the Porta Maggiore (see fig. 338). The impression of block mass, relieved only by relatively small Gothic windows, was intended not only for defense but also for psychological effect. The asymmetrical placing of the mighty bell tower was due to the requirements of the site and was not followed elsewhere; yet to modern eyes the result is extremely powerful.

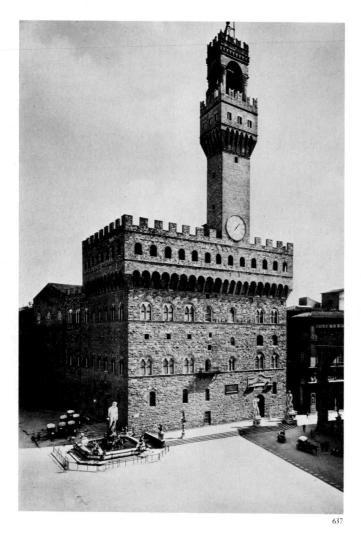

637. Palazzo Vecchio, Florence. 1299-1310

THE PALAZZO DUCALE IN VENICE One could hardly imagine a greater difference in appearance than that which distinguishes the mountainous structure of the Palazzo Vecchio from the elegant and largely open Palazzo Ducale (Doges' Palace) in Venice, built for a similar purpose, as the official residence of the doge (the chief magistrate of the Venetian Republic) and the grand council of a republic fortified only by

water. In spite of the fact that construction continued from 1340 until after 1424, the appearance of the building is remarkably unified (fig. 638). A simple arcade of pointed arches on low columns supports a more elaborate *loggia* (open gallery) on the second story, with twice as many columns under trefoil arches and quatrefoil tracery drawn from the standard High Gothic repertory. The massiveness of the upper story, broken only by pointed-arch windows, is relieved by an allover lozenge pattern of white-and-rose marble facing. The distinction between Florentine mass on the one hand and Venetian interest in color, texture, and light effects on the other is one we shall see maintained throughout the long history of these two leading Italian schools, especially in painting.

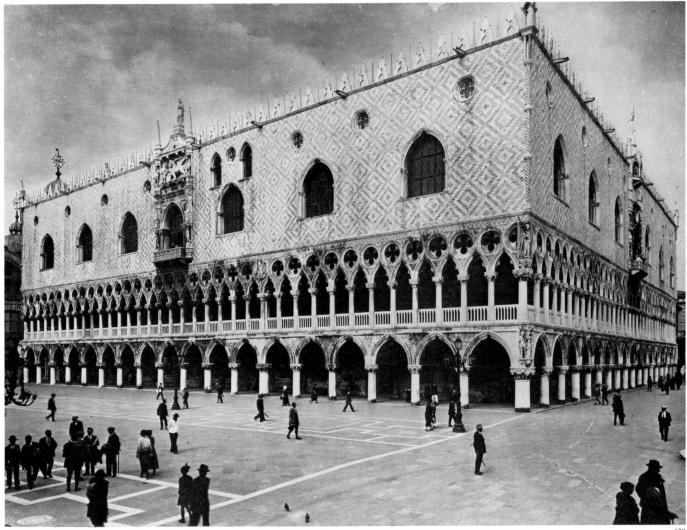

658

THE CA' D'ORO IN VENICE Through the first half of the fifteenth century (the Early Renaissance in Florence), Venetian architecture remained Gothic. The most sumptuous dwelling from this period is the Ca' d'Oro (Golden House), built between 1422 and about 1440 on the Grand Canal. The façade (fig. 639) was designed for the effect of glittering white arcades and interlaced arches against dark openings and of walls paneled in softly veined marbles in the Byzantine manner, rather than the hard contrast of white and green used in Tuscany; probably neither the architect nor the patron was oblivious to the beauty of the reflections of all

638. Palazzo Ducale (Doges' Palace), Venice. 1340–after 1424

this light and color in the blue-green water below, and the very existence of the open loggias reveals the Venetian delight in observing from such vantage points the passing spectacle of traffic on the Grand Canal. Insubstantial as such architecture may seem in comparison with the severity of the Florentine palaces built at the same time for the same class of wealthy merchants, it looks compact and unified, and thus thoroughly Italian, in contrast to the free improvisation of shapes in the almost contemporary house of Jacques Coeur at Bourges (see fig. 608).

Despite its special national variations from the European norm, Italian Gothic architecture can be considered as a part of European Gothic in general. But Italian sculpture and painting of the thirteenth and fourteenth centuries are another story. Unlike medieval artists elsewhere in Europe, about whom we seldom know even their names, the great Italian sculptors and painters of the Late Gothic period are fully rounded human beings. Their styles and achievements are so strongly individual that they demand separate consideration, not just as a prelude to the Renaissance but as an independent and impressive artistic group.

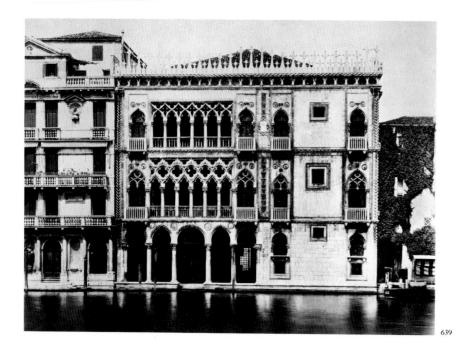

639. Ca' d'Oro, Venice. 1422-c. 1440

In retrospect, the achievements of the Gothic period are dazzling. This age produced the first post-Classical culture whose creations and discoveries could rival those of the vanished ancient world—and indeed, in a technological sense, surpass them. All of western Europe was united by a universal style, intended primarily for the new urban societies of the later Middle Ages and favored by the recently expanded monarchical governments. The fundamental unity of the Gothic style transcended national and regional boundaries and enabled it to be transplanted into regions as distant as Palestine and Mexico. So powerful did the Gothic style become, indeed, and so well did it satisfy the needs of urban populations throughout its vast geographic extent, that an extremely large proportion of Gothic religious buildings survive today, in spite of innumerable social upheavals and two world wars, with their sculptural and pictorial decorations (in Catholic countries at least) largely intact, and are still in daily use. The Gothic flourished for four hundred years, from the mid-twelfth to the mid-sixteenth century, save only in central Italy, where it was cut short in the early fifteenth by the Renaissance. In the mid-nineteenth century the authority of the Gothic was rediscovered—in England it had never been wholly lost—and Gothic revival buildings have been built off and on ever since, all over the world.

Urban humanity required a new self-image. For the first time since the ancient world a complete, three-dimensional human being reemerges in sculpture, even though bodily surfaces are veiled by clothing except when nudity is iconographically required. And for the first time since antiquity the human physiognomy is able to command a repertory of facial expressions answering to inner emotional states.

The growing kingdoms of northern and western Europe, the Empire in central Europe, and the papacy with its worldwide claims emanating from Rome were earthly counterparts of an intricate cosmic order of being, under the monarchical rule of the Christian Deity. In this encyclopedic universal structure, whose towering symbol was the cathedral, every smallest human or natural phenomenon—however imperfectly it might be understood—found its preordained niche. In contrast to the visionary withdrawal characteristic of the monastic Romanesque, the urban Gothic may have had its head in the stars but its feet were firmly planted on earth, and every intervening connection was thought out. Gothic universality may even be, more than we realize, the source of much of our enjoyment of Gothic art. We get to understand the system, we know what can be expected, and we rejoice when Gothic artists surpass each other and themselves in fulfilling its demands.

The Italian Renaissance was to break with the Gothic, perhaps less sharply than is generally supposed. But in northern and western Europe the new styles will rise effortlessly from the old, so that the Northern Renaissance will seem a natural outgrowth of the Gothic. The Gothic era, indeed, can be considered not only as the crowning expression of the Middle Ages but as the indispensable bridge between the medieval and the modern world.

TIME LINE VII

Rose window, Chartres

Façade, Notre-Dame, Paris

Amiens Cathedral

History

1150 Pope Innocent III recognizes Frederick Hohenstaufen as king of Sicily, 1198, later Frederick II, HRE, r. 1215–50 Third Crusade, to rescue Jerusalem, succeeds, 1189 - 92

1200 In Fourth Crusade, 1202-04, Crusaders sack Constantinople and found Latin Empire of the East (1204–61)

> Magna Carta signed in England, 1215 St. Louis IX, French king, r. 1226-70 Sixth Crusade led by Frederick II, 1228–29 Seventh Crusade led by Louis IX, 1248-54

CULTURE

Rise of universities: Paris, c. 1150-60; Oxford, 1167 Flowering of vernacular literature; Age of Troubadours Earliest use of compass for navigation Albertus Magnus (1193–1280) Nibelung epic, 1205 Age of minnesingers in Germany St. Dominic founds Dominican Order, 1206 Inquisition established to combat heresy Albigensian Crusade against heretics in southern France, 1208

St. Francis (1182–1226) founds Franciscan Order,

Roger Bacon (1214–92)

Wilton Diptych

St.-Denis, Paris

1250 Greeks retake Constantinople from Latins, 1261 Eighth Crusade, 1270 Marco Polo travels to China and India, c. 1275–93 Turks take Acre, last Christian holding in Holy Land, 1291

> Papacy moved to Avignon, 1309 Hundred Years' War between France and England, 1337-1453 Black Death epidemic in Europe, 1347–50 Philip the Bold, Burg. duke, r. 1363-1404 G. Visconti, Milanese duke, r. 1378–1402 Papacy returns to Rome, 1378 Great Schism begins

Dante Alighieri (1265–1321) Jacobus de Voragine (1266–83) St. Thomas Aquinas' Summa Theologica, 1266–73 Master Eckhart, German theologian and mystic (d. 1327) Spectacles invented, c. 1286 William of Occam (c. 1300–1349) First large-scale production of paper

Earliest known use of cannon, 1326 Earliest cast iron in Europe Boccaccio writes Decameron, 1353 John Wycliffe (d. 1384) Canterbury Tales by Chaucer, c. 1387

1350

GOTHIC

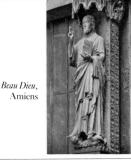

Bible Moralisée

Virgin of Paris

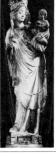

Sacrifice of Isaac, by Nicholas of Verdun

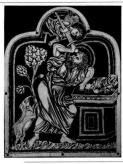

PAINTING, SCULPTURE, ARCHITECTURE

Ambulatory, Abbey Church of St.-Denis; south tower and Royal Portal, Cathedral of Chartres; Abbey of Fossanova Cathedrals of Laon, Notre-Dame, Chartres (architecture, sculpture, stained glass), Bourges, Le Mans, Reims (architecture, sculpture), Amiens (architecture, sculpture), Beauvais, Ste.-Chapelle Cathedral, Cologne; St. Elizabeth, Marburg Sculpture, Strasbourg, Bamberg, and Naumberg Cathedral, Salisbury Nicholas of Verdun, Sacrifice of Isaac and Shrine of the Three Kings Campo Santo, Pisa; Giovanni Pisano, façade of Siena Cathedral; Sta. Croce, Florence Bible Moralisée; Psalter of St. Louis; Herrad of Landsberg, Hortus

PARALLEL SOCIETIES

French Monarchy Byzantine Empire Holy Roman Empire in Central Europe Muslim

English Monarchy

1200

1150

Italian city-states

Deliciarum

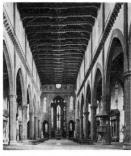

Duomo, Florence

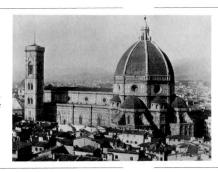

Cà d'Oro, Venice

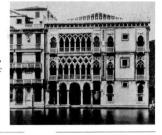

Virgin of Paris
Palazzo Vecchio, Florence
Cathedral, Gerona
Jean Pucelle, Belleville Breviary
Choir, Cathedral of Gloucester

Palazzo Ducale, Venice

Spanish Kingdoms Russian Empire

Moors

1250

Duomo, Florence
Wilton Diptych
Cathedral, Milan
Palais Jacques Coeur, Bourges
St.-Maclou, Rouen; Chapel of Henry VII, Westminster

1350

GLOSSARY

ABACUS (pl. ABACI). In architecture, the slab that forms the uppermost member of a CAPITAL and supports the Architrave.

ABBEY. The religious body governed by an abbot or an abbess, or the monastic buildings themselves. The abbey church frequently has special features such as a particularly large CHOIR to accommodate the monks or nuns.

ACANTHUS. A plant having large toothed and scalloped leaves whose forms were imitated on CAPITALS and used to ornament MOLDINGS, BRACKETS, and FRIEZES.

ACROTERIUM (pl. ACROTERIA). A sculpture or other ornament placed at the lower angles and the apex of a Pediment, or the Pedestal, often without a BASE, on which it stands.

ADOBE. A sun-dried brick used by the Indians of the western United States and Central America. A structure made of the same.

AEDICULA (pl. AEDICULAE). Latin word for niche or small shrine.

AGORA. Greek word for assembly, thus denoting the square or marketplace that was the center of public life in every Greek city.

AISLE. See SIDE AISLE.

ALABASTER. A fine-grained gypsum or calcite, often white and translucent, though sometimes delicately tinted.

ALTARPIECE. A painted and/or sculptured work of art that stands as a religious image upon and at the back of an altar, either representing in visual symbols the underlying doctrine of the Mass, or depicting the saint to whom a particular church or chapel is dedicated, together with scenes from his life. Examples from certain periods include decorated GABLES and PINNA-CLES, as well as a PREDELLA. See MAESTÀ.

Ambulatory. A place for walking, usually covered, as in an ARCADE around a cloister, or a semicircular passageway around the APSE behind the main altar. In a church or mosque with a centralized PLAN, the passageway around the central space that corresponds to a Side Aisle and that is used for ceremonial processions.

AMPHIPROSTYLE. Having a Portico in the rear as well as in the front, but not on the sides.

AMPHITHEATER. A double THEATER. A building of elliptical shape with tiers of seats rising one behind another about a central open space or

AMPHORA (pl. AMPHORAE). A storage jar used in ancient Greece having an egg-shaped body, a foot, and two handles, each attached at the neck and shoulder of the jar.

APOCALYPSE. The Book of Revelation, the last book of the New Testament, in which are narrated the visions of the future experienced by Saint John the Evangelist on the island of Patmos.

APOCRYPHA. A group of books included at one time in authorized Christian versions of the Bible (now generally omitted from Protestant versions).

APOSTLES. In Christian usage the word commonly denotes the twelve followers or disciples chosen by Christ to preach his GOSPEL, though the term is sometimes used loosely. Those listed in the Gospels are: Andrew; James, the son of Zebedee, called James the Major; James, the son of Alphaeus, called James the Minor; Bartholomew; John; Judas Iscariot; Matthew; Philip; Peter; Simon the Canaanite; Thaddeus; and Thomas (Matt. 10:1-4; Mark 3:13-19).

APSE. A large semicircular or polygonal niche. In a Roman Basilica it was frequently found at both ends of the NAVE; in a Christian church it is usually placed at one end of the nave after the CHOIR; it may also appear at the ends of the Transept and at the ends of chapels.

AQUEDUCT. From the Latin for duct of water. An artificial channel for conducting water from a distance, which, in Roman times, was usually built overground and supported on ARCHES.

ARCADE. A series of ARCHES and their supports. Called a blind arcade when placed against a wall and used primarily as surface decoration.

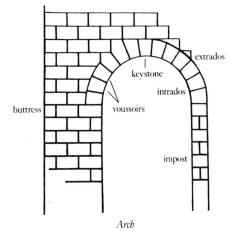

ARCH. An architectural construction, often semicircular, built of wedge-shaped blocks (called Voussors) to span an opening. The center stone is called the KEYSTONE. The weight of this structure requires support from walls, Piers, or COLUMNS, and the THRUST requires BUTTRESS-ING at the sides. When an arch is made of overlapping courses of stone, each block projecting slightly farther over the opening than the block beneath it, it is called a CORBELED arch.

ARCHBISHOP. The chief BISHOP of an ecclesiastical province or archbishopric.

ARCHITRAVE. The main horizontal beam and the lowest member of an ENTABLATURE; it may be a series of LINTELS, each spanning the space from the top of one support to the next.

ARCHIVOLT. The molding or moldings above an arched opening; in Romanesque and Gothic churches, frequently decorated with sculpture.

ARK OF THE COVENANT. The wooden chest containing a handwritten scroll of the TORAH. It is kept in the holiest place in the TABERNACLE, which, in Western countries, is usually against the east wall, the direction of the Holy Land.

Arriccio, Arricciato. The rough coat of coarse plaster that is the first layer to be spread on a wall when making a Fresco.

A Secco. See Fresco.

ATRIUM. The open entrance hall or central hall of an ancient Roman house. A court in front of the principal doors of a church.

ATTIC. The upper story, usually low in height, placed above an ENTABLATURE or main Cor-NICE of a building, and frequently decorated with PILASTERS.

BACCHANTE. See MAENAD.

BALDACHIN. From Italian baldacchino, a rich silk fabric from Baghdad. A canopy of such material, or of wood, stone, etc., either permanently installed over an altar, throne, or doorway, or constructed in portable form to be carried in religious processions.

BALUSTRADE. A row of short pillars, called balusters, surmounted by a railing.

BAPTISTERY. Either a separate building or a part of a church in which the SACRAMENT of Baptism is administered.

BARREL VAULT. A semicylindrical VAULT that normally requires continuous support and But-

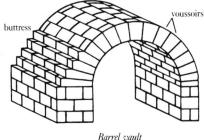

Barrel vault

BAR TRACERY. See TRACERY.

BASALT. A fine-grained volcanic rock of high density and dark color.

BASE. The lowest element of a COLUMN, temple, wall, or Dome, occasionally of a statue.

Basilica. In ancient Roman architecture, a rectangular building whose ground PLAN was generally divided into NAVE, SIDE AISLES, and one or more APSES, and whose elevation sometimes included a Clerestory and Galleries, though there was no strict uniformity. It was used as a hall of justice and as a public meeting place. In Christian architecture, the term is applied to any church that has a longitudinal nave terminated by an apse and flanked by lower side aisles.

BAY. A compartment into which a building may be subdivided, usually formed by the space bounded by consecutive architectural supports.

Bema. The Sanctuary of an Early Christian or modern Eastern Orthodox church.

BENEDICTINE ORDER. Founded in 529 by Saint Benedict of Nursus (c. 480-543), at Subiaco, near Rome, the Benedictine ORDER spread to England and much of western Europe in the next two centuries. Less austere than other early orders, the Benedictines divided their time into periods of religious worship, reading, and work, the last generally either educational or agricul-

BIBLE. The collection of sacred writings of the Christian religion that includes the Old and the New Testaments, or that of the Jewish religion, which includes the Old Testament only. The versions commonly used in the Roman Catholic Church are based on the Vulgate, a Latin translation made by Saint Jerome in the fourth century A.D. An English translation, made by members of the English College at Douai, France, between 1582 and 1610, is called the Douay. Widely used Protestant translations include Martin Luther's German translation from the first half of the sixteenth century, and the English King James Version, first published in 1611.

BISHOP. A spiritual overseer of a number of churches or a Diocese; in the Greek, Roman Catholic, Anglican, and other churches, a member of the highest order in the ministry. See CATHEDRAL.

BLIND ARCADE. See ARCADE.

Bracket. A piece of stone, wood, or metal projecting from a wall and having a flat upper surface that serves to support a statue, beam, or other weight.

Breviary. A book containing the daily offices or prayers and the necessary psalms and hymns for daily devotions. Frequently illustrated and generally intended for use by the clergy.

Broken Pediment. See Pediment.

Bronze and Iron Ages. The period from approximately 3000 B.C. to the first century B.C., characterized in general by the use of metal and the smelting of metal. Farming communities were settled, and the making and use of pottery became widespread.

BUTTRESS. A masonry support that counteracts the lateral pressure, or Thrust, exerted by an Arch or Vault. See Flying Buttress and Pier But-TRESS.

CALIPH. A leader of Muslims in both a spiritual and political sense; in theory, there should be only one, but in fact, after the loss of power by the Abbasid caliph in the tenth century, a Sunni caliphate was established at Córdoba (925-1030) and a Shia caliphate was established by the Fatimids (915-1171). With the murder of the last Abbasid caliph at Baghdad in 1258, a shadow caliphate survived in Egypt until the Turkish

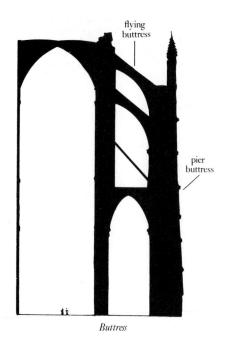

conquest of 1517. The claim of the later Turkish sultans to the caliphate was not legitimate.

CALLIGRAPHY. In a loose sense, handwriting, but usually refers to beautiful handwriting or fine penmanship.

Calvary. See Golgotha.

CAMEO. A carving in Relief upon a gem, stone, or shell, especially when differently colored layers of the material are revealed to produce a design of lighter color against a darker background. A gem, stone, or shell so carved.

CAMPANILE. From the Italian word for bell (campana). A bell tower, either attached to a church or freestanding nearby.

CAMPO. Italian word for field; used in Siena, Venice, and other Italian cities to denote certain public squares. See PIAZZA.

Campo Santo. Italian phrase for *boly field*; thus, a cemetery.

CANON. A clergyman who serves in a CATHEDRAL or a collegiate church.

CANON OF THE MASS. The part of the Christian Mass between the Sanctus, a hymn, and the Lord's Prayer; the actual Eucharist, or sacrifice of bread and wine, to which only the baptized were admitted.

CANOPY. An ornamental rooflike projection or covering placed over a niche, statue, tomb, altar, or the like.

CAPITAL. The crowning member of a COLUMN, PIER, or PILASTER on which rests the lowest element of the Entablature. See Order.

CARDINAL VIRTUES. See VIRTUES.

CARTOUCHE. An ornamental SCROLL-shaped tablet with an inscription or decoration, either sculptured or drawn.

Carving. The shaping of an image by cutting or chiseling it out from a hard substance, such as stone or wood, in contrast to the additive process of Modeling.

CARYATID. A figure, generally female, used as a COLUMN.

Casting. A method of reproducing a threedimensional object or Relief by pouring a hardening liquid or molten metal into a mold bearing its impression.

CATACOMBS. Subterranean burial places consisting of Galleries with niches for Sarcophagi and small chapels for funeral feasts and commemorative services.

CATECHUMEN. One under instruction in the rudiments of Christian doctrine, usually a new con-

CATHEDRAL. The principal church of a DIOCESE, containing the bishop's throne, or cathedra.

CATWALK. A narrow footway at the side of a bridge or near the ceiling of a building.

CELLA. The body of a temple as distinct from the Portico and other external elements, or an interior structure built to house an image.

CENOTAPH. An empty tomb; a commemorative sepulchral monument not intended for burial.

CENTAUR. In Greek mythology, a creature with the head and torso of a man and the body and legs of a horse.

CENTERING. A wooden framework used as support during the construction of a stone Arch or

CHANCEL. In a church, the space reserved for the clergy and the Choir, between the Apse and the Nave and Transept, usually separated from the latter two by steps and a railing or a screen.

CHASUBLE. A long, oval, sleeveless mantle with an opening for the head; it is worn over all other vestments by a priest when celebrating Mass, and it is used in commemoration of Christ's seamless robe.

CHERUB (pl. CHERUBIM). One of an order of angelic beings ranking second to the Seraph in the celestial hierarchy, often represented as a winged child or as the winged head of a child.

CHEVET. The eastern end of a church or CATHE-DRAL, consisting of the Ambulatory and a main APSE with secondary apses or chapels radiating from it.

CHEVRON. A zigzag or V-shaped pattern used decoratively, especially in Romanesque architecture.

CHITON. A sleeveless Greek Tunic, the basic garment worn by both men and women in ancient

CHOIR. A body of trained singers, or that part of a church occupied by them. See CHANCEL

CHOIR SCREEN. A partition of wood or stone, often elaborately carved, that separates the Choir from the Nave and Transept of a church. In Byzantine churches, the choir screen, decorated with Icons, is called an Iconostasis.

CHRISTUS MORTUUS. Latin phrase for dead Christ.

CHRISTUS PATIENS. Latin phrase for suffering Christ. A cross with a representation of the dead Christ, which in general superseded representations of the Christus Triumphans type.

CHRISTUS TRIUMPHANS. Latin phrase for triumphant Christ. A cross with a representation of the living Christ, eyes open and triumphant over death. Scenes of the Passion are usually depicted at the sides of the cross, below the crossarms.

CISTERCIAN ORDER. A reform movement in the BENEDICTINE ORDER started in France in 1098 by Saint Robert of Molesme for the purpose of reasserting the original BENEDICTINE ideals of field work and a life of severe simplicity.

CLAUSURA. Latin word for *closure*. In the Roman Catholic Church the word is used to signify the restriction of certain classes of nuns and monks prohibited from communication with outsiders to sections of their convents or monasteries. Those living within these restrictions are said to be *in clausura* or CLOISTERED.

CLERESTORY. The section of an interior wall that rises above adjacent rooftops, having a row of windows that admit daylight. Used in Egyptian temples, Roman Basilicas, and Christian basilican churches; in Christian churches, the wall that rises above the nave Arcade or the Triforium to the vaulting or roof.

CLOISTER. Generally, a place of religious seclusion; a monastery, nunnery, or convent. Specifically, a covered walk or Ambulatory around an open court having a plain wall on one side and an open Arcade or Colonnade on the other. It is commonly connected with a church, monastery, or other building, and is used for exercise and study. See Clausura.

CLOSED DOOR OF CLOSED GATE. Ezekiel's vision of the door or gate of the SANCTUARY in the temple that was closed because only the Lord could enter it (Ezekiel 44:1–4). Interpreted as a prophecy and used as a symbol of Mary's virginity.

CLOSED GARDEN. "A garden enclosed is my sister, my spouse; a spring shut up, a fountain sealed" (Song of Solomon 4:12). Used like CLOSED DOOR as a symbol of Mary's virginity.

CLUNIAC ORDER. A reformed ORDER of BENEDICTINE monks founded in 910 by William I the Pious at the monastery of Cluny in eastern France. For about 250 years it was headed by a succession of remarkable abbots who extended its rule over hundreds of monasteries in western Europe and exerted great influence in ecclesiastical and temporal affairs. With the rise of the CISTERCIAN and the mendicant ORDERS, its strength declined, and it became merely a group of French houses. The order was dissolved in 1790.

Codex (pl. Codices). A manuscript in book form as distinguished from a Scroll. From the first to the fourth century A.D., the codex gradually replaced the scroll.

COFFER. A casket or box. In architecture, a recessed panel in a ceiling.

COLONNADE. A series of COLUMNS spanned by LINTELS.

COLONNETTE. A small COLUMN.

COLOR. See HUE, SATURATION, and VALUE.

COLUMN. A vertical architectural support, usually consisting of a BASE, a rounded SHAFT, and a CAPITAL. When half or more of it is attached to a wall, it is called an *engaged column*. Columns are occasionally used singly for a decorative or commemorative reason. See also ORDER.

COMPOUND PIER. A PIER with COLUMNS, PILAS-TERS, or SHAFTS attached to it, which members usually support or respond to Arches or RIBS above them.

CORBEL. An overlapping arrangement of stones, each course projecting beyond the one below, used in the construction of an Arch or Vault, or as a support projecting from the face of a wall

Corbel Table. A horizontal piece of masonry used as a Cornice or part of a wall and supported by Corbels.

CORBEL VAULT. An arched roof constructed of corbeled masonry.

CORNICE. The crowning, projecting architectural feature, especially the uppermost part of an Entablature. It is frequently decorated. When it is not horizontal, as above a Pediment, it is called a *raking cornice*.

COURSED MASONRY. Masonry in which stones or bricks of equal height are placed in continuous horizontal layers.

CRENELLATED. Fortified or decorated with battlements (notched or indented parapets).

Cro-Magnon. A species of Paleolithic man, the ancestor of modern European man, whose remains were discovered in the Cro-Magnon cave in the Dordogne region of France.

CROMLECH. A circle of standing unhewn stones; the term is sometimes used interchangeably with DOLMEN.

Crossing. That part of a church where the Transept crosses the Nave; it is sometimes emphasized by a Dome or by a tower over the crossing.

CROSS SECTION. See SECTION.

CRUCIFIX. From the Latin word *crucifixus*. A representation of a cross with the figure of Christ crucified on it. See Christus Mortuus, Christus Patiens, and Christus Triumphans.

CRYPT. A VAULTED chamber, usually beneath the raised CHOIR of a church, housing a tomb and/ or a chapel. Also, a vaulted underground chamber used for burial as in the catacombs.

CUFIC. See KUFIC.

CUNEIFORM. From the Latin for wedge-shaped. Used to describe Mesopotamian scripts, which were written in soft clay with the wedge-shaped end of a reed.

CUPOLA. A rounded, convex roof or VAULTED ceiling, usually hemispherical, on a circular Base and requiring BUTTRESSING. See DOME.

Cusp. The pointed projection where two curves meet.

Cyclopean Masonry. Walls constructed with massive stones more or less irregular in shape, once thought to be the work of the mythical race of giants called Cyclopes.

Cyclops. A member of a mythical race of giants with one round eye in the center of the forehead. The Cyclopes were believed to have forged Zeus' thunderbolts and to have built massive prehistoric walls.

Deësis. The Greek word for supplication. A representation of Christ Enthroned between the Virgin Mary and Saint John the Baptist, who act as intercessors for mankind, which appears frequently in Byzantine Mosaics and in later depictions of the Last Judgment.

DENTILS. A series of small, ornamental, projecting, teethlike blocks found on Ionic and Corinthian Cornices.

DIAKONICON. See VESTRY.

DIOCESE. The district, or see, in which a BISHOP has authority.

DIPTERAL. Having a double Colonnade of Peri-

DIPTYCH. A pair of wood, ivory, or metal plaques usually hinged together, with the interior surfaces either painted or CARVED with a religious or memorial subject, or covered with wax for writing.

Doge. Italian word for the *chief magistrate* in the former republics of Venice and Genoa.

DOLMEN. A structure of large unhewn stones set on end and covered with a single stone or several stones.

Dome. A large Cupola supported by a circular wall or Drum, or, over a noncircular space, by corner structures. See Pendentive and Squinch.

DOMINICAN ORDER. A preaching ORDER of the Roman Catholic Church founded by Saint Dominic in 1216 in Toulouse. The Dominicans live austerely, believe in having no possessions, and subsist on charity. It is the second great mendicant order, after the Franciscan.

DOUAY VERSION. See BIBLE.

Drum. One of several sections composing the Shaft of a Column. Also, a cylindrical wall supporting a Dome.

ECHINUS. In architecture, the rounded cushionshaped molding below the Abacus of a Doric CAPITAL.

ELEVATION. One side of a building or a drawing of the same.

ENAMEL. Powdered colored glass thermally fused to a metal ground. *Champlevé* is a method by which the areas to be filled with enamel are dug out of the ground with a cutting tool. *Cloisonné* is a method in which the surface to be decorated is divided into compartments or *cloisons* by strips of metal attached to the ground. The compartments are filled with enamel powder and the piece is fused.

Encaustic. A method of painting on wood panels and walls with colors dissolved in hot wax.

ENGAGED COLUMN. See COLUMN.

ENTABLATURE. The upper part of an architectural ORDER, usually divided into three major parts: ARCHITRAVE, FRIEZE, and CORNICE.

Entasis. The subtle convex curvature swelling along the line of taper of classical COLUMNS.

EPISTLE. In Christian usage, one of the apostolic letters that constitute twenty-one books of the New Testament. See also Mass.

EUCHARIST. From the Greek word for *thanksgiving*. The SACRAMENT of the Lord's Supper, the consecrated bread and wine used in the rite of Communion, or the rite itself.

EVANGELISTS, FOUR. Matthew, Mark, Luke, and John, generally assumed to be the authors of the Gospels in the New Testament. They are usually represented with their symbols, which are derived either from the four mysterious creatures in the vision of Ezekiel (1:5) or from the four beasts surrounding the throne of the Lamb in Revelation (4:7). Frequently, they are referred to by the symbols alone: an angel for Matthew, a lion for Mark, a bull for Luke, and an eagle for John, or by a representation of the four rivers of Paradise.

Exarchate. A province of the Byzantine Empire ruled by a provincial governor called an *exarch*.

Exedra (pl. Exedrae). A semicircular Porch, chapel, or recess in a wall.

EXOSKELETON. By extension from zoology, the system of supports in a French Gothic church, including the RIBBED VAULTS, FLYING BUTTRESSES, and PIER BUTTRESSES.

FAÇADE. The front or principal face of a building; sometimes loosely used to indicate the entire outer surface of any side.

FAIENCE. Glazed earthenware or pottery used for sculpture, tiles, and decorative objects.

FAN VAULT. A complex VAULT, characteristic of late English Gothic architecture, in which radiating RIBS form a fanlike pattern.

FASCIA (pl. FASCIAE). Any long, flat surface of wood or stone. In the Ionic and Corinthian Orders, the three surfaces, the top two of which project slightly over the one below, that make up the Architrave.

Fluting. The shallow vertical grooves in the Shaft of a Column that either meet in a sharp edge as in Doric columns or are separated by a narrow strip as in Ionic columns.

FLYING BUTTRESS. An ARCH that springs from the upper part of the PIER BUTTRESS of a Gothic church, spans the AISLE roof, and abuts the upper NAVE wall to receive the THRUST from the nave VAULTS; it transmits this thrust to the solid pier buttress.

FONT. A receptacle in a BAPTISTERY or church for the water used in Baptism; it is usually of stone and frequently decorated with sculpture.

FORESHORTENING. In drawing, painting, etc., a method of reproducing the forms of an object not parallel to the PICTURE PLANE so that the object seems to recede in space and to convey the illusion of three dimensions as perceived by the human eye.

FORUM (pl. FORA). In ancient Rome, the center of assembly for judicial and other public business, and a gathering place for the people.

Four Rivers of Paradise. See Evangelists.

Franciscan Order. The first great mendicant Order. Founded by Saint Francis of Assisi (Giovanni de Bernardone, 1182?–1226) for the purpose of ministering to the spiritual needs of the poor and imitating as closely as possible the life of Christ, especially in its poverty; the monks depended only on alms for subsistence.

Fresco. Italian word for *fresb*. A painting executed on wet plaster with pigments suspended in water so that the plaster absorbs the colors and the painting becomes part of the wall. *Fresco a secco*, or painting on dry plaster (*secco* is the Italian word for *dry*), is a much less durable technique; the paint tends to flake off with time. The *secco su fresco* method involves the application of color in a vehicle containing some organic binding material (such as oil, egg, or wax) over the still damp plaster.

FRIEZE. The architectural element that rests upon the Architrave and is immediately below the Cornice; also, any horizontal band decorated with Moldings, Relief sculpture, or painting.

Gable. The vertical, triangular piece of wall at the end of a ridged roof, from the level of the eaves or Cornice to the summit; called a Pediment in Classical architecture. It is sometimes used with no roof, as over the Portals of Gothic cathedrals, and as a decorative element on Altarpieces.

Gallery. An elevated floor projecting from the interior wall of a building. In a Basilican church it is placed over the Side Aisles and supported by the Columns or Piers that separate the Nave and the side aisles; in a church with a central Plan, it is placed over the Ambulatory; in an ancient Roman basilica, it was generally built over each end as well as over the side aisles.

Gesso. A mixture of finely ground plaster and glue spread on wooden panels in preparation for Tempera painting.

GILDING. Coating paintings, sculptures, and architectural ornament with gold, gold leaf, or some gold-colored substance, either by mechanical or chemical means. In panel painting and wood sculpture, the gold leaf is attached with a glue sizing that is usually a dull red in color.

GLAZE. In pottery, a superficial layer of molten material used to coat a finished piece before it is fired in a kiln.

GLORY. The circle of light represented around the head or figure of the Saviour, the Virgin Mary, or a saint. When it surrounds the head only, it is called a *balo*. See MANDORLA.

GOLGOTHA. From the Aramaic word for *skull*; thus, the Place of the Skull. The name of the place outside Jerusalem where Christ was crucified (Matthew 27:33). Calvary, from calvaria meaning *skull* (Luke 23:33), is the Latin translation of the Aramaic word.

GORGON. In ancient Greece, one of three mythological sisters, having snakes for hair, whose hideous appearance turned every beholder to stone. Of the three, Medusa is represented most frequently.

GOSPEL. In Christian usage, the story of Christ's life and teaching, as related in the first four books of the New Testament, traditionally ascribed to the Evangelists Matthew, Mark, Luke, and John. Also used to designate an ILLUMINATED copy of the same; sometimes called a Gospel Lectionary. See Mass.

GREEK Cross. A cross with four equal arms.

Griffin. A fabulous animal usually having the head and wings of an eagle and the body of a lion.

GROIN. The sharp edge formed by two intersecting Vaults.

Groin Vault. A Vault formed by the intersection at right angles of two Barrel Vaults of equal height and diameter so that the Groins form a diagonal cross.

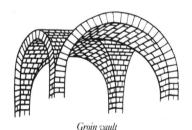

C -- D- ---

GROUND PLAN. See PLAN.

GUILDS. Arti (sing. Arte) in Italian. Independent associations of bankers and of artisan-manufacturers. The seven major guilds in Florence were: Arte della Calimala—refiners of imported wool; Arte della Lana—wool merchants who manufactured their own cloth; Arte dei Giudici e Notai—judges and notaries; Arte del Cambio—bankers and money changers; Arte della Seta—

silk weavers, to which sculptors in metal belonged; Arte dei Medici e Speziali—doctors and pharmacists, to which painters belonged; Arte dei Vaiai e Pellicciai—furriers. Other important guilds were Arte di Pietra e Legname—workers in stone and wood; Arte dei Corazzai e Spadai—armorers and sword makers; Arte dei Linaioli e Rigattieri—linen drapers and peddlers.

HALLENKIRCHE. German word for *ball church*. A church in which the AISLES are as high, or almost as high, as the NAVE; especially popular in the German Gothic style.

HALO. See GLORY.

HIEROGLYPHS. Characters (pictures or symbols representing or standing for sounds, words, ideas, etc.) in the picture-writing system of the ancient Egyptians.

HIMATION. A mantle worn in ancient times by Greek men and women and draped in a variety of styles over the CHITON.

Host. From the Latin word for *sacrificial victim* (*bostia*). In the Roman Catholic Church it is used to designate the bread or wafer, regarded as the body of Christ, consecrated in the EUCHARIST.

Hue. The name of a color. The spectrum is usually divided into six basic hues: the three primary colors of red, yellow, and blue, and the secondary colors of green, orange, and violet.

Hypostyle Hall. A building whose roof is supported on Columns.

Icon. Literally, any image or likeness, but commonly used to designate a panel representing Christ, the Virgin Mary, or a saint and venerated by Orthodox (Eastern) Catholics.

Iconoclasm. Breaking or destroying of images, particularly those set up for religious veneration. Many paintings and statues were destroyed in the Eastern church in the eighth and ninth centuries as a result of the Iconoclastic Controversy. In the sixteenth and seventeenth centuries, especially in the Netherlands, the Protestants also destroyed many religious images.

ICONOSTASIS. In Eastern Christian churches, a screen separating the main body of the church from the Sanctuary; it is usually decorated with Icons whose subject matter and order were largely predetermined.

ILLUMINATED MANUSCRIPTS. CODICES or SCROLLS decorated with illustrations or designs in gold, silver, and bright colors.

IMAM. Muslim teacher who, serving as a priest in a mosque, recites the prayers and leads the devotions of the faithful.

IMPERATOR. Freely translated from the Latin as emperor, but in Roman times it literally meant army commander.

IMPOST BLOCK. A block placed between the CAPITAL of a COLUMN and the Arches or Vaults it supports.

Insula (pl. Insulae). Latin word for *island*. In Roman antiquity, a mapped-out space or a city block. Also, a group of buildings or a large building similar to a modern apartment house.

Iron Age. See Bronze and Iron Ages.

Jamb. The vertical piece or pieces forming the side of a doorway or window. In Romanesque and Gothic churches, these supports were slanted or splayed outward to increase the impression of thickness in the walls and to provide space for sculptural decoration.

- Ka'Bah. The most sacred shrine of the Muslims. A small cube-shaped building in the great mosque at Mecca toward which Muslims face when praying. It contains a sacred stone said to have been turned black by the tears of repentant pilgrims or, according to another tradition, by the sins of those who have touched it.
- KEEP. The innermost central tower of a medieval castle, which served both as a last defense and as a dungeon and which contained living quarters, a prison, and sometimes a chapel; or a tower-like fortress, square, polygonal, or round, generally built on a mound as a military outpost.

KEYSTONE. See ARCH.

KING JAMES VERSION. See BIBLE.

- KORAN. The sacred Muslim writings as revealed by Allah to Mohammed and taken down by him or his companions.
- Kore (pl. Korai). Greek for *maiden*. An archaic Greek statue of a standing clothed female.
- Kouros (pl. Kouroi). Greek for *youth*. An archaic Greek statue of a standing nude young man.
- Krater. A Greek or Roman bowl with a wide neck, used for mixing wine and water. The body has two handles projecting vertically from the juncture of the neck and body.
- Kufic or Cufic. The earliest Arabic script used on Carvings and manuscripts, and, in the West, sometimes as pure ornament.
- KYLIX. In Greek and Roman antiquity, a drinking vessel shaped like a shallow bowl with two horizontal handles projecting from the sides; often set upon a stem with a foot.
- LABORS OF THE MONTHS. Representations of occupations suitable to the twelve months of the year; frequently CARVED around the PORTALS of Romanesque and Gothic churches together with the signs of the ZODIAC, or represented in the calendar scenes of ILLUMINATED MANU-SCRIPTS.
- LANCET WINDOW. A high, narrow window with a pointed arch at the top.
- Lantern. In architecture, a tall, more or less open structure crowning a roof, Dome, tower, etc., and admitting light to an enclosed area below.
- Lapis Lazuli. A deep blue stone or complex mixture of minerals used for ornamentation and in the making of pigments.
- La Tène. An Iron Age culture named after its site on Lake Neuchâtel in Switzerland.
- LECTIONARY. A book containing portions of the Scriptures arranged in the order in which they are read at Christian services.
- Lekythos. In ancient Greece, a tall vase with an ellipsoidal body, a narrow neck, and a flanged mouth. The curved handle extends from below the lip to the shoulder, and the narrow base ends in a foot. It was used to contain oil or perfumes.
- LIBERAL ARTS, SEVEN. Derived from the standard medieval prephilosophical education, they consisted of the trivium of Grammar, Rhetoric, and Logic, and the quadrivium of Arithmetic, Music, Geometry, and Astronomy. During the Middle Ages and the Renaissance, they were frequently represented allegorically.
- LINTEL. See POST AND LINTEL.
- LITURGY. A collection of prescribed prayers and ceremonies for public worship; specifically, in the Roman Catholic, Orthodox, and Anglican

- churches, those used in the celebration of the Mass.
- Loggia (pl. Loggie). A Gallery or Arcade open on at least one side.
- LUNETTE. A semicircular opening or surface, as on the wall of a Vaulted room or over a door, niche, or window. When it is over the PORTAL of a church, it is called a TYMPANUM.

LUTHER, MARTIN. See BIBLE.

- MADRASAH. Arabic word meaning place of study. An Islamic theological college providing student lodgings, a prayer hall, lecture halls, and a library. Perhaps first established in the tenth century by the Ghaznavids to combat the influence of dissenting sects, such as the Shi'ites; by the fourteenth century madrasahs were located in all great cities of the Muslim world. Usually consists of an open quadrangle bordered by VAULTED CLOISTERS called iwans.
- MAENAD. An ecstatic female follower of the wine god Dionysos (Greek) or Bacchus (Roman); hence, also called a *bacchante* (pl. *bacchae*).
- MAESTÀ. Italian word for majesty, and in religion signifying the Virgin in Majesty. A large ALTARPIECE with a central panel representing the Virgin Enthroned, adored by saints and angels.
- Magus (pl. Magi). A member of the priestly caste in ancient Media and Persia traditionally reputed to have practiced supernatural arts. In Christian art, the Three Wise Men who came from the East to pay homage to the Infant Jesus are called the *Magi*.
- Mandorla. The Italian word for almond. A large oval surrounding the figure of God, Christ, the Virgin Mary, or occasionally a saint, indicating divinity or holiness.
- MARTYRIUM. A shrine or chapel erected in honor of or over the grave of a martyr.
- Mass. The celebration of the Eucharist to perpetuate the sacrifice of Christ upon the Cross, plus readings from one of the Gospels and an Epistle; also, the form of Liturgy used in this celebration. See Canon of the Mass and Ordinary and Proper of the Mass.
- MASTABA. Arabic for *bench*. In Egyptian times, a tomb constructed of masonry and mud brick, rectangular in plan, with sloping sides and a flat roof. It covered a burial chamber and a chapel for offerings.
- MAUSOLEUM. The magnificent tomb of Mausolus, erected by his wife at Halikarnassos in the middle of the fourth century B.C. Hence, any stately building erected as a burial place.
- MAZZOCCHIO. A wire or wicker frame around which a hood or *cappuccio* was wrapped to form the turban-like headdress commonly worn by Florentine men in the fifteenth century.
- MEANDER. From the name of a winding river in Asia Minor. In Greek decoration, an ornamental pattern of lines that wind in and out or cross one another.
- Megaron. Principal hall in the Mycenaean palace or house.
- MENDICANT ORDERS. See DOMINICAN and FRANCISCAN.
- MENHIR. A prehistoric monument consisting of an upright monumental stone, left rough or sometimes partly shaped, and either standing alone or grouped with others.
- MESOLITHIC Era. Middle Stone Age, approximately 19,000-18,000 to 9000-8000 B.C. An

- intermediate period characterized by food-gathering activities and the beginnings of agriculture.
- METOPE. A square slab, sometimes decorated, between the Triglyphs in the Frieze of the Entablature of the Doric Order. Originally, the openings left by Greek builders between the ends of ceiling beams.
- MIHRAB. Arabic word for a niche in the QIBLA wall of a mosque, pointing in the direction of Mecca. Perhaps of Egypto-Christian origin, it was first installed in the early eighth-century rebuilding of the mosque at Medina.
- MINARET. A tall, slender tower attached to a mosque and surrounded by one or more balconies from which the MUEZZIN calls the people to prayer.
- MINBAR. Arabic word initially referring to the pulpit used in Medina by Mohammed, and later referring to the pulpit installed in each mosque to the right of the MIHRAB for the reading of the KORAN and prayers by the IMAM.
- MINOTAUR. In Greek mythology, a monster with the body of a man and the head of a bull, who, confined in the labyrinth built for Minos, king of Crete, in his palace at Knossos, fed on human flesh and who was killed by the Athenian hero Theseus.
- MITTER. A tall cap terminating in two peaks, one in front and one in back, that is the distinctive headdress of BISHOPS (including the pope as bishop of Rome) and abbots of the Western Church.
- Moat. A deep defensive ditch that surrounds the wall of a fortified town or castle and is usually filled with water.
- Modeling. The building up of three-dimensional form in a soft substance, such as clay or wax; the Carving of surfaces into proper Relief; the rendering of the appearance of three-dimensional form in painting.
- Molding. An ornamental strip, either depressed or projecting, that gives variety to the surface of a building by creating contrasts of light and shadow.
- Mosaic. A type of surface decoration (used on pavements, walls, and Vaults) in which bits of colored stone or glass (tesserae) are laid in cement in a figurative design or decorative pattern. In Roman examples, colored stones, set regularly, are most frequently used; in Byzantine work bits of glass, many with gold baked into them, are set irregularly.
- Muezzin. In Muslim countries, a crier who calls the people to prayer at stated hours, either from a Minaret or from another part of a mosque or high building.
- Mullion. A vertical element that divides a window or a screen into partitions.
- Mural. A painting executed directly on a wall or done separately for a specific wall and attached to it
- Muses. The nine sister goddesses of Classical mythology who presided over learning and the arts. They came to be known as Calliope, muse of epic poetry; Clio, muse of history; Erato, muse of love poetry; Euterpe, muse of music; Melpomene, muse of tragedy; Polyhymnia, muse of sacred song; Terpsici.ore, muse of dancing; Thalia, muse of comedy; and Urania, muse of astronomy.
- NARTHEX. A PORCH or vestibule, sometimes enclosed, preceding the main entrance of a church;

frequently, in churches preceded by an Atrium, the narthex is one side of the open Ambulatory.

NAVE. From the Latin word for *ship*. The central aisle of an ancient Roman Basilica or a Christian basilican church, as distinguished from the SIDE AISLES; the part of a church, between the main entrance and the CHANCEL, used by the congregation.

NEANDERTHAL MAN. A species of Middle Paleo-LITHIC man.

NEOLITHIC ERA. New Stone Age, approximately 9000–8000 to 3000 B.C. Characterized by fixed settlements and farming, and the beginnings of architecture and religion.

NIKE. See VICTORY.

Oculus (pl. Oculi). Latin word for eye. A circular opening in a wall or at the apex of a Dome.

OINOCHOE. A Greek pitcher with a three-lobed rim for dipping wine from a bowl and pouring it into wine cups.

Orant. From the Latin word for *praying*. Used to describe figures standing with arms outstretched in an attitude of prayer.

Order (architectural). An architectural system based on the Column (including Base, Shaft, and Capital) and its Entablature (including Architrave, Frieze, and Cornice). The five classical orders are the Doric, Ionic, Corinthian, Tuscan, and Composite.

Order (monastic). A religious society or confraternity whose members live under a strict set of rules and regulations, such as the Benedictine, Cistercian, Dominican, Franciscan, Carthusian, Cluniac, Jesuit, and Theatine.

Ordinary and Proper of the Mass. The service of the Mass exclusive of the Canon. It includes prayers, hymns, and readings from the Epistles and the Gospels.

ORTHOGONALS. Lines that are at right angles to the plane of the picture surface, but that, in a representation using one-point Perspective, converge toward a common vanishing point in the distance.

Palazzo (pl. Palazzi). Italian word for a *large town* bouse; used freely to refer to large civic or religious buildings as well as to relatively modest town houses.

Paleolithic Era. Old Stone Age, approximately 30,000 to 19,000 B.C. Populated by a society of nomadic hunters who used stone weapons and implements, and who lived largely in caves that they decorated with paintings.

PALESTRA (pl. PALESTRAE). In Greek antiquity, a public place for training in wrestling or athletics. A gymnasium.

PALETTE. A thin, usually oval or oblong tablet, with a hole for the thumb, upon which painters place and mix their colors.

Pantheon. From the Greek words meaning *all the gods*; hence, a temple dedicated to all the gods. Specifically, the famous temple built about 25 B.C. in Rome and so dedicated.

Pantocrator. A representation of Christ as the Almighty Ruler of the Universe (from the Greek) in which the attributes of God the Father are combined with those of the Son; an image frequently found in the apse or dome Mosaics of Byzantine churches.

Papyrus. A tall aquatic plant formerly very abundant in Egypt. Also, the material used for writ-

ing or painting upon by the ancient Egyptians, Greeks, and Romans. It was made by soaking, pressing, and drying thin strips of the pith of the plant laid together. Also, a manuscript or document of this material.

PARAPET. A low protective wall or barrier at the edge of a balcony, roof, bridge, or the like.

Parchment. A paper-like material made from animal skins that have been carefully scraped, stretched, and dried to whiteness. The name is a corruption of *Pergamon*, the city in Asia Minor where parchment was invented in the second century B.C. Also, a manuscript or document of such material.

Parecclesion. A funeral chapel.

Passion. In the Christian Church, used specifically to describe the sufferings of Christ during his last week of earthly life; the representation of his sufferings in narrative or pictorial form.

Pedestal. An architectural support for a Column, statue, vase, etc.; also, a foundation or Base.

PEDIMENT. A low-pitched triangular area, resembling a Gable, formed by the two slopes of a roof of a building (over a Portico, door, niche, or window), framed by a raking Cornice, and frequently decorated with sculpture. When pieces of the cornice are either omitted or jut out from the main axis, as in some late Roman and Baroque buildings, it is called a broken pediment. See Tympanum.

PENDENTIVE. An architectural feature, having the shape of a spherical triangle, used as a transition from a square ground Plan to a circular plan that will support a Dome. The dome may rest directly on the pendentives or on an intermediate Drum.

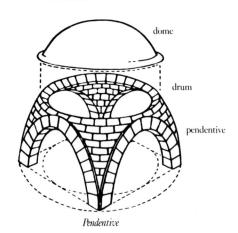

PENTATEUCH. See TORAH.

Peplos. A simple, loose outer garment worn by women in ancient Greece.

Pericope. Extracts or passages from the Bible selected for use in public worship.

Peripteral. Having a Colonnade or Peristyle on all four sides.

Peristyle. A Colonnade or Arcade around a building or open court.

Perspective. The representation of threedimensional objects on a flat surface so as to produce the same impression of distance and relative size as that received by the human eye. In one-point *linear perspective*, developed during the fifteenth century, all parallel lines in a given visual field converge at a single vanishing point on the horizon. In *aerial* or *atmospheric perspective* the relative distance of objects is indicated by gradations of tone and color, and by variations in the clarity of outlines. See Orthogonals and Transversals.

Pharaoh. From the Egyptian word meaning *great bouse*. A title of the sovereigns of ancient Egypt; used in the Old Testament as a proper name.

PIAZZA (pl. PIAZZE). Italian word for *public square*. See also CAMPO.

PICTURE PLANE. The actual surface on which a picture is painted.

PIER. An independent architectural element, usually rectangular in section, used to support a vertical load; if used with an ORDER, it often has a BASE and CAPITAL of the same design. See COMPOUND PIER.

PIER BUTTRESS. An exterior PIER in Romanesque and Gothic architecture, BUTTRESSING the THRUST of the VAULTS within.

PIETÀ. Italian word meaning both *pity* and *piety*. Used to designate a representation of the dead Christ mourned by the Virgin, with or without saints and angels. When the representation is intended to show a specific event prior to Christ's burial, it is usually called a *Lamentation*.

PILASTER. A flat vertical element, having a Capi-TAL and Base, engaged in a wall from which it projects. It has a decorative rather than a structural purpose.

PINNACLE. A small ornamental turret on top of BUTTRESSES, PIERS, or elsewhere; mainly decorative, it may also have a structural purpose, as in Reims Cathedral.

PLAN. The general arrangement of the parts of a building or group of buildings, or a drawing of these as they would appear on a plane cut horizontally above the ground or floor.

PODIUM (pl. PODIA). In architecture, a continuous projecting Base or Pedestal used to support Columns, sculptures, or a wall. Also, the raised platform surrounding the arena of an ancient Amphitheater.

Porch. An exterior structure forming a covered approach to the entrance of a building.

PORPHYRY. A very hard rock having a dark purplish-red base. The room in the Imperial Palace in Constantinople reserved for the confinement of the reigning empress was decorated with porphyry so that the child would be "born to the purple," or "Porphyrogenitus."

PORTA. Italian word for gate.

Porta Clausa. Latin phrase for Closed Door or Closed Gate.

PORTAL. A door or gate, especially one of imposing appearance, as in the entrances and PORCHES of a large church or other building. In Gothic churches the FAÇADES frequently include three large portals with elaborate sculptural decoration.

Portico. A structure consisting of a roof, or an Entablature and Pediment, supported by Columns, sometimes attached to a building as a Porch.

Post and Lintel. The ancient but still widely used system of construction in which the basic unit consists of two or more upright posts supporting a horizontal beam, or lintel, which spans the opening between them.

Potsherd. A fragment or broken piece of earthenware.

Predella. Pedestal of an Altarpiece, usually decorated with small narrative scenes that expand the theme of the major work above it.

Priori. Italian word for *priors*. The council or principal governing body of a town.

Priory. A monastic house presided over by a prior or prioress; a dependency of an Abbey.

Pronaos. The vestibule in front of the doorway to the Sanctuary in a Greek or Roman Peripteral temple.

Propylaion (pl. Propylaia). Generally, the entrance to a temple or other sacred enclosure. Specifically, the entrance gate to the Acropolis in Athens.

Prostyle. Used to describe a temple having a Portico across the entire front.

PROTHESIS. In an Early Christian or modern Eastern Orthodox church, a space or chamber next to the SANCTUARY for the preparation and safekeeping of the EUCHARIST. See BEMA.

PSALTER. The Book of Psalms in the Old Testament, or a copy of it, used for liturgical or devotional purposes; many psalters illuminated in the Middle Ages have survived. See ILLUMINATED MANUSCRIPTS.

PUEBLO. Communal houses or groups of houses built of stone or Adobe by the Indians of the southwestern United States.

Pylon. Greek word for *gateway*. In Egyptian architecture, the monumental entrance to a temple or other large edifice, consisting of two truncated pyramidal towers flanking a central gateway. Also, applied to either of the flanking towers.

QIBLA. The direction of Mecca, which Muslims face when praying, indicated by the MIHRAB in the qibla wall of a mosque.

Quatrefoil. A four-lobed form used as ornamentation.

RAKING CORNICE. See CORNICE.

REFECTORY. From the Latin verb meaning to *renew* or *restore*. A room for eating; in particular, the dining hall in a monastery, college, or other institution.

REGISTER. One of a series of horizontal bands used to differentiate areas of decoration when the bands are placed one above the other as in Egyptian tombs, medieval church sculpture, and the pages of a manuscript.

Relief. Sculpture that is not freestanding but projects from the background of which it is a part. *High relief* or *low relief* describes the amount of projection; when the background is not cut out, as in some Egyptian sculpture, the work is called *incised relief*.

Reliquary. A casket, Coffer, or other small receptacle for a sacred relic, usually made of precious materials and richly decorated.

RHYTON. An ancient Greek drinking vessel having one handle and, frequently, the shape of an animal.

Rib. A slender projecting Arch used primarily as support in Romanesque and Gothic VAULTS; in late Gothic architecture, the ribs are frequently ornamental as well as structural.

RIBBED VAULT. A compound masonry VAULT, the GROINS of which are marked by projecting stone RIBS

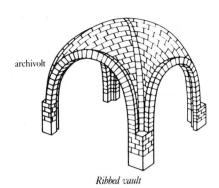

Rose Window. A circular window with stone Tracery radiating from the center; a feature characteristic of Gothic church architecture.

ROSTRUM (pl. ROSTRA). A pulpit or platform for public speakers. In the Roman FORUM, the orator's platform that was decorated with the beaks of warships captured in 338 B.C.

ROTULUS (pl. ROTULI). Latin word for SCROLL.

RUSTICATION. Masonry having indented joinings and, frequently, a roughened surface.

SACRAMENT. A rite regarded as an outward and visible sign of an inward and spiritual grace. Specifically, in the Roman Catholic Church, any one of the seven rites recognized as having been instituted by Christ: Baptism, confirmation, the EUCHARIST, penance, matrimony, holy orders, and extreme unction.

SACRISTY. See VESTRY.

SAHN. Arabic name for the open interior courtyard of a mosque; it usually has a pool in the center.

SANCTUARY. A sacred or holy place. In architecture, the term is generally used to designate the most sacred part of a building.

Sarcophagus. From the Greek words meaning flesh-eating. In ancient Greece, a kind of lime-stone said to reduce flesh to dust; thus the term was used for coffins. A general term for a stone coffin often decorated with sculpture or bearing inscriptions.

Saturation. The degree of intensity of a Hue and its relative freedom from an admixture with white.

SATYR. One of the woodland creatures thought to be the companions of Dionysos and noted for lasciviousness, represented with the body of a man, pointed ears, two horns, a tail, and the legs of a goat.

SCRIPTURE. See BIBLE and KORAN.

SCROLL. A roll of paper, PARCHMENT, or the like intended for writing upon. In architecture, an ornament resembling a partly unrolled sheet of paper or having a spiral or coiled form, as in the VOLUTES of Ionic and Corinthian COLUMNS.

Section. A drawing or diagram of a building showing its various parts as they would appear if the building were cut on a vertical plane.

SERAPH (pl. SERAPHIM). A celestial being or angel of the highest order, usually represented with six wings.

SHAFT. A cylindrical form; in architecture, the part of a Column or Pier between the Base and the

SIBYL. Any of various women of Greek and Roman mythology who were reputed to possess

powers of prophecy and divination. In time, as many as twelve came to be recognized, some of whom Michelangelo painted in the frescoes adorning the Sistine Chapel ceiling because they were believed to have foretold the first coming of Christ.

Side Aisle. One of the corridors parallel to the Nave of a church or Basilica, separated from it by an Arcade or Colonnade.

SINOPIA (pl. SINOPIE). An Italian term taken from Sinope, the name of a city in Asia Minor famous for its red earth. Used to designate the preliminary brush drawing executed in red earth mixed with water, for a painting in Fresco; usually done on the Arriccio.

SINS, SEVEN DEADLY. See VICES.

SIREN. In Classical mythology, one of several fabulous creatures, half woman and half bird, who were reputed to lure sailors to destruction by their seductive singing.

SLIP. Potter's clay reduced with water to a semiliquid state and used for coating or decorating pottery, cementing handles, etc.

Socie. A square block supporting a Column, statue, vase, or other work of art, or a low Base supporting a wall.

Spandrel. An area between the exterior curves of two adjoining Arches, or, enclosed by the exterior curve of an arch, a perpendicular from its springing and a horizontal through its apex.

SPHINX. In Egyptian mythology, a creature with the body of a lion and the head of a man, a bird, or a beast; the monumental sculpture of the same. In Greek mythology, a monster usually having the winged body of a lion and the head of a woman.

SQUINCH. An architectural device that uses ARCHES, LINTELS, or CORBELS across the corners of a square space to support a DOME and to make the transition from the square space to a polygonal or round one.

STEATITE. A variety of talc or soapstone.

STELE (pl. STELAE). A Greek word meaning *standing block*. An upright slab bearing sculptured or painted designs or inscriptions.

Stoa. In Greek architecture, a Portico or covered Colonnade, usually of considerable length, used as a promenade or meeting place.

STONE AGE. See MESOLITHIC, NEOLITHIC, and PALEOLITHIC.

STUCCO. Any of various plasters used for CORNICES, MOLDINGS, and other wall decorations. A cement or concrete for coating exterior walls in imitation of stone.

STYLOBATE. The top step of a stepped Base of a Greek temple, on which Columns rest.

Stylus. A pointed instrument used in ancient times for writing on tablets of a soft material, such as clay.

SUPERIMPOSED ORDERS. One ORDER on top of another on the face of a building of more than one story. The upper order is usually lighter in form than the lower.

TABERNACLE. The portable SANCTUARY used by the Israelites in the wilderness before the building of the Temple. Generally, any place or house of worship. In architecture, a canopied niche or recess, in a wall or a pillar, built to contain an image.

Tempera. Ground colors mixed with yolk of egg, instead of oil, as a vehicle; a medium widely

- used for Italian panel painting before the sixteenth century.
- Terra-Cotta. Italian words for *baked earth*. A hard glazed or unglazed earthenware used for sculpture and pottery or as a building material. The word can also mean something made of this material or the color of it, a dull brownish red.
- Tessera (pl. Tesserae). See Mosaic.
- THEATER. In ancient Greece and Rome, an openair structure in the form of a segment of a circle, frequently excavated from a hillside, with the seats arranged in tiers behind and above one another.
- THEOLOGICAL VIRTUES. See VIRTUES.
- Thеотокоs. The Virgin Mary as the Mother of God.
- Tholos. In Greek and Roman architecture, a circular building derived from early Greek tombs and used for a variety of purposes.
- Thrust. The outward force exerted by an Arch or Vault that must be counterbalanced by Buttressing.
- TIE ROD. An iron rod used as a structural element to keep the lower ends of a roof or Arch from spreading.
- Toga. A loose outer garment consisting of a single piece of material, without sleeves or armholes, which covered nearly the whole body, worn by the citizens of ancient Rome when appearing in public in times of peace.
- TORAH. The Jewish books of the law or the first five books of the Old Testament. Also called the *Pentateuch* in both Jewish and Christian usage.
- TOTEM POLE. A wooden post carved and painted with the emblem (totem) of a clan or family, and erected in front of the homes of the Indians of northwestern America.
- Tracery. Ornamental stonework in geometric patterns used primarily in Gothic windows as support and decoration, but also used on panels, screens, etc. When the window appears to be cut through the solid stone, the style is called *plate tracery*; when slender pieces of stone are erected within the window opening, the style is called *bar tracery*.
- Transept. In a Basilican church, the crossarm, placed at right angles to the Nave, usually separating the latter from the Chancel or the Apse.
- Transversals. Horizontal lines running parallel to the Picture Plane and intersecting the Orthogonals.
- Travertine. A tan or light-colored limestone used in Italy, and elsewhere, for building. The surface is characterized by alternating smooth and porous areas.

- Tree of the Knowledge of Good and Evil. A tree in the Garden of Eden bearing the forbidden fruit, the eating of which destroyed Adam's and Eve's innocence (Gen. 2:9; 3:17).
- Trefoil. A three-lobed form used as ornamentation or as the basis for a ground Plan.
- TRICLINIUM. The dining room in a Roman house.
- TRIFORIUM. The section of the wall in the NAVE, CHOIR, and sometimes in the Transept above the Arches and below the Clerestory. It usually consists of a blind Arcade or a Gallery.
- TRIGLYPH. From the Greek for *three grooves*. An ornamental member of a Doric Frieze, placed between two Metopes and consisting of a rectangular slab with two complete grooves in the center and a half groove at either side. Originally the end of a ceiling beam.
- Trillthon. Greek for *three stones*. A structure consisting of large unhewn stones, two upright and one resting on them like a LINTEL.
- TRIUMPHAL ARCH. In ancient Rome, a freestanding monumental ARCH or series of three arches erected to commemorate a military victory; usually decorated with sculptured scenes of a war and its subsequent triumphal procession. In a Christian church, the transverse wall with a large arched opening that separates the Chancel and the Apse from the main body of the church, and that is frequently decorated with religious scenes executed in Mosaic or Fresco.
- Trumeau (pl. Trumeaux). A central Pier dividing a wide doorway, used to support the Lintel; in medieval churches, trumeaux were frequently decorated with sculpture.
- Tufa. Any of various porous rocks composed of calcium deposited by springs or streams; or a volcanic stone.
- Tumulus (pl. Tumuli). An artifically constructed mound of earth raised over a tomb or sepulchral chamber.
- TUNIC. In ancient Greece and Rome, a knee-length garment with or without sleeves usually worn without a girdle by both sexes.
- TYMPANUM (pl. TYMPANA). In Classical architecture, the vertical recessed face of a Pediment; in medieval architecture, the space between the Arch and the Lintel over a door or window, which was often decorated with sculpture.
- VALUE. The degree of lightness or darkness of a Hue.
- Vault. An Arched roof or covering made of brick, stone, or concrete. See Barrel Vault, Groin Vault, Ribbed Vault, and Corbel Vault.
- Vellum. A fine kind of Parchment made from calfskin and used for the writing, Illuminating, and binding of medieval manuscripts.

- VESTRY. A room in or a building attached to a church where the vestments and sacred vessels are kept; also called a *sacristy*. Used, in some churches, as a chapel or a meeting room.
- VICAR. An ecclesiastic of the Roman Catholic Church who represents a pope or BISHOP; the pope himself as the vicar of Christ.
- VICES. Coming from the same tradition as the VIRTUES, and frequently paired with them, they are more variable, but usually include Pride, Avarice, Wrath, Gluttony, and Unchastity. Others such as Folly, Inconstancy, and Injustice may be selected to make a total of seven.
- Victory. A female deity of the ancient Romans, or the corresponding deity the ancient Greeks called Nike. The representation of the deity, usually as a winged woman in windblown draperies and holding a laurel wreath, palm branch, or other symbolic object.
- VIRTUES. Divided into the three Theological Virtues of Faith, Hope, and Charity, and the four Cardinal Virtues of Prudence, Justice, Fortitude, and Temperance. As with the VICES, the allegorical representation of the Virtues derives from a long medieval tradition in manuscripts and sculpture, and from such literary sources as the *Psychomachia* of Prudentius and the writings of Saint Augustine.
- VOLUTE. An ornament resembling a rolled SCROLL. Especially prominent on Capitals of the Ionic and Composite Orders.

Voussoir. See Arch.

VULGATE. See BIBLE.

- Westwork. The multistoried, towered western end of a Carolingian church that usually included a second Transept below and a chapel and Galleries above.
- ZIGGURAT. From the Assyrian-Babylonian word ziqquratu (mountaintop). A staged, truncated pyramid of mud brick, built by the Sumerians and later by the Assyrians as a support for a shrine.
- ZODIAC. An imaginary belt encircling the heavens within which lie the paths of the sun, moon, and principal planets. It is divided into twelve equal parts called *signs*, which are named after twelve constellations: Aries, the ram; Taurus, the bull; Gemini, the twins; Cancer, the crab; Leo, the lion; Virgo, the virgin; Libra, the balance; Scorpio, the scorpion; Sagittarius, the archer; Capricorn, the goat; Aquarius, the waterbearer; and Pisces, the fishes. Also, a circular or elliptical diagram representing this belt with pictures of the symbols associated with the constellations.

BOOKS FOR FURTHER READING

INTRODUCTION

- ARNHEIM, RUDOLF, Art and Visual Perception, 2d ed., University of California Press, Berkeley, 1974
- BERNHEIMER, RICHARD, The Nature of Representation, New York University Press, 1961
- COLLIER, GRAHAM, Art and the Creative Consciousness, Prentice-Hall, Englewood Cliffs, N.J., 1972
- FOCILLON, HENRI, The Life of Forms in Art, 2d ed., Wittenborn, New York, 1958
- GILSON, ÉTIENNE, Painting and Reality, Pantheon, New York, 1957
- GOMBRICH, ERNST H., Art and Illusion, 2d ed., Princeton University Press, 1961; 4th ed., Phaidon, London, 1972
- , Art, Perception and Reality, Johns Hopkins University Press, Baltimore, 1972
- HOLT, ELIZABETH B., A Documentary History of Art, 2d ed., 2 vols., Doubleday, Garden City, N.Y.,
- KRAUSE, JOSEPH G., The Nature of Art, Prentice-Hall, Englewood Cliffs, N.J., 1969
- Malraux, André, TVS, Doubleday, New York,

PART

MAGIC, FORM, AND **FANTASY**

ONE

MARSHACK, ALEXANDER, The Roots of Civilization: The Cognitive Beginnings of Man's First Art, Symbol and Notation, McGraw-Hill, New York, 1971

CHAPTER ONE ART BEFORE WRITING

Paleolithic Art

- BANDI, HANS GEORG, et al., The Art of the Stone Age, Crown, New York, 1961
- Brentjes, Burchard, African Rock Art, Dent, London, 1969
- Breuil, Henri, Four Hundred Centuries of Cave Art, Centre d'études et de documentation préhistorique, Montignac, France, 1952
- and LANTIER, R., The Men of the Old Stone Age, 2d ed., St. Martin's Press, New York, 1965

- BURKITT, MILES C., The Old Stone Age, 4th ed., Atheneum, New York, 1963
- GIEDION, SIGFRIED, The Eternal Present, 2 vols., Pantheon, New York, 1962-64 (Vol. 1, The Beginnings of Art; vol. 2, The Beginnings of Architec-
- GRAZIOSI, PAOLO, Paleolithic Art, McGraw-Hill, New York, 1960
- LEROI-GOURHAN, ANDRÉ, Treasures of Prehistoric Art, Abrams, New York, 1967
- LOMMEL, ANDREAS, Shamanism, The Beginnings of Art, McGraw-Hill, New York, 1967
- POWELL, T. G., Prehistoric Art, Praeger, New York,
- UCKO, PETER J., and ROSENFELD, A., Palaeolithic Cave Art, Weidenfeld & Nicholson, London,

Neolithic Art

- Arribas, Antonio, The Iberians, Praeger, New York, 1963
- DANIEL, GLYN E., The Megalith Builders of Western Europe, Praeger, New York, 1959
- MELLAART, JAMES, The Neolithic of the Near East, Scribner, New York, 1975
- PIGGOTT, STUART, Ancient Europe, Aldine, Chicago, 1966

CHAPTER TWO THE ART OF LATER ETHNIC **GROUPS**

Black African Art

- BASCOM, WILLIAM R., African Art in Cultural Perspective: An Introduction, Norton, New York, 1973
- LAUDE, JEAN, The Arts of Black Africa, University of California Press, Berkeley, 1971
- LEIRIS, MICHEL, and DULANGE, J., African Art, Thames & Hudson, London, 1968
- LEUZINGER, ELSY, The Art of Black Africa, New York Graphic Society, Greenwich, Conn., 1972
- WASSING, RENÉ S., African Art: Its Background and Traditions, Abrams, New York, 1968
- WILLETT, FRANK, African Art: An Introduction, Praeger, New York, 1971

Oceanic Art

- BÜHLER, ALFRED; BARROW, T.; and MOUNTFORD, C. T., The Art of the South Sea Islands, Crown, New York, 1962
- SCHMITZ, CARL A., Oceanic Art: Myth, Man, and Image in the South Seas, Abrams, New York, 1971

North American Indian Art

- ADAMS, RICHARD E. W., Prehistoric Mesoamerica, Little, Brown, Boston, 1977
- COVARRUBIAS, MIGUEL, The Eagle, the Jaguar and the Serpent: Indian Art of the Americas, Knopf, New York, 1954
- DOCKSTADER, FREDERICK J., Indian Art in America, New York Graphic Society, Greenwich, Conn.,
- FEDER, NORMAN, American Indian Art, Abrams, New York, 1971
- HIGHWATER, JAMAKE, Arts of the Indian Americas: Leaves from the Sacred Tree, Harper & Row, New York, 1983
- PATTERSON, NANCY-LOU, Canadian Native Art, Collier-Macmillan Canada, Don Mills, Ont.,

Pre-Columbian Art

- CORDY-COLLINS, ALANA, and STERN, JEAN, eds., Pre-Columbian Art History: Selected Readings, 2d ed., Peek Publications, Palo Alto, Calif., 1982
- HEMMING, JOHN, and RANNEY, EDWARD, Monuments of the Incas, Little, Brown, Boston, 1982
- HUNTER, C. BRUCE, A Guide to Ancient Mexican Ruins, University of Oklahoma Press, Norman,
- KUBLER, GEORGE, The Art and Architecture of Ancient America, rev. ed., Penguin, Harmondsworth and Baltimore, 1975
- LAPINER, ALAN C., Pre-Columbian Art of South America, Abrams, New York, 1976
- Soustelle, Jacques, Mexico, Barrie & Rockliff, The Cresset Press, London, 1969
- WINNING, HASSO VON, Pre-Columbian Art of Mexico and Central America, Abrams, New York, 1968

PART

THE ANCIENT WORLD

TWO

- AMIET, PIERRE, Art in the Ancient World: A Handbook of Styles and Forms, Rizzoli, New York, 1981
- GROENEWEGEN-FRANKFORT, HENRIETTE A., and ASHMOLE, BERNARD, Art of the Ancient World, Abrams, New York, and Prentice-Hall, Englewood Cliffs, N.J., 1971
- HAWKES, JACQUETTA H., Atlas of Ancient Archaeology, McGraw-Hill, New York, 1974
- LLOYD, SETON, et al., Ancient Architecture, Abrams, New York, 1974

CHAPTER ONE EGYPTIAN ART

- ALDRED, CYRIL, The Development of Ancient Egyptian Art from 3200 to 1315 B.C., 3 vols., Academy Editions, London, 1973
- BADAWY, ALEXANDER, A History of Egyptian Architecture, 3 vols., Sh. Studio Misr, Giza (I), University of California Press, Berkeley (II, III), 1954-68
- Breasted, James, History of Egypt, repr. ed., Scribner, New York, 1956
- EMERY, WALTER B., Archaic Egypt, Penguin, Baltimore, 1962
- Lange, Kurt, and Hirmer, Max, Egypt: Architecture, Sculpture, and Painting in Three Thousand Years, 4th ed., Phaidon, New York and London, 1968
- MICHALOWSKI, KAZIMIERZ, Art of Ancient Egypt, Abrams, New York, 1969
- PORTER, BERTHA, and Moss, R., Topographical Bibliography of Ancient Egyptian Hieroglyphic Texts, Reliefs, and Paintings, 7 vols., Clarendon Press, Oxford, 1927-51 (2d ed., 1964- , in progress)
- SMITH, WILLIAM STEVENSON, The Art and Architecture of Ancient Egypt, rev. ed., Penguin, New York, 1981

CHAPTER TWO MESOPOTAMIAN ART

- AKURGAL, EKREM, Art of the Hittites, Abrams, New York, 1962
- ALBRIGHT, WILLIAM F., The Archaeology of Palestine, 2d ed., Penguin, Harmondsworth, 1956
- AMIET, PIERRE, Art of the Ancient Near East, Abrams, New York, 1980
- FRANKFORT, HENRI, The Art and Architecture of the Ancient Orient, 4th ed., Penguin, Baltimore, 1969
- GHIRSHMAN, ROMAN, Iran from the Earliest Times to the Islamic Conquest, Penguin, Harmondsworth and New York, 1978
- Goff, Beatrice, L., Symbols of Prehistoric Mesopotamia, Yale University Press, New Haven, Conn., 1963
- KRAMER, SAMUEL N., The Sumerians: Their History, Culture, and Character, University of Chicago Press, 1963
- LLOYD, SETON, The Archaeology of Mesopotamia: From the Old Stone Age to the Persian Conquest, Thames & Hudson, London, 1978
- , The Art of the Ancient Near East, Thames & Hudson, London, and Praeger, New York,
- MELLAART, JAMES, Earliest Civilizations of the Near East, McGraw-Hill, New York, 1965
- MOOREY, P. R. S., Ancient Iraq: Assyria and Babylonia, Ashmolean Museum, Oxford, 1976
- PARROT, ANDRÉ, The Arts of Assyria, Golden Press, New York, 1961
- , Nineveh and Babylon, Thames & Hudson, London, 1960
- , Sumer: The Dawn of Art, Golden Press, New York, 1961
- PORADA, EDITH, The Art of Ancient Iran: Pre-Islamic Cultures, Crown, New York, 1965
- SMITH, WILLIAM STEVENSON, Interconnections in the Ancient Near East, Yale University Press, New Haven, Conn., 1965

- STROMMENGER, EVA, and HIRMER, MAX, 5000 Years of the Art of Mesopotamia, Abrams, New York,
- WOOLLEY, SIR CHARLES LEONARD, Mesopotamia and the Middle East, Methuen, London, 1961
- , Ur of the Chaldees, rev. ed., Norton, New York, 1965

CHAPTER THREE **AEGEAN ART**

- BLEGEN, CARL W., and RAWSON, M., The Palace of Nestor at Phylos in Western Messenia, 2 vols., Princeton University Press, 1966
- BOARDMAN, JOHN, Pre-Classical: From Crete to Archaic Greece, Penguin, Harmondsworth, 1967
- Branigan, Keith, Aegean Metalwork of the Early and Middle Bronze Age, Clarendon Press, Oxford, 1974
- Demargne, Pierre, Aegean Art: The Origins of Greek Art, Golden Press, New York, and Thames & Hudson, London, 1964
- EVANS, SIR ARTHUR JOHN, The Palace of Minos, 4 vols., Macmillan, New York, 1921-35; repr. ed., Biblo and Tannen, New York, 1964
- GRAHAM, JAMES WALTER, The Palaces of Crete, Princeton University Press, 1962
- HAMPE, ROLAND, and SIMON, ERIKA, The Birth of Greek Art, From the Mycenaeans to the Archaic Period, Oxford University Press, New York, 1981
- HIGGINS, REYNOLD, Minoan and Mycenean Art, rev. ed., Oxford University Press, New York, 1981
- HOOD, SINCLAIR, The Arts in Prehistoric Greece, Penguin, Harmondsworth and New York, 1978
- HUTCHINSON, ROBERT W., Prebistoric Crete, Penguin, Baltimore, 1962
- Marinatos, Spyridon, and Hirmer, Max, Crete and Mycenae, Abrams, New York, and Thames & Hudson, London, 1960
- MATZ, FRIEDRICH, The Art of Crete and Early Greece, Crown, New York, 1962
- PENDLEBURY, JOHN D. S., Archaeology of Crete, Norton, New York, 1965
- VERMEULE, EMILY, Greece in the Bronze Age, University of Chicago Press, 1964
- WACE, ALAN J. B., Mycenae: An Archaeological History and Guide, Princeton University Press, 1949; repr. ed., Biblo and Tannen, New York, 1964

CHAPTER FOUR GREEK ART

- ADAM, SHEILA, The Technique of Greek Sculptures in the Archaic and Classical Periods, Thames & Hudson, London, 1967
- ARIAS, PAOLO E., and HIRMER, M., A History of 1000 Years of Greek Vase Painting, Abrams, New York, 1963
- ASHMOLE, BERNARD, Architect and Sculptor in Classical Greece, New York University Press, 1972
- -, and YALOURIS, N., Olympia: The Sculptures of the Temple of Zeus, Phaidon, London, 1967
- BEAZLEY, SIR JOHN D., Attic Black-Figure Vase-Painters, Clarendon Press, Oxford, 1956
- , Attic Red-Figure Vase-Painters, 2d ed., 3 vols., Clarendon Press, Oxford, 1963
- -, and ASHMOLE, B., Greek Sculpture and Painting to the End of the Hellenistic Period, Cambridge University Press, 1966

- BECATTI, GIOVANNI, The Art of Ancient Greece and Rome, Abrams, New York, 1967
- BERVE, HELMUT; GRUBEN, G.; and HIRMER, M., Greek Temples, Theatres and Shrines, Abrams, New York, 1963
- BIEBER, MARGARETE, The History of the Greek and Roman Theater, 2d ed., Princeton University Press, 1961
- , The Sculpture of the Hellenistic Age, 2d ed., Columbia University Press, New York, 1961
- BOARDMAN, JOHN, Athenian Black Figure Vases, Oxford University Press, New York, 1975
- , Athenian Red Figure Vases, Oxford University Press, New York, 1979
- , Greek Gems and Finger Rings, Abrams, New York, and Thames & Hudson, London, 1972
- Greek Sculpture: The Archaic Period, Oxford University Press, New York, 1978
- et al., Greek Art and Architecture, Abrams, New York, 1967
- CARPENTER, RHYS, Aesthetic Basis of Greek Art of the Fifth and Fourth Centuries, B.C., 2d ed., Indiana University Press, Bloomington, 1965
- , Greek Sculpture: A Critical Review, University of Chicago Press, 1960
- CHARBONNEAUX, JEAN, Classical Greek Art, Braziller, New York, 1972
- -, Greek Bronzes, Viking, New York, 1962
- -, Hellenistic Greek Art, Braziller, New York,
- -, et al., Archaic Greek Art, Braziller, New York, 1971
- COOK, ROBERT M., Greek Art: Its Development, Character, and Influence, Farrar, Straus & Giroux, New York, 1973
- , Greek Painted Pottery, 2d ed., Methuen, London, 1966
- HIGGINS, REYNOLD A., Greek and Roman Jewellery, Methuen, London, 1961
- -, Greek Terracottas, Methuen, London, 1967
- KRAAY, COLIN M., and HIRMER, M., Greek Coins, Abrams, New York, and Thames & Hudson, London, 1966
- LANE, ARTHUR, Greek Pottery, 3d ed., Faber & Faber, London, 1971
- Langlotz, Ernst, and Hirmer, M., The Art of Magna Graecia: Greek Art in Southern Italy and Sicily, Thames & Hudson, London, 1965
- LAWRENCE, ARNOLD W., Greek Architecture, 2d ed., Penguin, Baltimore, 1967
- LULLIES, REINHARD, and HIRMER, M., Greek Sculpture, Abrams, New York, 1960
- POLLITT, J. J., The Ancient View of Greek Art, Yale University Press, New Haven, Conn., 1974
- , Art and Experience in Classical Greece, Cambridge University Press, 1972
- -,The Art of Greece (1400–31 B.C.): Sources and Documents, Prentice-Hall, Englewood Cliffs, N.J., 1965
- RICHTER, GISELA M. A., A Handbook of Greek Art, 6th ed., Phaidon, New York, 1969
- Perspective in Greek and Roman Art, Phaidon, London and New York, 1970
- -, The Portraits of the Greeks, 3 vols., Phaidon, London, 1965
- , The Sculpture and Sculptors of the Greeks, 4th ed., Yale University Press, New Haven, Conn., 1970

- RIDGWAY, B. S., The Archaic Style in Greek Sculpture, Princeton University Press, 1977
- ——, Fifth Century Styles in Greek Sculpture, Princeton University Press, 1981
- ——, The Severe Style in Greek Sculpture, Princeton University Press, 1970
- ROBERTSON, DONALD S., Greek and Roman Architecture, 2d ed., Cambridge University Press, 1969
- ROBERTSON, MARTIN, Greek Painting, Skira, Geneva, 1959
- ———, A History of Greek Art, 2 vols., Cambridge University Press, London and New York, 1975
- SCRANTON, ROBERT L., Greek Architecture, Braziller, New York, 1962
- Ward Perkins, John B., The Cities of Ancient Greece and Italy: Planning in Classical Antiquity, Braziller, New York, 1974
- Webster, Thomas B. L., Art and Literature in Fourth-Century Athens, Greenwood Press, New York, 1969

CHAPTER FIVE ETRUSCAN ART

- BANTI, LUISA, Etruscan Cities and Their Culture, University of California Press, Berkeley, 1973
- BOETHIUS, AXEL, and WARD PERKINS, J. B., Etruscan and Early Roman Architecture, 2d integrated ed., rev., Penguin, Harmondsworth and New York, 1978
- Mansuelli, G. A., The Art of Etruria and Early Rome, Crown, New York, 1965
- Pallottino, Massimo, Etruscan Painting, Skira, New York, 1953
- RICHARDSON, EMELINE, The Etruscans: Their Art and Civilization, University of Chicago Press, 1976
- Riis, P. J., An Introduction to Etruscan Art, Munksgaard, Copenhagen, 1953

CHAPTER SIX ROMAN ART

- Andreae, Bernard, The Art of Rome, Abrams, 1977
- BECATTI, GIOVANNI, The Art of Ancient Greece and Rome, Abrams, New York, 1967
- BIEBER, MARGARETE, The History of the Greek and Roman Theater, 2d ed., Princeton University Press, 1961
- BLAKE, MARION E., Roman Construction in Italy from Nerva Through the Antonines, American Philosophical Society, Philadelphia, 1973
- BOETHIUS, AXEL, The Golden House of Nero, University of Michigan Press, Ann Arbor, 1960
- Brendel, Otto, *Prolegomena to the Study of Roman Art*, Yale University Press, New Haven, Conn., 1979
- BRILLIANT, RICHARD, Roman Art from the Republic to Constantine, Phaidon, New York, 1974
- Hanfmann, George M. A., *Roman Art*, New York Graphic Society, Greenwich, Conn., 1964
- ——, The Seasons Sarcophagus in Dumbarton Oaks, 2 vols., Harvard University Press, Cambridge, Mass., 1952
- HODDINOTT, RALPH F., *The Thracians*, Thames & Hudson, London, 1981
- LEHMANN, PHYLLIS W., Roman Wall Paintings from Boscoreale in The Metropolitan Museum of Art, Metropolitan Museum of Art, New York, 1953

- L'Orange, Hans Peter, Art Forms and Civic Life in the Later Roman Empire, Princeton University Press. 1965
- MacCormack, Sabine, Art and Ceremony in Late Antiquity, University of California Press, Berkeley, 1981
- MacDonald, William L., The Architecture of the Roman Empire, I, rev. ed., Yale University Press, New Haven, Conn., 1982
- ——, The Pantheon: Design, Meaning and Progeny, Harvard University Press, Cambridge, Mass., 1976
- McKay, Alexander, G., Houses, Villas and Palaces in the Roman World, Cornell University Press, Ithaca, N.Y., 1975
- MAIURI, AMEDEO, Roman Painting, Skira, New York, 1953
- Mansuelli, Guido A., The Art of Etruria and Early Rome, Crown, New York, 1965
- NASH, ERNEST, Pictorial Dictionary of Ancient Rome, 2d ed., 2 vols., Praeger, New York, 1968
- Percival, John, *The Roman Villa: An Historical Introduction*, University of California Press, Berkeley, 1976
- Perkins, Ann, *The Art of Dura-Europos*, Clarendon Press, Oxford, 1963
- Pobé, Marcel, and Roubier, J., The Art of Roman Gaul, University of Toronto Press, 1961
- POLLITT, J. J., The Art of Rome and Late Antiquity: Sources and Documents in the History of Art, Prentice-Hall, Englewood Cliffs, N.J., 1966
- ROBERTSON, DONALD S., Greek and Roman Architecture, 2d ed., Cambridge University Press, 1969
- ROULLET, Anne, The Egyptian and Egyptianizing Monuments of Imperial Rome, Brill, Leiden, 1972
- Strong, Donald E., *Roman Art*, Penguin, Harmondsworth and Baltimore, 1976
- ———, Roman Imperial Sculpture: An Introduction to the Commemorative and Decorative Sculpture of the Roman Empire Down to the Death of Constantine, Tiranti, London, 1961
- TOYNBEE, JOCELYN M. C., The Art of the Romans, Praeger, New York, 1965
- ——, Roman Historical Portraits, Thames & Hudson, London, 1978
- Vermeule III, Cornelius C., Roman Imperial Art in Greece and Asia Minor, Belknap Press, Cambridge, Mass., 1968
- WARD PERKINS, JOHN B., Roman Architecture, Abrams, New York, 1977
- ——, Roman Imperial Architecture, Penguin, Harmondsworth and New York, 1981
- ——, and Boethius, Axel, Etruscan and Roman Architecture, Penguin, Harmondsworth, 1970
- WHEELER, MORTIMER, Roman Art and Architecture, Praeger, New York, and Thames & Hudson, London, 1964

PART

THE MIDDLE AGES

THREE

- Davis Weyer, Caecilia, Early Medieval Art, 300–1150: Sources and Documents, Prentice-Hall, Englewood Cliffs, N.J., 1971
- Kidson, Peter, *The Medieval World*, McGraw-Hill, New York, 1967

- KLINGENDER, FRANCIS D., Animals in Art and Thought to the End of the Middle Ages, MIT Press, Cambridge, Mass., 1971
- MARTINDALE, ANDREW, The Rise of the Artist in the Middle Ages and Early Renaissance, McGraw-Hill, New York, 1972
- OAKESHOTT, WALTER F., Classical Inspiration in Medieval Art, Chapman & Hall, London, 1959
- Saalman, Howard, Medieval Architecture: European Architecture, 600–1200, Braziller, New York, 1962
- SMITH, EARL BALDWIN, Architectural Symbolism of Imperial Rome and the Middle Ages, Princeton University Press, 1956
- ZARNECKI, GEORGE, Art of the Medieval World, Abrams, New York, and Prentice-Hall, Englewood Cliffs, N.J., 1975

CHAPTER ONE EARLY CHRISTIAN AND BYZANTINE ART

- BECKWITH, JOHN, The Art of Constantinople: An Introduction to Byzantine Art (330–1453), 2d ed., Phaidon, New York, 1968
- —, Coptic Sculpture, 300–1300, A. Tiranti, London, 1963
- ———, Early Christian and Byzantine Art, 2d integrated ed., Penguin, Baltimore, 1979
- Beza, Marcu, Byzantine Art in Roumania, Batsford, London, 1940
- BIHALJI-MERIN, Oto, Byzantine Frescoes and Icons in Yugoslavia, Abrams, New York, 1960
- BOVINI, GIUSEPPE, and VON MATT, L., Ravenna, Abrams, New York, 1972
- CHATZIDAKIS, MANOLIS, Byzantine and Early Medieval Painting, Viking, New York, 1965
- CREMA DE IONGH, DANIEL, Byzantine Aspects of Italy, Norton, New York, 1967
- Demus, Otto, Byzantine Art and the West, New York University Press, 1970
- ——, Byzantine Mosaic Decoration, Routledge & Kegan Paul, London, 1953
- ———, The Mosaics of Norman Sicily, Routledge & Kegan Paul, London, 1950
- Der Nersessian, Sirarpie, Armenia and the Byzantine Empire, Harvard University Press, Cambridge, Mass., 1945
- Forsyth, George H., and Weitzmann, K., The Church and Fortress of Justinian, University of Michigan Press, Ann Arbor, 1973
- Frazer, Margaret E., Age of Spirituality: Late Antique and Early Christian Art, Third to Seventh Century, Metropolitan Museum of Art, New York, 1977
- GALAVARIS, GEORGE, The Icon in the Life of the Church: Doctrine, Liturgy, Devotion, Brill, Leiden, 1981
- GRABAR, ANDRÉ, The Art of the Byzantine Empire: Byzantine Art in the Middle Ages, Crown, New York, 1966
- ——, The Beginnings of Christian Art, 200–395, Thames & Hudson, London, 1967
- -----, Byzantine Painting, Skira, Geneva, 1953
- ——, The Golden Age of Justinian: From the Death of Theodosius to the Rise of Islam, Odyssey Press, New York, 1967
- HAMILTON, GEORGE H., Art and Architecture of Russia, 2d ed., Viking, New York, 1975

- HAMILTON, JOHN A., Byzantine Architecture and Decoration, 2d ed., Batsford, London, 1956: reprint, Books for Libraries/Arno, Freeport, N.Y., 1972
- KITZINGER, ERNST, The Art of Byzantium and the Medieval West: Selected Studies, Indiana University Press, Bloomington, 1976
- Kostof, Spiro K., Caves of God: The Monastic Environment of Byzantime Cappadocia, MIT Press, Cambridge, Mass., 1972
- —, The Orthodox Baptistery of Ravenna, Yale University Press, New Haven, Conn., 1965
- Krautheimer, Richard, Early Christian and Byzantine Architecture, Penguin, Baltimore, 1965
- ——, Studies in Early Christian, Medieval and Renaissance Art, New York University Press, 1969
- MacDonald, William L., Early Christian and Byzantine Architecture, Braziller, New York, 1962
- Maguire, Henry, Art and Eloquence in Byzantium, Princeton University Press, 1981
- Mango, Cyril, The Art of the Byzantine Empire, 312–1453: Sources and Documents, Prentice-Hall, Englewood Cliffs, N.J., 1972
- ——, Byzantine Architecture, Abrams, New York,
- Mathews, Thomas S., The Byzantine Churches of Istanbul: A Photographic Survey, Pennsylvania State University Press, University Park, 1976
- MILLET, GABRIEL, and RICE, D. T., Byzantine Painting at Trebizond, G. Allen & Unwin, London, 1936
- Palol Salellas, Pedro de, and Hirmer, M., Early Medieval Art in Spain, Thames & Hudson, London, and Abrams, New York, 1967
- Papageorgiou, Athanasios, *Icons of Cyprus*, Cowles, New York, 1970
- RICE, DAVID TALBOT, The Appreciation of Byzantine Art, Oxford University Press, London, 1972
- ——, Art of the Byzantine Era, Praeger, New York, and Thames & Hudson, London, 1963
- ——, *Byzantine Art*, rev. ed., Penguin, Harmondsworth and Baltimore, 1962
- —, and Radojcic, S., *Yugoslavia: Mediaeval Frescoes*, New York Graphic Society, Greenwich, Conn., 1955
- ROSTOVTSEV, MIKHAIL I., *Dura-Europos and Its Art*, Clarendon Press, Oxford, 1953
- RUNCIMAN, SIR STEVEN, Byzantine Style and Civilization, Penguin, Harmondsworth and Baltimore, 1975
- Shug-Wille, Christa, Art of the Byzantine World, Abrams, New York, 1969
- Simson, Otto von, *The Sacred Fortress*, University of Chicago Press, 1948; repr. ed., 1976
- STYLIANOU, ANDREAS and JUDITH, The Painted Churches in Cyprus, Research Center, Cyprus, 1964
- SWIFT, EMERSON H., *Hagia Sophia*, Columbia University Press, New York, 1940
- UNDERWOOD, PAUL A., *The Kariye Djami*, 4 vols., Bollingen Foundation, New York, 1966–75
- Volbach, Wolfgang F., and Hirmer, M., Early Christian Art, Abrams, New York, and Thames & Hudson, London, 1962
- VOYCE, ARTHUR, The Art and Architecture of Medieval Russia, University of Oklahoma Press, Norman, 1967
- Walter, Christopher, Art and Ritual of the Byzantine Church, Variorum Reprints, London, 1982

- ——, Studies in Byzantine Iconography, Variorum Reprints, London, 1977
- Weitzmann, Kurt, Byzantine Book Illumination and Ivories, Variorum Reprints, London, 1980
- ------, Late Antique and Early Christian Book Illumination, Braziller, New York, 1977
- ——, The Monastery of Saint Catherine at Mount Sinai: The Icons, Princeton University Press, 1976
- —, A Treasury of Icons: Sixth to Seventeenth Centuries, Abrams, New York, 1967
 - , et al., The Icon, Knopf, New York, 1982

CHAPTER TWO ISLAMIC ART

- ASLANAPA, OKTAY, Turkish Art and Architecture, Praeger, New York, and Faber & Faber, London, 1971
- BINYON, LAWRENCE; WILKINSON, J. V. S.; and GRAY, B., *Persian Miniature Painting*, Oxford University Press, New York and London, 1933
- BLOCHET, EDGAR, Muselman Painting, XII–XVIIth Century, Methuen, London, 1929
- BRICE, WILLIAM C., ed., An Historical Atlas of Islam, Brill, Leiden, 1981
- CRESWELL, K. A. C., Early Muslim Architecture, 2 vols., Clarendon Press, Oxford, 1932–40; 2d ed. with van Berchem, Marguerite, Clarendon Press, Oxford, 1969
- ——, The Muslim Architecture of Egypt, 2 vols., Clarendon Press, Oxford, 1952–59
- ETTINGHAUSEN, RICHARD, Arab Painting, Skira, New York, 1962
- Grabar, Oleg, *The Formation of Islamic Art*, Yale University Press, New Haven, Conn., 1973
- Hill, Derek, Islamic Architecture and Its Decoration: A.D. 800-1500, University of Chicago Press, 1964
- Hoag, John D., *Islamic Architecture*, Abrams, New York, 1977
- Lane, Arthur, Islamic Pottery from the Ninth to the Fourteenth Centuries, A.D., Faber & Faber, London, 1956
- Pope, Arthur Upham, and Ackerman, P., eds., A Survey of Persian Art from Prebistoric Times to the Present, 7 vols., Oxford University Press, New York and London, 1977
- RICE, DAVID TALBOT, Islamic Art, Thames & Hudson, London, 1975
- ROBINSON, B. W., et al., *Islamic Painting and the Arts of the Book*, Faber & Faber, London, 1976

CHAPTER THREE BARBARIAN AND CHRISTIAN ART IN NORTHERN EUROPE

Barbarian Art

- Fox, Sir Cyril F., *Life and Death in the Bronze Age*, Routledge & Kegan Paul, London, 1959
- HUBERT, JEAN; PORCHER, J.; and VOLBACH, W. F., Europe of the Invasions, Braziller, New York, 1969
- JETTMAR, KARL, Art of the Steppes: The Eurasian Animal Style, Methuen, London, 1967
- KNOBLOCH, EDGAR, Beyond the Oxus: Archaeology, Art and Architecture of Central Asia, Benn, London, 1972
- Megaw, J. V. S., Art of the European Iron Age, Harper & Row, New York, 1970

- MELLAART, JAMES, The Chalcolithic and Early Bronze Age in the Near East and Anatolia, Khayats, Beirut, 1966
- Sandars, Nancy K., Bronze Age Cultures in France, Cambridge University Press, 1957

Christian (Hiberno-Saxon) Art

- Arnold, Bruce, A Concise History of Irish Art, Praeger, New York, 1968; rev. ed., Thames & Hudson, London, 1977
- Beckwith, John, Early Medieval Art: Carolingian, Ottonian, Romanesque, Thames & Hudson, London, 1964; Oxford University Press, New York, 1974
- —, Ivory Carvings in Early Medieval England, New York Graphic Society, Greenwich, Conn., 1972
- FINLAY, IAN, Celtic Art: An Introduction, Faber & Faber, London, 1973
- HARBISON, PETER, et al., Irish Art and Architecture from Prehistory to the Present, Thames & Hudson, London, 1978
- HENRY, FRANÇOISE, ed., *The Book of Kells*, Knopf, New York, 1974
- ——, Irish Art in the Early Christian Period, to 800 A.D., Methuen, London, and Cornell University Press, Ithaca, N.Y., 1965
- Lucas, A. T., *Treasures of Ireland*, Gill & Macmillan, Dublin, 1973
- Stoll, Robert, Architecture and Sculpture in Early Britain, Thames & Hudson, London, 1967

CHAPTER FOUR THE ART OF THE HOLY ROMAN EMPIRE

- Backes, Magnus, and Dölling, R., Art of the Dark Ages, Abrams, New York, 1971
- BECKWITH, JOHN, Early Medieval Art, Praeger, New York, and Thames & Hudson, London, 1964
- Conant, Kenneth, J., Carolingian and Romanesque Architecture, 800–1200, new ed., Penguin, Baltimore, 1974
- Dodwell, C. R., *Painting in Europe*, 800–1200, Penguin, Baltimore, 1971
- GRABAR, ANDRÉ, and Nordenfalk, C., Early Medieval Painting, Skira, New York, 1957
- HENDERSON, GEORGE, Early Medieval, Penguin, Baltimore, 1972
- Henry, Françoise, Irish Art During the Viking Invasions, 800–1200 a.d., Cornell University Press, Ithaca, N.Y., 1967
- HINKS, ROGER P., Carolingian Art, University of Michigan Press, Ann Arbor, 1966
- METROPOLITAN MUSEUM OF ART, The Secular Spirit: Life and Art at the End of the Middle Ages, Dutton, New York, 1975
- Mutherich, Florentine, and Gaehde, J. E., Carolingian Painting, Braziller, New York, 1976
- RICE, DAVID TALBOT, The Dawn of European Civilization: The Dark Ages, McGraw-Hill, New York, 1965

CHAPTER FIVE ROMANESQUE ART

Allsopp, Bruce, Romanesque Architecture: The Romanesque Achievement, John Day Co., New York, 1971

- Anthony, Edgar W., Romanesque Frescoes, Princeton University Press, 1951; distributed by Oxford University Press, London
- Aubert, Marcel, Romanesque Cathedrals and Abbeys of France, N. Vane, London, 1966
- Boase, T. S. R., English Art 1100–1216, 2d ed., Clarendon Press, Oxford, 1968
- Bologna, Ferdinando, Early Italian Painting, Van Nostrand, Princeton, N.J., 1964
- Braun, Hugh, English Abbeys, Faber & Faber, London, 1971
- ———, An Introduction to English Mediaeval Architecture, 2d ed., Faber & Faber, London, 1968
- CAHN, WALTER, Romanesque Bible Illumination, Cornell University Press, Ithaca, N.Y., 1982
- CLAPHAM, SIR ALFRED WILLIAM, English Romanesque Architecture, 2 vols., Clarendon Press, Oxford, 1964
- CONANT, KENNETH J., Carolingian and Romanesque Architecture, 800–1200, 3d ed., Penguin, Harmondsworth, 1973
- Courtens, André, Romanesque Art in Belgium, M. Vokaer, Brussels, 1969
- CRICHTON, GEORGE H., Romanesque Sculpture in Italy, Routledge & Kegan Paul, London, 1954
- DECKER, HEINRICH, Romanesque Art in Italy, Abrams, New York, 1959
- Demus, Otto, Romanesque Mural Painting, Abrams, New York, 1970
- DERCSÉNYI, DEZSÖ, Romanesque Architecture in Hungary, Kossuth, Budapest, 1975
- Duby, Georges, The Age of the Cathedrals: Art and Society 980–1420, University of Chicago, 1981
- Evans, Joan, Art in Medieval France 987–1498, Clarendon Press, Oxford, 1969
- ——, The Romanesque Architecture of the Order of Cluny, 2d ed., AMS Press, New York, 1972
- FOCILLON, HENRI, The Art of the West in the Middle Ages, 2d ed., Phaidon, London, New York, 1969
- GARDNER, ARTHUR, Medieval Sculpture in France, Macmillan, New York and London, 1931; repr. ed., 1969
- GARRISON, EDWARD B., Italian Romanesque Panel Painting: An Illustrated Index, Olschki, Florence, 1949
- Grabar, André, and Nordenfalk, C., Romanesque Painting, Skira, New York, and Zwemmer, London, 1958
- GRIVOT, DENIS, and ZARNECKI, GEORGE, Gislebertus: Sculptor of Autun, Orion, New York, 1961
- HAZARD, HENRY, ed., The Art and Architecture of the Crusader States, University of Wisconsin Press, Madison, 1977
- HELL, VERA and HELLMUT, The Great Pilgrimage of the Middle Ages, Barrie & Rockliff, London, 1966
- Kidson, Peter, The Medieval World, McGraw-Hill, New York, 1967
- Kraus, Henry, *The Living Theatre of Medieval Art*, Indiana University Press, Bloomington, 1967
- KUBACH, HANS E., Romanesque Architecture, Abrams, New York, 1975
- KÜNSTLER, GUSTAV, comp., Romanesque Art in Europe, Norton, New York, 1973
- MICHEL, PAUL H., Romanesque Wall Paintings in France, Éditions du Chêne, Paris, 1949
- Morris, Richard, Cathedrals and Abbeys of England and Wales: The Building Church, 600–1540, Dent, London, 1979

- PÄCHT, OTTO, The Rise of Pictorial Narrative in Twelfth Century England, Clarendon Press, Oxford, 1962
- PALOL SALELLAS, PEDRO DE, and HIRMER, MAX, Early Medieval Art in Spain, Abrams, New York, 1967
- PLATT, COLIN, *The English Medieval Town*, Secker & Warburg, London, 1976
- PORTER, ARTHUR KINGSLEY, Lombard Architecture, 4 vols., Yale University Press, New Haven, Conn., 1915–17
- ———, Romanesque Sculpture of the Pilgrimage Roads, 10 vols., Marshall Jones, Boston, 1923
- RICE, DAVID TALBOT, English Art 871–1100, Clarendon Press, Oxford, 1952
- Saalman, Howard, Medieval Cities, Braziller, New York, 1968
- SAXL, FRITZ, English Sculptures of the Twelfth Century, Faber & Faber, London, 1954
- SCHAPIRO, MEYER, Romanesque Art, Braziller, New York, and Chatto & Windus, London, 1977
- SMITH, J. T.; FAULKNER, P. A.; and EMERY, A., Studies in Medieval Domestic Architecture, Royal Archaeological Institute, London, 1975
- STODDARD, WHITNEY S., Art and Architecture in Medieval France, Harper & Row, New York, 1972
- STONE, LAWRENCE, Sculpture in Britain in the Middle Ages, Penguin, Harmondsworth and Baltimore, 1955
- SWARZENSKI, HANNS, Monuments of Romanesque Art, Faber & Faber, London, 1955; 2d ed., University of Chicago Press, 1974
- TIMMERS, J. J. M., A Handbook of Romanesque Art, Macmillan, New York, 1969
- Webb, Geoffrey, Architecture in Britain: The Middle Ages, Penguin, Harmondsworth, 1956; 2d ed., Penguin, Baltimore, 1965
- WHITEHILL, WALTER M., Spanish Romanesque Architecture of the Eleventh Century, repr. ed., Oxford University Press, London, 1968
- ZARNECKI, GEORGE, Romanesque Art, Universe Books, New York, 1971
- ——, Studies in Romanesque Sculpture, Dorian Press, London, 1979

CHAPTER SIX GOTHIC ART

- ACLAND, JAMES H., Medieval Structure: The Gothic Vault, University of Toronto Press, 1972
- Arnold, Hugh, Stained Glass of the Middle Ages in England and France, 2d ed., Macmillan, New York, 1940
- Arslan, Edoardo, Gothic Architecture in Venice, Phaidon, London, 1971
- AUBERT, MARCEL, The Art of the High Gothic Era, Crown, New York, 1965
- Avril, François, Manuscript Painting at the Court of France: The Fourteenth Century, 1310–1380, Braziller, New York, 1978
- BONY, JEAN, The English Decorated Style: Gothic Architecture Transformed, 1250–1350, Cornell University Press, Ithaca, N.Y., 1979
- ———, French Gothic Architecture of the 12th and 13th Centuries, University of California Press, Berkeley, 1983
- Branner, Robert, Chartres Cathedral, Norton, New York, 1969

- ——, Gothic Architecture, Braziller, New York, 1961
- -----, St. Louis and the Court Style in Gothic Architecture, Zwemmer, London, 1965
- BRIEGER, PETER, English Art 1216–1307, Clarendon Press, Oxford, 1957
- Bunt, Cyril G. E., *Gothic Painting*, Avalon Press, London, 1947
- Busch, Harald, and Lohse, B., Gothic Sculpture, Macmillan, New York, 1963
- Deuchler, Florens, *Gotbic Art*, Universe Books, New York, 1973
- Duby, Georges, *The Europe of the Cathedrals*, 1140–1280, Skira, Geneva, 1966
- ——, Foundations of a New Humanism, 1280–1440, Skira, Geneva, 1966
- DUPONT, J., Gothic Painting, Skira, New York, 1954
- FOCILLON, HENRI, The Art of the West in the Middle Ages, II, Cornell University, Ithaca, N.Y., 1980
- Frankl, Paul, The Gothic, Princeton University Press, 1959
- ———, Gothic Architecture, Penguin, Baltimore,
- Frisch, Teresa Grace, Gothic Art 1140-c. 1450: Sources and Documents, Prentice-Hall, Englewood Cliffs, N.J., 1971
- GIMPEL, JEAN, *The Cathedral Builders*, Grove Press, New York, 1961
- GRODECKI, LOUIS, et al., Gothic Architecture, Abrams, New York, 1977
- HARTT, FREDERICK, History of Italian Renaissance Art, Abrams, New York, 1969
- Harvey, John H., *The Gothic World*, Batsford, London, 1950
- ——, The Master Builders: Architecture in the Middle Ages, McGraw-Hill, New York, 1971
- ——, Mediaeval Craftsmen, Batsford, London, 1975
- JANTZEN, HANS, The High Gothic: The Classic Cathedrals of Chartres, Reims, and Amiens, Pantheon, New York, 1962
- KATZENELLENBOGEN, ADOLF, The Sculptural Programs of Chartres Cathedral, John Hopkins University Press, Baltimore, 1959
- Macaulay, David, Cathedral: The Story of Its Construction, Houghton, Mifflin, Boston, 1973
- Mâle, Émile, The Gothic Image: Religious Art in France of the Thirteenth Century, Harper, New York, 1958
- Martindale, Andrew, *Gothic Art*, Praeger, New York, and Thames & Hudson, London, 1967
- ——, The Rise of the Artist in the Middle Ages and Early Renaissance, McGraw-Hill, New York, 1972
- MEISS, MILLARD, French Painting in the Time of Jean de Berry: The Limbourgs and Their Contemporaries, 2 vols., Braziller, New York, 1974
- Panofsky, Erwin, Abbot Suger on the Abbey Church of St.-Denis and Its Art Treasures, 2d ed., Princeton University Press, 1979
- ——, Gothic Architecture and Scholasticism, Meridian Books, New York, 1963
- PORCHER, JEAN, Medieval French Miniatures, Abrams, New York, 1960
- SAUERLÄNDER, WILLIBALD, and HIRMER, M., Gothic Sculptures in France 1140–1270, Abrams, New York, 1973
- SIMSON, OTTO G. VON, *The Gothic Cathedral*, Princeton University Press, 1973

INDEX

Page numbers are in roman type. Figure numbers of black-and-white illustrations are in italic type. Colorplates are denoted with an asterisk.* Names of artists and architects whose work is illustrated are in CAPITALS.

Aachen, Germany, 382, 383, 385, 387; Palatine Chapel of Charlemagne (Odo of Metz), 383-84, 397, 417, 477; 497, 498

'Abbasid dynasty, 355

Abbess Hitda Presenting Her Book to Saint Walburga, illumination from Hitda Codex, 404; 521

Abbey churches, see under name of location or saint 'Abd al-Malik, caliph, 350

Abraham and the Three Angels, illumination from Psalter of Saint Louis, 313, 468; 607*

Abu Simbel, Nubia, rock temple at, 101; 120 Abu Temple, Tell Asmar, Iraq, statues from, 106; 128 Achaeans, 129

ACHILLES PAINTER, 181; Muse on Mount Helikon, 181; 253

Acrobat, ivory, 128; 165

Acropolis, Athens, 145, 168-79; Erechtheion, 147, 148, 174, 179, 239, 344, 451; 244–46; model of Acropolis, 228; Parthenon (Iktinos and Kallikrates), 129, 137, 147, 169–76, 177, 199, 253, 254; 229–38; Propylaia (Mnesikles), 129, 176-77, 179; 193, 240, 241; Temple of Athena Nike (Kallikrates), 147, 177, 179, 223; 242, 243

Adam and Eve Reproached by the Lord, bronze doors, 398;

Addaura, Sicily, cave drawing from, 40; 26 adobe pueblos, Taos, New Mexico, 42, 55; 54 Adoration of the Magi (Leonardo da Vinci), 22; preparatory drawing for, 8

Adoration of the Magi, mosaic, 302-3, 353; 410 Aegean art, 122-32, 133, 146; 1; 154-62, 163; 164-77 Aegina, Greece, Temple of Aphaia, 137, 151-52, 154, 163, 165, 172, 199, 213, 456; 199–203

African art, see Black African art

Age of Constantine, 292–308; 400–407, 408; 409; 410, 411, 412* 413* 414-16

Age of Justinian, 308–26, 328; 417–21, 422; 423; 424-30, 431* 432* 433, 434* 435, 436 Age of Pericles, 134, 157, 167-81; 228-49, 250; 251-53

agora, Assos, Turkey, 192, 226; architectural reconstruction of, 269, 270

Agra, India, Taj Mahal, 362-64; 478

Aix-la-Chapelle, see Aachen, Germany

Akhenaten, king of Egypt, 96-97, 191; portrait sculpture of, 96-97; 115, 116

Akkadian art, 108–10, 118, 122; 132, 133

Akkadian Empire, 103, 105, 110

Alaric, 308

Alberti, Leonbattista, 423

Alcibiades, 177, 179

Alcuin of York, 383

Alexander III, see Alexander the Great

Alexander the Great, 117, 119, 134, 183, 188, 190, 196, 202; portrait sculpture of, 195-96, 200, 222-23; 276 Alexandria, Egypt, 190, 192, 195

Alexius I Comnenus, emperor, 339

Alhambra, the, Granada, Spain, 364-65, 478; Court of the Lions, 330, 355; 479; Queen's Chamber, 23;

Altamira, Spain, cave paintings at, 13, 31, 34, 37; 20* Altar of Zeus, Pergamon, 192, 199-201, 202, 218, 236, 246, 279; 284, 285, 286

Amalfi, Italy, 407

Amenhotep III, king of Egypt, 93, 96

Amenhotep IV, see Akhenaten, king of Egypt Amiens, France, Cathedral of, 454, 463-64, 466, 473; 596-602; choir and south transept, 464, 468; 599; choir vaults, 463; 598; nave (de Luzarches), 284, 463; 597; plan and transverse section of, 463; 596; west façade, 464, 469; 600; west façade sculpture, 22, 464, 466; 601, 602

amphora with Odysseus Blinding Polyphemos, 139, 140, 143, 201; 181

amphora with sculptured handles, 204; 292* Anastasis (Resurrection), apse fresco, 343-44; 455* Anavyssos Kouros, marble, 143, 158, 159; 185

Andean art, 62-64; 66-69

Andronicus II, Byzantine emperor, 342 Angels, choir sculpture, 474-75; 617

Angels of the Lord Smiting the Enemies of the Israelites, illumination from Utrecht Psalter, 19, 390, 402;

Angles, 369

Anglo-Saxons, 369, 375

animal head for prow, from Oseberg ship burial, 375;

Animal Style, 373, 375; 489-93

Ankhesenamen, queen of Egypt, 97, 112

Ankhhaf, prince of Egypt, 83; bust of, 83; 89

Anna, princess of Kiev, 344

Annunciation, jamb sculpture, 461–62; 594

Annunciation, mosaic, from Church of the Dormition, 334, 335, 426; 443

Annunciation, mosaic, from Sta. Maria Maggiore, 302, 353: 410

Annunciation to the Shepherds, illumination from Gospel Lectionary of Henry II, 401-2, 436; 519

ANTELAMI, BENEDETTO, 427-28; Descent from the Cross, 427-28; 547; King David, 428; 548

ANTHEMIUS OF TRALLES, 317, 318, 321, 362; Hagia Sophia, Constantinople, 193, 284, 317-21, 324, 334, 361–62, 449, 458; *427–30*

Antioch, Syria, 190

Antiochos III, king of Syria, 198

Antiochos IV, king of Syria, 195

Antoninus Pius, Roman emperor, 257

Apelles, 188

Approdite of Cyrene, marble, 197–98; 280

Aphrodite of Knidos (Praxiteles), 186, 197-98; Roman copy of, 262

APOLLODORUS, 250, 252; Forum of Trajan, Rome, 250, 295; 333, 350

Apollo of Veii, terra-cotta, 213; 298*

Apollo with a Centaur and a Lapith Woman, relief sculpture, 163-64, 172-73; 223

Apoxyomenos (Lysippos), sculpture, 188; Roman copy

Appearance of the Angel to Joseph, fresco, 328, 332, 340;

aqueducts, 241-42; 337, 338

Ara Pacis (Altar of Peace), Rome, sculptural monument, 236-37, 239, 246, 266, 308; 328-30

Archer, marble, 151-52; 202

Architectural View, mosaic, 22, 353; 465*

Architectural View, wall painting, from Boscoreale, 22, 231: 321*

Architectural View, wall painting, from Herculaneum, 247, 301; 347*

Architectural View and "Panel Paintings," wall painting, 247, 332; 346

Arch of Constantine, Rome, 254, 274, 307; 356, 383 Arch of Septimius Severus, Rome, 274

Arch of Titus, Rome, 245–46, 252, 253, 267; 341*; relief sculpture from, 342, 343

Arch of Trajan, Beneventum, Italy, 245, 253-54, 307;

Arena Chapel, Padua, frescoes for (Giotto), 18; 2* Arezzo, Italy, sculpture from, 214; 300

Argonauts in the Land of the Bebrykes, The, frieze from Ficoroni Cist (Novios Plautios), 216; 303

ARISTOKLES, 143; Stele of Aristion, 143; 187

Aristotle, 183

Arnolfo di Cambio, 485

Arringatore, L', bronze, 22, 222, 236, 259, 310; 307*

Arsinoeon, Samothrace, Greece, 193; 272

Art as Experience (Dewey), 13

Ascension, The, ivory panel, 308, 394; 416

Ashurbanipal, king of Assyria, 115

Ashurnasirpal II, king of Assyria, 115; portrait sculpture of, 115; 144

Assos, Turkey, agora, 192, 226; 269, 270 Assyria, 116

Assyrian art, 103, 112-15, 118, 139, 355; 139-46

Asyūt, Egypt, sculpture from, 87; 97 Athena (Phidias), sculpture, 170, 172, 175-76; reconstruction of, 238

ATHENODOROS, SEE HAGESANDROS, POLYDOROS, and ATHENODOROS

Athens, Greece, 137, 157, 167-68, 183, 190, 197; Monument of Lysikrates, 184; 255; pottery from, 138-39, 152-53; 179; sculpture from, 143, 145, 195; 189; Temple of the Olympian Zeus (Cossutius),

195; 275; see also Acropolis, Athens Atlas Bringing Herakles the Golden Apples, metope frag-

ment, 162, 164-65, 462; 224 Attalos I, king of Pergamon, 198

Attila, king of the Huns, 308

Augustus, Roman emperor, 233, 234, 235, 236, 237, 238, 242, 386; portrait sculpture of, 235-36; 326,

Augustus as Pontifex Maximus, marble, 236; replica of original, 327

Augustus of Prima Porta, marble, 235-36, 259, 266, 310; 326

Aurangzeb, Mogul emperor, 364

Autun, France, Cathedral of, west tympanum of

(Gislebertus), 105, 416-17; 532 Avars, 330 Aztec Empire, 57, 58, 62 Baalbek, Syria, 261; Temple of Venus, 270-71; 381 Babylonian art, 110, 112, 116, 122, 211; 137, 147 Baghdad, Mesopotamia, 355 Bakota guardian figure, from Gabon, 26, 49; 44 Bamberg, Germany, Cathedral of, 402; sculpture from, 476-77; 619 Banqueting Scene, fresco, 166-67; 227 Banquet Scene, wall painting, 93-94; 111 baptismal font (de Huy), bronze, 417, 421-22, 473; Baptistery, Pisa, 424; 542 Baptistery of S. Giovanni, Florence, 422, 423, 486; 540*; bronze doors for (Ghiberti), 398, 422 BARMA, 345; Cathedral of St. Basil the Blessed, Moscow, 345-46; 458 Basil II, Byzantine emperor, 344 Basilica, Paestum, Italy, see Temple of Hera I, Paestum, Italy Basilica, Pompeii, Italy, 226-27; 317 Basilica of Maxentius and Constantine, Rome, 277; 388; architectural reconstruction of, 390; plan of, 389 Basilica of Trier, Germany, 277-78, 295, 317; 391, 392 basilicas, Early Christian, 292-93, 295-97, 310, 386 Basilica Ulpia, Rome, 250, 253, 277, 293; 351 Bassai, Greece, Temple of Apollo (Iktinos), 147, 180, 186, 254; 249, 250; 251 Baths of Caracalla, Rome, 243, 269-70, 277; 378; ground plan of, 379; tepidarium, 380 Baths of Titus, Rome, 243 Baths of Trajan, Rome, 269 Battle Between Romans and Barbarians, relief sculpture from Ludovisi Battle Sarcophagus, 267; 375 Battle of Gods and Giants, frieze sculpture, 150-51, 153; Battle of Greeks and Amazons, frieze sculpture, Mausoleum, Halikarnassos, 186, 254; 260 Battle of Greeks and Amazons, frieze sculpture, Temple of Apollo, Bassai, 180, 186; 251 Battle of Lapiths and Centaurs, relief sculpture, 163, 172-73; 222 Bayeux Tapestry, 442; 570* beaker, painted from Susa, 119; 153 Bearded Man (Lucius Junius Brutus), bronze, 214, 222; bear mask, Haida Indian, 56, 60; 57* bear screen, Tlingit Indian, 56; 56 Beatus of Liebana, 437 Beauvais, France, Cathedral of, 466, 473; 603 Belleville Breviary (Pucelle), 470, 472; 610 Bellye, Hungary, bracelet from, 370; 483 Benedictine order, 309, 383 Beneventum, Italy, Arch of Trajan, 245, 253-54, 307; 355 Benin art, Nigeria, 49; 40-42 BERLIN PAINTER, 156; Ganymede, 19, 156; 6 Bernini, Gianlorenzo, 293 Bernward, bishop of Hildesheim, 396, 397, 398, 406, Berzé-la-Ville, France, Priory Church, wall painting

from, 436; 562* Bible Moralisée, 27, 468; 12* Bible of Bury St. Edmunds, 440; 568* Bible of Charles the Bald, 390-93; 506* Bieber, Margarete, 162 Bibzad in the Garden (Junaid), illumination, 366-67; Bird in a Landscape, fresco fragment, 127; 163* Birds in Flight, drawing on limestone, 86; 96 Birth of Aphrodite, relief sculpture from Ludovisi Throne, 162, 166; *219* Biruni, al-, 366; Chronology of Ancient Peoples, 366; 481 Bison, antler carving, 34; 17 Bison, cave painting, 13, 31, 34, 37; 20*

Black African art, 47, 49-51; 39-47 blanket, nobility, Thompson Indians, 55; 55 Blind Harper, relief sculpture, 94; 112 Blond Youth, marble, 159, 456; 212 Bofill, Jaime, 479 Boğazköy, Turkey, Hittite citadel, 112; Lion Gate, The, 112, 113; 138 Book of Durrow, 23, 283, 365, 376, 482; 11 Book of Joshua, mosaic, 303; 412* Book of Kells, 27, 377, 379, 402, 418; 496* Books of the Dead, illustration from, 101, 417; 122 Boscoreale, near Naples, wall painting from villa at, 22, 231; 321* Bouleuterion (Council House), Miletus, Asia Minor, 192-93; 271 Bourges, France: Cathedral of, 459, 489; 590; House of Jacques Coeur, 469, 492; 608 Boxers (The Young Princes), fresco, 127-28; 162 bracelet, gold, 370; 483 Breaking of Bread, fresco detail, 20, 290; 396 Britons, 369 Brno-Malomeřice, Czechoslovakia, ornament from, 124, 372, 379; 486 Bruce, Thomas (Lord Elgin), 170 Brunelleschi, Filippo, 423 Bruno, archbishop of Cologne, 395 Bryaxis, 186 BRYGOS PAINTER, 156; Revelling, 156; 209 Bulgars, 330 Bull Dance, fresco, 126-27, 128, 132; 160 Burgos, Spain, Monastery of S. Domingo de Silos, relief sculpture from, 419; 536 Busketus, 425 Bust of Prince Ankbbaf, limestone, 83; 89 Byzantine art, 274, 286, 299, 308-48, 394; 417-21, 422*, 423*, 424-30, 431*, 432*, 433, 434*, 435-38, 439* 440-54, 455* 456-59, 460* 461* Byzantine Empire, 284, 308-9, 310, 326, 330, 348, 349, 361, 369, 382 Byzantium, 309; see also Constantinople

Ca' d'Oro, Venice, 491-92; 639 Caen, France, Abbey Church of St.-Étienne, 432-33, 453;557-59 Caesar, Gaius Julius, 231, 234, 235, 236, 252, 259 Cairo, Egypt: Madrasah of Sultan Hasan, 350, 361, 363; 474-76; Mausoleum of Sultan Hasan, 361; 476; Mosque of Ibn Tulun, 356, 360, 364, 412, 414; 469, Calf-Bearer, marble, 143, 149; 186

calyx-krater (Niobid Painter), 19, 166; 226 Campanile (Leaning Tower), Pisa, 424-25; 542 Campo Santo, Pisa, 424; 542 Canopus of Alexandria, at Hadrian's Villa, Tivoli, 257, 277; 361 Capet, Hugh, 395

Caracalla, Roman emperor, 265-66, 269; portrait sculpture of, 265-66; 372 Caracol (observatory), Chichén Itzá, Yucatán, 60; 62

Carolingian art, 330, 332, 383-95, 396, 406, 407; 497-505, 506* 507* 508

Carolingian dynasty, 382, 395

CARREY, JACQUES, Contest Between Athena and Poseidon, 172; 231

Cassander, king of Macedon, 189

Castelseprio, Italy, frescoes from, 328, 332, 340, 346;

Catacomb of SS. Pietro e Marcellino, Rome, ceiling fresco from, 290-91, 376; 397

Catacomb of Sta. Priscilla, Rome, fresco detail from, 20, 290; 396

catacombs, 289-92

Çatal Hüyük, central Turkey, excavations at, 32, 42, 54, 55, 96; 29–33

Cathedrals, see under name of location or saint Cattle Fording a River, painted relief, 84, 86; 95 Cavallini, Pietro, 341

cave art, 13, 31, 34-35, 37, 40; 16, 17, 20, 21-26

Cefalù, Sicily, Cathedral of, apse mosaics from, 324, 338, 436; 450 Celtic art, 283, 370, 371-73; 484-88 Celtic tribes, 369 Central American art, 57-62; 58-65 Centula, France, Abbey Church of St.-Riquier, 384-85; 499 Ceremonial Circular Gallop of the Cavalry, relief sculpture, 257, 259, 292; 362 ceremonial mounds, 53-54, 58-59; 51, 52 Cerveteri, Italy: sarcophagus from, 211, 213; 297; Tomb of the Reliefs, burial chamber, 218; 306 Cézanne, Paul, 303 Chalcotheca (Bronze Storeroom), Acropolis, Athens, Chamois, antler carving, 34; 18 Champollion, Jean-François, 73 Chapel of Henry VII, Westminster Abbey, London, 482; 626 Charioteer of Delphi, bronze, 157, 186, 474; 210 Charlemagne (Charles the Great), Frankish king, 284, 355, 370, 382, 383, 384, 386, 387, 390, 391, 421 Charles V, Holy Roman emperor, 357 Charles VIII, king of France, 469 Charles the Bald, Holy Roman emperor, 391 Chartres, France, Cathedral of, 449-51, 454, 455-59, 460;573-76,584-87,588*,589; nave, 284, 455; 585; plan of, 455; 584; rose and lancet windows, north transept, 457-58; 588*; Royal Portal, 450-51, 456; 575; Royal Portal, jamb statues from, 19, 451, 455, 456, 458; 576; sculpture from, 450-51, 455-56, 461, 466; 575, 576, 587; south tower, 449-50, 455; 574; south transept façade, 455, 461; 586; south transept portal, jamb statues, 455-56; 587; stained glass from, 456-59, 468; 588* 589; west façade, 449, 450; 573, 575 Chaucer, Geoffrey, 408 Chavín de Huántar, Peru, relief sculpture from, 63, Cheops, king of Egypt, 79, 83 Chephren, king of Egypt, 79; statue of, 22, 81; 9* Chichén Itzá, Yucatán, 60, 62; Caracol, 60; 62; wall painting from, 62; 65 Chigi Vase (Macmillan Painter), 139-40; 182 Chios, Greece, sculpture from, 198; 281 Chiusi, Italy, pottery from, 211; 296 Christ Enthroned Between Angels and Saints, mosaic, 313-14; 423* Christ Enthroned Between Saint Peter and Saint Paul, ivory diptych, 325-26; 436 Christ Enthroned, with the Archangel Michael Battling a Dragon, wall painting, 435; 561* Christianity, 272, 283, 284-85, 286, 287-88, 292, 309, 369, 375-76 Christ icon, panel, 324-25, 328; 433 Christ in Chora, Church of (Kariye Djami), Constantinople, 342-44, 346; 454, 455* Christ in Majesty, fresco, 436; 563 Christ Treading on the Lion and the Basilisk, portal sculpture, 22, 464, 466; 601 Christ with Saints, mosaic, 309-310; 417 Chronology of Ancient Peoples (al-Biruni), 366; 481 Church of Christ in Chora (Kariye Djami), Constantinople, 342-44, 346; fresco from, 343-44; 455*; mosaics from, 342; 454 Church of Our Saviour of the Transfiguration, Novgorod, Russia, fresco from (Theophanes the Greek), 346; 459 Church of St. George, Reichenau Island, Germany, wall paintings from, 400-401 Church of St. George, Voronet, Rumania, frescoes

Church of the Dormition, Daphni, Greece, mosaics

Church of the Holy Apostles, Constantinople, 336

Church of the Trinity, Sopoćani, Serbia, fresco from,

from, 324, 334-35, 338, 426; 443-45

from, 348; 461*

340-41, 342, 343; 452

Cimabue (Cenni di Pepi), 324, 338

cinerary urn, bronze and terra-cotta, from Chiusi, Italy, 211; 296

Cistercian Order, 440, 484

Citadel of King Sargon II, Dur Sharrukin, Iraq, 112-13; 139, 140

Citadel of Tiryns, Greece, 129, 137; 168

Cîteaux, France, monastery, 440, 484

Civate, Italy, S. Pietro al Monte, wall painting from, 435; 561*

Claudius, Roman emperor, 242

Claudius II (Gothicus), Roman emperor, 265

Cleopatra, queen of Egypt, 234

Cluniac Order, 412, 436

Cluny, France, Abbey Church of St.-Pierre (Gunzo), 352, 412, 414, 436, 480; 527-29

Coblenz, Germany, Abbey Church of Maria Laach, 385, 429; 550, 551

Coeur, Jacques, 469

Cologne, Germany: Cathedral of, 399-400, 472-74, 479; 516, 611, 612, 615; St. Pantaleon, 385, 395-96;

colossal head, Olmec culture, 59; 59

Colosseum, Rome, 242-43; 339, 340

Colossus of Barletta, bronze, 292; 399

Column of Antoninus Pius, Rome, 257; relief sculpture from, 257, 259, 292; 362

Column of Bishop Bernward, 398-99, 442; 515 Column of Trajan, Rome, 114, 250-53, 267, 303, 308, 325, 332, 468; 352, 353

Coma, Pedro ça, 478-79

Commentary on the Apocalypse (Beatus of Liebana), 437-39; illuminations from: (Ende), 417, 438; 564; (Garsia), 438-39; 566*

Commodus, Roman emperor, 263, 265; portrait sculpture of, 370

Commodus as Hercules, marble, 263, 265; 370 Communion of the Apostles, apse mosaic, 344; 456

Composite order, 146, 245

Conant, Kenneth John, 414

Conrad III, king of Germany, 477

Constantia, princess, 296

Constantine the Great, Roman emperor, 254, 259, 272-73, 274, 277, 284, 292, 293, 296, 309, 324; colossal statue of, 274; 384; see also Age of Constantine

Constantine the Great, marble, 274; 384

Constantine VII (Porphyrogenitos), Byzantine emperor, 330, 332

Constantinople, 284, 292, 317-21, 330, 332, 336, 339, 341, 348, 349, 361, 408, 458; Church of Christ in Chora (Kariye Djami), 342-44, 346; 454, 455*; Hagia Sophia (Anthemius of Tralles and Isidorus of Miletus), 193, 284, 317-21, 324, 328, 333, 334, 336, 341-42, 361-62, 449; 427-30, 453; see also Byzantium; Istanbul

Constantius, Roman emperor, 277

Contest Between Athena and Poseidon (Carrey), 172; 231 Copán, Honduras, Mayan ball court, 59-60; 60 Córdoba, Spain, Great Mosque, 119, 284, 355, 357,

359-60, 365, 415, 426; 471, 472, 473 Corfu, Greece, Temple of Artemis, 148-49, 151, 153;

195, 196 Corinth, Greece, vase painting from, 139-40, 152-53;

Corinthian order, 146, 179, 180, 184, 195, 209, 238

Cormont, Thomas de, 463, 464, 473

Coronation Gospels, 332, 387, 388; 502

Cossutius, 195; Temple of the Olympian Zeus, Athens, 195; 275

Council of Ephesus, 302

Council of Nicaea, 273, 284

Cretan art, see Minoan art

Cro-Magnon people, 33

cromlechs, ritual stone circles, England, 43-44; 37, 38 Crucifixion, The, illumination from Rabula Gospels, 325, 339; 435

Crucifixion, mosaic, 334-35; 444 Crucifixion, nave fresco, 434-35; 560 Crucifixion, stained-glass window, 458; 589

Crucifix of Archbishop Gero, wood, 399-400; 516 Crusades, 285, 330, 339, 341, 408, 416

Ctesiphon, Mesopotamia, Palace of Shapur I, 352,

360; 463 cult wagon, bronze, from Strettweg, Austria, 371; 484

Cuzco, Peru, 64

Cycladic art, 16, 18, 123; 1; 154, 155

Cycladic idol, marble, 123; 154

Cyrene, North Africa, sculpture from, 197–98; 280 Cyrus the Great, king of Persia, 117

dagger, bronze with inlay, from Mycenae, 131; 173 Damascus, Syria, 355; Great Mosque, 22, 353, 355; 464, 465*

Dancing Woman and Lyre Player, wall painting, 217; 304 Dante Alighieri, 285

Daphni, Greece, Church of the Dormition, mosaics from, 324, 334–35, 338, 426; 443–45

DAPHNIS OF MILETUS, 195; Temple of Apollo, Didyma, 193, 195; 273, 274

Darius I, king of Persia, 117, 156; portrait sculpture of, 118; 150

Darius and Xerxes Giving Audience, relief sculpture, 118, 371; 150

Darwin, Charles, 29

David the Psalmist, illumination from Paris Psalter, 332-33; 439*

Death of the Virgin, tympanum sculpture, 474; 616* Decius, Roman emperor, 287

Decorated style (Gothic), 481

Deer Nursing a Fawn, bronze, 139, 371; 180

Deësis, mosaic, 341-42; 453

Deir el Bahari, Egypt, 89; Funerary Temple of Mentuhotep III, 88, 89; 98; Funerary Temple of Queen Hatshepsut (Senmut), 88, 89-91, 146; 102-5

Deir el Medineh, Egypt, Tomb of Sen-ned-jem, wall paintings from, 94; 113

Delian League, 168

Delicata, La, marble, 22, 145, 150, 451; 190*

Delos, Greece, mural reconstruction from house at, 204, 228, 229; 293

Delphi, Greece, Sanctuary of Apollo: sculpture from, 157, 255; 210, 357; Treasury of the Siphnians, 147, 148, 149-51, 153, 179; 197, 198

Delphic Games, 157

De Monarchia/On Monarchy (Dante), 285

Demosthenes, 204; sculpture of, 196; 277

Demosthenes, sculpture, 196; Roman copy of, 277 Descent from the Cross, relief sculpture, from Burgos, Spain, 419; 536

Descent from the Cross (Antelami), relief sculpture, 427-28; 547

Desiderius, abbot, 433-34

De Soto, Hernando, 54

Dewey, John, 13

Dickinson, Emily, 15

Didyma, Turkey, Temple of Apollo (Paionios of Ephesus and Daphnis of Miletus), 193, 195; 273,

Diamini-na, Mali, Dogon dancers from, 26; 46 Diocletian, Roman emperor, 271, 272, 273, 274, 287,

Dionysiac Mystery Cult, wall painting, 189, 232, 332;

Dionysius the Pseudo-Areopagite, 404, 448 Dionysos in a Ship (Exekias), vase painting, 154-55; 206 Dipylon Ampbora, 138-39, 143, 153; 179

Diskobolos/Discus-Thrower (Myron), sculpture, 157, 160, 173, 188; Roman copy of, 214

Diver, The, fresco, 22, 167, 217; 225*

Dobbins, John J., 169

Doges' Palace, Venice, see Palazzo Ducale, Venice Dogon dancers, from Diamini-na, Mali, 26; 46 Dome of the Rock, Jerusalem, 350, 352, 353; 462*

Domitian, Roman emperor, 245, 250

Domus church (Christian community house), Dura-Europos, Syria, 289; 394

Donatello (Donato di Niccolo Bardi), 428 doors, bronze, from St. Michael's, Hildesheim, 397–98; *513*, *514*

Dorians, 132, 137, 369

Doric order, 125, 146, 147, 162, 171, 172, 180, 192, 193, 209; 192

Dormition, Church of the, Daphni, Greece, mosaics from, 324, 334-35, 338, 426; 443-45

Dormition of the Virgin, fresco, 340-41, 342, 343; 452 Dorypboros/Spear-Bearer (Polykleitos), sculpture, 160, 164, 235-36; fragment of (Roman copy), 216; reconstruction of, 215

Doubting Thomas, ivory plaque, 400; 517

Duccio di Buoninsegna, 484

Dura-Europos, Syria: domus church, 289; 394; Synagogue, wall painting from, 291-92; 398

Durham, England, Cathedral, 431-32; 555, 556 Dur Sharrukin, Iraq: Citadel of King Sargon II, 112-13; 139, 140; Palace of King Sargon II, 112-13, 117; 140, 141

Dying Lioness, relief sculpture from The Great Lion Hunt, 115; 145

Dying Trumpeter, sculpture, 198–99, 279; Roman copy

Dying Warrior, pediment sculpture, 152, 199, 456; 203

Early Christian art, 274, 286, 289-308, 385, 394, 412; 394-407, 408*, 409*, 410, 411, 412*, 413*, 414-16 Early English style (Gothic), 480, 481

Earth, Air, and Sea Personified, from frieze of Ara Pacis, 236-37, 308; 330

Easter Island, South Pacific, stone images from, 13,

Eastern Roman Empire, see Byzantine Empire Ebbo, archbishop of Reims, 388

Ebbo Gospels, 388-89; 504

Echternach Gospels, 377, 418; 495

Edfu, Egypt, Temple of Horus, 91, 93, 101; 106, 121

Edict of Milan, 273, 284, 287, 289, 292 Edward II, king of England, 481

Egypt, 69, 70, 72, 102, 103, 108, 134, 234, 348 Egyptian art, 28, 42, 58, 72-101, 103, 105, 133, 134;

9* 70-91, 92-94* 95-113, 114* 115, 116, 117* 118* 119-22; Archaic Period and the Old Kingdom, 54, 74-87, 88, 118; 70-91, 92-94, 95, 96; architecture, 23, 76-78, 80, 87-88, 89-91, 93, 101, 119, 146; 74-78, 84, 85, 98, 102-4, 106-10, 120, 121; Empire (New Kingdom), 89–91, 93–94, 96–97, 101, 122; 101-13, 114; 115, 116, 117; 118; 119-22; illuminated manuscripts, 101, 305; 122; Middle Kingdom, 87–89; 97–100; pyramids, 54, 76–77, 79–80, 88; 74, 82-84; relief sculpture, 74-76, 78-79, 83-84, 86, 90, 94, 96–97, 114, 115; 71, 72, 80, 81, 92, 95, 105, 112, 116; sculpture, 78, 80, 81, 83, 88-89, 96, 97, 106, 118, 140, 141–42; 79, 86–91, 99, 100, 115, 117, 118, 119; tomb paintings, 22, 62, 74, 83-84,

tombs, 76-80, 86-88, 90-91, 93

Einhard, abbot, 383 Ekkebard and Uta (Naumberg Master), choir sculpture, 476; 618

86, 93-94, 115, 127; 70, 92-94; 95, 111, 113, 114*;

Elamite Fugitives Crossing a River, relief sculpture, 114-15; 143

El Cerro Felío, Spain, cave painting at, 40; copy of, 25 El Faiyûm, Nile Valley, portrait paintings from, 265; 371*

Elgin, Lord (Thomas Bruce), 170

El Greco (Domenikos Theotokopoulos), 346, 389 Emperor Justinian and Attendants, mosaic, 314, 321, 324;

Empress Theodora and Attendants, mosaic, 314, 324; 425 ENDE, 437–38; Vision of Saint John, 417, 438; 564 Ephesus, Asia Minor, 137, 261; Library of Celsus,

262-63; 368* 369 Epidauros, Greece: Theater (Polykleitos the Younger), 185, 192; 256, 257; Tholos (Polykleitos the Younger), 180, 184; 254

Equestrian Statue of Marcus Aurelius, bronze, 259, 477; Erechtheion, Acropolis, Athens, 174, 179; plan of, 245; Porch of the Maidens, 147, 148, 239, 344, 451; 246; view from east, 244 ERGOTIMOS, 153; François Vase, 153; 204 Etruria (Tuscany), Italy, 153, 208 Etruscan art, 166, 208-18, 223; 294-97, 298* 299-304, 305*, 306 Etruscan temple (after Vitruvius), 209; 294 EUPHRONIOS, 155, 156; Sarpedon Carried off the Battlefield, 19, 22, 155-56; 207* Eusebius of Caesarea, bishop, 289 Evans, Arthur, 122 EXEKIAS, 154; Dionysos in a Ship, 154–55; 206 Exploits of Hercules, mosaic, 278-79, 298; 393* EYCK, HUBERT VAN, Gbent Altarpiece, 18, 342; 3 EYCK, JAN VAN, 18, 342; Gbent Altarpiece, 18, 342; 3 Family of Vunnerius Keramus, painting on gold leaf, 268; 376 Felix III, pope, 309 Female Head, fresco fragment, 132; 177 Female Head, marble, 105-6; 127 Ferdinand, king of Spain, 364 Ficoroni Cist (Novios Plautios), 216; frieze from, 303 Fidenza, Italy, Cathedral of, sculpture from (Antelami), 428; 548 Flamboyant style (Gothic), 23, 464, 469, 473, 480, 481, 482, 489 Flavian dynasty (Roman), 242, 243, 247, 250 Flavian Palace, Rome, 243 Florence, Italy, 285, 492; Baptistery of S. Giovanni, 398, 422, 423, 486; 540*; Cathedral, 485-86, 487, 489; 630-32; Palazzo Vecchio, 490; 637; Sta. Croce, 484-85, 487; 629; S. Miniato al Monte, Abbey Church of, 423; 541 Flying Buttresses (de Honnecourt), 452, 453, 461; 577 Forum, Pompeii, Italy, 226; 316 Forum of Augustus, Rome, 239, 250; 335; plan of, 333; reconstructed view of, 334 Forum of Julius Caesar, Rome, 239, 250; 333 Forum of Nerva, Rome, 250 Forum of Trajan, Rome (Apollodorus), 250, 295; 333, Fossanova, Italy, Abbey Church of, 484; 628 François Vase (Kleitias and Ergotimos), 153; 204 Franks, 369, 382, 384 (Imhotep), 76-78, 79, 80, 145, 147; Entrance Hall, 77; Entrance Hall and colonnade, reconstruction drawing, 78; model of, 76; plan of, 75; step pyramid, 74 Funerary Temple of Mentuhotep III, Deir el Bahari, Egypt, 88, 89; 98 Funerary Temple of Queen Hatshepsut, Deir el Bahari, Egypt (Senmut), 88, 89-91; 102; Anubis

funeral mask, beaten gold, 131; 172 Funerary Complex of King Zoser, Saqqqara, Egypt

Sanctuary, 89, 90, 146; 104; painted relief from, 90; 105; plan of, 103

Gabon, West Africa, sculpture from, 26, 49; 44 Galla Placidia, Roman empress, 303 Ganymede (Berlin Painter), vase painting, 19, 156; 6 Garden Room, wall painting, 20, 22, 127, 233; 325* GARSIA, STEPHANUS, 438; Plague of Locusts, 438–39; Gateway of the Sun, Tiahuanaco, Bolivia, 63-64; 67 Gauls, 369, 370 Geese of Medum, fresco detail, 20, 22, 86; 93* Gelasius I, pope, 309 Gemma Augustea, onyx cameo, 22, 237, 239; 331* Genius of the Senate Pointing to Gordianus III, The, relief sculpture, 266; 373 Genoa, Italy, 407 Gentileschi, Artemisia, 15, 16 Gerhard, bishop, 472

Germanic tribes, 369–70 Gero, archbishop of Cologne, 399 Gerona, Spain, Cathedral of, 478-80; 621 Ghent Altarpiece (Van Eyck, Hubert [?] and Jan), 18, 342; 3 Ghiberti, Lorenzo, 398, 422, 473 Gilgamesh, 106 GIOTTO DI BONDONE, 18, 341, 342, 344, 485, 486; Joachim Takes Refuge in the Wilderness, 18, 342; 2* Giovanni da Milano, 484 GISLEBERTUS, 417; Last Judgment, 105, 416-17; 532 Giza, Egypt: Great Sphinx, 80; 86; pyramids of, 79–80; *82–84*; sculpture from, 22, 81, 83; *9*,* *87*, 89; valley temples at, 80, 81; 84, 85 Glaber, Raoul, 408 Gloucester, England, Cathedral of, 481-82; 625 God as Architect, illumination from Bible Moralisée, 27, 468; 12* Goddess Giving Birth, clay, 42, 123; 30 Goddess Lilith, The, relief sculpture, 110; 136 Golden House, Rome, 239, 241, 242, 243 Good Shepherd, The, ceiling fresco, 290–91, 376; 397 Good Shepherd, The, mosaic, 22, 305, 310; 413* Gordianus I, Roman emperor, 266 Gordianus II, Roman emperor, 266 Gordianus III, Roman emperor, 266 Gospel Lectionary of Henry II, 401-2, 436; 519 Gospel of Matthew, 436-37; illumination from, 565* Gothic art, 29, 379, 443, 446–93; 12,* 571–87, 588,* 589-603, 604, 605, 606, 607, 608-15, 616, 617-26, 627, 628-39; architecture, 23, 352, 361, 430, 448-50, 452-55, 459-61, 463-64, 466, 469, 472-73, 478-82, 484-92; 571-74, 577-86, 590-93, 596-600, 603, 604, 605, 606, 608, 611-13, 621-26, 628-39; in England, 480-84; 622-26, 627*; in France, 448–72; 571–87, 588*, 589–603, 604, 605, 606, 607, 608-10; in Germany, 472-78; 611-15, 616; 617-20; illuminated manuscripts and painting, 27, 468, 470, 472, 477-78, 483-84; 12* 607, 610, 620, 627*; in Italy, 484-92; 628-39; sculpture, 450-51, 455-56, 461-62, 464, 466, 469-70, 473-77; 575, 576, 587, 594, 595, 601, 602, 609, 614, 615, 616*, 617–19; in Spain, 478–80; 621; stained-glass, 456-59, 468; 588, 589, 604* Goths, 466 Granada, Spain, the Alhambra, 23, 330, 355, 364-65, 478; 10, 479 Grands Boulevards, Les (Renoir), 18; 4 Great Mosque, Córdoba, Spain, 119, 284, 355, 357, 359-60, 365, 415, 426; interior of, 472*; plan of, 471; vestibule of mihrab, 473 Great Mosque, Damascus, 22, 353, 355; courtyard and façade, 464; mosaic portion from, 465* Great Mosque of al-Mutawakkil, Samarra, 119, 355, 356; plan of, 468; spiral minaret, 467 Great Palace, Constantinople, 330 Great Serpent Mound, Adams County, Ohio, 54; 51 Great Sphinx, Giza, 80; 86 Greece, 69, 70, 117, 133-36, 156-57 Greek art, 101, 133-205, 216, 223; 6, 178-89, 190* 191-206, 207* 208* 209-16, 217* 218* 219-24, 225*, 226-49, 250*, 251-55, 256*, 257-65, 266*, 267-89, 290-92, 293; Archaic Period, 118, 134, 140-56, 157; 184-89, 190, 191-206, 207, 208, 209; architectural sculpture, 147-52, 163-65, 171-76, 179, 180, 186; 196-98, 201-3, 222-24, 231-38, 243, 251, 259, 260; architecture, 136, 137, 145-47, 151, 162-63, 169-71, 176-77, 180, 183-86, 211, 224, 243; 178, 191-95, 199, 200, 220, 221, 228-30, 240-42, 244-46, 249, 250*, 252, 254, 255, 256*, 257, 258; Classical Period, 134, 136, 140, 147, 152; Classical Period—Age of Pericles, 134, 157, 167-81; 228-49, 250*, 251-53; Classical Period-Fourth Century, 183-90; 254, 255, 256; 257-65, 266*; Classical Period—Severe Style, 156-67; 210-16,217*, 218*, 219-24, 225*, 226, 227; Geometric style, 137-39, 143, 153, 371; 178-81; Hellenistic Period, 134, 136, 145, 146, 190-204;

267-89, 290-92*; Orientalizing style, 139-40; 181-83; painting, 22, 135-36, 152, 165-67, 181, 188-90, 202, 204, 305; 225, 227, 266*; Proto-Attic style, 139; 181; Proto-Corinthian style, 139; 182; sculpture, 118, 136, 139, 140-43, 145, 157-62, 176, 179-80, 186-88, 195-202, 222; 180, 183-89, 190* 210-16, 217*, 218*, 219, 239, 247, 248, 261-65, 276-89; town planning and, 191-93, 195; 267-75; vase painting, 19, 22, 136, 138, 139-40, 152-56, 165, 181; 6, 179, 181, 182, 204-6, 207; 208; 209, 226, 253 Greek temples, 145-47; model of, 137; 178; orders of, 192, 193; plan of typical, 191 Grotte du Pape, Brassempouy, France, 34; 16 Gudea, 110; portrait sculpture of, 110, 273; 134, 135 Gundestrup Caldron, silver, 372-73; 488 GUNZO, 412, 414; Abbey Church of St.-Pierre, Cluny, 352, 412, 414, 436, 480; 527-29 Hadrian, Roman emperor, 195, 219, 250, 254, 255, 256, 257, 274, 386 Hadrian's Villa, Tivoli, 256-57, 274, 277, 278, 310, 330; architectural reconstruction of, 360; Canopus of Alexandria, 361 HAGESANDROS, see HAGESANDROS, POLYDOROS, and ATHENODOROS HAGESANDROS, POLYDOROS, and ATHENO-DOROS, 201; Head of Odysseus, 135, 201; 288; Laocoön and His Two Sons, 135, 201, 202; 287; Wreck of Odysseus' Ship, The, 202; 289 Hagia Sophia, Constantinople (Anthemius of Tralles and Isidorus of Miletus), 317-21, 324, 333, 336, 361-62, 458; exterior of, 193, 284, 319; 429; interior of, 193, 317, 334, 449; 427; mosaics from, 328, 330, 341-42; 438, 453; section and plan of, 317; 428; view from gallery, 321; 430 Hagia Sophia, Cathedral of, Kiev, Russia, 344; 456 Hagios Demetrios, Salonika, 425 Hagios Georgios, Salonika, mosaics from, 301, 353; Haida Indian bear mask, 56, 60; 57* Halikarnassos, Greece, Mausoleum, 185-86; 258-60 Hall of Bulls, Lascaux, cave painting, 13, 34, 37; 21 Hallstatt culture (Celtic), 371 Hama, Syria, mosaic from, 268-69; 377 Haman and Mordecai, wall painting, 291-92; 398 Hammurabi, king of Babylon, 110; portrait sculpture of, 110, 112; 137 Hanging Gardens, Babylon, 116 Harlinde, 406 harp, from Ur, 106-7, 375; 129 Harun ar-Rashid, caliph, 355 Harvester Vase, The, 128-29, 132; 166 Hasan, Mamluk sultan, 361 Hatshepsut, queen of Egypt, 70, 89, 90; statue of, 89; 101 head, colossal, Olmec culture, 59; 59 Head (Skopas), marble, 186; 261 Head of a Girl, marble, 22, 198; 281 Head of an Akkadian Ruler, bronze, 109, 110, 113; 132 Head of a Roman with a Wart over His Eye, marble, 222, 246;309 Head of Gudea, diorite, 110; 135 Head of Odysseus, from Odysseus Blinding Polyphemos (Hagesandros, Polydoros, and Athenodoros), marble, 135, 201; 288 Head of Pompey, marble, 222-23, 246; 310 Head of Queen Olokun, clay and bronze, 47; 39 He-Goat, wood with overlay, 107-8; 130 Helden, The Netherlands, shield ornament from, Helladic art, 122, 184; see also Cycladic art; Mycenaean Henry I (duke of Saxony), king of Germany, 395 Henry II, Holy Roman emperor, 402

Henry VII, king of England, 482

Hera, marble, 143; 188

Herakles and the Infant Telephos, fresco, 20, 136, 189, 202; 290* Herculaneum, near Naples, 226, 247; Roman copy of Greek fresco from, 20, 136, 189, 202; 290*; wall painting from, 247, 301; 347* Herd of Fleeing Gazelles, relief sculpture, 115; 146 Hermes with the Infant Dionysos (Praxiteles), marble, 135, 187-88: 263 Hermit Saints, from Ghent Altarpiece (Van Eyck, Hubert [?] and Jan), 18; 3 Herodotus, 208 HERRAD OF LANDSBERG, abbess of Hohenburg. 477, 478; Woman of the Apocalypse, 285, 477-78; 620 Hesira, relief sculpture, 72, 79, 83; 81 Hiberno-Saxon art, 23, 355, 365, 375-77, 379, 387, 416; 11, 494, 495, 496* Hierakonpolis, Egypt, 74; tomb painting from, 74, 84; 70 High Gothic art, 455, 459, 463-64, 466, 469, 482; see also Gothic art HILDEGARDE OF BINGEN, 440-41; Vision of the Ball of Fire, 285, 441–42; 569 Hildesheim, Germany, St. Michael's, 396–99, 421, 442; 510-15 Hippodamos, 191 Hitda, abbess of Meschede, 402, 406 Hitda Codex, 402, 404; 521 Hittite art, 112, 113; 138 Holy Apostles, Church of the, Constantinople, 336 Holy Roman Empire, 382, 395, 429 Holy Sepulcher Church, Jerusalem, 296–97 Holzgerlingen, Germany, sculpture from, 372, 416; 487 Homer, 123, 139 HONNECOURT, VILLARD DE, 452, 461; Flying Buttresses, 452, 453, 461; 577 Honorius, Roman emperor, 303 Hopewell culture, pipe from, 54; 52 Hortus Deliciarum (Herrad of Landsberg), 285, 477-78; 620 Hosios Loukas, Monastery of, Phocis, Greece, 333-34, 344; 441, 442 House of Julia Felix, Pompeii, wall painting from, 189, 233; 324 House of Menander, Pompeii, wall painting from, 387;503 House of M. Lucretius Fronto, Pompeii, wall

House of Jacques Coeur, Bourges, France, 469, 492;

painting from, 247, 332; 346

House of the Centaur, Pompeii, 229; 320 House of the Faun, Pompeii, 228; 319

House of the Silver Wedding, Pompeii, 228; 318

House Orchestra, mosaic, 268-69; 377 houses, from Çatal Hüyük, 42; reconstruction of, 29

Huns, 308, 370, 446 Hunting and Fishing, wall painting, 22, 152, 217; 305*

Hunting Scene, cave painting, 40; copy of, 25 HUY, RENIER DE, 417, 421–22, 473, 474; baptismal

font, 417, 421-22; 539 Hyksos, Asiatic rulers, 88-89

Ibn Tulun, Ahmad, 'Abbasid ruler, 356 Ife civilization, Nigeria, 47, 49; 39

Ikerre, Nigeria, 49; Yoruba door from, 49; 43 IKTINOS, 170, 180; Parthenon, Acropolis, 129, 147, 169-71; 229; Temple of Apollo, Bassai, 147, 180; 249, 250*

Île-de-France region, France, 425, 443, 446, 449 Iliad (Homer), 139, 155

illuminated manuscripts: Byzantine, 325, 330, 332; 434*, 435, 439*, 440; Carolingian, 387–95; 502, 504, 505, 506, 507, 508; Early Christian, 305-7; 414; Egyptian, 101, 305; 122; Gothic, 27, 468, 470, 472, 477-78; 12*, 607*, 610, 620; Hiberno-Saxon, 23, 376-77, 379; 11, 494; Islamic, 365-67; 480, 481, 482*; Ottonian, 401-2, 404-6; 518, 519, 520; 521,

Imago Hominis (Image of Man), illumination from Echternach Gospels, 377, 418; 495

IMHOTEP, 76–78, 91, 93; Funerary Complex of King Zoser, Saggara, 76-78, 79, 80, 145, 147; 74-78 Imperial Forums, Rome, 239, 250, 259; 333, 364 Imperial Procession, from frieze of Ara Pacis, 236, 266;

Imperial Villa, Piazza Armerina, Sicily, 278; floor mosaics at, 278-79, 298; 393*

Impressionism, 18, 22, 29

Inca culture, Peru, 57, 58, 62-63, 64; 66, 69

Indian art, see North American Indian art Initial L and scenes of the Nativity, illumination from Gospel of Matthew, 436-37; 565*

Initial R with Saint George and the Dragon, illumination from Moralia in Job, 439-40; 567

insula (Roman housing), Ostia, Italy, 241, 288; 336 Interior of the Pantheon (Pannini), 20, 22, 256; 7

Ionian League, 191 Ionians, 137

Ionic order, 119, 146, 147, 148, 172, 180, 192, 209, 223; 192, 193

Innocent III, pope, 299

Isabella, queen of Spain, 364

Isabelle, countess of Champagne, 468

ISIDORUS OF MILETUS, 317, 318, 321, 362; Hagia Sophia, Constantinople, 193, 284, 317–21, 324, 334, 361–62, 449, 458; 427–30

Isin-Larsa period (Sumerian), 110

Ishtar Gate, Babylon, 116; 147

Islam, 283, 349-50, 368

Islamic art, 23, 283, 349, 350-68; 10, 462, 463, 464, 465* 466-71, 472* 473-81, 482*

Istanbul, 361; Mosque of Ahmed I, 362; 477; see also Constantinople

Ivan IV the Terrible, czar of Russia, 345

Jericho, southern Palestine, excavations at, 41-42;

Jerusalem, 350, 384-85, 408; Dome of the Rock, 350, 352, 353; 462*

Joachim Takes Refuge in the Wilderness (Giotto), fresco,

Joseph and His Brethren, illumination from Vienna Book of Genesis, 325, 332; 434*

Joshua Leading the Israelites Toward the Jordan River, illumination from Joshua Roll, 251, 332, 442; 440 Joshua Roll, 251, 332, 442; 440

Iudaism, 287

Julian-Claudian dynasty (Roman), 239, 242

Julian the Apostate, Roman emperor, 273

Julius II, pope, 168 JUNAID, 366, 367; Bibzad in the Garden, 366-67; 482* Justinian I, Byzantine emperor, 308, 309, 314, 317,

321, 326, 330, 336, 370, 387; mosaic of, 314, 321, 324; 424; see also Age of Justinian

Kaaper (Sheikh el Beled), wood, 83; 90

KALLIKRATES, 170, 177; Parthenon, Acropolis, 129, 147, 169-71; 229; Temple of Athena Nike, Acropolis, 147, 177, 179, 223; 242

Kallimachos, 179

Kamares jug, beaked, 124; 156

Kariye Djami, Constantinople, 342-44, 346; 454, 455

Karnak, Egypt, 89, 91; Temple of Amon-Ra, 93, 195; 109, 110; Temple of Aten, 96; 115

Kassites, 112

Katholikon Church, Monastery of Hosios Loukas, Phocis, Greece, 333-34, 344; 441, 442

Kelermes, Scythian sculpture from, 56, 373, 375; 489

Khafre, see Chephren, king of Egypt Khufu, see Cheops, king of Egypt

Khwaju Kirmani, 366 Kiev, Russia, 344; Cathedral of Hagia Sophia,

mosaics from, 344; 456 King Akhenaten, sandstone, 96; 115 King Akhenaten and His Family Sacrificing to Aten, relief sculpture, 96–97; 116

King and Queen of Punt, painted relief sculpture, 90; 105 King Asburnasirpal II Killing Lions, relief sculpture, 115, 139; 144

King Chephren, diorite, 22, 81; 9*

King David (Antelami), façade sculpture, 428; 548 King Mycerinus Between Two Goddesses, schist, 81, 83, 118, 142; 87

King Sesostris III, granite, 88; 99 King Zoser, limestone, 78, 81; 79

KLEITIAS, 153; François Vase, 153; 204

KLEOPHRADES PAINTER, 156; Rapt Maenad, 22, 156; 208*

Klosterneuburg, Germany, Abbey of, pulpit from (Nicholas of Verdun), 473; 614

Knight's Communion, The, relief sculpture, 462; 595 Knights of St. John, 185

Knossos, Crete, Palace, 124-27, 128, 129, 158-61, 163, 164, 165, 167

Koran, 350; page in Kufic script from, 365-66; 480 Kore (maiden) figures, 141, 143, 145; 188, 189, 190* Kouros of Sounion, marble, 141-43, 158; 184 Kouros (youth) figures, 141-43, 158, 160; 184-87

Kremlin, Moscow, 345

Kritios, 157

Kritios Boy, marble, 158-59, 160; 211 Kufic script style, 365–66; 480

Kydia, 216

Labors of the Months, relief sculpture, 22, 466; 602 Laconia, Greece, sculpture from, 131-32; 174, 175 Lady of Auxerre, limestone, 140, 143; 183 Laestrygonians Hurling Rocks at the Fleet of Odysseus, The, wall painting, 22, 231-32; 322 Lagash, Iraq, 110; sculpture from, 108, 110, 273; 131,

134, 135 Lake Neuchâtel, Switzerland, excavations at, 372

La Madeleine, France, cave art from, 34, 37; 17, 24 Lamentation, fresco, 339-40, 473; 451

Landing of Horses from Boats, The, detail of Bayeux Tapestry, 442; 570*

landscape painting, from Çatal Hüyük, 32, 42; 33 Landscape with Figures, stucco relief, 250; 349 Laocoon and His Two Sons (Hagesandros, Polydoros, and Athenodoros), marble, 135, 201, 202; 287

Laon, France, Cathedral of, 452-53, 454, 455, 464, 480; choir, 579; plan of, 580; west façade, 578 Lapith Fighting a Centaur, metope fragment, 174; 234

Lascaux, France: cave paintings at, 13, 34, 37; 21, 22; plan of, 34; 19

Last Judgment, fresco, 348; 461*

Last Judgment (Gislebertus), tympanum sculpture, 105, 416-17; 532

Last Judgment, The, illumination from Utrecht Psalter, 19, 390, 402; 505

Last Judgment Before Osiris, from Books of the Dead, 101, 417; 122

La Tène art, 124, 371–72, 373, 375, 376, 416; 486, 487 Lateran Palace, Rome, 259

Laughing Man, Mochica pottery, 64; 68 Leaning Tower, Pisa, see Campanile, Pisa

Le Mans, France, Cathedral of, 453, 459-60, 461; 591

Le Mas d'Azil, France, carving from, 34; 18 Lemnian Athena (Phidias), sculpture, 176; Roman copy of, 239

Leo III, pope, 382

LEONARDO DA VINCI, 22; Adoration of the Magi, preparatory drawing for, 22; 8

Leo of Ostia, 434

Leopard, ivory, 49; 41

Le Tuc d'Audoubert, France, cave relief from, 37; 23 Liber Scivias (Hildegarde of Bingen), 285, 441-42; 569 Libon of Elis, 162, 163

Library of Celsus, Ephesus, Asia Minor, 262-63; 368* 369

Licinius, Roman emperor, 284

Liège, Belgium, 241

Lindau Gospels, 395, 399, 434; 507* Lindisfarne, England, 375 Lindisfarne Gospels, 365, 376; 494 lintel relief, from Mayan house, 61-62; 64 Lion Gate, from Citadel of Mycenae, Greece, 129, Lion Gate, The, from Hittite citadel, 112, 113; 138 Livia, Roman empress, 70, 233 Lombards, 369, 382, 407, 446 London, Westminster Abbey, Chapel of Henry VII, Lorsch, Germany, Abbey, 386; 501 Lorsch Gospels, 394; 508 Lothair II, king of Italy, 395, 421 Lotharingia, 421 Louis VII, king of France, 448 Louis IX, king of France (Saint Louis), 466, 468, 484 Lucca, Italy, 425 Lucius Junius Brutus, 214 Ludovisi Battle Sarcophagus, 267; 375 Ludovisi Throne, relief sculpture, 162, 166; 219 Luxor, Egypt, 89, 91; Temple of Amon-Mut-Khonsu, 93, 101, 195; 107, 108 LUZARCHES, ROBERT DE, 463; Cathedral of Amiens, 463; 597 Lyre Player, marble, 123; 155 Lysikrates, 184 LYSIPPOS, 188, 195, 197, 254; Apoxyomenos, 188; 264

Macedonia, 338-40, 343 Macedonian Renaissance, 330, 332-33 Machu Picchu, Peru, 64; 69 MACMILLAN PAINTER, 139-40; Chigi Vase, 139-40; 182 Madrasah of Sultan Hasan, Cairo, 350, 361, 363; courtvard, 474; East Iwan, 475; exterior of, 476 madrasahs, 360-61 Magyars, 395 Maidens and Stewards, from Panathenaic Procession, frieze sculpture, 175; 237 Maison Carrée, Nîmes, France, 238-39; 332 male figure (Herakles?), pediment sculpture, 173-74; Mali, Dogon dancers from, 26; 46 Mallia, Crete, Palace, 124 Malraux, André, 15 Malta, 43; temple relief from, 13, 43, 124, 370; 35; trilithon portals from, 43; 34 Mamluk sultans, 360 Manetho, 72 Mannerism, 265 Mansur, al-, caliph, 355 Marburg, Germany, St. Elizabeth, 453, 473; 613 Marcus Antonius (Mark Anthony), 234 Marcus Aurelius, Roman emperor, 259, 261, 263, 272, 274; equestrian statue of, 259, 477; 363 Maria Laach, Abbey Church of, near Coblenz, Germany, 385, 429; 550, 551 Market of Trajan, Rome, 253; 354 Marshack, Alexander, 35 Martel, Charles, 382 Martini, Simone, 484 Martyrdom of Saint Lawrence, wall painting, 436; 562* martyrium, 289, 296-97, 310, 352 mask of King Tutankhamen, 97, 131; *118** masks, 46, 50, 52, 56, 97, 131; *45*, *47*, *57*, *118*, *172* mastabas (Egyptian tombs), 76, 80; 73 Matisse, Henri, 40

Mausoleum, Halikarnassos, Greece, 185-86; architec-

tural reconstruction of, 258; sculpture from,

Mausoleum of Galla Placidia, Ravenna, 295, 303;

exterior of, 411; mosaics from, 22, 303, 305,

Mausoleum of Sultan Hasan, Cairo, 361; 476

Mausoleum of Hamayun, Delhi, 363

Mausolus, prince of Caria, 185

310; 413*

Mentuhotep III, king of Egypt, 88 Merovingians, 382, 387 Mesa Verde, Colorado, 55; Cliff Palace, 54-55; 53 Mesolithic art (Middle Stone Age), 40; 25, 26 Mesopotamia, 69, 70, 72, 102-3, 134 Mesopotamian art, 42, 102-19, 133, 134, 355, 375; 123-53 Metellus, Aulus, 222; portrait of, 222; 307* Metz, France, 387 Michael VIII (Palaeologus), Byzantine emperor, Michelangelo Buonarroti, 27, 259 Mignot, Jean, 488, 489 Milan, Italy, 272, 277, 284, 292, 303; Cathedral of, 479, 488-89; 634-36; Sant'Ambrogio, 429-31, 432, 433; 552-54 Miletus, Asia Minor, 137, 191, 261; Bouleuterion, Minoan art, 42, 101, 122, 124-29, 132, 138; 1; 156-62, 163* 164-67 Minos, king of Crete, 122, 126 Miracle of Ascanius, illumination from Vatican Virgil, 306-7, 325; 414 mirror back, engraved bronze, 214, 216; 302 Mission of the Apostles, tympanum sculpture, 415-16, 417, 436; 531 Mitannians, 112 MNESIKLES, 176; Propylaia, Acropolis, 129, 176-77, 179; 193, 240, 241 Mochica culture, Peru, 64; 68 Modena, Italy, Cathedral of, relief sculpture from (Wiligelmo da Modena), 427; 546 Moguls, 362 Moissac, France, Abbey Church of St.-Pierre, sculpture from, 417–18, 420, 428, 438, 450, 474; 533–35 Molière (Jean Baptiste Poquelin), 446 Monastery, St. Gall, Switzerland, 385-86; 500 Monastery of Hosios Loukas, Phocis, Greece, 333–34, 344; *441, 442* Monastery of St. Catherine, Mount Sinai, Egypt, 321; mosaic from, 22, 321-22, 324, 328, 338, 344, 458; 431*; panel paintings from, 324–25, 328; 432*; 433 Monastery of S. Domingo de Silos, near Burgos, Spain, relief sculpture from, 419; 536 MONDRIAN, PIET, 18; Red Tree, The, 18; 5 Mongols, 355, 366, 370 Monreale, Sicily, 338; Cathedral of, 425-26, 485; 544, 545 Monte Cassino painting style, 433, 434 Montezuma, 57 Monument of Lysikrates, Athens, 184; 255 Moralia in Job, 439-40; 567* Moscow, 346; Cathedral of St. Basil the Blessed (Barma and Postnik), 345-46; 458 Mosque, Kufah, Mesopotamia, 350 Mosque of Ahmed I, Istanbul, 362; 477 Mosque of Ibn Tulun, Cairo, 356, 360, 364, 412, 414; mosques, 119, 350, 353, 355-60, 362; 464, 465* 467-71, 472* 473, 477 mounds, ceremonial, 53-54, 58-59; 51, 52 Mounted King with Attendants, relief sculpture, 49; 42 Mounted Procession Followed by Men on Foot, from Panathenaic Procession, frieze sculpture, 175, 253; 236

Mausolus, marble, 186; 259

Maximianus, bishop, 317

Mecca, 350 Medes, 116

Maxentius, Roman emperor, 273, 277

see also Maya Toltec culture, Yucatán Maya Toltec culture, Yucatán, 60, 62; 62, 65

Medusa, pediment sculpture, 148-49, 153; 196

megalithic monuments, 43-45, 52, 129; 34-38

Memphis, Lower Egypt, 76, 87, 112

Menkure, see Mycerinus, king of Egypt

Menes, see Narmer, king of Egypt

Melchizedek and Abraham, see Knight's Communion, The

Maya culture, Yucatán, 57, 58, 59-62; 60, 61, 63, 64;

Mount Sinai, Egypt, 321-22, 324-25; Monastery of St. Catherine, 321-22, 324-25, 328, 338, 344, 458; 431* 432* 433 Mshatta, Jordan, Palace, 283, 354-55, 365 Muhammad, 349, 350, 365 Mumtaz Mahal, Mogul empress, 362 mural decoration, from Delos, 204, 228, 229; 293 Muse on Mount Helikon (Achilles Painter), vase painting, 181; 253 Museum Without Walls, The (Malraux), 15 Muslims, 330, 349-50, 382 Mu'tasim, al-, caliph, 355 Mutawakkil, al-, caliph, 355 Mycenae, Greece: Citadel, gate from, 129; 169; fresco from, 132; 177; sculpture from, 131, 132; 172, 173, 176; Treasury of Atreus, 129, 131, 217, 224, 296; 170, 171 Mycenaean art, 122, 129, 131-32, 137; 168-77 Mycerinus, king of Egypt, 79; statue of, 81, 83; 87 MYRON, 160, 170, 188; *Diskobolos*, 157, 160, 173, 188; 214 Naples, Italy, 407 Napoleon Bonaparte, 72-73, 284, 382 Naram Sin, king of Akkad, 109 Narmer, king of Egypt, 72, 75 Nasrid kings, 364 Nativity, narthex mosaic, 342; 454 Naumburg, Germany, Cathedral of, sculpture from (Naumburg Master), 476; 618 NAUMBURG MASTER, 476; Ekkehard and Uta, 476; 618 Neanderthal people, 33 Nebamun Hunting Birds, wall painting, 20, 93; 114* Nebuchadnezzar II, king of Babylon, 116 Nefertiti, queen of Egypt, 97; portrait sculpture of, 97; 116, 117* Nefertiti, painted limestone, 97; 117* Neo-Babylonian period, 116; see also Babylonian art Neolithic art (New Stone Age), 40-45, 57, 72, 74, 123; 27-38, 154, 155 Neo-Sumerian period, 105, 110; see also Sumerian art Nerezi, Macedonia, St. Pantaleimon, fresco from, 339-40, 473; 451 Nero, Roman emperor, 239, 241, 242, 247, 272 Nerva, Roman emperor, 250 Newgrange, Ireland, 370 New Guinea, 51-52; 48, 49 NICHOLAS OF VERDUN, 473–74, 478; Sacrifice of Isaac, 473; 614; Shrine of the Three Kings, 461, 473-74; 615 Nike of Samothrace, marble, 198; 282 Nîmes, France: Maison Carrée, 238-39; 332; Pont du Gard, aqueduct, 241; 337 Nimrud, Iraq, Palace of King Ashurnasirpal II, relief sculpture from, 114–15; 143, 144 Nineveh, Iraq, 109; Palace of King Ashurbanipal, relief sculpture from, 115; 145, 146 NIOBID PAINTER, 165, 166, 167; calyx-krater, 19, nobility blanket, Thompson Indians, 55; 55 Noli me tangere, stained glass, 458; 589 Normans, 425 North American Indian art, 53-56; 51-56, 57* Notre-Dame, Paris, 361, 453-54, 455, 459, 461, 464, 485; nave, 583; plan of, 582; west façade, 581 Notre-Dame-la-Grande, Poitiers, France, 345, 420-21; 538 Nougier, Louis-René, 37 Novgorod, Russia, fresco from (Theophanes the Greek), 346; 459 NOVIOS PLAUTIOS, 216; Argonauts in the Land of the Bebrykes, The, 216; 303 Nunnery Quadrangle, Uxmal, Yucatán, 60; 61

Oceanic art, 51–53; 48–50 Octavian, see Augustus, Roman emperor octopus vase, 124; 157 Odoacer, Gothic king, 284 Odon, bishop of Bayeux, 442 ODO OF METZ, 383, 384; Palatine Chapel of Charlemagne, Aachen, 383-84, 397, 417; 497, 498 Odysseus Blinding Polyphemos, vase painting, 139, 140, 143, 201; 181 Odysseus Blinding Polyphemos (Hagesandros, Polydoros, and Athenodoros), marble, 135, 201; 288 Odyssey (Homer), 139 Old St. Peter's, Rome, 293, 295, 298, 386; fresco of, 400; isometric view of, 402; plan of, 401 Old St. Peter's, Rome, fresco, 293; 400 Old Testament Trinity (Rublev), panel, 346, 468; 460* Olmec culture, Mexico, 59; 59 Olympia, Greece, 162, 179; Temple of Zeus, relief sculpture from, 162-65, 169, 171, 172-73, 176, 274, Olympic Games, 134, 162, 163 Omar I, caliph, 350 openwork ornament, bronze, 124, 372, 379; 486 Orbais, Jean d', 460 Oriental Archer, pediment sculpture, 23, 151, 154; 201 Oriental Between Two Horses (Psiax), vase painting, 153-54; 205 Orkney Islands, Scotland, tomb chamber, 43, 131; 36 ornament, bronze openwork, 124, 372, 379; 486; silver shield, 375; 491 Orvieto, Italy, sculpture from, 166; 226 Oseberg, Norway, ship burial at, 375; 493 Ostia, Italy, insula, 241, 288; 336 Ostrogoths, 308, 309, 310, 369 Otto I, Holy Roman emperor, 395 Otto II, Holy Roman emperor, 395, 401 Otto III, Holy Roman emperor, 396 Otto Imperator Augustus, illumination, 401; 518 Ottoman Turks, 361-62 Ottonian art, 395-406, 407, 412; 509-19, 520* 521, 522 Our Saviour of the Transfiguration, Church of, Novgorod, Russia, fresco from (Theophanes the Greek), 346; 459 Oxus Treasury, rhyton from, 119, 371; 152 Padua, Italy, Arena Chapel, frescoes for (Giotto), Paestum, Italy: Greek tomb, 22, 166-67, 217; 225,* 227; Temple of Hera I, 125, 148, 151, 171; 194; Temple of Hera II, 147, 163, 172; 220, 221 PAIONIOS, 179; Victory, 135, 179, 198; 247 PAIONIOS OF EPHESUS, 193, 195; Temple of Apollo, Didyma, 193, 195; 273, 274 Palace at Knossos, Crete, 124-27, 128, 129; frescoes from, 125-27, 132; 160, 161, 163*; main staircase and light well, east wing, 125; 159; plan of, 125; 158; Queen's Megaron, 125; 161; sculpture from, 128, 129; 164, 165, 167 Palace at Mshatta, Jordan, façade, 283, 354-55, 365; Palace of Darius and Xerxes, Persepolis, 117-19, 350; Apadana (Audience Hall), 149; plan of, 148; relief sculpture from, 150; Throne Hall of Xerxes, 151 Palace of Diocletian, Split, Yugoslavia, 274, 276-77, 278; architectural reconstruction of, 385; peristyle court, 386; plan of, 387 Palace of King Ashurbanipal, Nineveh, 114; relief sculpture from, 115; 145, 146 Palace of King Ashurnasirpal II, Nimrud, 114; relief sculpture from, 114-15, 139; 143, 144 Palace of King Sargon II, Dur Sharrukin, 112-13, 117; 140, 141 Palace of Shapur I, Ctesiphon, Mesopotamia, 352, 360; 463 Palace School (Carolingian), 330, 387, 421 Palaikastro, Crete, pottery from, 124; 157 Palatine Chapel of Charlemagne, Aachen, Germany

Palazzo Ducale (Doges' Palace), Venice, 336, 490-91; 638 Palazzo Vecchio, Florence, 490; 637 Paleolithic art (Old Stone Age), 34-35, 37, 53, 58; 14, 15* 16-19, 20* 21-24 Palette of King Narmer, relief sculpture, 72, 74-76, 79, Panagyurishte, Bulgaria, amphora from, 204; 292* Panathenaic Procession, frieze sculpture, 174-75, 236, 253, 254; 235-37 PANNINI, GIOVANNI PAOLO, Interior of the Pantheon, 20, 22, 256; 7 Panofsky, Erwin, 448 Pantheon, Rome, 20, 22, 131, 193, 255-56, 269, 296, 397; *358*; interior, painting of (Pannini), *7*; plan of, 359 Panther, gold, 56, 373, 375; 489 Pantocrator, dome mosaic, 324, 335, 338, 426; 445 Paris: Abbey Church of St.-Denis, 430, 447, 448-49; 571, 572; Notre-Dame, 361, 453-54, 455, 459, 461, 464, 485; 581–83; Ste.-Chapelle, 466, 468; 604* Paris Psalter, 332-33; 439* Parma, Italy, Cathedral of, relief sculpture from (Antelami), 427-28; 547 Parthenon, Acropolis, Athens, 129, 137, 147, 169-76, 177; architecture of (Iktinos and Kallikrates), 169-71; 229, 230; cella entrance with frieze, 235; east pediment, 19; 232, 233; frieze from, 235-37; metope fragment from, 234; plan of, 230; sculpture from (Phidias and others), 171-76, 199, 236, 253, 254; 231–38; view from west and north, 229; west pediment, drawing of (Carrey), 172; 231 Patrician Carrying Two Portrait Heads, marble, 222, 474;308 Pausanias, 135 Pella, Greece, 202; mosaic from, 202, 204, 298; 291* Peloponnesian War, 177, 179 Pentecost, dome mosaic, 337-38; 449 Pepin the Short, Carolingian king, 382 Peplos Kore, marble, 143, 145; 189 Pergamene Baroque style, 201, 279 Pergamon, Asia Minor, 305; Altar of Zeus, 192, 199-201, 202, 236, 246, 279; 284-86; sculpture from, 195–96, 198–200, 218, 279; 276, 283–86; town planning at, 192, 199; model of, 268 Pericles, 167, 168, 169, 170, 177; see also Age of Pericles Perpendicular style (Gothic), 481, 482 Persepolis, Iran, 117; Palace of Darius and Xerxes, 117-19, 350; 148-51 Persian art, 117-19, 371; 148-52 Persian Empire, 117, 156-57, 168, 183 Perugia, Italy, Porta Marzia, 211; 295 Phaistos, Crete, Palace, 124 PHIDIAS, 170, 176, 179; Athena, 170, 172, 175-76; reconstruction of, 238; Lemnian Athena, 176; Roman copy of, 239 Philip II, king of Macedon, 183 Philip the Arab, Roman emperor, 266; portrait sculpture of, 266, 267; 374 Philip the Arab, marble, 266, 267; 374 Philoxenos, 189 Phocis, Greece, Monastery of Hosios Loukas, 333-34, 344; 441, 442 Photios, 328, 330 Piazza Armerina, Sicily, Imperial Villa, mosaics at, 278-79, 298; 393* Pisa, Italy, 425; Baptistery, 424; 542; Campanile, 424-25; 542; Campo Santo, 424; 542; Cathedral, 424, 425; 542, 543 PISANO, GIOVANNI, 487; Cathedral of Siena, west façade, 487; 633 Plague of Locusts (Garsia), illumination from Commentary of the Apocalypse (Beatus of Liebana), 438-39; 566* plaque with animal interlace, gold, 375; 490 Plastered Skull, from Jericho, 41-42; 28 Plato, 157, 183 Pliny the Elder, 135, 136, 189, 201

Poitiers, France, Notre-Dame-la-Grande, west facade of, 345, 420-21; 538 POLYDOROS, see HAGESANDROS, POLYDOROS, and ATHENODOROS Polygnotos, 165-66, 167, 188, 259 POLYKLEITOS, 160, 165, 166, 170, 188, 197; Doryphorus, 160, 164, 235-36; 215, 216 POLYKLEITOS THE YOUNGER, 184; Theater, Epidauros, 185, 192; 256, 257; Tholos, Epidauros, 180, 184; 254 Polyzalos, 157 Pompeii, Italy, 202, 226-29, 232, 233, 239, 242, 247; Basilica, 226-27; 317; Forum, 226; 316; House of Julia Felix, wall painting from, 189, 233; 324; House of Menander, wall painting from, 387; 503; House of M. Lucretius Fronto, wall painting from, 247, 332; 346; House of the Centaur, 229; 320; House of the Faun, 228; 319; House of the Silver Wedding, 228; 318; mosaic from, 189-90; 266*; plan of the city, 226; 315; Villa of the Mysteries, wall painting from, 189, 232, 332; 323; wall painting from, 127, 249; 348 Pont du Gard, aqueduct, 241; 337 Porta Maggiore, aqueduct, 241-42, 490; 338 Porta Marzia, Perugia, 211; 295 Portrait of a Graeco-Roman Egyptian, encaustic, 265; 371* Portrait of a Lady, marble, 246; 345 Portrait of Alexander, marble, 195-96, 200, 222-23; 276 Portrait of Antinoüs, marble, 255; 357 Portrait of Caracalla, marble, 265-66; 372 Portrait of King Sargon II, relief sculpture, 113; 142 Portrait of Menander, wall painting, 387; 503 Portrait of Vespasian, marble, 246; 344 POSTNIK, 345; Cathedral of St. Basil the Blessed, Moscow, 345-46; 458 Praeneste, Italy, 214, 216; Sanctuary of Fortuna, 225-26, 231; 313, 314 PRAXITELES, 186, 188, 195, 197, 254; Aphrodite of Knidos, 186, 197-98; 262; Hermes with the Infant Dionysos, 135, 187-88; 263 Pre-Columbian art, 57-65; 58-69 prehistoric art, 33-45; 14, 15,* 16-19, 20,* 21-38 Priene, Asia Minor, 191-92; 267 Prima Porta, Italy, Villa of Livia, sculpture from, 235-36; 326; wall painting from, 233; 325* Prince Rabotep and His Wife Nofret, painted limestone, 83;88 "Princess," bronze, 49; 40 Princess Sennuwy, granite, 72, 88, 89; 100 Priory Church, Berzé-la-Ville, France, wall painting from, 436; 562* Priory Church, St.-Gilles-du-Gard, France, triple portal of, 419-20, 428, 451; 537 Procopius, 320 Prophet, portal sculpture, 418, 474; 535 Prophet Habakkuk (Nicholas of Verdun), detail of Shrine of the Three Kings, 461, 473-74; 615 Propylaia, Acropolis, Athens (Mnesikles), 129, 176-77, 179; 193, 240, 241 Protagoras, 133, 140 Proto-Attic style, 139; 181 Proto-Corinthian style, 139; 182 Psalter of Saint Louis, 313, 468; 607* PSIAX, 153; Oriental Between Two Horses, 153-54; Puabi, queen of Ur, 106 PUCELLE, JEAN, 470; Belleville Breviary, 470, 472; 610 pueblos, adobe, Taos, New Mexico, 42, 55; 54 purse lid with animal interlace, from Sutton Hoo, 375, 376; 492 Pyramid of Cheops, Giza, 79-80; 82, 83 Pyramid of Chephren, Giza, 79-80; 82, 84 Pyramid of Mycerinus, Giza, 79-80; 82 pyramids: Egyptian, 54, 76-77, 79-80; 88; 74, 82-84; Pre-Columbian, 58-59; see also ziggurats Pythagoras, 160

Poiana-Cotofenești, Rumania, 371

(Odo of Metz), 383-84, 397, 417, 477; 497,

Oal'at Saman, Syria, St. Simeon Stylites, 297; 406 Queen Hatsbepsut, limestone, 89; 101

Rabula Gospels, 325, 339; 435 Raimondi Monolith, relief sculpture, 63, 64; 66 Ramses II, king of Egypt, 93, 101 Raphael (Raffaello Sanzio or Santi), 27 Rapt Maenad (Kleophrades Painter), vase painting, 22, 156; 208*

Ravenna, Italy, 303, 308-9, 310-14, 317, 382; Mausoleum of Galla Placidia, mosaics from, 295, 303, 305, 310; 411, 413*; Sant'Apollinare in Classe, mosaic from, 27, 317; 426; S. Vitale, 295, 296, 310-14, 317, 321, 324, 334, 384; 418-21, 422, 423, 424, 425

Rayonnant style (Gothic), 464, 466 Reclining Woman, relief sculpture, 37; 24 Red Tree, The (Mondrian), 18; 5 Regensburg, Germany, 404

Reims, France, Cathedral of, 454, 460-62, 463, 464, 466; nave, 460; 592; west façade, 461; 593; west façade jamb statues, 461-62, 474; 594; west interior wall, sculpture from, 462; 595

Reims School (Carolingian), 387, 388, 389, 391, 421 Relinde, 406

RENOIR, PIERRE AUGUSTE, 18; Grands Boulevards, Les, 18; 4

Republican Forum, Rome, 259; 364 Revelling (Brygos Painter), vase painting, 156; 209 Rhodes, Greece, 195

rhyton, from Oxus Treasury, 119, 371; 152; from Pal= ace at Knossos, 129; 167

Riace, Italy, sculpture from, 161; 217, 218* Richard II, king of England, 483, 484 Rider, sandstone, 476-77; 619 Ritual Dance, cave drawing, 40; 26

Rodin, Auguste, 22

Roger II, king of Sicily, 338 Roman art, 133, 201, 216, 218, 219-79; 7, 307; 308–20, 321* 322–24, 325* 326–30, 331* 332–40, 341* 342–46, 347* 348–67, 368* 369, 370, 371* 372–81, 382* 383–92, 393*; architecture, 131, 146, 193, 211, 223-28, 238-39, 241-44, 245, 250, 253-54, 255-57, 259, 261-63, 269-71, 274, 276-78; 311-19, 332-40, 341; 350, 351, 354, 355,

358-61, 364-67, 368*, 369, 378-81, 385-92; Early Empire, 233-50; 326-30, 331*, 332-40, 341* 342-46, 347, 348, 349; end of the Pagan Empire, 271-79; 382; 383-92, 393*; mosaics, 268-69, 278-79, 298; 377; painting, 22, 127, 166, 189, 229, 231-33, 247, 249-50, 268, 387; 320, 321*, 322-24, 325; 346, 347; 348, 376, 503; Republic, 220-33; 307; 308-20, 321; 322-24, 325*; sculpture, 114, 222-23, 235-37, 245-47, 249-50, 251, 253-55, 257, 259, 263, 265-67, 273-74; 307, 308-10, 326-30, 331*, 342-45, 349, 352, 353, 355-57, 362,

363, 370, 372-75, 382*, 383, 384; Second Century, 250-65;7,350-67,368;369,370,371*; Third Century, 265-71; 372-81

Roman Empire, 69, 70, 72, 101, 190, 219-20, 233-35, 250, 271-73, 283, 284, 348, 369-70

Romanesque art, 379, 407-43; 12*, 523-539, 540*, 541-60, 561, 562, 563, 564, 565-68, 569, 570*, architecture, 23, 352, 408, 410-12, 414-15, 420-21, 422-26, 428-33, 453; 523-28, 530, 538, 540* 541-45, 549-59; in England, 431-32, 436, 440; 555, 556, 568*; in France, 410-12, 414-22, 432-33, 436, 438-40, 442; 12*, 523-39, 557-59, 562* 565-67* 570*; in Germany, 428-29, 440-41; 549, 569; illuminated manuscripts, 436-42; 564, 565-68*, 569; in Italy, 422-28, 429-31, 434-35; 540, 541-48, 552-54, 560, 561*; mural painting, 433-36; 560, 561*, 562*, 563; sculpture, 408-9, 414, 415-20, 421-22, 426-28; 529, 531-37, 539,

546-48; in Spain, 436, 437-38; 563, 564

Romanus II, Byzantine emperor, 395 Rome, Italy, 197, 208, 220-21, 259, 272, 289, 292, 308, 309-10, 407; Ara Pacis, 236-37, 239, 246, 266,

308; 328-30; Arch of Constantine, 254, 274, 307; 356, 383; Arch of Titus, 245-46, 252, 253, 267; 341, 342, 343; Basilica of Maxentius and Constantine, 277; 388-90; Basilica Ulpia, 250, 253, 277, 293; 351; Baths of Caracalla, 243, 269-70, 277; 378-80; Catacomb of SS. Pietro e Marcellino, ceiling fresco from, 290-91; 397; Catacomb of Sta. Priscilla, fresco from, 20, 290, 376; 396; Colosseum, 242-43; 339, 340; Column of Antoninus Pius, 257, 259, 292; 362; Column of Trajan, 114, 250-53, 267, 303, 308, 325, 332, 468; 352, 353; Forum of Augustus, 239, 250; 333-35; Forum of Julius Caesar, 239, 250; 333; Forum of Trajan (Apollodorus), 250, 295; 333, 350; Imperial Forums, 239, 250, 259; 333, 364; Market of Trajan, 253; 354; Old St. Peter's, 293, 295, 298, 386; 400-402; Pantheon, 131, 193, 255-56, 269, 296, 397; 7, 358, 359; Porta Maggiore, 241-42, 490; 338; Republican Forum, 259; 364; SS. Cosma e Damiano, mosaic from, 309-10, 417; Sta. Costanza, 296, 310; 404, 405; Sta. Maria Maggiore, mosaics from, 301-3, 353; 410, 412*; St. Peter's, 293, 295, 299, 310, 324, 382, 385, 412, 479; 407 408*; Sta. Sabina, 293, 295, 412; 403; Shrine of St. Peter, 289; 395; Temple of Fortuna Virilis, 223, 238-39; 311; Temple of Mars Ultor, 238, 239, 253; 334, 335

Romulus Augustulus, Roman emperor, 284, 308 room with landscape frescoes, from Thera, Crete, 16, 18, 127, 193, 233; 1*

Rosetta Stone, 72-73

rotuli, 305-6

Rouen, France, St.-Maclou, 23, 469, 482; 605, 606 royal harp, from Ur, 106-7, 375; 129

RUBLEV, ANDREI, 346; Old Testament Trinity, 346, 468; 460*

Rumania, 346, 348 Russia, 330, 344-46

Sabina, 475, 476

Sabratha, Libya, theater, 262; 367 Sacred Landscape, wall painting, 127, 249; 348 Sacrifice of Isaac (Nicholas of Verdun), 473; 614 Sacrifice to Apollo, marble medallion, 254, 274; 356 Saints include S., San, Sant', SS., St., Sta., Ste. St.-Aignan, Paris, sculpture from, 469-70; 609

Sant'Ambrogio, Milan, 429-31, 432, 433; 552; interior of, 554; plan of, 553

Sant'Angelo in Formis, near Capua, Italy, nave fresco from, 434-35; 560

Sant'Apollinare in Classe, Ravenna, apse mosaic from, 27, 317; 426

Saint Augustine, 375

St.-Barthélémy, Liège, baptismal font in (de Huy), 421-22; 539

St. Basil the Blessed, Cathedral of, Moscow (Barma and Postnik), 345–46; 458 Saint Benedict of Nursia, 309

Saint Bernard, 416, 440, 441, 442, 458, 468, 484 St.-Bertin, France, Gospels of, 436-37; 565*

St. Catherine, Monastery of, Mount Sinai, Egypt, 22, 321-22, 324-25, 328, 338, 344, 458; 431; 432; 433 Ste.-Chapelle, Paris, 466, 468; 604*

S. Clemente de Tahull, Spain, fresco from, 436; 563 SS. Cosma e Damiano, Rome, mosaic from, 309-10;

Saint Cosmas and Saint Damian, dome mosaic, 301, 353; 409*

Sta. Costanza, Rome, 296, 310; interior of, 405; plan of, 404

Sta. Croce, Florence, 484-85, 487; 629 St. Demetrius, Cathedral of, Vladímir, Russia,

St.-Denis, Abbey Church of, Paris, 430, 447, 448-49;

571, 572

Saint Denis, cult of, 404

S. Domingo de Silos, Monastery of, Burgos, Spain, relief sculpture, 419; 536

Saint Dominic, 484

St. Elizabeth, Marburg, Germany, 453, 473; 613 Saint Erhard, bishop of Regensburg, 404-5 Saint Erbard Celebrating Mass, illumination from Uta Codex, 405-6; 522

St.-Étienne, Abbey Church of, Caen, France, 432-33, 453; interior of, 558; plan of, 557; west façade, 559

Saint Francis of Assisi, 484

St. Gall, Switzerland, monastery, 385-86; 500 St. George, Church of, Reichenau Island, Germany, 400-401

St. George, Church of, Voronet, Rumania, frescoes from, 348; 461*

St.-Gilles-du-Gard, France, Priory Church, sculpture from, 419-20, 428, 451; 537

San Giovanni in Laterano, Rome, 298

Saint Gregory, 439, 440

Saint Hugh, Cluniac abbot, 412

Saint James, 408

San Lorenzo Tenochtitlán, Mexico, 59

Saint Louis, 466; see also Louis IX, king of France St.-Maclou, Rouen, France, 23, 469, 482; plan of, 606; west façade, 605

Ste.-Madeleine, Vézelay, France, 22, 414-16, 417, 429, 436, 474; interior of, 530; tympanum of central portal, 531

S. Marco, Venice, 284, 336–38; 447; dome mosaic from, 449; interior of, 448; plan of, 446

Sta. Maria Maggiore, Rome, mosaics from, 301-3, 353; 410, 412*

Saint Matthew, illumination from Coronation Gospels, 332, 387, 388; 502

Saint Matthew, illumination from Ebbo Gospels, 388-89;

St. Michael's, Hildesheim, 396-99, 421, 442; 511; bronze doors for, 513, 514; column from, 515; interior of, 512; plan of, 510

S. Miniato al Monte, Abbey Church of, Florence, 423; 541

St. Pantaleimon, Macedonia, fresco from, 339-40, 473; 451

St. Pantaleon, Cologne, 385, 395-96; 509 Saint Paul, apse mosaic, 293, 299, 310, 324; 407,

St. Peter's, Rome, 295, 382, 385, 412, 479; apse mosaic from, 293, 299, 310, 324; 407, 408*; see also Old St. Peter's, Rome

St.-Philibert, Abbey Church of, Tournus, France, 23, 410, 456; 523

St.-Pierre, Abbey Church of, Cluny, France (Gunzo), 352, 412, 414, 436, 480; capital from choir, 529; interior of (reconstruction drawing), 528; plan of, 527

St.-Pierre, Abbey Church of, Moissac, France, 417-18, 420, 428, 438, 450, 474; corner pier from cloister, 533; south portal figure, 535; south portal tympanum, 534

S. Pietro al Monte, Civate, Italy, wall painting from, 435; 561*

St.-Riquier, Abbey Church of, Centula, France, 384-85; 499

Sta. Sabina, Rome, 293, 295, 412; 403

St.-Sernin, Toulouse, France, 410-12, 448, 449; 524; nave and choir, 526; plan of, 525

St. Simeon Stylites, Qal'at Saman, Syria, 297; 406 Saint Thomas Aquinas, 286

S. Vitale, Ravenna, 295, 310-14, 317, 334, 384; 418; capital from, 421; chancel of, 422*; interior of, 420; mosaics from, 313-14, 317, 321, 324; 423; 424, 425; plan of, 419

Salamis, Greece, 157

Salisbury Cathedral, England, 480; 624; nave and choir, 623; plan of, 622

Salonika, Greece, 425; Hagios Georgios, dome mosaics from, 301, 353; 409*

Samarra, Mesopotamia, 355; Great Mosque of al-Mutawakkil, 119, 355, 356; 467, 468

Samos, Greece, Temple of Hera, sculpture from, 143; Samothrace, Greece, 198; Arsinoeon, 193; 272 Sanctuary of Apollo, Delphi, Greece: sculpture from, 157, 255; 210, 357; Treasury of the Siphnians, 147, 148, 149–51, 153, 179; 197, 198 Sanctuary of Artemis Brauronia, Athens, 169 Sanctuary of Fortuna, Praeneste, Italy, 225-26, 231; 313, 314 Sanguineto, Italy, sculpture from, 222; 307* Santiago de Compostela, Spain, shrine at, 408, 411 Sappho, 70 Saqqara, Egypt: Funerary Complex of King Zoser (Imhotep), 76–78, 79, 80, 145, 147; 74–78; painted reliefs from, 83–84, 86; 92* 95, 96; sculpture from, 78-79, 83, 94; 80, 81, 90, 91, 112 sarcophagus, terra-cotta, 211, 213; 297 Sarcophagus of Junius Bassus, marble, 307-8; 415 Sargent, Marion Roberts, 440 Sargon I, king of Akkad, 108, 109, 116 Sargon II, king of Assyria, 112; portrait sculpture of, Sarpedon Carried off the Battlefield (Euphronios), vase painting, 19, 22, 155–56; 207* Satyr, sculpture, 197; Roman copy of, 279 Saxons, 369 Scenes from the Life of Saint Paul, illumination from Bible of Charles the Bald, 391-93; 506* Schapiro, Meyer, 387, 447 Schliemann, Heinrich, 122, 131 Scholasticism, 286 Sculptors at Work, relief sculpture, 78-79, 142; 80 Scythian art, 56, 373, 375; 489, 490 Scythians, 116 Seated Boxer, bronze, 197; 278 Seated Scribe, painted limestone, 83; 91 Segesta, Sicily, Doric temple, 180; 252 SENMUT, 90-91; Funerary Temple of Queen Hatshepsut, Deir el Bahari, 88, 89-91; 102-4 Septimius Severus, Roman emperor, 265, 269, 271 Serbia, 338-39, 340-41, 343 Sergius, Russian abbot, 346 Seti I, king of Egypt, 93 Shah Jehan, Mogul emperor, 362, 364 Shapur I, king of Persia, 352 She-Wolf, bronze, 214; 299 shield ornament, silver, 375; 491 Shrine of Saint Peter, Rome, 289; 395 Shrine of the Three Kings (Nicholas of Verdun), 461, 473-74; 615 shrines, from Çatal Hüyük, 42; 31, 32 Sicily, Italy, 338, 425 Siege Operations During a Battle, wall painting, 62; 65 Siena, Italy, Cathedral of, west façade (Pisano), 487; Signs of the Zodiac, relief sculpture, 22, 466; 602 Simo mask, from Guinea, 26, 50–51; 47 SKOPAS, 186, 195; Head, 186; 261 Slavic tribes, 330, 369, 373, 395 Snake Goddess, faience, 128; 164 Socrates, 70, 176 Sopocáni, Serbia, Church of the Trinity, 340-41, 342, 343; 452 "soul boat," wood, 52; 49 Sounion, Greece, sculpture from, 141-43; 184 Sparta, Greece, 137, 183 Sperlonga, Italy, sculpture from, 201-2; 288, 289 Speyer, Germany, Cathedral of, 428, 454; 549 Split, Yugoslavia, Palace of Diocletian, 274, 276-77, 278; 385-87 Spoils from the Temple at Jerusalem, relief sculpture, 245-46, 252; 343

Stele of King Naram Sin, relief sculpture, 109-10; 133 stele with the Code of Hammurabi, relief sculpture, 110, 112: 137 Still Life, wall painting, 189, 233; 324 Stone Age art, see Mesolithic art; Neolithic art; Paleolithic art Stonehenge, Salisbury Plain, England, 43-45; 37, 38 stone images, Easter Island, 13, 52-53; 50 Stornaloco, Gabriele, 488 Strasbourg, France, Cathedral of, sculpture from, 474-75, 478; 616, 617 Strettweg, Austria, 371 Stylite (Theophanes the Greek), fresco detail, 346; 459 Suger, abbot, 430, 448, 449 Sulla, Roman emperor, 222, 226, 234 Sumerian art, 58, 104-8, 110, 122, 375; 123-31, 134-36 Sumerians, 103 Summa (Aquinas), 286 Suppiluliuma I, Hittite king, 112 Surrealism, 379 Susa, Iran, 109-10, 119; 133, 153 Sutton Hoo, Suffolk, England, ship burial at, 375, Synagogue, Dura-Europos, Syria, wall painting from, 291-92; 398 Synod of Whitby, 376 Taj Mahal, Agra, India, 362-64; 478 Talenti, Francesco, 485, 486 Tamerlane, 366 Taos, New Mexico, adobe pueblos, 42, 55; 54 Tarquinia, Italy, wall paintings from, 217; 304, 305* Tarxien, Malta, Temple, 13, 43, 124, 370; 35 Tell Asmar, Iraq, sculpture from, 106; 128 Tell el Amarna, Egypt, 191; sculpture from, 96-97; Temple, Segesta, Sicily, 180; 252 Temple, Tarxien, Malta, 13, 43, 124, 370; 35 Temple of Amon-Mut-Khonsu, Luxor, Egypt, 93, 146, 195; court of Amenhotep III, 107; plan of, 108 Temple of Amon-Ra, Karnak, Egypt, hypostyle hall, 72, 93, 195; model of, 109; portion of, 110 Temple of Aphaia, Aegina, Greece, 22, 137, 151-52, 154, 163, 165, 172, 199, 213, 456; 199; plan of, 200; pediment sculpture from, 201-3 Temple of Apollo, Bassai, Greece (Iktinos), 147, 180, 186, 254; 250*; interior of, 249; relief sculpture from, 251 Temple of Apollo, Didyma, Turkey (Paionios of Ephesus and Daphnis of Miletus), 193, 195; east front, architectural reconstruction of, 274; inner Temple of Artemis, Corfu, 148-49, 151, 153; relief sculpture from, 196; west façade, reconstruction Temple of Aten, Karnak, Egypt, 96 Temple of Athena, Pergamon, 192 Temple of Athena, Priene, Asia Minor, 192 Temple of Athena Alea, Tegea, Greece, sculpture from (Skopas), 186; 261 Temple of Athena Nike, Acropolis, Athens (Kallikrates), 147, 177, 179, 223; 242, 243 Temple of Fortuna Virilis (Temple of Portunus), Rome, 223, 238-39; 311 Temple of Hera I, Paestum, Italy, 125, 148, 151, 171;

Temple of Hera II, Paestum, Italy, 147, 163, 172; 220, Temple of Horus, Edfu, Egypt, 91, 93, 101; colonnaded court, 106; entrance pylons, 121 Temple of Jupiter Optimus Maximus, Rome, 223 Temple of Mars Ultor, Rome, 238, 239, 253; 334, 335 Temple of the Divine Trajan, Rome, 250, 253 Temple of the Jaguars, Chichén Itzá, wall painting from, 62; 65 Temple of the Olympian Zeus, Athens (Cossutius),

Temple of the Sibyl, Tivoli, Italy, 223-24; 312 Temple of Venus, Baalbek, Syria, 270-71: 381 Temple of Zeus, Olympia, Greece, 162–65, 169, 171, 172-73, 176, 274, 462; metope fragment, 224; west pediment, 222, 223 Temptation of Adam and Eve, illumination from Chronology of Ancient Peoples (al-Biruni), 366; 481 Tenochtitlán, Mexico, 57, 62 Teotihuacán, Mexico, 58-59, 60-61; Ciudadela court, 58; 58 Tetrarchs, The, façade sculpture, 22, 273-74, 303; 382* Theater, Epidauros (Polykleitos the Younger), 185, 192; 256* 257 Theater, Sabratha, Libya, 262; 367 Thebes, Greece, 183 Thebes, Upper Egypt, 87, 88, 89, 91; Tomb of Nebamun, wall paintings from, 93-94; 111, 114* Themistocles, 176 Theodora, Byzantine empress, 314, 317; mosaic of, 314, 324; 425 Theodoric, Ostrogothic chieftain, 308, 313, 314, 370, THEOPHANES THE GREEK, 346; Stylite, 346; 459 Theophano, 395 Theotokos, apse mosaic, 344; 456 Theotokos Church, Monastery of Hosios Loukas, Phocis, Greece, 333-34; 441 Thera, Greece, 122, 127; frescoes from, 16, 18, 127-28, 193, 233; 1* 162 Thibaut V, count of Champagne, 468 Tholos, Epidauros (Polykleitos the Younger), 180, 184, 185: 254 Thompson Indians, 55 Three Deities, ivory, 132, 451; 176 Three Goddesses, pediment sculpture, 19, 173; 232 Three Marys at the Sepulcher, The, ivory panel, 308, 394; throne of King Tutankhamen and his Queen Ankhesenamen, 97; 119 Tiahuanaco culture, Bolivia, 63-64; 67 tiara, from Rumania, 371; 485 Tiberius, Roman emperor, 201, 237 Timgad, Algeria, 261-62; colonnaded street, 366; plan of, 365 Tiryns, Greece, Citadel, 129, 137; 168 Titus, Roman emperor, 242, 245, 350 Tivoli, Italy: Hadrian's Villa, 256-57, 274, 277, 278, 310, 330; 360, 361; Temple of the Sibyl, 223–24; 312 Ti Watching a Hippopotamus Hunt, painted relief, 22, 83-84; 92 Tlingit Indian bear screen, 56; 56 Tomb of Horemheb, Valley of the Kings, Egypt, 72, 79, 86; 94* Tomb of Hunting and Fishing, Tarquinia, wall painting from, 22, 152, 217; 305 Tomb of Nebamun, Thebes, Egypt, wall paintings from, 20, 93-94; 111, 114* Tomb of Neferirkara, Saqqara, Egypt, drawing from, Tomb of Patenemhab, Saqqara, Egypt, relief sculpture from, 94; 112 Tomb of Queen Puabi, Ur, royal harp from, 106-7, Tomb of Sen-ned-jem, Deir el Medineh, Egypt, wall paintings from, 94; 113

Tomb of the Reliefs, Cerveteri, Italy, burial chamber

Tomb of Triclinium, Tarquinia, wall painting from,

Tomb of Ti, Saqqara, Egypt, painted reliefs from, 22, 83–84, 86, 94; 92*, 95

Tomb of Tutankhamen, near Thebes, Egypt, 97;

mask from, 97, 131; 118*; throne from, 119

Toulouse, France, St.-Sernin, 410-12, 448, 449;

in, 218; 306

Stele of King Eannatum (Stele of the Vultures), limestone, Tournus, France, Abbey Church of St.-Philibert, 23, 410, 456; 523

108; 131

Stag Hunt, mosaic, 202, 204, 298; 291*

Stele of Aristion (Aristokles), marble, 143; 187

Steinbach, Erwin von, 475-76

Stele of Hegeso, marble, 179-80; 248

Tours, France, 387 Tower of Babel, Babylon, 103, 116 Trajan, Roman emperor, 219, 250, 251, 253, 254, 259, Transfiguration, mosaic, 22, 321-22, 324, 328, 338, 344, 458; 431* Treasury of Atreus, Mycenae, Greece, 129, 131, 217, 224, 296; interior of, 171; plan of, 170 Treasury of the Siphnians, Sanctuary of Apollo, Delphi, Greece, 147, 148, 149-51, 153, 179; façade of, 198; north frieze of, 197 Tremper Mound, Ohio, 54; pipe from, 52 Trier, Germany, Basilica, 277-78, 295, 317; 391, 392 trilithon portals, from Malta, 43; 34 Trinity, Church of the, Sopoćani, Serbia, fresco from, 340-41, 342, 343; 452 Triumph of Titus, relief sculpture, 245-46, 252; 342 Troy, 122 Turks, 330 Tuscan order, 146, 209, 243 Tutankhamen, king of Egypt, 97, 101, 112, 131; 118* Tuthmosis I, king of Egypt, 89 Tuthmosis II, king of Egypt, 89 Tuthmosis III, king of Egypt, 89 Two Bison, relief sculpture, 37; 23 Two Warriors, bronzes, 71, 160-62; 217, 218* Umayyad dynasty (Muslim), 355

Ur, Iraq, 106–8; Žiggurat, 58, 105, 110, 113; 125 Urn, cinerary, bronze and terra-cotta, from Chiusi, Italy, 211; 296 Urnammu, governor of Ur, 110 Uruk, Iraq, 105–6, 108; Ziggurat, 58, 104–5, 113; 123, 124 Uta, abbess of Niedermünster, 404, 405, 406 Uta Codex, illumination from, 404–6; 522 Utrecht Psalter, 19, 389–90, 402; 505

Valley Temple of Chephren, Giza, 80, 81, 125; 84, 85 Vandals, 308, 369, 370, 446 Vapbio Cups, The, gold, 131–32; 174, 175 Vasari, Giorgio, 29, 446 vase, octopus, 124; 157; sculptured alabaster, 105; 126 Vatican Virgil, 306–7, 325; 414 Veii, Italy, sculpture from, 213–14; 298*

Uxmal, Yucatán, Nunnery Quadrangle, 60; 61

Venice, Italy, 336, 407-8; Ca' d'Oro, 491-92; 639; Palazzo Ducale (Doges' Palace), 490–91; 638; S. Marco, 284, 336-38; 446-49 "Venus" of Lespugue, ivory, 34; 15* "Venus" of Willendorf, limestone, 34, 37, 42; 14 Vespasian, Roman emperor, 242; portrait sculpture of, 246; 344 Vesuvius, eruption of, 226, 247 Vézelay, France, Ste.-Madeleine, 22, 414-16, 417, 429, 436, 474; 530, 531 Victory (Paionios), marble, 135, 179, 198; 247 Victory of Alexander over Darius III, Roman mosaic, 189-90, 298; 266* Victory Untying Her Sandal, marble, 179; 243 Vienna Book of Genesis, 325, 332; 434* Vikings, 395, 442 Villa of Livia, Prima Porta, Italy, wall painting from, 20, 22, 127, 233; 325* Villa of the Mysteries, Pompeii, wall painting from, 189, 232, 332; 323 Vinescroll Ornament, from frieze of Ara Pacis, 236; 330 Virgil, 306 Virgin and Child Enthroned, apse mosaic, 328, 330; 438

Virgin and Child Enthroned Between Saint Theodore and Saint George, The, panel, 324, 328; 432* Virgin Enthroned Between Angels, The, ivory diptych, 325–26; 436 Virgin of Paris, stone, 469–70; 609

Visconti family, 488
Visconti family, 488
Visigoths, 308, 309, 369, 370
Vision of Isaiab, illumination, 402; 520*
Vision of Saint Jobn (Ende), illumination from Commentary on the Apocalypse (Beatus of Liebana), 417, 438;

564 Vision of Saint John, tympanum sculpture, 417–18, 420, 438, 450; 534

Vision of the Ball of Fire (Hildegarde of Bingen), illumination from Liber Scivias, 285, 441–42; 569

569
Visitation, jamb statue, 461, 474; 594
Vitruvius, 209, 223, 245, 410
Vládimir, grand prince of Kiev, 344
Vladímir, Russia, Cathedral of St. Demetrius, 344–45; 457
Voronet, Rumania, Church of St. George, frescoes

from, 348; 461*

Walid, al-, caliph, 353 war shield, wood, from New Guinea, 51–52; 48 Water Goddess, basalt, 60–61; 63 Western Rôman Empire, 284, 303, 305, 308 Westminster Abbey, London, Chapel of Henry VII, 482; 626

White Temple, on Ziggurat, Uruk, Iraq, 58, 104–5; 123, 124

Wild Boar Hunt, marble medallion, 254, 274; 356
WILIGELMO DA MODENA, 426–27; Old Testament scenes, façade sculpture, 427; 546
William II. king of Sicily, 425

William II, king of Sicily, 425 William of Sens, 480

William the Conqueror (William I), king of England, 432, 442

Wilton Diptych, panel, 483–84; 627*
Woman of the Apocalypse (Herrad of Landsberg),
illumination from Hortus Deliciarum, 285, 477–78;
620

Woman's Head, ivory, 34; 16 Women at the Tomb, The, illumination from Rabula Gospels, 325, 339; 435

Wounded Bison Attacking a Man, cave painting, 13, 34, 37; 22

Wounded Chimaera, bronze, 214; 300 Wreck of Odysseus' Ship, The (Hagesandros, Polydoros, and Athenodoros), marble, 202; 289

Xerxes I, king of Persia, 117, 156, 157; portrait sculpture of, 118; *150* XPI page, illumination from *Book of Kells*, 27, 377, 379, 402, 418; 496*

Yaxchilán, Mexico, lintel relief from, 61–62; 64 Yoruba culture, Nigeria, 49–50; 43, 45 Youtb, bronze, 22, 188; 265

Zeus Fighting Three Giants, relief sculpture, 200, 218, 279; 286

Zeus of Artemision, bronze, 157, 159–60, 188; 213

Ziggurat, Ur, Iraq, 58, 105, 110, 113; 125

Ziggurat, Uruk, Iraq, 58, 104–5, 113; 123, 124

ziggurats, 58, 103, 104–5, 110, 113, 116

Zoser, king of Egypt, 76; portrait sculpture of,

78, 81; 79

PHOTOGRAPH CREDITS

The author and publisher wish to thank the libraries, museums, and private collectors for permitting the reproduction of works of art in their collections and for supplying the necessary photographs. Photographs from other sources are gratefully acknowledged below.

© A.C.L., Brussels, 3, 539; Agarwal, Jagdish, Uniphoto Picture Agency, Washington, D.C., 478; Alinari, Florence, 2, 91, 214, 216, 223, 283, 296, 299, 304, 312, 318, 323, 327, 336, 338, 342, 343, 346, 352, 355, 356, 357, 360, 363, 370, 375, 376, 378, 385, 399, 400, 403, 410, 413, 417, 418, 421, 424, 435, 447, 448, 449, 450, 541, 543, 545, 546, 547, 552, 554, 560, 629, 630, 632, 633, 634, 635, 637, 638, 639; American School of Classical Studies, Athens, 228; Anker, Peter, Oslo, 493; Antiken-Sammlung, Staatliche Museen zu Berlin, Haupstadt der DDR, 284; Archivio Fotografico dei Musei e Gallerie Pontificie, Vatican City, Rome, 361, 407, 408; Arnold, Dieter, Der Tempel des Koënigs Mentubotep von Deir el Bahari, Band I, Architektur und Deuting, Mainz am Rhein, Verlag Philipp von Zabern, 98; The Athlone Press, University of London, 34, 35; Audinet, Jack, Boulogne, 564; Austin, James, 532; Avery Library, Columbia University, New York, 351; Babey. Maurice, Basel, 97, 122; Balestrini, Bruno, Electa Editrice, Milan, 120; Bell-Scott, Donald, 285; Biblioteca Apostolica Vaticana, Rome, 508; Bibliothèque Nationale, Paris, 518; Böhm, Erwin, Mainz, 544, 550; Boltin, Lee, 118, 292; Buch- und Kunstsammlung St. Hildegarde, Rhein-Eibingen, 569; Bulloz, Paris, 183; Bundesdenkmalamt, Vienna, 614; Caisse Nationale des Monuments Historiques, Paris, 17, 21, 22, 153, 523, 524, 529, 530, 531, 533, 534, 535, 537, 538, 571, 573, 576, 579, 581, 589, 592, 593, 605, 617; Canali, Ludovico, Rome, 298, 325, 412, 422; Chambi, Victor, Cuzco, Peru, 69; Clements, Geoffrey, New York, from a color proof supplied by Kurt Weitzmann, Princeton, 431; Compania Mexicana Aerofoto, Mexico City, 58; Conant, Kenneth John, Wellesley, 527, 528; Courtauld Institute, London, © Mrs. J. P. Summer, Essex, England, 628; De Antonis Fotografo, Rome, 165, 384; Department of Antiquities, Algeria, 365; Department of the Environment, Edinburgh (British Crown Copyright), 36; Deutsche Fotothek, Dresden, 457; Deutscher Kunstverlag, Munich, 497, 618 (Walter Hegge); Deutsches Archäologisches Institut, Athens, 174, 196, 212; Deutsches Archäologisches Institut, Cairo, 96; Deutsches Archäologisches Institut, Istanbul, 267; Deutsches Archäologisches Institut, Rome, 261, 288, 301, 328, 335, 344, 345, 349, 372, 373, 383; Dieuzaide, Jean, Toulouse (YAN), 23, 24; Directorate General of Antiquities and Museums, Damascus, 377; Dumbarton Oaks Center for Byzantine Studies, Washington, D.C., 438; École Française d'Athènes, 292; Éditions Cercle d'Art, Paris, 456; Éditions d'Art Skira, Geneva, 465; Enciclopedica Romana, Bucharest, courtesy the Romanian Library, New York, 485; Rev. Fabbrica di S. Pietro, Rome, 415; Felton, Herbert, London, 626; Fotocielo, Rome, 542; Fototeca Unione, Rome, 287, 295, 311, 313, 314, 315, 329, 330, 337, 339, 340, 350, 354, 358, 364, 367, 380, 381, 388, 503; Frantz, Alison, Princeton, 169, 181, 210, 229, 242, 244, 252, 441, 442; Fraser, 402; Fürböck, Graz, 484; Gabinetto Fotografico, Florence, 300; Gabinetto Fotografico Nazionale, Rome, 297, 437; GAI, Baghdad, 123; Gardner, Art Through the Ages, Fifth Edition, Revised by Horst de la Croix and Richard G. Tanney, copyright © 1970 by Harcourt Brace Jovanovich, 500; Giraudon, Paris, 463, 583, 588, 604; The Green Studio, Ltd., Dublin, 496; Held, André, Ecublens, 93, 290, 455; Hell, Dr. Helmut, Reutlingen, 406; Hinz, Hans, Basel, 44, 45; Hirmer Fotoarchiv, Munich, 71, 77, 81, 82, 85, 86, 87, 88, 95, 102, 104, 106, 107, 112, 115, 119, 125, 126, 131, 133, 143, 156, 157, 159, 160, 161, 164, 166, 171, 176, 178, 179, 182, 185, 186, 187, 188, 189, 190, 194, 197, 199, 204, 206, 209, 211, 213, 217, 220, 221, 224, 226, 232, 233, 234, 235, 237, 240, 241, 243, 246, 247, 248, 250, 256, 259, 260, 263, 273, 276, 278, 279, 282, 411, 425, 426, 427, 430, 453, 454, 561, 562, 601; Holton, George, New York, 50; Hornung, Professor Erik, Basel, 94; Hurlimann, Martin, Zurich, 458; Istituto per la Collaborazione Culturale, Rome, 148; Istituto di Etruscologia e Antichità Italiche, Università di Roma, 294; Kaster, Mr. Gert, 245; Kelemen, Pal, 67; Kersting, A. F., London, 469, 476, 555, 585; Kessel, Dmitri, Paris, 1, 162; Studio Koppermann, Gauting, Germany, 201, 202, 215; Lampl, 394 (adapted from J. W. Crowfoot), 395 (adapted from J. C. M. Toynbee and J. B. Ward Perkins); Mannino, Giovanni, Rome, 26; Bildarchiv Foto Marburg, Marburg/Lahn, Germany, 90, 99, 254, 275, 308, 501, 512, 549, 558, 559, 574, 575, 586, 590, 591, 595, 599, 603, 608, 609, 611, 612, 613, 619; Mariani, Enrico, Como, 477; Markowski, Eugene D., 368; Marzari, P., Milan, 348; MAS, Barcelona, 10, 473, 479, 536, 564, 565, 621; Matt, Leonard von, Buochs, Switzerland, 167, 320; Mellaart, James, London, 29, 30, 31, 32, 33; Metropolitan Museum of Art, New York, Egyptian Expedition, 113; Meyer, Erwin, Vienna, 331; Mills, Charles, Philadelphia, 129; Ministry of Public Building and Works, London, 37, 38; Musées de la Ville de Strasbourg, France, 620; Museum of the American Indian, Heye Foundation, New York, 51; Museum of Fine Arts, Boston, Harvard-Boston Expedition, 100; Museum voor Land- en Volkenkunde de Rotterdam, courtesy Mr. René Wassing, 46; Mylonas, Professor G. E., Athens, 177; National Monuments Record, London, 623, 624, 625; Ohio Historical Society, Marietta, 52; Oriental Institute, University of Chicago, 128, 138, 139, 141, 149, 150; Peabody Museum, Harvard University, Cambridge, Massachusetts, 61, 65; Percheron, René, Puteaux, France, 475; Pericot-Garcia, Galloway and Lommel, Prehistoric and Primitive Art, © 1967 by Sansoni Editore, Florence, 18; Perkins, J. B. Ward, 316, 319, 334, 379; Pickard, Theatre of Dionysus in Athens, Cambridge, 257; Pontificia Commissione di Archittetura Sacra, Vatican City, Rome, 396, 397; Powell, Josephine, Rome, 225, 227, 317, 443, 444, 445, 451; Proskouriakoff, Tatiana, An Album of Maya Architecture, 1946, The Carnegie Institution of Washington, D.C., 60; Rémy, Dijon, 567; Rheinisches Bildarchiv, Cologne, 509, 516, 615; Rheinisches Landesmuseum, Trier, 391, 392; Roos, George, New York, 393; Foto Rosso, Turin, 142; Sansoni Editore, Florence, 25; Scala Fine Arts Publishers, Inc., 80, 423, 540; Schmidt-Glassner, Helga, Stuttgart, 332; Service de Documentation Photographique de la Réunion des Musées Nationaux, Paris, 134; Smith, Edwin, Essex, England, 145; Smith, G. E. Kidder, New York, 110, 353, 366, 389, 429, 474; Soprintendenza alle Antichità, Rome, 280; Sovfoto, New York, 460; Staatsbibliothek Preussischer Kulturbesitz, Berlin, 371; Stierlin, Henri, Geneva, 62, 74; Stoedtner, Dr. Franz, Düsseldorf, 198; T.A.P., Athens, 184; Tasic, D., Belgrade, 452; Taylor & Dull, Inc., New York, 47; Uht, Charles, New York, 42; United States Department of the Interior, Washington, D.C., 53; Foto Vaghi, Parma, 548; Vertut, Jean, Issy-les-Moulineaux, France, 20; © H. Villani e Figli, Bologna, 237; Ward, Clarence, Oberlin, 597, 600; Webb, John, London, 627; Wehmeyer, Hermann, Hildesheim, 511, 513, 514, 515; Yugoslav Tourist Office, New York, 386.